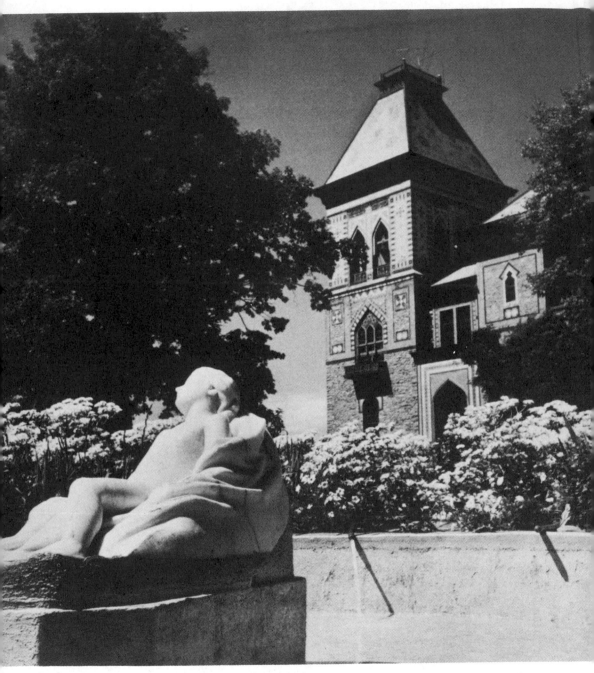

Olana, the residence of the painter FREDERIC E. CHURCH, designed by him with the aid of CALVERT VAUX, architect, and built in the 1870s at Hudson, N.Y. (*Photo Russell Lynes*)

THE ART-MAKERS

An Informal History of Painting,
Sculpture and Architecture
in Nineteenth-Century America

Russell Lynes

DOVER PUBLICATIONS, INC.
NEW YORK

Published in Canada by General Publishing Company, Ltd.,
30 Lesmill Road, Don Mills, Toronto, Ontario.
Published in the United Kingdom by Constable and Company,
Ltd., 10 Orange Street, London WC2H 7EG.

This Dover edition, first published in 1982, is an unabridged,
slightly corrected republication of the work first published in
1970 by Atheneum, New York, under the title *The Art-Makers of
Nineteenth-Century America.*

Manufactured in the United States of America
Dover Publications, Inc.
180 Varick Street
New York, N.Y. 10014

Library of Congress Cataloging in Publication Data

Lynes, Russell, 1910-
The art-makers.

Reprint. Originally published: The art-makers of nineteenth-
century America. 1st ed. New York: Atheneum, 1970.
Bibliography: p.
Includes index.
1. Art, American. 2. Art, Modern—19th century—United
States. I. Title.
[N6510.L95 1982] 709'.73 81-17359
ISBN 0-486-24239-0 AACR2

TO

KATHERINE GAUSS JACKSON

CONTENTS

ILLUSTRATIONS

THE ART-MAKERS

1

A POINT OF DEPARTURE

". . . the elements of creative vitality in American civilization matter a great deal, not only to Americans but to other people as well."
JOHN A. KOUWENHOVEN in
Made in America, 1948

It took nerve and a certain gall to set out to be an art-maker in the early years of the nineteenth century, but men who are determined to be artists are difficult to distract from their purpose. They can, furthermore, be as matter-of-fact as any businessman when it comes to a bargain and as tough as any trade association or craft union when they band together in their own interests. They are just as likely as other men to engage in politicking and to make divisive factions in their own ranks. They fight not just for their rights but for their aesthetic beliefs, and they are not soft on those who happen to come along with new ideas that challenge their well-tried ones.

There was, however, a very great difference between the attitude of the artist toward the society in which he lived in the early 1800s and the attitude of the artist in revolt against society in the late nineteenth century in Europe and in the twentieth in America. The artist wanted to become a part of society, not a thorn in its flesh. He wanted by any means he could to warm the climate of the arts in a civilization that he looked upon as primarily commercial and whose sights he believed he could help to raise to higher things. Furthermore, he wanted to be as good as other people, socially as acceptable in the parlors of the prosperous as any frock-coated

politician or banker or real-estate operator. The spectacle of the artist trying to make himself socially acceptable is one that can be watched far into the century.

There were more basic concerns to which he devoted himself. First was his craft, his determination to master his tools and then to invent personal ways of using them. Again and again the art-maker was also an inventor— sometimes, as in the cases of Samuel F. B. Morse and Robert Fulton, of very great importance, but most often a lesser inventor with what was regarded as a characteristic Yankee talent for tinkering and gadget-making. While he started with craftsmanship, he aspired to make art of a noble sort, to rival the great artists of the past, whose work he knew almost entirely from such engravings as had been imported to these shores. There were no Old Masters here and only a few respectable copies of such treasures. There were, moreover, almost no other art-makers who had had the opportunity to study in the great European centers of art and could tell him how to set his palette, use a glaze, or create a flesh tone. Very early on, any artist who could persuade a parent, a friend, or a patron to send him sailed for London, then considered the art capital of Europe by Americans. As often as not he came home ready to set the new republic afire with his art, only to see his ambitious flames quenched by icy indifference.

The tenacity of those early artists was intense, and gradually they saw the climate grow warmer. Their aspirations changed because there were opportunities to ornament the young nation with their pictures and sculptures and decorative arts. From merely breaking ice they turned to making receptive hearts warm to their aspirations and sensitive to their observations. They began to render into paint and marble the heroes of the Revolution on an heroic scale; they turned their firmly controlled hands to depicting the bucolic beauties of the Eastern landscape or the fierce Western wildness, to creating nostalgia for open spaces in a society that was turning from the land to the cities. They tried to transplant the glories in sculpture and architecture of ancient democracies and make them root in an alien soil that finally rejected them for something no more appropriate—a babel of styles from Egyptian to rococo.

It is not the purpose of this book to trace in detail the development of all of the arts of the nineteenth century in America, but rather to show how the art-makers worked to change the climate of the arts, how they went about their daily business, how they struggled to give their craft the stature of a profession and their personal self-esteem the status of respectability and honor in a community dominated by commerce.

In order to do this I have chosen many of the most prominent figures of

the century, but I have omitted others the quality of whose work would demand that they be included in a comprehensive or even a just history of American painting, sculpture, architecture, and the decorative arts. The reader will find only a mention of one of our greatest artists, John James Audubon, because in the context of this book he is more naturalist than art-maker. George Catlin, the painter of our Western Indians, gets short shrift because he is more anthropologist than art-maker, or so it seems to me. Still-life occupies only a small place in this account, not because there were not remarkable still-life painters like Raphaelle Peale and William Harnett, but because they stand aside from my intention. I also bypass most of the famous illustrators such as Frederic Remington and Edwin Abbey, though Winslow Homer, the greatest of them all, is here because he was also in some respects our greatest art-maker. So far as the popular visual arts are concerned (those most aptly characterized by the productions of firms like Currier & Ives of New York) I have walked around them here because I dealt with them at some length in *The Tastemakers*, a book concerned with popular taste and culture. I have ignored what we are pleased to call the "primitives" because my concern here is with self-conscious and tutored art-making and not with untrained and unsophisticated amateurs, fascinating and important though they often are in the context of our total productivity. Obviously, omission here is most assuredly not condemnation. Far from it.

There is an almost irresistible urge on the part of historians to discover what is essentially American about the art of our native sculptors and painters and architects and the designers of the decorative arts. An urge that runs parallel to this is the desire to pin down in specific ways the influences of Europe, most especially, and the Orient on what was produced in American studios. This is an interesting game but, I think, a rather fruitless one except as an academic exercise. The American artists who are the most interesting to us (and I suppose I mean to me) are those who are the most individual—those who have a vision that is their own, no matter what influences may have helped to create it.

No artist finds the way to his own style without trying the styles of others, without some awareness of what has come before (even if he rejects it), and since awareness is his principal virtue, he cannot but absorb what, as he grows, he has fixed his searching eye upon. The artists who seem to us least American are, I believe, those who never managed to work their way through the things that other people had made into art and reach the point where they could see for themselves. There are, let it be said, never a great many men in any century or country who see for themselves and, seeing, can

both use what others have seen and see through it to announce their own clear vision. What is American about Winslow Homer or Thomas Cole or Thomas Eakins, or about Louis Sullivan or H. H. Richardson or Louis Comfort Tiffany, is interesting to quibble about, but it is their individuality, not their nationality, that makes them artists of the first rank.

There is, obviously, a kind of chauvinism which makes us want to emphasize the American characteristics of our artists, a "Look, we're not so bad after all" attitude which hangs over from our nineteenth-century feelings of cultural provincialism. But now that New York is the cultural capital of the world (or, to be more modest about it and probably more realistic, where "the action" is) and it is to our shores that European artists want to come, it seems to me that we do not need to worry about our past but can look at it merely for whatever enjoyment and enlightenment we may find in it.

I invite you, then, to start with me on a journey through the nineteenth century, approached by an eighteenth-century driveway, that begins in a cold climate and ends in a burst of fireworks on the shores of Lake Michigan. I trust that you will find the sights along the route (which occasionally doubles back on itself) interesting if not always attractive, and the people talented if only rarely of the stature of genius.

2

ART IN A COLD CLIMATE

". . . the time had scarcely arrived when the
superstructure of the beautiful could be reared."
HENRY T. TUCKERMAN in
Book of the Artists, 1867

Trying to carve a place for the arts in the hearts of one's countrymen in America in 1800 was like chipping a statue out of a block of ice. It was a cold, hard thing to start with, and you could see what you had been to so much trouble to make melt before your eyes as soon as it took shape. It was a very rare citizen of the young republic who gave art a second thought, because almost no one gave it a first thought. Architecture, of course, had its place in the rapidly expanding cities (though there were almost no professional architects) and furniture was an essential to all houses (and there were a good many cabinetmakers to meet the demand, some of them very sophisticated and, unlike the architects, thoroughly professional). But painting was a frivolous stepchild to business-minded Americans, except for store and tavern signs and an occasional portrait, and sculpture was suitable only to ornament the figureheads of the ships that made commerce in Boston and New York and Philadelphia whirl as it had never whirled before.

On July 10, 1804, the New York *Commercial Advertiser*, somehow conscious of a public responsibility, treated its readers to a slight lecture on art. It is unlikely that many men looked away from the business reports to read it, but if they brought the paper home to their wives, it is possible that

the ladies scanned it in their parlors. A critic, if that is what he was, writing under the pseudonym of "Clio," tried to put as good a face as possible on public indifference by heading his article "Progress in Art," but his remarks hardly supported his optimism. "No one who has a partial knowledge of our history," he wrote,

> will be surprised to hear that the arts are in their infancy among us. They have taken a goodly nap on this side [of] the water. . . . As it respects learning and wealth, we are fast emerging from darkness to light. From this happy circumstance it may fairly be calculated, that our progress in the arts will be in just proportion to our advancement in the sciences.

The "goodly nap" was far from over, but even so there had been frequent attempts to shake the sleeping arts awake—frequent but scarcely effective. Sometimes the attempts had foundered on the craggy rocks of prudery (especially, it seems, in Philadelphia), sometimes on the slippery reefs of pious sentiment. Occasionally it was the art-makers themselves who split into factions and railed at one another, and their quarrels hampered what Clio called "progress." Sometimes it was gentlemen who considered themselves patrons of the arts but who, because they were managers and merchants at heart, were the unwitting villains: their professions of devotion to the arts did not include devotion to artists, on whom they not only looked down socially but whom, for moral reasons, they regarded with uneasiness and suspicion. The principal enemy of the arts as the century opened, however, was the hoary enemy that artists were still trying to tame as the century closed. Today we call it materialism; Thomas Cole, the gentle father of American landscape painting, called the enemy "the tide of utility" which, he said, "sets against the fine arts."

The nation when it was young was so busy with commercial matters, was spilling so fast across its own forests and prairies and mountains and reaching out so far across the seas, that it had little time, energy, or interest to spare for what were generally considered to be cultural frills better left to a decadent Europe. It was not until the century was three-quarters gone that universities paid any attention to the fine arts or thought their study worthy of being an academic discipline, and art first turned up in schools as an adjunct to the textile business because the New England manufacturers needed designers. The wonder is not that the infant arts fared so poorly in the early years of the century but that they managed, with whatever desperation, to survive at all in such a climate and grow into a robust, respected, respectable, and often distinguished adulthood.

The climate in which they started was scarcely conducive to great achievements. An English painter, Francis Guy, who came to America in 1790 and produced landscapes which he was accused of plagiarizing from Claude and cityscapes (especially a delightful New York waterfront scene in the collection of the New-York Historical Society), called us a "sly, say-nothing, smiling, deep speculating, money-hunting, negro driving, cow-skin republic." There was more than a grain of truth in what he said. The British, and especially Mrs. Frances Trollope, the heartily disliked author of *Domestic Manners of the Americans* (she often cut too close to the bone for comfort), could not abide our doctrine of free-and-equal. She called it a "mischievous sophistry," and she believed that only out of an aristocratic society with proper aristocratic patrons could the arts grow and prosper, an opinion she shared, indeed, with our most autocratic "Old Master," Colonel John Trumbull. The truth of the matter was that painters had only one sure way of making a living, and that was to paint flattering portraits for men and women who wished to enrich their parlor walls with their own features or for those who, because of personal or public reasons, wished to buy portraits of national heroes. Artists had their ways of supplementing their portrait incomes, usually minor ways. A number of painters, like Francis Guy, came from Europe and painted landscapes and still-lifes and found a market for them among the prosperous. Guy is said to have sold more than three hundred views and seascapes, mostly in Baltimore (referred to by a woman journalist of that city in 1809 as "the Siberia of the arts"), where he worked for about twenty years. But there were also "history pictures," as they were called—often large canvases of mythological or religious subjects or of battles, which the public might possibly be induced to pay admission to see. But for the most part the tiresome business of turning out portraits, sometimes several a week at $15 a head, was the art-maker's bread and butter.

That is not to say that there were not art-makers who tried desperately to convince their compatriots that art was not just faces and places but an ennobling activity in which the young republic should be encouraged to involve itself. The practical attitude of most Americans toward art was succinctly put by the father of Matthew Harris Jouett, a successful portraitist in the first decades of the century. "I sent Matthew to college to make a gentleman of him," he said, "and he has turned out to be nothing but a damned sign painter." Many years later the verbose and tiresome (but also indispensable) critic and historian of our early painters, Henry T. Tuckerman, when writing about the once distinguished and reasonably prosperous artist John Vanderlyn, who died penniless in a tavern in 1852,

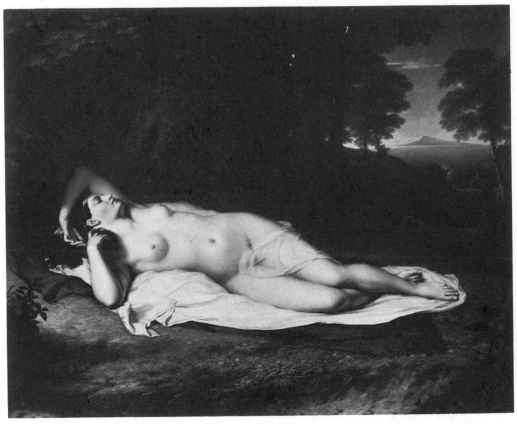

JOHN VANDERLYN, who painted his now famous (then notorious) "Ariadne Asleep on the Island of Naxos" in 1814, was the first American painter to study in Paris. "Ariadne" was considered by Americans an example of French depravity. (*The Pennsylvania Academy of the Fine Arts, Philadelphia*)

speaks of "the antagonism between an essentially practical community . . . and artistic enthusiasm." It was the familiar conflict between art and materialism that had, he contended, ruined Vanderlyn's extremely promising career. "Utility, the basis of national growth still demanded an exclusive regard," he wrote; "the time had scarcely arrived when the superstructure of the beautiful could be reared."

The idea that art was a superstructure on top of commerce rather than an essential part of the edifice of a culture was strong in the nineteenth century. It showed as plain as day in the romanticism and frivolities of architecture—the houses built to look like little temples or like Gothic

parish churches or like châteaux on the banks of the Loire. It showed in furniture that was appliquéd with carved griffins and fruits and roses, and in parlors set about with bric-à-brac and gewgaws that Mrs. Trollope called "coxcomalities" and we call clutter. The veneer of the "beautiful" had little to do with the realities of life or, indeed, with the moral, political, or intellectual substructure of the nation.

But there were some serious, hard-working art-makers who did not like to be merely icing on the public cake and who tried to construct a foundation on which the arts could stand firm, kneaded in, as it were, to the dough of society. It was not that they quarreled with "the superstructure of the beautiful"—far from it. They would have been enchanted to dress materialism in silks and laces, so to speak, but they wanted the "beautiful" to be something that was demanded at a time when in fact it was barely tolerated. Their methods of converting philistines into art-lovers were ingenious even though they often met with frustration. The art-makers were a dogged lot.

AN EIGHTEENTH-CENTURY PRELUDE

It was well before the turn of the century that the art-makers commenced their assault. Even before the Revolution a few distinguished painters had thrown up their hands at their fellow colonials' concerted indifference to art and, quite naturally, had gone to the capital city of the Empire to seek their fortunes. John Singleton Copley of Boston, who has sometimes (and it seems unjustly) been accused of running away from the Revolution, left for London just before hostilities broke out. He was surely the most distinguished portraitist America produced until Thomas Eakins emerged about a century after the Revolution, but he insisted that, with all his skill, he could not make a decent living for his aristocratic wife and several children in Boston. Benjamin West of Philadelphia left even earlier. An ambitious young man who wanted to be at the heart of the matter of art-making, he set himself up in London, where he became one of the founders of the Royal Academy and succeeded Sir Joshua Reynolds as its president.

There were also those who stayed home and dug in. Without their determination to make the artist a man to be reckoned with in the young republic, the American art-maker could not have risen as he did from modest craftsman to powerful tastemaker in the course of a century. One of these

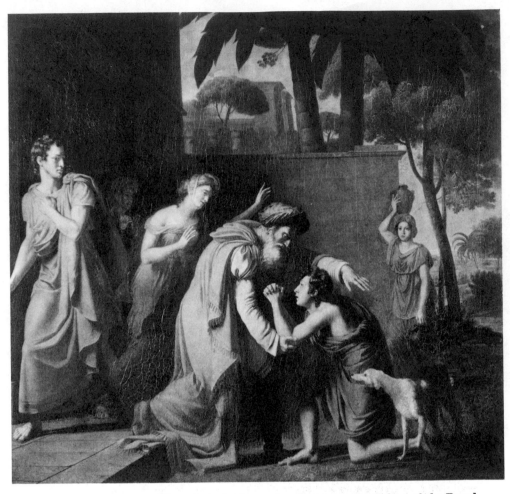

BENJAMIN WEST, born in Pennsylvania, became president of the Royal Academy in London. To his studio a generation of young American artists went for inspiration and instruction. He painted this characteristic "Return of the Prodigal Son" in the 1770s. (*The Metropolitan Museum of Art, Maria De Witt Jesup Fund, 1923*)

men in particular, Charles Willson Peale, was stage center when the play opened, and the drama of what happened to the arts in the nineteenth century cannot be adequately unfolded without something more than a glimpse of his imposing figure. He was a man with a characteristically eighteenth-century attitude toward the arts and sciences, but he had a vision that carried his influence far into the nineteenth century.

Peale was a maker by temperament, manual dexterity, and inventiveness. There was scarcely anything, from saddles to clocks, from paintings to stoves and steam baths and false teeth, that he did not set his mind and hand to construct and improve upon. He wrote essays on farming and bridge building and preventive medicine. He was a correspondent of the most famous naturalists of his time, a friend of Benjamin Franklin and Thomas Jefferson, and General Washington sat to him fourteen times—a good many more than that President, beleaguered by artists, sat to anyone else. He was a remarkable dilettante in the eighteenth-century sense of that word, a man who delighted seriously in the arts and sciences both practical and philosophical, contributed to them, and worried about their well-being.

It was on art, however, that Peale depended for his living, and it was on the shape of the arts in America that he most emphatically left his influence. Like many another young painter of the time who showed talent as a youth, he found a sponsor in his native Maryland to send him in 1767 to England, where he studied in Benjamin West's studio. He returned after two years with a style somewhat less stiff and more elegant than that of most of his American contemporaries, but not so fluid as the fashionable style was soon to become in the hands of more facile artists such as Gilbert Stuart and the prolific and charming Thomas Sully.

Not long after he got back from England, Peale decided Philadelphia was the likeliest place to find sitters for his miniatures and portraits. A town of about 25,000 souls, Philadelphia had a reputation for aristocratic culture, and it seemed to Peale that here he might be able not only to cultivate his own career but to foster the careers and elevate the status of his fellow artists.

In 1782, the year after Cornwallis had surrendered his armies at Yorktown and the shooting was over for good, Peale opened a picture gallery next to his house. In it he hung his large portraits of the "principal American characters who appeared upon the stage during the late revolution" in the hope of attracting portrait commissions. Peale believed that, as he declared, "the people here have a growing taste for the arts, and are becoming more and more fond of encouraging their progress amongst them." But to make sure that "the people" came to his gallery he added other attractions. With the encouragement of Franklin the gallery became an extraordinary "repository for natural curiosities." It displayed more than 100,000 beasts and fish and other specimens and the bones of a mastodon which Peale had exhumed (an occasion of which he had painted a delightful picture, "The Exhuming of the Mastodon"). This was the first important museum and the very first picture gallery on this continent, but

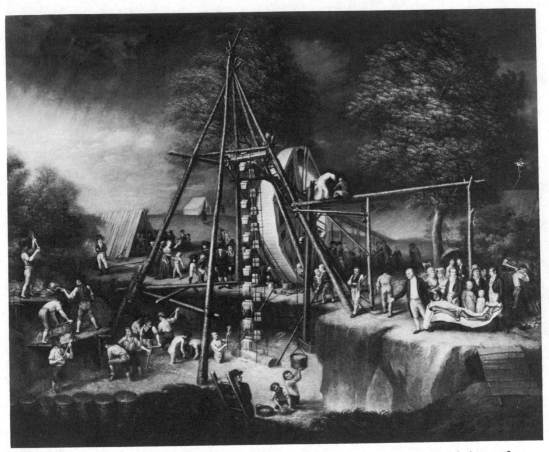

CHARLES WILLSON PEALE, showman, soldier, inventor, scientist, and art-maker, painted "The Exhuming of the Mastodon" in about 1807. The bones of the beast were found near Newburgh, N.Y., and Peale supervised their recovery. (*The Peale Museum, Baltimore*)

six years after it opened it had not matched Peale's financial hopes for it. "I now find it necessary to travel to get business in the portrait line to maintain my family, which is not small," * he wrote to Benjamin West in London. "I mention these things to show you that the state of the arts in America is not very favorable at the moment."

Peale was not the sort of man to let the situation go at that, and he assaulted indifference to the arts on several other fronts. There were in Philadelphia at that time a number of French and English artists who had

* Peale had seventeen children, eleven of whom lived to adulthood. He was married three times.

come to peddle their presumably sophisticated wares and who, in the manner of European artists for the next 150 years, were scornful of American taste and more especially of the ways of American artists. What was a city without an art school? they wanted to know. And a city without a gallery where the genteel members of the community could examine the products of a variety of brushes? Peale, rather than quarreling with them, tried to get them to join with native artists in a scheme to organize an art school and gallery. But they evidently enjoyed quarreling more than they enjoyed improving the situation they vilified, and the result was an explosion. When the artists stopped shouting at each other, they took to castigating each other in the newspapers with relish. As a result, the plan was temporarily —but only temporarily—abandoned. Peale, who was not inclined to give up a project that he thought might contribute to the public welfare just because of a few bursts of temperament, regrouped his forces once the recriminations had died down. The effort and the patience were worth the trouble. The result was the Columbianum, an organization made up about equally of professional artists and amateurs of the arts.

The Columbianum was quite unlike anything that had been seen on this continent before, and its progeny are with us today in museums and art schools and (to stretch the concept a little) cultural centers. The Columbianum (also called the Association of Artists of Philadelphia) introduced two new elements into the life of the arts in America. In 1795 it opened an art school in Philosophical Hall with classes in painting, perspective, anatomy, and paint chemistry, and in the spring of the following year it held the first public exhibition of works by a group of native artists ever to be examined by the prototypes of today's art-lovers. The school also had a small collection of casts of classical sculptures from which the students might draw. It included a small "Venus de Medici," which because of her nudity had to be kept in a cupboard except when a professional artist, working entirely by himself, might be permitted to contemplate and draw her.

The necessity of secreting the Venus should have warned Peale that an attempt to introduce life classes would call down wrath on his head, and when he proposed such an astonishing innovation at a meeting of the Association of Artists, a group of wealthy young men who were members stomped out in protest, insisting that the proposal was "inconsistent and indecent." Unshaken by this display of what he considered nonsensical behavior, Peale proceeded with his plan. Unable to find a male model to pose in the nude, he posed himself.

So much for the art school. The scandal created by Peale's exposure

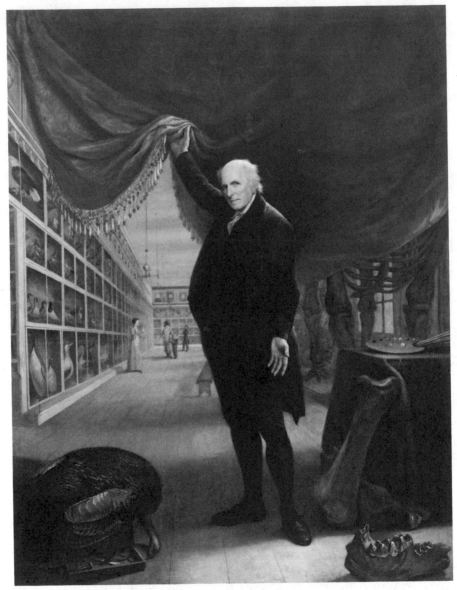

CHARLES WILLSON PEALE painted this portrait of himself in his
museum—a vast collection of specimens and portraits of heroes of the
Revolution. Part of the reconstructed mastodon can be seen behind
him at the right. (*The Pennsylvania Academy of the Fine Arts,
Philadelphia*)

closed it. Prudery was an attribute not limited to Philadelphians, but they somehow managed to make more of an issue of it than the citizens of most cities. Ninety years later Thomas Eakins, surely the most distinguished artist Philadelphia has ever produced, was forced to resign his post in the Pennsylvania Academy of the Fine Arts because of his insistence on teaching his students to draw from the nude.

THE BEGINNING OF THE THAW

Peale's efforts to improve the climate of the arts at the end of the eighteenth century had reduced the chill a little, and if Philadelphia was the acknowledged center of art in America when the nineteenth century arrived, he was as responsible as anyone for giving the city that distinction. But cultural moods moved slowly then, as people moved slowly by horse-drawn conveyances, and it took many years for the warmth to spread to New York and even longer to Boston. When John Wesley Jarvis, an able portrait painter and a free spirit, moved from Philadelphia to New York in 1805, he found the arts in a parlous state in the bustling city that was growing so fast it could scarcely hear itself think because of the noise of hammers and saws. Some years later he recalled modestly, "I was the best painter [in New York] because the others were worse than bad—so *bad* was the best." Boston, as Copley had discovered some years before, was even less hospitable to artists than New York (it had not yet come to the conclusion that it was "the hub of the universe"), and painters who tried to make a living there drifted away to other cities. Even the popular Sully found it "a sad place for an artist," and the critic James Jackson Jarves, looking back from the middle of the century to its beginnings when Washington Allston, though extravagantly admired elsewhere, was largely ignored there, spoke with scorn of "the aesthetic chill of Boston."

There were stirrings nonetheless. The art-makers were determined to establish themselves as something more than artisans who could be hired like pieceworkers to turn out goods acceptable to the vanity of the people who sat to them—merchants and importers and landed gentry and their wives. They were also determined to make the arts as respectable in America as in Europe and artists as acceptable in drawing rooms as anyone who was looked up to for his wealth or station. It was Europe, of course, that

provided them with the only models of patronage they knew. A great many of them had been there—especially in England—and they had seen for themselves that their ex-compatriot Benjamin West was a friend of the king and was sought after by dukes and duchesses. Such models of patronage were not, of course, suited to the kind of exuberant republicanism that, in James Fenimore Cooper's view, was to make everybody think himself a connoisseur just because, since he was "everyman's equal," he ought to have an opinion about art as well as about politics.

There was, however, money in several tills into which the artist might dip his hand if he were clever enough. His problem was to get access to them, and since those who were their proprietors were not in the least likely to go looking for artists, the artist had to find ways to make himself invitingly conspicuous. One of these tills was then (as it is in a niggardly way today) the federal government. It had a Capitol in the process of being built, and the seat of government deserved to be embellished with paintings of scenes of great historical significance. Assaults on this bastion met, as we shall see in a later chapter, with only moderate success. The art-makers soon learned that government patronage in a republic was very different from what one could expect of a monarch. Another target was the rapidly rising class of moneyed merchants who might be cajoled and flattered into becoming patrons of the arts, but even when they succumbed to the blandishments of the muses they were very different from an aristocracy that had lived long with the arts and felt at home in their company. Finally, there were folk living in distant parts of the country in clapboard and log communities with tree stumps in the dooryards and dirt roads often churned into mud; their only acquaintance with art in any form was the sight of an occasional engraving of an Old Master or the handiwork of an itinerant limner who carried his tools with him, paused a few days or a few weeks to saturate the local market with glum visages against murky backgrounds, and then moved on.

Here, then, were the targets—the government, the new rich, and "the people"—and to score on any of them the artist needed to find ways of doing more than just make the arts attractive; he needed to make a claim on the public's conscience. He needed to raise its sights, the level of its taste, and the extent of its belief in the value of the arts to society. To use a current cliché, the first thing he must have was "exposure." He needed to be conspicuous, and his work, if not he himself, must be fashionable.

Peale in Philadelphia had paved the way for public exhibitions of groups of paintings. He, as no one else, had attacked the problem of making the arts respectable and their cultivation the province of the prosperous

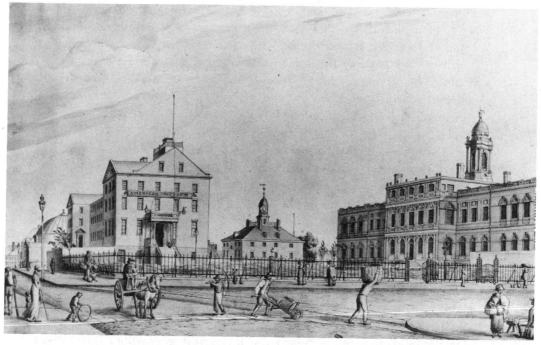

In the 1820s ARTHUR J. STANSBURY painted this watercolor of New York's art and political center. The back of the City Hall is at the right, the American Museum (formerly the "Old Almshouse") in the center, and Vanderlyn's Rotunda in the back on the left. (*Museum of the City of New York*)

members of the community, and while he may have shocked a portion of the citizenry with his teaching techniques, he had pleased a great many with his Columbianum exhibition and made some converts to his cause. Even though his attempt to found a permanent academy of artists and amateurs had died ("I endeavored for some time," he wrote his friend Thomas Jefferson, "to keep it alive as a tender beautiful plant"), he had set a pattern to be followed soon in New York, revived in Philadelphia, and copied some years later in Boston. Museums of art were another matter. The first institution that could properly be given that name, the Metropolitan Museum of Art in New York, was not to open its doors, in a former dancing academy at Fifth Avenue and 53rd Street, until the century was nearly three-quarters gone.

The first forthright attempt to grasp the New York public by the lapel and lead it to art took place in the summer of 1802 with an ambitious exhibition. It was held at 80 Greenwich Street in a building called the

Pantheon, which housed, along with the City Museum, several rooms called the Columbian Gallery. There were some two hundred pictures in the show, many of them prints bearing the lordly names of masters whose originals had never been seen on this side of the Atlantic. There were works attributed to Van Dyck, Romney, Rubens, and Salvator Rosa; there were a self-portrait by Benjamin West and a group of paintings by a number of American portraitists, including Edward Savage, who, in fact, put on the exhibition.

Savage announced the occasion in the New York *Mercantile Advertiser*. "This elegant place of genteel resort," his notice read, "is repleat with objects highly gratifying to every rank of citizens; they are displayed together with valuable collections of curiosities of nature, the elegancies of art, in the richest collection of valuable paintings ever exhibited on the shores of Columbia." Mr. Savage, who had become well known for a portrait of the Washington family that he had painted in 1796, charged admission to the gallery—"25¢, children half price. Annual ticket at two dollars." The use of "curiosities of nature" (two-headed calves, "mermaids," and the like) as bait to get the public to look at art became a standard practice most extravagantly exploited by the great Phineas T. Barnum in his museum in New York in the next generation. But Savage was primarily interested in art, and his exhibition provoked just the sort of response he must have hoped for. A writer who called himself "an admirer of the polite arts" reviewed the exhibition largely with enthusiasm, preceding his encomiums and his reservations with a note that "Philadelphia boasts a museum, so I trust will New York under the fostering hands of its citizens." He ended his comments with: "One word, however, to the proprietor of the Gallery. His best pictures are placed so low as to render it impossible to have a good view of them without lying flat on the floor. . . ."

There is no record of how many ladies in bonnets, dragging reluctant children, or how many gentlemen in tall hats, truant from their counting rooms, rose to Mr. Savage's genteel bait of elegancies and curiosities. Though it was addressed, he said, "to every rank of citizens," it was obviously aimed at the prosperous who might be beguiled into having their portraits painted or, better yet, buying art of a more adventurous nature for their parlors. The exhibition certainly did not herald a series of such shows, nor did it promote a new class of collectors or make the market for art look promising for dealers. Possibly it encouraged a few young ladies to join the art classes of John Wesley Jarvis, who announced in the *Mercantile Advertiser* at just about the same time the opening of a "drawing school" on William Street, "where Young Ladies and Gentlemen may be taught to

draw in India Ink, Colours, Chalk, on paper, satin, vellum &c or to paint in oil on canvas." He charged a dollar each for private lessons and six dollars per quarter for two-hour classes, five days a week. Alexander Robertson, a portrait painter from Scotland, also had an "academy" for drawing classes, and he specialized in importing the latest designs from London. It was possible, in other words, for the aspiring artist whose imagination might have been inflamed by what he saw at Savage's exhibition to find some form of instruction. Few young men thought there was a future in art, and most of the pupils were genteel young ladies waiting for matrimony.

IN PURSUIT OF THE PUBLIC

In the early, aesthetically (and for painters economically) chilly years of the century, artists had to fend for themselves. There were no dealers, and not until nearly the middle of the century, when the Art Union was organized to popularize and distribute paintings and prints and a few framers showed pictures, was there anyone to act as middleman between the artist and his clients. Jarvis and his partner Joseph Wood were not alone when they addressed to "the ladies and gentlemen of New York" an offer to "execute likenesses for two shillings each, either on glass or paper" with a gadget called a physionotrace, and added, "No likeness no pay." In other words, any way to make a shilling was looked upon with favor, and the competition was often fierce. Many painters traveled to the back country, as Peale had had to do, in order to find portrait clients, and they frequently discovered that some other limner had got to town just ahead of them and skimmed the cream off the market. When, for instance, Samuel F. B. Morse was a young man just returned in 1815 from studying in West's studio in London (it was some years later that he revolutionized communications with the invention of the electric telegraph), he soon ran headlong into competition with the skillful and cantankerous Gilbert Stuart in Boston, found that it was too much for him, and headed for Concord, New Hampshire. He reported to his family from there that he had painted five likenesses at $1 apiece in just eight days, but when he got to the town of Walpole he wrote, "the quacks have been here before me." This particular private till was a tiresome one for the art-makers to plunder.

In any case, it was not the way to aesthetic salvation or to the estab-

lishment of the fine arts in their rightful place in the cultural spectrum of the young republic, nor was it one of the avenues to the cultivation of the public sensibilities. Very few painters who had any aspirations to being more than mere journeyman art-makers did not struggle to emulate the European masters in the creation of what were loosely classified as "history" paintings. "History" encompassed everything, or almost everything, that was considered high and noble for the artist to achieve. It included such anecdotal works as West's "King Alfred Sharing His Last Loaf with the Pilgrim" and religious subjects like Washington Allston's "Dead Man Revived by Touching the Bones of the Prophet Elisha" and classical subjects like his "Jason Returning to Demand His Father's Kingdom." It included romanticized reportage such as Copley's painting of the rescue of Brook Watson from the jaws of a shark (he lost one leg) in Havana harbor, scenes from Shakespeare, battles of the Revolution, an eerie landscape strewn with corpses as in Joshua Shaw's "The Deluge," and such allegorical subjects as the vast "Court of Death" by Rembrandt Peale, one of Charles Willson Peale's three painter sons.

In England such paintings were the main attractions of the Royal Academy exhibitions, but there was almost no market for them in America. Very nearly the only way American painters could hope to be repaid, even partially, for having set their sights on "high art" of this sort was to charge admission to the public to view their masterpieces. This income was sometimes further supplemented by paying an engraver to make a large plate of the painting for which the artist then, hopefully, found subscribers.

The most spectacular success of any painting thus exhibited and engraved was Rembrandt Peale's "The Court of Death," and its origins and its popularity are worth looking at less for what they tell us about art than for what they have to say about the critics and the public and the sentiment and piety of the times.

Rembrandt was obscured somewhat by the shadow of his eminent father. He painted portraits in America and in Europe for his father's museum, helped him with the exhumation of the mastodon, with its installation, and with carving substitutes for missing bones. Like other portrait painters of his day, he moved from city to city looking for clients, and in 1811 he opened Rembrandt's Picture Gallery in Philadelphia. (He was tired of being confused with all the other Peales—his father, his uncle, and his two brothers, Raphaelle and Titian—who were also painters, and for a time he dropped the family name.) His Philadelphia venture was not a success, and with his younger brother Rubens he moved to Baltimore in 1814 and opened a picture gallery and museum of natural history which he

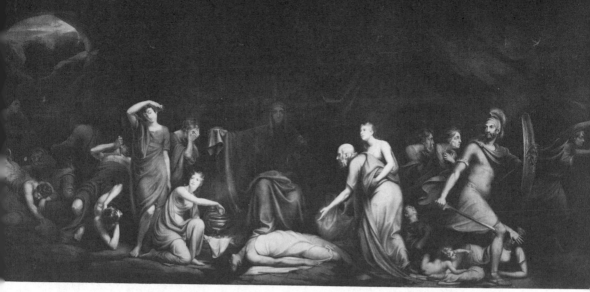

REMBRANDT PEALE'S "The Court of Death" (1808) traveled for years from city to city, and crowds paid to view it. Engravings of it hung in many thousands of parlors—possibly the most over-exposed picture of the century. (*The Detroit Institute of Arts*)

For many years JOSHUA SHAW's "The Deluge" was attributed to Washington Allston—not unreasonable because of its mood and manner and because it had once belonged to Allston's father. (*The Metropolitan Museum of Art, gift of William Merritt Chase, 1909*)

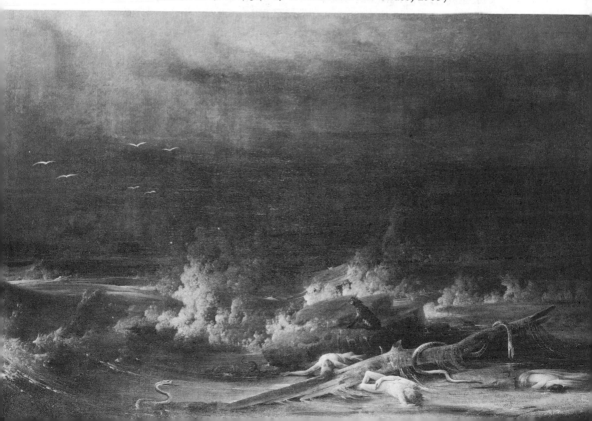

advertised as an "elegant Rendezvous for taste, curiosity and leisure." It was the first building in America constructed for the specific purpose of housing a museum, and, not incidentally, though it has endured many vicissitudes and uses, it is so used today. The museum, filled though it was with specimens of natural wonders (including the "Head of a New Zealand Chief, very richly tatooed") and live beasts and portraits of dead heroes, was a financial catastrophe for the Peale brothers. It was in an attempt to recoup his losses that Rembrandt painted "The Court of Death."

The painting, Peale recalled many years later, was inspired by reading a poem on death by the English divine Bishop Proteus, and he called it a "moral allegory." It covered 312 square feet of canvas and it contained, bathed in gloom, twenty-three life-size figures. There was something on its vast surface for everyone who might gaze upon its ponderous composition and its thunderous message. Here was Death enthroned surrounded by figures of War, Conflagration, Famine, and Pestilence. Here was Pleasure pressing a cup on Intemperance. Here embodied were the horrors of Delirium Tremens and Suicide and a huddled group of Consumption, Despair, Fever, Apoplexy, Hypochondria, and that now-tamed demon Gout. In the foreground, with Death's foot resting upon his chest, was the corpse of a man felled at the height of his powers, his feet lying in the "waters of oblivion." But there was also a note of pious hope or at least of resignation: Old Age, guided by Faith, was being politely introduced to Death.

Peale, as you can see, gave his customers their money's worth of drama (perhaps melodrama is more accurate), of morality, of piety, and a vast and dismal prospect on which they might speculate about the meaning of life and the wages of death. He explained that his brother Rubens, "though of irreproachable temperance, stood for the inebriated youth" and his wife and others "served to fill up the background." The corpse at Death's feet, he said, was partly painted from a corpse he got from the local medical college and partly from "my brother Franklin, lying prostrate with inverted head, which was made a likeness of Mr. Smith, founder of the Baltimore hospital. . . ." He also noted: "My good and venerable father stood as the representative of Old Age, the draped and stooping body, that is; the head was copied from an antique bust of Homer." *

In the first thirteen months during which "The Court of Death" was on tour it took in the astonishing sum of $9,000, enough in those days to make a man wealthy, and it continued from city to city and town to town

* The very same one that Peale's namesake, Rembrandt, had used in his famous "Aristotle Contemplating the Bust of Homer," now in the Metropolitan Museum.

for over half a century. When it was shown in Albany, New York, in 1846 a clergyman wrote that "As a work of art, all seemed to think it unsurpassed —all but faultless," and that it exhibited "a power of imagination, and a refined elevation of taste which must place the author among the first of this or any other age. But it was in its character as a great moral painting that all seemed to feel the deepest and most lively interest." The Boston *Courier* praised it for being "free from everything indelicate or objectionable" and noted that it "conveys a most vivid moral lesson." Peale was eighty years old in 1859 when 100,000 colored engravings were made of the painting and sold for a dollar apiece. The publisher, who claimed the original was worth $25,000, reassured his potential customers that "This beautiful work does not represent Death in the form of a skeleton but as a King or Monarch, placed in obscurity. There is, therefore, nothing repulsive or forbidding."

Traveling murals, as they were called, were a common source of uplift and also of entertainment in the early years of the century, especially in towns where there was little enough vicarious pleasure imported from the sophisticated seaboard cities. William Dunlap, one of the many art-makers who fell short of Rembrandt Peale's success with this kind of exploitation, has left an entertaining account of how the business worked.

Dunlap, whom we will encounter frequently in these pages, had a great deal more charm as a man and a writer than talent as a painter, though he was not untalented. His financial affairs seem always to have been on the edge of disaster, and in the 1820s he tried to shore them up with history pictures. He was, by his own account, a rather inept portraitist, and though as a young man he had followed the accepted formula of going to London to study with West, he had found other things more entertaining than learning his profession, which in the long run was probably just as well. He tried his hand at a variety of ways of making a living: he was a writer and translator of plays and a theatrical producer and historian, but, above all, he was the author of a two-volume work called *A History of the Rise and Progress of the Arts of Design in the United States*, published in 1834. In spite of its ponderous title, it is a richly entertaining, gossipy, informative, and critical account of the lives and works of his predecessors and contemporaries in our early art world. One section of it is autobiographical, and in it he recalls that he had three pictures on the road in the early part of 1826.

It was the custom, he explained, to send an agent along with each picture to hire a room, advertise the presence of the "masterpiece," take in the receipts, and often give a lecture on the picture's moral message and artistic virtues; then, when the show was over, the agent would roll up the large canvas and set out for the next town. "In one place," Dunlap wrote,

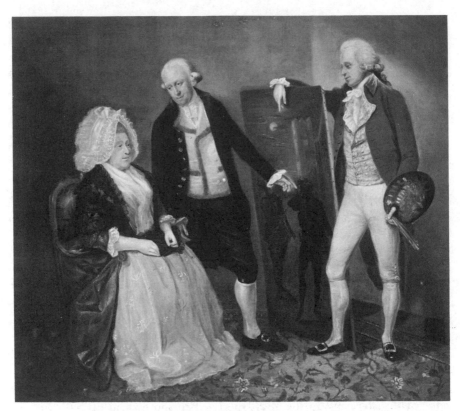

The first historian of the early arts of America, WILLIAM DUNLAP, was equally famous in his day as a theatrical producer and playwright and as a painter. In this 1788 portrait of his parents and himself he displays a painting of Hamlet. (*The New-York Historical Society, New York City*)

a picture would be put up in a church, and a sermon preached in recommendation of it; in another, the people would be told from the pulpit to avoid it, as blasphemous; and in another the agent would be seized for violating the law taxing puppet shows, after permission had been given to exhibit; and when he is on his way to another town, he is brought back by the constables, like a criminal and obliged to pay the tax, and their charge for making him a prisoner. Here the agent of a picture would be encouraged by the first people of the place, and treated by the clergy as if he were a saint; and there received as a mountebank, and insulted by a mob.

It was obviously a precarious business for an agent (who evidently worked on commission) if not for the absent artist. Dunlap added, "Such is the variety of our manners, and the various degrees of refinement in our population. On the whole, the reception of my pictures was honorable to me and to my countrymen."

THE GENTLEMEN OF TASTE AND FORTUNE

Melodrama, pious sentiment, likenesses, and showmanship may have been the limits of the arts so far as many of Dunlap's countrymen could see, but there were members of the community, some of them Dunlap's friends, who were concerned as laymen with what was regarded as art's more serious purposes. In New York a group of "gentlemen of taste and fortune," as the "patriot painter" John Trumbull called them, recognized that the growing city owed it to itself to don a cultural mantle commensurate with its commercial importance in the new nation. Charles Willson Peale's efforts to establish an academy in Philadelphia were known to a few New Yorkers who thought they could serve the ancient muses more efficiently than the Philadelphians had. In 1802, with Edward Livingston, the mayor of the city, as president, the New York Academy of Fine Arts (which a few years later decided, with characteristic self-importance, to call itself the American Academy of Fine Arts) was founded. No one today would be surprised that the Academy was run by businessmen who, rightly or wrongly, believed that artists were impractical men incapable of conducting the affairs of the arts. In this it set a precedent which is still the pattern for all of America's art museums; their policies are laid down by boards of directors selected for their reputations for philanthropy or social prestige or business acumen, and are administered by scholarly tastemakers. Artists, as one historian put it, were not then and are not now invited "to meddle in their own affairs," at least so far as the conduct of public institutions is concerned.

There were, to be sure, no artists of consequence working in New York in 1802 when the solid citizens, encouraged by the mayor's brother, the distinguished Robert R. Livingston (he later negotiated the Louisiana Purchase), put their heads together and formed the Academy. It seemed not to make any difference that Trumbull had not yet got back from Europe, where he had been speculating in foreign currency and buying Old

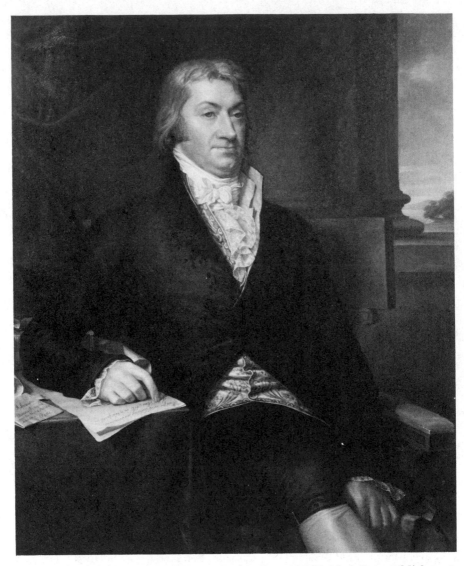

Robert R. Livingston was the moving spirit behind the establishment of the American Academy of Fine Arts. He was the American representative to Paris in 1804 when JOHN VANDERLYN painted his portrait as a gift to the Academy. (*The New-York Historical Society, New York City*)

Masters which had been dislodged by the Napoleonic wars; Stuart was working in Philadelphia, which was still the acknowledged center of the arts in America; Vanderlyn had not yet returned from Rome, by way of Paris, clutching a gold medal from Napoleon; Sully was just beginning his career in Virginia; and Washington Allston was in London. Artists, however, were not in the least necessary to the project of the gentlemen of taste; it was "culture" that mattered to them, and their view of culture did not include what was being created in their midst or even, for the most part, in their era. They were concerned with the glories of ancient Greece and Rome which had inspired a democracy and a republic like their own. According to Dunlap, it was "with a view to raising the character of their countrymen, by increasing their knowledge and taste, [that they] associated for the purpose of introducing casts from the antique into the country."

When Robert Livingston recommended the purchase of a collection of casts from statues in the Louvre for their educational and inspirational value, he was concerned not just with character building and cultural uplift but with providing models for artists and students. (It also occurred to him to invite Napoleon Bonaparte, then First Consul of the French Republic, to be the first honorary member of the new Academy. Napoleon responded to this gesture by presenting the Academy with twenty-four volumes of Piranesi prints and a number of books of drawings.) Livingston ordered the casts and they arrived in New York in 1803, a gleaming spectacle of goddesses and gladiators and emperors, of gods and philosophers, among them the bust of Homer that Rembrandt Peale transplanted in paint to the figure of his aging father in "The Court of Death." The public was permitted to feast its eyes on this white, august company in the Pantheon on Greenwich Street, where Edward Savage not many months before had treated them to their first exhibition of Old Masters.

It did not take long for the young Academy to run into trouble—trouble of the cold kind, passive trouble of the sort that springs from indifference rather than from opposition, trouble of the sort it is most difficult to grapple with. The public soon became bored (and who can blame them?) with the unchanging exhibit of blind-eyed imitation statuary. It had been the hope of the founders of the Academy to sell shares at $25 each to a thousand members, and they expected the sympathy and the allegiance of artists. Few artists, however, bothered to join. When Trumbull came back from Europe in 1804, he involved himself with the affairs of the Academy and was elected its vice-president. Whatever prestige he may have had (it surely did not match his delighted view of himself) did little to improve public interest in the Academy, and the casts were put away in storage.

There was a slight flurry of interest and a torrent of oratory when De Witt Clinton (who had been mayor of New York City and was later to become governor of the state) tried to revive the Academy in 1816. He found a new home in a building known as the Old Almshouse facing City Hall, refurbished it, and opened the newly decorated galleries with an exhibition of paintings and the dusted-off casts.

The exhibition, to its promoters' surprise and pleasure, was a great deal more successful than they had dreamed it might be. People came in gratifying numbers to look at the four pictures by West which Robert Fulton's widow had lent for the occasion, the twenty Trumbulls, eight portraits by Gilbert Stuart, a landscape with figures by Washington Allston, and the Piranesi prints and drawings given by Napoleon. Indeed, the future looked so promising that Clinton, who had become president, resigned in 1817 and turned over the presidency to Trumbull.

The "patriot painter," by that time sixty-one years old and contentious, made the Academy his private preserve and in his autocratic fashion presided over its slow demise. The mood of artists had changed and they would no longer tolerate the old *noblesse oblige* attitude of the gentlemen of taste and fortune who, whatever their fortunes, evidenced no discernible taste. Surely, they served a purpose as clients, but that artists should be expected to be sycophants of the business community for deigning to offer them the chance to buy the privileges of membership in the Academy was more than the artists would put up with. Only under pressure was old Trumbull persuaded to let young artists draw from the Academy's casts and then only between the hours of six and nine in the morning. He saw no reason why the Academy should bother with a school for art students, and he made himself quite clear on this point one morning when the janitor failed, as he often did, to open the doors at six and the students sat waiting for several hours to get in. Dunlap, who had a studio in the building, mentioned this to one of the directors of the Academy, who in turn spoke to Trumbull about it.

"When I commenced my study of painting," Trumbull said, "there were no casts to be found in the country. I was obliged to do as well as I could. These young men should remember that *the gentlemen* have gone to great expense in importing the casts, and that they [the students] have no property in them. . . . They must remember that beggars are not to be choosers."

Beggars, indeed! Dunlap's comment on this highhanded remark was, "We may consider this the condemnatory sentence of the American Academy of Fine Arts." It took only a few more years before the Academy sank

The first home of the Pennsylvania Academy of the Fine Arts—"to improve and refine the public taste in works of art"—was built in 1805–06 and destroyed by fire in 1845. Watercolor by P. P. SVININ. (*The Metropolitan Museum of Art, Rogers Fund, 1942*)

into a coma as the result of wounds it suffered in a battle with a new organization composed entirely of artists and led by the quick-witted, tolerant, and farsighted Samuel F. B. Morse. The National Academy of Design was founded in 1824, a daring challenge to gentlemen of taste and self-sufficiency then, but now (and it still exists) a challenge to no one.

Academies cropped up in various cities following the initial excitement among the proper and the prosperous about the New York venture of 1802. Three years later in Philadelphia a group of laymen, most of whom were lawyers, were granted a charter for the Pennsylvania Academy of the Fine Arts, and, like the Academy in New York, it opened with a splendid display of casts of sculpture from the Louvre. Philadelphia reacted in character. Old Peale could not have been surprised when a group of artists objected to the nudity of the statues as "indecorous and altogether inconsistent with the

purity of republican morals." So shocked were the upright citizens of the city that, according to one historian, "the managers were obliged to set apart one day each week for female visitors, when the nude figures were swathed from head to foot in muslin sheets." When Mrs. Trollope visited the Academy some twenty years later, she professed to be revolted at "the disgusting depravity which had led some of the visitors to mark and deface the casts in a most indecent and shameless manner," and she blamed this on "the coarse-minded custom which sends alternate groups of males and females into the room."

The Pennsylvania Academy, however, fared better than the one in New York because it did what the New York Academy had initially thought it might do: it provided from the first a school for artists. Its objectives had been set forth as: "to improve and refine the public taste in works of art, and to cultivate and encourage our native genius, by providing specimens of the arts for imitation, and schools for instruction." In case there was any doubt in anyone's mind that this was to last for the ages, the new Academy erected an elegant building, designed by the amateur architect John Dorsey in "modern Ionic." Old Peale snorted at this extravagance, but Robert Fulton, who had started his career as an artist but who had grown rich on his inventions, deposited his collection of paintings by famous European artists with the Pennsylvania Academy.

Philadelphians were impressed by what appeared in the domed and columned building. Indeed, they were so enthusiastic that the Society of Artists of the United States, an organization largely of Philadelphia painters which came into being in 1810, was invited to hang a display of contemporary work. In 1811 the Academy held its first annual exhibition, and in addition to a selection of the antiquities and the usual portraits there were more unusual landscapes and still-lifes.*

Benjamin Henry Latrobe, the most famous architect in the country and vice-president of the Society of Artists, gave the "annual oration" that year.

"At the opening of this infant institution," he declaimed, "instruction . . . is less necessary than the labour of proving that these arts have not an injurious effect, but a beneficial effect upon the morals, and even on the liberties of our country. For we cannot disguise from ourselves that far from enjoying the support of the general voice of the people, our national

* There has been an annual exhibition at the Academy ever since, though its original building burned in 1845, a mishap "attributed to a maniac relative of the janitress." It is also said that "The volunteer fire companies . . . damaged more than they saved in their unintelligent zeal."

prejudices are unfavorable to the fine arts."

He did not, however, despair.

"Art is a hardy plant," he said. "If nursed, tended, and pruned, it will lift its head to heaven, and cover with fragrance and beauty the soil that supports it; but, if neglected, stunted, trodden under foot, it will still live; for its root is planted in the very ground of our own existence."

THE ENVIABLE ARTISANS

Latrobe surely knew as well as anyone in America that there was one corner of the arts which was far from "neglected, stunted, trodden under foot," and that its practitioners were prospering. It was an art with which he, as an architect, was intimately concerned, one of which he had very considerable knowledge and for which he had great respect. This was the art of cabinetmaking. The position of the cabinetmaker at that time provides an interesting contrast to the plight of the painter, and the products of his skill equal or surpass all but a few of the products of the brushes of his contemporary painters—if such an equation is just or possible.

Master artisans fared far better than art-makers at the beginning of the century. The aristocratic tradition hung on, and the homes of the old rich and the new rich provided a constant market for the products of cabinetmakers. There was a long tradition of excellent craftsmanship in America, and if the designers were not quite the peers of their English and French contemporaries, they were nonetheless far more up to date than the contractor-builders and better trained than the amateur architects and most of the painters of the day. Instead of engravings of buildings and paintings, which was all the architects and artists had to instruct them in the work of European masters, cabinetmakers had as models imported pieces of furniture of excellent quality both to copy and to use for inspiration for their own designs.

As the nineteenth century got under way, New York, Boston (and its neighbor Salem), Philadelphia, and Baltimore were producing furniture of elegance. Duncan Phyfe was the leader of the profession, if it can be called that, in New York and Henry Connelly in Philadelphia. They produced spare and graceful tables and chairs, based on the precedent of the Adam brothers in London, for the houses of prosperous merchants. Shortly after the turn of the century a Frenchman named Charles Honoré Lannuier

DUNCAN PHYFE's elegant furniture shop was on Fulton Street in New York. The display room in the center is flanked by the workshop on the left and the warehouse on the right. (*The Metropolitan Museum of Art, Rogers Fund, 1922*)

turned up in New York and ran an advertisement in the New York *Evening Post* announcing that he had "worked at his trade with the most celebrated Cabinet Makers of Europe," that he made all kinds of furniture "in the newest and latest French fashion," and that he did repairs on "all kinds of old furniture." His notice was written in the third person, and it said: "He wishes to settle himself in this city, and only wants a little encouragement." He became one of the celebrated cabinetmakers of his day.

If the climate for art-makers was cold at the beginning of the century and grew continuously warmer, the very opposite was true for artisan-designers such as cabinetmakers. As the country grew industrially, artists found an expanding market for their products, but as the machine replaced the hand tools of the artisan and furniture began to be turned out of factories cheaply and in masses, the artisan gradually lost some of his

status, independence, and trade. In many respects the first decades of the
century produced the most characteristically American furniture, some-
times called Adamesque-Federal, to sit rather sparely but gracefully in
mansions designed with unerring reserve, whose interior details were of the
most elegant and genteel taste—oval parlors with pale-green walls and
ceilings ornamented with delicate pargetry, mantels and overdoors orna-
mented with carved reliefs of urns and flowers and with tasteful moldings.
Furniture and ornament insisted on good posture in parlors and dining
rooms; they were not for lounging.

The staple piece of everyday furniture, however, had a long history. In
an advertisement in the *Weekly Museum* published in New York in 1801
James Howlett, Jr., offered: "For Sale 5,000 Windsor chairs of various
patterns" and another chairmaker not only offered Windsor chairs of
"every description, both plain and fancy colors" but promised to paint what
his customers already owned "green or any fancy color in the best manner."
The Windsor chair, introduced to America in Philadelphia in about 1725
(indeed, it was often called "the Philadelphia chair"), had been, with
modifications, the standard chair for all but the rich ever since.

Art-makers early in the century must have looked upon cabinetmakers
with some envy. It was obvious that the community regarded cabinetmakers
as creators of objects not only beautiful but useful as well. The useful that
could have "the superstructure of the beautiful" added for a reasonable
price was precisely to the taste of the American housewife and her practical
husband. However, the cabinetmaker, because he was as much businessman
as his clients, encountered difficulties to which most art-makers were im-
mune. The master cabinetmaker obviously did not turn the lathes himself to
make his bedposts, nor did he carve the ornaments on his chairbacks with his
own wood chisel; he was as much employer and merchant as he was provider
of taste to his customers. This meant that, to some degree, he was the
creature of the men who worked for him, and strikes were not unknown in
those days of presumably unorganized labor.

There was such a strike at the very beginning of the century. In
December 1802 the journeymen cabinetmakers published a strike notice in
several New York newspapers, accusing their employers of highhandedly
conspiring to cut their wages by "at least fifteen percent." It was customary
for master cabinetmakers to publish a price list showing exactly what their
journeymen would be paid for "every particular piece of workmanship,"
and these prices were arrived at by a joint committee of the employers and
the journeymen. The journeymen claimed that the employers had conspired
to set new prices and refused to hire any artisans who wouldn't accept them;

This Boston "Tea Party" in an interior in the Empire style, the epitome of chic, was one of the earliest American genre pictures. It was painted about 1820 by HENRY SARGENT, an officer who had fought in the Revolution. (*Museum of Fine Arts, Boston*)

in retaliation the artisans were going to set up their own warehouse, where they would display "a quantity of as Elegant Furniture as has ever been exhibited for sale in this city." The employers, announcing business as usual, claimed that they were innocent of any such conniving, and that a small group of journeymen had caused all the trouble; it was just that styles had changed, and this necessitated a new price list.

Such minor insurrections were not common, however, and master cabinetmakers prospered, enjoying the confidence of the community and a sense of being necessary to its well-being which very few painters knew.

Slowly the position of the artist in the eyes of that limited public who at any time might be expected to concern itself with him was changing. If Latrobe had made his speech to the Society of Artists in 1825 instead of 1811, he might not have felt quite so constrained to bemoan "our national prejudices . . . unfavorable to the fine arts." It was evident that the "superstructure of the beautiful" was being taken seriously in at least some high places as a part of the ornament that a nation on the verge of becoming a world power must acquire. By the 1820s there were a number of substantial private collections of European painting in America (though they were filled with copies and fakes of Titians and Leonardos and Salvator Rosas). To be sure, the arts that were considered most worth collecting were the European arts. Most prosperous American gentlemen wished to make their homes acceptable by European standards in just the same way that their wives believed that to be properly dressed meant their fashions must originate in Paris, "the seat of taste and elegance," or in London. There was considerable agitation on the part of believers in the cultural future of the nation to encourage the prosperous to spend their wealth on art rather than on baubles and fancy carriages, and they exhorted the scions of the rich to devote themselves to cultivating the arts rather than waste themselves in gambling and debauchery.

Slowly the nature of patronage of the artist was changing; very slowly he was gaining social stature; more slowly still he was freeing himself from the bondage of portrait painting and was becoming a maker of art—indeed, of "fine art." There were prominent men who were willing to put up cash to send young painters to Europe to study. Even before the turn of the century Aaron Burr had financed John Vanderlyn's excursion to Paris (he was the first American painter to study there); a group of six Philadelphia gentlemen advanced $200 each to finance Thomas Sully's trip to work with West, and he repaid them with copies he made of Old Masters in West's own collection. Painters had no more sincere friend and none more concerned

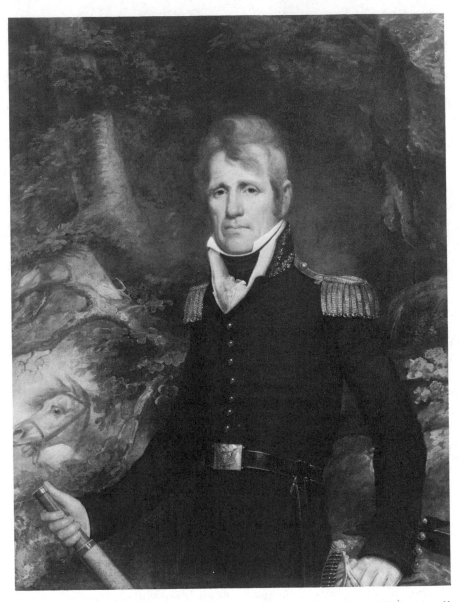

JOHN WESLEY JARVIS, called "New York's first real Bohemian," painted Andrew Jackson in 1819 when the General was in New York enjoying his fame as the hero of the Battle of New Orleans. (*The Metropolitan Museum of Art, Harris Brisbane Dick Fund, 1964*)

with their well-being than Congressman Gulian Verplanck of New York, who fostered their interests in Washington and did what he could to get them commissions for decorating the Rotunda of the Capitol. Washington Allston professed to be greatly honored when the Pennsylvania Academy purchased his "Dead Man Revived" for $3,500 in 1816 (it was a big picture, eleven by thirteen feet), though it was a price well below what he had hoped to get.

Not for many years was the American artist permitted by the mentors of refined taste to emerge from beneath the fashionable shadow of Europe. Mrs. Trollope in 1832 felt compelled to observe: "With regard to the fine arts, their paintings, I think, are quite good, or rather better, than might be expected from the patronage they receive; the wonder is that any man can be found with courage enough to devote himself to a profession in which he has so little chance of finding a maintenance. The trade of carpenter opens an infinitely better prospect. . . ." Even so, the evidence that we have seen (and which, if Mrs. Trollope saw, she preferred to ignore) hinted that artists were on the verge of breaking out of some of the old bondage and of stifling some of the old prejudices.

3

PARTHENONS FOR
THE PEOPLE

*"One such temple placed in a wood might be a
pleasant object enough; but to see a river lined
with them . . . is too much even for a high
taste."*

JAMES FENIMORE COOPER, in
Home as Found, 1838

At the beginning of the nineteenth century American architecture em-
barked on an excursion which, by the time the century was over, had turned
out to be very nearly a world cruise. There was scarcely a civilization from
which it did not take something to its bosom and scarcely a continent or a
European nation which did not find itself politely plundered of inspiration
and ideas. The trip was in many respects a rather disorderly lark, a
romantic exploration with something from the far corners of the earth to
suit everybody's taste, and the tastes of America were then as they are now
extremely quixotic, fickle, and catholic. There were the grandeur of Rome,
the classic purity of Greece, the mysteries of Egypt and Turkey, the
romanticism of medieval France, the elegance of its Renaissance, and the
heartiness (turned into fustiness) of Elizabethan England. Architects and
amateurs discovered and domesticated for their own purposes temples and
tombs, castles, manor houses, châteaux, and chalets. Indeed, not until the
century was very nearly over did America have an architecture of its own

invention, and only a very few of those who recognized it as such in the first skyscrapers of Chicago had any real notion that America had set off a revolution which would change the architecture of the world.

The excursion stopped first at Rome, or, more precisely, in an outpost of the long defunct Roman empire—the French city of Nîmes. There in 1787 Thomas Jefferson fell in love with the elegant ruin of a temple known as the Maison Carrée, or so, indeed, he said. He wrote to a friend in Paris, the Comtesse de Tessé: "Here I am, Madam, gazing whole hours at the Maison Carrée, like a lover at his mistress." So concentrated was his gaze at the little temple, which had been repaired by Louis XIV, that the local folk, he said, thought he must be "a hypochondriac Englishman, about to write with a pistol the last chapter of his history." It was the beginning of a long affair. "From Lyons to Nîmes," he wrote, "I have been nourished with the remains of Roman grandeur." It was nourishment that, in a manner of speaking, stuck to his ribs; it was the introduction of this most extraordinary of all American gentleman architects to Roman architecture at first hand, and he brought its inspiration back to Virginia with him. With it Jefferson changed the looks of the young nation—slowly and by precept, of course—from an architectural appendage of England to what might have looked to an ancient Roman like a promising colony in the Western Hemisphere.

The Maison Carrée was Jefferson's model for the State Capitol in Richmond, Virginia. Work had already started on a capitol when Jefferson wrote from France that everything must stop and wait for his return. "How is a taste for this beautiful art [of architecture] to be formed in our countrymen," he wrote to James Madison, "unless we avail ourselves of every occasion when public buildings are erected, of presenting to them models for their study and imitation?"

The Virginia Capitol is in no sense a copy of the Maison Carrée; its proportions are quite different (as its functions prescribed that they must be), and though it has the same six columns on its façade, their capitals are not the Corinthian acanthus leaves of Nîmes. Jefferson would, he said, have preferred that they had been, but the complications of making such elaborate carvings had to yield to the practical considerations of what the stonecutters could manage. In any event, he had the satisfaction of having been responsible for the first modern structure in the Western world based on an ancient classical temple—no mean accomplishment or vision for an amateur architect. His building was twenty-two years ahead of the next such temple, the Church of the Madeleine in Paris.

Jefferson's house, Monticello, which looks down across Charlottes-

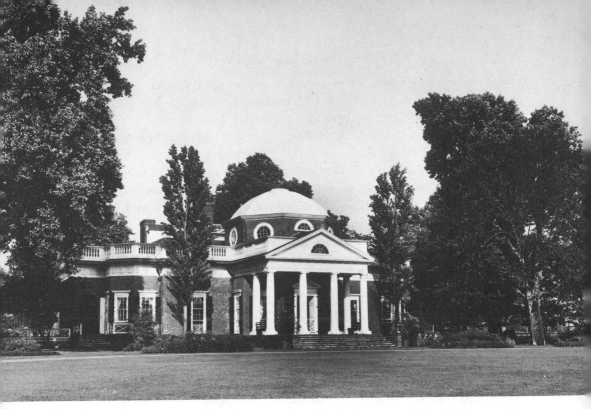

America's most impressive amateur architect, THOMAS JEFFERSON, began his house, Monticello, near Charlottesville, Va., in 1769; it was not completed until forty years later. (*Photo Wayne Andrews*)

ville and thus the valley in which his University of Virginia glistens today, was started by him in 1769 when he was a young lawyer of twenty-six and it was not completed with all its ingenious devices and plans and its domed and columned elegance until 1809, his last year as President of his country. What Jefferson could see today of the sprawling university that he founded, and whose basic architecture with its monumental Rotunda and serpentine walls he designed, would probably seem to him timid and un-suited to its epoch, as would the pristine and soaplike monument to him set in an artificial pond in Washington. His was a passionate concern with order (and "the orders"), with adaptability of plan to usefulness, and with expanding the public sensibilities—not with freezing them. His house was based on the designs of Andrea Palladio, the great Renaissance architect of north Italy who inspired the architecture of the Englishmen Inigo Jones and Sir Christopher Wren, and though Jefferson was outspoken in his distaste for English architecture, he greatly admired the source of its inspiration. There is in his invention at Monticello and in its gadgetry a playfulness and a delight in scientific and mechanical experiment that is

very like that of his friends Charles Willson Peale and Benjamin Franklin. His curiosity and ingenuity were as passionate as his attention to the most minute details of mortar and molding and nail; he devised an intricate mechanism of chains and sprockets beneath the floor by which double doors that were apparently independent of each other opened and closed simultaneously. He framed beds in alcoves (his own was placed so that it divided two rooms with different exposures, thereby assuring him of cross-ventilation on hot Virginia nights). He thought grand staircases took up too much room, and at Monticello he concealed out of sight shockingly narrow ones that must have made the maneuvering of a hoopskirt to the ballroom under the dome an exercise in feminine ingenuity and, possibly, immodesty.

Handsome as Jefferson's buildings are and sophisticated as was his plan for the university campus, they were by no means his most important contribution to the ultimate path on which American architecture was to stride for more than half a century. In 1800 only a statesman, gentleman, and amateur could have accomplished what he did with the weight of his prestige, his friendship with Washington, his determination that the nation must learn to speak culturally as well as politically for itself, and his remarkable dilettantism. At a time when the climate of the arts was cold and concern with such presumably secondary matters left most of Jefferson's contemporaries unmoved, he wrote to his friend Madison: "I am an enthusiast on the subject of the arts. But it is an enthusiasm of which I am not ashamed, as its object is to improve the taste of my countrymen, to increase their reputation, to reconcile to them the respect of the world, and procure them its praise."

Where better to start than with the new national capital?

Between them Jefferson, the accomplished amateur, and Washington, a man of educated taste, offered by their very presence and concern a formidable argument for creating a national capital that would be not only a city of suitable dignity and ultimately of grandeur, but one which would inspire citizens to build beautifully and firmly in their own cities. By 1800 the plan for Washington which Major Pierre L'Enfant had devised nine years before was sketchily established, with the Capitol rising on the Hill and the President's Palace (which was not a white house then but a gray one) at the other end of Pennsylvania Avenue. L'Enfant, who when he was twenty-three had fought in Lafayette's command and been wounded at Savannah, had been trained as an engineer in France, and he had already made a pleasant reputation for having remodeled the City Hall in New York into a temporary seat for the federal government. President Washington, whom he pestered to get the job to design the master plan for the

capital, thought him "better qualified than anyone who had come within my
knowledge, in this country." The scheme L'Enfant devised was not only
quite unlike anything that had been conceived in America before, but was
far in advance of any city plan as yet evolved in Europe. The fact that
scholars recently have discovered that it was based closely on the plan of the
gardens at Versailles does not diminish the delights of the vistas and circles
and radiating boulevards which he managed to couple ingeniously with the
grid plan that was (and still is) characteristically American.

It was true in Washington in 1800, as it is true today, that the
practice of architecture seems to create its own special tensions. Painters,
even though they may disagree on matters of aesthetics, are likely to get
along with other painters who are their contemporaries at least as well as
bankers get along with brokers, and sculptors rub elbows with each other at
least as well as other athletes do. Architects, however, and especially tal-
ented, architects, seem to work on each other like emery paper and have a
way of disparaging each other's intentions and results, and, not infre-
quently, each other's characters. Their quarrels are not just aesthetic
(though they frequently take this public or external form) ; they are likely
to be based primarily on competition for important commissions. There are
usually in a successful partnership of architects today a designer who is the
idea and aesthetics partner, an engineer who is the practical and cost
partner, and a front man who captures clients and who through some
miracle of suasion, diplomacy, and charm, keeps his colleagues from letting
their resentments and misgivings come to the point of explosive revolt.

In the nation's capital in the 1790s there were no such modern associa-
tions of architects. The tensions were further enhanced by the fact that the
competition was not just among professional peers but included many
amateurs and a few professionals. In retrospect it seems remarkable that
either the Capitol or the President's Palace got built at all. The story is one
of rather complicated, albeit understandable, entanglements of politics,
temperaments, aesthetics, and aspirations.

The saga of the building of the Capitol starts in 1792 with a competi-
tion, the prize for which was a gold medal worth $500 or a piece of
Washington real estate of equivalent value. There was only a handful of
professionally trained architects in America at the time, and none of them
had been born or trained in America. It was a most miscellaneous lot of men
who entered the competition—a carpenter, a bridge builder, at least one
European-trained architect, a woodcarver-turned-architect from Salem,
Massachusetts, and a number of amateurs including a physician from the
West Indies by way of Scotland, who won it. He was Dr. William Thornton,

a man of considerable personal charm and wit and, as it turned out, a fierce infighter in architectural squabbles. His career as an architect started in Philadelphia in 1789 when he was twenty-eight. He saw a notice of a competition for a public library building and thought he might try his hand at it. "I got some books," he wrote later, "and worked a few days, and gave a plan in the Ionic order which carried the day." It took him a little longer to prepare himself to compete for the design of the nation's Capitol. He spent several months working day and night, sorry, he admitted, that he had never studied architecture, and finally he had to ask the Commission for a little extra time before submitting his drawings. There seems to be some evidence that he had had a peek at the design submitted by the most thoroughly trained architect who competed for the prize, Etienne Sulpice Hallet, a fairly recent arrival from France, and pilfered some of its essential ideas. President Washington, however, was pleasantly impressed by Thornton's drawings (which have, unfortunately, disappeared and can only be conjectured about today). The President wrote the Commission: "Grandeur, simplicity, and convenience appear so well combined in this plan of Dr. Thornton's, that I have no doubt of its meeting with that approbation from you, which I have given it under an attentive inspection."

Thornton's scheme for the building evidently had in it the very Roman elements which so charmed Jefferson and which he and the President believed far more suitable to the creation of a new architecture for a new nation than the adaptations of English architecture submitted by most of the other contestants. It was the lot of poor Hallet, the runner-up, to try to pull Thornton's chestnuts out of the fire of inexperience. Hallet was given the job of supervising the construction of Thornton's plan, which he continually tried to alter to suit his own convictions, and after only a couple of years he was relieved of his job and disappeared—scholars do not seem to have discovered where.

There is no need to trace the building of the Capitol through the maze of bickering, political interference, personal jealousies, and changes of taste which brought it to its final state . . . if its state is or ever will be final. Hallet was succeeded by a talented Englishman, George Hadfield, who had studied at the British Royal Academy and in Rome. It was Colonel John Trumbull, whose friendship he had gained, who persuaded him to try his fortunes in America, but, greatly to Trumbull's dismay, American manners and politics were too much for him. The painter was afraid that he was responsible for ruining what might have been a brilliant career for his friend in England. Hadfield did not disappear entirely, as Hallet had, but in his journal Benjamin Henry Latrobe wrote of him, "He loiters here,

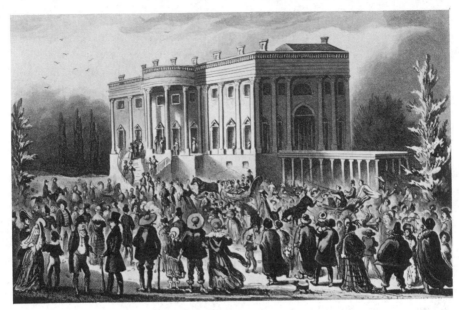

The "White House" was not white and was called the "President's Palace" until the British burned it in 1814. It looked like this in 1841 in an engraving called "President's Levée or All Creation Going to the White House, Washington" by ROBERT CRUIKSHANK. (*Library of Congress, Washington, D.C.*)

ruined in fortune, temper, and reputation, nor will his irritable pride and neglected study ever permit him to take the station in the art which his elegant taste and excellent talent ought to have obtained." Hadfield was succeeded in his supervision of the Capitol's construction by an Irishman from Kilkenny County, James Hoban. He had emigrated to Charleston, designed the State House of South Carolina, and in 1792 had distinguished himself by winning the competition for the design of the President's Palace in Washington when he was only thirty-four. One of the contestants he defeated was Thomas Jefferson, who anonymously submitted a design based on Palladio's Villa Rotunda, a noble building overlooking Vicenza in Italy.

Hoban was succeeded by Latrobe, the remarkable architect who has frequently and with good reason been called the "father of American architecture." When he arrived in Washington in the spring of 1803 the nation's capital was more mud and thickets than city. One wing of the Capitol and the gray sandstone President's Palace dominated what was little more than a village of about 3,500 inhabitants. There were a few scattered buildings

—a brick structure for the Treasury, housing for the State and War Departments, boardinghouses for Congressmen on a ridge along New Jersey Avenue, and several buildings that General Washington had caused to be built to encourage other investors to join him in converting what must have seemed a singularly unpromising site into a noble city. Even thirty-five years after Latrobe arrived as superintendent of the works, the English novelist-sailor Captain Frederick Marryat wrote: "Everybody knows that Washington has a Capitol; but the misfortune is that the Capitol wants a city. There it stands, reminding you of a general without an army, only surrounded and followed by a parcel of ragged dirty little boys; for such is the appearance of the dirty, straggling, ill-built houses which lie at the foot of it."

Latrobe's impact on the looks of America can scarcely be exaggerated, and if finally this impact was denounced by mid-century critics with thundering rhetoric, for nearly fifty years it was his spirit which dominated not only public but domestic architecture. He was the progenitor of the Greek Revival in America, an architecture that filled cities and villages and farmlands with little temples, the grandest of which were faced with marble and the simplest with wooden siding. But in the beginning of his public career the magic of his talent and convictions worked slowly on the public imagination. It was Jefferson's Romans who dominated the public taste; Latrobe's Greeks had to wait their turn.

Latrobe's reputation was already well established when President Jefferson asked him to come to the rescue of the Capitol and the President's Palace. He had been thoroughly trained in England by the most distinguished engineers and architects and was on the verge of a promising career in London when his young wife died and in despair he decided to come to America. He arrived on these shores in 1795, worked for a while in Virginia, and in Philadelphia in 1799 he designed the Bank of Pennsylvania, his first important public commission and the opening salvo of Greek Revival in America.

His job in Washington was twofold: he had to shore up Thornton's plans for the Capitol (and he radically changed them), and he was given the responsibility for seeing the President's Palace through to completion. He had an immediate falling out with Thornton when he asked to see his plans for the Capitol. Thornton refused to give them to him, saying that he didn't know where they were, and an altercation ensued which was so acrimonious that Thornton tried unsuccessfully to call Latrobe out in a duel and Latrobe sued Thornton for libel. Though Thornton retained as his lawyer Francis Scott Key, the author of what became the national anthem,

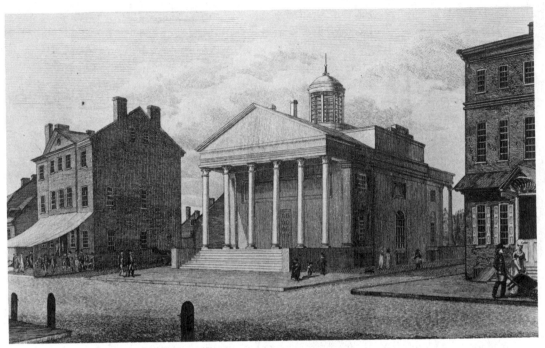

This "pure specimen of Grecian simplicity," as its architect, BENJA-
MIN HENRY LATROBE, called his Bank of Pennsylvania in Philadelphia,
was the progenitor of the style that swept America thirty years after
it was built in 1799–1801. (*Engraving by William Birch, The His-
torical Society of Pennsylvania, Philadelphia*)

Latrobe won a verdict and costs after years of litigation which ended in
1813. It had been one of the most spirited name-calling, scandalmongering,
and two-sided attempts at professional assassination in the annals of this
not always friendly profession.*

The President's House (sometimes it was called a house and sometimes
a palace) when Abigail Adams and her husband, John, moved into it left
some comforts and conveniences to be desired, but that is not to say its
intentions were not lavish. Mrs. Adams wrote to her daughter that it was on
"a grand and superb scale, requiring about thirty servants to attend and
keep the apartments in proper order." But there were other problems. The
main staircase to the second floor had not yet been built, and "The lighting,
the apartments, from the kitchens to parlors and chambers, is a tax indeed;
and the fires we are obliged to keep to secure us from daily agues. . . ."

* It is described in great detail in *Benjamin Henry Latrobe* by Talbot Hamlin
(New York, 1955), pp. 255 ff.

There was not a single bell in the house with which to summon a servant, and "promises are all you can obtain" when bells were asked for. There was no fenced-in yard for the laundry, and so, she wrote, "the great unfinished audience room I made a drying-room of, to hang up the clothes in." She was not, however, disheartened, and she thought that when the house was finally completed it would be beautiful. But she did suggest that if the national capital were in New England, things would have got done a great deal faster and more efficiently.

When Jefferson moved in in 1801 the East Room was unfinished, the roof leaked, and the plaster was falling. The construction under Hoban had been hardly more secure than that of the Capitol. Furthermore, the waste from the water closet poured out into the driveway, and the building stood unadorned by any attempt to landscape its surroundings. The design of the house was basically Hoban's, as it is today, an elegant eighteenth-century English palace; it was very little to Latrobe's taste (he called the plan with its great entrance hall "all stomach"), but he successfully encouraged Jefferson to add two porticos with Ionic columns, a semicircular one on the south (much later to have a balcony inserted in it by President Truman amid howls of antiquarian dismay) and the other a pedimented porte-cochère on the north entrance. Latrobe not only acted as architect for the shoring-up and the exterior alterations, but he also turned his talents to the more intimate problems of interior decoration. From the time that the Jeffersons moved out and the Madisons moved in in 1809 until the beginning of the War of 1812, Latrobe not only designed many pieces of furniture for the house but acted as purchasing agent for all sorts of mantels, furniture, carpets, mirrors, chandeliers, curtains, china, plate, and even stoves. Mrs. Madison, as it happened, was a great friend of Mrs. Latrobe, and there was as a consequence an easy enthusiasm between them and Latrobe in their joint attempts to make the President's house as splendid as its national eminence deserved. Most of the furniture was made in Washington and Baltimore; such things as carpets, plate, china, and lighting fixtures came from Philadelphia, and Jacob Mark in New York supplied mirrors and table linen. Latrobe ordered the lamps for the East Drawing Room from Bradford & Inskeep in Philadelphia and suggested that they should be bronze rather than cut glass with drops and festoons which "would soon be demolished by the clumsy and careless servants of this part of the world." When they arrived, he wrote of the enthusiasm of the President and his lady for them, but added, "I cannot say that I admire the mixture of Egyptian, Greek, & Birmingham taste which characterizes them."

According to Talbot Hamlin, Latrobe's distinguished biographer, "The final achievement was worth all it had cost and all the labor and imagination which the Madisons and Latrobe had put into it." It is difficult to guess how he knew, for when the British attacked the Capitol and the President's House on August 25, 1814, all of Latrobe's work vanished in flame and smoke. Mrs. Madison cut the Stuart portrait of General Washington from its frame and fled with it, according to one account, under her dress. She wrote to Mrs. Latrobe:

> Two hours before the enemy entered the city, I left the house where Mr. Latrobe's elegant taste had been justly admired, and where you and I had so often wandered together; and on that *very day* I sent out the silver (nearly all) and velvet curtains and General Washington's picture. The Cabinet Papers, a few books, and the small clock—left everything else belonging to the public, our own valuable stores of every description, a part of my clothes, and all my servants' clothes, etc., etc. In short, it would fatigue you to read the list of my losses, or an account of the general dismay or particular distresses of your acquaintance. . . .

AN INFANT PROFESSION

The architecture of the years from the end of the Revolution to about 1820 is generally referred to as "Federal," but it would be inaccurate to put any firm beginning or ending date on any style. Styles have a way of announcing themselves timidly some time before they become insistent and popular, and they often linger on because people are accustomed to them and feel affectionate toward them years after a new style has established itself. Federal, when it went out of fashion, however, was more than usually swamped by the fad for a less aristocratic and more "republican" kind of architecture, as it was thought to be, which was at the same time a great deal more "romantic" in several senses of that pliable word.

Latrobe can be classified as a Federal architect, of course; however, he was unlike most of the men who were designing buildings—both private and public—between the 1780s and the 1820s in that he was not only thoroughly trained, talented, and (as he had accused Hadfield of being) irritably proud, but was also an innovator. Most of his contemporaries were, as we have noted, amateurs or carpenter-builders who became designers or, as

in the case of Samuel McIntire of Salem, Massachusetts, a woodcarver who turned into a stylish and elegant builder of houses (see page 52). An architectural generalization is almost never safe, but it is not wide of the mark to say that Federal architecture in the South, following Jefferson's example and precepts and also the example of the Capitol, is basically Roman, and in the North—in New York and Boston and other cold cities—it carries on the traditions of England, most notably the spirit of the Adam brothers: refined, carefully balanced, restrained, and delicate in detail.

Sometimes Roman attributes in the South were an afterthought, as in the great portico that President Madison, at Jefferson's suggestion, added to his basically English house at Montpelier, Virginia. Indeed, classical columns and pediments rising the full height of façades pierced by solemnly placed windows flanking a grand doorway, itself often pedimented, are so characteristically Southern that they have become a trademark of ante-bellum Southern mansions.

It took the North longer to be converted to a be-columned classical style of architecture for the home and for the bank and town hall and church. The revolution against things English was, as one historian commented, "not so much an anti-English war, as a war to support liberties founded on Magna Carta," and after the Revolution it was the inspiration of Robert Adam of London which produced the quietly elegant exteriors and drawing rooms with their sometimes almost over-refined details of pilasters and mantels and moldings, of ceiling ornaments and cornices. It was, one might say, an era of exquisite taste, and in Salem and other New England seaports the delicacy of the architecture contrasted strangely with the life lived there by sea captains—adventurous, hard-bitten, and commercially tough. The inspiration of the Adam brothers was also Roman, but of a different sort from that which stirred feelings of awe in Jefferson. This was the Rome not of grandeur but of domesticity as revealed by the excavations of the Palace of Diocletian at Spalato (Split) and the ruins of Pompeii—the Rome of a sophisticated bourgeois society.

McIntire, who made of Exeter Street, Federal Street, and Washington Square in Salem one of the most elegantly ornamented and stylish bits of America, was the son of a carpenter or, as he was also called in this boat-building community, a housewright. There was, however, no one to teach him the refinements of ornamental carving and design, and he turned, obviously with a far more discerning eye than most of his contemporaries, to books like Pain's *British Palladio*, which was an extremely popular handbook among American craftsmen after the Revolution. To what he examined he added his own imagination, always tempered by delicate restraint.

The so-called Gardiner-White-Pingree House is in Salem, Mass., the work of a carpenter-cabinetmaker-woodcarver who became one of the most distinguished architects of the Federal style. SAMUEL McINTIRE built this house in 1810. (*Photo Wayne Andrews*)

When he submitted a design in the competition for the Capitol in Washington, he offered a beautifully rendered and proportioned palace, suited better to a royal family than to what Jefferson and Washington thought of as the choice of a robust electorate and a nation putting monarchy behind it. When McIntire died in the early part of 1811, his obituary in the Salem *Gazette* said: "To a delicate native taste in this art he had united a high degree of that polish which can only be acquired by an assiduous study of the great classical masters." He had applied his skill not only to splendid, foursquare houses with slender columns on their porches and balustrades to

conceal their gently sloping roofs, but to public buildings in Salem as well
—the Court House and the North and South Meeting Houses. He was
evidently a man of great personal charm and of talents other than visual
ones. On his tombstone it was recorded that he was "distinguished for
Genius in Architecture, Sculpture, and Musick."

Something was obviously happening to the public attitude toward
architecture when a man like McIntire could command such respect among
the practical citizens of a booming seaport, but it was a good many years
before most Americans thought that they needed to bother with architects
and even longer before any university thought it worthwhile to establish a
school of architecture. Even twenty-one years after McIntire died, a visit-
ing French architect who arrived in New York in April of 1832 said, "I
found that the majority of people could with difficulty be made to under-
stand what was meant by a professional architect; the builders, that is, the
carpenters and bricklayers all called themselves architects." Plans, he said,
were run up by a handful of draftsmen—all there were in New York—"for
a trifle," and not infrequently, he was appalled to note, "some proprietors
built without any regular plan" at all! It was customary for a family
wishing to put up a new house to look around at what already had been
built, pick out one they liked, and tell a carpenter-builder to make them one
like it "with such alterations upon the model as they might point out."
Carpenters relied on such guides as Abraham Shaw's *British Architect* of
1775, the first architectural book published in America, and on a series of
manuals by Asher Benjamin, a canny and deft carpenter who lived in
Greenfield, Massachusetts. It was through his books of precise details and
renderings and instructions (the first of which was *The Country Builder's
Assistant*, published in 1797) that carpenter-builders were assured of get-
ting their Roman and Greek columns and capitals and moldings correct and
in the most proper taste. Dozens of manuals of details and elevations and
floor plans were published for the benefit of builders and their clients during
the first half of the century, and they provide today an entertaining,
accurate, and sometimes exuberant reflection of the changes in temper and
tastes.

Nevertheless, thanks to clever craftsmen like McIntire and Benjamin,
to imported professionals like Hoban and Hadfield and Latrobe, and to
gifted amateurs like Jefferson and Thornton and Bulfinch, architecture in
America was turning from a craft or a hobby into a profession. Of all of
these men Bulfinch was the only gentleman dilettante who was forced by
circumstance to become a professional, and unquestionably his skill and
charm influenced the public attitude toward architecture as a suitable

calling for the well born and well educated.

Charles Bulfinch was just twenty years younger than Jefferson and outlived him by all but one of the same number of years. The son of a prosperous and well-connected Boston physician, he graduated from Harvard College and married a member of the prominent and rich Apthorp family. Architecture, he believed, was one of the tastes a young gentleman should cultivate, and it was his privilege, when he visited Paris after graduating from college, to be shown the marvels of the city by Jefferson. When he returned to Boston, he was, he said, "warmly received by friends, and passed a season of leisure, pursuing no business, but giving gratuitous advice in Architecture, and looking forward to an establishment in life." Then—either fortunately or unfortunately, as one interprets history—he decided to invest his energies, talents, and funds in the building of a crescent of sixteen brick houses in the manner he had admired in Bath when he visited England. The project was a financial catastrophe; he ran out of money, and as the year he chose to build, 1793, was a depressed one, the men who had agreed to back him pulled out and those who were expected to occupy the houses, merchants feeling the pinch in the market, decided they had best renege.* Bulfinch had to go into bankruptcy. From that moment on, the dilettante architect turned into the hard-nosed professional, to the very great advantage of Boston and other New England cities and eventually of the Capitol and the abiding reputation of America's young architecture.

Bulfinch's designs for houses and churches and public buildings were strongly influenced by the Adam brothers, and there is a cleanness and clarity about them which is at once light and firm, dignified without being ponderous. Both McIntire and Asher Benjamin watched his work with admiration and took from it for their own designs. He was responsible for changing the floor plan of houses, which had so long been standard that even a slight alteration seemed shocking. Four rooms to a floor with a central entrance hall was the way Bulfinch's contemporaries believed a proper house was meant to be. As Wayne Andrews has written, "he had the imagination to introduce a great oval drawing room between the sitting and dining rooms, an innovation that must have startled the merchant princes of Boston. The news in 1800 of the collapse of the Federal political machine was scarcely more alarming."

Bulfinch's reputation ultimately took him to Washington to replace Latrobe as the architect of the Capitol, an encounter with professionalism

* The sixteen houses were a success in the hands of the receivers. They were, however, demolished in the middle of the nineteenth century.

Surely one of the finest churches in the Federal style in America, Christ Church in Lancaster, Mass., was designed by Charles Bulfinch and completed in 1816. (*Photo Wayne Andrews*)

which set him back on his gentlemanly (and, he discovered, somewhat
old-fashioned and provincial) heels. Latrobe was unable to get along with
President Monroe, as he was temperamentally incapable of rubbing elbows
with many other political figures; tact and diplomacy were in short supply
in his determined, aesthetically dedicated, proud, and—evidently—stub-
born character. In 1817 he was not so much eased out of his position as
architect in charge of rebuilding the Capitol after its burning in 1814 by
the British as he was shoved with the eager cooperation of Colonel Samuel
Lane, the commissioner in charge of the public works. It was not only
personal animosity between the two men, each jealous of his position, but
what Congressmen considered Latrobe's flamboyantly extravagant plans
that finally resulted in his resignation in November of 1817. Bulfinch was
invited to replace him.

When Bulfinch looked at Latrobe's plans, he was astonished at what he
saw. It was his first professional encounter with the necessity to work with
the plans of a thoroughly trained, bold, and imaginative architect. "At the
first view of the drawings," he wrote, "my courage almost failed me—they
are beautifully executed, and the design is in the boldest stile [sic]." He
added what seems to be almost an apology for being in Washington at all:
"After long study I feel better satisfied and more confidence in meeting
public expectation. . . . There are certainly faults enough in Latrobe's
designs to justify the opposition to him. His stile is calculated for display in
the greater parts, but I think his staircases in general are crowded and not
easy of access, and the passages intricate and dark." This is not a statement
made by an overconfident man.

The Capitol extended Bulfinch's career, not without honor. He worked
on it until 1830, primarily following Latrobe's plans but adding his own
Adamesque touches, especially in the interior. The prominence of his Wash-
ington experience brought him commissions outside his native New Eng-
land, but when he again returned there, he once more suffered financial
reverses, this time in land speculation, and he had to retreat from his
splendid home to a smaller one. His wife, indeed, consented "to take charge
of two young ladies as boarders" to augment their income.

It was Latrobe, however, who had the last word on the quite different
Roman styles of Jefferson and Bulfinch. It was he who was the progenitor of
the architecture that was to salt the American landscape with white Grecian
temples. His was the new voice; like most new voices, it sounded clearly
before it traveled far.

The nation's Capitol was a battlefield of aesthetic and political animosities. It looked this way in 1848 after both Latrobe and Bulfinch had revised the original plans by the amateur Dr. William Thornton. (*Engraving by Alfred Jones, Library of Congress, Washington, D.C.*)

UP WITH THE GREEKS

On the occasion when Latrobe delivered the "oration" at the annual meeting of the Society of Artists of the United States in Philadelphia in 1811, he was, you will recall, not sanguine about the state of the arts in America or about their public acceptance. He was not, in fact, at all happy about the way things were going architecturally, and he spoke his mind: his text might be paraphrased as *Down with the Romans; Up with the Greeks!* "The history of Grecian art," he said, "refutes the vulgar opinion that the arts are incompatible with liberty. . . . In Greece every citizen felt himself an important, and thought himself an essential, part of his republic." He liked the Romans only when they were being most Greek. "The buildings and

sculpture of the Romans," he said, "which are nearest in point of time to the
days of the republic, are those of the best taste in design, and of the most
exquisite workmanship. For as the monuments of Roman art, during the
reigns of the emperors, grow into colossal size and expense, they dwindle
into absurdity in the style of the decoration, and the imperfection of their
execution. . . ."

Latrobe was intellectually, if not temperamentally, on the side of the
republican government that represented the whole people and not, like the
Federalists, a government by the élite. Imperial Rome was repulsive to him;
democratic Athens was ideal, and even if one were to leave out his aesthetic
considerations (which is impossible), one could assume that he would prefer
every work of the Greeks to any of the works of the Romans as a matter of
principle.

It was as though Latrobe had overturned a cornucopia out of which
spilled columns, fluted and plain, capitals of every order, pediments, pilas-
ters, fascias, and metopes—all the trappings of Greek temples except, of
course, the gods they housed—and scattered them helter-skelter over cities
and countrysides. What was meant to be an orderly, restrained, classical
reflection of an ancient democracy which would lend dignity to a new one
became known as "the Greek mania." The scarcely godlike inhabitants of
the new temples, which they domesticated with brick chimneys and some-
times with lean-to and sometimes with basement kitchens, lived everywhere.
From their front doors they looked between columns at city streets in which
pigs foraged for garbage as they did most prominently in New York and
Cincinnati. They stood beneath their porticoes and looked down upon the
Hudson, the Connecticut, the Ohio, the Charles, the Erie Canal, the James,
and the Mississippi. Even log cabins in Wisconsin were sometimes sheathed
in boards and donned porticoes when their owners grew prosperous by
wrenching tillable land from forests. Every carpenter, with the aid of a
handbook like one of Asher Benjamin's, became his own art-maker. Never
was it so easy for every housewife to be artistic, never were the rules of taste
so easy to follow, and never was there a time in America when taste reflected
more dimly the practical needs of its inhabitants. The excursion which had
paused briefly in Rome, and borrowed a few ideas there, seemed to have
fallen upon Greece and plundered it.

Latrobe cannot be blamed for this: art-makers can never be blamed for
what happens to their ideas once they have hit the public fancy and are
turned into something which, though it may have its own vitality, is far
from what its progenitor had meant it to be. The best of Greek Revival
architecture is among the handsomest building that America has produced.

The Greek Revival style was rarely purer than in WILLIAM STRICK-LAND's Second Bank of the United States, built between 1818 and 1824 and still standing in Philadelphia. (*Lithograph by Deroy from a drawing by Köllner, Library of Congress, Washington, D.C.*)

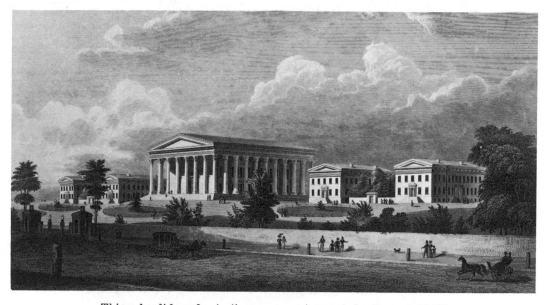

This splendid academic (in two senses) temple by THOMAS U. WALTER was built in 1833–47 for Girard College in Philadelphia. Its address is, suitably, Corinthian and Girard Avenues. (*Engraving by A. W. Graham, The Metropolitan Museum of Art, Harris Brisbane Dick Fund, 1924*)

In Philadelphia it was Latrobe's pupils who committed the most elegant temples: the Second Bank of the United States, which was designed by William Strickland and completed in 1824, and T. U. Walter's Girard College, created under the eagle eye of the powerful banker Nicholas Biddle in 1833. James Fenimore Cooper, who had looked discerningly at European versions of classical buildings, said of Strickland's bank: "There are certainly a hundred buildings in Europe of a very similar style . . . ; but I cannot remember one in which simplicity, exquisite proportion, and material unite to produce so fine a whole." Walter's building for Girard College was not only designed to convert to American stone a dream of Nicholas Biddle's but was drawn almost entirely to his specifications. Biddle had visited Greece in 1806 when he was in his early twenties and had given half his conscience to it. He wrote in his journal: "The two great truths in the world are the Bible and Grecian architecture." His own house, Andalusia, built on the banks of the Delaware, is an imposing Doric temple on which he collaborated with Walter and which is still lived in by his descendants. The primary problem these architects faced was to find ways not to depart too radically from the Grecian models they used as inspiration and at the same time construct buildings that were useful for the purposes of practical clients. Possibly a bank fits into a temple with less sacrifice than a family, but banks, like houses, have to have windows (as temples need not) and the resulting compromises taxed the ingenuity of the designers as the results, in many cases, taxed the patience of the buildings' occupants.

The extravagant success of the Greek Revival—popular success, that is—cannot be credited to architects alone, though it was they who put a romantic ideal into a form that nearly everyone could embrace whether he could comprehend it or not. A book called *The Antiquities of Athens* by two Englishmen, James Stuart and Nicholas Revett, the first volume of which was published in London in 1762 by the Society of the Dilettanti, was in the Library Company in Philadelphia by 1770. It is difficult to think of any publication that had a more far-reaching effect on fashion or design of any sort than this one. Athens was a squalid city controlled by the Turks when Stuart, an architect and archaeologist, and Revett went there in the 1750s and made most meticulous measured drawings of the ruined buildings, especially of the Acropolis. Their books (there were five volumes in all by the time the last one was published in 1830) quite literally brushed aside the dust of time and of indifference from classical Greek building, opening an astonishing new vista to architects which changed for a century their concept of what was beautiful.

Latrobe pored over the volume that was in the Library Company and

understood its refinements as none of his American contemporaries did. So also must have Strickland and Mills and Walter known this volume, and of course so must Mr. Biddle. But to most Americans in the 1830s, when Greek Revival was spreading like a grass fire across the nation, the Greek War of Independence in which the romantic Lord Byron had given his life recalled their own Revolution and symbolized their own struggle for a democratic Utopia. The ideal of republicanism, an equal sharing by all citizens in the affairs of state, had been given a rather rough-and-tumble leg up with the election of Andrew Jackson in 1828 and the arrival the next year at the White House of what the old aristocracy called "the ruffians" from the back country. So taken were the Americans with their enthusiasm for the Greek ideal that towns with Greek names were scattered across the nation's map. Captain Marryat, when he visited upstate New York in 1837, wrote: "I felt becomingly classical, whilst sitting on the precise birth place of Jupiter [Mount Ida], attended by Pomona, with Troy at my feet and Mount Olympus in the distance." Athens, too, turned up in New York and also in Georgia, Maine, Vermont, and sixteen other states, some of which were still territories in those days. Marryat was interested to discover when he visited the frontier town of Sault Sainte Marie, still a collection of log cabins surrounded by a palisade, two complete editions of Byron's poems.

There were, of course, practical reasons as well as romantic ones for the fad of the Greek Revival. Asher Benjamin explained the style's popularity by saying, in effect, that it was an easy way to show off: people liked it because its details were bold, could be seen from some distance, and afforded a great deal of display for a very little money. Temples, in other words, could be built of wood, or brick and wood, with a maximum effect of grandeur at a minimum of expense. As we have seen, there were adequate manuals which any carpenter could follow—not only Benjamin's but also a very popular one by the excellent architect Minard Lefever—and produce a structure that, no matter how ill-conceived and uncomfortable its interior plan, gave an outward effect of tastefulness and even of splendor. Furthermore, Greek Revival seemed to offer something for everybody—the small-town banker, the vast landowner, the farmer, and the mechanic could each put his own interpretation (or, just as likely, his wife's interpretation) on what it might mean.

Greek Revival houses came in all sizes and degrees of luxury, in spirit not unlike the mass-produced automobiles of today, all of which speak similar if by no means identical languages of taste. They ranged from large mansions with massive columns rising to gleaming pediments which sat on hilltops and dominated villages and valleys, houses with perfect symmetry

Greek Revival came in all sizes and degrees of elegance. This wooden, domesticated temple was built by an unknown architect (or carpenter-builder) in Old Mystic, Conn., in 1835. (*Photo Wayne Andrews*)

of plan as well as of façade, to small story-and-a-half houses whose Greek attributes were reduced from columns to pilasters at the corners and from pediments to copybook moldings. Large or small their roofs were temple-flat or shallow-peaked, and the rooms under the tin sheathing that covered them, especially in the small houses that had no attics, were ill-ventilated by windows at floor level and fearfully hot in the summer. The typical large house, because of its symmetrical plan, was likely to have two of everything divided by a central hall—two identically shaped parlors, two so-called "French Rooms," often two first-floor bedrooms, with the dining room, the pantry, and servants' rooms fitted in somehow in the back. The kitchen was likely to be in the cellar, under the pantry, along with the "wash room" (laundry) and the sauce cellar (for storing vegetables). In the story-and-a-half house, which must have seemed a very peculiar innovation to people used to houses with their front doors always in the center, the entrance was at one side and led into a narrow hall out of which rose a steep staircase. This arrangement made for a somewhat more flexible distribution of rooms and avoided the old problem of a central hall that acted like a wind tunnel through the house in winter. Ceilings on the first floor in the Greek Revival house, however, were fashionably high, and this made the rooms difficult to heat.

In cities Greek Revival houses, except those mansions that were set on vastly expensive pieces of real estate in midtown or that were built in open land on the periphery, were mostly set in rows with high stoops, if they were in New York, or with three or four white marble steps to the front door which were considered essential in Philadelphia and Baltimore. Like the story-and-a-half house, the typical city dwelling had its entrance at one side; it opened into a long narrow hall on what was called the parlor floor, which very often boasted not just one but two parlors separated by columns that did not necessarily match those on either side of the front door but were in the same Grecian spirit. The dining room was sometimes on this floor instead of a "back parlor," but often it was in the basement, which was at ground level; the cellar was under that.

Visitors from Europe were quicker to see the ridiculousness of much American Greek Revival than were most Americans. A great deal of it was not an architecture at all but exterior decoration or stage-setting—boxes with white icing on them. When Alexis de Tocqueville, whose vision nothing seemed to escape, arrived in New York by way of "that part of the Atlantic Ocean which is called the East River" in the early 1830s, he wrote: "I was surprised to perceive along the shore at some distance from the city, a number of little palaces of white marble, several of which were of classic architecture. When I went the next day to inspect more closely one which had particularly attracted my notice, I found that its walls were of white-washed brick, and its columns of painted wood. All of the edifices I had admired the night before were of the same kind." He was moved by this encounter to comment: "No longer able to soar to what is great, they cultivate what is pretty and elegant, and appearance is more attended to than reality."

"Pretty and elegant" were precisely the right words for the socially most acceptable kinds of Greek Revival houses. When the owners could afford to throw out their old furniture and start fresh, they made the interiors as modishly classical as the exteriors, with chaste moldings that would have met with the approval of Asher Benjamin and Minard Lefever, and with mantelpieces sturdier and less finicky than those inspired by the Adam brothers for Federal houses. Mantels, indeed, often were supported by columns with capitals and sometimes by caryatids. From the center of the parlor ceiling hung a chandelier with cut-glass prisms, often suspended from a bull's-eye molding of plaster. If the owner lived in New York and could afford the best, he patronized Duncan Phyfe and his neighbor Michael Allison, whose designs, like those of other master cabinetmakers, were based on English and French price books. After the ugly war of 1812

Washington Square in New York was the scene of elegant urban living in Greek Revival row houses when these were built in the 1830s. Happily, some of the buildings, if little of the elegant life, still exist. (*Photo Landmarks Preservation Commission, City of New York*)

The Old Merchant's House, of which this is the parlor floor in the Greek manner, is at 29 East Fourth Street in New York and is open to visitors. Seabury Tredwell, for whom it was built in the 1830s, might have bought his furniture from Joseph Meeks & Sons, whose advertisement is reproduced on page 187. (*Photo Landmarks Preservation Commission, City of New York*)

anything English was considered distasteful by most Americans and "the French taste," as it was called, was far more acceptable. The Empire style was most fashionable in furniture, as it was for ladies in their high-waisted dresses with little sleeves and scooped-out necklines. Empire echoed some of the details of the house itself; traceable to the Romans and the Greeks (indeed, sometimes to the Egyptians because of Napoleon's exploits there), it had a pleasantly archaeological flavor built into its chic. There were side chairs in the klismos form with splayed front legs and backs ornamented with Pompeian decoration; there were chairs with cross-front legs, and there were sofas of unyielding formality with gilt and ormolu decoration that might have been lifted bodily from the paintings of Jacques Louis David, who celebrated the ancient world with singular skill, taste, and

frozen rigidity. Pier tables stood on pillars made of alabaster with gilt capitals; and dolphins and griffins and sphinxes and eagles supported side tables and the arms of chairs that stood on lions' paws. Above the mantel was a mirror, sometimes to the ceiling and imported from France—the bigger the better, for mirrors were considered one measure of a man's wealth. Sometimes it was framed with pilasters and topped with urns sprouting grasses and strung together with garlands'. In front of it were ormolu dancing maidens supporting candles on their heads, or putti holding candelabra aloft, or dolphins peering through cut-glass prisms with candles above them. There might also be a bell glass covering an urn filled with wax flowers and in the center of the mantel an ormolu clock ornamented with a standing figure of George Washington handing a scroll to an eagle.

No one for a moment would have accused the master cabinetmakers of not being art-makers as well. It was a good deal more important for a prominent man to have his house properly embellished with their products than with the paintings of contemporary artists who thought of themselves as working in the noble traditions of Poussin or Titian or Salvator Rosa or Benjamin West. There were a few collectors of paintings, as we have seen, but the pictures that decorated the walls of most Greek Revival houses were family portraits; engravings of portraits of such prominent historical figures as George and Martha Washington; engravings of landscapes with cattle, of scenes from Shakespeare, of battle scenes like those of Trumbull; watercolors of willows weeping over maidens in graveyards; samplers made by little ladies; and in more prosperous but no more sophisticated households, "cast-iron" copies of Old Masters with fancy and false attributions. If a great deal of what passed for "art" was spurious, a great deal of home-grown furniture was genuine and splendid.

Architects went on designing and carpenters went on concocting Greek Revival houses and public buildings until well past the middle of the century. The first palace hotel built anywhere in the world was the Tremont House in Boston, which opened its doors in October 1829 with a dollar-a-plate banquet at which Daniel Webster was present. Its designer, a young Yankee from Marshfield, Massachusetts, named Isaiah Rogers, had put a Doric porch on its front, with the result that for decades no self-respecting hotel owner dared to have anything but a Doric porch as the entrance to his building; it became a sort of palace-hotel trademark. Alexander Jackson Davis, one of the greatest designers of the first half of the century, built elegant houses and public buildings in the Greek mode; we will meet him face to face later when we also meet his extraordinary friend Andrew Jackson Downing, who perpetrated the great Gothic rage that became so

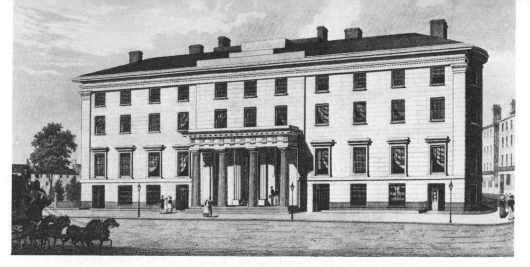

Tremont House, the first "palace hotel" in the world, was built by
Isaiah Rogers in 1829 in Boston and set a fashion for Doric entrances
which lasted for many decades as a sort of trademark of luxury.
(*Frontispiece of W. H. Eliot*, A Description of Tremont House, *1830.
The New-York Historical Society, New York City*)

Alexander Jackson Davis, architect and draftsman *par excellence*,
made this rendering of an exceedingly stylish Greek Revival interior
with furniture, probably imported from Europe, in the fashionable
Empire style. It was the residence of J. C. Stevens. (*The New-York
Historical Society, New York City*)

The architect who built Rattle & Snap, the residence of George Polk, in 1845 in Columbia, Tenn., is not known, but the house is a commandingly elegant temple in the best mansion tradition of the ante-bellum South. (*Photo Wayne Andrews*)

lively in the 1840s. In the South, stately mansions (custom requires the cliché) with colonnades or porticoes of great elegance like Belle Grove at White Castle, Louisiana, and Rattle & Snap, the home of George Polk at Columbia, Tennessee, were still being built almost as late as 1860. But the fashion had been fading for a decade or more. This style had a long period in the sun of popular favor, as such periods are measured by American cycles of taste. It lasted longest in the Western part of the nation, where columns and porticoes made settlers from the East feel at home in the new territories.

The temple style did not die without a bombardment of critical pressures. There were Americans as well as Europeans like Tocqueville and Marryat and Mrs. Trollope who thought it ridiculous. James Fenimore Cooper, who had so admired Strickland's Second Bank of the United States in Philadelphia, had had his fill of temples by the time he wrote his bitter novel *Home as Found*, whose publication in 1838 made him a host of American enemies. It was in many respects a snobbish attack on American manners and tastes, but when he snapped his whip at temple architecture, it stung.

"An extraordinary taste is afflicting this country in the way of architecture," said one of his characters,

nothing but a Grecian temple being now deemed a suitable resi-
dence for a man in these classical times. Yonder is a structure, for
instance, of beautiful proportions, and at this distance appar-
ently of precious material, and yet it seems better suited to
heathen worship than to domestic comfort. . . . One such temple
placed in a wood might be a pleasant object enough; but to see a
river lined with them, with children trundling hoops before their
doors, beef carried into their kitchens, and smoke issuing, more-
over, from those unclassical objects chimneys, is too much even
for a high taste; one might as well live in a fever. . . . The fault
just now is perhaps to consult the books too rigidly, and to trust
too little to invention; for no architecture, and especially no
domestic architecture, can ever be above serious reproach, until
climate, the use of the edifice, and the situation, are respected as
leading considerations. . . . While nothing much can be more
beautiful [than a temple], *per se*, nothing can be in worse taste
than to put them where they are.

Fifteen years later Horatio Greenough, a more perceptive critic than
sculptor, though the latter was his calling, also berated the temple style and
its practitioners. "The mind of this country," he said, "has never been
seriously applied to the subject of building. . . . We have been content to
receive our notions of architecture as we receive the fashion of our garments
and the form of our entertainments from Europe. In our eagerness to
appropriate we have neglected to adapt, to distinguish,—nay, to under-
stand. . . . We have sought to bring the Parthenon into our streets, to
make the Temple of Theseus work in our towns." And, he thought, with
ridiculous results.

The critic James Jackson Jarves was even more ruthless. "Strictly
speaking we have no architecture," he said. "It is simply substantial build-
ing with ornamentation, orders, styles, or forms borrowed or stolen from
European races . . . chaotic, incomplete, and arbitrary, declaring plagia-
rism and superficiality and proving beyond all question the absolute pov-
erty of our imaginative faculties, and general absence of right feeling and
correct taste."

Time frequently heals the wounds inflicted by changes of taste, and it
has healed those which afflicted the Greek Revival in the generation after its
flowering. In many respects it was the first architecture that was self-con-
sciously an American production, and if it borrowed foreign forms, orders,
and ornamentation, it honestly attempted (and not infrequently with dis-

tinctly beautiful results) to adapt these to our needs and our aspirations. Perhaps more important than this, it was the architecture that introduced professional architects to America, and it was the first tradition in which Americans were trained to build as something more than journeymen. In the shadow of the Greek temple, builders became art-makers, and it was as art-makers that they divorced themselves from the building trades and became members of a new order of practical men who were proud to be truly architects and thus purveyors of art.

Mr. Jefferson would have been pleased.

4

THE END OF A BEGINNING

*"I cannot be happy unless I am pursuing the
intellectual branch of the art. Portraits have
none of it; landscapes have some of it; but his-
tory has it wholly."*

SAMUEL F. B. MORSE in
a letter to his parents, 1814

Washington Allston was an intellectuals' artist and an artists' artist, a
burdensome thing for any man to be. He bore the burden with uncommon
grace and external modesty, but his passion for perfection finally broke
him.

Colonel John Trumbull, the "patriot artist," was a gentlemen's and
businessmen's artist—self-assured, clever, soundly trained, with a highly
polished manner and technique, aristocratic of birth and bearing, and, on
the side, a sharp trader. He was a sort of General MacArthur of the arts,
full of the importance of his own destiny, an opportunist, and deeply
concerned with what posterity would think of him. Like Allston, he was
ultimately the victim of the image he created of himself.

Samuel F. B. Morse, whom most people think of only as one of the
inventors of the electric telegraph and the man for whom a code was named,
was a very different sort of artist from either Allston or Trumbull, though
he knew and respected them both. He was devoted to Allston, who be-
friended him as a young man of exceedingly promising talent, and he finally
came to do open battle with Trumbull, whose eighteenth-century posture ill

became a nineteenth-century artist. Morse was an American of a new kind
that Trumbull could not understand—republican in spirit, easy of manner
but dignified, quick-witted but not acid, thoroughly serious about his mis-
sion as an artist and determined to excel all others, but a man with a talent
for men, a practical streak, and the consuming curiosity and the ingenuity
of a scientist who was also an inventor.

　　This crowd of three dominated, in a sense, the art circles of the open-
ing decades of the nineteenth century. All three of them painted portraits,
of course; all three of them had encountered encouragement in Benjamin
West's studio in London as aspiring young men; and all three of them
wanted to be famous as "history" painters. There the similarities cease.
They were not all equally talented, though they were a great deal more
talented than nearly all their contemporaries in America (none of them
painted portraits as fluid and subtle as Gilbert Stuart's, for example, or
nudes as delicious as Vanderlyn's), and their temperaments sent them off in
quite different directions. It was through the strength of their personalities
and intelligence as much as their talents that they dominated the making of
art and led the attempts to better the environment of the arts and to find
ways to live with and in a new kind of society which promised a new kind of
patronage.

THE "PATRIOT ARTIST"

Trumbull was the oldest of the three by twenty years. He was born in 1756,
the sixth child of Jonathan Trumbull, who later became the Colonial Gover-
nor of Connecticut and whom General Washington nicknamed "Brother
Jonathan." As Dunlap, who knew Trumbull well and cordially disliked him,
reported in his *History of the Arts of Design,* "This painter was emphati-
cally well-born; and . . . he reaped, as is generally the case through life, the
advantages resulting from the accident." Trumbull was a sickly child; he
had a curious malformation of his skull which caused convulsions, a
condition that after several years was cured by the infinitely patient manip-
ulations and massagings of his mother. He was bright, and because as a
child he had lost the sight of an eye in an accident, he was pampered by his
parents. By the age of twelve he was considered intellectually prepared to
enter Harvard, but he was not permitted to do so. He became an undergrad-

uate, however, when he entered the junior class at fifteen, a situation which he later considered "one of the misfortunes of his life." He was a better scholar than boys several years older than he, and to fill his spare time he took French lessons from a French family in the neighborhood and, according to Dunlap, "ransacked the college library for books on the arts." He also made copies in oils of paintings that were owned by the college (including a copy by Smibert of a portrait by Van Dyck),* getting the colors he used from a house painter.

He also got, while at Harvard, an inaccurate and grandiose notion of what a painter's life was like. Copley was still living in Boston (he did not leave for England for good until 1774), and young Trumbull paid a call on him. It happened to be at a time shortly after Copley's marriage when he was entertaining a group of friends, and Trumbull was astonished to find him dressed to the nines in a suit of crimson velvet with gold buttons. "The elegance of his style and his high repute, impressed the future artist," Dunlap wrote, "with grand ideas of the life of a painter." The young man's father, however, had a quite different notion of art as a career for his brilliant young son. Trumbull's tutor wrote the boy's father, "I find he has a natural genius and disposition for limning. As a knowledge of that art will probably be of no use to him I submit to your consideration whether it would not be best to endeavor to give him a turn to the study of perspective, a branch of mathematics, the knowledge of which will be at least a genteel accomplishment, and may be greatly useful in future life." Back came the reply, "I am sensible of his natural genius and inclination for limning; an art I have frequently told him will be of no use to him."

It may be unfair to say that the Revolution played into Trumbull's hands, but there is no question that he played his hand in it swiftly, pettishly, and for the rest of his long life made the most of his brief excursion into the military.

After he graduated from Harvard in 1773, he painted for a while with homemade materials and taught school in Lebanon, Connecticut, where as the clouds of conflict became ominous he undertook to train a group of local men in the rudiments of military science and deportment. When the first regiment of Connecticut troops was mustered after the battle of Lexington, he was appointed adjutant. His regiment was stationed at Roxbury, Massachusetts, south of Boston, when the battle of Bunker's Hill (as it was then called) was fought. Some years later, when Trumbull painted his dramatic

* John Smibert was a Scotsman who came to America in 1729 with Bishop Berkeley, lived in Newport, Rhode Island, and Boston, and was a successful painter of portraits.

picture of the event, he claimed to have been an eyewitness, but Dunlap pointed out that though he may have seen the smoke of the battle, he was a good four miles from the action. This part of his military career about which he boasted throughout his life resulted from a suggestion of his elder brother, Jonathan, who was on Washington's staff. At his request the young man made a drawing of the British fortifications on Boston Neck, and his skill and evident accuracy so impressed the General that he appointed Trumbull to be his second aide-de-camp, a position in which he gloried for nineteen days.

Trumbull's military career lasted in all only a few months. He was transferred to the command of General Gates, and before he was twenty-one was made adjutant to a regiment and commissioned a colonel. When the commission came through in the following February, however, it was dated September instead of June; furious at what he considered (possibly rightly) an injustice, he quit the army, though he insisted on using the title of Colonel for the rest of his life.

"I cannot but think," Dunlap wrote of the incident, "that the young man made a great mistake even upon the narrow calculation of self-interest . . . ; he abandoned the cause of his country, at a time that 'tried men's souls,' and gave up prospects, as fair as any young man of the period could have, of being an agent in the great events which followed."

The benign Henry Tuckerman, who liked to see nothing but beauty in the souls of artists, wrote in his account of Trumbull's life: "with the sensitiveness which characterized him as a soldier, a gentleman, and an artist, he felt aggrieved at the date which Congress assigned to his commission, threw it up in disgust, and quitting the army, resumed the pencil."

In 1780 the well-born and handsome young colonel was off to Europe to pursue the muse his father thought so feckless. In Paris, Benjamin Franklin gave him a letter to Benjamin West in London. West, who played such an important role in the lives of so many American artists, had been living in London for seventeen years and had achieved a reputation of almost unparalleled distinction in England's art world. He had been born in Philadelphia, where he was regarded as an astonishingly precocious boy (he was a professional painter when he was twelve), and, financed by a group of Philadelphia gentlemen, he had left for Europe in 1759 when he was twenty-one. He went directly to Italy to study the great masters, whose pictures he knew only from engravings, and after three years, mostly in Rome, where he soaked himself in the works of Raphael, he decided to go to London for a brief visit on his way back to America. London was, after all, the capital city of the kingdom of which he was a citizen and, as his father

pointed out to him, it was "home." The paintings that he had made in Italy and brought with him were an immediate success; he made friends easily, and they encouraged him to "take rooms" and set himself up as a history painter, a challenge he found irresistible. By the time Trumbull arrived to pay his respects to the famous American artist, West had become an intimate friend of George III, "historical painter to the king," and a charter member of the Royal Academy, of which a decade later he was to become the successor to Sir Joshua Reynolds as president.

When Trumbull arrived at West's studio, the older painter asked if he had a sample of his work to show; when he said he had none, West told him to "Go into that room, where you will find Mr. Stuart painting, and choose something to copy." The fastidious Trumbull was rather alarmed to find Gilbert Stuart, just a year older than himself, "dressed in an old black coat with one half torn off the hip and pinned up, looking more like a beggar than a painter." He picked a picture to copy, and when West asked if he knew what he had chosen and he said he did not, West said, "You have made a good choice; if you can copy that, I shall think well of you." Trumbull had chosen Raphael's "Madonna della Sedia," and West did indeed come to think well of the young man's gifts.

After just a few months of work in West's studio Trumbull was arrested as a spy—not because the authorities had any evidence against him, but in revenge for the capture and hanging of Major John André, who had been caught dealing with Benedict Arnold for the betrayal of West Point. It was characteristic of Trumbull that when he was brought before the court his aristocratic blood boiled. "Gentlemen," he said to his examiners, "you are rude. You appear to be more in the habit of examining pickpockets and highwaymen then gentlemen. I will cut this examination short . . . by telling you who I am. I am the son of him you call the rebel governor of Connecticut and I have been aide-de-camp of him you call the rebel General Washington. . . ." He spent eight months "in confinement," but, thanks to West's speedy intercession with his friend the King, he was assured that he would not be executed and was allowed to choose his own prison. There he was supplied with canvas and paint by West, and Stuart took advantage of his colleague's confinement to paint a portrait of him.

When Trumbull was at length released, he returned to America, where his father tried to persuade him to give up art and become a lawyer. Trumbull was eloquent in defense of the artist's mission and of the glories a life of art promised. "You have omitted one point, as the lawyers call it," his father said.

"What is that, sir?" the son asked.

"That Connecticut is not Athens," his father replied and, according to Dunlap, "He then bowed and left the room, and never after interfered in the choice of life."

Trumbull never wanted to accept the fact that no Athens was to be built in America in his time. He was a history painter in the romantic tradition, and he believed in the glorification of heroes and of great deeds. He felt strongly the need to provide a new country, full of hope though mired in political jealousies and torn with conflicting philosophies, with a pantheon of demigods, many of whom still stalked the earth; indeed, some still stalked the halls of Congress. History and histrionics suited his plastic as well as his personal style: he composed battles like baroque pageants with banners flying, the eyes of the dying raised to heaven or to generals as aloof as gods. Beneath lowering clouds and skies bright with fire, gentlemen struck poses that were aggressive or statuesque or resigned to fate, but there was never any question that battles were fought by gentlemen being gentlemanly within the romantic and aristocratic codes of behavior as they applied to the noble business of war.

Trumbull painted his first pictures glorifying the Revolution, "The Battle of Bunker's Hill" and "Death of General Montgomery," while he was working in London under the eye of the benign West. They were not large pictures, only twenty-five by thirty inches, but they were filled (if not crowded) with figures of soldiers and portraits of officers in dramatized poses. In manner they derived directly from West's "The Death of Wolfe," which James Thomas Flexner in his admirable *America's Old Masters* calls "the first boots and breeches picture." History paintings of men in contemporary dress and uniforms were unfashionable when West took his heroes out of togas and put them in the clothes they might have worn. It was a shocking innovation, but greatly successful; the public was delighted and paid well to see it. In the next few years Trumbull added other paintings to his Revolution collection, and when he returned to New York in 1789, he set about making miniatures of heads which he would use in his historical series—most notably in his "Declaration of Independence," which was later referred to derisively as his "shin picture" because of its exposure of so many pairs of legs in breeches and hose.

Trumbull's career as an art-maker was subject to frequent interruptions and infuriating disappointments. He spent seven years as, first, a secretary to John Jay and then as a member of a reparations commission in Europe. He speculated successfully in European currencies and in Old Masters and met such mighty figures as Talleyrand, Madame de Staël, and

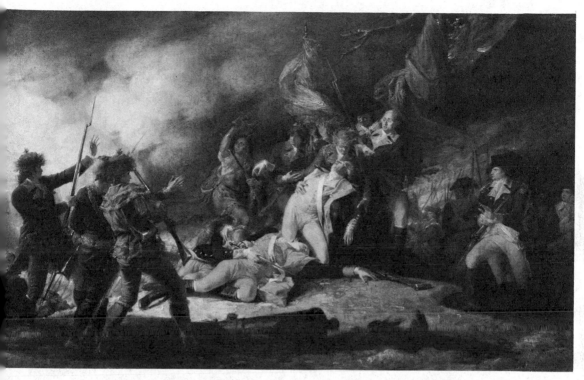

"Death of General Montgomery in the Attack on Quebec" by JOHN TRUMBULL was highly regarded as realistic history painting when it was executed in 1786. (*Yale University Art Gallery*)

the great official father of French painting at the time, Jacques Louis David. His return to New York in 1804 was a deflating experience in spite of the fact that West had written him: "I am happy to have so good an account of your pencil being employed at New York. I hope it is the beginning of the arts in that city, and that they take a firm possession there, as well as in other cities of America."

The New York to which Trumbull returned was a booming city of nearly 75,000 souls and growing so fast that it more than doubled its population in the next two decades. The harbor bristled with the masts of ships from the ports of Europe and Africa and Asia; they sailed up the Narrows at the rate of 150 a month, and the wharves were crowded with wheelbarrows and drays loaded with hogsheads and the streets were loud with the cries of vendors. The cornerstone of the new City Hall, an elegant building designed by Joseph-François Mangin and John McComb, Jr., in

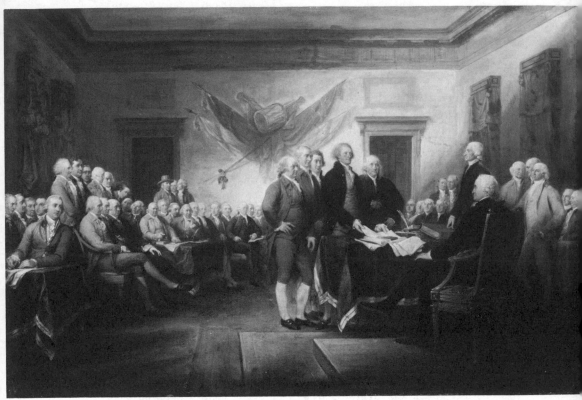

It was because of JOHN TRUMBULL's small paintings such as "Declaration of Independence," which is only thirty-one inches wide, that he was commissioned to paint four murals for the Rotunda of the National Capitol in 1817. The big versions were considered a catastrophe. (*Yale University Art Gallery*)

the manner of Louis XVI, had been laid the year before "in a large three-cornered piece, shaded by beautiful trees," as a Swedish artist, who did a charming watercolor of it, described its site.* The town rattled and hummed to the sound of hammers and saws as upward of seven hundred buildings a year were rising two or three or four stories on lower Manhattan. Buildings, indeed, were going up at such a rate that the price of brick had climbed to $10 a thousand and several large structures were left to languish for want of materials to complete them.

What we now call "culture, serious, pop, and folk," was lively, and it

* Baron Axel Leonhard Klinkowstrom visited New York in 1818–19. He published two volumes of *Letters About the United States,* which he illustrated with aquatint engravings of his watercolors and drawings.

does not appear to have been solemn. Theaters were crowded with playgoers who delighted to indulge a taste for the macabre and the eerie. As one historian said, "Shakespeare himself might tremble for his supremacy had he not fortunately created the sportive Ariel and the ghost of Hamlet's father." Indeed, the full range of Shakespeare, from his least impressive plays to his greatest, were popular fare. Since actors were regarded as social pariahs in the United States (as they most certainly were not in Europe), theater managers imported thespians from abroad and most frequently from England. Candle drippings rained down from chandeliers on the audience in the pit along with all manner of things thrown by the shouting and jeering inhabitants of the top gallery. Most musical performances were recitals by individual musicians, but there also existed a Philharmonic Society to which Trumbull and his elegant friends might take themselves. There was in addition a New York Musical Society of Amateurs, and the popular songs of the day seem to have forecast the sentimental engravings over which it so delighted Victorian maidens to sigh two generations later. They were "Thou Dear Seducer of My Heart," "The Maid with a Bosom of Snow," and "Rosy Smiles Her Cheek Adorning." Trumbull might have preferred (if it was not too vulgar for him) a ballad called "Let Washington Be Our Boast."

For the less refined there were rougher spectacles: bull-baiting was popular, and occasionally a panther "from the wilderness of Niagara" was chained and set upon by dogs for, as an advertisement in the *American Citizen and General Advertiser* in 1801 said, "the lovers of sport," who were assured their safety as "the animal will be confined with a strong chain fourteen feet long, so that no danger may be apprehended from its breaking loose."

What Trumbull came back to was not exactly what might be called an American Athens, though it was the city which had recently established America's first Academy of the Arts and equipped it with a collection (which Trumbull had helped to assemble) of casts of classical statues. He set himself up, Dunlap says, in a "large house on the corner of Pine Street and Broadway, as a portrait painter in his second style," his first style presumably being that of a history painter. He had no rivals in New York. Gilbert Stuart, who was more competent, was working "at the seat of Government," muddy and unhatched as it was. John Wesley Jarvis, the incorrigible Bohemian, was still largely unknown, and so was the amiable Thomas Sully. Trumbull painted portraits of Alexander Hamilton and other distinguished characters, but commerce ran into trouble in 1808 and the number of gentlemen in New York who felt impelled to have their

features immortalized declined accordingly. Furthermore, the reputations of Jarvis and Sully increased and Stuart moved north. "In 1808 Mr. Trumbull again returned to England," Dunlap says, "loudly complaining of the taste, manners and institutions of America." London did no better by him, though he stayed there until 1816. Because of the War of 1812 "everything American was unpopular," he claimed, but in any case *he* was unpopular, and he even had a falling out with Benjamin West, who he had once claimed had been a father to him for thirty years. Trumbull's star, which had never risen as high as he had convinced himself it had, was falling, and with the decline in his fortunes came a decline in his temper and a rise in his pettishness. It was when he came back to New York that De Witt Clinton turned over to him the presidency of the moribund Academy, and though he still had twenty-seven years of life ahead of him and a good deal of increasingly muddy paint left in his brushes, he became less and less an art-maker and more and more a politician of the arts.

He thought it was his destiny—or so, anyway, he boasted—to be the Master of the Rotunda of the Capitol and that in that noble location all men would see and be inspired by his record of the great events of the Revolution. In the same year that he took over the presidency of the Academy, Congress commissioned him to make four vast paintings which, when they were completed and installed eight years later, called forth hooting criticism. One Congressman said they weren't worth 32 cents, much less the $32,000 that the nation had paid for them. Could these be by the same hand that had painted the brilliant little history paintings on which they were based? They were "large, cold, flat, chalky." They were, indeed, the failures of warmed-over inspiration. Many years had gone by since their original conception, and the fire in the old Colonel's one eye had dimmed.

VICTIM BY ASSOCIATION

An artistic casualty who was in some respects a by-product of Trumbull's temperament and ambition and must be mentioned along with him was John Vanderlyn. He was a talented painter from Kingston, New York, and he deserves more than casual mention. He was indeed very prominent in the public eye in his day, and many of his contemporaries regarded him as a

genius; his is still one of the memorable names in the annals of American painting.

It was one of Vanderlyn's many misfortunes to run afoul of Trumbull over the commissions for the Rotunda paintings. Vanderlyn hoped to share in these, but Trumbull's lobby of friends prevailed over Vanderlyn's efforts to secure the patronage of the government, and the defeat came at a time when Vanderlyn's fortunes were more than just precarious; they were deeply discouraging. Vanderlyn's failure to make his mark with the public was partly a matter of a carefree temperament, an ineffable incapacity to deal with his own finances, a pride that was not arrogant but was touchy, and the misfortune to have fallen a victim to guilt by association. It had been to Aaron Burr's attention that his considerable gifts had been drawn, and the ill-starred politician who in 1804 killed Hamilton and his own future with the same bullet from a dueling pistol had been his patron. Burr arranged for Vanderlyn to work for a few months in Stuart's studio (Stuart had made a portrait of Burr) and then sent his young protégé to Paris, satisfied that he was "rescuing Genius from Obscurity."

When Vanderlyn arrived in France in 1796 he was a handsome, blond young man, filled with enthusiasm and charm, something of a dandy, with an eye and talent for the ladies and a determined ambition to be a great artist. He was admitted to the Ecole des Beaux Arts and the classes of André Vincent, an exacting taskmaster and ardent advocate of David, and thus of the most rigid classical training, which kept his pupils' eyes on the dead forms of plaster casts for many months before they were allowed to gaze upon live models. When Vanderlyn was not at school (or enjoying the frivolous pleasures of the Palais Royal) he spent long hours copying masterpieces in the Louvre, hoping to absorb the techniques of the past. In 1801 he came back to America for a brief stay, painted portraits of Burr's daughter, Theodosia, and her French companion, Natalie de Lage, and took himself, as so many painters in the nineteenth century did, to Niagara to paint the spectacle which so fascinated the world and which promised its recording artists successful sales of engravings. On his second trip to Europe he went with a commission from the Academy in New York "to produce casts from antique statues and other pieces of sculpture" which he agreed to accomplish in Italy and France in a year, and he took his Niagara, hoping to find a Parisian engraver to transfer it to metal. He was partially successful with the first project but not with the second. Robert Livingston, the United States Minister in Paris, intervened with the French authorities to accomplish the first, but Vanderlyn could not find an engraver who met his standards and was not too busy to take on the work. As a consequence,

he went to London looking for an engraver and, as all young American artists were wont to, turned up in West's studio, where he and young Washington Allston met for the first time and immediately became friends. It happened that a cousin of Allston's had married Theodosia Burr. Allston and Vanderlyn shared a delight in many of the same pastimes and admired each other's talents, and in 1803 they decided to go to Paris together by way of Holland and Belgium.

Vanderlyn should have gone to Italy to complete his contract with the Academy, but he dawdled in Paris; Allston did go to Italy, and Vanderlyn joined him there the following year under pressure from the Academy. Once he got to Rome, however, the Academy seemed to have lost interest in him, or in any case would send him no further funds. He disliked Italy, but for the sake of his reputation it is fortunate that he went there. He came back to Paris with a painting of "Marius Among the Ruins of Carthage" which was to rocket him to the zenith of his career. It was shown at the Salon of 1808, and, according to the pleasantest version of what happened, the Emperor Napoleon, walking with his entourage through the exhibition, stopped before Vanderlyn's painting, stared, and instructed the committee to bestow a gold medal on its creator. However the distinction took place, Vanderlyn was indeed given a gold medal, which pleased him tremendously but which in later years he was frequently obliged to pawn. "Marius," which is now in the M. H. de Young Memorial Museum in San Francisco, came back to New York with him in 1815 together with his best-known and most successful painting, a voluptuous nude "Ariadne" (now in the Pennsylvania Academy of the Fine Arts) in the Venetian manner. It is one of the masterpieces of early nineteenth-century American painting, but many of Vanderlyn's contemporaries found its classical nudity clothed only in a skin inspired by Titian too improper for their tastes. Taste in that particular cold climate insisted that art keep its clothes on; to New Yorkers in 1815 respectability was a quality not just of manners and morals but of aesthetics—and nudity, however chaste, was not respectable.

Vanderlyn and Trumbull did not get along, and more than competition for patronage was at the root of their quarrel. Vanderlyn was angry with the Academy, which he thought had treated him badly (though there is much to be said on the Academy's side; Vanderlyn had not, after all, turned out to be its most reliable emissary) and the situation was not helped by an incident that happened at the Old Almshouse, where the Academy held its exhibitions. Vanderlyn, according to Dunlap, had "an apartment adjoining the gallery [that] had been allotted to him for his pictures." At a meeting of the organization, another artist, John Ruben Smith, who acted as the

Napoleon, it is said, was so impressed by JOHN VANDERLYN'S ''Marius
Amidst the Ruins of Carthage'' at the Paris Salon of 1813 that he
ordered a gold medal bestowed upon its creator. (*M. H. de Young
Memorial Museum, San Francisco*)

keeper of the Academy and had drawing classes in rooms on the same floor, objected to Vanderlyn's paintings on the grounds that "the parents of his pupils would not allow their children to come to a room adjoining to which a number of indecent pictures were exhibited, making use of a term respecting them still more improper." According to Dunlap, Smith was abrupt of manner, pretentious, dictatorial, and "at times disgustingly obsequious." Smith made it quite clear to the assembly that either Vanderlyn's pictures went or he resigned as keeper.

"Very well, Mr. Smith," the chairman of the meeting said and rose and bowed Mr. Smith out of the room.

That was not, however, the end of the incident. "The consequence of some silent influence," Dunlap said, "was that Vanderlyn removed his pictures, and never [again] would associate or take part with the institution. Mr. Trumbull was left dictator."

Vanderlyn's reputation could never rise above the stigma of his past association with the disgraced Aaron Burr, but that was not the only handicap to his gaining the reputation and livelihood that he thought was due him. He tried to supplement the slender income he made from painting portraits by painting a vast panorama of Versailles and its gardens, which he installed in a building called the Rotunda, erected in City Hall Park in New York with funds supplied by his friends. He planned to exhibit a series of such panoramas to attract the public, a form of static entertainment that he had discovered to be extremely successful in Europe. The picture was painted in Kingston—mostly, it appears, by a helper, though the figures that give it accent are evidently Vanderlyn's work. New Yorkers were disappointingly uninterested, and so were Philadelphians when it was shown there. The city evicted Vanderlyn from his Rotunda in 1829, and the building became a post office.

In a characteristically mid-nineteenth-century example of encrusted rhetoric, Henry Tuckerman pardoned Vanderlyn's failures. "Yet we can easily forgive," he wrote,

> the ardent votary of a noble art, after successful competition for its highest honors, for yielding to a feeling of disappointment, bitter in proportion to his natural sensitiveness, at the indifference and calculation against which he so vainly strove in the land of his nativity, the distrust was increased by the charge of indelicacy somewhat grossly urged against his works, by ignorant prudery. . . .

Vanderlyn's final fling at capturing the public reputation that he firmly believed he deserved and at recouping his fortunes was engineered by

a group of his friends and especially, it appears, by Gulian Verplanck. Verplanck, that influential and versatile New Yorker, was at one time a member of Congress (authors owe him as much, as do painters, for the copyright law he introduced there), a writer of no mean skill, a professor at the General Theological Seminary, and a vestryman of Trinity Church. Through his influence Vanderlyn was at last commissioned to paint one of the large murals for the Rotunda in the Capitol, and he promptly went off to Paris to start work on "The Landing of Columbus." Eight dilatory years went by before it was finished, and there is considerable doubt as to whether he painted it himself or whether it was largely the handiwork of some young Frenchman working under his supervision. In any event, it was greeted with much the same disdain as had met Trumbull's paintings for the same hall.

Vanderlyn died in the autumn of 1852. The day before his death, on his way to Kingston from the river-steamer dock, he met a friend and borrowed a coin from him to "pay for the transport of his baggage from the steamboat to the town." "He was ill," a letter to *The Crayon* said, "and on reaching the hotel retired at once. His friends, meanwhile, . . . went about the neighborhood to collect the means for his present relief. Vanderlyn requested to be left alone, and the ensuing morning, was found dead in bed, in a low room that looked out into a stable-yard, without even a curtain to shade his dying eyes from the sunlight."

THE ARTISTS' ARTIST

While Trumbull was successfully playing his hand with the financiers and politicians of New York and making his mark as a statesman of the art community and while Vanderlyn was slowly succumbing to despair and impoverishment, Washington Allston, the artists' artist, was minding his own business.

Allston's business was to become a painter of the very first order in the tradition of the greatest painters who had ever lived. He came closer to artistic success than either Trumbull or Vanderlyn, who were easily distracted from their art by external pressures and enticements, and he was an innovator as neither of the others was. Allston, whatever his shortcomings as a history painter (his histories were not political but religious and

mythological) may have been, opened the doors of American art to a vast landscape filled with mystery, the overwhelming power of natural phenomena, and romance.

[One of the delightful, if sometimes confusing, games that art historians play might be called "artificial dissemination." In the tradition of scientific classification, they gather artists together in a conveniently identifiable group, label it with a name, and dispense it as a package to their constituency, which in our time of cultural impetuosity and snobbism is a very great many persons. They call such a group a "school," and the ideas that they identify with a school are called a "movement." In this sense Allston can be called the initiator of the romantic *movement* in America and the father of a *school*. The artificial aspect of this dissemination of abstractions, for that is what they are, lies in the vagueness with which schools are defined, their blurred edges, and the fact that art does not lend itself to such neat external categorization as, say, rocks or wildflowers, trees or clouds, beasts or bodies of water, all of which, incidentally, are characteristically part of romantic landscapes as they were painted in the nineteenth century. Art does not lend itself this way and neither does the artist, for the artists are bent on discovery, and thus are likely to change constantly their ideas of the world and the comment they wish to make on it. Artists have "periods" (early, middle, or late, for example) as centuries have "schools," and these incline to flow one into another with no sharp lines of demarcation. It is generally said of the eighteenth century that it was "classical" and the "age of reason," and that the first half, at least, of the nineteenth century was "romantic." It is further said that the adoption by architects of *classical* forms in the nineteenth century was a *romantic* idea. These are tenable, if confusing, theories, but, however convenient for helping scholars to organize materials, they should be taken not as truth but merely as artifice. Art-historical "truths" are not self-evident. They are approximations at best, and they change with each generation of scholars and critics.]

When Vanderlyn and Allston met at West's studio in London, Allston was fresh from Harvard College. One of his classmates recalled that he "was distinguished by the grace of his movements and his gentlemanly deportment." When he was a young man, as when he was aged, passers-by turned to look at him. "His countenance, once seen, could never be forgotten," his classmate wrote. "His smooth, high, open forehead surrounded by a profusion of dark wavy hair, his delicately formed nose, his peculiarly expressive mouth, his large, lustrous, melting eyes . . . formed a face that was irresistibly attractive. . . ." He was, moreover, friendly and well liked even by "those who hated one another most heartily," for he evidently made his

presence felt by an easy charm and not by insistence. His caricatures and light verse are still in the files of the Hasty Pudding Society, and though he was a serious young man who, by his own account, spent his leisure hours "chiefly devoted to the pencil," he was not solemn. Like Trumbull before him, he had no youthful training as an artist except what he gave himself, and, like Trumbull, he made a careful copy of the "Van Dyck" portrait of Cardinal Bentivoglio which hung in the college library.

Allston was born on a plantation in South Carolina in 1779. His father, who had served as an officer in the Revolution, died when his son was only three, and his mother then married a physician from Newport, Rhode Island; he had gone south as chief of General Greene's medical staff. When Allston was eight he moved north with his family to Newport, his mother's marriage to a Northerner having been considered by the Allstons a step down socially. Before he left, however, an impression was made on him which he long remembered. In a letter to Dunlap he said:

> It seems that a fondness for subjects of violence is common with young artists. One might suppose that the youthful mind would delight in scenes of an opposite character. Perhaps the reason of the contrary might be found in this: that the natural condition of youth being one of incessant excitement, from the continuous influx of novelty—for all about us must *at one time be new*—it must have something fierce, terrible or unusual to force it above its wonted tone. But the time must come to every man who lives beyond the middle age, when 'there is nothing new under the sun . . .' I delighted in being terrified by the tales of witches and hags which the negroes used to tell me.

By this definition every child is a romantic and has the proper background to become a painter of romantic canvases filled with mystery and dire prospects. Dunlap noted that Allston had escaped the South just in time to avoid the pernicious lesson of being a young master of Negro slaves, "whose servility would make a deep impression . . . cherishing self-love and self-importance if continued beyond a very early age." Dunlap was an early, ardent, and active opponent of slavery.

Allston was determined to follow the artists' path to knowledge and skill, which meant to London, when he graduated from Harvard in 1800. He was twenty-one, and he had some funds that were his patrimony. (He is said to have been hasty in converting his inheritance of land in Carolina into cash and to have got far less for it than he should have, an indiscretion he paid for many years later with a struggle to meet his financial needs

entirely with his brush.) He declined an offer from a "gentleman named
Bowman" of Charleston to provide him with £100 a year during his stay
abroad. Mr. Bowman had been impressed by his "college verses and . . . a
head of St. Peter" which he had painted while at Harvard. "It would have
been sordid to have accepted it," Allston wrote to Dunlap. "Such an
instance of generosity speaks for itself. But the kindness of manner that
accompanied it can only be known to me who saw it."

The art world of London in which Allston arrived was dominated by
Benjamin West; Sir Thomas Lawrence, the elegant portrait painter;
Henry Fuseli, "a wild romantic"; and John Opie, who painted direct and
realistic portraits and whom Sir Joshua Reynolds had said was "like Cara-
vaggio, only better." Allston was greatly impressed by Fuseli's strange
canvases, which delighted in the supernatural and the morbid and reflected
some of Allston's own preoccupation with "witches and hags." West, to
Allston's surprise, turned out to be a great master and not what he had
expected from the inferior engravings he had seen of West's paintings.
Lawrence he found inferior to Gilbert Stuart. But it was not on contem-
porary English painting that Allston wanted to base his art; nor was it on
the eighteenth century (he found it decorative but unserious), but it was on
the tradition that had been so rich from the Renaissance through the seven-
teenth century. Great works of art demanded great subjects—the wide,
wild, mysterious world of landscape, the dramas of the Bible and the myths
of Greece were subjects to which Allston turned. He was not interested in
depicting recent battles or scenes from the plays of Shakespeare or contem-
porary manners, though the streak of the caricaturist which he exercised in
college stayed with him and he occasionally painted a presumably humorous
genre scene like "The Poor Author and the Rich Bookseller" which might
better have been left unpainted.

The continent was a more natural home for his talents than England,
and he and Vanderlyn arrived in Paris in 1803, the year after the Louvre
opened as a public museum. Here was a treasure house surely unparalleled
by anything that Allston had ever beheld and perhaps unparalleled in the
world. Here in profusion were masterpieces from the great tradition to
which the young man wished to devote his life; here was a taste of a feast to
be found in Italy. And he took off for the banquet and arrived in Rome
early in 1805.

Rome was a quiet, shrunken city in the few years when Allston lived
there, not the bustling metropolis it had been in the distant past and was to
become again. But it held for Allston the inspiration he thirsted for in an
atmosphere congenial to artists. The landscape was controlled and placid,

fountains plashed in nearly deserted squares, gardens and vineyards grew within the city; there were the ruins of antiquity, the noble churches of the Renaissance, the "great pile" of St. Peter's; there were the miracles wrought by Raphael and Michelangelo and the ancients. Allston painted landscapes that were echoes of earlier masters—whispers of Claude, of Salvator Rosa, of Poussin—and his paintings became in turn the progenitors of a whole school of landscapes that recorded the vastness of the American continent. From the composites that Allston painted of Swiss lakes and Alps and tortured trees and the tamer stretches of Italy it was no great step to the sweep of the Hudson Valley and of the Catskills, to gorges in the Berkshires and the plains of the West which occupied American painters a generation later. But the wonder is that Allston was able to tear himself away from Rome, where he was content and exhilarated, and where he was happy in the friendship of Washington Irving and Samuel Taylor Coleridge, both of whom became his lifelong friends.

Irving was twenty-two when he got to Rome and was destined, he feared, to become a lawyer, a profession he did not much want to pursue and for which he suspected he had little talent He got caught up in Allston's enthusiasm for art, the passion of his concern, the expertness of his eye, and his ability to define his preferences. "Never attempt to enjoy every picture in a great collection," Allston warned him, "unless you have a year to bestow upon it. . . . The mind can only take in a certain number of images and impressions . . . ; by multiplying the number you weaken each and render the whole confused and vague." Irving was so charmed by Allston and his way of life that for a few days he thought he wanted to become a painter himself. "I mentioned the idea to Allston," Irving wrote many years later, "and he caught at it with eagerness. Nothing could be more feasible. We would take an apartment together. He would give me all the instruction and criticism in his power, and I was sure to succeed." Fortunately, he thought better of it, but his was a long devotion to the art of painting, and he became one of the best friends and champions of American artists. Literary men enjoyed a far higher public regard than art-makers did in America; and without writers to espouse their cause, artists would have gained acceptance far more slowly than they did.

Allston returned to Boston in the spring of 1809, set himself up in an old house in which Smibert and Copley and Trumbull all had worked, and went about the serious business of painting and of matrimony. He married Ann Channing, whom he had met in Newport before he went abroad, and a friend noted that he had found him in his studio (then called a "painting room") "on the morning after his nuptial at his usual hour engaged at his

customary occupation." He produced landscapes and portraits (mostly of friends and family) and "humorous" pictures in the Cruikshank manner, and he devoted many hours to writing poems. A friend who had not seen him since he left Harvard wrote that "I . . . found him the same unsophisticated, pure minded, artless, gentle being that I had known him at College." Boston was no place for this painter to make a living by his brush, as it had been no place for Copley before him, and he went back to England in 1811, taking his bride and his young protégé, Samuel F. B. Morse. His wife died in London in 1815, a shock so great that Allston suffered what seems to have been a severe breakdown. His young friend Morse and another gifted young painter from America, Charles R. Leslie, saw him through the crisis. He had been working well in London; these were, indeed, his most productive years, a time in which he was firm in his ideas of proper subjects and increasingly in command of his technique, which to him meant the accomplishment of a surface that glowed like the canvases of the great Venetians. He painted the "Dead Man Revived" (which the Pennsylvania Academy bought); an admirable portrait of his friend Coleridge; a dramatic throwback to the bandits he had admired as a boy, called "Donna Mencia in the Robber's Cavern" (from *Gil Blas*), a scene mysteriously lighted from within by a lamp, like a Honthorst or La Tour. He painted a "Rebecca at the Well," an "Elijah in the Desert," and the sketch for the canvas that was to plague him for the rest of his life, "Belshazzar's Feast." He had achieved an admirable reputation in London, and his friends said when he decided to return to America in 1818 that if he were willing to stay in England he might well succeed Benjamin West as president of the Academy.

The Boston to which he returned was no more interested in painters than the Boston he had left. The city had never yet held an exhibition of paintings (the Athenaeum finally held its first in 1827); it was a literary town, and Allston again took to writing verses, essays, and even a novel. "Washington Allston," Van Wyck Brooks recorded in *The Flowering of New England*, "wrote his poems and nursed his dreams of Titian under a cold and distant sky." He lived across the Charles in Cambridgeport, which he detested and where (according to the sculptor W. W. Story, who as a young man looked with admiration and awe at the aging painter) "he turned all his powers inward and drained his memory dry. His works grew thinner and vaguer every day and in his old age he ruined his great picture. I know no more melancholy sight than he was, so rich and beautiful a nature, in whose veins the south ran warm, which was born to have grown to such a height . . . stunted on the scant soil and withered by the cold winds of that fearful Cambridgeport."

The "great picture" was "Belshazzar's Feast," a vast composition that he believed would be the crowning accomplishment of his career, a noble and romantic subject painted on a noble and romantic scale. Its reputation as a masterpiece existed almost before it was begun, and an uncommonly generous group of ten Boston gentlemen, aware of Allston's financial straits and devoted to him as a figure, a prophet, and the ideal of an artist, each agreed to put up $1,000 to form a trust on which Allston might draw while he gave himself entirely to finishing the painting. In 1820 he made the mistake of showing the canvas to Gilbert Stuart, and a very great mistake it was. Stuart thought that the point of view (*Augenpunkt,* that is, not attitude) was not right and suggested that Allston shift it, which Allston set about doing, but he was never satisfied with the picture again, and it came to plague him unmercifully. Years passed and the picture stayed on the easel as Allston worked and reworked it with increasing discouragement. "It was in all respects," E. P. Richardson says in his study of Allston, "a great personal tragedy, humiliating to the artist and embarrassing to the men who wished to help him." He turned down the opportunity to paint one of the pictures for the Rotunda in the Capitol in Washington. He was unwilling to expose himself to the kind of public and political criticism which might befall him if he could not complete his commission. He wrote to a Congressman, " 'Will he never finish that picture for the Government?' might be asked from Castine to St. Louis. No money would buy off the fiends that such words would conjure up." He worked on the unfinishable picture the day he died.

Allston's reputation as an artist quickly dimmed after he died (as did the delicate colors in his paintings) and has been revived only recently. James Jackson Jarves and Tuckerman both speak of him as a great man, a luminary of the early American arts, and credit him with being the "father" of American painting. He was to a generation of artists in the early years of the century the epitome of the artists' artist—visionary, dedicated, incorruptible, intelligent, and greatly talented. He was, moreover, generous with his friendship and encouragement to other artists—most notably the painter Morse and the sculptor Horatio Greenough.

"Allston . . . was to me a father," Greenough wrote to Dunlap, "in what concerned my progress of every kind. He taught me first how to discriminate—how to think—how to feel. Before I knew him I felt strongly but blindly, as it were; and if I should never pass mediocrity, I should attribute it to my absence from him. So adapted did he seem to kindle and enlighten me, making me no longer myself, but, as it were, an emanation of his own soul."

"Dead Man Revived by Touching the Bones of the Prophet Elisha" won a prize of two hundred guineas for WASHINGTON ALLSTON at the British Institute in London in 1813, a time when England and America were at war. (*The Pennsylvania Academy of the Fine Arts, Philadelphia*)

WASHINGTON ALLSTON's "Elijah in the Desert" (FACING, ABOVE) (1817) was one of the great early romantic landscapes painted by an American in the Italian manner before American artists discovered their own native romantic landscapes. (*Museum of Fine Arts, Boston*)

WASHINGTON ALLSTON painted this first study of "Belshazzar's Feast" (FACING, BELOW) in 1817. It was the work he counted on to be his masterpiece, but it became his anguish, and when he died in 1843 it was still unfinished. (*Fogg Art Museum, Harvard University, Washington Allston Trust*)

MORSE, A GENIUS WITH TALENT

Samuel Finley Breese Morse came more particularly than Greenough within the orbit of Allston's personality and was his very special protégé. With humor and talent and doggedness Morse struggled to make the arts his home and America a place in which an artist could hold up his head, but his success and his fame found a haven elsewhere. His fame became international, and he found his home eventually in the laboratory rather than at the easel.

Morse was one of the most attractive personalities ever to make a name in the American arts. He was born in New Haven in 1791, the son of a parson, and his good, solid, virtuous upbringing stood by him as long as he lived. He was pious in the best nineteenth-century sense of that once overused word, which did not mean that he was a prig, and he was very much a man of his era. He tried hard to reconcile the startling expansion of his nation's commerce—the speculation, the quick riches, and the industrialization—with his ideals of art. One historian of painting said that "his ideals were not too far ahead of his public," but they were just far enough ahead to be irritating to him for many years and finally frustrating. Fortunately, he was, like Charles Willson Peale and Robert Fulton, an artist who was a scientist and a visionary tinkerer. The science he ultimately fell back on (or leaped forward to) was closer to the ebullient spirit of his native land than the cushion for discouragement that Allston found in writing romantic verses.

Morse went to Yale and graduated in 1810. He was briefly exposed there to the sciences in the lectures and demonstrations of Benjamin Silliman, who said, "With the Bible in my hands and the world before me, I think I perceive a perfect harmony between science and revealed religion." Silliman was one of the early experimenters with electricity and, incidentally, a relation of Colonel Trumbull, whom he invited to stay with him and his family in New Haven; it was he who encouraged the old painter to write his memoirs. Morse was clever with his pencil as a boy, and his father (as most fathers were wont to do in those days and as they seem to do now) thought poorly of art as a career for his son. It was grudgingly that he at last gave his blessing to Samuel's ambitions; possibly the parson would not

have let his son set out for London in the company of anyone but a man of Washington Allston's unquestioned probity, piety, and idealism. In any case, Morse went to London in 1811 with the Allstons, determined, of course, to study with West.

To "study with" in those days meant less to be taught by than to seek the criticisms of an established artist. There is an attractive anecdote told by Dunlap of Morse's first encounter with West. The young man made a careful drawing from a small cast of the Farnese "Hercules" and showed it to West, whose only comment was, "Go and finish it." Morse went off and worked over the drawing until he thought he had perfected it, and again, when he showed it to West, the old man told him to "Go and finish it." This happened several more times, and finally Morse, "almost in despair," said, "I cannot finish it." To this West replied, "I have tried you long enough; now, sir, you have learned more by this drawing than you could have accomplished in double the time by a dozen half-finished beginnings. It is not numerous drawings, but the character of one, which make a thorough draughtsman. Finish one picture, sir, and you are a painter."

For a young man Morse cut a considerable swath in London's art world. In preparation for a painting of "The Dying Hercules" he made a terra-cotta figure (following a method Allston used in preliminary studies), and West was so impressed that he suggested the little statue be shown at the Adelphi Society of the Arts. It won a gold medal, and, to Morse's great satisfaction, the painting for which it was made, when it was shown in 1813 at Somerset House in the Royal Academy exhibition, was one of just twelve pictures among two thousand that were singled out for special critical praise.* It was enough to convince him that his future lay in "history painting," and he wrote, to his parents: "I cannot be happy unless I am pursuing the intellectual branch of the art. Portraits have none of it; landscape has some of it; but history has it wholly." His mother replied with considerable accuracy, "It has always been a failing of yours, as soon as you found you could excel in what you undertook, to be tired of it. . . . You must not expect to paint anything in this country for which you will receive any money to support you, but portraits."

It was necessary for Morse to come back to America in 1815, though

* Six casts of the terra-cotta figure were made. Morse gave one to Bulfinch when he was the architect of the Capitol, and many years later, when Morse was exploring the basement of the Capitol preparatory to installing wires there for a telegraph, his light fell on a familiar object and he was astonished to find the cast, which Bulfinch had stored there years before. This cast is now at Yale, as is the gold medal it won for Morse.

"The Dying Hercules" in terra cotta, prepared by Samuel F. B. Morse as a model for a figure in a painting, won a gold medal for him in London when he was only twenty-one. (*Yale University Art Gallery*)

he desperately wanted to stay. He had painted "The Judgment of Jupiter" (now at Yale), which West thought might win the medal at the Royal Academy and the prize of fifty guineas; it could not, however, be considered for the prize unless Morse was there to exhibit it himself. But his family's finances could not sustain their son's study in Europe any longer, and they told him firmly that he must come home. Allston wrote them on August 4, 1815:

> I cannot suffer my young friend to leave me without some testimonial. . . . It is a subject of no slight gratification to me that I can with sincerity congratulate you on what religious parents must above all appreciate—the return of a son from one of the most dangerous cities in the world, with unsullied morals.

"If he meets with encouragement," Allston also said, "he will be a great painter."

When Morse got to Boston his reception was extremely flattering and extremely unprofitable. He met with great encouragement but no orders. He was considered the ideal guest and an ornament at any dinner party, and the fuss that was made over him was full of promise for his career. He had brought his "Judgment of Jupiter" with him and exhibited it in his painting room, where it was greatly praised. No one, however, so much as asked its price or the price of any other work he had to sell. After a year of this he took off to New Hampshire in search of portrait customers at $15 a head.

There was room for only one portrait painter in Boston when Morse arrived there, and Gilbert Stuart was the one. His fame was secure, his technique was fashionable, and not only were portraits his métier but he was untroubled by ambition to be a history painter. He was sixty when Morse came to Boston, and behind him stretched a series of portraits of the most prominent American leaders of the Revolution and the first families of New York and Philadelphia and Washington, in each of which cities he had practiced his profession. He had made the painting of General Washington's portrait into a subsidiary business that was extremely profitable. He produced, for example, seventeen known replicas of his first (so-called Vaughan) portrait of Washington, the original of which was painted in 1795, and at one time he had orders for thirty-nine. He never became a nineteenth-century artist, though he lived until 1828. His style was rooted in the grand manner of the eighteenth-century portraitists of England, and he had competed successfully as a young man in London with such elegant and fashionable talents as Romney, Reynolds, and Gainsborough. Unlike Trumbull, almost exactly his contemporary, he not only stuck to the business of portraits but shunned the politics of art. He was a friend to young artists and greatly influenced the portrait style of such men as Thomas Sully and Morse and John Neagle and Matthew Jouett. He was charming and crusty, alternately prosperous and poverty-stricken, humorous and dour, a subtle colorist and occasionally a sloppy draftsman, a man of extremes, and—with the possible exception of John Singleton Copley—the most distinguished portrait painter of his time in America.

For the next three years Morse managed to support himself with portraits. On his New Hampshire expedition he met a young woman of seventeen, dark-haired and, if his miniature of her is faithful, beautiful. Her name was Lucretia Pickering Walker and they were married in 1818, but only after he had proved that he could be relatively prosperous as a portrait painter. He went for several winters to Charleston, South Carolina, a socially lively city with elegant becolumned houses and spacious drawing rooms in which he was richly entertained and whose owners became

his clients. He got $60 for a head and for a full figure with accouterments as much as $200 or $300. He benefited from the opportunity to adopt some of Sully's techniques as his own (as Sully portraits hung in many Charleston houses) and to evolve a somewhat less rigid and more fluent style. Charleston, however, was fickle, and his fashion ran out after four seasons. "A fresh gang of adventurers in the brushline," he said, had supplanted him; by 1821 he had completely run out of sitters and some who had said they had wanted to sit stalled him off. One of his principal competitors was John Wesley ("bad was best") Jarvis from New York, famous as a raconteur, bon vivant, and charming eccentric.

On one of his trips to the South, Morse had made a pilgrimage to see Thomas Sully in Philadelphia. After Stuart, Sully was the most fluent and accomplished portraitist of his time, and, like Stuart's, his excursions into other kinds of painting were inconsequential. The community of artists in those days was small enough so that each seemed to know what the others were up to, and Morse made a pleasant gesture of respect to his "elder and better" when he wrote (in a letter now in the Historical Society of Pennsylvania) to Sully from Boston in May 1816:

> *Dear Sir:*
>
> Understanding you are engaged in painting two battle pieces, and thinking the accompanying prints of the *Costumes of the British Army* may assist you in your undertaking, I feel happy in the opportunity of loaning them to you till I have the pleasure of seeing you on some future day. . . .

The day came in 1819 when the portrait business, along with all business, was in the doldrums. The nation was suffering from a financial setback resulting from land speculation, the mismanagement of banks, and overextension of manufacturing. Conditions for the artist were so bad that Sully had taken to trying his hand at a history picture, "Washington Crossing the Delaware," which was not at all his line of goods. It did not sit well with him, and he wasted a great deal of time for no return. His reception of Morse on the Philadelphia visit was evidently in character: he was generous to younger artists, encouraging them as he had been encouraged by West and Trumbull and Stuart. As a young man he had arrived in London with only $400 of the money advanced by his six Philadelphia patrons, since he had had to leave behind a wife and two children with sufficient funds to maintain them. West gave him permission to make copies from paintings in his own collection, and Sully recorded in his journal that he worked at them "from the moment of rising until afternoon when I studied at the Antique School of the Royal Academy under the instruction of

Fuseli." Sully's journal is one of the few complete records of an American artist's ups and downs. He meticulously kept track of his commissions—what he was paid, where he went, how his portrait prices increased with his reputation—and included notes on how he mixed his colors. It is a record from 1801 until the year before he died at the age of eighty-nine in 1872, and it reveals a man of generosity, adventurous spirit, and thorough professionalism. If he added no new dimensions to the art of portraiture, he committed himself in the tradition of the English school (and especially in the manner of Thomas Lawrence) with freshness and charm and, though he was no delver into the recesses of his sitters' characters, with subtlety.

For several years after his fortunes declined in the South, Morse's life was plagued with personal tragedy and professional discouragement. His second child, a daughter, died a week after she was born in March 1821; his clergyman father lost his parish in Charlestown, the victim of a theological row in which the Unitarians prevailed; Lucretia bore a third child in 1821, a son who was sickly. The Morses had moved to New Haven, and Samuel found congenial company there—the architect Ithiel Town, one of the progenitors of the Gothic Revival, had just built Trinity Church on the green; Hezekiah Augur, a cabinetmaker with ambitions to become a sculptor (he was, as we shall see, the first American to carve a group in marble), worked with Morse to perfect a machine for cutting stone figures. In spite of the necessity of making what money he could from portraits, Morse was determined to paint a great history picture that, like Rembrandt Peale's "The Court of Death," would make his fortune. With the utmost care and planning he set out to draw meticulous studies for "The Old House of Representatives." He spent hours making perspective drawings from the gallery and many more hours on sketches of the members of the House, for each portrait had to be faithful. He worked, he wrote his wife, fourteen hours a day, and she remonstrated with him, fearful for his health. The picture was eight feet by ten and took Morse eighteen months to paint. When it was finally exhibited, it cost Morse "several hundred dollars" more in agent's fees and exhibition rooms than he took in, and in a footnote Dunlap says: "This picture was rolled up and packed away for some years. Finally a gentleman offered $1,000 for it, which was accepted, and our House of Representatives in a body removed to Great Britain." * In 1825 Morse achieved the zenith of his career as a portraitist when he was commis-

* After Morse's death a pupil of his, Daniel Huntington, wrote; "His large picture, 'The House of Representatives,' for many years owned in England, was brought to this country by an amateur, taken to San Francisco for exhibition, returned to New York, and is now in my studio." Its permanent home is the Corcoran Gallery in Washington, D.C.

SAMUEL F. B. MORSE's most ambitious canvas, "The Old House of Representatives," was completed in 1822. All but one of the Congressmen in it (there are eighty-five) posed for their portraits. The painting was a financial failure for its creator. (*The Corcoran Gallery of Art, Washington, D.C.*)

sioned to paint Lafayette—a commanding portrait in the grand manner, now in City Hall in New York—and in that same year he hit the nadir of his personal life. Lucretia died while he was working in New York on his preliminary sketches of Lafayette.

Morse had become a lively and involved participant in the art world of New York, the conservative factor of which was dominated by the aging and irascible Trumbull and the laymen who supported the Academy. The progressive factor was a group of young men in whom republican ideals were struggling against old forms of patronage and against the European domination of taste. By the time Morse settled in New York the city was nearly twice the size it had been when Trumbull came back in 1804, and its literary life was distinguished by the occasional presence of Washington

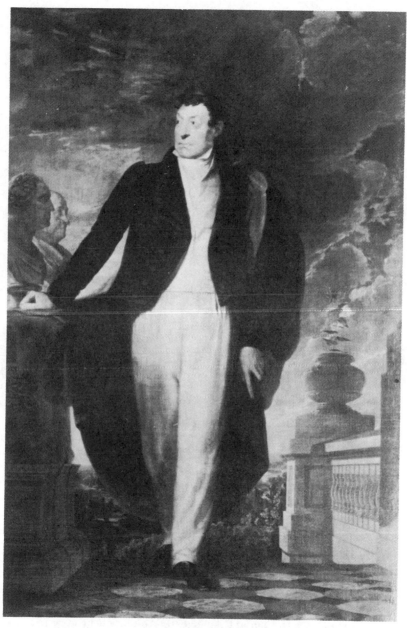

The Marquis de Lafayette visited America on a triumphal tour in 1824 and S. F. B. Morse was awarded the coveted commission to paint the official portrait. He received $700 plus fifty percent of the price for which engravings would sell. (*Art Commission of the City of New York*)

Upstate New York with an Italian look—"The View from Apple Hill" was painted by Samuel F. B. Morse in 1828–29 as the result of a visit to the home town (Cooperstown) of his close friend, the novelist James Fenimore Cooper. (*New York State Historical Association, Cooperstown*)

Irving and James Fenimore Cooper, by James K. Paulding and such rising young men as William Cullen Bryant (who became part owner and editor of the *Evening Post* in 1829) and the literate politician, patron, and satirist Gulian Verplanck. Many of these men met at the Bread and Cheese Club along with young artists who were to set new patterns in American art —indeed, who were to turn art American. Among them were the engraver-turned-landscapist Asher B. Durand; Henry Inman, portraitist and genre painter; and Thomas Doughty, a painter of gentle landscapes that had established his reputation with his peers by the time he was thirty. Morse was distressed by the schism in the artists' world. "He made it his business

to heal these wounds," Tuckerman relates, and tells how "one evening [Morse] invited them all to his room, ostensibly to eat strawberries and cream, but really to beguile them into something like agreeable intercourse." The upshot of Morse's efforts at diplomacy was the organization in November 1825 of the New York Drawing Association, with Morse as president, Inman as vice-president, and Durand as secretary. It was because the Academy under Trumbull's domination failed to come to terms with the Association that the National Academy of Design came into being in early 1826. The story of Trumbull's arrogant treatment of the young artists whom he considered upstarts is of an autocracy that is scarcely credible today. He arrived at a meeting of the Drawing Association, where the men were sketching, as they did three evenings a week, seated himself in the president's chair, and demanded that those present sign a book stating that they were students of the Academy. When no one signed, he stalked out, leaving the book behind and saying that when they had signed it, the book was to be delivered to the secretary of the Academy.

It is a credit to Morse's composure that his Association offered to join the Academy if it could have six places on the Academy board. As only two of the six men proposed were members of the Academy, the Association raised $100 for membership for the other four. The Academy agreed to this, but when it declared that only two of the six men proposed by the Association were acceptable, the young men organized their own National Academy. The older institution declined to return the $100.

The American Academy could never forgive the National Academy for existing at all, and the quarrel between the two organizations provided newspapers with lively and sometimes vituperative argument for nearly a decade. Basically, the argument was between those who thought that an academy should be administered by laymen for the benefit of "the arts" and those who believed that an academy should be a teaching institution administered by artists for the sake of training artists and for exhibiting the work of members and promising students. The quarrel was a symptom of a basic change in the attitude of the artist in America, and this was nowhere more clearly delineated than in an exchange of opinion on the subject of patronage which took place between Trumbull and Morse in 1833, when a final attempt was made to bring the old Academy and the new one together. In Trumbull's address opposing the projected union (he had three hundred copies printed) the old man said:

It has been proved by all experience, and, indeed, it is a truism, that the arts cannot flourish without patronage in some form,

that artists cannot interchangeably purchase the works of each other and prosper; they are necessarily dependent upon the protection of the rich and great. In this country there is no sovereign who can establish and endow Academies. . . .

This was too much for Morse the republican. "Let us see how this paragraph will be read by substituting *literature* for the *arts*," he rejoined,

for it is as applicable to the one as to the other. It is a truism, that *literature* cannot flourish without patronage in some form; it is manifest, that *Authors* cannot interchangeably purchase the works of each other and prosper; they are necessarily dependent on the protection of the rich and great &c. . . . Is there a man of independent feelings, of whatever profession he may be, who does not feel disgust at language like this? And is it to be supposed that the Artists of the country are so behind the sentiments of their countrymen, as not to spurn any *patronage* or *protection* that takes such a shape as this? . . . If there are any who desire to have such a patronizing institution as this—if there are Artists who desire to be thus *protected* and thus *dependant* [sic], it is a free country, and there is room for all; every man to his taste— but the Artists of the National Academy have some sense of character to be deadened, some pride of profession to be humbled, . . . some of the independent spirit of their country to lose, before they can be bent to the purposes of such an anti-republican institution. . . .

It was the battle of the art-makers to be inside society, as an integral part of a growing national sense of destiny, and not to be peripheral ornaments and servants of the few. It was part of the democratic surge that elected Andrew Jackson to the presidency.

Morse's personal battle as an art-maker continued to meet with frustrations. He went a second time to Europe in 1828 and painted in France and Italy until 1832, though in his lectures at the new Academy he had cautioned the students against the dangers of exposing themselves too long to Europe if they were to develop an American art. The trip produced one of Morse's most interesting pictures, a very large painting of the interior of the Louvre (now at Syracuse University) with walls hung with more than two dozen small replicas, faithfully transcribed, of Titian, Leonardo, Veronese, Van Dyck, Correggio, Claude, and other masters. It was exhibited in New York, but in spite of enthusiastic notices in the press, the public was uninterested. Morse's fortunes reached a new low. When his friend Feni-

S. F. B. MORSE provided a "descriptive catalogue" identifying the Old Masters in his "The Exhibition Gallery in the Louvre." First shown in New York on November 2, 1832, it won critical acclaim, but the public ignored it. (*Syracuse University, Syracuse, N.Y.*)

more Cooper came back to New York in November of 1833 he found Morse living in a single room that served as his studio, his laboratory, his classroom, and his lodgings. Only a couple of years more of being an artist were left in him, and his last picture, "Allegorical Landscape" (1836), which curiously set the Gothic Revival library of New York University in an idyllic and romantic landscape, was as far removed from reality as Morse's imagination could fling it.

In December of 1833, after the failure of the Louvre picture, he wrote to his friend S. de Witt Bloodgood in Albany what he thought of the position of the artist in America. "No, Bloodgood," he said,

> my profession is that of *beggar*, it exists on *Charity*. Have I not proof of it every day? How many are there like yourself who

purchase pictures because they love them? Do not most who purchase pictures give as the reason, *their wish to encourage the artist?* . . . Who purchases a coat, or a table, or a book to encourage the tailor, the cabinetmaker, or the bookseller? . . . A profession so precarious as mine is made to appear and really is from the *motives* of encouragement, is looked at by fathers, brothers &c. with suspicion, and objections are of course made to any family connection with it. . . . I assure you, Bloodgood, that neither talent nor character, nor education nor standing in society, will avail an artist against the secret distrust of him from the precariousness of his professional labor.

It was as though Morse were submitting his resignation to the Board of Muses. "What do I mean to do?" he continued.

To live if I can, to last through life, to stifle all the aspiring thoughts after an excellence in art about which I can only dream, an excellence which I see and feel I might attain, but which for twenty years has been within sight but never within my grasp. My life of poetry and romance is gone. I must descend from the clouds and look more at the earth. . . .

On his way back from Europe he fell into conversation in the cabin of the ship one evening with Dr. Charles Thomas Jackson, an expert on electricity. Morse asked him if a long circuit could carry an electromagnetic impulse to its very terminus, and when assured it would, he said (by his own account) : "If this be so, and the presence of electricity can be made visible in any desired part of the circuit, I see no reason why intelligence might not be instantaneously transmitted by electricity to any distance." That evening he drew in his notebook a sketch that, according to Oliver Larkin, his biographer, "foreshadowed a recording telegraph in all essentials."

When Morse died in 1871 at the age of seventy-three, people who remembered him as an artist were few indeed. He was known as the inventor of the telegraph, all across a world that he had linked with his "wonder-working wires."

With the deaths of Trumbull and Vanderlyn and Allston and Morse's resignation from the arts, the last traces of the eighteenth-century influence of the kind, enthusiastic, and immensely persuasive Benjamin West faded from the American arts. History painting lost its aesthetic standing as the highest achievement the artist could attain, though "the ideal" and the romantic continued to inspire the painters of landscapes and the rising

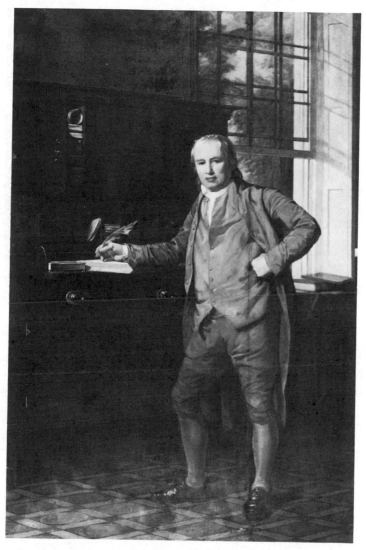

THOMAS SULLY was already a very successful portraitist at twenty-nine when he painted Samuel Coates of Philadelphia in 1813. He went on painting for nearly sixty years more. (*Pennsylvania Hospital, Philadelphia*)

GILBERT STUART was the master of American portraits in the genera-
tion following John Singleton Copley. He painted this remarkable
portrait of Mrs. Richard Yates in New York in about 1793. (*National
Gallery of Art, Washington, D.C*)

generation of sculptors. The climate was changing, and though Morse had
done much to abet the change by raising the standing and the spirits of
younger artists through his devotion to their cause, he failed to be com-
forted by the slight warmth he had helped to create.

It was those artists who had wanted to be more than just face painters
who had felt most acutely the chill in the air and who had tried to keep their
ideals and ambitions warm by never relinquishing their hopes to achieve the
ideal even in the face of continued discouragement and indifference. Cu-
riously, those who set their sights highest were not necessarily the most
talented painters of their time, nor have they by any means left the most
distinguished works of art behind them. Trumbull was no match for Gilbert

THOMAS SULLY painted this characteristically sentimental portrait of his daughter, Jane Darley, and her son Francis in 1840. Others might object to flattery in portraits, but, he contended, sitters never did. (*The Metropolitan Museum of Art, Bequest of Francis T. W. Darley, 1914*)

Stuart, for example, and no picture that he painted equals in subtlety, acuteness, or authority the best of Stuart's portraits. Sully achieved a grace and a humanity and a fluid kind of charm which Morse never quite managed. Allston (it seems to me a question whether he was more art-maker or literary pretender) struggled for an ideal based on a long but dying artistic exploration and excitement, and though he pursued tradition with poetic intensity, he lacked the passionate excitement of both intellectual and visual discovery. He was involved in re-creation, not creation; in archaeology, not

exploration; in echoes of legends no longer quite believed, not in the guts of new convictions.

These artists were concerned with abstractions—with the *ideal,* the *beautiful,* the *heroic,* the *noble,* the *classical,* the *historical*—partly because they had been taught that these were what art should concern itself with, partly because this was the kind of culture they believed a new nation needed to set it upon the path of greatness, and partly because this had been for centuries the highway to personal salvation for the artist. Portraiture, after all, was a process of one man subjecting himself to the features and ambitions and vanities of another man; art was concerned with the extrahuman, the divine, the epic. Portraiture was a means to a dollar; history painting was a passport to posterity, or so these artists ardently believed— at a cost, as it turned out, of seeing themselves engulfed by a new nation's need to discover itself. The art-makers were off in pursuit of a new mistress, wild and earthy and romantic.

The painters, that is; the sculptors, a new breed in America, seemed to have to go back to antiquity and start all over again at the beginning.

5

THE STATUE-MAKERS

"Art is not a low, idle trade, as practical men sometimes insist. Rightly followed, nothing is nobler and higher. . . . It is the sister of religion. . . . It is the interpretor of the high and pure. Its material is humanity."

WILLIAM WETMORE STORY
in a speech in New York, 1877

It is difficult to conjure up any form of art more remote from the facts of life in America than the first full-scale aesthetic fling of our native sculptors. This was Tuckerman's "superstructure of the beautiful" to a fare-thee-well. If art is a reflection of a culture or a statement of its aspirations or an expression of its beliefs (and it is often one or more of these), what in heaven's name did our artists, wielding their mallets and chisels, think they were doing when they gave their full hearts and clever hands to turning marble into Persephones, Clyties, and Greek slaves, into Cleopatras, cherubs, and sibyls? It is not difficult to explain their tastes art-historically (they fell in with what was fashionable in Europe), and they thought they were doing the only thing that artists by their lights should do—that is, make a living and raise the sights of their contemporaries from the sordid materialism of a rather grubby and grubbing society to the "higher things," lifting their eyes from their counting tables and political squabbles to the slopes of Parnassus. It was "the ideal" that mattered, or a reasonable facsimile thereof, and the concept fitted both the current popularity of rediscovered antiquity and the wave of gentility which was about to engulf

American manners and tastes. Gentility always plays it safe, and what could have been safer than dead goddesses birdseyed in white marble?

Colonel Trumbull is recorded as having said to John Frazee, a New Jersey stonecutter, in 1816 that sculpture "would not be wanted here for a century." Trumbull was not notable for his ability to read shifts in the public taste or to predict its unlikely future. He might, however, have realized that precisely what a young nation would want was to immortalize its heroes in stone, to commemorate its achievements in a durable material for posterity, and to ornament its public edifices—especially those in the capital of the nation—with sculpture. He was in no doubt of the importance of rendering the Revolution in paint; it is surprising that he should not have recognized that sculpture would appeal equally, if not more than paint, to the legislators who selected what should ornament the Capitol. In the century during which he predicted that we would not want sculpture, an avalanche of shaped marble and bronze engulfed the nation. There was scarcely a hamlet that did not boast a monument of some sort, and though a great deal of the sculpture was made with exacting skill, very little of it had any aesthetic bite, originality, or staying power.

William Rush, a carver of figureheads for ships, is customarily called the first American sculptor, though our early sculptors liked to quibble over the distinction between carving in wood and what they considered the more noble art of cutting in stone. Rush was a Philadelphian, and he ornamented his city, as well as frigates, with carved figures of a kind of rococo elegance, grace, and vitality that make many of his successors who worked in stone seem heavy-handed. He was able to find a young lady who would pose for him in the nude (chaperoned, of course) as the model for his "Water Nymph and Bittern." This was just about at the turn of the century— about the same time old Charles Willson Peale was having such troubles over the scandal of his attempted life classes. Rush understood the human body from the inside out; indeed, he carved models of the body's organs for medical schools to use in their teaching. His draped figures burst with life under their garments, and his portraits, filled with vitality and character, were built from the bone structure out. In a footnote to the published version of Latrobe's lecture to the Society of Artists in 1811, Latrobe (or perhaps it was his editor) said: "There is a motion in his [Rush's] figures that is inconceivable. They seem rather to draw the ship after them than to be impelled by the vessel. . . . Ashore his figures want repose, and that which is the highest excellence afloat becomes a fault." Evidently they were not classical enough for Latrobe, not stylishly calm in the restrained Greek manner he so loved.

One of several so-called "fathers of American sculpture," WILLIAM
RUSH carved "Water Nymph and Bittern" originally in wood, his
usual medium, about 1838. This bronze copy is in Fairmount Park,
Philadelphia. Many years later Rush in his studio was the inspiration
for the painting by Thomas Eakins reproduced on page 370. (*Com-
missioners of Fairmount Park, Philadelphia. Photo Philadelphia Mu-
seum of Art*)

Horatio Greenough, who referred to himself as a "Yankee stonecutter," is, like Rush, often called the first American sculptor, although he was not even, to be sure, the first to assault the bastion of that fine art with mallet and stone chisel. The first American sculptor in stone was John Frazee, whom Trumbull tried to warn away from the profession. He was a farm boy who when he was eighteen carved a stone tablet for a bridge over the Rahway River, liked the chisel, and spent his spare time learning the craft of stonecutting from a man who had worked on the details of City Hall in New York. When Dunlap was compiling his history of American artists, Frazee wrote him and said, "I began my career among the tombstones." In 1815 he had carved what was probably the first piece of American stone sculpture, a figure of "Grief" for the grave of his son. He is also credited with having made in 1825 the first portrait bust in stone by an American, the effigy of John Wells which is in St. Paul's Chapel in New York. To him also went the first commission given by the government for a piece of sculpture to ornament the Capitol—a bust of John Jay, for which he received $400.

His almost exact contemporary as a stonecutter (they were born a year apart) was a friend of S. F. B. Morse whom the painter-scientist had got to know when he lived in New Haven. He was Hezekiah Augur, a testy and morose man, a tinkerer with the kind of inventive ingenuity that appealed to Morse. (Among other devices Augur invented a wooden leg.) Morse gave him a classical cast of Apollo, which he copied directly in stone; the result was exhibited in the Academy of Arts in New York in 1825. It was Augur's claim that he carved the first group of figures ever made by an American in stone, earlier than a celebrated group by Greenough of "Singing Cherubs," and they found their way, with a push from their maker, into the Trumbull gallery at Yale. Augur wrote to Professor Silliman in October 1826:

> That the figures are worthy of a place at least among the *curiosities* in the Trumbull gallery must, I think, be readily admitted—they are, I believe, the first marble group executed in this country, certainly the first by an American, and were commenced before Greenough's Cherubs (in Florence) so that in priority of design, they are probably the first by an American artist.

Neither Augur nor Frazee, artists born and raised in the craft tradition, though they became respected members of the art fraternity, could forgive Greenough for being what they were not—an educated man who chose deliberately to be an artist and never thought of himself as an

HEZEKIAH AUGUR claimed that his "Jephtha and His Daughter" was "the first marble group executed in this country, certainly the first by an American." These "marble people," as Emerson called them, were carved in 1830. (*Yale University Art Gallery*)

upgraded craftsman, and who was, moreover, a philosopher of design. Greenough set out to be an artist, he did not just happen to become one, and it was the poetic Washington Allston who set him upon the path toward both antiquity and posterity.

Greenough, priorities of stonecutting aside, has justifiably been called "the first American sculptor of the first American School of Sculpture." He

was born in Boston in 1805 when that city was a town of about 25,000 with little to recommend it to artists, or to nourish artistic ambitions in the young, though as a youth Greenough "made copies of plasters" in the Boston Athenaeum. He went to Harvard, where a helpful librarian introduced him to a "valuable collection of original drawings," and he supplemented his studies with anatomical books, skeletons, and "preparations" that were made available to him by Dr. George Parkman of Boston. According to Greenough's brother Henry, he felt that he gained from his formal studies in college "little in comparison to what he obtained from the friendship of Mr. W. Allston," whom he had met at the house of Edward Dana, brother of the poet and critic Richard Henry Dana. "With Mr. Allston much of his time during his junior and senior years was spent," Henry wrote. "By him his ideas of his art were elevated, and his endeavours directed to a proper path." It was Allston who encouraged Greenough to go to Rome to study. The young man left Cambridge just before he was to graduate in 1825 (there happened to be a ship sailing for Marseilles), and his diploma was sent after him.

Rome very nearly did Greenough in. He tried, in effect, to swallow it whole, and the banquet was too rich even for his youthful appetite and intellectual grasp. When he arrived there the mood was severely (if superficially) classical, and the presiding gods of sculpture were the ghost of Antonio Canova, recently dead, and the amiable and gifted Bertel Thorvaldsen from Denmark. Each in his way had been bent on realizing, in stone of pristine whiteness, the classical doctrines preached so convincingly by the German Hellenist J. J. Winckelmann and the painter Raphael Mengs, men whose passion for the classical was inspired by the excavations in the middle of the eighteenth century at Herculaneum and Pompeii. Their discourses were devoured as gospel by artists and patrons alike, and their doctrine of classic purity (based on Roman copies of Greek statues and not on the polychromed originals) arrived at precisely the right moment to catch one of the great swings in the pendulum of taste. It seems to be a truism that when the arts get overblown and sentimental, there is likely to be not just a desire to clean house, but a new aesthetic and a new artistic morality and a new concept of "the ideal." It was this very insistence on clearing out what taste had decided was claptrap and replacing it with purity which Greenough encountered in Rome and which determined what American sculpture was going to look like for nearly forty years. (Anyone who is in any doubt of the power and influence of Canova or the seriousness with which he was regarded should look in the Frari in Venice at the elaborate memorial to him by his pupils, an almost unparalleled piece of neoclassical nonsense.) Green-

ough was merely the first of a parade of American sculptors who managed on their own or with the help of enthusiastic friends to go to Rome, where they basked in the white light of neoclassicism and learned the proper vocabulary of idealism and how to get Italian stonecutters to do most of the hard work for them.

But Greenough was of a very different temperament from the mechanics (like Hiram Powers, the contriver of the famous "Greek Slave") and literary men (like W. W. Story, who was at least as much poet as sculptor) who followed him in the 1830s and '40s. Greenough was tall and energetic, had a gift for languages, and, as Margaret Farrand Thorp says in her admirable book *The Literary Sculptors,* "he was so handsome that the *Achilles* he modeled in the 1830s was reputed to be a self-portrait." The attitude of his father, a Boston businessman, toward his son's determination to be an artist was a rare exception to the rule. He encouraged him, but insisted that before he embarked on a career in the arts he must take a degree at Harvard. Essentially, Greenough was more intellectual than artist, more theorist than stonecutter, more articulate with his tongue than with his hands; as Emerson wrote of him to Thomas Carlyle, his "tongue was far cunninger in talk than his chisel to carve." He was an impassioned believer in the democratization of taste and the ultimate judgment by the people of the validity of works of art. He was, as we shall see, a remarkable theorist of design whose intellectual perceptions seem curiously at odds with the works that issued from his studio.

Greenough's interests were omnivorous, and with his friend Robert Weir, a gifted American painter who was there when he arrived, he pursued the wonders of Rome. From very early morning until very late at night they explored galleries, where Greenough saw to his amazement subtleties of stone carving at which he could not even guess from the casts he knew in Boston; he drew from the model at the French Academy, worked at his own modeling in his studio, talked late at the Caffè Greco with other artists, and explored the ruins of the city after others had gone to sleep. He had a letter of introduction to Thorvaldsen, the famous sculptor who had inherited Canova's mantle, and the grand old man helped him with criticism. But the pace was too great, the pitch of excitement too high, and the Roman fever brought him down not only physically but mentally. He succumbed to a severe depression that rendered him incapable of coping with even the least necessities of daily life. Weir nursed him through the fever and finally brought him back to America, a gesture of the most unselfish friendship. By the time they arrived in Boston after a long and heaving voyage, Greenough had regained his health, equanimity, and equilibrium; he had reached

a plateau on which he could work, and he set about his profession, making busts of President Adams, Chief Justice Marshall, and other dignified citizens.

He could not long be kept from Italy. When he returned there in 1828 he sensibly avoided the excitement of Rome and settled in the quieter atmosphere of Florence, where he lived with occasional visits to America for most of the rest of his life.

So far as the demand for his skills was concerned, Greenough's lot was much like that of his contemporary painters. Portraits were what the public wanted, though it was not until later in the century, when men like Hiram Powers were at the full throttle of their marketing ingenuity, that the sculptured bust became something like the later portrait photograph, a memento one had run up to ornament the parlors of one's relations and friends. Greenough wanted to make proper art, personal art, and not just likenesses, and he fretted because his countrymen did not seem to be ready for "ideal" sculpture. It was his friend James Fenimore Cooper who broke the monotony and freed him to exert his imagination and test his skill. In 1829 Cooper, then in Florence with his family, commissioned Greenough to make a sculptural group that was indirectly inspired by the cherubs in Raphael's "Madonna del Baldacchino" in the Pitti Palace, a favorite picture of Cooper's daughters'. Some years later, in a letter to Dunlap, Cooper gave two reasons for selecting this subject for his commission: first, he could not afford to pay for a more elaborate concept, and, second, he thought it a good idea to distract Greenough from his concern with the "heroic" school and turn his attention to more delicate figures that might "do something to win favors from those accustomed to admire Venuses and Cupids, more than the Laocoön and the Dying Gladiator."

These were the "Singing Cherubs" over which Augur's group of marbles at Yale claimed priority, and they had a mixed reception. Allston was delighted when he saw this first ideal group by his protégé at the Boston Athenaeum, but most Bostonians were shocked by the nakedness of the figures. When the "Cherubs" were shown in New York, it was not shock that greeted them but disappointment that they did not actually sing. "When the man turned them around to exhibit them in a different position," a friend wrote to Greenough, "they exclaimed 'Ah, he is going to wind them up: we shall hear them now.'" He went on to say, "I wish the scene of this story lay anywhere but in New York, but it cannot be helped, and I must continue to consider my townsmen as a race of cheating, lying, money-getting blockheads." The sculptor Frazee assumed a contemptuous stance toward the "Cherubs," but his motive was competitive and not, like

that of the New Yorkers, philistine. Through Allston's intervention, Greenough was a candidate for making a sculpture of George Washington for the Rotunda of the Capitol, the most distinguished commission any sculptor might gain and a job that Frazee coveted. In a letter to Gulian Verplanck, pleading his case, Frazee denigrated Greenough's "Cherubs" as anti-classical, prosaic, and, because their eyes did not gaze at heaven, unspiritual. What was more, he implied, there was something un-American about a sculptor who employed the aid of Italian stonecutters. Greenough, however, got the job in 1832. It was to make him both famous and a target for merciless ridicule.

The portrait of Washington was the first grand commission given to any sculptor by Congress; Frazee's $400 for the portrait of John Jay was puny compared with the $20,000 voted to Greenough. He could scarcely believe what had happened, and he wrote from Florence to Dunlap: "When I went, the other morning, into the huge room in which I propose to execute my statue, I felt like a spoilt boy, who, after insisting upon riding on horseback, bawls aloud with fright at finding himself in the saddle, so far from the ground! I hope, however, that this will wear off."

It did, but the sculpture was eight years in the making, and still another year passed before it reached Washington in July 1841. It was a colossal figure, the father of his country in the guise of Zeus (indeed, the pose was inspired by a Roman copy of a Zeus that Phidias had carved for Olympia), seated upon a throne ornamented with lions' heads and chariots, his legs draped in a toga, a part of which also covered his upper right arm, which was raised in a gesture of authority. The torso was nude, and in his left hand Washington proffered a Roman sword in a scabbard, its hilt held out in a gesture of friendship. Greenough was warned that his compatriots might not take kindly to a semi-nude, classicized version of their greatest flesh-and-blood hero. "It will give you fame," Charles Sumner wrote him after visiting Greenough's studio. "Still, I feel it must pass through a disagreeable ordeal. . . . I refer to the criticisms of people knowing nothing about art. In Europe, an artist is judged at once, in a certain sense by his peers. With us, we are all critics. . . ." Fenimore Cooper also warned him that his compatriots would judge the sculpture "by the same rules as they estimate pork and rum and cotton," and he added: "Luckily you get a good sum, and the statue that has cost *them* $20,000 may stand some chance."

The warnings were justified. Everybody from Davy Crockett to the civilized retired mayor of New York, Philip Hone, sounded off. "I do not like the statue of Washington in the State-House," Crockett said. "They have a Roman gown on him, and he was an American; this ain't right. . . .

HORATIO GREENOUGH's colossal "George Washington" called down on
the sculptor's head a rain of vivid epithets when it was unveiled in
1841. It was the first important sculpture commission awarded by the
United States government. (*National Museum of History and Tech-
nology of the Smithsonian Institution, Washington, D.C.*)

He belonged to his country—heart, soul, and body and I don't want any other [country] to have any part of him—not even his clothes." Hone called the statue "a grand martial Magog, undressed, with a napkin lying in his lap." The wiseacres had a field day. They said that Washington was surely not dressed for the living room and not quite ready for the bath. They said that he was proclaiming, "Here is my sword—my clothes are in the Patent Office yonder."

But what distressed Greenough far more than the gibes was how his colossal undertaking looked when it was installed in the Rotunda. He had carved it believing that a diffused light would fall upon it from the dome; instead, hard shafts of light threw his modeling into deeply contrasting light and shadow, destroying the dignity and subtlety of his intention. He tried to find ways of softening the effect with artificial lighting, but to no avail, and he finally petitioned Congress to remove it from the Rotunda and install it on the lawn in front of the Capitol. It would have seemed reasonable to expect that a man with Greenough's perception and sense of architectural rightness would have examined the light in the Rotunda before spending years creating a figure that it would in a sense destroy. The figure was no happier on the lawn. The classical nudity looked even less appropriate than in the Rotunda, and the rain collected in puddles or ran in rivulets in the deeply cut drapery. In 1908 it was finally moved to the main hall of the Smithsonian Institution, which is still its custodian; it is now in the new Museum of History and Technology.

There is a remarkable combination of modesty and self-assurance in Greenough's attitude toward his Washington. Tuckerman quotes him as saying of it:

> It is the birth of my thought. I have sacrificed to it the flower of my days and the freshness of my strength; its very lineament has been moistened by the sweat of my toil and the tears of my exile. I would not barter away its association with my name for the proudest fortune that avarice ever dreamed.

And he wrote to R. C. Winthrop in 1847:

> Allow me to exult a little that during the months I spent at Washington, while my statue was the butt of wiseacres and witlings, I never in word or thought swerved from my principle—that the general mind is alone a quorum to judge a great work. When in future time the true sculptors of America have filled the metropolis with beauty and grandeur, will it not be worth $30,000 to

be able to point to the figure and say, "there was the first struggle of our infant art."

The Congress seems not to have been disenchanted by the criticisms of the Washington, for it awarded another commission to Greenough in 1847—a group called "The Rescue," which adorned the east front of the Capitol. It was not installed until after Greenough's death, and the group of figures (pioneer, wife, child, dog, and Indian) seems not to have been put together as Greenough intended it. There was a more noble quality in Greenough's conceptions than in their realization in stone. The founding father of our first school of sculpture was wiser than he was accomplished as an art-maker, and between his devotion to the art of antiquity and his acute perception that the new democracy of America must evolve an art uniquely its own there was a conflict that stayed his hand.

He came back to America to live in 1851, as he found the occupation of Florence by the Austrians and their treatment of his friends intolerable. In the following year he put together a collection of essays he had written and published from time to time—articles on American architecture, on art, on aesthetics in Washington, but also on subjects such as abolition and chastity—and they were published under the title *Travels of a Yankee Stonecutter* and signed with the pseudonym "Horace Bender." Emerson, to whom he sent the proofs, was delighted. "I assure you," he wrote,

> it is a very dangerous book, full of all manner of reality and mischievous application, fatal pertinence, and hip-and-thigh-smiting personality, and instructing us all against our will. . . . it contains more useful truth than anything in America I can readily remember; and I should think the entire population well employed if they would suspend other work for one day and read it.

In it Greenough stated his "stonecutter's creed":

> Three things, my child, have I seen worthy of thy love and thought. Three proofs do I find in man that he was made only a little lower than the angels—Beauty—Action—Character.
>
> > By beauty I mean the promise of function.
> > By action I mean the presence of function.
> > By character I mean the record of function.

Greenough's concept of function in architecture anticipated Louis Sullivan's ("Form Follows Function") by half a century, and it has only

been within the last thirty years that Greenough, long forgotten, was recognized as one of the principal philosophers, if not *the* principal philosopher, of architecture produced by any nation in the nineteenth century. "If there be any principle of structure more plainly inculcated in the works of the Creator than all others," he wrote, "it is the principle of unflinching adaptation of forms to function." His distaste for the fashion for Greek Revival architecture was much like that of his friend Cooper, as we have noted, because of its sham and its denial of function. He shocked the aestheticians of his day by declaring that the clipper ship and the trotting wagon and the American yacht "are nearer to Athens at this moment than they who would bend the Greek temple to every use. I contend for Greek principles, not Greek things."

Greenough died in the same year that he published his volume of essays, of what was called "brain fever." He went out of his mind, as he had many years before in Rome when Weir nursed him back to health. "He was suddenly taken ill in the midst of delivering a course of lectures in Boston," Albert Gardner wrote in *The Yankee Stonecutters*. "He grew voluble and obscure, excitable, nervous, irritable, turning and passing from subject to subject. Mercifully the end was near."

Emerson noted in his *Journal* in that same year:

> Horatio Greenough—lately returned from Italy, came here and spent the day,—an extraordinary man, a man of sense, virtue, and rare elevation of thought and carriage. . . . He makes most of my accustomed stars pale by his clear light. His magnanimity, his idea of a great man, his courage, his cheer, and self-reliance, and depth, and self-derived knowledge, charmed and invigorated me as none has . . . these many months . . . the grandest of democrats. His democracy is very deep, and for the most part free from crotchets,—not quite,—and philosophical.

A FLOCK OF SCULPTORS

Henry James called the American sculptors who crowded into Rome and Florence from the 1840s on "the White, Marmorean Flock," and they were a flock indeed! It was considered as essential for an aspiring American

sculptor to go to Rome to drink at the fountain of antiquity as it had been
for the generation of painters that included Allston and Morse to go to
London to bask in the light of Benjamin West's countenance. Only a
handful of American sculptors who made substantial reputations before
1875 had failed to study in Rome, and very few of those who went to Italy
ever returned from this "exile," as Greenough called his expatriation, to
work for any length of time at home. Divorcement from the materialism of
America was not only suitable to an immersion in "the ideal" and good for
business (art made in Europe had a cachet that art made at home did not),
but the most expert stonecutters were in Italy and they were useful both to
translate plaster models into marble and to act as teachers.

The sculpture business—and it was indeed a business—was suffused
with a theatrical haze, partly by the sculptors themselves, who believed in
the nobility of their calling, partly by American hopes of siring artists as
great as any the world had ever seen, and partly by the mist that gathered
in the eyes of patriot patrons of the arts as they gazed upon the statues
wrenched from the stone by the ingenuity of native American democrats in
the studios of classical Italy.

Americans were sure that they had political heroes as great as any-
one's, and they wanted and expected artistic geniuses to match them. The
desire was so strong that it blinded all but a few who cared about the arts to
the fact that comparable genius was in negligible supply. Thomas Craw-
ford, one of the earliest American sculptors to go to Rome, and the first to
settle there, was just such an imaginary genius who satisfied his contempo-
raries more by his modesty and industry and the tragedy of his end than by
the intelligence of his eye or his imagination. He started his artistic career
at the age of fourteen as a wood carver and later worked for Frazee at his
stoneyard, cutting tombstones. By 1835, when he was twenty-two, he was in
Rome with a letter of introduction to Thorvaldsen, and he became (along
with William Wetmore Story) a sculptor held in high regard not just by
his countrymen but by Europeans as well. Posterity has not served his
reputation well (as it has Greenough's, which is based on words, not mar-
bles), and his most famous work, the "Armed Victory" which is the spike on
the top of the Capitol in Washington, seems as ridiculous a concept and
object today as Greenough's Zeus-like Washington seemed to most of his
contemporaries—a hard-faced maiden with staring eyes and an angry eagle
and a wreath of stars for a hat, clothed in Victorian upholstery (ball fringe
and tassels on her dress), a sword held like a walking stick in her right hand
and a shield resting on her pedestal in her left.

It is easy to ridicule the works of Crawford, his Indian chiefs and

This colossal bronze casting of "Armed Free-
dom" by THOMAS CRAWFORD has stood like a
spike atop the dome of the Capitol in Washing-
ton since December 2, 1863. (*Library of Con-
gress, Washington, D.C.*)

Greek gods, as it is also easy to explain the fashionable aesthetic trap in
which he and most of his contemporaries were caught. It is less easy to
comprehend the lack of their need as artists to extend their personal vision,
to discover their own truths about the world, to devise their own vocabu-
laries, and to explore for themselves. Art to them was a matter of improving
on the sculpture of the ancients, of refining refinement, of polishing the
polished, but not of looking beneath the surface or discovering the world
around them, much less the world within themselves.

Crawford's personal tragedy was deeply mourned. He died in Paris in

extreme pain of a brain tumor that started in an eye. He was forty-four, and the author of the "Easy Chair" in *Harper's New Monthly Magazine*, George William Curtis, in reporting this beloved man's illness and imminent death in June 1857, inadvertently summed up in a sentence what was the matter with art in mid-century America. "To be lamented is to have been loved," he said; "to have been loved is better than to have built the Parthenon."

The White Marmorean Flock in Rome and Florence was not, it appears, pursued by the demons of genius; they were a group of charming men and women, skilled at creating pleasant surfaces, with spacious studios that were besieged with visitors from America who commissioned statues from them or ordered copies of already completed models. The chief charmer among them in Rome was William Wetmore Story, an art-makers' art-maker, poet, historian, lawyer, biographer, aristocrat, and a friend of Lowell, Hawthorne, the Brownings, and, though much older, of Henry James, who wrote a two-volume biography of him.

Story's father, Joseph, was only thirty-two when he was appointed to the Supreme Court, and he was a founder and the first professor of law at the Harvard Law School. His son, William, followed his father's example, and though he had toyed with clay and showed considerable proficiency in its manipulation, his career in the law seemed not only assured but uncommonly promising. He was the author of several texts on the law and practiced successfully in Boston; he was popular, a conversationalist of unusual vitality, discernment, and wit, and clever with his pen. When his distinguished father died in 1845, William was asked by friends to make a life-size portrait statue of the eminent jurist, to be established in a chapel to perpetuate his memory—an undertaking the young lawyer thought well beyond his knowledge and skill to execute, if not beyond the scope of his talents. To improve the former, he set out for Rome to learn to be a sculptor, or as much of a sculptor as a lawyer needed to be to immortalize his father in marble.

For most prominent citizens (other than bonded heroes) in the last century immortality in stone was largely confined to the graveyard, and the impetus (and perhaps the chill of the dead hand) which the garden cities of tombs gave to our early sculptors cannot be overestimated. The first of the "rural cemeteries," as suburban homes for the city dead were called, was Mount Auburn, overlooking the Charles River near Cambridge—the inspiration of a physician, Dr. Jacob Bigelow, who feared for the health of Boston because of its overcrowded churchyards. Mount Auburn was as much a park as a "resting place," and ladies and gentlemen on Sundays

wandered through its glades and in the cool of its tree-lined walks between marble temples and wondered at the effigies and mourning maidens and guardian angels and the names of powerful families carved forever, like the names of banks, in stone. James Jackson Jarves was less impressed than most of his contemporaries by these pietistic parks. "The artistic tone of the cemetery," he wrote in *The Art Idea*, "is mechanical, heavy, and cold. . . . A philosopher of no creed might wander long about it unable to decide whether the pagan, pantheistic spirit, the mere mercantile, practical, or skeptical modern feeling, the sectarian sentiment, or the family desire to honor the dead predominated."

It was the desire of family and friends that set Story on the road to Rome in 1847 and changed the lawyer into a stonecutter and poet, and in the estimate of his contemporaries a genius and permanent ornament to culture. Rome was precisely to Story's taste. *Dolce far niente* was deliciously far from the self-satisfied bustle of Boston; the conversation was lively and endless, the antiquities to explore were inexhaustible. Artists were not looked upon with suspicion; indeed, they were regarded as essential to society and not as parasites upon it. After he had been there a few years learning to cut marble (he had a gift for it) and working on the statue of his father, Story wrote to his intimate friend James Russell Lowell, "As the time draws near I hate the more to leave Rome, so utterly exhaustless it is, and so strongly have I become attached to it. How shall I ever again endure the restraint and bondage of Boston?"

When Story came back to Boston in 1850, he had not yet decided to gamble his future on the arts, but Rome was in his blood, and in the following year, though his mother called him a fool, he took his wife and two children back to Rome. His ties to Boston were not yet broken, however, and in 1855 he came home again because his mother was critically ill and because he was somewhat shaken in his resolve to be a sculptor. His mother died before he arrived, and he was soon engulfed in family matters and once more took to writing legal texts, an occupation that bored him immeasurably. He was, moreover, galled by Boston's attitude toward the arts. "We love nothing, we criticize everything. Even the atmosphere is critical," he wrote. "The heart grows into stone." He could not stand it for long. In 1856 he sailed back to Rome with his family and lived there for the rest of his long life.

Both Story and his wife were charming and rich (they each had inherited wealth), and Mrs. Story is said to have been very beautiful. They were considered the liveliest and most delightful of hosts and became, even to Romans, something of a Roman institution. Their opulent apartment in

the Barberini Palace attracted every American or Englishman of stature in the world of the arts or literature or politics who happened to visit Rome. Their receptions, their amateur theatricals (Story, a gifted actor, also wrote plays in verse which he tried out on his guests), and their conversational gifts were famous, as was their generosity to aspiring young artists, especially those who came from America.

Story owed the establishment of his reputation as a sculptor largely to the generosity of Pope Pius IX. At a moment when Story was rather discouraged about his own talent, the Pope decided to pay for sending two of his pieces, the "Libyan Sibyl" and "Cleopatra," to the London Exhibition of 1862 and showing them in the Roman Pavilion. They were, somewhat to Story's surprise, both a critical and a popular success. Both pieces were bought, and replicas of them were ordered. The Pope's blessing had been a blessing indeed. Whatever doubts Story may have harbored of his own genius, they do not seem to have been doubts shared by most of his contemporaries.

In *The Marble Faun*, a novel about an American sculptor in Rome, Hawthorne described his hero's studio and, it is said, based his observations on the studio in which his friend Story worked: "a dreary looking place, with a good deal of the aspect, indeed, of a stonemason's workshop." It could have been any sculptor's studio up to the time in our own century when marble and bronze ceased to be the ideal materials and welding and other industrial skills took over from those of the stonecutter and the caster. Hawthorne continued:

> Bare floors of brick or plank and plastered walls, an old chair or two, or perhaps only a block of marble . . . to sit down upon, some hastily scrambled sketches of nude figures on the whitewash of the wall. . . . Next there are a few very roughly modeled little figures in clay or plaster, exhibiting the second stage of the idea . . . ; and then . . . the exquisitely designed shape of clay, more interesting than the final marble. . . . In the plaster cast from this clay . . . the beauty of the statue strangely disappears, to shine forth again with pure white radiance in the precious marble of Carrara. . . .

Thorvaldsen is said to have described the making of a sculpture as a three-stage metamorphosis: "The clay may be called creation," he said, "the plaster cast death, and the marble resurrection." A critic writing at the end of the century about the sculptors in Rome said: "So alive are sculptors to

the fact of the injury done to their works by being seen in plaster casts, that they bestow great pains in working them over by hand to restore something of the firmness and sharpness which the process of modeling [apparently the author means "molding"] has destroyed." The "resurrection" in marble was not a process that many of them undertook by themselves. It was a skill for specialists, and stonecutters divided up the labor (and the body) according to their individual proficiencies. There were men with special techniques for carving drapery, others who were masters of hair, and still others who specialized in rendering the texture of skin. There were also, to be sure, generalists who could do anything asked of them, and there was one in particular, a man called Camillo who worked for the greatly respected English sculptor John Gibson, of whom it was reported: "with his slight figure and almost effeminate hands . . . a master of the mallet and chisel and from head to foot [he] renders and interprets his model with artistic power and feeling."

Unlike most of his American contemporaries in Rome, Story liked to wield the mallet and chisel himself. "I work my models with great care, and finish them perfectly," he said. "I suppose I might let the stone be cut by other hands if I could find other hands to suit me; not but what they would copy my model accurately, but I do not feel bound to copy my model. Don't you see how much freer I am than they could be? If I want a line different —a blow, and there it is."

If there were carvers who specialized in parts of the body, so, it seems, there were models similarly specialized. When Dr. Samuel Osgood, a clergyman, visited the studios of sculptors in Rome, he reported on his discoveries in *Harper's Magazine*. He found William Henry Rinehart, one of the most successful American sculptors in Rome, "at work on a statue of Clytie," Osgood wrote. "He was modeling the arm from that of a woman before him, who was one of six different living models that he employed in completing this figure."

LADIES ON LADDERS

One of the most entertaining, high-spirited, and talented of the sculptors in Story's circle was, surprisingly, a young woman. Her name was Harriet Hosmer, and when she arrived in Rome in 1852 she was just twenty-two years old.

It was all very well then for a woman to dabble in the arts, to paint a bit in watercolors, and to make gentle drawings, and there had been female still-life painters of considerable skill, among them the nieces of Charles Willson Peale. But to set out to be a professional, with all the commitment that entailed, was not considered ladylike. That a woman should stand up and attack a block of marble with a hammer and chisel was looked upon as downright preposterous and shocking. Think, too, what she needed to know about anatomy to be a sculptor, and the models she must face! Harriet Hosmer, however, was not in the least worried about being ladylike, and Victorian gentility was no concern of hers. She had a natural instinct for individualism, a generous spirit, and a personality that made her the darling of a wide circle of friends. Her manners suited her convictions rather than current conventions.

She had been brought up to be a tomboy. Her father, who was a physician, was determined that she would escape the fate of her mother, two of her brothers, and her older sister, all of whom died of tuberculosis. He saw to it that she was out of doors a great deal, that she rode and swam and skated and shot both guns and bows and arrows, and of course she climbed trees. She became something of a law unto herself and something too much for the schools in the neighborhood of Boston to cope with.

The final straw was a revenge she took on her family doctor, who had a way of being late for the appointments he made to come to her father's house to check on her health. Harriet resented being kept from her rides and games and complained to the doctor, who made the mistake of saying, "If I am alive, I will be here" on a certain day at a certain hour.

"Then if you are not here," Harriet said, "I am to conclude that you are dead."

The doctor failed to keep the appointment, and, according to Elizabeth F. L. Ellet, who recounts this incident in her book *Women Artists* (1859): "That evening Miss Hosmer rode into Boston, and the next morning the papers announced the decease of Dr. ———. Half of Boston and its neighborhood rushed to the physician's door to leave cards and messages of condolence for the family, etc."

The upshot of this prank was the transfer of Harriet to a school in Lenox, which is about as far as it is possible to get from Boston and still be in Massachusetts. Whatever young Harriet may have thought of this exile, Mrs. Sedgwick's school turned out to be precisely what was needed to give her the chance to become an artist. The novelist and essayist Catharine Maria Sedgwick (it was her sister-in-law who ran the school) lived near by, and so did the famous actress Fanny Kemble. They took a liking to this

rambunctious young woman, recognized her talent for modeling in clay, and encouraged her. As Mrs. Thorp says in *The Literary Sculptors*, "They tamed Harriet sufficiently for company and taught her how to employ her energies to advantage."

Three years after she left Lenox she turned up in Rome. In the interval she had studied drawing and had learned to model in the studio of the Boston sculptor Paul Stephenson. She had also managed to study anatomy; as no New England medical school would admit her to classes, she had arranged through a friend to be accepted by a medical school in St. Louis. She arrived in Rome full of purpose and with daguerreotypes of a piece called "Hesper." A young sculptor who thought well of Harriet and of the pictures is said to have shown them to the great John Gibson, who studied them and commented: "Whatever I can teach her, she shall learn." Harriet became his protégée, and he established her in a small room in his garden which once had been used by Canova.

She shocked the local citizenry by riding her horse unaccompanied in the streets and was forbidden by the authorities to continue such an unlady-like practice. She worked in just the same manner as her male contemporar-ies—up at dawn, breakfast alone at the Caffè Greco, the artists' hangout, and at work until the evening. Mrs. Ellet described her as she found her in her studio:

> a compact little figure, five feet two in height, in cap and blouse, whose short, sunny brown curls, broad brow, and resolute expres-sion of countenance give at first glance one the impression of a handsome boy. It is the first glance only, however, which misleads one, the trim waist and well developed bust belong unmistakably to a woman, and the deep earnest eyes, firm-set mouth, and modest dignity of deportment show that woman to be one of no ordinary character and ability.

Harriet Hosmer's talent was not great, by no means as filled with gusto or individuality as she was herself, but she was an extremely dedicated and successful art-maker with a more than usual mechanical proficiency and far more than the usual number of fashionable clients. Forced at one moment by her father's financial troubles to discover ways to stay on and support herself in Rome, she did so partly by stringent economy (she sold her horse) and partly by devising a small, insolent, and entertaining statue of "Puck" sitting on a toadstool which became an immediate hit. Even the Prince of Wales bought a replica of it for his rooms at Oxford, and as a result Miss Hosmer sold fifty copies that fetched $1,000 each. He was not her only

royal patron; so, too, were the empresses of Russia and Austria, several Bavarian kings, and the beautiful Queen of Naples. She moved in aristocratic circles as her fame grew and attracted, as one should expect of a woman who had such financial and social success, the vituperation of less successful male sculptors in Rome. They accused her of exhibiting as her own work pieces that had been created by her mentor, Gibson, a libel that she answered with threats of suit.

Her reputation at home was as great as in Europe, and she was besieged with orders for her work, one piece of which was a truly colossal statue of Senator Benton of Missouri. There exists a photograph of Miss Hosmer looking tiny at the top of a scaffolding, a beret on her head, clad in a shocking (above the middle of the calf) skirt and blouse, one hand on the shoulder of the model of the Senator, which is about three times her height. She was not above wearing trousers when she felt they were called for. "Tomorrow," she wrote to a friend, "I mount a Zouave costume, not intending to break my neck upon the scaffolding, by remaining in petticoats."

In his life of Story, Henry James remembers Harriet Hosmer ("Story's Hattie") as a woman of talent and "above all, a character, strong, fresh, and interesting, destined, whatever statues she made, to make friends that were better still even than these at their best. The Storys were among her friends. . . ." Indeed, she moved into the Hotel d'Italia, where she took a room that overlooked the Barberini Gardens because, as another of Story's biographers, Miss Phillips, says, "it made her feel close to her dear friends, the Storys, whose home was a second home to her, and where she was one of the most privileged guests and admitted to their private parlor—or their boudoir rather—which they called 'Little Bohemia.' "

There were a number of other women sculptors in Rome, though none was so successful as Miss Hosmer or so close to the magic circle of the Storys. Anne Whitney, Louisa Lander, Emma Stebbins, and Edmonia Lewis all found ways of getting to Rome to study and, finally, to make their reputations and establish their livings. Anne Whitney, like Harriet Hosmer, was born in Watertown, Massachusetts, and the home of her principal reputation and the source of her commissions for portrait busts and park-size statues of eminent gentlemen and ladies was Boston. Louisa Lander, from Salem, Massachusetts, impressed Nathaniel Hawthorne by the combination of her independence and propriety, a matter of some wonder to pious eyes of the 1850s. He was delighted by her "going fearlessly about these mysterious streets, by night as well as by day; with no household ties, nor rule or law but that within her; yet acting with quietness and simplicity, and keeping, after all, within a homely line of right." Emma Stebbins was

HARRIET HOSMER, here at work in Rome in the 1860s on a colossal statue of Senator Benton of Missouri, said that she had no intention of breaking her neck "upon the scaffolding by wearing petticoats." (*From a photograph in* Harriet Hosmer: Letters and Memories *by Cornelia Carr, 1912*)

evidently not a favorite of the Storys, possibly because she was awarded a commission to make a statue of Horace Mann which Story would have liked to do. She was, however, a close friend of the opera-singer-turned-actress Charlotte Cushman, famous for her Shakespearean performances and the center of another circle of artists. Miss Stebbins' work was admired by her contemporaries, and she was, indeed, a thoroughly competent maker of statuary.

"One of the sisterhood, if I am not mistaken," Henry James wrote in his biography of Story, "was a negress, whose colour, picturesquely contrasting with that of her plastic material, was the pleading agent of her fame."

James was not mistaken. Edmonia Lewis, the daughter of a Negro father and an American Indian mother, was a sculptor of considerable technical ability, and, surely, as much imagination as the rest of her Roman contemporaries. Though she was largely caught in the same neoclassical trap as the others, there was a bite to some of her work which genteel observers of art in her day thought repulsive. She was born in upper New York State, and her parents died when she was an infant. She was raised by members of her mother's tribe, the Chippewa, and, though the trail is not clear, she found her way to Oberlin College, where she became a student. She was about twenty in 1865 (the date of her birth is not precisely known) when she finished at Oberlin and went to Boston with letters of introduction to prominent abolitionists, most notably William Lloyd Garrison. It was evidently Garrison who sent her to the sculptor Edward Brackett. He gave her a cast of a foot to copy in clay, and after several tries (which Brackett broke when he saw them, as Benjamin West had sent Morse back to finish again and again the drawing he submitted to the master) he encouraged her to work on ideas of her own. Her first ambitious piece was a portrait bust of Colonel Robert Shaw, who died a hero's death commanding his Negro regiment in an attack on Fort Wagner at Charleston, South Carolina. A cast of it was exhibited at a Soldiers' Relief Fair in Boston, and a hundred copies of it were purchased. Miss Lewis invested the earnings from this windfall in a passage to Rome, and she went bearing a letter of introduction to Harriet Hosmer. Hattie, obviously impressed by Edmonia's courage, free spirit, and talent, persuaded Gibson to introduce the young artist to the refined mysteries of the sculptor's calling.

Like Miss Stebbins, she became a member of Charlotte Cushman's entourage, and her studio became one of the places that tourists and celebrities felt impelled to visit when they came to Rome. She was a friend of Robert and Elizabeth Browning and of the Hawthornes, and she sold a "Madonna" to Lord Bute, a gesture of patronage which stood her in

This detail of ''An Old Arrow Maker and His Daughter'' by EDMONIA LEWIS, a black American artist who was active and famous in Rome in the mid-century, is from one of the few pieces of hers now known. (*Collection James Ricau*)

excellent stead. The attention of a gentleman of title went far in those days to endorse the quality of art, especially in the eyes of Americans. Tuckerman in *Book of the Artists*, which was published when Miss Lewis was still a young woman, quotes from a letter from Rome (he declines to name its author) which said, among other things: "Miss Lewis is unquestionably the most interesting representative of our country in Europe." It was not, the letter writer says, because "she belongs to a contemned and hitherto oppressed race, which labors under the impunity of artistic capacity" but because of her genuine talents—"great natural genius, originality, earnestness, and a simple, genuine taste."

The first piece she made in Rome was a figure of Hagar because, as she said, "I have strong sympathy for all women who have struggled and suffered." Most of her work was busts of public figures whom she especially admired—Lincoln and Longfellow and Charles Sumner—and subjects from the Bible and the history and myths of Indians. She kept away from

classical subjects (she had a different notion of the function of art and of its components from most of her Roman contemporaries), though she made a "Death of Cleopatra" that was exhibited at the Centennial Exhibition in Philadelphia in 1876. It depicted the effect of death on beauty with such forthrightness, like an angry costume piece, that it was found "absolutely repellent" by the critics of the day. The piece has disappeared.

It is interesting that the old age of Harriet Hosmer has been recorded by biographers and tragic that Edmonia Lewis' has not. It is well known that Miss Hosmer lived a long, energetic life (she died in 1908 at the age of eighty-two, her vogue long past) and, good mechanic that she was, went on making things as long as she lived. Indeed, she squandered a good deal of money trying to devise a perpetual-motion machine worked with magnets. Miss Lewis, nearly as well known as Miss Hosmer in her day, dropped out of sight, and the date of her death is not, so far as scholars have discovered, recorded. When James's biography of Story was published in 1903, a whole new age of sculpture had supplanted the fame of the statue-makers of Story's world. Of the females of that circle James wrote: "The world was good natured to them—dropped them even good naturedly; and it is not our fond perspective that they must show for aught less than artless."

END OF STORY

Story's own fame is now as hollow as that of the White Marmorean Flock, and it is difficult to believe that he was once considered by perceptive and clever men to be one of the geniuses of the century, a man of commanding talent, his skill as an artist supplemented by a bushel of other gifts. Hawthorne, one of his closest friends while living in Italy, said he enjoyed Story's company more than that of anyone else he knew there. He wrote in his *Italian Note-Books* that Story was "the most variously accomplished and brilliant person, the fullest of social life and fire, whom I have ever met," but he detected beneath the social and intellectual façade a man discontented with himself, and with a melancholy strain, afflicted, he said, with "pain and care, bred, it may be, out of the very richness of his gifts and abundance of outward prosperity."

Story once said of himself: "Sculptors profess much admiration for my writing; poets amiably admit that my great talent lies in my sculpture." The jest was surely not without some basis in bitterness or some justifica-

tion by fact. Story not only made a "Cleopatra," of which a friend of Hawthorne, who wrote him of seeing it at the exhibition in London, said, "everyone admires it,—everyone thinks it is the finest statue there"; but he also wrote a poem about Cleopatra, the final stanza of which was:

> *Come to my arms, my hero,*
> *The shadows of twilight grow,*
> *And the tiger's ancient fierceness*
> *In my veins begins to flow.*
> *Come not with cringing to sue me!*
> *Take me with triumph and power,*
> *As a warrior storms a fortress!*
> *I will not shrink or cower.*
> *Come as you came in the desert,*
> *Ere we were women and men,*
> *When the tiger passions were in us,*
> *And love as you loved me then!*

It had been a sense of inadequacy in his early training and his lack of knowledge of anatomy that had very nearly turned him back to the law at the time of his mother's death, fearful that he would never be a great sculptor. Perhaps he would have been right to remain in Boston, though Rome and its artists would have been poorer for the lack of his amiable presence. He worked hard for the cause of art, and at one time, in 1885, he headed a large committee of artists which tried to persuade Congress to withdraw a duty of thirty percent which it had voted to levy on work by foreign artists. "If it be levied for the purpose of protection of American artists, we submit that they are opposed to such protection," the petition to the Congress read. The petition argued that the taxing of foreign art was a tax on the American people, and especially on American artists. "Art is in itself an education, a benefit, a delight, and a refining influence that no great nation can forego. . . . It is claimed as an excuse for this duty that art is a luxury, and therefore should be taxed. . . . If art is a luxury, so is education." The petition concluded: "We, as American artists, proud of our country, confident of its future, and jealous of its honour and credit, are opposed to all special privileges and discrimination in our behalf. We ask no protection, deeming it worse than useless. Art is a universal republic of which all artists are citizens. . . ." *

* The attitude of politicians toward art has changed almost imperceptibly since Story's day (only a few years ago the city of New York imposed a special tax on the Seagram Building because of its excellence), but it has changed somewhat in favor of artists, and the battle Story began was finally won by dealers and museums, who fought import duties on works of art to a standstill.

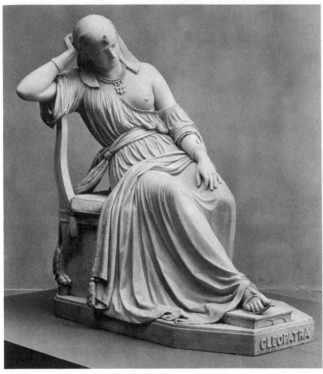

WILLIAM WETMORE STORY, Boston lawyer turned expatriate sculptor in Rome, caused a sensation with his "Cleopatra" when it was exhibited, thanks to the Pope, in London in 1862. (*The Metropolitan Museum of Art, Gift of John Taylor Johnston, 1888*)

Story was too kindly to be a critic, too friendly, too concerned with the welfare of his colleagues. When he was asked about another artist, he is reported to have said, "Ho, ho! I refuse to answer that question plumply. Do you know, I'm too good-natured to say one artist is better than another." He did not have the same reticence about dead artists. Of West's "Venus and Adonis" he said, "We used to wonder at the unnatural taste of Adonis in preferring the chase to the embraces of Venus, but Benjamin West has solved the riddle. If this be Venus, we do not wonder at Adonis, and if this be Adonis, Venus was a greater fool than we took her to be." This can scarcely be called art criticism; it is more like the comments that Congressmen made about Trumbull's "shin picture" and about Greenough's Zeus-like version of Washington.

When he was in his late fifties, Story paid a visit to the United States and was delighted to discover that he was treated as an ornament of the

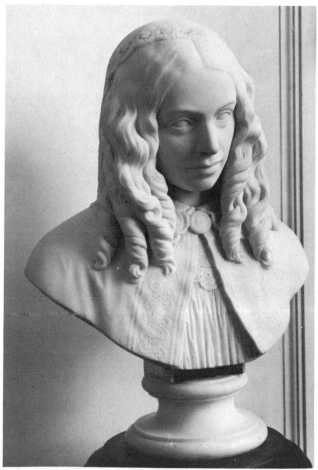

The Robert Brownings were among the closest friends of W. W. STORY
and his wife, who lived in the Palazzo Barberini in Rome surrounded
by artists and writers. Story first sculpted Elizabeth Barrett Brown-
ing in 1861; this copy was made about three years later. (*Boston
Athenaeum*)

nation both as poet and as sculptor. His effigies of the famous decorated
Harvard College, the Boston Common, and the city of Washington. His
several books of biography and archaeology were known, and his reputation
as a charmer was well publicized. A writer in *Harper's Magazine* in 1879
said of him, "No American in the art world now occupies a more prominent
position or shows greater versatility." Probably no American artist had had
more friends among prominent literary men, both American and English,
than this crony of Lowell and Hawthorne and the Brownings. He returned

to Italy to live out his life, secure in the knowledge that his reputation was secure. Story's daughter had married into the Medici family, and when he died at her villa in 1895, the idealism in which he believed had given way to a different sort of marble grandeur which he could not understand, a new kind of realism. "A servile imitation of nature results in nothing," he wrote. "The great vice of modern art is its over-fidelity to literal details. . . . Art is not a low, idle trade, as practical men sometimes insist. Rightly followed, nothing is nobler and higher. . . . It is the sister of religion. . . . It is the interpreter of the high and pure. Its material is humanity."

A MASTER MECHANIC

One of the most remarkable artistic reputations of the nineteenth century was based on the flimsiest accomplishment. Hiram Powers, who earned this reputation with a single piece of sculpture, a sparkling, boneless nude called "The Greek Slave," managed to maintain it partly by mechanical ingenuity (with which he was richly endowed), partly by personal charm, partly because to his contemporaries he looked the way an artist ought to look, partly by shrewd business dealings (not altogether scrupulous), partly because of the artistic naïveté of the English (who praised him inordinately), and partly because if the English liked something, the genteel (and art-buying) American thought he ought to like it, too. If you add to this the magic invoked by the exhibition of a nude that nearly everyone agreed was the embodiment of purity, courage, grace, modesty, and, except for a chain that bound her delicate wrists, was unsullied by anything but the zephyrs that caressed her machine-wrought skin—and this at a moment in 1845 when women had limbs, not legs, and laminated themselves with layers of cotton and linen and wool and silk—you will understand how Powers swept himself into the stout hearts of men and into the sighing bosoms of women.

There is no question that "The Greek Slave" was the best-known work of the mid-century, and quite possibly of the entire century, in America. It was a creature of its context, and it arrived at precisely the right moment to satisfy the sentiments, the manners, and the external piety of its age.

The creator of this phenomenon was born in 1805 in Woodstock, Vermont, the same year in which Horatio Greenough was born in Boston.

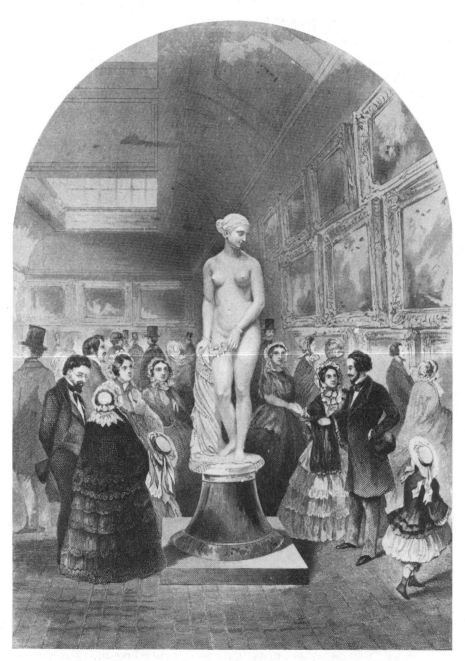

Even children were permitted to look upon this undeniably modest
maiden, "The Greek Slave" by HIRAM POWERS, when she was exhib-
ited at the Düsseldorf Gallery in New York in 1858. Figures like this
and Palmer's "The White Captive" (page 154) first made the nude
socially and morally acceptable to Americans in the 1850s. (*Engraving
by R. Thew, Photo New York Public Library*)

Powers went west with his parents to Cincinnati as a boy, a move that served him well for a number of practical and what might generously be called artistic reasons. He escaped the chill of New England and was brought up in the robust atmosphere of a frontier city that was experiencing a boom in land values, commerce, and industry, and was a lively river port. Powers' father died of malaria when Hiram was a boy. After a variety of odd jobs, he went to work in a clock factory, where his real genius as a mechanic and inventor quickly revealed itself. There were those who said he would have served his country better if he had never got involved with art-making and had stuck to his gift for mechanical invention, though such sentiments were rare at the height of his prominence. After several years in the clock factory, where, among other things, he invented a mechanism for cutting wooden clock wheels, he left at the age of twenty-four to test his ingenuity in the Western Museum. It displayed along with geological, biological, and archaeological specimens, and what passed for art (a "splendid transparent Painting of the Battle of New Orleans," for example) a number of wax figures. The figures were a display, somewhat in the manner of Mme. Tussaud's famous wax museum in London, of monsters and Indian chiefs and Presidents. Joseph Dorfeuil, the Museum's director, hired Powers to mend and touch up the damaged images at a wage better than he was paid in the clock factory. Curiously, it was Mrs. Trollope, the energetic busybody who became the author of *Domestic Manners of the Americans*, who claimed to have released Powers' imagination and given wings to his mechanical skill.

Attendance had fallen off at the Museum because the citizens of Cincinnati were tired of its static displays. Mrs. Trollope undertook to help Dorfeuil find ways to bring crowds to the Museum's doors; she reasoned that a little sensationalism would go a long way, and she was right. She suggested that Powers and her friend Auguste Hervieu, a young French artist who had come to Cincinnati with her, concoct scenes from Dante's *Inferno*, a project that they attacked with, quite literally, a howling success. Against lurid transparent backdrops, mechanical life-size figures writhed in agony, emitting shrieks and groans. The tortured spectacle was called "The Infernal Regions," and the enthralled public came in such crowds and pressed so close to the exhibits that Powers put up an electrically charged wire to protect them. They were thrilled by the little shocks they received when they touched it, and by its mysterious sparks. Ladies fainted at the horrors; gentlemen gritted their teeth; it is no wonder that Mrs. Trollope regarded Powers as a "young man of exceptional talent and promise."

Powers' first (and probably only) formal training in art came while he lived in Cincinnati. He studied modeling with Frederick Eckstein, a German who had set up a one-man art academy there (Hervieu later joined him). Many years later Powers told Henry W. Bellows in Florence that he had done his first portrait at that time, a head of a little girl. "Knowing that my job would be a long one," Powers said, "I was afraid to begin with clay, which was liable to harden or freeze, and I made my first bust in bees'-wax—here it is—and, so far as the flesh and the likeness are concerned, I don't believe I have ever done better since."

Powers' serious intentions to become a sculptor had not escaped the attention of Nicholas Longworth, who had made a fortune in Cincinnati real estate, and who was devoted to the proposition that the young nation needed artists and especially sculptors. He was one of the most generous and effective of the art patrons of the young republic, and he helped to finance Powers' trip, first to Washington, where he made a portrait of President Jackson, and then to Europe. The Jackson portrait was one of Powers' most successful sculptures and the making of it one of his most interesting adventures, which he loved to relate to later sitters in his studio in Florence. Jackson was cautious when first approached by Powers; he wanted to know whether the sculptor planned to put plaster on his face to get an impression of his features. He had heard that when Browere had made a life mask of Jefferson it had been an unpleasant experience. "And for my part," Powers recalls the President's saying, "I should not like to be tortured or have my ears pulled off, as was the case with that great man when he was obliged to go through that dreadful process." Powers reproduced the features of the President with exact attention to detail, and one of his aides objected to the caved-in mouth of a toothless man. Powers asked the President what he thought, and he replied: "Make me as I am, Mr. Powers, and be true to nature always. It is the only safe rule to follow. I have no desire to *look* young as long as I *feel* old: and then it seems to me, although I don't know much about sculpture, that the only object in making a bust is to get a representation of a man who sits, that it be as nearly as possible a perfect likeness. If he has no teeth, why then make him *with* teeth?"

Powers spent two years in Washington making portrait busts in clay before he set out for Europe with his wife and two children. His wife fell ill of smallpox on the voyage, and the family was delayed for several months in Paris while Mrs. Powers recuperated and Powers devoured the Louvre, though what he saw seems to have had little effect on his work. Florence, when he arrived there in 1837, had already been Greenough's home for eight

years; it was a quieter city than Rome, Bostonian "in its spirit," as Story said, and Charles W. Eliot, who later became Harvard's president, said of it, "As a place wherein to wait for death on a small income, Florence struck me very pleasantly." There was an English colony there and a number of American families whom the Powerses found congenial. They settled in, never to return to America but, rather, to become fixtures as essential a sight for visiting celebrities as the Pitti Palace or the Uffizi. Anybody who was anybody, to use a nineteenth-century euphemism, stopped by at Mrs. Powers' "Wednesdays" and visited Powers in his studio.

Such, however, was not the case when he first arrived in Florence. He had trouble finding stonecutters to put his clay busts into marble in a manner that satisfied him (he brought four with him, including the Jackson, from Washington), and, by his own account, he wasted a great deal of time and therefore money doing the cutting himself. Eventually he discovered an unsuccessful but facile sculptor who satisfied him and who remained the foreman of his studio for many years. Mrs. Trollope was distressed when she came to Florence in 1843, her American experience behind her, to find her protégé unable to afford to have put into marble the "ideal" figures that he made when he was not busy with portrait heads of American tycoons. The moment of prosperity was not far off, however, and the basis of his reputation had already been laid. The miracle of riches and fame was almost instantaneously performed by "The Greek Slave" in 1845 when she was first exhibited in London. So lavish was the praise accorded her and so delighted with her anecdotal purity was the public who saw her that in the next decade Summerly's Art Manufactures re-created her on a small scale in Parian, a fine, unglazed porcelain invented in the 1850s that looked astonishingly like marble, and sold her at two guineas apiece. Two years after she was shown in London she turned up in New York, where ladies in crinolines and bonnets and gentlemen in stovepipe hats stood in line to pay a quarter to be admitted to her presence. Furthermore, such was the modesty of this Carrara lady, miserably bound with a chain by the evil Turks, that even children were permitted to gaze upon her. It was, however, the stir she caused at the Crystal Palace in London in 1851, when she was the sensation of the American exhibition at that first of all world's fairs, that spread Powers' reputation around the globe. As Gardner records in *The Yankee Stonecutters*, "it had been purchased by a duke of the realm; Queen Victoria and the Consort admired it; Elizabeth Barrett Browning wrote a sonnet about it; the clergy rhapsodized from the pulpit on the subject." Not only was Powers famous now, but money poured in. He made six replicas of "The Greek Slave," for which he got an average of $4,000 each. Orders for his

other "ideal" pieces kept his stonecutters busy, and a portrait bust by him became more important than ever for those seeking immortality in stone. It is no wonder that Powers considered himself one of the geniuses of the age. Critics compared Michelangelo unfavorably to him. The great Thorvaldsen said, "The entrance of Powers upon the field constituted an era in art." In our own day the only comparable reputation of an American artist whose mechanical skill and anecdotal gift are equal to those of Powers has been made by the painter Andrew Wyeth.

The average price for a portrait bust by an average sculptor in Florence in the 1850s, according to James Jackson Jarves, was about $200; Powers got as high as $1,000 for a portrait. Most "Eves," "Judiths," and "Slaves" (Powers was not the only one to use this subject) brought $800 or $1,000, a fraction of Powers' price for replicas. Ordinarily an ideal bust brought about $100; Powers produced fifty copies of his "Proserpine" at $400 apiece. Public monuments were even better business. He got $19,000 for a Webster monument in Boston, which gave him a profit of about $16,000.

"Every representative American traveler longs to have his Ciceronic features immortalized by this sculptor," a writer in *Harper's* said in 1866, "and joyfully exchanges his thousand silver *scudi* for one of his exquisitely finished busts." But woe to those who did not fork over the *scudi!* "It would be a relief," another traveler reported from Florence four years later, "to see one feature of his studio disappear. I mean the shelf of busts marked 'Delinquent,' whether by having the delinquents pay their arrears or by the sculptor forgiving the debt, or at least keeping it out of sight."

Powers lived on in Florence, the center of a charmed circle in a lavish house and studio, until he died at the age of sixty-eight in 1873. His contemporaries found him an entertaining talker with opinions on everything from a better way of laying the Atlantic cable to the anatomical shortcomings of the Venus de Medici. Hawthorne, who was not impressed by Powers' importance as an artist, was captivated, if not always convinced, by his talk. "I have hardly ever before felt an impulse to write down a man's conversation as I do that of Mr. Powers," Hawthorne wrote in his *Note-Books*, but it was not because Powers' ideas were profound or suggestive— just the opposite; it was because they were "square, solid and tangible." Unlike Story, Powers talked freely about other artists and especially about other sculptors and rarely had a good word to say for them. Hawthorne remarked, "He has said enough in my hearing to put him at swords' points with sculptors of every epoch and every degree," and he said that Powers believed that "no other man besides himself was worthy to touch marble."

Next to his studio Powers had a shop in which he tinkered with inventions of various sorts and about which he was not reluctant to talk. One of his devices was a special file for giving marble the precise texture of skin. It is no wonder that one Boston critic called him "the sublime mechanic."

James Jackson Jarves was not taken in. "By nature Powers is a mechanic," he wrote.

> He has paid more attention to improving the tools with which he works than to developing his aesthetic faculty. The popular esteem for his statuary lies in its finish, which is like ivory-turning. No other American has so suddenly won for himself a reputation, but being founded simply on a talent for the manufacture of pretty forms . . . not even a student of art, but content with transitory triumphs, his fame has no solid basis, although his manual skill and taste still preserve for him an honorable rank.

Jarves had this to say in 1864 when Powers was still at the height of his fame.

It was not only the surface of his statuary that was glossy and marble-skin deep. So, evidently, were his brand of Americanism and the homespun Vermont pose that made him boast he would work only with American clay. Though he carefully stayed away from America for thirty-six years, he insisted on bringing up his children as unsullied as possible by Florentine manners. It has been suggested that there was a very good reason for his not returning to his native country. Powers employed an agent, Miner K. Kellogg, who not only lent him money when he first got to Florence and the going was difficult but also arranged for the exhibition of "The Greek Slave" in America which brought him such kudos and, not incidentally, about $25,000. When Powers' reluctance to settle his account impelled Kellogg to threaten to sue the sculptor, Powers insisted that Kellogg produce his account books. Kellogg, as it turned out, was foolish to do so. Powers flatly refused to return them because, as he said before witnesses, "he did not wish a paper to get before the world in which he acknowledged his indebtedness for his success in any way to Mr. Kellogg." Powers, threatened with a lawsuit and the consequent unpleasant publicity, evidently thought it advisable not to return to America. Powers' papers, along with the contents of his Florence studio, were acquired by the National Collection of Fine Arts in Washington in 1967, and it is possible that when they are sorted out this unpleasant cloud over his reputation may be dispelled. Even allowing for the most rampant vagaries of taste, however, it is unlikely that time will ever make him seem more than an able portraitist and a competent maker of ornamental statuary.

ANECDOTES AS STATUES

The number of American sculptors who studied and worked in Italy in the years between Greenough's arrival there and the decade after the Civil War was, if not legion, at least plentiful. Randolph Rogers, born in Waterloo, New York, was one who cut a wide swath in Rome when he settled there in 1851. It was he who was called upon to complete some of the commissions that the United States government had given to Thomas Crawford and were unfinished at his death in 1857. Rogers' most popular piece was "Nydia, the Blind Girl of Pompeii" (it was shown at the Centennial Exhibition in Philadelphia along with a "Ruth"), of which he sold many replicas. A visitor to his studio on Rome reported seeing "seven *Nydias,* all listening, all groping, and seven marble cutters at work cutting them out. It was a gruesome sight." Rogers died in Rome in 1892.

One of the best known, most beloved, and in many respects most accomplished of the sculptors to go to Italy was a different Rogers—John Rogers, the maker of mass-produced parlor sculpture known as "Rogers Groups." He was not in the least at home there, and he wrote his father: "I don't think I shall ever get into the classic style. I do not take to it. I think my best course is to pursue the path that I have begun and make small figures in bronze or very nice plaster . . . and not attempt any *high art,* for I shall certainly step out of my depth if I do." Rogers was too practical a man to get caught up in what seemed to him fancy theories and an art that had nothing to do with the age in which he lived. People, not personages, were his taste—persons, not fictional or mythical personifications. He added in his letter to his father: "I think if I get my name up for that style and represent pure *human nature* I can make a living by it as well as enjoying it exceedingly."

Rogers Groups which sold from $6 to $25 apiece, depending on the size, were made of plaster and came with instructions for repainting them if the surface was damaged or the paint chipped off. His subjects ranged from the most serious ("The Slave Auction," one of the earliest of his pieces, established his reputation) to the most gently humorous family scenes such as "Coming to the Parson" and "Checkers up at the Farm," which between them sold some 13,000 copies. They were greatly admired for their attention to precise detail—the ball fringe on furniture, the ruching on a little

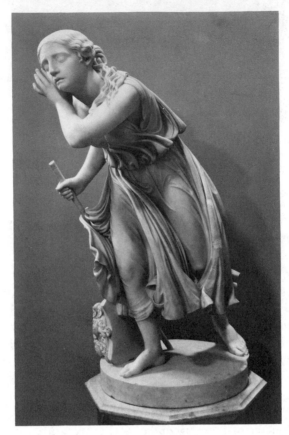

A visitor to RANDOLPH ROGERS' studio reported seeing "seven
'Nydias' all listening, all groping, and seven marble stone cut-
ters at work cutting them out. It was a gruesome sight!" This
lifesize "Nydia" (based on a character in Bulwer-Lytton's *The
Last Days of Pompeii*) is dated 1859. (*The Metropolitan Mu-
seum of Art, Gift of James Douglas, 1899*)

girl's pinafore, the rim on the spectacles of a bewhiskered gentleman whose
gloves were carefully folded on the top hat that sat under his chair. But
they were loved for their sentiment, sometimes lofty, more often just cozy or
funny.

As an avowed and straightforward anecdotalist, Rogers was not taken
in by colleagues with high-flown pretentions. He was not fooled by Powers,
not for a minute, and he wrote his father, "Look at the Greek Slave, there is
nothing in the world that has made it so popular as that *chain*. The chain
showed that she was a slave and the whole story was told at once. There are
plenty of figures as graceful as that and it is only the effect of the chain
that has made it so popular." In his way Rogers commanded as much
attention as Powers, if from a less Olympian eminence. He is said to have

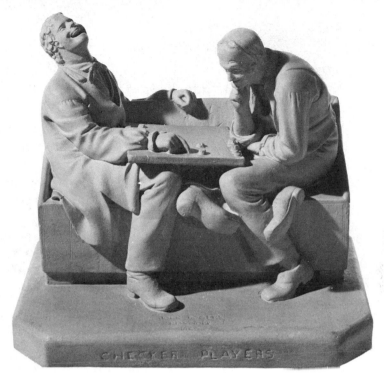

"The Checker Players" was JOHN ROGERS' first piece of "parlor sculpture." He made it in Chicago in 1859 and gave it to a charity fair, where it was greeted with such delight that Rogers decided to make a career of modeling and mass-producing such pieces. (*The New-York Historical Society, New York City*)

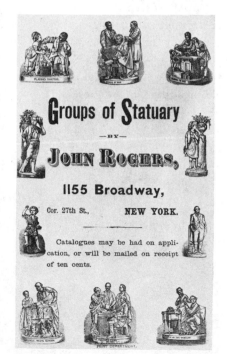

JOHN ROGERS sold more than 100,000 of his "groups" made of plaster. This advertisement shows a characteristic selection of his work, which sold at prices ranging from $10 to $25. (*Photo New York Public Library*)

sold 100,000 of his little statuary groups, mostly by mail, and, unlike Powers, he commanded the critical respect of the fussy Mr. Jarves, who wrote of him in *The Art Idea:*

> We know no sculptor like John Rogers, of New York, in the Old World, and he stands alone in his chosen field, heretofore in all ages appropriated by painting, a genuine production of our soil, enlivening the fancy, enkindling patriotism, and warming the affections, by his lively, well-balanced groups in plaster and bronze. Although diminutive, they possess real elements of greatness. In their execution there is no littleness, artifice, or affectation. The handling is masterly, betraying a knowledge of design and anatomy not common, and a thoroughness of work refreshing to note. His is not high art, but it is genuine art of a high naturalistic order, based on true feeling and a right appreciation of humanity. It is healthful work, and endears itself by its mute speech to all classes.

There were not many art-makers of his day who could evoke such approval from Jarves. Not only did Rogers Groups suit the high value placed on sentiment by the Victorians in America as in England, but the manner of their manufacture and their wide distribution seemed a most natural process at a time when mass production was invading all sorts of "art manufactures" for the home, such as carpets and furniture and lamps. Currier & Ives, the makers of colored lithographs (often hand-tinted), satisfied a similar desire of Americans to bring art into their houses, however modest, however close to the frontier or deep in the forest. Statuary was for the parlors of the rich, for graveyards and public edifices and parks, but statuettes of Parian or painted plaster were for those with modest incomes, for farmers and mechanics and businessmen and merchants with moderate incomes and a taste for the bric-à-brac of the age. Rogers helped to satisfy this demand, though by the time he died in 1904 at the age of seventy-five the vogue had shifted to the crafts movement inspired by William Morris and promoted here by the followers of Charles Eastlake, and to the art manufactures of Louis C. Tiffany, and to Art Nouveau.

TWO SCULPTORS AMONG THE STATUE-MAKERS

Two other sculptors who conscientiously repudiated the slippery neo-classi-
cism of Italy in favor of keeping their eyes on nature left their marks on the
age of Greenough and Story and Powers. One was an ex-carpenter from
upstate New York, Erastus Dow Palmer; the other an erratic, restless, and
tragic physician with delusions of grandeur, William Rimmer, who came
closer to displaying genuine sculptural genius than any of his contemporar-
ies.

Palmer was born in the town of Pompey and, because of his father's
death, had to give up school at the age of eleven and practice the craft of
carpentry, at which, it is recorded, he was already unusually accomplished.
In the next twenty years he became known in his district as a designer of
exacting architectural details, of paneling and staircases and ornaments.
To amuse himself he took up carving cameos when he was in his early
thirties; discovering that he had a gift for portraits, he decided to pursue
the delicate art of carving faces in shells. It was hard on his eyes, however,
and he turned to making bas-reliefs instead; his fame as a sculptor began to
spread beyond the city of Albany, where he had moved to set up a studio.

The catalogue of an exhibition of "The Palmer Marbles," which was
held at the Church of the Divine Unity in New York in November 1856,
included a letter asking Palmer to permit his sculpture to be shown in New
York. "We feel persuaded," the letter said, "that we should render an
acceptable service to the cause of public taste, give an incentive to right
appreciation of what is true and beautiful in Art, and secure a source of
refined gratification to the community, by inducing you to consent to a
public exhibition in this city, at an early date, of a few creations of your
genius."

Palmer was a modest, pious man, and this must have seemed to him
rather effusive and a gift not of his own talents but of a Divine Providence.

The letter continued (it is worth quoting for the light it throws on
Palmer's character): "We know how carefully you have hitherto withheld
your works from public notice, and applaud the motives which have led you
to pursue the path of duty, and labor in solitude and silence. But the time

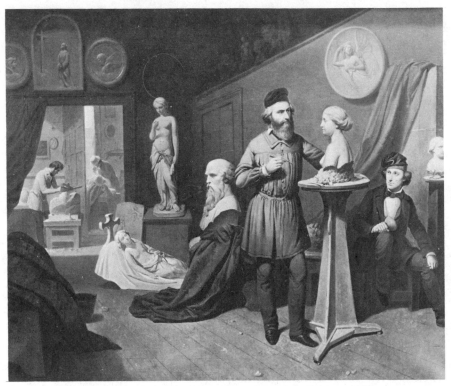

Erastus Dow Palmer works on an "ideal" bust while stonecutters turn his models into marble in his Albany, N.Y., studio. No studio could have been quite as tidy as this one painted by TOMPKINS H. MATTESON in 1857. (*Albany Institute of History and Art*)

has come when your countrymen have a right to ask you to let them share in the pleasure which ever follows success in a noble design."

The letter was signed by some twenty names that Palmer must have looked upon with respect and in some cases with awe. There were artists, patrons, authors, businessmen, and statesmen, including the poet William Cullen Bryant; Frederic E. Church, landscapist; Gulian Verplanck, the influential Congressman and patron; the statesman Hamilton Fish; and the publisher William H. Appleton.

Many years later the sculptor Lorado Taft, who was also an important historian of American sculpture, wrote, "In 1876 Mr. Story was our most noted sculptor abroad and Palmer the most popular at home." There is no question that he thought Palmer the better of the two.

Palmer's initial popularity was based on a white marble figure of a maiden (his daughter was probably its model) called "The White Captive."

Like those of Powers' "Slave," her hands are tethered, but her gaze does not fall modestly on the ground (if the blind eyes of Powers' girl could see that far); rather it looks out to meet those of her captors. Unlike Powers' "Slave," she does not seem to float slightly above the marble cloth (with fringe) on the pedestal beneath her, but stands on her feet, and the surface of her young body seems to contain not only bone but muscle and to be warm with life and not jellied in stone. The difference between the two pieces is the distinction between sculpture and statuary: sculpture is conceived from the inside out, statuary is carved from the outside in.

Palmer's fame was spread, as that of none of his contemporaries, by the new medium of photography. Like Rogers Groups, photographs of his work, especially his religious pieces such as "Hope," "Mercy," and "Resignation," became the ornaments of many parlors, elegantly framed and prominently displayed above the mantel. "Faith," now in Albany, was the most popular of all.

When Lorado Taft wrote his history of American sculpture, which was first published in 1903, he gave William Rimmer very short shrift indeed in a very few sentences: ". . . his own works, however remarkable when the method of their production is considered," Taft wrote, "were valueless as sculpture. He persisted in executing nudes, and even important monumental commissions, without models, and while he 'never missed a muscle nor forgot an attachment' the results are curious rather than edifying."

One of the sculptors whom Taft greatly admired (a contemporary of his), Daniel Chester French, did not share this blind spot. French was so impressed by Rimmer's "The Falling Gladiator" that in 1906, nearly thirty years after Rimmer's death, he had it cast in bronze. As a young man, French had studied anatomy with the eccentric physician and anatomist, and if it were not for French's respect, it is possible that Rimmer's reputation, which in no way competed with those of his flashy contemporaries, might have been buried far longer than it was. It is only within the last twenty-five years that he has come to be recognized as one of the very few real American sculptors of the nineteenth century. Scarcely more than half a dozen pieces of his sculpture have survived. They are sufficient to judge the man.

Rimmer was a dark figure, pursued by demons partly of his own creation, partly willed to him by his father, a Frenchman brought up in the belief (as also was the ornithologist-painter Audubon) that he was the "lost Dauphin" and the rightful heir to the throne of Louis XVI. When William was a boy his family moved from England to Newfoundland and thence to Boston, where the father of the family, considering himself a royal person-

"To think," wrote the sculptor Lorado Taft in 1903 of E. D. PALMER's "The White Captive," "that anything so refined and sympathetic should have been carved in this country in 1858!" This detail is from the marble in the Metropolitan Museum of Art. (*The Metropolitan Museum of Art, Bequest of Hamilton Fish, 1894. Photo Russell Lynes*)

age and fearing reprisals in a democratic country, took to the humble craft of cobbler as much to keep out of sight (who would suspect a cobbler of being a Dauphin?) as to support his wife and daughter and six sons.

William was the eldest of the children, and his education at the hands of his eccentric and in many respects brilliant father was, though informal, a rich one. When his father died of drink, William, still a boy, continued in the belief of his royal lineage and assumed the dissatisfactions of not being accorded his rightful place. He supported his family, as his father had, by making shoes, but he had been taught drawing by his father and he tried his hand at carving as well. The earliest piece of his sculpture that still exists (it was made when he was a boy) is called "Despair" and was cut from a piece of gypsum he found in a quarry near where he lived in South Boston. This was no "ideal" statue of a mournful maiden but a tense little nude sculpture of a seated man, one hand clasped over his mouth as if to stifle a cry, the other pulling up his right leg in a gesture of trying to hold body to soul.

When he was twenty-four William married and moved to Randolph, Massachusetts, where he supplemented his income by painting signs and making religious pictures for the local Catholic church. The income, however, was not sufficient to his needs (he had six children), and with the aid of a local physician who lent him books, taught him, and made it possible for him to work in the dissecting rooms of a medical school, he became a physician himself and practiced successfully (mainly with the miners of Quincy as his patients) for ten years. He so impressed the professionals of the Suffolk County Medical Society that they accorded him a doctor's degree, though a degree was not considered essential to practice medicine in those days.

Dr. Rimmer was far better known as a teacher of drawing and especially of anatomy than as a sculptor. His lecture demonstrations evidently mesmerized his audiences by the brilliance of his speech, the depth of his knowledge, and the exquisite drawings with which he covered the blackboard. He did not like to lecture; he was naturally reticent and fretted at being away from the security of his family and at exposing himself before an audience. His fame spread. The first lectures were given in Boston before an audience of artists, art students, and dilettantes; he was invited to repeat them at the Lowell Institute, and the audience was so great that he had to give each lecture twice. Peter Cooper invited him to be director of design at Cooper Union in New York, a job he held for four years and enjoyed, and he lectured at Yale and Harvard, at the National Academy of Design school in New York, and in various New England cities.

WILLIAM RIMMER was a boy in his teens when he carved this small (eleven inches high) figure of "Despair" from a piece of gypsum in about 1830. It has an intensity of feeling very rarely found in nineteenth-century sculpture in America. (*Museum of Fine Arts, Boston*)

His career as a sculptor, which did not start until he was in his mid-forties, was surely not a popular success and only in a moderate way a critical success, though he had a few ardent supporters who did their best to help him. Stephen H. Perkins of Milton, Massachusetts, a collector and an encourager of artists, first commissioned him to make a head in granite, and it was this head which launched Rimmer's reputation and caused the stir in Boston which resulted in his being invited to lecture on anatomy. Rimmer elected to carve a head of the martyrdom of St. Stephen (he was stoned to death), cutting it directly in a piece of granite from the quarry at Quincy. This was a labor for which he had no training. He went at it so passionately that tears of weariness were in his eyes as he worked and his hands were blistered and bruised from the tools. The head that he hewed from the block of stone in a month bears no resemblance to what came from the chisels of the stonecutters who were his contemporaries—a face in genuine agony, as strong as the stone of which it was made, rough and genuinely tragic.

Three of Rimmer's sculptures have become well known in recent years, "The Falling Gladiator" (the piece French had cast), a "Dying Centaur," and a pair of "Fighting Lions," now all in bronze. They share a passionate excitement with the mechanics, subtleties, and stresses of anatomy (the more remarkable because Rimmer never worked from a model), but their virtuosity in no way conceals the anguish of the man who made them or the need to transmit this anguish to his sculpture. One of the commissions he received as a result of the efforts of his patron, Stephen Perkins, was a full-length figure of Alexander Hamilton for Boston, and in eleven days Rimmer had the clay model of it finished. It was not well received either by the men who commissioned it or by the public. What today seems a powerful representation of a powerful man (as Mrs. Thorp has pointed out, not unlike Rodin's "Balzac") seemed unreal to Rimmer's contemporaries.

Rimmer died in 1879 when he was sixty-three. His several books on anatomy were generally well thought of, and he was remembered as a difficult and eccentric man. His moody pictures were looked upon as oddments, and anyway there were not many of them—strange paintings of figures being pursued through empty palaces, curious portraits (one of Mrs. Bamberger, clutching a spar in the Atlantic after a shipwreck, with every hair in place), and many drawings of unearthly monsters and floating figures and dismal landscapes. To all intents and purposes he was quickly forgotten.

But so were his more famous—indeed, exceedingly famous—contemporaries. Story and Greenough and Powers dropped out of fashion and out of

WILLIAM RIMMER, physician and lecturer on anatomy, was as little regarded as a sculptor in his day as he is highly regarded now. He modeled "The Dying Centaur" in about 1871, but it was not cast in bronze until 1906, twenty-seven years after his death. (*The Metropolitan Museum of Art, Gift of Edward Holbrook, 1906*)

sight. So, of course, did Crawford and Rinehart, and both Randolph and John Rogers, and so did the women, Harriet Hosmer and Edmonia Lewis and the others of the White Marmorean Flock. Even at the height of their fame the most astute observers of what they were doing gave them little credit for being more than expert plagiarists. Hawthorne in *The Marble Faun* said: "Greenough imagined nothing new; Crawford either, except in the tailoring line. . . . A person familiar with the Vatican, the Uffizi Gallery, the Naples Gallery, and the Louvre, will at once refer any modern production to its antique prototype." Jarves said it too in *The Art Idea:* "Plagiarism is rife among some of our artists. . . . We have Pandoras, Ganymedes, Cupids, and other similar reproductions of classical sculpture in scores."

It did not matter much what a sculpture was called. One nude female by the sculptor Joel Hart kept changing names. At first she was "Venus," but, as that seemed a little coarse, she changed her name to "Purity," which one would think acceptable if static. She ended up as "The Triumph of Chastity."

If the time was exceedingly ripe for statue-making to suit the personal, political, and patriotic conceits and yearnings of a new nation, it was no time at all for the tougher art of sculpture. None of the geniuses of the slick marble surface, the parasites on antiquity, and the aesthetic offspring of Canova—charming, intelligent, skillful, and dedicated to lofty ideals as many of them were—could hold a candle as honest sculptors to the painter Samuel F. B. Morse, whose "Hercules" won him a gold medal in London in 1813 long before their days of fame, or to William Rimmer, the physician who turned sculptor to save his soul in middle age. Neither Morse nor Rimmer was superimposing art on life; they were contriving life from their own insides out.

By the 1850s the nude, if garbed in the dignity of antiquity, was considered suitable for viewing by ladies and gentlemen at the same time, as is here demonstrated in the Athenaeum "statuary room" in Boston in 1855. (*From* Ballou's Pictorial, *Photo New York Public Library*)

6

THE AGE OF DOWNING

". . . the Beautiful is, intrinsically, something
quite distinct from the Useful. It appeals to a
wholly different part of our nature; it requires
another portion of our being to receive and en-
joy it."
> ANDREW JACKSON DOWNING in
> *The Architecture of Country Houses,* 1850

Philip Hone, who besides being mayor of New York was an auctioneer and art patron, noted in his diary on September 16, 1834, that the hazards of travel on the Hudson River were getting to be enough to make a man want to turn the clock back. "I would rather consume three or four days in the voyage," he wrote, "than be made to fly in fear and trembling, subject to every sort of discomfort, with my life at the mercy of a set of fellows whose only object is to drive their competition off the river."

Hone, if he had thought of it, could have blamed an art-maker for loosing this menace on the people. Robert Fulton, the successful portrait painter and deviser of panoramas, had invented the parent of the steamers that now fled up and down the majestic Hudson with its romantic morning mists and its steep and wooded banks fringed with templed villas. It was he who was indirectly responsible for the sparks that flew from the tall stacks, for the overheated boilers that surely frightened and nearly cooked the passengers, for the side paddles that churned the waters, and for the pennants, fifty or sixty feet long, that streamed from the masts above their

sterns. Fulton was not the sort of man who would have been surprised by the progress made in steamboats or, probably, by their abuse, as he was a worldly man and sensitive to the foibles of others, but he would most surely have disapproved of this particular manifestation of what was happening to America. It was growing too fast, too carelessly, and in many respects too ruthlessly for its own good.

Or so, in any case, it seemed to many responsible citizens. Cities were sprawling over grids laid out with the best interests of real-estate speculators in mind and with little regard for the comfort and convenience of the people who had to live in the rows of almost identical houses with doorways and windows and cornices that might all have been cut out by the same set of cookie cutters. Houses built by speculators, like the rectangular pieces of land on which they were built, were chips in the land game, and the pressures to join in were acute. In New York, for example, Mayor James Harper (one of the founders of the eminent publishing firm) caved in and sold a park known as the Parade Ground for development, and if it had not been for a poet, William Cullen Bryant, and a landscape gardener who was also a prime mover in the arts, Andrew Jackson Downing of Peekskill, it is likely that what became Central Park would have been still another wasteland of brick and brownstone and cobbles.

There were several revolutions going on at the same time in America in the 1830s and '40s, and each had its effect on the makers and patrons of art. With the election of Andrew Jackson to the Presidency and what polite society called his "ruffians" to the seats of power, a new republican spirit (the British travelers in America thought it less a spirit of equality than just downright bad manners) was replacing the aristocratic traditions of taste and manners and of social class which had hung on from before the Revolution. It was a time of intense social and physical mobility, of quick fortunes made in land speculation and railroads and manufactories, and of flights of pioneers to the West—or, in our terms, the Middle West. It was a time of almost frantic picking up and moving on, of exploration and its inevitable counterpart, exploitation. Smoke began to billow from the chimneys of factories and mills that spotted the landscape with clusters of brick boxes pierced with windows, just as smoke billowed from the stacks of riverboats on the Hudson and the Ohio and the Mississippi. Pioneers, far less impelled by adventure and the hope of riches than by bread riots in Eastern cities and the poverty of their old farms, ground their way by wagon across the Alleghenies. The opening of the Erie Canal in 1825 speeded up the process of getting to the frontier; indeed it cut the time from New York to Buffalo from twenty days to an incredible six. ("Time to

an American is everything," an English visitor, the novelist Captain Frederick Marryat, observed, "and space he attempts to reduce to a mere nothing.") It was a time, as Lewis Mumford has noted, when mining was the national fever. "The name pioneer has a romantic color," he wrote in *Sticks and Stones*, "but in America the land pioneer mined the forests and the soil, and the industry pioneer almost as ruthlessly mined the human resources, and when the pay-dirt got sallow and thin, they both moved on." At the same time that communities were emerging from clusters of log cabins to enclaves of little Greek temples in clearings where a few years before had been forests, the cities of Philadelphia and Boston and Baltimore and especially New York were oozing like lava over their grids, and immigrants from Ireland and Germany especially crowded their sprawling slums.

This was the age of Manifest Destiny, when Americans first began to flex their national muscles and envisioned a future in which their nation would be a world power. It was also an age in which mechanical invention and progress, among other things, created the Age of Taste, a time when objects which in the past had been made by craftsmen suddenly began to be turned out by the thousands in factories. Carpets came off power looms almost by the mile; rosewood chairs were turned on lathes and sold for a dollar apiece; power presses stamped out wallpapers that almost anyone could afford. Indeed, almost everyone could afford to have taste, and for those who were not sure what their taste should be, there were new magazines like *Godey's Lady's Book* to encourage them in the paths of gentility. Books on how to manage a household and books of etiquette suddenly in the 1830s began to be read by the thousands as housewives sought to discover how they should behave in a manner suitable to their new prosperous stations, how to cope with servants, serve burgundies and clarets, ornament their dining-room tables with candelabra and epergnes, decorate their parlors in the "French taste" with tufted satin chairs and settees and dos-á-dos and whatnots and gilded mirrors and flowered Brussels carpets. It was a time when being genteel was almost as important as seeming to be pious, when voluminous skirts billowed out over crinolines and swept the dirt of city streets and the muddy roads of frontier towns and were worn both in ballrooms and, as the English novelist Anthony Trollope was surprised to note, in log cabins on the banks of the Mississippi.

"Americans calculate, interrogate, accumulate, debate," the critic Jarves wrote.

> They yet find their chief success in getting rather than enjoying;
> in having, rather than being: hence, material wealth is the great
> prize of life. Their character tends to thrift, comfort, and means,

rather than final aims. It clings earthward, from faith in the substantial advantages of things of sense. We are laying up a capital for great achievements by and by.

If most Americans were more interested in having than in being and more concerned with comfort than with ideals, a number of artists and architects and advocates of the arts were looking at the vast, exploitable landscape of their country and discovering in it a sort of mine quite different from that which urged their contemporaries to plunder in the name of progress. One of these was Andrew Jackson Downing; though he was neither an architect nor an artist but a landscape architect and horti-culturalist writer, he spoke the language of the arts eloquently and believed profoundly in their civilizing nature. To his voice, though it was quiet, many of his contemporaries listened. Among them were Alexander Jackson Davis, an architect of unparalleled talent in his time, and Frederick Law Olmsted, a journalist who became the designer of Central Park in New York and, indeed, of subsequent great municipal parks across the continent. Today we associate Downing and Davis and Olmsted, as we do the painters Thomas Cole and Asher B. Durand and John Frederick Kensett, with romantic landscapes—with vistas of mountains, of valleys half lost in mists, of rivers reflecting the palest lights of the sky, of cataracts dashing beneath meticu-lously outlined leaves over meticulously crisp and craggy rocks, with little figures lost in mysterious expanses.

Downing's first concern was with the country family and not with those benighted souls who huddled in the cities, which means that his concern was with the vast majority of Americans, for two thirds of them then lived on farms or in villages. If these could be led to the well of beauty and be persuaded to drink, he believed, there was no reason why America should not be as great as any nation in the world. "A nation whose rural popula-tion is content to live in mean and miserable huts," he wrote in the preface to his book *The Architecture of Country Houses* (1850), "is certain to be behind its neighbors in education, the arts, and all that makes up the external signs of progress. With the perception of proportion, symmetry, order, and beauty, awakens the desire for possession, and with them comes the refinement of manners which distinguishes a civilized from a coarse and brutal people." Downing was the editor of *The Horticulturalist*, for which he wrote on all manner of problems of concern to rural America—on architecture and fruit trees and gardening—and his effect on the looks of America and its tastes in the middle decades of the last century is almost immeasurable.

Downing's influence all but vanished as the century waned. When taste

revolted against what is today commonly called American Victorian archi-
tecture and decoration, and as functional theories of architecture grew
popular, Downing's romantic ideas, based largely on those of Ruskin,
seemed the antithesis of sound doctrine. Downing's theories were a far cry
from Horatio Greenough's belief in the intrinsic beauty of what was func-
tional. "The truth . . . is undeniable," Downing wrote, "that the Beautiful
is, intrinsically, something quite distinct from the Useful. It appeals to a
wholly different part of our nature; it requires another portion of our being
to receive and enjoy it." Did anyone believe, he asked, that an ass, "one of
the most useful of animals," was as beautiful as a gazelle? Or a cotton mill,
"one of the most useful of modern structures," was as beautiful as the
temple of Vesta? Or a head of grain as beautiful as a rose?

Indeed, to the romantic of the early nineteenth century a ruin in a
proper setting was more beautiful than any functioning building, and
Downing, like many of his contemporaries, believed that a suitable architec-
ture for America was one that used time—continuous time, that is—which
by tying the present to the past made a continuity of tradition which would
stretch into the future. Downing considered the Greek Revival the "temple
disease," and was relieved that the nation could survive its crisis. Gothic he
thought more suitable because of its flexible plan and pleasant irregulari-
ties, though he did not encourage any but the rich and important to build in
a crenelated style; in general, the Tudor Gothic he thought was better
suited to less grand folk, and tasteful cottages in the manner of the Tuscan
villa or the Switz cottage for the modest. A house, he believed, could exert a
moral effect upon its occupants, lifting them to its own standards of beauty.
On the other hand, a dishonest man could wither the beauty of a house by
his continued presence in it.

By the time he was twenty-one Downing already had made a reputa-
tion in the Hudson Valley as a horticulturalist of sound expert knowledge, a
practical man, and, above all, a gentleman. His father had been a nursery-
man, and Downing, in a sense, had been raised in a garden, but as he grew
older his attention turned more and more to the problems of domestic
architecture and the beautification of the countryside, and his reputation
spread not just across America but across the Atlantic as well. In 1841,
when he was twenty-eight, he published his first book, *Theory and Practice
of Landscape Gardening*, and in the following year another called *Cottage
Residences*, both of which sold well here and in England. In 1845 he
published *The Fruits and Fruit Trees of America*, and in the next year he
was elected a corresponding member of the Royal Botanic Society of Lon-
don and became the editor of *The Horticulturalist*. His books, according to

one of his contemporaries, were "invaluable to the thousands in every part of the country who were waiting for the master-word which should tell them what to do to make their homes as beautiful as they wished."

Downing's words transformed the American landscape more profoundly than those of any of his contemporaries, but he was not a builder, and his admonitions were turned into structures most successfully by his close friend A. J. Davis.

A. J. DAVIS AND HIS ELEGANT FORMAT

Davis, who was born in New York, was older than Downing by twelve years, though their reputations were established at about the same time. As a youth Davis regarded life as a matter to be conducted for the interests of the moment and without any rigid plan for reaching some future destination. He thought it better, as he wrote to an aunt, to "jog along," an attitude that probably had little to recommend it to his father, who was the editor and publisher of a Congregationalist paper. When he was seventeen Davis went to work for his brother, who edited a newspaper in Alexandria, Virginia. Young Davis amused himself, when he was not setting type, with amateur theatricals, for which he evidently had some talent, and with making sketches of sets for romantic dramas; his gift for drawing was to develop to the point where he made the most exquisite architectural renderings produced in America in the nineteenth century.

Rembrandt Peale, to whom young Davis took some of his drawings, told him that it was architecture and not painting which promised him the greatest future. In Colonel John Trumbull's studio (Trumbull had once said that he himself could have been a great architect if he had merely troubled to put his mind on it) he learned the elements of architectural drawing, and he supported himself with making views of New York for booksellers and by drawing plans for the architect Josiah Brady, a not very talented specialist in churches. When he was twenty-four Davis went to Boston, where he was befriended by, among others, Dr. Jacob Bigelow, the physician and patron of sculptors who had been responsible for the establishment of that first of rural cemeteries, Mount Auburn. When Davis came back to New York in 1828, the famous bridge builder Ithiel Town, whom he had met in New Haven, took the obviously talented twenty-five-year-old to

be his partner and then, having barely settled him into his Wall Street
office, went off to Europe for a Grand Tour, leaving the young man in
charge.

As you would expect, Davis' first buildings were in the Greek style—a
house for the poet James Abraham Hillhouse in New Haven (now de-
stroyed) ; a residence for a gentleman in the China trade in Middletown,
Connecticut, now a part of Wesleyan College; row houses in New York and
a customs house for this same seaport. Davis' partner, Ithiel Town, was not
just a bridge builder; he was an inventor who had made a comfortable
fortune from his bridge patents and had acquired the finest architectural
library in America, a source of inspiration on which Davis drew with
ingenuity and great taste. Taste, indeed, rather than invention or boldness,
seems to be the essential quality of Davis' best designs—an unerring sense
of the discreet use of architectural elements to achieve a quiet, almost typo-
graphical elegance of format. His structures are compositions with an
impeccable regard for balance and a delight in detail, which he contrived
without a trace of fussiness even when it was at its most intricate; this was
as true of his early Greek manner as of the Gothic style that he and his
friend Downing came to believe was perfect for the gentleman's manor and
for the farmer's cottage.

Davis' first grand Gothic house was designed for Robert Gilmor, Jr.,
of Baltimore, one of America's earliest and most energetic collectors of Old
Masters (he was sharp enough to know that many of them did not deserve
the splendid attributions that had been given them) and a generous patron
and friend of his contemporaries who were trying to make their way in the
arts. Some five hundred pictures came and went in his collection (and some
remained, of coursé). Gilmor wrote to a friend in 1837 of his collection: "It
is no doubt equal if not superior to most in the country both for numbers
and originality, yet one good picture of a London cabinet would be worth
the whole. I have however seen much worse collections abroad, and if mine
only stimulates my countrymen to cultivate a taste for the Fine Arts I shall
be well compensated for my experience in making it even such as it is." This
was a proper sort of patron for young Davis to try to please; Gilmor was
devoted not merely to the arts of the past but to supporting the likeliest and
liveliest young painters and sculptors of his day. Especially attentive to the
works (and the financial needs) of Thomas Doughty, the landscapist, and
to Thomas Cole, Gilmor owned portraits by Stuart, by members of the
Peale family, by Sully, and by Jarvis, and he was one of the earliest
collectors to detect the talents of William Sidney Mount, whose genre scenes
set American artists to exploiting one of their most productive veins in the
nineteenth century. The house that Davis designed for Gilmor in Townsend,

Maryland, near Baltimore, in 1832 was called Glen Ellen (Mrs. Gilmor had been Ellen Ward) and was a crenelated mansion with turrets and towers and finials of which Downing would have thought a gentleman of Gilmor's stature fully worthy. Unfortunately, it no longer exists, though renderings of its imposing façade and plan by Davis (now in the Metropolitan Museum collection) confirm that it was one of the great houses of its time.

A series of designs in the Gothic manner followed Glen Ellen from Davis' drafting table: Lyndhurst, at Tarrytown, New York, which he built for the merchant William Paulding in 1838, a freer and even more magnificent romantic manor than Mr. Gilmor's house; less pretentious and more elegant houses, like the Harral house in Bridgeport, Connecticut, and the Rotch house in New Bedford, Massachusetts; and some official buildings, like the one erected by New York University on Washington Square, which became a curiously dreamlike element in Samuel F. B. Morse's rather clumsy fantasy, "Allegorical Landscape Showing New York University."

Not all of Davis' contemporaries were as impressed as Downing by such Gothic nostalgia. Mayor Hone visited Lyndhurst in 1841, three years after it was built, and recorded in his diary that it was

> an immense edifice of white or gray marble, resembling a baronial castle, or rather a Gothic monastery with towers, turrets, and trellises; minarets, mosaics, and mouseholes; archways, armories, and airholes; peaked windows and pinnacled roofs, and many other fantasies too tedious to enumerate, the whole constituting an edifice of gigantic size, with no room in it; great cost and little comfort, which, if I mistake not, will one of these days be designated as *Paulding's Folly*.*

Davis was not the sort of man to be stung by such criticism, and while he could not have known what Hone had confided to his diary, there were

* Hone was not the only mayor who failed to be seduced by the charms of Davis' Gothic. The Harral house, surely one of the best houses built in America in the nineteenth century, was left by its owner to the city of Bridgeport with a park around it. In the 1950s the mayor wanted to use the land to put up a city office building, and when local citizens who thought the house should be saved protested his plan, he whittled away at it, had pieces of its interior removed, and let the structure deteriorate. Such a hue-and-cry was finally raised in national magazines that in the next mayoral election the conservationists backed a candidate for mayor who promised to save the building; they wrote petitions and rang doorbells and raised money and got him elected. It is unfortunate that when he became the chief executive of Bridgeport, a city which has little enough to boast of, he had the house torn down in spite of his promises to the contrary.

ABOVE: Lyndhurst, one of the great surviving Gothic Revival houses, was designed by A. J. DAVIS and built for William Paulding in 1838. Once the butt of wiseacres, it is now an "historic monument" open to the public at Tarrytown, N.Y. BELOW: known as the Rotch House, this dignified symmetrical dwelling in New Bedford, Mass., was designed by the master of American Gothic Revival, A. J. DAVIS, in 1850. (*Photos Wayne Andrews*)

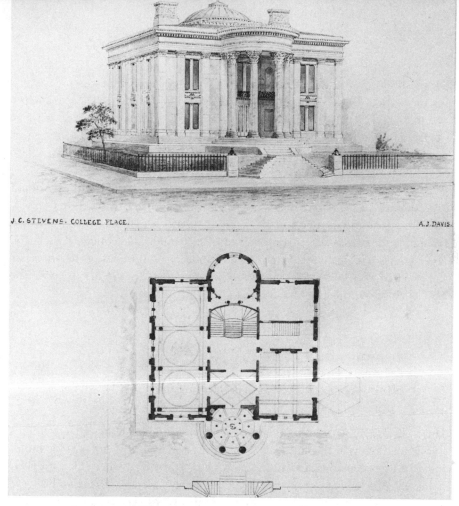

J.C.STEVENS. COLLEGE PLACE. A.J.DAVIS.

ALEXANDER JACKSON DAVIS designed this stylish residence in the
Greek style for John Cox Stevens on College Place, New York. Mr.
Stevens was first commodore of the New York Yacht Club and skipper
of the famous yacht *America*. (*Museum of the City of New York,
Edward W. C. Arnold Collection*)

other practical men who were content to appear in print with castigations
of the Gothic. Indeed, a critic writing in the *Broadway Journal* attacked
the very house in which Davis' mentor, Downing, lived: "We observe two
octagonal blind towers," he wrote, "which have puzzled us exceedingly to
guess at their uses. Perhaps they may be cases for depositing fishing rods—
we can conceive of no other use for such appendages." The fact of the mat-
ter was that Davis was so much in demand that he did not even have the
time to supervise the construction of a great many of his designs, and, in
spite of the opinions of Downing, he was quite willing to design in the

Greek manner if a client he liked wanted him to do so. Hone was pleased by the house that Davis did for his friend John C. Stevens seven years after Lyndhurst. It was a precisely symmetrical classical mansion with a Corinthian portico, and Hone approvingly said, "The house is, indeed, a palace," and was moved that "a simple citizen of our republican city" could pay for and live in it.

Davis retired from the practice of architecture, except as an occasional diversion, in 1859, when he was only fifty-six (he lived to be eighty-nine), but the expanding nation was by then scattered with edifices that had come from his pencil—statehouses, state capitols, innumerable college structures, large houses of stone, small ones of wood, museums, libraries, gatehouses. In the year he retired, a contemporary wrote: "We thank Mr. Davis, the Michel Angelo of his time, for what he has done for us."

ROMANTIC HOUSES FOR GOD AND MAN

Davis was by no means the only American architect who shared Downing's preoccupation with the suitability of Gothic for America, nor are his buildings the most conspicuous ones to survive into our own time. Though their names may be known to fewer people than Davis', whose reputation has been assiduously revived in the last few decades by critics and scholars, the public exposure of the works of Richard Upjohn and James Renwick, Jr., because of their locations, is greater. How many thousands of New Yorkers each day walk past Trinity Church on Broadway at the head of Wall Street and look up at its slender steeple rising above its steeply pitched roof and know that it was designed by an English immigrant named Upjohn? How many visitors to Rockefeller Center gaze across Fifth Avenue at the lofty façade of St. Patrick's Cathedral or tourists in Washington walk across the Mall to the red, irregular battlements of the old Smithsonian building and know that they were the work of a New York yachtsman, well heeled and well born, named Renwick? Indeed, how many people know who designed any but a handful of buildings? For, of all the arts, architecture is to the broad public the most anonymous.

One would think that Downing's contemporaries would have accepted Gothic as an entirely suitable style for churches, whatever they may have thought of it for domestic architecture—more suitable, in any case, than

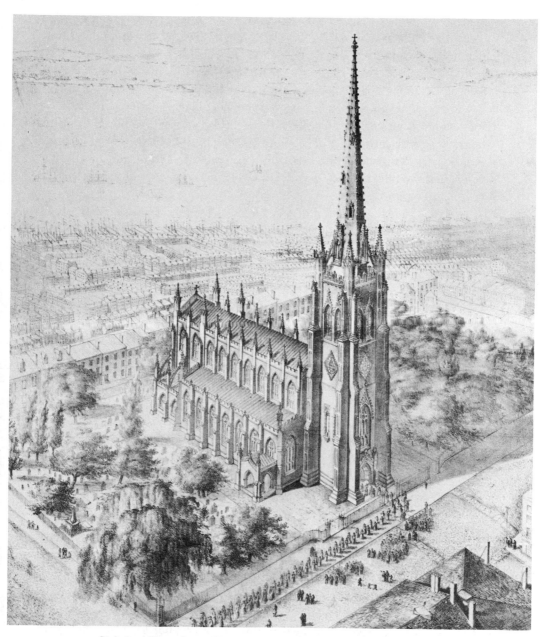

Trinity Church at Broadway and Wall Street in New York, by
RICHARD UPJOHN, was consecrated in 1846. This bird's-eye view was
drawn and lithographed the following year by JOHN FORSYTH and
E. W. MIMEE. (*Museum of the City of New York, J. Clarence Davies
Collection*)

modernized pagan temples with spires growing out of their wooden pediments in a manner inspired by Sir Christopher Wren. Many did, to be sure, but not the *Broadway Journal*, one of whose editors was a young poet, Edgar Allan Poe. Gothic, the magazine (and perhaps it was Poe himself) said of Upjohn's Trinity Church in particular but of all such notions in general, was "of necessity . . . incongruous." It conceded that Trinity was "a very good object for the Wall Street brokers to contemplate, as they hurry to and from *the board*, reminding them, by its tall spire, to look up, occasionally." But otherwise it was an extravagant expenditure of church funds that should have been devoted to less lofty, perhaps, but more strictly religious purposes.

Upjohn must have been deeply offended by such criticism. He was a High-Church Episcopalian, committed to the importance of ritual and the solemnity of God's temple, and no expenditure, he must have felt, so long as it stayed within the aesthetics of taste, could be considered an extravagance. (Such was his devotion to High-Church ideals that he flatly refused to design a church for Unitarians in Boston.) It is likely that those who looked upon Trinity as a monument, rather than as a ledger of moneys expended, agreed with Downing, who thought it "as far above all other Gothic structures in this country, as a Raphael's madonna before a tolerable sign painting." As Wayne Andrews has written, "In the years that have gone by since the consecration on Ascension Day, 1846, critics have agreed that this is one of the greatest, if not the greatest church erected in America."

Churches were Upjohn's most successful creations, but he was a domestic architect as well, and the first important commission he was awarded several years after he arrived in America with his wife and small child was a substantial house for Robert Hollowell Gardiner on the Kennebec River at Gardiner, Maine. It cost the client $60,000, and Hawthorne was moved to comment on its Gothic splendor that "It well deserves the name of castle or palace." This one house was not enough to make his reputation, and it was some years before he managed to escape from the fringes of poverty to the commanding position from which he could afford to turn down the Unitarians. Once he became known, however, commissions for churches and houses kept him steadily at his drafting table with his thoughts on plans and details and morality. "The object is not to surprise with novelties in church Architecture," he wrote to a client in Philadelphia, "but to make what is to be made truly ecclesiastical—a temple of solemnities—such as will fix the attention of persons, and make them respond in heart and spirit to the opening service—'the Lord is in his holy temple—let all the earth keep silence.' " He tried, too, to endow his houses with an aura of dignity, though not solemnity. Downing reproduced one of them in his *Country Houses*, a

A. J. Downing described this house (ABOVE) in Newport, R.I., designed by RICHARD UPJOHN in the 1840s for Edward King, as "one of the most successful specimens of the Italian style in the United States. . . . There is dignity, refinement and elegance about all its leading features." Upjohn designed a number of small rural churches such as St. Thomas's in Amenia Union, N.Y. (BELOW), which was built in 1850–51 at a cost of $3,000. Its brick is now painted yellow and it has a bright red door, which Upjohn would have found profoundly shocking. (*Both photos Russell Lynes*)

"villa in the Italian Style" for Edward King of Newport, Rhode Island. "It is one of the most successful specimens in the Italian Style in the United States," Downing wrote, "and unites beauty of form with spacious accommodations. . . . The first impression which this villa makes on the mind is that of its being a gentleman's residence. There is dignity, refinement and elegance, about all its leading features. It next indicates varied enjoyments, and a life of refined leisure—especially abounding, as it does, with evidences of love of social pleasure." Upjohn designed houses for New Yorkers and for those who dwelt on the banks of the Hudson. What "commodity, firmness, and delight" had been to the ancient Roman architect Vitruvius, "dignity, refinement, and elegance" were to the architects of Downing's day. Since not many communities could afford to engage the services of architects to build their churches but heeded the words of Downing, Upjohn produced a book of designs for wooden churches that vestries and boards of elders could choose from and local carpenters could erect.

Upjohn was a man of modest parentage, and his early training was as a cabinetmaker and as an apprentice in an English architect's office. Renwick, on the other hand, was the son of a Columbia College professor who had married into the Brevoort family, and, brought up in luxurious surroundings, he took the diversions of the rich for granted. His contemporary as an undergraduate at Columbia, George Templeton Strong, a remarkable diarist with a sharp eye for the arts and a sharper tongue, thought him the "most windy of all the bags of conceit and coxcombry that ever dubbed themselves Architect." If St. Patrick's Cathedral is Renwick's most conspicuous ecclesiastical edifice, Grace Church in New York (it was completed when Renwick was only twenty-eight in 1846) is his most conspicuous architectural accomplishment, a moody and picturesque Gothic structure with a handsome parish house and rectory adjoining it. Most of Renwick's contemporaries were greatly impressed by it, though Mayor Hone was shocked at the prices for which pews were sold and the pew rents that were charged. (Owning a pew in those days was like owning a cooperative apartment now; a family paid for its pew and then had to pay the equivalent of "maintenance" to retain it for its private use.) "The new church at the head of Broadway is nearly finished and ready for consecration," Hone wrote in his diary.

> This is to be a fashionable church, and already its aisles are filled . . . with gay parties of ladies in feathers and "mousseline-de-laine dresses" and dandies with moustaches and high-heeled boots; the lofty arches resound with astute criticisms upon "Gothic ar-

James Renwick, Jr., was an inexperienced young engineer when he won the competition for Grace Church at Broadway and Tenth Street in New York. He was twenty-eight when it was completed in 1846, and with it his reputation was made. (*Photo Landmarks Preservation Commission of the City of New York*)

chitecture" from fair ladies who have had the advantage of for-
eign travel, and scientific remarks upon "acoustics" from elderly
millionaries who do not hear quite as well as formerly.

There was a competition for Grace Church, though it appears that
family position and favoritism got Renwick the job. His only qualifications
as an architect were training as an engineer and employment on the build-
ing of the Erie Railroad and the Croton Aqueduct. He was, in a sense, part
of the tradition of the gentleman amateurs who had built (or initiated) the
buildings in the nation's capital and the great mansions on the James.
Strong, who could not find it in his heart to say a good word for Renwick,
wrote of a conversation about Grace Church with its architect:

> If the infatuated monkey showed the slightest trace or germ of
> feeling for his art, one could pardon and pass over blunders and
> atrocities so gross as to be palpable even to my ignorance; but
> nature cut him out for a boss carpenter and the vanity and
> pretension that are endurable in an artist are not to be endured in
> a mechanic, and especially not in one who is a mechanic in spite of
> his ennobling vocation, and degrades, vulgarizes, and pollutes
> every glorious idea of form of the successive eras of Christian art
> that he travesties and tampers with, as a sacrifice to the stolidity
> of building committees and his own love of fat jobs and profitable
> contracts.

He had many fat jobs. He designed hotels and stores, asylums and hospi-
tals, apartment houses, row houses, and a workhouse for prisoners. He
designed the main building for Vassar College, basing it on the Tuileries.
But as a young man he was caught up in the prevailing romantic preoccu-
pation with keeps and dungeons illuminated by flashes of lightning and
ringing with the clash of sword on shield.

The Smithsonian Institution's building, which Renwick designed when
he was in his late twenties, is such a sight, more suitable to a tournament of
knightly exercises and sports, or to the rescue of a damsel from a dragon,
than to scientific displays. Greenough, the confirmed functionalist, could
scarcely believe his eyes when "the dark form of the Smithsonian palace rose
between me and the white Capitol." He stopped and stared. "I am not about
to criticize the edifice," he wrote. "I have not quite recovered from my alarm.
There is still a certain mystery about those towers and steep belfries that
makes me uneasy. This is a practical land. They must be for something. Is
no *coup d'état* lurking there?"

"Is no coup d'état lurking there?" asked the sculptor Horatio Greenough of the Smithsonian Institution's fortress in Washington, designed by JAMES RENWICK, JR., in the 1840s. This photograph was made by Mathew Brady, America's first great photographer. (*U.S. Signal Corps Photo, Brady Collection, in the National Archives*)

Downing was responsible for the landscaping of the Smithsonian Institution's grounds, and the romantic aspect of its battlements must have delighted his sense of the appropriate as it offended Greenough's sense of the functional. But it was another forty or more years before Greenough's doctrine was reasserted and applied by the Chicago architect Louis H. Sullivan. Downing's concept of the good life, lived with moderation in beautiful (if by no means necessarily luxurious) surroundings, and his belief that civilization could come to the rude new nation only through the perfecting of its homes had an immediate appeal to his contemporaries. The word was spread through his books, for which his friend A. J. Davis, who frequently visited him at his Gothic villa on the Hudson at Newburgh, made elegant drawings of plans and elevations. Houses in the "pointed style" (or Gothic) were not the only ones that Downing and Davis offered to beguile the taste of country gentlemen and farmers; there were also the Switz cottages, of which they were so fond, with very deep eaves and balconies, and villas in a style called Tuscan, with square corner towers and wide verandas, with windows rounded at the top, and little upstairs balconies on their bedrooms from which to survey the landscape. Taste, in Downing's doctrine,

had nothing to do with money except that it was easier for a man of wealth to show his innate vulgarity than it was for a man of modest means. Downing's *Country Houses* set off a salvo of books aimed at the aspirations and uncertainties of taste of those who wished to live in genteel surroundings in the current fashion. There were books such as *The Economic Cottage Builder, Modern House Builder from the Cottage to the Log Cabin to the Mansion,* and others too numerous to list. But there was one worth mentioning, not merely because it was widely distributed and parts of it were reprinted in *Harper's New Monthly Magazine* (which then boasted the largest circulation of any magazine in the world) but because it was written by an architect whom Downing had brought to America from England to be his assistant.

Calvert Vaux was a student in Paris when Downing met him, gifted but by no means in command of an important talent. He long survived Downing, and his book *Villas and Cottages* (1857) kept Downing's quiet voice alive when more raucous preachments about taste were calling to homeowners. Vaux became a very successful practitioner in New York, a greatly respected citizen of his adopted country, and, most importantly, the architect associated with the greatest of all American landscape gardeners, Frederick Law Olmsted, in the creation of Central Park. It was Vaux who designed the initial structure in the park for the Metropolitan Museum of Art, a building now incorporated and all but vanished in that vast complex of Victorian, Renaissance, and modern styles that by some miracle seems to function admirably as a museum.

THE ROMANTIC INDOORS

The romantic style that Downing and his followers believed so profoundly to be the proper surroundings for republican America cried aloud for romantic decoration in its parlors and dining rooms and bedrooms as it did in its gardens and groves and rambles. Downing would not have used the word "romantic"; "*fitness* and *truthfulness*" of the interior in relation to the exterior were his criteria, and this was to be achieved by "attention to details," no matter whether the house was in the Grecian style, the Italian, or the Gothic. Downing did not look kindly on the mixed metaphor of a thrown-together interior, and he cautioned his readers against the "blunder

SOUTH-EAST VIEW AS ALTERED.

SOUTH-EAST VIEW BEFORE ALTERATION.

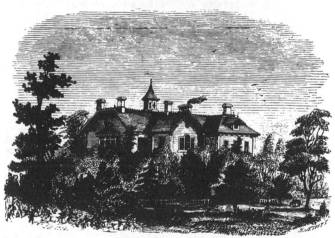

NORTH-WEST VIEW AS ALTERED.

CALVERT VAUX, architect and author of *Villas and Cottages* (1857), shows how to remodel a plain though spacious farmhouse into an elegant villa in the bracketed style, a job he did for Homer Ramsdale, president of, as he put it, "that gigantic American fact, the Erie Railroad." (*Collection of the author*)

extended along both sides or all round the library. The spaces below afford excellent closets for pamphlets and manuscripts, and the busts of distinguished men, in different departments of letters, may be so placed along the top as to designate to what particular class of books the space directly below is allotted.

[Fig. 276.] [Fig. 277.] [Fig. 278.]

Drawing-room and library chairs in the Gothic style are generally expensive and elaborate, being covered with rich

[Fig. 279.]

In his *Country Houses* (1850), A. J. Downing remarked that furniture in the Gothic style tended to be expensive, "being covered with rich stuffs and highly carved." On the whole, he found it "quaint" and "suitable" for a gentleman's villa. (*Collection of the author*)

stuffs, and highly carved. Fig. 276 is an arm-chair in the English taste, partly Elizabethan and partly Gothic. Fig. 277

[Fig. 280.]

is a quaint arm-chair, very suitable for the library. Fig. 278 is the most chaste and refined design of the three, and, if made rather smaller than here shown, would be a very suitable drawing-room chair for a villa in this style. The top of Fig. 276 is too elaborate and ecclesiastical in character for most private houses—or, at least, only one or two such chairs, at the most, are all that should ever be introduced there. We much

[Fig. 281.]

prefer, when richness is requisite, to get it, in Gothic furniture, by covering rather plain and simple designs with rich stuffs, rather than by the exhibition of elaborate

of confounding *fashion* with *taste*": "the most fashionable furniture may be in the worst taste," he wrote, "while furniture in the most correct taste is not always such as is easily obtained in the cabinet warehouse."

Downing's warning was not without justification. By 1850 the business of cabinetmaking was very different from what it had been when the artisans went on strike in New York in 1802. It had, in effect, stopped being cabinetmaking and become furniture manufacturing, and though the artisan was still needed in the process (as he is still needed today in Grand Rapids), furniture had felt the impact of the Industrial Revolution in full force. Just two years before the publication of *Country Houses* the Chamber of Commerce in Cincinnati, a furniture center, reported that "seven steam-powered establishments produced annually 4,250 bedsteads, 7,500 bureaus, 4,500 wash stands, 14,500 *dozen* chairs, 1560 sofas, 3,500 card tables and 200 wardrobes."

The style most popular in the 1850s was called "French Antique" (it later became known as rococo), and its principal perpetrators were John Henry Belter, who set himself up in business in New York in 1844, and Charles A. Badouine, who established himself a few years before Belter but evidently made his greatest success by infringing Belter's patents and imitating his designs. There was also George Platt, to whom Downing refers as "at present the most popular interior decorator in the country," with "talent enough to take an apartment or a suite of apartments, design and execute the decorations, and color, and furnish them throughout in any style." Alexander Roux was another of Downing's enthusiasms, of whom he said, "In New York, the rarest and most elaborate designs, especially for drawingroom and library use are to be found in the warehouse of Roux in Broadway." Praise from Downing was an endorsement to which the public paid heed.

French Antique was elaborate, with rosewood frames carved with the intricacy of a grapevine that has fallen into the blossoms of a garden—elegant, rich, but quite different from the earlier French Empire. It followed a more robust style of the 1830s which is now called "Restauration"; this was characterized by a comparatively weighty interpretation of Directoire, as though many of the same shapes that were adapted from antiquity by the designers of Napoleon's era to a spare and sharpened delicacy and unforgiving rigidity were bulked up to stand rougher treatment in a rougher country. The legs of Restauration furniture were those not of a lady of fashion but of a bearer of burdens; the curves those of a buxom woman, not a fragile courtesan; the pedestals of the tables stout enough to hold a banker and not just a vase with snakes for handles or a bell glass bright with stuffed birds.

GEORGE PLATT, interior decorator and furniture designer, made this rendering of his own New York parlor in about 1850. He was highly recommended by A. J. Downing, the foremost tastemaker of his day. (*Collection of the author*)

Gothic furniture was available to the fastidious and, one suspects, the purists. Gothic beds echoed the choir stalls of churches, Gothic chairs were miniature bishops' thrones, headboards were sections of rood screens, and Gothic desks were altered altars. Whether because this furniture was unremittingly uncomfortable or because exposure to a Gothic interior once a week on Sunday was all that even pious citizens felt called upon to endure, the vogue for Gothic interiors, though they could be elegant (as in Davis' house for Mr. Harral in Bridgeport), was short-lived. The gaiety of the French taste, with its flickering ornament, its somewhat feminine archness, its satin upholstery, its boudoir-in-the-parlor flirtatious look, was what those who could afford it indulged in, and those who could not bought it in factory-made imitations and tarted it up with whatever bric-à-brac they could lay their hands on. At its most elaborate, the rococo furniture stood in carefully asymmetrical arrangements in parlors on whose walls were flock papers, frequently in deep, rich colors, sometimes striped, sometimes patterned. Flowered Axminster carpets completely covered the floor; tall, gilded mirrors crowned with tangles of golden fruit and vines or acanthus

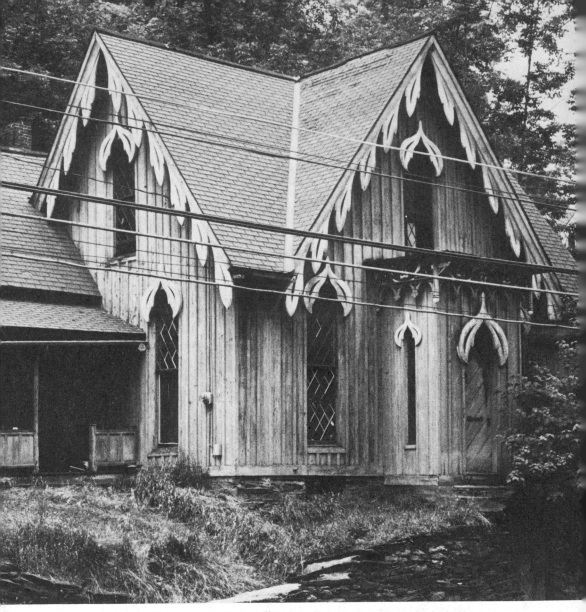

The Gothic took some curious forms, as this house in Montpelier, Vt., attests. Carpenters let their imaginations take flight in the mid-century when they had the scroll saw to play with. (*Photo Russell Lynes*)

It is unlikely that any parlor of the 1850s looked quite like this so-called "view in a New York dwelling house." It was an advertisement for furniture made by "the French house of Bembe and Kimbel" of New York, specialists, it appears, in "the French taste." (*Collection of the author*)

leaves stood above white marble mantelpieces on whose shelves were bell glasses filled with wax flowers and quite possibly an ormolu maiden draped over a clock. At the windows fringed curtains held back at their waists by tasseled cords and gilded tie-backs, hung to the carpet from carved pelmets or lambrequins edged with galloon. On the walls were portraits, sometimes in fashionable oval frames, hung by silken cords from moldings that, like the rosette in the center of the ceiling, were a credit to the plasterer's art and the envy of the pastry chef. In a few parlors there were, along with portraits, somber landscapes by Thomas Doughty or Henry Inman or, rarer still, livelier ones by the newcomers Thomas Cole or Asher Durand, or just possibly pastoral genre scenes by William Sidney Mount. On a pedestal in front of one of the windows there might be a copy in Parian of Powers' "Greek Slave," or even a bust in marble by W. W. Story or Erastus Palmer.

In the air hung the scent of pomander and wax candles and dried lavender and, perhaps, the faintest odor of illuminating gas. Never was there the heavy smell of cigar smoke—never under any circumstances in the parlor, however persistently it may have lingered in the library, to which the gentlemen repaired after dinner for their coffee and Madeira.

Downing approved of "the French taste"; it seemed to satisfy his theories about the distinction between the useful and the beautiful without offending his sense of moderation, and enough of it was tasteful, he thought, to escape the solecism of being merely fashionable.

The era when Alexander Jackson Davis was applying his precise and facile pencil to the design of houses and public buildings, when Richard Upjohn was changing the architecture of churches from airy temples to mysterious Gothic halls, when James Renwick was providing dungeons for the public to explore, can properly be called the Age of Downing. It was he more than any of the others who left his stamp upon the looks of America in the 1840s and '50s and whose gentle voice still echoed in the public parks of the nation's cities after the others disappeared from public view. He left no monuments created by himself which are of any consequence; his residue was a point of view which was civilized and dedicated to the advancement of the arts in the most democratic of ways. "Certainly the national taste is not a matter of little moment," he wrote; ". . . the real progress which a people makes in any of the fine arts, must depend on the public sensibility and the public taste."

Downing was the victim of precisely what had so frightened Mayor Hone in his hazardous trip down the Hudson in 1824. On a July morning in 1852, Downing and his wife and mother-in-law embarked on a steamer at Newburgh headed for New York. The ship, a new one with a captain determined to demonstrate its superiority to any other that plied the river, was, Downing soon discovered, engaged in a race with another steamer. As the sparks flew from the stacks, the boilers grew so hot that the passengers could not go from one end of the boat to another without being subjected to intense heat amidships. Pleas to the captain to call off the race went unheeded, and just twenty miles from its destination the ship burst into flames. The Downings were separated in the ensuing panic. Mrs. Downing was saved, but Downing, according to one account, was drowned trying to save his mother-in-law's life. Another account said that he was last seen on the top deck of the blazing ship hurling deck chairs into the water for the passengers to use as rafts.

Downing was thirty-seven when he died in the middle of the Age of Downing. "No American," wrote his friend George W. Curtis twenty years

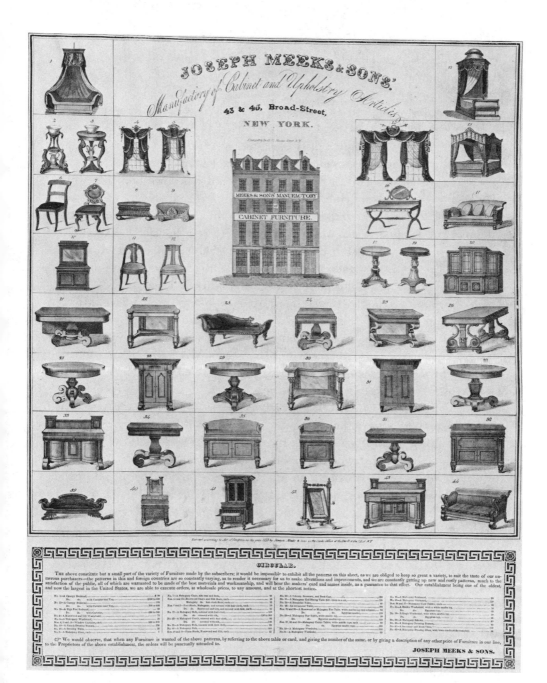

In 1833 JOSEPH MEEKS & SONS offered this line of fashionable furniture to discriminating New Yorkers. Unquestionably they looked more at home in Greek Revival parlors and bedrooms than in this mixed gallery of styles. (*The Metropolitan Museum of Art, Gift of Mrs. R. W. Hyde, 1943*)

after his death, "has built himself a more permanent monument than Downing the landscape gardener."

When Greenough had said that the Smithsonian's "towers and steep belfries" made him uneasy and that "they must be for something," he had precisely defined the conflict between the romantic and the practical in which the art-makers of Downing's day found themselves.

Architects, as useful professionals, had established the fact that when it came to the design of important buildings and great houses they were preferable to carpenter-builders, though architects, except through the influence of the plan books which they produced for the use of carpenters, had little to do with either city or rural building. Hone noted in his diary in 1831: "The city is now undergoing its usual annual metamorphosis; many stores and houses are being pulled down, and others altered to make every inch of ground productive to its utmost extent." It was surely not architects who were in charge of this tearing down and building up, but carpenters and masons in the employ of speculators. Only the rich and rich institutions thought architects worth bothering with; others who lived in the country heeded the moral aesthetics of Downing and in the city accepted whatever was at the moment the fashionable means of treating a wooden or brick or brownstone box of a house.

From the painter's point of view, the old conflict between making a living painting portraits and being the creator of history pictures had only half changed. Now the conflict was between portraits and romantic landscapes or genre scenes of American life. Even so, by the 1840s the lot of the painters had, like the lot of the sculptors who had fled to Italy, improved financially, and so had their status in the community. They were still a long way from making more than a minor dent in the public consciousness (much less in the concerns of those who controlled political life, the elected custodians of our civilization), but there were movings and stirrings that anyone but the morose Thomas Cole would have thought promising if not as yet comforting.

There were men like Robert Gilmor and Luman Reed, a New York wholesale grocer, who were not only collecting paintings by their contemporaries but also helping artists to foot their bills for travel and study. There were new dealers in prints and pictures, like Goupil and Company, a Paris firm that opened a branch in New York in 1850 (it was the forebear of Knoedler's, one of the grandest dealers of our time). There was the Apollo Association (which changed its name to the American Art Union), an organization that, as we shall see, did more than any other institution to put

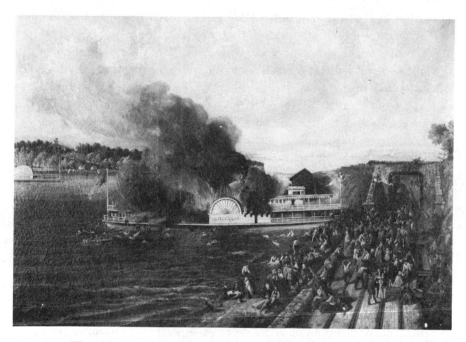

The side-wheeler *Henry Clay,* racing the *America* down the Hudson on July 28, 1852, burst into flames twenty miles from New York. ANDREW JACKSON DOWNING, author and tastemaker and distinguished horticulturalist, lost his life in the holocaust. (*Museum of the City of New York, Edward W. C. Arnold Collection*)

art on the walls of America's parlors and to make the national reputations of painters. Even before these assaults on the public taste made art fashionable, Dunlap in the early 1830s was constrained to observe: "Artists know their stand in society, and are now, in consequence of that conduct which flows from their knowledge of the dignity and importance of art, looked up to by the best in the land, instead of being looked down upon by those whose merits will only be recorded in their bank books." But even if businessmen and artists could meet on an equal footing of respectability, a wide chasm still separated the artist from what he believed to be his rightful place in the national culture, a breach not closed even in our own time, when we are engaged in promoting a kind of mass love affair with the arts. George W. Bethune, who addressed the Artists Society of Philadelphia at the opening of its spring exhibition in May 1840, was not in the least sanguine about how the arts were faring. "It is melancholy to think of the talent which now lies dormant among yourselves, gentlemen," he told the assembled artists, "for want of encouragement; and to see in your annual catalogues such a

repetition of 'Portrait of a Lady'; 'Portrait of a Gentleman'; when we know that some, at least, of the pencils that produce them are capable of far higher achievement. . . ." It was up to the artists themselves, he said, to teach taste not by dictating to the public but by providing it with great examples that it would find irresistible. "You can neither write nor lecture us into a sense of Art; but your brush or chisel may win, when the best pen and most eloquent tongue can avail nothing." Mayor Hone a few years earlier had gone to the opening of the annual exhibition at the Academy of Fine Arts in New York "at new rooms in Barclay Street," and had reacted similarly. "Portraits, portraits enough, in all conscience!" he jotted in his diary.

But it is not the portraits of Downing's and Hone's and Bethune's day that matter now, though many skillful and worthy ones were painted then which look down now from the walls of libraries and city halls and gentlemen's clubs—stern or benign faces with intelligent eyes emerging from dark backgrounds. The best of them were by no means hack work; often they exhibit great subtlety of observation, both of textures and of character, and most skillful manipulations of the brush. Portraiture was just one of the requirements of being an artist; not the least, perhaps, but not what really mattered to the makers of art or to their most perceptive patrons. What mattered was the landscape, the magnificent and the mysterious vista, the poetry of space in a given mood at a given time, the infinite power of nature and the smallness (not meanness) of man. It was also the age of ghosts and visions, of Coleridge's "caverns measureless to man," of Washington Irving's headless horseman, of Scott's *Ivanhoe*, of the ghosts of the Middle Ages haunting the imaginations of playwrights. But it was also, in aspects not just grasping and speculative, a time of discovering America—the primitives about whom Cooper wrote in *The Deerslayer*, mesmerizing his contemporaries, and William Cullen Bryant's romance with the streams and forests and fields. If it was romantic for plain Americans to dwell in temples and Gothic castles, it was also romantic for them to dwell upon the finite details and the infinite mysteries of the vast lands that spread around their turgid, stinking, noisy cities which were illuminated only rarely by flashes of brilliant architecture. Romantic painting and sculpture and building were a sort of tranquilizing prescription for the accumulating ills of a society that here, as in Europe, was suffering the first aches and vapors of industrialism.

7

LITTLE PEOPLE
IN BIG PLACES

"Go forth, under the open sky, and list
To Nature's teachings, while from all around—
Earth and her waters, and the depths of air—
Comes a still voice."
WILLIAM CULLEN BRYANT in *Thanatopsis*, 1811

Thomas Cole, who became the titular father of American landscape paint-
ing when he was still in his twenties, looked down his nose at the sculptors
who were making such a popular and official stir. "It seems to me," he wrote
to his friend and fellow practitioner, the painter John M. Falconer, at a
time when his own reputation was at its zenith, "that sculpture has risen far
above par of late: painters are but an inferior grade of artists. This
exultation of sculpture above painting, which in this country has prevailed,
is unjust, and has never been acknowledged in the past. . . . He who cannot
distinguish one color from another may be a sculptor. I only intend to say
that undue importance has been given lately to sculpture."

John Trumbull, who in 1816 had warned John Frazee away from
becoming a sculptor because "it would not be wanted for a century," would
have been surprised by this remark that his protégé Cole made just thirty-
one years later. In truth Cole had less reason than any other man of his
profession to complain about the short shrift given to painting. He was by
1847, the year before he died, widely known and heartily acclaimed; his

works adorned not only the collections of the most important patrons of American art but the parlors of more humble but no less genteel folk who had acquired engravings of his popular "Voyage of Life." But he was falling into melancholy in his retreat in the Catskill Mountains, and the statement by Charles Lanman, the critic, that "Thomas Cole is unquestionably the most gifted landscape painter of the present age. In our opinion none superior ever existed," if Cole heard it at all, fell on reluctant ears. He was a man with a mission that carried him in two directions at once, a visual mission, which was to capture the full power of nature in all its grandeur and scale and infinite detail, and a spiritual mission, which put uplift above all other considerations and prompted him to such statements as, "A beautiful sentiment even if feebly expressed is far more worth than the most skillful display of execution without meaning." Not infrequently in his work visual hunger and spiritual vision canceled each other out, leaving a kind of overblown pompousness that did neither the painter nor the moralist justice. When his love of landscape and his extraordinary knowledge of it, not only in detail but in scope, prevailed over his rather routine moralizing and reduced it to an excuse rather than a sermon, the results were among the great paintings produced in America in the nineteenth century. They were also among the most despised or forgotten by the time the century came to an end. Built into Cole's work were all the elements of fashion, of contemporary sentiment, of flashy virtuousity which are certain to consign what becomes vastly popular to a long period of neglect—indeed, sometimes permanent neglect and indifference. But there were also elements of truth in them which, now that the sentiments can be overlooked or forgiven, speak again with authority and can be harkened to with respect and pleasure.

Cole was no more the "father of American landscape painting" than Greenough was the "father of American sculpture," but we seem to like to assign artistic parentage to the glossiest reputations rather than to the first men to seduce the Muses. Serious flirtations with landscape were pressed by Ralph Earl, the eighteenth-century portrait painter, in a rather stiff and formal manner, but as a by-product of portraiture—a diversion rather than any attempt to create a lucrative branch of his art. The Englishman Francis Guy, who came to America in 1790 and, as we noted, called ours a "money-hunting, negro driving, cow-skin republic," had specialized in what might more properly be called "scenery" than landscape, which, when young, he did by stretching a piece of black gauze on a stretcher, holding it up to the scene, and drawing with white chalk what he could see through it. Washington Allston also painted landscapes, but they seem to issue more from the mind than the eye, a kind of recitation by rote of the classical

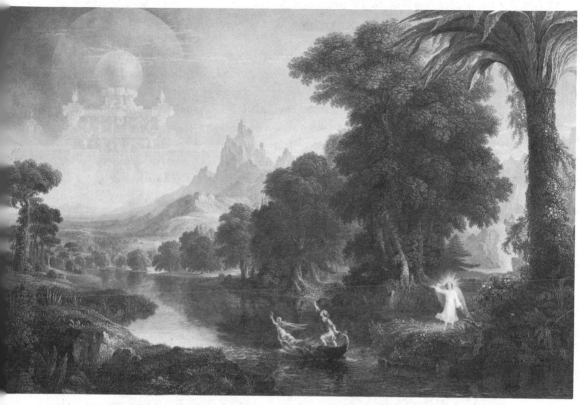

THOMAS COLE'S "Youth," from his series of four paintings, "The Voyage of Life," was engraved by James Smillie and was widely distributed to the members of the Art Union in 1849. (*The New-York Historical Society, New York City*)

vocabulary of Poussin and Claude and the romantic vocabulary of Salvator Rosa, more reverie than excitement at capturing nature and making it behave. Trumbull, too, struggled with landscape as inherent parts of his history pictures, and Samuel F. B. Morse somehow managed to make his few American landscapes look as though the trees and the light had been shipped over from Italy for the occasion.

The first American painter to set out deliberately to make a living by painting landscapes and to make a success of it was Thomas Doughty, a Philadelphian who was the son of a shipwright. He was born in 1793, and at thirty he gave up the leather business to which he had been apprenticed by his father and, as Tuckerman says, "to the surprise and disappointment of his friends," became an artist. He worked under the tutelage of Sully, whose

sophistication was partly imported from England and who taught him how to give his canvases a consistency of tone; more important, the landscape he tried to capture was the American landscape, and in this he was a progenitor of a school of painters fascinated by the expanses and wonders of what belonged to them rather than what belonged to the European tradition of conventionalized landscape. According to Dunlap, "Mr. Doughty has long stood in the first rank as a landscape painter—he was at one time the first and the best in the country." It was Cole who superseded him and made his vistas look stiff and edgy. Mayor Hone, when asked by Dunlap for a list of the works in his collection, described Doughty as accurately as anyone when he listed as one item: "10. The Water Gap on the Delaware River, by T. Doughty. The mountains, like all of this artist, very fine; but the outline, in some parts, is very hard, and the water not sufficiently transparent." Doughty was having to compete with the works of a man who opened the eyes of a generation to wonders in the landscape of which he, and they, had not before dreamed.

When Cole arrived in New York in 1825 at the age of twenty-four, he brought with him from Philadelphia three canvases that he had been unable to sell there for $10 apiece. They were paintings of the Catskills, images of nature (in Cole's eyes, nature was always somewhat awesome, tortured and torturing) that he had captured on a walking trip up the Hudson. They were in a framer's window when John Trumbull saw them and hurried off to his friend Dunlap with the astonishing, and uncharacteristically modest statement, "This young man has done what all my life I attempted in vain to do." Trumbull bought one of them for $25, Dunlap another, and eventually they turned up in Mayor Hone's back parlor—"glowing impressions of a warm imagination," Hone called them, "the rich fruits of an artist's study, the children of prolific genius." And he speculated when he mentioned them in his diary in 1848 that they would fetch "$600 or $800."*

Cole's reputation was quickly made by this admiration in high artistic places. He was not an American by birth, though he is reported to have said (Dunlap had it at second hand), "I would give my left hand to identify myself with this country, by being able to say I was born there." He was born in the Midlands in England, and was apprenticed by his father, a maker of handicrafts, to a calico designer, work he found as distasteful as he did the surroundings in which he had to perform it. When his father went bankrupt because he was unable to adjust to the mechanization of industry

* A large painting by Cole called "The Pic-nic" was bought in 1968 by the Brooklyn Museum for a reputed $130,000.

that increasingly hemmed him in, young Thomas persuaded his family to move to America to recover their fortunes. Cole was seventeen when they sailed. They first settled in Philadelphia, where Cole worked as a wood engraver while his family tried unsuccessfully to establish a dry-goods business. The family—Cole's parents and his sisters—moved on to Ohio, a journey that in those days meant an agonizing three or, more likely, four weeks in a shuddering wagon on rutted roads, especially those over the Alleghenies. Thomas followed them to Steubenville on foot in 1819.

"My school opportunities," he recalled some years later in a letter, "were very small; reading and music were among my recreations, but drawing occupied most of my leisure hours. My first attempts were made from cups and saucers, from them I rose to copying prints, from prints to making originals." Then in 1820 came a revelation in the person of an itinerant portrait painter to whom he refers as "Mr. Stein." Young Cole watched him paint and "considered his work wonderful," though on maturer consideration he guessed that it was "respectable." Stein lent him an English book on painting which was illustrated with engravings and filled with instructions on such basic matters as composition, color, and design. "This book was my companion day and night," he wrote, "nothing could separate us—my usual avocations were neglected—painting was all in all to me . . . my love for art excelled all love—my ambition grew, and in my imagination I pictured the glory of being a great painter. . . ."

The path from Steubenville, where he watched Stein paint, to New York, where he encountered the admiration of Trumbull and Dunlap and, at about the same time, of Asher B. Durand, was a rugged and ragged one. He took to the back roads of Ohio as an intinerant portrait painter, which was at least better than not painting at all. At $10 a portrait head, a fee which frequently was promised but not paid, he could not make enough to pay his board bills. He survived on handouts from friends and on painting pictures for barrooms. Painting portraits made Cole uneasy; he disliked the intimacy of the relation between him and his sitter which the practice occasioned, and a friend of Cole's told Dunlap "that nothing delighted him so much as that his sitters should fall asleep . . . he then felt that he had them in his power."

Finally he made his way back to Philadelphia, carrying his paints and a flute that he delighted to play and wearing a tablecloth for a coat. In the Academy he found landscapes by Doughty which seemed to him the miracle for which he was searching. Here was the American landscape through which he had traveled so far and so intimately. Here was the intimation of what he was later to describe as the "subject that to every American ought

to be of surpassing interest . . . it is his own land; its beauty, its magnificence, its sublimity—all are his; and how undeserving of such a birthright, if he can turn towards it an unobserving eye, an unaffected heart!"

Ten years had elapsed between the time Cole sold his pictures to Trumbull and Dunlap and his remarkable "Essay on American Scenery" in which he made this exhortation. In those years he had become as famous as any artist in the land and, far from having to seek purchasers for his pictures, he was sought by patrons who kept him unremittingly busy with commissions. He had in the meanwhile gone back to England (his trip financed by Robert Gilmor of Baltimore), expecting to be praised, but instead his landscapes encountered only indifference. "I did not find England so delightful as I anticipated," he wrote to Dunlap. "The gloom of the climate, the coldness of the artists, together with the kind of art in fashion, threw a melancholy over my mind that lasted for months even after I had arrived in sunny Italy. Perhaps my vanity suffered. I found myself a nameless, noteless individual, in the midst of an immense, selfish multitude." He saw little of interest in the paintings of Constable, who was revolutionizing the art of landscape in Europe, and though he thought the early works of Turner the noblest of landscape paintings, he deplored the later pictures in which the shapes were obscured by atmospheric effects. Cole felt that he himself had contributed more to landscape painting than either of them, and he might have conceded that it was because there was nothing in Europe, in his estimation, to inspire the landscape artist which could compare with the wildness that was "perhaps the most impressive characteristic of American scenery." He went on from England to Paris, where he found the works of French artists "either bloody or voluptuous . . . artificial and theatrical." In Italy he fell under the spell of Raphael and wondered if, after all, landscape was the highest of the arts. He tried his hand unrewardingly at figure painting, but he painted the Italian landscape with the very same directness and concern with natural phenomena which he had used in painting the majestic and often misty Hudson and the rugged Catskills.

Cole met his most generous patron, Luman Reed—his "best and kindest friend," as he called him—shortly after his return from Europe. Cole had a studio in New York at the corner of Wall Street and Broadway, across the street from the site on which Upjohn would build Trinity Church in the next decade. In the winter of 1832, according to Cole's biographer, the Reverend Louis L. Noble, "There came in one day a person in the decline of life, took a hasty turn around the room serving for a gallery, and went without a word." The man was Reed, a successful wholesale grocer, a man greatly respected in the business community for his honesty, his gener-

ous dealings with his employees, and his civic-mindedness. He was, it is true, in "the decline of life," though he was only in his forties; he died at fifty-one. His reputation has survived as one of the most perceptive, most genuinely enthusiastic and generous, and in many respects the most adventurous patron of American artists in the last century. He was a very rare exception to the rule that successful businessmen expended their largesse on hospitals and orphanages and other such good works, though he evidently did his share. Few were concerned, as he was, with the arts, fewer still with the well-being, the dignity, and the prosperity of artists themselves.

Reed came to collecting his contemporaries partly out of disgust with having been taken in by a dealer in Old Masters. The dealer has become legendary as "Old Paff," a German, whom Tuckerman described as "an eccentric man." He always, according to legend, "had something new in the old line," and Reed was one of those who fell into his trap, though not for long. Tuckerman tells of Paff's dealings with Reed in an anecdote:

> "Ah, Mr. Reed," said he to one of the most liberal and discriminating of the early friends of American art, in New York, "der is a gem for you, but I don't think I sell it to you. I was cleaning a landscape I bought in auction, and I cleaned one corner a lettle hard and I thought I saw something underneath, and sure enough, someone has stolen an old master in Italy, and painted a landscape over it to prevent detection, and now I have him. I don't know, but I think it is a Correggio. I sell him now for one t'ousan' dollar. But come tomorrow." Well, he came tomorrow and the picture was all cleaned and varnished, with a nice glass in front. "Ah, Mr. Reed, I can't sell him for one t'ousan'; it is a fine Van Dyck, here is the original engraving of it; no doubt about it. I must have five t'ousan' dollar for it."

It is not known how many Old Masters Reed bought before he realized that he was being made a fool of, but, once he caught on, according to the son of one of his artist friends, he "got rid of his acquisitions in much less time than it took to buy them. Abandoning 'Michael Paff, Esq.' he trusted his own tastes and sympathies." It was at an exhibition of the National Academy of Design in 1834 that he found "an art which he could comprehend, consisting of subjects derived from local life, history, and scenery." He bought widely and wisely; he commissioned portraits and landscapes and genre pictures, and, in the case of Cole, he commissioned allegories. He built himself a splendid but not ostentatious house, on the top floor of which was the first private picture gallery in America, and he opened it one day a

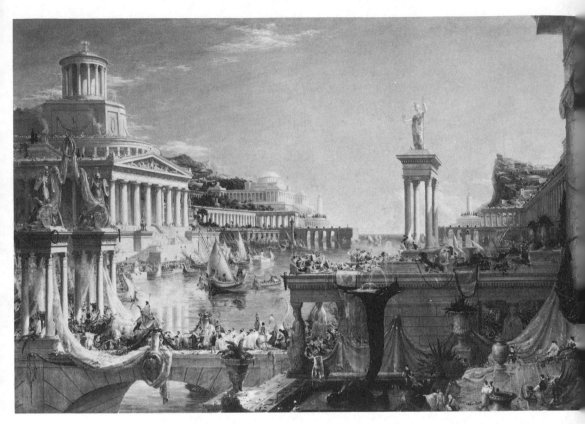

Luman Reed commissioned THOMAS COLE to paint "The Course of Empire," five large pictures of which "Consummation of Empire" (ABOVE) is the center piece and "Desolation" (OPPOSITE) is the final piece, a romantic landscape much to nineteenth-century taste. (*The New-York Historical Society, New York City*)

week to the public. There in the evenings he met with artists such as Cole and Asher Durand and Mount and with such amiable conversationalists as Washington Irving and the poet Bryant and the novelist Cooper. The artists respected his criticism, which was generous but acute; he understood them because they were, like himself, workingmen and not dilettantes, and he looked up to them, as few of his contemporaries did, as superior creatures serving a noble art.

While he was in Europe, Cole had conceived an elaborate scheme to paint a series of large pictures to be called "The Course of Empire," an ambitious program by which, he said, "I may hope to establish a lasting

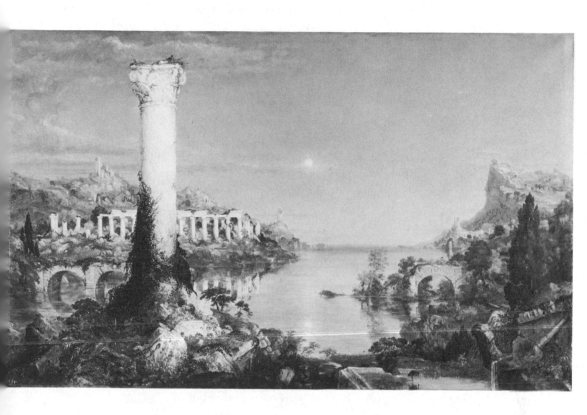

reputation." On September 18, 1833, he wrote to Luman Reed describing his plan: "a favorite subject that I have been cherishing for several years with the faint hope that someday or other I might be able to embody it." Reed was immediately responsive and asked Cole to fill a room in his house with the paintings. "The philosophy of the subject is drawn from a history of the past," Cole explained, "wherein we see how nations have risen from the savage state to that of power and glory, and then fallen and become extinct." The scenes would all be of one location looked at from slightly differing points of view, with "some striking object in each scene—a mountain of peculiar form, for instance. . . . The scene must be composed so as to be picturesque in its wild state, appropriate for cultivation, and the site of a seaport. There must be the sea, a bay, rocks, waterfalls, woods." In other words, it must command all of Cole's skills in the depiction of natural wonders in their wild state, plus his delight in what can only be called overblown and grandiose anecdote. As to the price for such an ambitious undertaking, though he demurred that "it is the subject I am least willing

to encounter," Cole said that since he was afraid "an opportunity may never offer again," he therefore might "forget, in a measure, my pecuniary interests." He offered to paint fifteen pictures of which "The Course of Empire" would be five, and ten small ones, all to fill a single room, for $5,000. Reed agreed with alacrity and Cole went to work.

The series, now with the rest of Luman Reed's collection in the New-York Historical Society, was considered one of the wonders of the age. William Cullen Bryant said that the paintings were "among the most remarkable and characteristic of his work." James Fenimore Cooper went further: "As an artist, I consider Cole one of the very first geniuses of the age. . . . The Course of Empire ought to make the reputation of any man. . . . I know of no painter whose works manifest such high public feelings as those of Cole. . . . It is quite a new thing to see landscape painting raised to a level with the heroic in historical composition." Cooper could scarcely contain himself. "Not only do I consider the Course of Empire the work of the highest genius this country has ever produced, but I esteem it one of the noblest works of art that has ever been wrought," he went on. Then he made the prediction—modest, as it has turned out: "The day will come when, in my judgment, the series will command fifty thousand dollars."

Today "The Course of Empire" seems somewhat less than immortal, somewhat less "noble" than less pretentious canvases by Cole. His genius was for landscape, not for moralizing or storytelling, though his most popular paintings set a romantic philosophizing against a background of romantic, albeit meticulously observed, nature. Another of his series, "The Voyage of Life" (now in the Munson-Williams-Proctor Institute in Utica, New York) consists of four large canvases, showing a gloomy journey from youth to death in something resembling a swan boat. "The Voyage of Life" mesmerized Cole's contemporaries with its literary sort of piety, its flashes of bright scenic detail against a cavern of mystery, and its obvious sincerity.

The most satisfying of Cole's pictures today are those which are most nearly pure landscape, great expanses of earth, in many cases, with tiny figures somewhere in them—a painter at an easel, a woman walking with a child, a few picnickers in a meadow—little accents of color and humanity to counterbalance sometimes tumultuous and stormy nature, sometimes nature cool and placid and gently sunbathed. Occasionally he combined both aspects in a single canvas, as in his splendid painting of the Connecticut River near Northampton called "The Oxbow"; sunlight falls upon the sweep of river as a storm disperses in part of the sky to let the sun come through onto the freshly washed trees and shrubs and meadows. Cole's

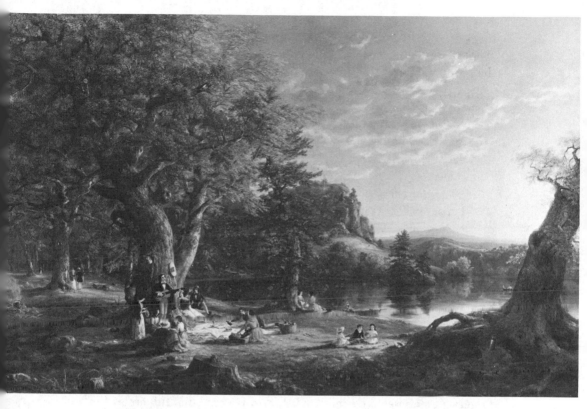

This delightful pastoral scene called "The Pic-Nic" was painted by
THOMAS COLE, "father of American landscape," in 1846 and was ex-
hibited at the National Academy of Design in that year. (*The
Brooklyn Museum*)

concern with the landscape was a passion; it was something not merely to be
looked at but to be explored at length and in detail. He spent days walking
and sketching and making written notes of what he observed; the wilder the
terrain, the more it was to his taste. "I was overwhelmed with an emotion of
the sublime, such as I have rarely felt," he wrote on finding himself in "a
wild mountain gorge called Franconia Notch in New Hampshire." He went
on: "It was not that the jagged precipices were lofty, that the encircling
woods were of the dimmest shade, or that the waters were profoundly deep;
but that over all, rocks, wood, and water, brooded the spirit of repose, and
the silent energy of nature stirred the soul to its inmost depths."

As a young man Cole played a lively part in the artistic life of New
York, such as it was, and along with Morse he was one of the founders of the

National Academy of Design. But as he grew older he also grew to detest the city, and he spent more and more time at his house in the Catskills. It was always a moment of some despair to him when he had to pack up in the autumn and return to New York. He noted in his journal one November:

> In the city although I enjoy the society of my family and of artists, and other persons of taste and refinement, yet my feelings are frequently harrowed by the heartlessness and bad taste of the community, the ignorant criticisms on art and the fulsome eulogisms that so often issue from the press on the vilest productions. I also dislike fashionable parties. I have not either confidence enough or small talk to shine. I escape from them with as much delight as if just liberated from jail.

On another occasion he noted in a letter to a friend: "our critics are strange creatures, half-fledged chickens that twist their necks with a crow, perfectly ludicrous at times." Cole was by no means alone in his scorn of journalistic praise. The *Broadway Journal* in 1845 felt called upon to say, "Infinite harm has been done to Art by the indiscriminate and unmeaning praise which has been bestowed upon all who labor at the easel among us."

A critic whom Cole might have read with respect, Jarves, put his finger on Cole's weakness in *The Art Idea*. He gave him full credit for being the "father of landscape art in America," but he said: "Cole is greater in idea than in action. Yet in the latter he had skill enough to make the reputation of a lesser man; though, like most artists who live in the ideal, he was unequal in his work." He found many of his landscapes "glowing with color, warm, translucent, and harmonious, simple and pure in composition," but Cole's series, like "The Course of Empire," he found "exaggerated in parts in composition, surcharged with action and scenic in effect" but "cold and inharmonious, inclining to extremes of paleness and thinness in color."

Cole was only forty-seven when he died in his house in the Catskills. "Poor Cole!" Mayor Hone noted in his diary. "He struggled against every discouragement to reach the top of the hill, but was not long permitted to enjoy his elevated station." He died, however, leaving a host of followers (if only one pupil, Frederic Edwin Church). As the catalogue of American Painting of the Metropolitan Museum says, "a large number of painters were roaming our hills and vales and forests and meadows looking for picturesque scenery, and landscape painting had become one of the principal concerns of American art."

IN COLE'S FOOTSTEPS

The painters like Cole who roamed the landscape came in time to be called, derisively at first, the Hudson River School. They have also been called the first school of American art-makers that could be described as both native and quite unlike any school or group of artists in Europe—a school, in other words, with a vision and an intention unique to itself. The epithet "Hudson River School" still evokes in many minds images of vast and dreary landscape, over-detailed, overblown, overbearing in scale, the epitome of the conventional and the academic, the antithesis of what landscape became at the hands of the Barbizon School, fashionable here by the 1870s, and at the hands of the later Impressionists. It stood for fussiness and stuffiness, for pictures that seemed to melt into the flock wallpaper of Victorian parlors, yellowed not just with age but with distaste, suitable to an age when gentility meant prissiness. What could be less offensive to the priggish than a landscape? What could be more gentlemanly than to admire—and indeed, purchase—a piece of splendid real estate on canvas? It almost made one landed gentry.

This was not, however, what was in the minds of the artists who painted the landscapes or of the gentlemen who bought them. Painters and patrons alike had learned from Thomas Cole that the American landscape deserved the most intense scrutiny, the most loving and sometimes awe-struck attention, the most modest respect for its grandeur, the distance of its horizons, the height of its peaks, the thunder of its cataracts, and the breadth of its skies. In the course of the first two-thirds of the century, artists had wandered far from the Hudson to the plains of the West and to the Rockies, their canvases (if not necessarily their concepts) growing ever larger and more dramatic. For the most part these artists were quiet men, diligent, and as unspectacular as the landscape they painted was often spectacular. Like the little figures in their landscapes, they seem to be accents in the fore or middle ground of the art of their century, there because composition or anecdote required them, part of the world in which America existed but totally removed from what was going on in that world, as though it was none of art's business, as to them it was not.

"I would sooner look for figs on thistles," Asher B. Durand, who might properly be called the first member of the Hudson River School, wrote in

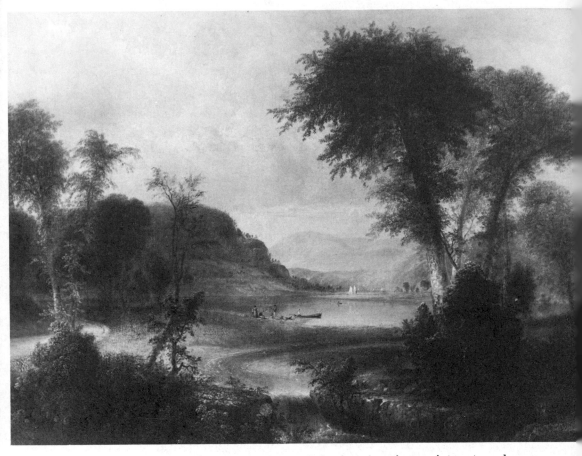

THOMAS DOUGHTY was one of the first American painters to make a career as a landscapist. "In the Catskills" is characteristic of the romantic Hudson River School, of which he was a progenitor. (*Addison Gallery of American Art, Phillips Academy, Andover, Mass.*)

The Crayon, "than for the higher attributes of art from one whose ruling motive is the pursuit of money."

The fact was that whatever had to do with making money, the expansion or aggrandizement or despoiling of an increasingly commercial and industrial nation, was, even as a subject for satire, considered outside the province of art. If the paintings of the Hudson River School seem Arcadian and remote from our times, it is well to remember that in a very real sense they were equally remote from the people who lived in the times in which they were painted.

In many respects Asher Durand typified the ideals and aspirations of

the artists who painted the landscape from the third decade of the century until the time when the nation was a century old in 1875. He was a quiet and kindly man, a diligent worker, thoroughly schooled in the disciplines of his art; he was not, like Cole, of a moody temperament, but moved with ease among his contemporaries, went out of his way to help other artists, got along readily with his patrons, and had a gift for a telling phrase. He believed that art could be achieved only by the most painstaking observation and the complete subjection of the hand to the eye; there was no substitute for accurate drawing. "If you ask me to define conventionalism," he wrote, "I should say that it is the substitution of an easily expressed falsehood for a difficult truth." He wore his hair long and a beard but not a mustache, in a fashion considered suitable to artists in his day. In Charles Loring Elliot's portrait of him, painted when he was sixty-four, there is a half-smile on his generous mouth, and his eyes and slightly raised eyebrows suggest that he is not a man to be easily fooled or flattered—somewhat skeptical, perhaps, but not a skeptic. He was a pious man who found God in the landscape.

Durand made a distinguished reputation as an engraver many years before he was persuaded by his friend, the persuasive Luman Reed, to turn his hand to painting. When he was a small boy living on his family's farm in New Jersey, he had delighted his elders by hammering copper pennies into smooth disks on which with tools of his own devising he engraved images from which he made little prints. In 1812, when he was sixteen, he was apprenticed to a New York engraver named Peter Maverick, whose skills he soon rivaled and surpassed. He became Maverick's partner in 1817, and when John Trumbull was looking for someone to make a large engraving of his painting of "The Declaration of Independence," he selected twenty-four-year-old Durand to do it. The commission broke up Durand's partnership with Maverick, who wanted to join him in the work, a suggestion to which, according to Durand's friend, the painter Daniel Huntington, "Trumbull wisely demurred." It was three years before Durand finished the plate, but once finished it was regarded as something of a miracle and it secured his reputation as the finest engraver in the country.

It was not until 1836 that Durand turned to painting, but so important was engraving to the dissemination of art that the young man was already considered one of the ornaments of New York's artistic community. He had engraved Vanderlyn's "Ariadne," and Greenough so admired the quality that, according to Tuckerman, "he handed the print around in a conclave of foreign artists at a café in Florence, and with difficulty persuaded them of its American origin, so greatly were they all impressed with

its mature skill." He spent his evenings practicing drawing at home or at the old American Academy or, later, in the school of the National Academy of Design, of which he was one of the initiators. He made engravings for parlor books, and he is said to have introduced "the Gods of Olympus to the banks of finance" when he was commissioned to design and engrave banknotes. "You may find the gods and goddesses adapted to the most utilitarian subject," Huntington recalled many years later. "In a common dollar banknote he introduced a beautiful antique figure of Justice holding the scales, and in an illustration of the Erie Canal, Neptune starting the waters of the lakes to the sea. . . ." Before he engraved the "Ariadne" he tried his hand at a nude of his own design which he called "Musidora," but it was a financial failure because, his friend noted, "the taste of the public did not lead in that direction; on the contrary there was a decided prejudice against nude figures." Nudity made decent by such sculptural gadgetry as the chain that bound the wrists of Powers' "Greek Slave" was still some years in the future.

When Reed encouraged Durand to turn painter in 1835, it was not as a landscapist but as a portraitist. Only Doughty and Cole were held in repute because of their landscapes; the movement had still to gain momentum, and Reed commissioned Durand to paint a series of portraits of Presidents and other distinguished political figures. Durand set off to Washington to paint Andrew Jackson and Henry Clay in the early winter of 1835, a time when these distinguished gentlemen were engaged in acrimonious dispute. Jackson turned out to be a reluctant and difficult subject. "For a whole fortnight I have been able to obtain only two sittings of the President," Durand wrote home, and in the same letter he added: "since writing the above I have had another half-sitting . . . ; he smokes, reads, and writes, and attends to other business while I am painting, and the whole time he sits is short of an hour; but all say that I have an excellent likeness. . . . The General has been part of the time in a pretty good humor, but sometimes he gets his 'dander up' and smokes his pipe prodigiously." On other occasions Durand could hear him next door in the cabinet room, swearing at his colleagues and denouncing Clay "in unmeasured terms."

Luman Reed died in the following year, a dreadful shock to Durand and to Cole, who became close friends in their anguish at losing so generous, so affectionate, so encouraging and understanding a patron. "He died," Cole wrote, ". . . after a sickness of five weeks. His mind was clear and calm to the last. In Mr. Reed I have lost a true, a generous, and noble friend." But if he had lost a friend, he gained a disciple. Durand turned his attention primarily to exploring—indeed, dissecting—the landscape with

Luman Reed, of whom his protégé ASHER B. DURAND painted this portrait in the 1830s, was a wholesale grocer who became the most important collector and patron of American art of his day. His collection is now in the New-York Historical Society. (*The New-York Historical Society, New York City*)

an engraver's precision and attention to detail, to atmospheric effects, and to the quieter drama of nature. "Durand seldom attempted scenes of storm or violence," Huntington said of him. "Such were not in his natural vein and one not executed with the hearty spirit of his gentler work." *Hearty* and *gentle* defined him well. When he turned from portraits and figures to landscapes, he said: "I leave the human trunk and take to the trunks of trees."

Unlike Cole, who made written notes and pencil sketches as he tramped through the woods and climbed the high ground, Durand liked to paint directly in the open air details that he might later incorporate in a composi-

tion. When he went to visit Cole in the Catskills the year after Reed died, he asked what paints he should bring with him; Cole replied that "I scarcely know what can be got in bladders" and urged Durand to bring enough for both of them.*

Durand believed in "painting carefully finished studies directly from nature out of doors," as his friend Huntington said. His engraver's training in minute observation of shapes and subtle variations in tone—or "values," as painters call them—carried over to the rendering of trees and leaves and rocks. At first he was seduced by the historical kind of uplifting subjects which Cole so loved and inserted in his landscapes, but he came to realize that this was not for him, that landscape straight was preferable and, indeed, more noble than landscape diluted with alien sentiments. There was religion enough in nature as observed without foisting anecdote on it. "The external appearance of this our dwelling place," he wrote, "apart from its wondrous structure and functions that minister to our well-being, is fraught with lessons of high and holy meaning, only surpassed by the light of Revelation." It was he rather than Cole who established the purity of landscape as a model for the painters we call the Hudson River School. He was a naturalist, not a preacher; a scientist, not a mystic; an explorer, not a philosopher. So for the most part were the men who started from his example and followed their own temperaments into a variety of interpretations of what their eyes showed them.

Like any artist who could afford it or could find a patron to finance his travels, Durand took himself off to Europe, traveling with three other artists: a young engraver, John W. Casilear, who turned landscapist for a time but reverted to his earlier profession; Thomas Rossiter, who became a history painter; and John Frederick Kensett, who became one of America's most distinguished landscapists and most popular art-makers. In England Durand, unlike Cole, was impressed by Constable's refreshing landscapes, and on the Continent, though he found most works by Claude disappointing, he wrote, "I see but two or three of his works which meet my expectations, but to me they are worth the passage across the Atlantic." It was

* It was not until four years later in 1841 that the painter John Rand invented a collapsible tin tube with a screw top to hold paint, a device that was to have a re-markable and far-reaching effect especially on landscape painting. Not only did the tube make paints more portable and relieve the artist of the drudgery of grinding his own colors but, in order to keep the color soft in the tube, paints were made to dry less quickly than those which artists had been used to. Artists therefore found them-selves painting directly, rather than glazing over underpainting, and they laid their colors on with a heavier impasto, a method that led to the techniques used by the Impressionists a few decades later.

their remarkable sense of atmosphere, of the air in which objects in a landscape have their being, that changed his vision. In Holland he was delighted to find streets named for artists. "It is here that masters in the fine arts are duly honored," he wrote. "It makes one feel proud to be one of the fraternity." He had been warned before he went abroad, as Cole had by his friend Bryant, not to get lost in the refinements of European art and landscape, and that "there was danger that the wild freshness of our American forests, lakes, and mountains might lose their hold on his heart." He came home, indeed, to rejoice in his wild landscape and to bask in an atmosphere in which art-makers were regarded with increasing warmth and esteem and in which his personal reputation became as commanding as that of any painter of his time.

The demand for paintings from Durand's easel was, happily for him, greater than his capacity to fill the requests that came to him for his "glorious scenery," as one suppliant put it. Tuckerman complained that "of late years the public have enjoyed comparatively few opportunities of examining a fresh landscape by Durand, for the reason that the works pass at once from his studio to the fortunate owner." Durand was not the only painter thus smiled upon by a public whose sensibilities seem to have awakened by the 1840s. The awakening, to be sure, had not been spontaneous. Art was looked upon benignly as it had never been before, and the principal agency of this cultural uprising was, not surprisingly, a commercial adventure in the promotion of high tastefulness which paid off handsomely both to its promoters and to the artists it promoted.

A NEW KIND OF PATRONAGE

In 1838 a young painter named John Herring set himself up in the art-dealing business on Broadway in New York—a "suitable depot," he called his shop, where artists might show their work and the public might come for edification and, he hoped, to purchase. He named his shop the Apollo Gallery and charged admission of 25 cents and sold catalogues for half that. The public did not respond, so he plunged into a scheme that he had heard was being successfully used for the promotion of painting in Scotland. He started an organization that he named the Apollo Association, to which the public was invited to subscribe for $5 a year. Each member of

the association would receive an engraving of a painting and, more impor-
tant, a lottery ticket that, with luck, might bring him an original, "hand-
painted" work of art. It seemed to artists, to friends of the arts, and to the
general public (or at least to the relatively tiny segment of it which is ever
interested in art) an excellent and high-minded scheme in which everyone
benefited and in which everyone could take satisfaction from sharing in the
promotion of culture. When the Apollo Association changed its name to the
American Art Union in 1844, William Cullen Bryant became its president.
Nothing could have been more promising or raised the hopes of artists
higher than this ingenious device to marry art to the spirit of gambling,
with the odds so arranged that nobody could lose. The Art Union, as it was
generally called, burgeoned. Its agents sold subscriptions not just in the
principal cities of the East but in the hinterland, and they had to work hard
at it. "Our soil does not yield these rich fruits without thorough culture,"
the manager of the Union reported.

In the year in which the Union changed its name, 94 pictures in
addition to the engravings were distributed to lucky winners at the lottery.
Four years later the number had grown to 450, and artists that year were
paid to the tune of $40,907. Certainly the most popular engraving distrib-
uted to its members by the Art Union was Cole's "Youth" from his "Voyage
of Life" series, all four paintings of which were exhibited in the Union's art
gallery. In the year they were shown and were included in the lottery, more
than half a million people came to the gallery to see them, and the number
of subscribers reached 16,000. This kind of interest in the arts would have
been beyond the dreams of old Peale and Colonel Trumbull. Indeed, it had
an uneasy aura of unreality about it even to those art-makers who saw it
happening.

But in 1852 the Art Union went aground and broke apart on the
shoals of professional jealousy. Many artists, especially members of the
Academy, benefited richly from its purchases (the Union in one year bought
about three dozen paintings from the Academy), but others felt slighted
and resented the fact that the work of younger men was given preference
over their own. William Sidney Mount, the most accomplished and most
popular painter of genre scenes in his day, wrote in his journal in 1849, "I
understand that the committee of the Art Union objected to my picture of
the sportsmen at the well because one of the figures supported a moustache.
What a noble committee surely—" The malcontents, supported by the New
York *Herald*, brought suit against the Union as an illegal lottery and won
their case. The Union tried to operate without the enticement of gambling
as a regular picture gallery, but the customers, the presumed new "art-lov-

ers," stayed away. Other art unions were tried in other parts of the country, but none enjoyed the success or the reputation of the American Art Union, and none had the same effect on the proliferation of painting. John Durand, the son of the painter, recorded in his biography of his father that in 1836 the number of artists in America was trifling but by 1851, when the Art Union vanished, "American artists formed a large band." Perhaps more important was a change in what artists set their brushes to; people did not want to win portraits of personages with whom they had no connection, and with relief painters turned to landscape and sentimental anecdote, to illustration and genre and still-life, much of it happily lost now in obscurity.

Something had happened not only to the public reputation of art (the art unions had done a great deal to make it fashionable), but artists had risen in the public esteem to the point where it was possible for William Cullen Bryant to look back at the time when hostesses would "almost as soon have thought of asking a hod-carrier to their entertainments as a painter." Bryant took satisfaction in the respectability to which the profession had grown, and in the visits paid to artists' studios by "distinguished men and elegant women." When Durand had first arrived in New York in 1812, according to Huntington, "he said there was but one store in which the most ordinary print could be found for sale, and a lithograph he saw seemed to him an extraordinary masterpiece of art." By the 1850s Boston boasted half a dozen art emporiums that also sold mirrors and frames, Philadelphia (which had long since lost its standing as the art center of America) had several, and New York was the seat of fervent activity in the arts and the acknowledged center of commerce in paintings and prints, of exhibitions of American work and importations from Europe.

Durand had a hand in these matters. He was a promoter of the International Art Union, which the firm of Goupil, Vibert & Company launched. It was no great success, to be sure, but the firm prospered as dealers. Durand succeeded Morse in the presidency of the National Academy of Design, by which election, Tuckerman wrote, "his brother-artists testified their respect for his character and admiration of his talent." The exhibitions of the Academy were by all odds the most important art shows in America, and young artists were more than eager to have their works displayed there. Durand was on the hanging committee, and, not surprisingly, he was accused of "partiality, favoritism, keeping down young artists [and] hoisting up the Academicians." He was, to be sure, impatient of the young who were in too much of a hurry to make reputations before they had mastered the fundamentals of their art.

When he was eighty-three years old, Durand worked on a painting which he called "A Souvenir of the Adirondacks" and which a friend described as "a sunset in which the softly diffused light, spreading over a placid lake and quiet sky, aptly figures the tranquillity of his closing years." It was his last work. "My hand," he said, "will no longer do what I want it to do." Without the dexterity that enabled him to render with an engraver's precision what he saw, there was for him no art. His was not a style in which a "happy accident" might enliven a canvas; control was the *sine qua non* of his method. Thought inspired by observation, not vision inspired by temperament, conducted this amiable seeker-after-truth through his long career. His most famous painting was a tribute to Cole and to Bryant: two figures standing on a high rock above a waterfall in mountainous landscape, little figures in a big place, called "Kindred Spirits." Unlike most· of his contemporaries and followers in landscape painting, he later eschewed figures and painted only the elements of nature —American nature.

"Go not abroad then in search of material for the exercise of your pencil," he counseled young artists, "while the virgin charms of our native land have claims on your deepest affections. Many are the flowers in our untrodden wilds that have blushed too long unseen, and their original freshness will reward your research with a higher and purer satisfaction, than appertains to the display of the most brilliant exotic." He urged on them "the lone and tranquil lakes embosomed in ancient forests . . . the unshorn mountains . . . the ocean prairies of the West. . . ."

It was good advice, sensible but romantic advice, the very kind of advice that produced a sensible, observant, well-disciplined and romantic Hudson River School of artists.

The peace and quiet that settled gently in even those landscapes which were threatened by storms and towered over by snow-capped peaks had little to do with what America was like and was becoming. One would never guess that cities were creeping over the wooded hills, that factories were exuding their waste into the rivers and their columns of black smoke into the skies. There was not a hint of the threatened strife between the South and the North; even in genre paintings everyone lived happily with everyone else, black with white, merchant with farmer, parents with children. There were no "gaps" of understanding or of generation or of communication to fret the people, or so it appeared. The war might never have happened, so far as the landscape painters were concerned—indeed, so far as nearly all artists were concerned in their work. Neither was the plundering of peoples

This tribute to the painter Thomas Cole and the poet-editor William Cullen Bryant was painted by ASHER B. DURAND in 1849, the year after Cole's death. It is entitled "Kindred Spirits." (*The New York Public Library, Astor, Lenox and Tilden Foundations*)

and resources which followed the war any of the artists' business. The purpose of landscape was to remove men from the squalid facts of their lives and to invite them to contemplate the verities, to lose themselves in wonders of forests and plains and mountains, to substitute for the sound of machinery and hooves on cobbles the imagined rush of the waterfall, the song of a bird, the rumble of thunder, the wind in trees.

There were, needless to say, dozens of art-makers ready and eager to meet the demand for escape from the cities into the comforting countryside. There were many who painted pleasantly whose works have disappeared into attics and museum storerooms, and whose names are found today only in the most conscientious art histories. Others, hardly more than a handful, who were in command of very considerable skill and who were exceedingly famous in their time, are now emerging from obscurity into the light of fashion. The revulsion against their work at the end of the nineteenth century was a natural swing of the pendulum of taste; the public, and especially the art public, had decided again that European painting was a great deal more interesting than the native product, that the work of young men was more vital than that of old academicians, and that there was something better for art to concern itself with than little people (and cows) in big, open spaces. The name "Hudson River School" became once more, as it had originally been, a term of opprobrium, but in a different sense. Originally it was used by a foreign critic to denote a sort of local chauvinism, a provincial view of the world; it came to mean just stuffiness. Now it again is becoming respectable, and we are able to look into those landscapes with much the same kind of pleasure that those who first saw them found there.

Of the painters who followed Durand, only a few speak for the many. There was Cole's only pupil, the spectacularly talented Frederic E. Church. There was George Inness, who started as a follower of Durand and ended a reluctant disciple of Impressionism. There was Worthington Whittredge from Cincinnati, who was recognized as a young man of talent by Nicholas Longworth (Hiram Powers' patron) and was sent off to Europe to study by him and some other local businessmen. He returned to paint not just in the East; some of his most luminous canvases are of the plains and mountains and rivers of the West. There was Martin Johnson Heade, who was not only a landscapist, especially of the edge of the sea, but a passionate naturalist. His landscapes have a kind of arrested violence which is at once calm and threatening, sweet and menacing. He is better known now for his paintings of tropical flowers and hummingbirds, for which he had, he said "an all-absorbing craze." There was Fitz Hugh Lane, who painted meticu-

This spacious but intimate interior, "A Window, House on the Hudson River," was painted by WORTHINGTON WHITTREDGE in 1863. He is better known for his luminous landscapes of Eastern woods and the plains and rivers of the West. (*The New-York Historical Society, New York City*)

lous seascapes inhabited by meticulous schooners. There was Jaspar Francis Cropsey, who made a specialty and a living out of New England's autumn foliage. There was Albert Bierstadt, tremendously popular in his day, a flashy genius from Germany who painted the Rockies with splendid brilliance and drama if not with conscientious accuracy. He was a master at making vast spaces look vast on canvas. His large paintings fetched high

FITZ HUGH LANE is commonly regarded as America's first truly successful marine painter, or, more accurately, the first successful one to specialize in harbors and ships and yachting. This busy scene is New York harbor, probably about 1850. (*Museum of Fine Arts, Boston, M. and M. Karolik Collection*)

MARTIN HEADE, landscapist and naturalist, went in 1863–64 with a friend to Brazil to study hummingbirds. He painted a series of small brilliant pictures of which this "Study of an Orchid" with two hummingbirds is one. (*The New-York Historical Society, New York City*)

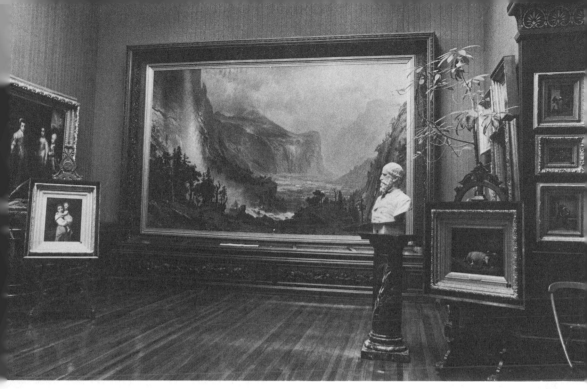

The St. Johnsbury (Vermont) Athenaeum, dominated by ALBERT BIERSTADT'S vast (9½ by 15 feet) ''Domes of the Yosemite,'' is one of the few galleries of the 1870s—and perhaps the only one—which are today just as they have always been. The bust is of the donor, Governor Horace Fairbanks, by JOHN Q. A. WARD. (*Photo Russell Lynes*)

prices and extravagant praise, and his small pictures were often marked with a quiet poetry. There was Thomas Moran, who also found drama in the Rockies, which he painted with considerable panache. But more endearing than any of them to their contemporaries was the quiet New Englander, John Frederick Kensett.

A PROPHET WITH HONOR

"There is hardly a parlor, or a private or public gallery in our city, and I might say in our country, that does not contain one or more of the production of Mr. Kensett's hand." This statement was made at a memorial meeting of the Century Association in New York shortly after John Freder-

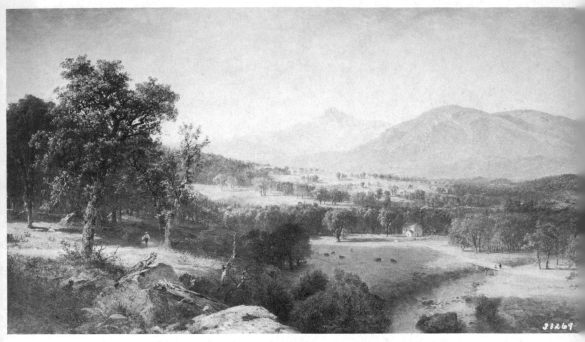

The antithesis of Bierstadt, JOHN FREDERICK KENSETT, was a poet of the placid landscape thoroughly under his control. "Mount Chocorua" was painted in 1864 at the behest of members of the Century Association in New York for the sum of $4,000. (*The Century Association, New York City; Photo Frick Art Reference Library*)

ick Kensett's death in 1872. No member of the Hudson River School provided more placid, more dreamlike, more nostalgic landscapes than the amiable Mr. Kensett. He was a kindly, modest man, not much given to light conversation but an ardent and attentive and encouraging listener. He was generous in his praise, and he gave encouragement lavishly to other artists. He was a diligent—indeed, almost compulsive—worker; he was constantly sketching or converting his literal sketches into paintings of recognizable places. After his seven-year stay in Europe "he returned home to a series of noiseless victories," according to George W. Curtis, writing in "The Easy Chair" in *Harper's Magazine*. "He was a recognized master of landscape, and all his pictures are biographical, for they reveal the fidelity, the tenderness, and the sweet serenity of his nature. Universally beloved, he was always welcome."

Kensett was twenty years younger than Durand, the acknowledged master of the Hudson River School, with whom he had gone to Europe

as a pupil. He was born in Connecticut in 1816, the son of an engraver, and, like Durand's, his first encounter with the arts was in the demanding techniques of the burin on metal. Precision of drawing was a basic element in the work of both men, though as Kensett matured he achieved a sensibility in the use of color, an airiness and atmospheric delicacy that Durand never was capable of equaling. If it can be said that Durand remained always essentially a draftsman, it can also be said that Kensett became essentially a painter.

He had tried to break away from the profession of engraving and pursue his dream of being a landscape painter before he left for Europe, but he had had no success, though one of his landscapes (which a critic found "a very fair production . . . a little too green, however, to be a good representation of nature") was exhibited in 1838 at the National Academy. In England, when he first arrived there, he feasted on the pictures in the National Gallery and other collections, so much richer than anything he could have seen at home, but he had to make his living by engraving banknotes, even after he managed to get to Paris. He studied there at the Ecole Préparation des Beaux Arts with his friend Thomas P. Rossiter and wrote to his uncle in England that they devoted the day "to painting and engraving—the evening until 10 o.c. to drawing [from the antique and life]—French till 12½. . . ." A number of young American painters in Paris were friends of Kensett, and John Vanderlyn, by now in his late sixties, befriended them. He tried to help the young Americans by "the establishment of a small society for copying the works of the best masters," as Kensett described the plan in a letter home. But the old man was working away, in a manner of speaking, on his "Landing of Columbus" for the Capitol in Washington, and, as Kensett said: "He is a gent—whose generosity exceeds the limits of his purse and is consequently seldom in a situation to do much more than give his advice . . . ; it is valuable to us coming from a man who has occupied a distinguished rank at home and abroad."

Kensett's grandmother, who lived in England and whom he had visited, died while he was in Paris, and he went back to England to claim his legacy. It was more difficult than he expected, for he became entangled in legal squabbles with relatives and found himself having to stay on and on. It was while he was there, however, that he began to paint in a manner that freed him from the constraints of the burin. He told Tuckerman, "My real life commenced there, in the study of the stately woods of Windsor, and the famous beeches of Burnham, and the lovely and fascinating landscape that surrounds them." He was free from engraving for good when he left again for Paris in 1845. His travels took him sometimes by diligence, sometimes

Like many other successful (and some unsuccessful) art-makers, JOHN
FREDERICK KENSETT worked in the Tenth Street Studios in New York.
This photograph of him was taken in the 1860s when both critics and
public regarded him as a national ornament. (*Photo Archives of
American Art*)

by river steamer, often on foot with a companion and a sketch pad, to Germany (the banks of the Rhine, he said, were "one succession of picturesque scenes"), to Switzerland, to which he reacted with awe and enthusiasm in the most proper manner of the romantic landscape painter, and into Italy and to Rome, where he settled down in the company of other painters and sculptors in the Caffè Greco to talk the nights away. Kensett left Rome with a friend, the writer George William Curtis, at just about the time that Story, the sculptor, arrived. It was a lovely time to live and work in Rome, but Kensett felt he should get back to New York. He was confident by then that he had something with which to make a reputation.

Indeed, the year before he left Rome he sold eight paintings to the Art Union, and the year after he returned he was elected an associate of the National Academy. He was by then thirty-two and about to embark on a career that never faltered. John Gourlie, who had been the treasurer of the Art Union, noted that "In looking over the Report of the Art Union for 1849 I find a list of his works which were distributed to the members that year. They are as follows, viz: 'Anio—a scene near Subiaco,' 'Passing Shower,' 'A Beech Grove, near Windsor Forest,' 'A Landscape,' 'Environs of Ithaca,' 'Raven Hill, Elizabethtown, N.J.,' 'Trout Stream,' and 'Study from Nature.' " The list of titles somehow bespeaks the man and the public taste for which he was so successfully painting.

When he died in December of 1872 in his studio in New York, the city apparently felt that it had lost one of its most distinguished citizens. On the day of his funeral "delicate women and busy men" braved a snowstorm to have "the last view of his handsome, delicate, and genial face." The Reverend Dr. Bellows, a friend of Kensett, asked the rhetorical question, "When have so many men of mark and worth met over the bier of any man not the representative of political or military station?" And when did the sketches and paintings that an artist left behind ever bring such a fortune to his heirs? His friend Curtis said that "there was no wall in New York so beautiful as that of his old studio," where his work "hung in a solid mass." Seventy years after Kensett died, Homer Saint-Gaudens in his *The American Artist and His Times* was still impressed by the fact "the scenes of the mountains, rivers, and lakes of New England and New York which remained in his studio at the end of his life brought at public auction what was then, or now, the enormous sum of $150,000."

The climate in which the art-makers worked had grown warmer.

SENSATION!

Frederic Edwin Church did more than his share to capture the imagination of the public and impress it with the importance of "art," or what, in any case, they were ready to be convinced was art. Temperamentally, he and Kensett could hardly have been less alike. Church was as flamboyant as Kensett was modest and as spectacular on canvas as Kensett was poetic. He understood showmanship and the principles of P. T. Barnum, the supreme showman of the nineteenth century, who also understood that art could be good box office. (Barnum had advertised at his museum in New York in 1842: "The Great Picture of CHRIST HEALING THE SICK IN THE TEMPLE by Benjamin West, Esq., the Albino Lady; and 500,000 curiosities.") In 1859 Church caused a sensation in New York (and a flurry of disgust in the Caffè Greco in far-off Rome) when he put on exhibition at his studio a painting called "The Heart of the Andes." It was a big picture, about five and a half by ten feet, every minute particle of which was a microscopic examination of tropical vegetation, terrain, clouds, mountains, sky, and intervening atmosphere. Church had set it up in his studio hung with black crepe draperies in a frame that gave the appearance of a window which opened onto an exotic world. He lighted the picture in the otherwise darkened room with gas jets, and set palms about the room to enhance the tropical illusion.

One cannot imagine any picture that could cause such a sensation today. No single object now offered to the public combines such a satisfying sense of moral uplift, entertainment, and cultural involvement, or could be looked upon with such awe for its manual magic as "The Heart of the Andes." Certainly no work of art could elicit the kind of response that it did. Poems were written in its praise and published in newspapers and journals. Pamphlets to guide the observer were printed with the most detailed and windy appraisals of the picture, square inch by square inch. The clergy praised it for its high morality and were gratified to note that it provided "a wholesome antidote to the sensual nakedness of the Greek Slave and the White Captive." It was called "the finest painting ever painted in this country, and one of the best *ever* painted." It was compared to Raphael, and Washington Irving observed that it was "Glorious—magnifi-

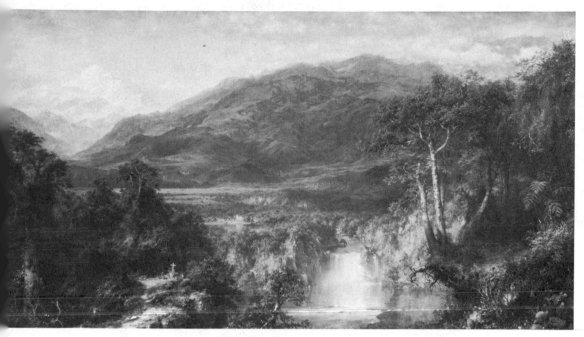

When "The Heart of the Andes" by FREDERIC E. CHURCH was first
exhibited surrounded by tropical plants in New York in 1859, it was
greeted as "the finest painting ever painted in this country and one
of the finest *ever* painted." (*The Metropolitan Museum of Art, Be-
quest of Mrs. David Dows, 1909*)

cent—such grandeur of general effect with such minuteness of detail—
minute without hardness; a painting to stamp the reputation of an artist
at once." After it had been on display for seven weeks in New York, the
crowd on the final day was "so great that many were obliged to turn away
and not see the picture." When the news reached Rome, artists there were
disgusted with what they considered the cheap sensationalism with which
the picture was displayed. Palm leaves brought all the way from the Andes,
indeed!

This was not the first sensation, though it was the greatest, that
Church had achieved before he was thirty-five. His vast painting of Niag-
ara Falls, a subject that had fascinated or repelled landscape painters in
America for a long time, had caused a most uncommon stir. Vanderlyn had
hoped to create a sensation with a Niagara many years before, and Thomas
Cole, before setting out for England, had gone to the Falls looking for
inspiration and found that it had "a horrible appearance." But the Falls
were precisely to Church's taste and suited to his talent. There was talk in

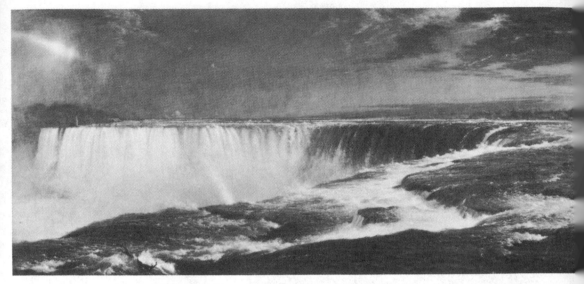

Niagara Falls was painted again and again in the nineteenth century, but never to greater acclaim than by FREDERIC E. CHURCH in 1857. Even the severe John Ruskin was impressed when the picture was exhibited in London that same year. (*The Corcoran Gallery of Art, Washington, D.C.*)

the press about the painting on which he was working even before it was exhibited in a gallery on lower Broadway in New York in 1857, and when it was hung the press reported with characteristic exaggeration that "all New York flocked to see it." Nothing like it had yet come from the brush of an American landscape painter. People could scarcely believe that water could look so wet or that spray could sparkle so convincingly and be mere paint. The picture was reproduced by chromolithography and sold by the thousands at $30 or $20 a print, depending on what sort of "proof" it was. It was also a sensation in London when it was displayed there, and the fearsome John Ruskin, primate of aesthetes, could not believe that the suggestion of rainbow in the falls actually was part of the canvas until he had assured himself that it was not a prismatic effect caused by light through the gallery window. "Niagara" was, a good many people (among them, Europeans) believed, the beginning of a new school of American art, a new vista on the world, a new rival to the greatest paintings of Europe. They did not know that a dead end was painted into this beginning.

The young man who created this sensation was born in 1826 in Hartford, Connecticut, of rich parents. As a youth he wanted to be an inventor, a prospect his family found alarming because inventors usually started as

mechanics and mechanics were certainly far below the social stratum of the Churches. They had hoped young Frederic would become a physician, but when he set his heart on being a painter, his family finally acquiesced and arranged for the famous Thomas Cole to accept him as a pupil; he worked with the master in Catskill for the last four years of Cole's life. Cole was greatly impressed by the young man's prospects and said that he had "the finest eye for drawing in the world." Indeed, he was so impressed that he sent two of Church's landscapes to the National Academy show in 1845 when Church was still only nineteen. The young man was, at first, seduced by the history-cum-landscape formula of Cole's moralistic approach to painting, and it was only after Cole died that Church realized he would have to say what he needed to say through the landscape—not pure and simple but pure and complicated. Church was by far more scientist than preacher.

Church was elected a full member of the National Academy of Design when he was not quite twenty-three. The painting that most impressed the members of the Academy and the public was a view of "West Rock, New Haven," an expanse of meadow and river and, in the middle ground, woods with a hill of rock rising into a sky scattered with glowing clouds. It was the precision of his observation, "the accuracy of a daguerreotype," that most delighted his contemporaries, and each year his reputation as the leader of a new school grew until it seemed firmly established by a composite landscape that is sometimes called "New England Scenery" and sometimes "Scene in the Catskills." It could be named either, for it was most surely both. Church spent his summers drawing in the Catskills and New England, and he created his landscapes out of the forms and flora and fauna that he recorded in his sketches, collections of details and masses rearranged to suit his theories of composition. In the final dispersal sale of the Art Union, this particular picture fetched the astronomical price of $1,300, which even Church thought was more than it was worth. It was, as one historian says, "probably the highest price that had ever been paid for an American landscape painting," but it was little enough compared to the $2,000 that the "Niagara" fetched a few years later or the $10,000 that a New York manufacturer named William T. Blodgett paid for "The Heart of the Andes."

It was in 1853 that Church took off for South America with his friend Cyrus W. Field (the man later responsible for laying the transatlantic cable) and with the dicta of Baron Alexander von Humboldt in his head. Humboldt's book *Kosmos* had been published in 1845, and in it he had dwelt at length on the function of the landscape painter as a scientific discoverer

as well as recorder. It was the perfect admonition to a factualist who believed that the highest art was made out of things explicitly described and rearranged—filtered through the eye and subjected to the hand without passing through the heart or much fussed over by the spirit. "I believe an artist should paint what he sees," Church said, and this simple statement seems to have encompassed his total philosophical considerations about art.

His travels took him to Ecuador and Colombia, where he made his way by mule, by boat, and on foot six hundred miles up the Magdalena River into the Andes, a feast of volcanoes and falls and wild terrain, a hoard of impressions both minute and massive to inspire canvas after canvas when he got home. He made a second trip to South America four years after the first one, and it was from sketches he made this time that he produced one of his most spectacular—indeed, lurid—canvases: the volcano of Cotopaxi pouring forth smoke that a setting sun turns to blood red and orange. He was forty-one before he first ventured to Europe, and he stayed there less than two years. He was less impressed with what he saw in western Europe than in the Holy Land, in Lebanon and Syria, in Greece and Sicily, where the subject matter was more exotic and his discoveries seemed fresher.

At the height of his fame he was crippled by inflammatory rheumatism that afflicted his right hand and, to all intents and purposes, brought his career to an end. He had built a strange and remarkable villa in the Persian manner on a hill overlooking the Hudson River a few miles south of the city of Hudson. Calvert Vaux, Downing's protégé, had helped him with the designs, though the concepts were his own. The house was named by him "Olana," thought to be a variant on the Arabic "Al'ana" meaning "our place on high." Its turrets and minarets, its painted slender columns and patterned roofs, its carefully landscaped acres, accented with ponds and vistas to the Hudson, make it one of the great surviving Victorian mansions in America. It was saved from destruction by energetic preservationists and the state of New York. By a complicated trick of circumstance it is today precisely as it was when Church died in 1900, some years after his fame, once so splendid, had faded to a whisper. He left a house that bespeaks the wealthy traveler who was a naturalist, a collector of curiosities, and an indefatigable observer of anything and everything.

A full century passed between the birth of Thomas Cole, "the father of American landscape," and the death of Frederic Church, who might accurately be called the last of the romantic naturalists. In this time an unreal world made up of an infinite number of realities had covered acres of canvas, had provided escape into drama and poetry and fantasy for three generations of Americans, and had subsided quietly into an obscurity from which it is just beginning to emerge.

8

BIG PEOPLE
IN LITTLE PLACES

"I tell you sir, the business of a few generations of artists in this country, as in all others, is to prepare the way for their successors; for the time will come when the rage for portraits will give way to a higher and purer taste."

HENRY INMAN
to the critic Charles E. Lester

H enry Inman was a kind of bridge between the older generation of face painters and the newer art-makers, who, though they often had to fall back on portraits, made it their primary business to paint the life around them. The big people in little places were often men and women occupying almost an entire canvas for the sake of their vanity; less often it was a new kind of portrait in which the "sitter" stood in a room where one of his intimates might have encountered him, a man at home; a third kind of picture was of people going about their daily business (or relaxation)—a genuine genre picture of a kind not previously taken seriously by art-makers or by the public. Let us look briefly at the art-makers who were primarily concerned with portraits and at somewhat greater length at the new breed who were starting a remarkable new kind of genre which was to become a jaunty feather in the cap of nineteenth-century America.

Inman was born in Utica in 1801 when upstate New York was rough country spotted with log houses whose dooryards were filled with tree

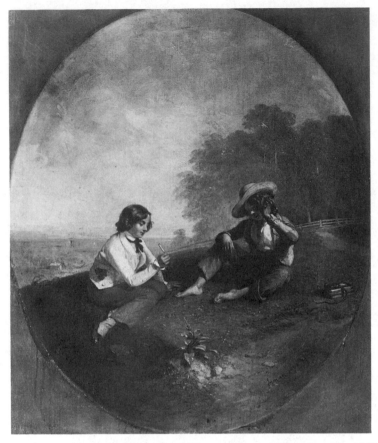

"Mumble the Peg" by HENRY INMAN was painted in 1842, when genre pictures were just beginning to be regarded as worthy of the talents of serious art-makers. (*The Pennsylvania Academy of the Fine Arts, Philadelphia*)

stumps. He was among the first American artists to push the craft in a direction which it successfully pursued to the end of the century, a direction which is popularly (if not necessarily critically) thought to be the best tradition of American graphic accomplishment: illustration. But Inman made his living as a portrait painter; indeed, at the height of his career he made as much as $9,000 a year, a substantial income not exceeded by many businessmen in the 1830s. He could afford, in other words, to experiment, and one of the early genre paintings produced by a professional American art-maker (as opposed to genre scenes painstakingly made by untrained "primitives") was a picture of two rather cherubic boys in a docile land-

scape playing mumbledy-peg. Tuckerman, with characteristic effusiveness, described the picture thus: "the freshness of their looks, like the verdure on which they are stretched, is as the smile of the blest spring that preceded the manhood 'of our discontent,'—gleaming through the long vista of years. . . ."

But portraits were bread and butter, and in the generation following Stuart and Sully, Inman stood among the most sought-after practitioners. He was apprenticed to Jarvis, the charming Bohemian who moved from Philadelphia to New York when it was a cultural backwater, and most of his life, except for a few prosperous years in Philadelphia, was spent in New York. Inman was one of the movers and shakers who started the National Academy with Morse and became its first vice-president. His self-portrait, now in the Pennsylvania Academy of the Fine Arts, shows him in a yellow top hat, a dashing figure with a humorous mouth and rather skeptical eyes. The picture, which is one of his most successful portraits, was done in a few hours to show students how he worked, and it has a vitality infrequently found in portraits painted before the Civil War. He was not, however, as robust as the portrait suggests. He suffered from ill health, and in one of those not infrequent gestures of friendly patronage which marked the early history of our arts, several businessmen commissioned him to do portraits for them in England, hoping that the change in scene and climate would restore his health. He was a great success in London, and one of the men he was commissioned to paint was Lord Codringham, a friend of one of his patrons. Inman, however, got the names confused and asked the Lord Chancellor, whose name was Cottenham, to sit for him. Cottenham demurred, saying that he didn't know the man who wanted his portrait, and, according to tradition, Inman said, "But he knows you and is a most prominent and respectable citizen." The Lord Chancellor finally agreed and posed in full regalia. "The portrait was one of Inman's best," Samuel Isham wrote in one of the earliest (and most readable) histories of American painting, "and great was his disappointment when it was thrown on his hands in spite of the similarity of names."

When Inman died in New York in 1846 he was only forty-five and his fortunes had declined to such a point that the National Academy called a special meeting to amend its constitution so that it might vote funds to save his widow from destitution. The emergency meeting was held in the room where Inman was dying, as the members were one short of a quorum and had to enlist Inman himself to cast a vote.

In some respects Inman's career was pivotal, in others it merely followed the well-established pattern of the face painters. Something, however,

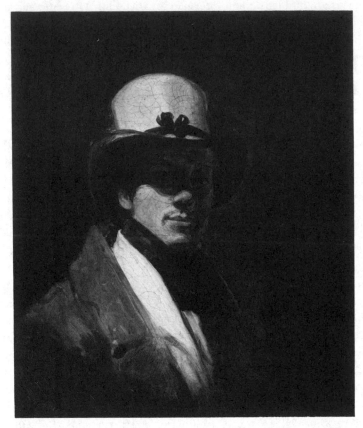

HENRY INMAN, extremely popular with his fellow artists, painted this self-portrait in a yellow top hat in a few hours in the early 1830s as a demonstration in technique for his students. (*The Pennsylvania Academy of the Fine Arts, Philadelphia*)

pervaded the work of his generation of portraitists which was quite different from the style that Stuart and Sully had learned from the fashionable portraitists of London. The work of the older artists retained some of the flamboyance—the billowy draperies and stage-set architectural clichés—urns and columns and distant temples—that seemed to be a part of the stock vocabulary of the eighteenth-century notion of elegant portraiture. Inman and his contemporaries, who learned to paint at home, adopted a more matter-of-fact attitude, a more straightforward, man-to-man, republican stance. They kept their eyes on the sitter and not on his surroundings either real or imagined. The result is a kind of monotony of intellectual tone in picture after picture by painter after painter. They were not, however,

unaccomplished, and a few of them broke away from conventional patterns to achieve portraits that are on the edge of genre—persons in situations rather than just faces emerging from murk. But even among the conventional there were art-makers so characteristically American as to warrant our pausing briefly to meet them.

By the nature of their calling, most portrait painters in Inman's day were itinerants, working from city to city wherever there might be customers, just as Charles Willson Peale had complained to Benjamin West that he had to do before the turn of the century and as Morse had done as a young man. Inman had traveled with Jarvis on such journeys when he was hardly more than a boy, painting the clothes of sitters to go with his master's heads. One of Inman's most accomplished contemporaries, Chester Harding, was not only a deft portraitist but so characteristically American and so of his era that he seems almost to be the prototype of the rags-to-riches legend. He was a giant of a man from the wilderness of western New York, totally uneducated, who after working as a soldier, tavernkeeper, chairmaker, house painter, and sign painter, finally discovered that he had a remarkable talent for getting a likeness. To pursue his career he kept his family continually on the move, looking for sitters in Kentucky, in Cincinnati and St. Louis and towns along the way. When he finally went back to New York State, he was looked upon by his former neighbors as something of a worker of miracles, but his father, in the characteristic manner of even urbane fathers of the day, was displeased with his son's calling. "Chester," he said, "I want to speak to you about your present mode of life. I think it is very little better than swindling to charge forty dollars for one of those effigies. Now I want you to give up this course of living and settle down on a farm and become a respectable man." Instead he went to Massachusetts, and after successes in the western part of the state (especially in Pittsfield and Northampton) he was encouraged in the early 1820s to go to Boston. Gilbert Stuart was then at the height of his power and prestige in Boston, but even so young Harding gave him a considerable run for his money. "How rages the Harding fever?" Stuart is said to have asked.

Harding decided to try his fortunes in England, not as a student but as a full-fledged practitioner, and in 1823 he set out for London. His forthright backwoods charm, his geniality and simplicity of manner, and the expertness of his brush made him immediately popular. He was fortunate to have the Duke of Sussex sit to him, and the success of this portrait inundated him with commissions from fashionable people, in spite of the fact that Sir Thomas Lawrence dominated the portraiture of London. Harding stayed there for three years (he had established his wife and

CHESTER HARDING followed Daniel Boone into the back country of Missouri in about 1819. "He was much astonished at seeing his likeness," Harding wrote many years later. This and a sketch by Harding are said to be the only authentic likenesses of Boone. (*Private collection*)

children at Northampton, Massachusetts, before he left America, but they joined him in 1825), but the combination of an economic depression and the wariness of an American about bringing up his children on foreign soil caused him to return to Boston. There he set up his home and his headquarters, though his commissions kept him traveling to wherever there was business. He is said to have painted more than a thousand portraits in his career, and many prominent political figures sat to him and had their features limned with forthright fidelity if not with great subtlety. He died in 1866 at the age of seventy-four in Boston, having long outlived his younger contemporary Inman.

Inman and Harding were at the top of their profession as much

because of their personal charm as because of their talents, and if they
added little to the progress of art, they did much to advance the cause of the
artist as a respectable member of society. As the century progressed, some
patrons went so far as to invite artists to stay in their houses as guests while
their portraits were in progress, and it was generally conceded that there
was no better way for a man to make the acquaintance of the most promi-
nent citizens than to be a successful portraitist. A story that is told both of
Jarvis and of Charles Loring Elliott, a somewhat later and even more
successful portrait painter, is a case in point. It does not matter to which of
them it should be attached. (Tuckerman confessed he didn't know and
commented, "*Se no vero, è ben trovato.*") An eminent bishop was sitting for
his portrait to, let's say, Elliott and, disapproving of the artist's way of life,
he felt called upon to remonstrate with him. It took several sittings before
the divine could summon his courage to hold forth to the painter, but, as
Tuckerman tells it,

> with what he believed to be consummate tact, gave a personal turn
> to his remarks, began by expressing sympathy, gradually hinted
> at faults, and at last, with a vigilant eye on his companion,
> ventured upon appeals and remonstrances. All the time Elliott
> worked away upon the likeness, giving no sign of annoyance; and
> taking courage, his reverend and venerable sitter wound up his
> discourse with a severe admonition, not without a secret dread of
> the artist's anger. He paused for a reply, doubtful whether he had
> provoked an enemy or won a convert; and confessed afterwards
> that he never felt so utterly insignificant as when the artist with
> the urbane but positive authority of his profession merely said,
> "Turn your head a little to the right, and *shut your mouth.*"

When an art-maker could speak to a bishop in such a manner, the
tables had surely turned from the days when artists were worried about
being considered the equals of merchants and bankers.

There was a host of portrait painters successfully plying their brushes,
and they all stuck close to the fashionable formula that has remained the
formula for official portraits ever since, a figure set against a background of
nothing but paint—a figure, in other words, existing in a void. Among the
prominent there was Francis Alexander, like Harding a farm boy. He was
befriended by Gilbert Stuart, who, he said, told him that he lacked many
things that might be acquired by practice but that he had "*that* which could
not be acquired." Alexander traveled where his fortunes took him. He went

GEORGE P. A. HEALY painted "The Arch of Titus" in 1869 and peopled it with his friends. Under the arch are the poet Longfellow and his daughter Edith. At the right are the landscapist Sanford Gifford, Healy himself, and the sculptor Launt Thompson. (*The Newark Museum*)

The fearsome Mrs. Thomas Goulding posed for CHARLES LORING ELLIOTT in 1858. He had been a pupil of John Trumbull, who told him to take up architecture if he wanted to make a living. Elliott became the most successful portraitist of his day. (*National Academy of Design, New York City. Photo Frick Art Reference Library*)

to Europe when Thomas Cole was there, and they shared lodgings for a time in Rome. He was never happy in America after that and he eventually returned to Italy to live out his life, unable to reconcile himself to the crassness and materialism of America. There were Alvan Fisher and William Jewett and Samuel Lovett Waldo; there was the Irishman Charles Cromwell Ingham, who was especially expert at painting the textures of fabrics and the frills of ladies' dresses, and with endowing his lady sitters with a romantic delicacy. There were John Neagle and George P. A. Healy, who turned out as many as a hundred portraits a year, and, somewhat younger, there was Charles Loring Elliott who, as we have seen, in his day was thought to be (as a writer in *Harper's New Monthly Magazine* said in 1879) "the most important portrait painter of this period of American art." Daniel Huntington, nearly as prolific as Healy, did not confine himself to portraits, but ventured into allegorical excursions called "Mercy's Dream" or "Christiana and Her Children," and into landscape, historical scenes, and illustrations of fiction. The work of this amiable and intelligent man had broad popular appeal, though it is well to remember that popular taste was perhaps at its nadir when he was at his apex. He floated on a sea of sentimentality and gentility and prissiness. There were still others, most notably William Page, a man of curious temperament and uncommon and unconventional talent whom we must set aside for the moment to encounter later. He is too interesting to be lost in a list of this sort, more artist than art-maker.

A NEW BREED OF ART-MAKERS

While the face painters were prospering on the reliable vanity of their contemporaries (though a new gadget, the daguerreotype, introduced to America in 1839, was beginning to take the edge off their monopoly), and while some others were off in pursuit of the landscape, a few other art-makers were intensely interested in what was right under their noses. There exist, for example, two famous interiors by a Boston painter, Henry Sargent—one of a dinner party of men and one of a large and elegant tea party. They were painted about 1820 and are as descriptive of formal entertaining, dress, manners, and the furnishings of Greek Revival interiors as the most meticulous social historian could hope for. There were occa-

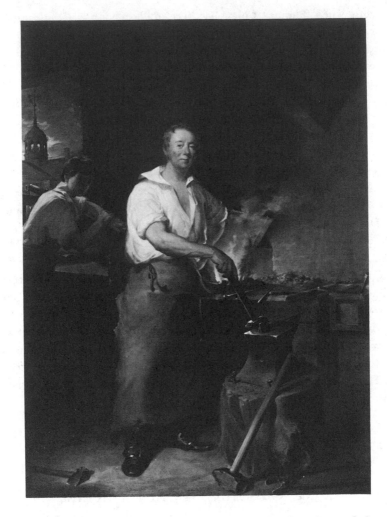

Pat Lyon, a blacksmith imprisoned on false charges, used the money he received as restitution to pay JOHN NEAGLE to paint this spirited portrait in 1826–27. The prison tower can be seen through the window. (*Museum of Fine Arts, Boston, lent by the Boston Athenaeum*)

sional portraits that might almost be called genre, the best known of which is "Pat Lyon at the Forge" by John Neagle, a picture commissioned by a blacksmith falsely arrested on the accusation of a bank. He used the money he finally received as damages to have his picture painted standing at his anvil with his young assistant behind him and a view of the prison in which he had been confined seen through a window. Like the Sargent interiors, it is as much a picture of a way of life as of a person, though it is painted in a rather overblown, eighteenth-century, grand manner.

But the days of serious interest in aristocratic traditions were waning, and a new breed of art-makers had their eyes on the virtues, colors, costumes, pleasures, and everyday diversions of the so-called common man. They were less interested in what a man did to earn a living than in how he relaxed from the long hours he spent at his counting table, or the counter of his store, or in his fields. No one wanted to be reminded of the drudgery of life; it was the comical, the poetic, the entertaining, the anecdotal that took the public fancy, and with very rare exceptions art-makers were primarily concerned with the sale of their wares and with the opportunities to have their paintings engraved for the widest possible distribution.

One of the exceptions, however, was John Quidor, who earned his living painting ornamental pictures on fire engines but made serious attempts at being an artist to please himself. He is not a painter who can be overlooked (though he disappeared for more than a century before he was revived in the early 1940s), but neither does he deserve the extravagant praise lavished on him today by historians and, of course, by dealers. Quidor was a sport, as eccentric as Dr. Rimmer the anatomist-sculptor, and as outside the mainstream of the way the arts were developing in America, but he was by no means Rimmer's intellectual equal or his artistic peer. He delighted especially in illustrating (or perhaps caricaturing is more exact) the stories of Washington Irving. He was a bold draftsman in the mocking tradition of Hogarth, a talented buffoon, a vulgarian who used well-worn romantical tricks of animated landscape and theatrical gestures to produce complex pictures filled with secondary images and meanings that have neither satirical bite nor illustrative subtlety. He is commonly called a genre painter for reasons that are elusive, and he had no followers.

If Quidor was an artistic will-o'-the-wisp without heirs, his slightly younger contemporary William Sidney Mount was a rock on which a tradition was constructed. Quidor was born in 1801 and lived to be eighty; Mount was six years younger, and his quietly brilliant career lasted until he was sixty-one. He was more highly thought of by the public of his day than by the aestheticians and critics, who were rather patronizing of his talents and especially of his preoccupation with the matter-of-fact and the commonplace. Tuckerman referred to him as "the comic painter of American life," surely not an accolade from a man who based his hopes for the future of America's artistic salvation on the "superstructure of the beautiful."

"Most of our artists are obliged to paint portraits that they may live; not so Mount," a journalist in the New York *Mirror* wrote in 1835. "His pictures will, even in a pecuniary point of view, reward him better if confined to domestick, comick, or rural scenes, than if his time and talents were thrown away on muffin-faces, or even in portraying *gentlemen* and

Genre painting and illustrating were pastimes to JOHN QUIDOR, who made his living painting ornamental pictures on fire engines. "The Money Diggers" (1832) is characteristic of his romantic preoccupation with ghouls and spooks. (*The Brooklyn Museum*)

ladies." The journalist reflected the public attitude rather than the highbrow opinion of his day, but he felt called upon to add: "We do not mean by this any disrespect to the human face, or to the art of portrait painting . . . but Mr. Mount has talents if not of a higher order than the portrait painter, at least of a very different description."

Mount was a man with confidence in his talents and a sure sense of the direction in which he wanted to use them. As a boy he was, we are told, rather sickly, "very beautiful from his babyhood and as tenderly nurtured as one of Queen Victoria's children." He was the youngest of three sons of a farmer turned tavernkeeper in the village of Setauket, Long Island, and both his older brothers became sign painters who graduated ultimately to painting portraits as well. Young William learned his craft from his oldest brother, Henry, who plied his brushes in New York and reached a distinction uncommon among sign painters: he was elected an associate member of the National Academy of Design. William was seventeen when he was apprenticed to his brother, and two years later he was one of the first

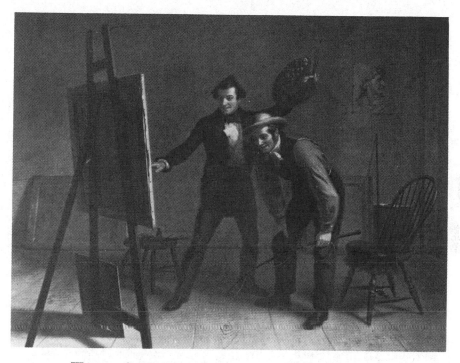

WILLIAM S. MOUNT painted "The Painter's Triumph" in 1838 for E. L. Carey of Philadelphia, the publisher of an annual called *Gift*, a Christmas book. He charged $250 for the picture and $24 for "frame and box." (*The Pennsylvania Academy of the Fine Arts, Philadelphia*)

students to attend the drawing classes instigated by Samuel F. B. Morse at the Academy, which opened that year. His first attempts at serious picture-making were, as one would expect, "history paintings." Only two of them are known, "Saul and the Witch of Endor" and "Christ Raising the Daughter of Jairus," wooden, self-conscious efforts probably better forgotten. He did not stay long in New York. He found it unhealthful and little to his taste, and he commented some years after he had moved to Stony Brook near his birthplace that "the city is the place to stimulate an artist. He is compelled to work,—more dirt, and consequently more color. One can live cheap in New York—the air being thick with villainous smells, two meals a day is quite sufficient."

Mount hit his stride and had his first public success with a picture called "The Rustic Dance After a Sleigh Ride." It caused something of a sensation when exhibited at the National Academy, from which it was bought by a collector. As Asher Durand's son John wrote, the painting

showed "his powers on the humorous side of American rural life . . . the admiration of which by the public established his artistic position." This was in 1830, and four years later Mount and Luman Reed became friends. Reed bought two of Mount's paintings, "Bargaining for a Horse" and "Unruly Boys." As Durand noted, "After this Mount was never without a commission."

The humor of Mount's paintings was by and large gentle, and their subjects were suggestive of narrative rather than actually telling stories. He avoided the moral overtones, the sermons against infidelity, gambling, and overindulgence which permeated the contemporary narrative painting in England with a somewhat mawkish albeit slick piety. He painted, for example, a picture filled with rural detail, with the still-life of the farmyard —tools and baskets and water jugs—the subject of which is two men in top hats about to complete the sale of a horse. It is called "Coming to the Point," and a newspaper of the day described it thus: "This is an image of pure Yankeeism and full of wholesome humor. Both of the yeomen seem to be reckoning, both whittling, both delaying. The horse which is the subject of their crafty equivocations, stands tied as 'sleek as a whistle,' waiting for a change of owners." There is never a hint of disrespect in Mount's humor, and the people he painted, whether they were farmers or children or slaves or hired hands, were treated with dignity. As Flexner has pointed out, there is not a suggestion, as there so frequently is in English and French painting of rural scenes in the nineteenth century, of the artist looking over the fence into the fields at the quaint peasants. Mount's men, women, and children were citizens of a republican nation that was basically a rural nation as well. Mount especially enjoyed painting blacks, and in his journal he gives a detailed formula for the successful rendering of Negro flesh tones. Two of his finest pictures are dominated by blacks: in "Eel-Spearing at Setauket" the figure of a black woman stands at the bow of a skiff while a boy paddles at the stern. The dignity of the figure against the pale, cool land-and-water scape is monumental. In "Music Hath Charms" a black dominates the composition as he leans against the side of a barn near its open door, beyond which a young man is playing a fiddle to two friends.

Mount could be criticized today for treating the Negro as a comic figure, and with justification, but it can also be said that he treats everyone with a similar lighthanded humor, whoever they are, when he wishes to establish a comic mood or to illuminate a comic anecdote. He does not care, in other words, whom he laughs at or, more exactly, smiles at, for the nature of his humor is sly rather than bold. It has been suggested because of his occasional depictions of naughty boys about to be whipped, and because of

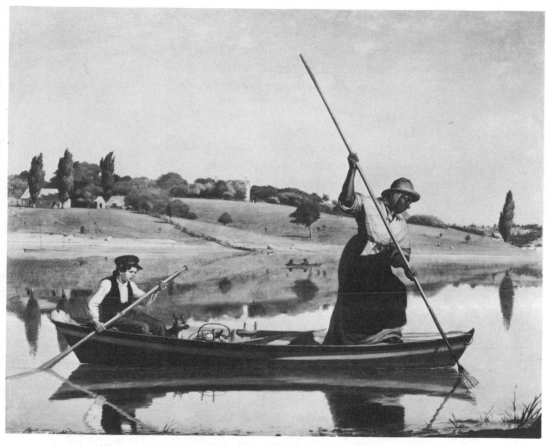

WILLIAM S. MOUNT'S "Eel-Spearing at Setauket" was painted for George W. Strong in 1845. Strong's house is in the distance and his son is in the stern of the boat. The woman with the spear was the last slave owned by the Strongs. (*New York State Historical Association, Cooperstown, N.Y.*)

scenes such as "Ringing the Pig," that there is a strain of sadism in this ostensibly amiable man, but he himself said of his subject matter, "I ran upon the favorable side. It is the sign of a good heart."

No less a figure than Washington Allston was impressed by Mount's genre paintings and suggested that he could do well to study the works of Van Ostade and Jan Steen, Dutch "Little Masters" who were paragons in the depiction of homely scenes; there was not much chance for Mount to see their works in American collections unless, possibly, he were to visit Robert Gilmor in Baltimore, who listed Dutch Little Masters among his prizes.

Gilmor, in fact, was one of Mount's patrons who not only bought one of his pictures from a show at the American Academy but who also commissioned paintings from him. Actually, Mount might have gone to Europe to see such works in profusion had he wanted to, but he preferred to stay at home. In a letter to his friend, the landscape painter and writer, Charles Lanman, he said:

> I have always had a desire to do something before I went abroad. Originality is not confined to one place or one country, which is very consoling to us Yankees. The late Luman Reed of New York, desired me to visit Europe at his expense; Jonathan Sturgis, Esq., has also made me an offer of friendship if I desired to visit Europe; and the firm of Goupil, Vilbert & Company have offered to supply me with ample funds if I would spend one year in Paris and paint them four pictures.

He was not tempted, and he added: "I have plenty of orders, and I am contented to remain awhile longer in our own great country."

What Mount was greatly praised for in his own day and what accounted for the continuous sale of his pictures, both the originals and the engravings and lithographs that were made from them in quantity, was their humor, which evoked, as Virgil Barker put it, "silly verses and boring prose" from his contemporaries. It was Lanman, however, who wrote of Mount: "His productions are stamped with an entirely American character, and so comically conceived that they always cause the beholder to smile, whatever may be his troubles." The humor seems mild to us today and unimportant; the "entirely American character," however, remains because Mount's work is based on the most precise and sensitive observation not only of place and object but of personality. He combined a clarity of eye with a great felicity of execution and an obvious delight in the individual nature of objects, their relations with their surroundings and with the people who used or ignored them but part of whose *mise en scène* they inevitably were.

The results of Mount's labors are implicit in his straightforward aesthetic theory. "I shall endeavour to copy nature as I have tried to do with truth and soberness," he wrote in his journal. "There has been enough written on the grand style of Art, etc., to divert the artist from the true study of natural objects. Forever after let me read the volumes of nature— a lecture always ready and bound by the Almighty." As for advice to young artists, the practical accompanies the moral:

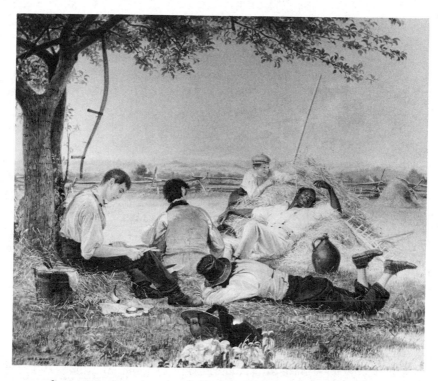

Scenes of relaxation rather than of labor delighted WILLIAM S. MOUNT and his contemporaries. He painted "Farmers Nooning" in 1836 for Jonathan Sturgis of New York, one of the foremost patrons of American art-makers in the mid-century. (*Suffolk Museum at Stony Brook, Long Island*)

Paint in a style different from others as regards size and subject. Paint familiar pictures, comic heads, and groups—or single figures—any kind of picture that will be artistic and true to nature. Follow the bent of your own mind—do not paint to order. Please yourself as to subject. When I painted to please myself I was myself. When one paints to order he sells his birthright.

It is plain what he thought of the face painters who painted only to order and almost only to please their customers. Not many of his contemporary art-maker friends could follow their bent to success. Thomas Cole was one of them, and he and Mount were close friends; Eastman Johnson was another friend whose work had a close affinity with his own. But Mount lived in the country apart from the art colony in the city almost continuously, making trips to New York only when compelled to. He found Long Island

"very attractive" and approved of the fact that "some of the farmers have not been to New York in thirty years." When he did have to go to the city, he preferred to go by boat rather than by "the cars"; these he found "not so pleasant as a vessel with a fair wind," which could make it from Setauket to New York under favorable conditions in six hours. (If the conditions were not favorable, it might take two days.)

Like Morse and Fulton, Mount was an inventor, though his efforts were minor and the results mere gadgets. He devised a studio on wheels which made it possible for him to practice at all seasons and in all kinds of weather his preachments about working directly from nature. ("Paint pictures in private houses," he wrote, "also by the wayside, in Porter saloons, blacksmith shops, shoe shops, wherever character can be found—and not be confined to your *studio*.") It took a pair of horses to draw Mount's studio, and a contemporary of his described it as able to be "turned about from one point of view to another so as to allow the artist, sitting comfortably within, to make, not merely sketches, but the most deliberate and finished studies from nature." Mount had thought of everything for his comfort and efficiency.

> On one side of the room the wall is formed by a large parallelo-
> gram of strong plate-glass, like those used in the sumptuous shops
> in Broadway, but of the most perfect and aëreal transparency,
> and through this the artist has his view of the objects he chooses to
> delineate. Within is every convenience which the painter requires
> —easels, tables, drawers for the paints, and a stove for keeping
> the room warm in cold weather. The ventilation of the room is also
> provided for. By means of the accommodation afforded by this
> studio a winter landscape may be transferred to the canvas, at the
> artist's perfect leisure, when the mercury in Fahrenheit's ther-
> mometer is below zero.

Mount also invented a violin to which he was partial and which he claimed was superior to all other violins because, he said, of its "great simplicity of construction and of increased power and sweetness of tone." He patented it and exhibited it at the Crystal Palace in New York in 1853. He also claimed to have invented a device "to increase the speed of vessels propelled by steam" and a "tin flute whistle" on which he played compositions of his own, including "Babes in the Woods." Like his contemporary Hiram Powers of "Greek Slave" prominence, he was an art-maker with a practical turn of mind. He understood his craft thoroughly and knew how

to render a kind of surface that pleased the customers. He also understood how to select subject matter and delineate it in a manner that not only invited public demand but readily lent itself to the available techniques (engraving and lithography) for mass-producing it. Like Powers, he understood the importance of anecdote, but the two men could not have been further apart in their notions about art. Powers' concern with the ideal was a far cry from Mount's delight in the earthy. Mount and John Rogers, the maker of mass-produced plaster statues of homely scenes for parlor tables, had a great deal in common—a respect for the commonplace that could be raised by intensity of observation and sympathy to the level of art.

Like Rogers and Powers, Mount was a good merchant of his work, and he was a staunch defender of artists against what he regarded as incursions on their rights by dealers and especially by the Art Union. "Art Unions encourage artists to paint poor pictures by buying so many poor ones," he noted in his journal in August 1848. "The Artist is also beat down in his price in almost every case." His only run-in with the Art Union was not the incident already mentioned about the picture that was refused because one of its characters had a mustache. In November of 1848 he wrote in his journal:

> If the committee of the Art Union should ever desire to have one of my pictures they must come to me or give me an order. I shall never take a picture to them again. I painted a picture expressly for the Art Union and one of the Committee saw it and requested me to take it up to the office of the Art Union. . . . I did so. The next morning I called at the office and was told that the Committee did not think proper to vote for so high a priced picture until they had a fuller meeting in about twenty days. I considered it a gentle hint that they did not want my picture, and I removed it from the wall forthwith. . . . I am sorry so many artists allow themselves to be controlled by such a one sided affair as the Art Union. I hope for the sake of art that it will be managed better. I hope the artists will not suffer themselves to be debased by a gang of speculators. . . .

Mount worked slowly and meticulously, dwelling at length on each detail of texture, every nuance of structure of fence and barn and farm house, every idiosyncrasy of costume or object of utility, with the consequence that the body of his work was not large. When he could not finish his genre pictures quickly enough to keep him in the funds he felt he needed, he

fell back on portraits of local Long Islanders at $50 a head. His pictures in 1854, when he was at the top of his career, were bringing $200 for a canvas twenty-five by thirty inches and $50 extra for "a privilege to have them engraved." They were good prices for those days, though Elliott, more in demand than anyone else, was fetching $250 for a portrait. By 1850 Mount said that he had produced in all about a hundred paintings, about half of them portraits, half of them "comic scenes." This made his average about five paintings a year—quite a contrast to the hundred portraits a year said to have been turned out by his contemporary George P. A. Healy. In 1863, five years before the end of his career, he wrote: "I hope never to paint for private individuals or for the Government unless my heart goes with the order, therefore I had rather select the subject to be painted and thoroughly understand it before the work is commenced. To paint simply to make money, I cannot do it. A painter should know his own ability and have regards for his reputation."

His reputation when he was alive was largely a popular one rather than a critical one, though he was admired by his fellow practitioners. Jarves spoke of "the cold purity of his style and thoroughly English tone" and said that "his figures are well designed and expressive." He was compared to the Scottish artist Sir David Wilkie, on whom the critic Roger Fry blames the dreadful downfall of nineteenth-century British painting into pious anecdote, and to George Morland, who peopled his landscapes with figures of farmers and their families. Actually the affinity to neither of these painters is close, not in the nature of observation or subject matter nor temperament. Whatever else Mount was, he was thoroughly republican in his attitude toward his contemporaries, their occupations and diversions, and the places they inhabited and made use of. His paintings are for the most part pleasing rather than impressive. Their surfaces are thin and slick and somewhat monotonous in tone, and he was far more expert in painting the objects on which his eye fell than the atmosphere in which they had their being. There is a romantic touch to his factualism, but it does not detract from a claim which might be made for him, that he was the father of American romantic realism in painting, a style that reached its heights in Homer and Eakins and degenerated to its depths in our own time in the anecdotal cuteness of the *Saturday Evening Post* covers of Norman Rockwell.

A MAN OF "THE WESTERN WATERS"

Except for the precarious activities of the portrait painters who scoured the Western towns for business, art-making in Mount's day was by and large an Eastern Seaboard occupation. Men like Powers escaped from cities like Cincinnati as quickly as possible, partly because they wanted to go where they could expose themselves to the work of more sophisticated artists in order to learn their craft, partly in hope of making a living, and also because artists, at least when they are young, feel the need to be part of a group of like-minded individuals gathered in a center of cultural vitality and experimentation. To landscape painters of the Hudson River persuasion, and especially to Bierstadt and Thomas Moran, the Far West was a romantic expanse of untrammeled and happily terrifying and grandiose nature. To anthropologists like the painter George Catlin, who deserted his wife in Philadelphia because he was fascinated by the appearance on the streets of Indian chieftains and determined to be their immortalizer, the West was a lode of primitive culture to be mined with scientific, albeit romantic, exactitude. To a naturalist like John J. Audubon, it was a wild sanctuary of beasts, as the South was of birds, to be studied with infinite pains and recorded with infinite elegance. But the life of the settlers of the West, or more properly of the Middle West, their everyday activities, their political shenanigans, and their robust diversions were no more considered proper subjects for serious artists than were Mount's "comic scenes." How could one's sights be raised to the ideal and to the higher sentiments with which art was meant to be concerned by subjects that the genteel audience and a good many art-makers considered "low life"?

And yet it was out of this roughneck, backwoods, low life that came the work of one of the most genuinely poetical and yet entirely virile and unsentimental artists of the century. His name was George Caleb Bingham. He was born in Augusta County, Virginia, in 1811, and moved with his family to Kentucky when he was eight. When his father died while young Caleb was still in his teens, he undertook to support his family first as a farmhand and later as a cabinetmaker, a craft which, considering his latent gifts, quite naturally led him to sign painting as well. It is said (and also disputed by some scholars) that his inspiration was the backwoods artist

from upstate New York, Chester Harding, who was on his way to paint a portrait of Daniel Boone. Bingham watched him at work, did his best to emulate him, and decided to devote himself to making a living as an artist. His neighbors in Kentucky were greatly impressed by his talent for a likeness; indeed, he became during the course of his career a popular hero in his own part of the country, but his reputation even in the West died (or, more properly, went dormant) with him. It was Easterners who made ultimate decisions on aesthetic matters, and they buried Bingham for about eighty years under a blanket of patronizing indifference.

As a young man he traveled successfully through the towns on the banks of the Missouri and the Mississippi, painting competent portraits—indeed, quite remarkably accomplished pictures for a young man with no professional training—and his heart became set on being an artist of the first rank. In May 1837 he wrote to his friend James S. Rollins from Natchez: "I have been regularly employed during the winter, at from $40 to $60 per portrait, and flattered myself that I was doing well, not withstanding the exorbitant price of living in this country." He told his friend that he hoped to visit him in Columbia, and if Rollins could arrange to find him subscribers for "a dozen portraits at $25," he would be glad to stay there for six or eight weeks. After that he was determined, he said, to make a trip to the East. "I cannot foresee where my destiny will lead me," he wrote, "it may become my interest to settle in some one of the eastern cities. The greater facilities afforded there for improvement in my profession would be the principal inducement." And he added: "There is no honorable sacrifice which I would not make to attain eminence in the art to which I have devoted myself. . . ."

His determination took him to Philadelphia in 1838, where he had his first exposure to formal instruction; he spent three months studying in the Pennsylvania Academy of the Fine Arts. "In personal appearance," his friend Rollins wrote of him, "Bingham was not a striking figure. Small of stature, five feet eight inches in height, and weighing never more than 150 pounds, of delicate constitution always, there was yet a dynamic quality in the man that distinguished him in any crowd. I think this quality sprang from the fact that he was the very embodiment of moral and physical courage." Politics was almost as important to Bingham as painting; he believed in the political process and was amused by it, liked its rough-and-tumble, enjoyed watching the extravagances of it, and he went back to Missouri to take part in the rip-roaring "Log Cabin and Hard Cider" campaign that got William Henry Harrison elected to the Presidency, and, incidentally, made the log cabin the only kind of architecture in America

ever to have had any political significance. Nowhere was such a campaign more to the local taste, and no one, in all probability, enjoyed it more than Bingham, who lent his talents not only to painting enormous banners but also to haranguing his neighbors.

It was not long, however, before Bingham was back in the East. He set up a studio in Washington (he called it a shanty), hoping to paint portraits of prominent politicians. He did, according to Rollins, seduce old John Quincy Adams into having his features set on canvas. Adams evidently happened into the studio at the base of the Capitol, engaged Bingham in conversation about the Bible, and was greatly impressed by the artist's erudition. "Young man," Adams said, "if you know as much about painting portraits as you do about the Bible, you are an artist and I'll give you a sitting." This seems an unlikely encounter, but Bingham did paint Adams' picture, and the old man is said not to have liked the result.

Portraits were not Bingham's forte. When he visited Philadelphia on his second trip East, he almost surely saw two pictures by John Lewis Krimmel, a German immigrant who, as Flexner says, "created American genre before such subject matter was considered acceptable." The paintings which impressed Bingham (and which had a direct influence not only on his subject matter but on his composition) were "Election Day at the State House" and "Fourth of July in Center Square." They are filled with men and women, with children and animals, and while there is a somewhat static quality to the individual figures, they manage together to give the effect of a good deal going on. Bingham also had a chance in Philadelphia to see work by Mount, who had raised genre to a far higher power than Krimmel achieved; the encounter must not only have given Bingham a sense of the poetry to be revealed in the commonplaces of everyday living, but he must have felt released by it to follow his own bent. In 1844 Bingham went back to Missouri to throw his weight behind Clay's campaign against Polk, a losing battle but one that turned Bingham's hand to painting scenes of the country and people he knew so well and with whom he was in such sympathy.

Bingham had no intention of letting his prowess as an artist go unsung beyond the immediate vicinity in which he lived. When he was first in the East he had sent a picture (now lost), a river scene with figures, to the Apollo Gallery, so that when the Apollo turned into the American Art Union his work was already known to that powerful organization. In one year he sent them five paintings, of which they bought four, and—to his delight but to the dismay of the critics—one of them, "The Jolly Flatboatmen," was engraved and distributed by the thousands. The result was that

suddenly Bingham found himself famous. Indeed, his fame, judging by contemporary critical comment, seems to have rested largely on that one picture. Tuckerman said in his most patronizing manner (usually Tuckerman could find something good to say about anything): "Such representations . . . of border life and history as Bingham made popular, though boasting no special grasp of refinement in execution, fostered a taste for primitive scenes and subjects which accounts for the interest once excited in cities and still prevalent at the West in such pictures as 'The Jolly Flatboatmen.' " A critic writing in the New York *Literary World* was appalled that the Art Union should have selected "The Jolly Flatboatmen" to engrave and distribute to its subscribers, "the very sense of which gives a death blow to all one's preconceived notions of 'HIGH ART.' " He declared with offended sensibilities that the picture was "by no means what a student of art would select as a standard of taste, and it contains no redeeming sentiment of patriotism." He conceded, however, that it would "please a portion of the subscribers whose tastes are yet to be formed." He did not, perhaps out of some sort of diffidence or because he did not frequent such places, mention that the picture was a great favorite to hang over the bars of saloons.

"The Jolly Flatboatmen" is not one of Bingham's most successful paintings, though it has many of the characteristics of his most attractive work. Life on the river as Bingham painted it was never work, it was relaxation. His boatmen dance and drink and play cards, they loll and puff on their pipes, they play their fiddles, and they stare back at the people who stare at them from outside the picture, caught off guard, perhaps, but entirely unabashed. "The Jolly Flatboatmen" is a composition of a dozen or more figures built, as Bingham's pictures so often were, into a pyramid of sorts. It was a favorite device of his and one that, according to a discrediting critic, should have been reserved for grand religious and historical subjects and not demeaned by use in displaying low life and frivolity.

In many respects the earliest of Bingham's river scenes is the simplest and the most poetic—indeed, one of the truly first-rate pictures produced by any American artist in the nineteenth century. It is the "Fur Trappers Descending the Missouri," painted in 1845 and now in the Metropolitan Museum of Art in New York. It is just three figures in a flat dugout boat seen in profile against water as still as glass and a river mist through which the trees of the far shore are dimly revealed. It was originally called "French Trader and Half-breed Son." The trader, in a peaked hat and a loose blouse, holds a paddle in the stern, the son leans across a rifle on a case presumably containing pelts, and the third figure is a small black animal,

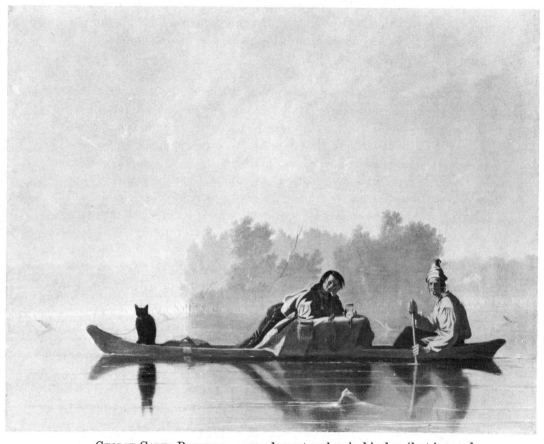

GEORGE CALEB BINGHAM, a popular art-maker in his day (but ignored by critics), painted this version of "Fur Traders Descending the Missouri" about 1845. It is one of the century's great poetic master-pieces. (*The Metropolitan Museum of Art, Morris K. Jesup Fund, 1933*)

possibly a bear, chained in the bow. All three figures look directly at the painter with a mild curiosity which suggests that something on the river-bank has caught their casual attention. This device of "eye to eye" has some quality of the posed photograph, but it also establishes an easy intimacy between the painting and one who looks at it, as though the figures in the picture are saying, "I am as interested in you as you are in me—more or less." It was among the first four pictures that Bingham sold to the Art Union, and he painted a later (and less successful) version that is in the Detroit Institute of Arts.

When Bingham went back to Missouri to engage in politics, he

emerged from the scuffle bruised and battered in spirit. He was nominated for the legislature by the Whigs and won by three votes, or so he thought. His election, however, was contested, and he was forced to yield. In a letter to his friend Rollins he wrote:

> If when you see me again you should not find me that pattern of purity which you have hitherto taken me to be, let the fact that I have been for the last four months full waist deep in Locofocoism plead something in my behalf. An angel could scarcely pass through what I have experienced without being contaminated. God help poor human nature. As soon as I get through with this affair and its consequences, I intend to strip off my clothes and bury them, scour my body all over with sand and water, put on a clean suit, and keep out of the mire of politics forever. . . ."

It was not in Bingham's nature to give up politics, either as a participant or as an observer. His most ambitious paintings, from the point of view of the numbers of figures involved and in the complexity of their compositions, were of politics as practiced by himself, his friends, and his neighbors in Missouri. "Stump-Speaking," "The County Election," and "The Verdict of the People" all were painted in the early 1850s, a time when Bingham was working with the full force of his talent, which, unfortunately, was to fall into a mire of artiness and cuteness soon after. There are dozens of figures in each of these paintings (indeed, there are more than a hundred in "The Verdict of the People"—well-tailored and portly politicians, bored and drunken boatmen, their heads in their hands or thrown back in laughter, attentive farmers, grinning children, and dogs. There are no women in these crowds (a few are looking down from a balcony in "The Verdict of the People"); politics was a man's game, played largely out of doors at crossroads or in the town streets. Each figure is studied with great care, each pose calculated and fitted with precision into the composition, which is tied together by the way the light falls on them in intricate patterns of light and shade, conceived with an expertness, as one critic has put it, worthy of the Venetian masters. No American painter, with the possible exception of Trumbull, handled groups of figures with such authority, and surely Bingham had no rival in Trumbull in handling groups with humanity. His was the new spirit of Jacksonian democracy; Trumbull had separated men into aristocrats and others.

Bingham lost his way as an art-maker when he was about forty-five. Succumbing to a temptation that Mount had had the good sense to resist, he

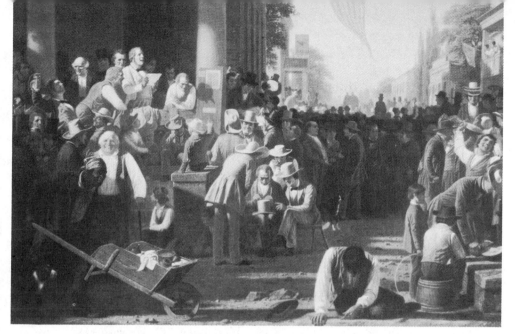

Politics were almost as close to GEORGE CALEB BINGHAM's heart as painting.
"The Verdict of the People" was painted in 1855, when back-country politics
in Missouri were a somewhat riotous business. (*Boatmen's National Bank of
St. Louis*) Like Mount's farmers, BINGHAM's boatmen were always depicted
taking their leisure. "Raftsmen Playing Cards," popular with the public,
elicited from a critic the observation that pyramidal compositions should be
reserved for noble subjects, not used for roughnecks. (*City Art Museum of
St. Louis*)

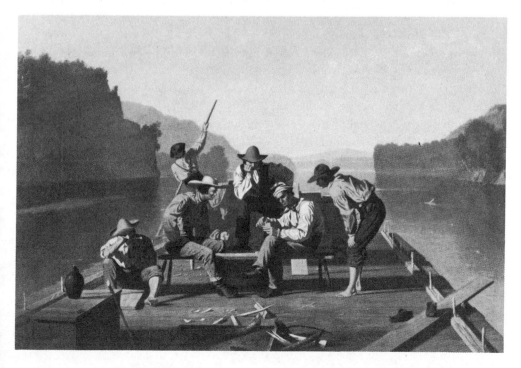

went off to Europe. It did him no good—quite the contrary. It is curious, but nonetheless true, that Bingham painted all of his best pictures in the brief span of a decade. He never committed a better picture than the "Fur Trappers" of 1845, but his work from then until 1856 was a singularly distinguished accomplishment. There were not only the political pictures brimming with vitality and rich in characterization and drama, there were peaceful landscapes, scenes of boatmen on the river filled with a pinky glow and a quiet that somehow tames and at the same time emphasizes the rough-and-ready nature of the characters who people them. There was a splendid picture of "Daniel Boone Escorting a Band of Pioneers into the Western Country," the hero wearing a hat with a rolled brim (he is said to have despised coonskin caps). He carries a rifle over his shoulder; on a white horse beside him sits a madonna-like woman, and with them is a crowd of settlers making their way through a rugged pass with blasted trees to frame their progress and a wild landscape behind them. There were also genre scenes such as "Shooting for the Beef," which differs from most of Bingham's pictures in that most of the characters are concentrating on a distant target and only the beef, his head appearing at the left of the picture, looks out mournfully at the artist.

On August 14, 1856, Bingham set out from Boston on the steamship *Vigo* for France. When he got to Paris and had had a chance to catch his breath, he took himself rather tentatively to the Louvre, whose riches he found confusing and whose lessons in the painting of nature in its "various guises in which she is here portrayed" (as he wrote his friend Rollins) were too much for him. Düsseldorf suited him better. He knew of it, as did all American artists except those most remote from the art centers, as the site of a school of realists whose work had been shown at the Düsseldorf Gallery, a commercial enterprise established in New York in 1849. Düsseldorf was dominated by a school of most exacting academic discipline, and Bingham said of it: "the striking peculiarity of the school which flourishes here by its own inherent vitality is a total disregard of the 'old masters' and a direct resort to nature for the truths which it employs."

Bingham found a large studio near the one occupied by Emanuel Leutze, famous already in the 1850s as the author of one of the most celebrated of all popular paintings in America, "Washington Crossing the Delaware." He felt curiously at home in this alien environment. "Düsseldorf is but a village compared with Paris," he wrote, "or with one of the large American cities, yet I question much if there can be found a city in the world where an artist, who sincerely worships Truth and Nature, can find a more congenial atmosphere, or obtain more ready facilities in the prosecu-

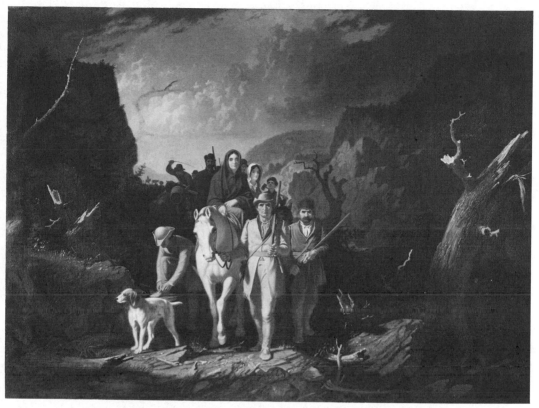

The frontier hero in BINGHAM's "Daniel Boone Escorting a Band of Pioneers into the Western Country" looks quite different from his portrait by Chester Harding, reproduced on page 232. (*Washington University, St. Louis*)

tion of his studies." And later he wrote: "you ask me if I can make a living by my profession here, I can only reply, that if a painter cannot support himself in Düsseldorf, or any large city in Germany or Italy, he has not merit to entitle him to support anywhere. . . ."

But Düsseldorf seems to have been too much for the back-country American art-maker who perceived the poetry of his native environment instinctively and rendered it conscientiously, skillfully, and unself-consciously. When he was in Düsseldorf he painted another version of "The Jolly Flatboatmen"; this time it was theatrical, almost like an operetta, in its manner. It was "artistic" in a way unlike him, and he was never again to recapture the directness of his vision, though he went on painting portraits and occasional genre scenes for the next twenty-two years. He became

increasingly absorbed in politics and was successively the adjutant of the
state guard in Missouri and the state treasurer, neither of which jobs he
liked. He detected the ominous clouds of the Civil War on the horizon
before most of his contemporaries did, and the political shenanigans that he
had once so delighted in came to revolt him.

Popular taste does not sustain an artist's reputation for long, and
when contemporary critical taste does not support what the general public
likes, a painter's work is likely to languish for a little and then drop out of
sight. Bingham and his reputation seem to have disappeared entirely. Jarves
did not think him worthy of a single mention in *The Art Idea*, though he
had no scunner against popular art, as he made clear in his praise for Rog-
ers Groups and his kindly comments on Mount's anecdotal pictures. When
Isham wrote his history of American painting, generally so perceptive, in
1905, he managed only to say: "Few of the other painters of the life of the
time were above mediocrity. Bingham produced rustic scenes in the style of
Mount, and his 'Jolly Flat Boat Men,' engraved by the Art Union, may
still be found hanging in old tavern barrooms; but his skill was not great."
Today, considering what art of Bingham's time was fulsomely praised by
his contemporaries, we cannot but regard such oversights as the blind spots
caused by the prevailing gentility and by the conviction that it was a
primary function of art to be morally uplifting, or, if not uplifting, at least
filled with proper sentiments. It was a time when taste found the sentimental
excursions of Daniel Huntington safe to call "high art," when an "ideal
head" with blind eyes was looked upon with wide eyes, and engravings of
mournful spaniels moved young ladies to tears. The people of the West
liked Bingham because they could recognize themselves portrayed honestly,
without rancor, and with dignity. Easterners were neither impressed nor
amused. It took the East, indeed, about seventy-five years after Bingham
had reached the summit of his reputation to discover in the 1930s that it
had overlooked one of America's most remarkable painters.

A GENTLEMAN OF THE NEW SCHOOL

John Durand, Asher's son and biographer, who at one time espoused the
cause of the English Pre-Raphaelites as editor of a New York art magazine
called *The Crayon*, dated what he called "the decline of the American

School" from the opening of the Düsseldorf Gallery in New York in 1849. It was, he said, "the first appearance among us of foreign art on a large scale," and it opened the door to an unwelcome kind of competition with the local product. Many artists so resented this incursion that they tried to have a protective tariff placed on foreign paintings "by the square foot" rather than on whatever value might be placed on them by dealers or artists. The Düsseldorf Gallery was the brain child of John G. Boker, a native of Düsseldorf and later the Prussian consul to New York. The first show of the meticulously detailed concoctions of the Düsseldorf craftsmen, who had been rigidly trained and had achieved a precise if uninspired skill, was, according to Durand, "a success but not in the way of sales." The public, he said, "were not prepared for it intellectually or financially." Indeed, many of them seem to have been unaware that there was any such place as Düsseldorf, much less that it represented a school of painters; they thought that all of the pictures either were owned by a Mr. Düsseldorf or had been painted by an artist of that name.

But if the public was unprepared, not all of the painters were, and Bingham was by no means the only young American who sought to learn how to paint nature truthfully in that Westphalian town with its somber academy and, as Eastman Johnson said, its acute shortage of pretty women. Richard Catton Woodville was the first of the genre painters from America to turn up there, and he was just past his twentieth birthday. He was the son of a wealthy Baltimore merchant and recently married to the daughter of a well-respected physician. Even as a boy he had been a talented caricaturist, and had spent many hours enchanted by the collection of his father's friend Robert Gilmor; it was not surprising that he should want to go to Europe to sharpen his skills or that he should have chosen Düsseldorf. His work made his contemporaries laugh; it was mildly satirical, highly anecdotal, and somewhat patronizing, and his name was well known to the members of the Art Union, through which a number of his paintings, sent home from Düsseldorf, were distributed and engraved. His best-known works then (as now) were a "Politics in an Oyster House" (two men arguing across a table), "The Sailor's Wedding," as filled with arrested narrative as a movie still, and "War News from Mexico," frantic figures in front of a post office pouring over a newspaper. Woodville's life was a brief one. He deserted his wife in Düsseldorf and eloped with a young woman painter to Paris, where at the age of thirty in 1856 he committed suicide.

The only important American art-maker who appears to have benefited from exposure to Düsseldorf and who rose above it was Eastman Johnson, one of the most successful portraitists of his day and in some

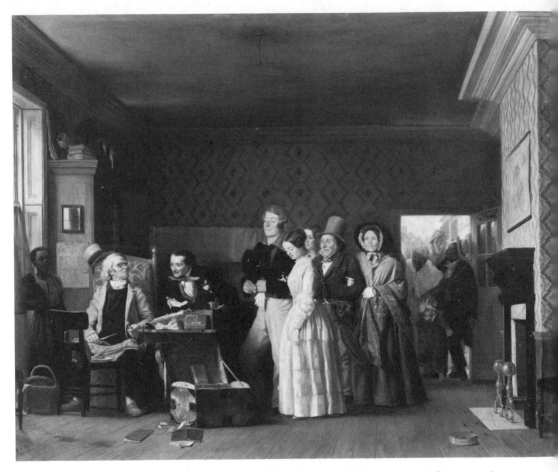

"The Sailor's Wedding" by RICHARD C. WOODVILLE (whose marriage ended in early divorce and his life in early suicide) is as full of implied anecdotes as it is of characters, a situation much to the taste of the 1840s and 1850s. (*The Walters Art Gallery, Baltimore*)

respects superior to both Mount and Bingham as a painter of genre. Anecdotally he was more concerned with atmosphere and far less with situation than Mount, and poetically his eye was somewhat sentimental (though never mawkish), as Bingham's at his height never was. He was not quite a man of the people painting for his peers, like Bingham, but he escaped being patronizing, as Woodville could not or did not want to. Eastman Johnson was a gentleman artist both by birth and by inclination, and in this he realized without effort what many of his predecessors had striven to attain—social standing for the art-makers.

Johnson was a Down Easterner, born in Lovell, Maine, the son of a political leader who came to occupy an important post in the United States Treasury. His father was sufficiently impressed by his son's dexterity with a pencil to apprentice him to a lithographer in Boston when he was only fifteen, which, considering the prominence of his position and the attitude of most fathers toward the artist's life as a suitable calling for their sons, bespoke an uncommon liberality. Young Johnson (his full name was Jonathan Eastman Johnson, and he dropped the Jonathan as a boy) was quickly bored with the lithographer's trade, however, and by the time he was eighteen he had set himself up as a portraitist—not in paint but in crayon and pencil. Partly because of his father's friendship with the prominent citizens of the capital, Eastman had as sitters such eminent persons as Dolly Madison and old John Quincy Adams, ornaments to attract other paying sitters rather than as patrons themselves. When he was twenty-two he went back to Boston, by now very much a young man of the world, likable and easy of manner. He was befriended by Longfellow, who sat to him and was so impressed that he commissioned the young man to make portraits of his family and encouraged friends to sit to him. Boston, however, could not contain Johnson's ambitions to be more than a limner, and he chose the currently fashionable road to Düsseldorf and immersed himself in learning the craft of painting in that rigid school.

If Johnson was serious of purpose, he most assuredly was not solemn of temperament. He found Düsseldorf a dreary town but a good place to work. "I am painting away with men companions, and very diligently trying to get the hang of it which I find, I assure you, no easy matter," he wrote to one of his old friends at home. He seemed to be getting the hang of it with unusual alacrity. He felt sufficiently proficient to send several paintings to the Art Union when he had been in Düsseldorf less than two years, and in 1851 he had two others ready to send, "an Italian girl and a monk," he said, "very bad."

He worked in Emanuel Leutze's studio, where life was by no means dull. "Our studio is a large hall where six of us paint with convenience," he wrote,

> three on large pictures. The chief is Leutze's of "Washington Crossing the Delaware," twenty feet by sixteen, figures size of life. It is already perhaps two-thirds finished, and I am making a copy in a reduced scale from which an engraving is to be made. It is sold to the International Art Union of New York and will be exhibited through the states in the fall.

No stuffed shirt, Leutze was "an energetic, talkative fellow, generous and full of spirits," according to Johnson, and though the work went on methodically, there was always a supply of beer stored behind the "Washington" and a "disposition to be jolly." And evidently to be as noisy as possible, too. "To give more tone to the place," Johnson explained,

> three cannon were recently brought and a battery constructed with the stars and stripes waving on one side and the black and white of Prussia on the other. Nothing could exceed the enjoyment produced by the sound of the entire battery, so that almost everyone that enters is received with three guns, and accordingly up to the present there has been a pretty uninterrupted cannonade. The fun has been increased by shooting with bullets also, and the walls are fearfully scarred with the continued bombardment.

Two years of Düsseldorf were enough for Johnson. There were techniques to be learned in Paris, and he studied there with the eminent Couture and learned something of his slick handling of paint. He then went on to The Hague, where he not only soaked his vision in the Dutch masters of genre (Vermeer and de Hooch and the homelier and rowdier Jan Steen and Brouwer) and the chiaroscuro of Rembrandt, but he painted portraits so successfully that he was invited to become court painter to the royal family. He had the sense to come home. This was in 1855.

His reputation as a painter of the American scene was established with a picture at first called by him "Negro Life in the South" but which later became famous as "Old Kentucky Home." It is difficult in looking at such pictures as this one today to remember with what care they were read by the art-lovers and even the casual observers of the mid-century. Every detail had its narrative significance, and its "phrases" were loaded with message and moral overtones. If the painter had not always intended them, the critics were sure to ferret them out, sometimes ascribing meanings to a picture which, one suspects, the artists had never dreamed of. "Old Kentucky Home" is a backyard scene containing ten Negro figures variously occupied in courting, playing the banjo, and just looking on. A woman plays with her little boy, who is dancing; another little boy, clasping the string of a homemade toy cart, listens to the banjo; a rooster crows on the broken lean-to roof, and a cat climbs through the broken glass of a window of the dilapidated dwelling. Behind the dwelling is a glimpse of the elegant house of the owner of these slaves, the sun shining on it in contrast to the shadow in which the figures are deployed somewhat loosely but obviously

EASTMAN JOHNSON painted "Old Kentucky Home" in 1859. "Here we see the 'good old days,' " a critic wrote after the Civil War, "before the 'peculiar institution' was overturned. . . . The very details of the subject are prophetical." (*The New-York Historical Society, New York City*)

placed by the artist with great compositional care. At the extreme right of the painting a lavishly dressed young white woman appears through the courtyard door and looks upon the scene.

Tuckerman, whose *Book of the Artists* was published after the Civil War, quotes "a critic" of "Old Kentucky Home" who wrote in a manner that was characteristic of the time and unthinkable on several counts today.

> But the picture is now interesting in another respect. Here we see the "good old times" before the "peculiar institution" was overturned—time that will never again return. The very details

of the subject are prophetical. How fitly do the dilapidated and decaying negro quarters typify the approaching destruction of the "system" that they serve to illustrate! And, in the picture before us, we have an illustration also of the "rose-water" side of the institution. Here all is fun and freedom. We behold the very reality that the enthusiastic devotees of slavery have so often painted with high-sounding words. And yet this dilapidation, unheeded and unchecked, tells us that the end is near.

The prophecy has been fulfilled. No more does the tuneful banjo resound in that deserted yard; no more do babies dance or lovers woo; no more does the mistress enjoy the sport of the slave, but scowls through the darkened blind at the tramping "boys in blue." The banjo is silent; its master sleeps in the trench at Petersburg. The lover has borne the "banner of fire" through hard-fought battles, and now is master of the soil.

It seems unlikely that Johnson would not have been surprised that anyone could read such prophecy into what he probably intended as an uneditorial statement of fact. Whatever virtues the picture has (and it has many of observation and tone and handling of the brush and sound drawing), it betrays no emotion and no identification with the figures or the place beyond reportorial ones. It is a charming picture without bite of any sort.

As a genre painter, Johnson, indeed, never seems much involved with his subject matter; he stands outside it, somewhat amused, occasionally somewhat sentimental, using it as a backboard off which to bounce his serious visual purpose. One cannot but feel that subject matter was always a secondary consideration—never the source of inspiration, as it seems to have been with both Mount and Bingham. It was, in other words, an excuse to him, as it had been to Vermeer and de Hooch and Terborch, for making pictures, not for making comment. It was the way light played on people and objects that concerned him, not the people or the still-life, and in this sense he was closer to the Impressionists in attitude if not in technique than he was to either the realism of the Düsseldorf School or the realism epitomized in France by Courbet.

Johnson painted genre pictures for twenty-five years. He traveled in the Midwest searching for Indians to put on canvas; he painted a series of pictures of maple-sugaring in New England and scenes of corn-husking and cranberry-picking on Nantucket, where he spent his summers for many years. His sketches in oil have a brilliant immediacy that is almost always lost in his final versions, a sureness of hand and a grasp of light that are

EASTMAN JOHNSON delighted in painting his neighbors and friends in the fields near his house on Nantucket Island, where he spent many summers. "In the Fields" was painted there in the 1870s. (*The Detroit Institute of Arts*)

obscured by a final smoothness of rendering, which, if he had belonged to the next generation of painters, he would not have felt it necessary to belabor. But breadth of handling was not fashionable in America when Johnson was at the peak of his fame. Indeed, his public measured the worth of any painting almost as much by the slickness of its surface as by its sentiment or humor or morality.

As with so many of his contemporaries, it was portraiture that occupied a good portion of his time and provided the mainstay of his livelihood. Shortly after his return from Europe he went to Cincinnati, a likely market for his skills. "He was often out of pocket," a historian of the city recalled, "but in spite of this fact he was unwilling to work at a price he considered unworthy of his art." His price, $75, was high for the 1850s, but a later historian says that he swapped a portrait of "a person with little money" for a comfortable chair in the possession of his sitter.

When Johnson finally gave up genre entirely to devote himself to

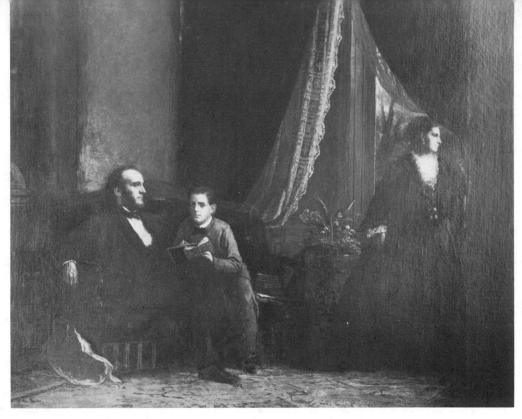

Family portraits were a not uncommon part of EASTMAN JOHNSON'S repertoire. This portrait of Joseph M. Warren of Troy, N.Y., with his wife Adelaide and son Stephen was painted in 1874 in the room photographed below. (ABOVE: *Photo Shelburne Museum, Shelburne, Vt.* BELOW: *Webb Gallery of American Art, Shelburne Museum.*)

portraiture, a course he followed during the last twenty years of his life, his prices had reached a luxuriance that obscured those of other portraitists. His nephew, Rear Admiral Alfred W. Johnson, who said that as a young man he had "once posed for John D. Rockefeller's pants and one of Vanderbilt's arms," noted that he believed that the highest price his uncle had got for a painting was $10,000 for a family group. It seems likely that this was for the group portrait of the Hatch family, all fifteen of them, distributed with a somewhat studied casualness about a richly upholstered parlor decorated in the Eastlake manner. It is a painting of great charm and a document to delight the historians of taste. For a full-length portrait Johnson was paid as much as $5,000 and for a head and shoulders $1,500. Gilbert Stuart and Samuel Morse would have been appalled by such inflation of both money and the egos of sitters and astonished by the wealth that it was possible for a businessman to amass in the last decades of the century and by the lavishness with which he spent it.

The Civil War came and went almost unnoticed, or at any rate almost unrecorded, by most genre painters who lived through it; it did not fit the comic talent of Mount or the backwoods poetry of Bingham, and it touched, at least on canvas, only the more sentimental side of Johnson's character. He followed the Union army for a while and painted a picture of a drummer boy wounded at Antietam riding aloft on the shoulder of an infantryman; it has the qualities of a recruiting poster and was widely distributed, enhancing Johnson's fame with his contemporaries if doing little for his permanent reputation as an artist. It was not his only notice of the war; there was also, as Tuckerman noted, a "more pathetic, but equally true to life and nature" painting of a wounded but convalescent soldier dictating a letter to a young woman who sits beside his cot, which is placed under a tree. "The picture," Tuckerman says, "described the sunnier side of the soldier's life, but it may be the one we most love to remember."

Johnson lived to be nearly eighty-two and the span of his life brought him from the days when Trumbull and Morse were battling over the Academy, when Gilbert Stuart was fading from the Boston scene and Thomas Sully's star was at its zenith, and when Greenough was a frantic young man in Rome, to the arrival of the Ashcan School of painters which so disturbed after 1900 the sensibilities of the by then aged Victorians. America had turned from a nation of farmers and shopkeepers into a roaring industrial complex, its frontiers tied together with steel rails, its slums thick with factory smoke, its rich living in palaces that would have given pause to Renaissance princes, its middle class already deserting the cities for tidy suburbs with wide lawns and flowering trees. A desire for art of some sort had spread beyond the parlors of the rich to the houses of farmers and even

to the log cabins of the frontiers. The firm of Currier & Ives stated a fact when they advertised that "Pictures have become a necessity"; household manuals gave advice on what "chromos" (including Johnson's "Barefoot Boy") could be bought for $5 apiece, and recommended the little statuary groups by John Rogers which were sold by mail. *Godey's Lady's Book* printed instructions on how to build villas and cottages of the kind that Downing recommended; monthly literary magazines like *Harper's* were illustrated with engravings and devoted column after column of small type to discussions of the rise of the arts in America. News magazines like *Harper's Weekly* and *Leslie's* reproduced paintings and sculpture in engravings and used promising young draftsmen, including Winslow Homer, to report on the Civil War. Museums—not just in New York and Boston, whose great galleries were founded in the early 1870s, but in the cities of the Midwest—were appearing at a rate not unlike the mushrooming of culture centers today—with just about as much art to put in them, in most cases, or as little. America had become taste-conscious, and tastemaking was big business.

Through all these changes Johnson remained a nineteenth-century gentleman, a small rotund man with luxuriant whiskers, not aloof but always somewhat detached, kindly, humorous, an easy and generous friend.

On April 6, 1906, a New York newspaper reported: "Last evening Mr. Johnson got up from his dinner table saying he would go to the library for a smoke. As he was filling his pipe, he fell back in his chair, dead."

Something a little too friendly, too eager to please, too willing not to ruffle the surface, restrained Johnson's hand. He was extremely gifted, with an eye that detected subtleties and a hand that could render them; he saw, indeed, more than he cared to put down, or if he put it down in his sketches, as he often did, he had to temper it in his final works. There is little evidence of his awareness of the changing nature of America or of the problems that industrialism brought with it; if he was aware of them, he did not think they were suitable subject matter for his art. In an article published in *Scribner's Magazine* in the year he died, a critic said in praise of him, "his conception of the rendering of 'the life of the poor,' of 'the tillers of the soil' . . . preaches no ugly gospel of discontent, as does so much of the contemporary French and Flemish art of this genre." It would be easy to blame Johnson for not coming to grips with the realities of the characters that peopled his pictures, but he was not a preacher. He was an art-maker whose business was to observe and to interpret the visual world, not to probe it or to reveal its discontent. He was neither philosopher nor reformer. He was a pleasant man who liked to please. With a little more passion and a little less detachment he might have been an artist of the first rank.

9

CONVENTION AND INVENTION

"It has been represented to me that America was not ready for the fine arts, but I think they are mistaken. There is no place in the world where they are more needed, or where they should be more encouraged"

RICHARD MORRIS HUNT
in a letter to his mother, 1855

The number and variety of kinds of architecture that slid by the eyes of painters from Mount's young manhood to Eastman Johnson's declining years was, and was meant to be, dazzling to the imagination. When Mount was a boy the Greek Revival was fashionable both for the houses that rimmed Washington Square so tidily in New York and lined the streets of Baltimore and Philadelphia and for the houses with majestic columns and spreading rural lawns as far south as New Orleans and as far west as Cincinnati. He saw, though he did not bother to record it, the arrival of Mr. Downing's Gothic cottages and the rising spire of Upjohn's Trinity Church, and he exhibited his patented violin in a brand-new kind of architecture: an iron-framed glass building—the Crystal Palace, which was built in 1853 where Bryant Park now spreads behind the New York Public Library, a monument to a later and more classical notion of architectual suitability. The painters, both those who depicted the landscape with such scrupulous brushes and those who painted intimate daily life, paid astonishingly little attention to what the architects were up to. Thomas Cole was not above painting the portrait of a columned villa tucked into a romantic

landscape, and prints of Currier & Ives sometimes paid the compliment of recognition to Gothic and Tuscan villas, but by and large the arts of painting and of architecture led separate and mutually uninterested lives. If they had anything in common, it was on the lowest levels, not the highest. The families that hung sentimental pictures on their parlor walls lived in houses that were, if they could afford them, as insubstantial and frilly as lace-paper valentines. By the time Eastman Johnson had more or less retired entirely into the safe and profitable practice of portrait painting, architecture and decoration had spanned several millennia of styles (from Egyptian to Napoleon III) and had settled into what we now call Late Victorian but which then was known to its enthusiasts by the name of an English writer on taste, Charles Eastlake. One of Johnson's late great pictures, as we have seen, is of the Hatch family scattered carefully about a rich "Eastlake" interior.

Downing, who so firmly believed in the civilizing powers of architecture and the spiritual values of the disciplined landscape, had he survived the fire and waters of the Hudson would have been appalled at what followed his gentle preachments. He believed in "taste" and its ability to improve men's character, but he apparently had no conception of how quickly "good" taste can be degraded or how voraciously any kind of taste in America could get used up then, as it does now. His admonitions against temples and their "dishonesty" as dwellings for Americans had no sooner had their effect in bringing the downfall, almost Samson-like, of the pillars, than a new fashion came to replace the peaceable Gothic and Tuscan and Switz villas that he had advocated as suitable to the American countryman and as refining in their influence. Downing died nine years before the holocaust of the Civil War destroyed the economy of the South and much of the morale of the North and let loose a free-wheeling, dog-eat-dog exploitation of people and places which, despite everything it destroyed, created almost overnight an industrial nation. Along with exploitation came railroads and factory towns, steel mills and suburbs, bloody strikes and thunderous preachers, and more untaxed millionaires than anyone could keep track of. (A member of the Astor family is said to have observed that "a man who has a million dollars is almost as well off as if he were rich." The problem was to keep the million; large failures came as fast as small fortunes.) Private style in this era was, as style is likely to be in any era except those most economically depressed, a matter of show, not of aesthetic consideration, and it was in the direction of the gaudy rather than of the restrained that architecture took off. This was the age that prompted Veblen to his theories on "conspicuous consumption," and no wonder.

There were, to be sure, architects who worked conscientiously as custodians and guides of the public taste and who tried not to lose themselves in the extravagances that were let loose on the public by the plan books available to carpenters and even modest home builders. Calvert Vaux, Downing's protégé, argued that only education of the public through the press could assure restrained taste, and his own articles were filled with temperate advice on the kinds of structures that were suitable to the American family. But the public example was too florid not to encourage private extravagance. If the aesthetically sensitive members of the National Academy of Design thought it was suitable in 1865 to build a version of the Doge's Palace in the Venetian Gothic style as a headquarters, what layman would think twice about the suitability of a modest little palace for himself if he could afford it?

Venetian Gothic did not become fashionable in America until after the Civil War, though England had earlier listened to John Ruskin, its pious prophet of the Middle Ages, and taken his *The Stones of Venice* to heart. But other styles just as unlikely had preoccupied American architects and speculative builders, and none more extensively than the Italianate, which had first appeared in the Tuscan villas that Downing so admired and Davis and Upjohn designed with such elegant restraint. It became the standard for dwellings and many business buildings in the 1850s and '60s wherever cities were growing on their grids. A walk down any one of thousands of blocks in New York today takes one past Italianate houses in rows—houses that seem to be made of gelled brown gravy with heavy cornices held up by scrolls, with windows set in ornamented stone frames, and with steps whose banisters are supported by wrought-iron fantasies, leading to high stoops and doorways with rounded arches. Italianate villas also became the mansions of leading citizens, not only in large cities but in small ones and in suburbs, sitting on lawns surrounded by balustraded fences ornamented with urns. Square towers rose high about such houses to announce the presence of important personages; the porches were supported by Ionic columns; the balconies outside the arched bedroom windows sat on scrolls; and the structures were often capped with shallow roofs that caught and held the snows of New England and upstate New York, where some of the most splendid of them were built.

By no means all grand citizens were satisfied with such dignity and conventionality. There were also marvels of eccentricity, of confusion, of taste gone frivolous or, perhaps one should say, experimental. P. T. Barnum, a showman without peer, hoping to rival the piquancy of the Prince Regent's "folly" at Brighton, England, built in Hartford, Connect-

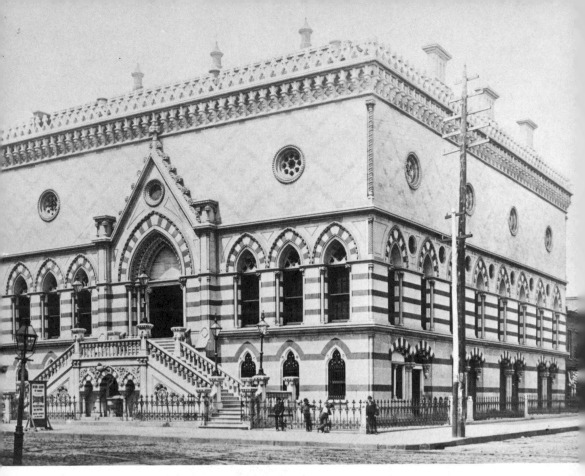

Venetian Gothic of just the sort John Ruskin so admired first appeared in New York with the construction of the National Academy of Design's new building by PETER BONNET WIGHT in 1863. It has since been demolished. (*Museum of the City of New York, J. Clarence Davies Collection*)

icut, a confection suitable to a maharajah and called it Iranistan. It was as exotic as any house built in America in a century that treasured the exotic and the picturesque, though it had its worthy competitors. Haller Nutt, who improved his family's fortune by improving on Whitney's cotton gin, built an octagon in Natchez topped by an onion dome and hung with balconies; the outbreak of the war prevented his finishing it. It is still there, charming and eccentric, set about with moss-hung trees for the curious to inspect. So is the so-called Wedding Cake House in Kennebunk, Maine, an eighteenth-century brick dwelling over which someone (no one knows who) put a pinnacled and frilly Gothic slipcover of painted white wood to make a kind of enchantment that remains enchanting. There were Byzantine villas and Egyptians bastions (the old Tombs prison in New York, for

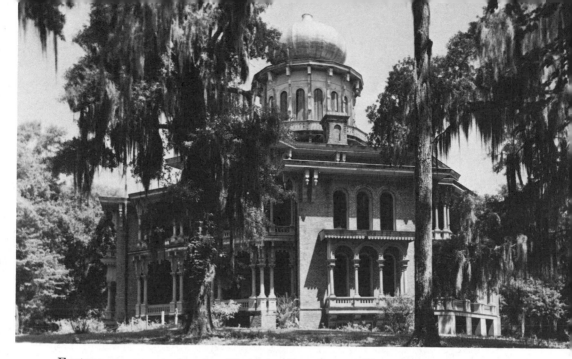

Fantasy was commonplace in mid-nineteenth-century architecture, but there was nothing commonplace about Longwood in Natchez, Miss. Never completed because of the Civil War, this house is still standing. (*Photo Wayne Andrews*)

The frilly Gothic ornament on the Wedding Cake House in Kennebunk, Me., was probably applied to its simple structure in about 1850, or half a century after it was built. (*Photo Russell Lynes*)

example) and state capitol buildings and plantation houses whose crene-
lated towers might reasonably have dominated Italian hill towns in the
twelfth century.

The confusion of styles was accompanied by a confusion of structural
practices. Downing had preached the doctrine of the honest use of materials
—a wooden house should look like a wooden house, for example, and not be
stuccoed and painted to look as though it were made of stone, but it was
more important to most builders and their clients to get a maximum of
dandyism applied to their buildings, as many architectural ribbons and
bows and feathers and laces as possible, than to build them, as the builders
of the seventeenth and eighteenth centuries had, to withstand the rigors of
time. Externals came first, and to them went the money and the care. There
are, to be sure, delightful examples of this imaginative extravagance which
have survived (and most assuredly should be preserved) along with some
preposterous examples, all show and no style, which nonetheless are often
entertaining.

One of the fancier façades erected in the 1840s, however, contained
behind its tiers of windows set between columns the seed of a revolutionary
idea of how a building, and especially a commercial building, should be
constructed. James Bogardus put up a factory with a cast-iron front in
1848 in New York, and for the first time cast-iron supports were used
inside. A few years later he took a logical but revolutionary next step when
he made the frame of the building entirely of cast iron. His iron basket on
which to attach walls and floors was the obvious progenitor of the steel
basket on which the walls of skyscrapers came to be hung. But it was the
façades which made the most immediate change in the aspect of cities.
Windows were set in bays beneath arches and between columns to which
acanthus leaves of iron were bolted to make Corinthian capitals, and a
builder could order up fancifully (and sometimes tastefully) designed
cast-iron fronts from firms like the Badger Architectural Iron Works or the
Mott Iron Works in Italianate style or Gothic. It was considered tasteful to
sand such façades and paint them so that they looked almost precisely like
stone of the most extravagant sort. The architects of Bogardus' time were,
for the most part, unimpressed (and it is hard to blame them) by a system
which seemed dishonest as structure and which ran diametrically against the
principles they had been at such pains to learn and the individuality that it
was their professional pride to exhibit. Many of them were happy to shake
their heads in mock dismay when fires ravaged these supposedly fireproof
buildings. Cast iron melted in the extreme heat and the buildings collapsed
in the most alarming manner, a manner that a building of stone would have

The Haughwout Building, one of the great remaining "cast-iron fronts," was built in 1856 for an importer and manufacturer of silver, glass, and china by the architect JOHN P. GAYNOR. It stands at Broadway and Broome St. in New York. (*Photo Landmarks Preservation Commission of the City of New York*)

resisted. Besides, this was poured architecture, not built architecture; architecture turned out by the yard like printed cotton. It was an insult to individual taste and creativeness. One young architect, Henry Van Brunt, a founder of the American Institute of Architects (the distinguished and conservative Mr. Upjohn was its president), spoke up on behalf of what Bogardus had initiated. "This is called an iron age," he said, "for no other

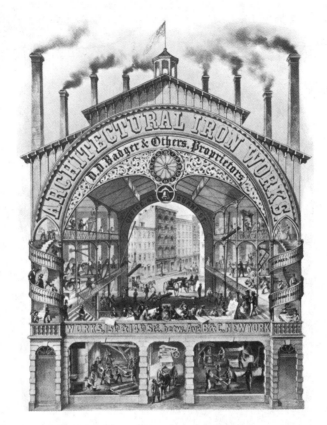

This fanciful advertisement for a manufacturer of cast-iron building fronts was published by Daniel D. Badger in 1885. Badger was the principal rival of James Bogardus, the innovator who built the first building that was iron inside as well as out. (*Avery Library, Columbia University*)

material is so omnipresent in all the arts of utility. . . . But architecture, sitting haughtily on her acropolis, has indignantly refused to receive it, or receiving it, has done so stealthily and unworthily, enslaving it to basest uses, and denying honor and grace to its toil." His words were greeted with something less than enthusiasm by his colleagues. The profession was equally slow to adopt another structural innovation, this one made possible by the development of machine-made nails that replaced the old handmade ones in the early part of the century, and at about the same time by the demand for quick, easy construction of houses, especially in the frontier cities, which grew with a speed that sent them sprawling. This was the balloon frame, a sort of wooden birdcage of two-by-fours, easily slapped together by any moderately competent handyman who could wield a ham-

mer and saw and use a plumb line. In the 1830s Chicago grew from half a dozen structures to more than four hundred dwellings and warehouses and shops in a single year, an explosion that would have been impossible without the balloon frame. Technology before the Civil War had introduced methods that were to change the looks of America radically after it.

It was not, however, the new technology that inspired the architects to stretch their imaginations to new assaults on the ever present problem of devising an architecture suitable to the needs and ambitions of Americans. It was a revulsion against the very technology that was making the nation into an industrial complex that inspired them to build bastions of borrowed culture to ward off the assaults of the machine. It was architecture by antithesis, so to speak: the less the architecture had to do with the mundane considerations of those who made the money to build it, the better. It was architecture of escape, not of confrontation; an architecture that told problems to go away and lose themselves, not an architecture that found ways to acknowledge problems and solve them. The result was a proliferation of heartless boxes for factory workers to live in in company towns on the one hand, and houses for their employers and for the offices of government and business in cities of almost unparalleled grandeur (and often pomposity) on the other, that was to be the pattern of the second half of the century.

A MOST AMIABLE MASTER BUILDER

The first American architect to study at the Ecole des Beaux-Arts in Paris and to return home to set himself up in practice was to become a past master at putting the Lords of Creation (as Frederick Lewis Allen called our first tycoons of finance and industry) in palaces that the Medici would have envied. He was Richard Morris Hunt, a short, stocky man with a splendid mustache, whom everyone from the stonecutters who carved his marble staircases and massive portals to the men who had to pay for them was equally charmed by. A serious art maker of expansive good will and humor, he loved his profession and loved his clientele (most of it) and worked hard at cultivating and mastering and furthering the interests of both.

It was more than two decades after he came back to the United States that Hunt found his fortune among the Vanderbilts and Goelets and Bel-

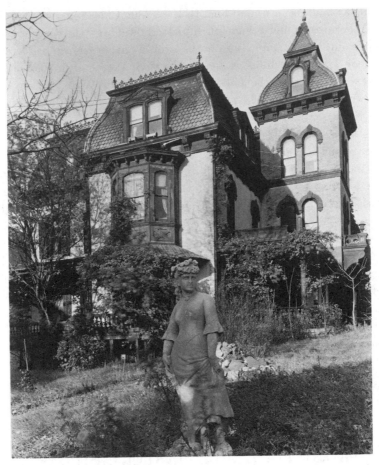

"Second Empire" had its effect on domestic as well as official and
business building. Berenice Abbott made this photograph of one such
house for the Federal Art Project "Changing New York" in the
1930s, shortly before the house was torn down. (*Museum of the City
of New York*)

monts, and it was not until then that he began to put his personal stamp on
the style of the country. What he found when he stepped off the ship in
1855, far better prepared than most young men to set himself up in
practice, was the beginnings of a fashion that he had just left behind in
Paris, a style, in fact, on which he had been working as one of the designers
of the Pavillon de la Bibliothèque at the Louvre. The fashion put steep
mansard roofs trimmed with wrought-iron lace on the tops of hotels and
business buildings, on city halls and suburban villas and barns, and even on

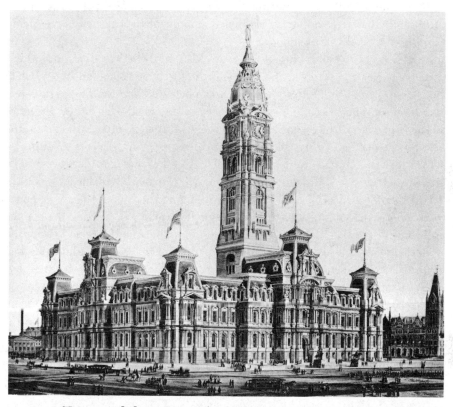

Now crowded among routine skyscrapers (but none taller than the statue of Penn that tops it), Philadelphia City Hall, built in 1871–81 by the architect JOHN MCARTHUR, JR., was the epitome of the Mansard style now called "Second Empire." (*Rendering by E. Eldon Deane, Atwater Kent Museum, Philadelphia*)

birdhouses that stood on poles in carefully trimmed front lawns, set about with precise evergreens and shrubs and illuminated with the fire of flowerbeds filled with yellow and red cannas. The style, now generally called Second Empire, supplanted in considerable degree the fashion for the Italianate. For nearly twenty years Hunt and his colleagues devoted themselves almost entirely to buildings that, no matter how playfully the classic orders might mingle and compete with one another from the ground to the top story, inevitably ended in a steep mansard roof, often in slates patterned of various colors and pierced by dormers. It was a grand manner considered especially suitable for official buildings after the Civil War. The old State, War, and Navy Building in Washington, which was completed in 1871, is a prime example of how vigorous a style it could be, and Philadel-

phia has yet to build a competitor to its towering City Hall, still the tallest building in the city, and an unparalleled monument to American civic pride and architectural extravagance.

When Hunt was trying to make up his mind whether to stay in Paris or come home to practice architecture, he had written to his mother, "It has been represented to me that America was not ready for the fine arts, but I think they are mistaken. There is no place in the world where they are more needed, or where they should be more encouraged." His enthusiasm for setting the matter right was not met with encouraging success, though he threw himself into the fight for the arts with all of his considerable intelligence and energy. He immediately joined the newly formed American Institute of Architects, and when a dentist for whom he designed a house refused to pay the five-percent commission he demanded, he took the matter to court. While the jury allowed him only two and a half percent, the case nonetheless established the right of the profession to a set fee, a matter that up until then had been catch-as-catch-can. Considering the rate at which the population was growing (it jumped from 31 million to 55 million in the quarter-century after the war), one would have thought that architects would have found themselves in a commanding position, but most building was run up by speculators and developers as though from an assembly line, or it was carpenter-built from plans that could be found in plan books and bought for a few dollars by mail. The "art" of architecture remained the plaything of the newly rich and of government agencies and educational institutions. In his letter to his mother Hunt had also said, "It is the same in painting or any branch of the arts, merit must eventually command its position with us. There are no greater fools in America than in any other part of the world: the only thing is that the professional man with us has got to make his own standing."

It was the Centennial Exhibition of 1876 at Philadelphia, by all odds the greatest world's fair ever to have astonished anyone, that put "art" in America on a lofty, if not very secure, pedestal. Europe had never had a fair that came close to it in size; it covered some 236 acres, not counting a great enclosure for livestock. Flags and pennants fluttered from dozens and dozens of pavilions erected by foreign governments from as far away as Japan to display their crafts and culture and by the states of the Union to expose their produce and manufacture. Curved roofs, peaked roofs, mansards, cupolas, and domes capped all manner of picturesque structures in a babel of styles that lent exotic enchantment and gaiety to buildings that now seem to us to have had pomposity and dreariness built into their very timbers. Top-hatted gentlemen led ladies in bustles and carrying parasols

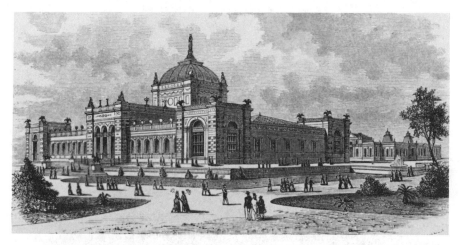

Nothing had such an impact on American taste as the Centennial Exhibition in Philadelphia in 1876. Hundreds of thousands of people crowded into the vast galleries of Memorial Hall, where the greatest (in size) art exhibition ever seen in America was held. (*Collection of the author*)

from exhibit to exhibit, past the Total Abstinence Fountain and the Bear Pits (constructed in the Gothic manner) to the Agricultural Building, which covered ten and a quarter acres, or to the even larger Machinery Hall, where they watched in wonder and chauvinist pride the "pair of monster Corliss steam engines" with their fifty-five-ton flywheels that supplied the power for all the exhibits in the fourteen-acre building. Before the week was out (and families came with their trunks and their children from all parts of the country and settled in for a proper stay) they surely arrived at the granite steps of Memorial Hall. One of the official guidebooks described it as "the most inspiring and ornate of all the structures," and it was built at a cost of $1,500,000 to house the art exhibitions. Vast bronze eagles spread their wings at its corners, and its glass-and-iron dome was topped by a colossal figure of Columbia. Inside there were 75,000 square feet of wall space for paintings and 20,000 square feet of floor space for sculptures. That should have been enough, but it was necessary to tack an annex on the back of the building to accommodate all the exhibits that were submitted.

Memorial Hall may have introduced a great many people to a great many works of art which are now totally discredited or nearly forgotten (among them several statues by William Wetmore Story and Randolph Rogers, by that time already out of date), but it was the British Pavilion

The British Buildings at the Centennial Exhibition at Philadelphia in 1876 had a marked effect on American taste, both good and bad. They were largely responsible for the Queen Anne craze that swept the nation. (*Reproduced from* The Shingle Style *by Vincent J. Scully, Jr.*)

that was responsible for changing the looks of American towns and suburbs and, to a lesser degree, cities. Here was something at the same time new and satisfyingly quaint, a style originated by an English architect, Richard Norman Shaw, and called "Queen Anne." It was not quite Tudor, but it had tall chimneys like those on Elizabethan country houses. It had steeply peaked roofs and frequently an octagonal corner tower. There were sheltered balconies outside bedrooms and wide porches that in many cases went halfway around the house, made private and cool by wisteria vines, and furnished almost like living rooms with wicker chairs and settles and swings and tables, and rugs of straw or sisal. Roof lines were frequently broken with high gables, so that the total effect was one of carefully controlled disorder, the very opposite of the symmetrical mansard house with its tower up the center and windows in equal numbers and ranks on either side and matching porches. But if the exterior of the Queen Anne house satisfied the appetite for the quaint and the picturesque, the inside was a delightful revolution in planning which brought new kinds of pleasure, some of them mysterious, that were denied to those who lived in mansard houses. Here was a large hall, often with a fireplace and a piano in it, the heart of the house and in itself a living room, out of which rose a wide staircase at whose top were a sewing room or upstairs sitting room and bedrooms and a bath. Downstairs rooms flowed from one into another off the main hall—an open plan suitable to an informal way of living that, if the house was a moderately large one, required the attention of three or four servants.

Queen Anne was not, however, a rich man's architecture; it came in all sizes to suit all purses and at its best to satisfy the most fastidious taste, or to gratify at its most flamboyant (and it could be wildly ornamented by the scroll saw and the spindle lathe) the most unbridled taste. The style had arrived before the Centennial, and Shaw's buildings were known through drawings to American architects. Hunt, for example, had designed a house in the Queen Anne manner for a client, T. G. Appleton, in the resort city of Newport, Rhode Island, that was a clarion call for the picturesque. It was a riot of Queen Anne clichés that, skillfully put together, made an entertaining albeit confusing progenitor of what in the hands of other architects became the elegant shingle style. The Centennial made Queen Anne everyman's dream of a dwelling for about thirty years and filled towns with such houses from Portland, Maine, to Portland, Oregon, and from Minneapolis to Dallas.

Hunt's genius, however, lay elsewhere, and his reputation as a designer, which for many years was looked down upon by purists and scoffed at by all right-thinking social critics, can now be reappraised without

rancor. Hunt was a rich man's darling, and he did more than any other architect to inflate the egos of his clients by designing settings for them which satisfied their most opulent dreams and their most anguished social pretensions. He was a creator of palaces—not imitation palaces, but genuine ones that, if anachronistic in style, were not anachronistic to the temper of their times. They may have had nothing whatsoever to do with the culture or the background of the families for whom they were built, but they had a great deal to do with accumulated wealth at a time when the rich were the equivalent of today's television "personalities" and professional quarterbacks as the focus of the popular gaze and curiosity. The rich lived in a world apart, a world that all conscientious social climbers not already arrived would have given their virtue to penetrate; they bought dukedoms for their daughters (as Alva Vanderbilt did for her Consuelo), entertained on gold plate in bowers of orchids, and had summer "cottages" that required staffs of forty servants, not including the grooms and gardeners. It can be said with justification that there could not possibly be an architecture suitable to such a view of life in a republican society, but Hunt succeeded in making one up, suitable or not, that gratified his clients' tastes—which, to be sure, he helped to mold.

"The first thing you've got to remember," he said to his son, "is that it's your clients' money you're spending. Your business is to get the best result/ you can, following their wishes. If they want you to build a house upside down, standing on its chimney, it's up to you to do it and still get the best results possible."

None of Hunt's houses stood on their chimneys; indeed, they stood precisely how and where Hunt wanted them to, for his powers of persuasion and tact were the sort that endeared him to his clients. He created their desires when they only vaguely knew what they wanted, and, having defined them, it was his pleasure to see them fulfilled.

Hunt's first grand house was built for Mrs. William K. Vanderbilt, née Alva Smith of Mobile, Alabama, at 660 Fifth Avenue. In the years between the time he set up practice in New York and 1881, when he became the Vanderbilts' architect, he had built a number of interesting if not important buildings; he was credited, for instance, with having designed the first "French flats," as apartments were then called, to be built in New York. (Americans thought there was something slightly immoral about living in layers between other families. That was in 1869, when, however, it was considered entirely respectable for families to live in boardinghouses, which existed in all degrees of elegance, modest propriety, and squalor.) Hunt did not hit his stride until he made friends with the Vanderbilts; his concept of

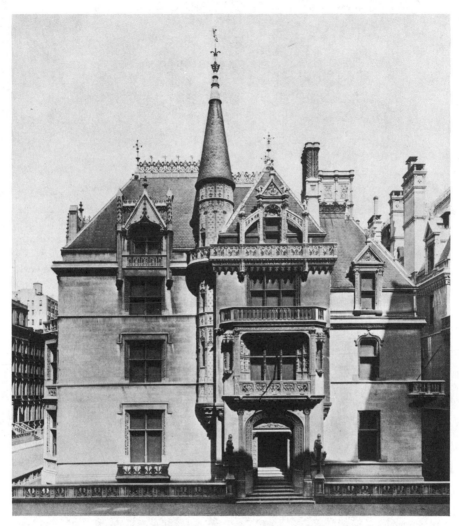

One dissenting voice was raised in criticism of RICHARD MORRIS HUNT's house for Mrs. William K. Vanderbilt at 660 Fifth Avenue. Louis Sullivan commented: "Must I show you this *French Chateau*, this little Chateau de Blois, on this street corner, here in New York, and still you do not laugh?" (*Photo The Metropolitan Museum of Art*)

splendor matched theirs, though when he was asked by William Henry Vanderbilt to design a family mausoleum for a site on Staten Island which commanded a view of New York harbor, he produced drawings that evoked from his client the comment: "You entirely misunderstand me, Mr. Hunt. This will not answer at all. We are plain, quiet, unostentatious people, and

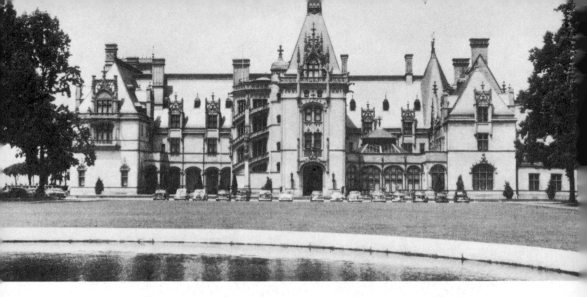

The largest building under one roof in America when it was built in the 1890s, George Vanderbilt's château called Biltmore, near Asheville, N.C., was designed by RICHARD MORRIS HUNT and built at a cost of about $4,000,000. (*Photo Wayne Andrews*)

R. M. HUNT designed The Breakers, the most famous of the Newport, R.I., "cottages," for Cornelius Vanderbilt. It was completed in 1895 and is now open to the public. (*Photo Wayne Andrews*)

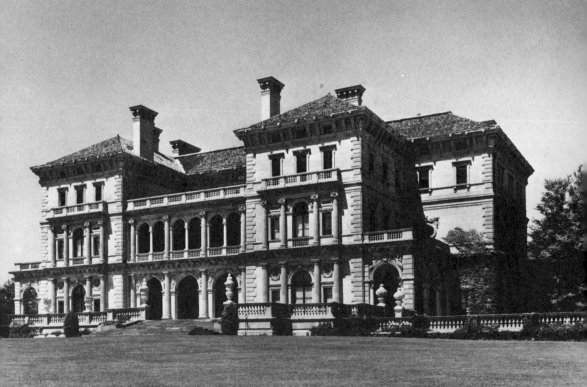

we don't want to be buried in anything as showy as that would be. The cost of it is a secondary matter, and does not concern me. I want it roomy and solid and rich. I don't object to appropriate carvings, or even statuary, but it mustn't have any unnecessary fancy work on it." Hunt redrew his plans and they were satisfactory—a stone chapel based on St. Gilles in Arles, over which, for fear of body-snatching, the Vanderbilts maintained watchmen around the clock.

Neither Alva, for whom Hunt built the house on Fifth Avenue, a château in the late French Gothic style with attributes that Mrs. Vanderbilt's friends who had taken the grand tour would have recognized as reminiscent of Blois, nor Cornelius Vanderbilt II, nor his brother George was troubled by the same restraints. For Cornelius he built a cottage called The Breakers at Newport (now open to the public) as lavish as Hunt's imagination and Vanderbilt money could make it. The house he built for George Vanderbilt near Asheville, North Carolina (also open to the public) is a château so large that when it was built in the late 1890s (it took five years to complete) it was the largest building under one roof in the country. It had a commanding presence and was landscaped by the great Frederick Law Olmsted, with its gardens and experimental forests presided over by a young conservationist named Gifford Pinchot. It was said that George Vanderbilt, who spent more than $4,000,000 on the house, employed more people in house and garden and forest than there were on the payroll of the Department of Agriculture.

Hunt, however, was not just a showman. He was diligent, intelligent, and a man of taste, a product of the Ecole des Beaux-Arts and the doctrines of Viollet-le-Duc, who was responsible not only for the reconstruction of Carcassonne but for an orderly philosophy of architecture which was to inspire later architects, including Frank Lloyd Wright, to contemplation of functional design. "Adaptation" was Hunt's basic credo—the adaptation of earlier styles to the uses of his own time. He was no copyist, neither was he a purist, but he was an art-maker as conscientiously trying to make architecture as any man of his time. If his concept of elegance is not congenial to twentieth-century concepts of elegance achieved through simplicity, it nonetheless had validity not only for Hunt's clients but for the architects, most of them, of his time.

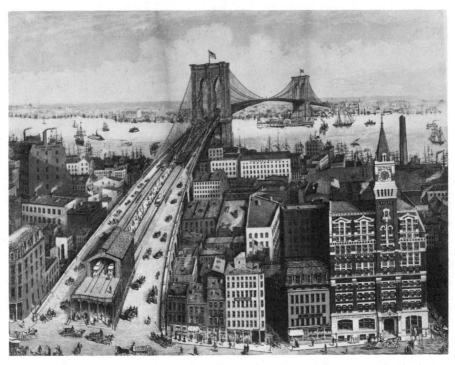

At the extreme right is R. M. Hunt's Tribune Building (1873–74), one of the first elevator office buildings. It was as much the dead end of a style as ROEBLING's Brooklyn Bridge (1867–83) was the trumpet sounding a new age of engineering. (*Museum of the City of New York*)

A GIGANTIC GENIUS

Compared with his somewhat younger contemporary Henry Hobson Richardson (1838–1886), Hunt for all his gifts seems more like a deviser of tasteful follies than like an architect, though it takes a major talent to put Hunt in the shadow. Richardson, the second American architect to be trained at the Ecole des Beaux-Arts, was Hunt's junior by ten years, and if it had not been for an impediment in his speech (he stammered), he might well have spent his life as an army engineer. Recommended for appointment at West Point, he was turned down because of his disability, and after a year of tutoring to make up for his want of classics, went to Harvard instead. He had been brought up in the South, where he had spent his

summers on the family plantation in the Parish of St. James, Louisiana, and his winters in New Orleans, and he brought to Cambridge with him an easy charm, a marked talent for mathematics, a rudimentary knowledge and aptitude in drawing, a delight in meticulously tailored clothes, and an ability to attract friends with promising futures. Indeed, friends he made when he was elected to Harvard's fashionable Porcellian Club were later to be numbered among his most important clients. When he arrived at Harvard it had been his intention to pursue a career as a civil engineer. Possibly it was his romantic spirit, perhaps it was the buildings he looked at in Boston and Cambridge, quite different from what he had known in the South, perhaps it was his facility with the pencil—at any rate, while he was still an undergraduate, he made up his mind to become an architect. Why he chose to go to France to get his training when none of his generation had gone (Hunt had been living there as a boy with his brother and mother, and it was natural that he should stay on) is not easy to guess. Paris was a city in which architects were engaged primarily on official projects—on the extensions to the Louvre, on which Hunt worked, on the Opéra, on a new building for the Ecole des Beaux-Arts (built while Richardson was a student)—not, as in America, on domestic projects and hotels. Before going to Paris Richardson spent a summer traveling in England and Wales, and on his first try at gaining admission to the Beaux-Arts he failed in every examination except mathematics and was constrained to spend a year in a *pension* on the Rue de Vaugirard boning up. On his second try he was eighteenth in a field of 120 applicants and entered the school in 1860. His French, which he had spoken since he was a child, obviously stood him in good stead.

For all his delight in the niceties of life, his taste for food and wine, congenial company, and fashionable clothes, he threw himself into the academic training of the Beaux-Arts with his full heart. When funds from home were stopped by the war, he reluctantly gave up school and went to work for the architect Théodore Labrouste, who put the young man on a project in which he was then engaged, the design of a hospital for incurables at Ivry. But Richardson spent his evenings at the atelier where his student friends were working, and when they and other young men of the Beaux-Arts demonstrated against the appointment of Viollet-le-Duc to the staff of the school, he was trundled off to jail. He shared a cell with the distinguished writer Théophile Gautier, a coincidence that caused his being released the next day by no less a personage than the Minister of Fine Arts himself. When he had been forced to take employment and give up school, he had written his fiancée in Boston, "How I have suffered from it you will never know, for you know not how I love my art." And he told her, "I

cannot say how long I will remain in Europe. It depends on various things
. . . and you would prefer to have me remain a few months longer in
Europe than to return to America a second-rate architect. Our poor coun-
try is overrun with them just now. I will never practice till I feel I can at
least do my art justice."

He was twenty-seven when he arrived back in America in the autumn
of 1865. His parents wanted him to come home to New Orleans to practice,
and his fiancée urged him to set up in Boston, but New York was where the
activity was, and he decided to try his fortunes there. His fortunes were
scanty. In seven years only one commission in New York came his way, and
he was reduced to selling some of his books (though probably not any of his
architectural library, which was vital to his profession) to keep body and
soul together. "Look at me," he said to his landlady. "I wear a suit made by
Poole of London, which a nobleman might be pleased to wear, and— and —
and I haven't a dollar to my name." That is not to say, however, that in the
seven years he was in New York he was without jobs. He won a competition
for the Unity Church in Springfield, Massachusetts (it was one of his
Porcellian Club friends who managed to get his name entered among the
competitors), and he also won a competition for a somewhat smaller church
in West Medford, Massachusetts, Grace Episcopal Church. Both buildings
were adaptations of English country churches. He also did two commercial
structures in Springfield, both for banks, along with an occasional house for
a friend, several other commercial buildings and minor churches, a high
school, and a town hall. When fame finally came to him, it came in a rush
and, in a manner of speaking, with ecclesiastical trumpets blaring.

In 1872 he won the competition for Trinity Church on Copley Square
in Boston, and it seems to have been the excitement that surrounded the
building, the fact of its being built when and where it was, as much as the
building itself, that made Richardson's reputation. He and his wife were
living on Staten Island in a house with a mansard roof which he had
designed. At that time he made an association with Charles Gambrill, an
architect chosen not for reasons of his ability as a designer but as a
convenient business arrangement. There was in his office, however, a young
man just returned from the Beaux-Arts named Charles Follen McKim who,
in later partnership with Stanford White, another of Richardson's
protégés, was to become one of the architectural ornaments of the century.
It was White, we are told, who was responsible for the famous tower on
Trinity Church, modeled on the tower of the old cathedral in Salamanca in
Spain.

Phillips Brooks, one of the most famous preachers of his time, was the

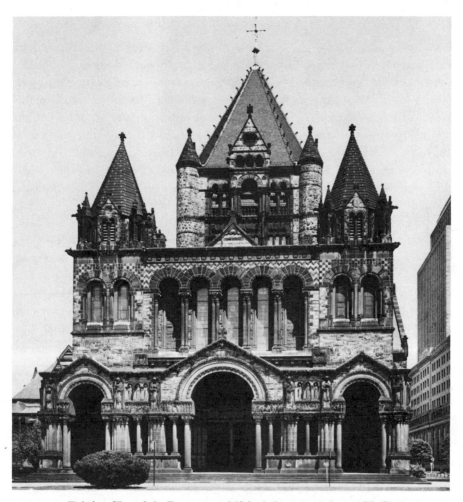

Trinity Church in Boston established the reputation of H. H. RICHARD-
SON as America's foremost architect when it was built in the 1870s.
The porch was added by other architects, SHEPLEY, RUTAN & COOLIDGE,
in the 1890s. (*Photo Wayne Andrews*)

rector of Trinity in Boston, and he and Richardson became fast friends.
The church that won the competition was not the church that finally stood
on the square. Richardson kept altering the design, with Brooks's enthusias-
tic blessing, even as the work was under way. In 1874 he moved his offices to
a house in Brookline to be close to his work and, as much as any outsider is
allowed to, became a Bostonian. He took up with his old Harvard friends,
and though he was no less a *bon vivant* than he had been as a student in
Paris, he was just as diligent a worker as he had been then. He ate well,
talked brilliantly, and worked hard, and as Trinity Church evolved from its

first to its penultimate stages (it was completed after his death, and its familiar porch on Copley Square was not Richardson's design), so did his personal style evolve, a style related to the Romanesque of France but by no means a copy of it; it became a mannerism called "Richardsonian" in the hands of less gifted men. Richardson was only thirty-four when he got the Trinity commission and not yet thirty-nine when the Governor of Massachusetts, the Mayor of Boston, and pews packed with guests watched at its consecration as 107 clergymen chanting the Twenty-fourth Psalm ("Lift up your heads, O ye gates, and be ye lift up, ye everlasting doors; and the King of Glory shall come in") proceeded up the nave.

Trinity established Richardson as the leading architect of his time, and commissions poured into his office in Brookline, which, as the work increased, spread out around his house to become what was very nearly an architectural factory. Plans and elevations poured out of it, all of them carefully studied and revised by Richardson. The years during which Trinity was being built were depression years: banks were failing at an alarming rate, and some 50,000 businesses had disappeared in the panic that preceded the Centennial. Richardson in the face of this prospered, and though it was Trinity to which he owed his fame and, indeed, his fortune, it was not churches that he most liked to design or on which his greatest talents had the chance to speak a firm and individual language. He was a man of the expansive, adventurous, and financially muscular (if often precarious) times he lived in, and he delighted in the excitement of growing commerce, the thousands of miles of new railroad track, the mills and mines and foundries. "The things I most want to design," he said, "are a grain elevator and the interior of a great river steamboat." He never designed either, but among his most successful buildings are ones he built for railroads (a number of wonderfully solid and original stations) and for commerce. His now vanished wholesale store for Marshall Field in Chicago (it was demolished in 1930, forty-five years after it was completed) was one of the great buildings of the century. It was a structure of massive stone and towering arched windows, and Louis Sullivan, one of the most powerful progenitors of modern architecture and one of its philosophers who echoed the functional doctrine of Greenough, said of it:

Four square and brown it stands, a monument to trade, to the organized commercial spirit, to the power and progress of the age, to the strength and resource of individuality of character; spiritually it stands as the index of a mind, large enough, courageous enough, to cope with these things, master them, absorb

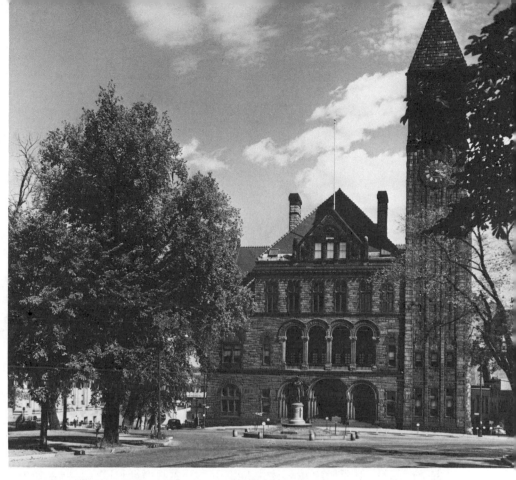

Out of the post-Civil-War chaos of styles RICHARDSON brought a remarkable order based on Romanesque themes which are at the same time entirely personal creations, as the City Hall in Albany, N.Y. (1880–81), attests with great dignity. "Richardsonian" became a style that was widely popular in the 1880s, but most instances were poor renderings of a style that was powerful as RICHARDSON himself used it in the Crane Memorial Library in Quincy, Mass. (1880–83). (*Photos Wayne Andrews*)

Crowded among tall buildings today (and therefore difficult to photograph) is the Allegheny County Courthouse in Pittsburgh, Pa., by H. H. RICHARDSON, built in the years 1884–1885. (*Engraving from Henry Hobson Richardson* by *Mrs. Schuyler Van Rensselaer, Boston 1888*)

them, and give forth again, impressed with the stamp of a large and forceful personality.

In 1880, five years before the Marshall Field building dominated the architecture of Chicago, a symposium of architects, when asked to list the ten greatest buildings in America, decided that five of them were by Richardson. He had placed his indelible stamp on the landscape with the vigor of his design in houses and public buildings. Much of his best work was still to come: two buildings for Harvard (Seaver Hall and the law-school building, Austin Hall), the Albany City Hall, a number of public libraries, an astonishing gatehouse for a friend in North Easton, Massachusetts, built of boulders, and one of his favorites, the masterly Pittsburgh Courthouse and Jail, of which he said, "If they honor me for the pigmy things I've done, what will they say when they see Pittsburgh . . . ?"

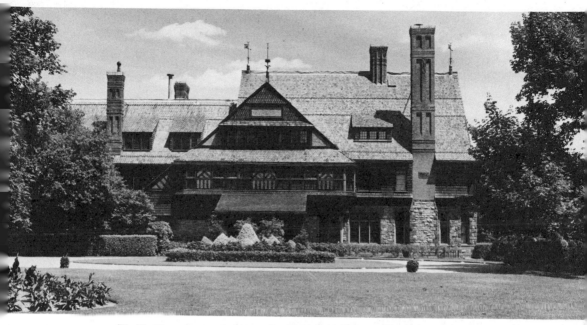

H. H. RICHARDSON's house for William Watts Sherman in Newport, R.I., shows the architect at the height of his powers as a domestic architect working (1874–76) in the "shingle style." It is now an old ladies' home, excellently maintained. (*Photo Wayne Andrews*)

Richardson died when he was forty-seven, famous in England as in America (he was elected an Honorary and Corresponding Member of the Royal Institute of British Architects), an enormously fat and friendly man with a joy in life that killed him. He refused to submit to the kind of regime that might have prolonged his life if not his pleasure. Augustus Saint-Gaudens the sculptor, who was one of his close friends, wrote:

. . . whenever I visited . . . he would say before dinner: "S-S-Saint-Gaudens, ordinarily I lead a life of abstinence but tonight I am going to break my rule to celebrate your visit, you come so rarely." He would thereupon order a magnum of champagne which, as none of the family drank it, had to be finished by him and me. Unfortunately I am very moderate in such matters, and the result was the consumption of virtually the whole magnum by my good friend. This had to be accompanied by cheese, which was also proscribed by the doctor, and of this he ate enormous quantities. The proceeding doubtless occurred every night, as he always managed to bring home a guest.

Richardson's funeral was held in Trinity Church, and his friend Phillips Brooks read the service. This was at the end of April 1886.

THE KINGDOM OF THE TASTEFUL

One of the most devastating blows ever to strike design in America was dealt by one of the mildest of men. He was Charles Lock Eastlake, an English writer about things aesthetic and an architect *manqué*. He was the son of a famous father, Sir Charles Eastlake, the president of the Royal Academy who contrived ponderous canvases filled with gorgeous figures in historical costumes. Young Eastlake's career never came to anything very distinguished; he never quite realized any of his ambitions, and he seems always to have been passed over when the big jobs he yearned for were dangled before his eyes. He became the keeper of the National Gallery in London, for instance, and he reorganized the collections by national schools (an innovation in museum techniques for which he was responsible), but when the time came when he thought he would be named director of the museum, someone else got the job. Sir Charles is now forgotten, and the pomp of his office bears little weight today. His son, however, gave his name to a style of furniture and decoration and did more to change the looks of the insides of American homes than any other single individual in the nineteenth century.

The moment was ripe for a messiah of taste with a doctrine that was at once moral and aesthetic, that preached honesty and sincerity and tastefulness, and at the same time assuaged the hunger for the "picturesque" which had delighted Downing and had gone wild after his death. Eastlake wrote a little book called *Hints on Household Taste* which became the bible for all right-thinking housewives who suddenly became concerned with "the artistic" and "the quaint," and off whose tongues tripped words like "harmonies" and "gradations," and who talked about the "morality" of Dutch tiles for a fireplace. Eastlake's book was published in America in 1872, and it is very difficult today to understand why it caused such a stir unless one recalls the clutter that filled Victorian parlors: whatnots groaning with bibelots, with shells and stuffed birds and pretty stones and souvenir saucers with town halls painted on them, with butterflies and curios from the Orient. The flowers on carpets had become blossoms suited to the gardens of giants, and the carving of marble mantels rich enough to ornament the portal of a

prelate's palace. The time had come to clear out the clutter, Eastlake solemnly declared, and forswear the sin of novelty for novelty's sake. First things first, and no nonsense, was his doctrine; the function of a piece of furniture was the first thing, and the second thing was that it should look like what it was and not like a grapevine turned into a settee. Ornament was acceptable as long as it did not conceal the honest purpose of what it ornamented. It was not what a piece of furniture or wallpaper or teapot cost that mattered. "Excellence of design," he said, "may be, and, indeed, frequently is, quite independent of cost."

It is characteristic of Americans to like to have a moral justification for their taste; to be persuaded that there is something not only inherently "good" but good for their characters in what they admire, and Eastlake gave them a credo. "I believe in the sincere, the artistic, and the healing qualities of honest design," it might have begun. "Suddenly the voice of the prophet Eastlake was heard crying in the land," a writer in *Harper's Bazar* said. " 'Repent ye, for the Kingdom of the Tasteful is at hand!' "

Eastlake had his disciples in America, other writers and architects who carried the word to the public in books and magazines, but unquestionably the greatest purveyor of the new taste for which he stood was the Centennial Exhibition in Philadelphia. It was heralded as a marriage of industry and art, but it must be remembered that art in those days was not considered to be even remotely inherent in an industrial product; it was something laid on, something to make the useful look artistic. Functionalism as Greenough used the word "function" was still a long way in the future as a doctrine of design for manufacturers of household appurtenances. But the "artistic" was everywhere at the Centennial, and hundreds of thousands of Americans who studied the exhibits that covered the acres of buildings overlooking the Schuylkill River went away with a new conviction about how to think about art and how to furnish their houses.

The new style that Eastlake promoted is difficult to describe, partly because it is so miscellaneous and often contradictory. The words that come first to mind are "solid," "stolid," and "square." But to these one immediately wants to add "ornamented by machine," often in geometric or floral patterns of a formal sort incised by machine into the surface. Curves did not disappear entirely, but they were subservient (as they were most surely not in the rococo of a generation before) to straight legs on tables and chairs and mantels. A straight leg was more "sincere" than a curved one, according to the doctrine, just as a piece of furniture put together with dowels was more sincere than one made with nails or screws. In any event, Eastlake interiors were entirely at home in the Queen Anne houses that from

the 1870s to the end of the century were the standard patterns (in thousands of variations) for domestic building everywhere in America. There have been few styles in the history of the American arts and crafts that rose so high and fell so far as Eastlake, which, characteristically, is now creeping back into respectability.

Richard Morris Hunt, when he was stimulating and satisfying the tastes of his clients in their Fifth Avenue mansions and Newport cottages, had quite different ideas from Eastlake's about what was suitable. Palaces needed palatial and exotic furnishings. Entrance halls that rose through tiers of marble three stories high had little use for foursquare sincerity; such houses called for massive marble tables, for carved chests and painted cassones, for chairs wrested from Renaissance palaces or Elizabethan country houses and covered with ancient velvets and tapestries. Ecclesiastical furniture such as bishops' thrones were not out of place or out of scale; antiquities were to be preferred to anything of modern manufacture, and the further away they came from and the longer ago, the better. Hunt's clients occupied Byzantine rooms, suites in the Jacobean manner, ballrooms inspired by Versailles, and sitting rooms in the Moorish style. The result was clutter of a ponderousness unparalleled except by hotel lobbies in the great days of palace hotels.

"Artistic" furniture, however, was considered suitable for shingle-style houses designed by Hunt in his earlier days and by Richardson and the most distinguished of his followers to work in the shingle style, Charles F. McKim and Stanford White. Behind Eastlake lay the authority of John Ruskin and William Morris and the spirit of the English crafts movement, which was engaged in a moral battle with the deprivations and depredations of the Industrial Revolution and the evil that was wrought by it to men's bodies and souls and to the noble handmade arts. Hunt and Richardson and their contemporaries who considered themselves architects and master craftsmen in their various ways stood shoulder to shoulder against the incursions of technology on design. In doing so, they stood with their clients in creating what they thought of as a new Renaissance, a noble architecture in the great traditions of great nations, rising in power to who knew what positions of dominance. Who can blame them if their vision of what was going on in the steelmills that was about to change architecture was beclouded by the heady brew of optimism of which they drank so deeply?

10

BRONZE WAS FOR HEROES

"We artists sometimes whine about lack of appreciation, but in nine cases out of ten the cause of our sorrow lies in ourselves. A true work of art will meet the wants and therefore stir the feelings of the ordinary human heart. It is sure to win recognition."

JOHN QUINCY ADAMS WARD,
from an interview in
Harper's Magazine, 1878

There was something soft, insistently and intentionally soft, about the sculpture that had made Powers' "Greek Slave" and Story's "Cleopatra" seem like such wonders of art, so almost beyond the limits of human skill to the men and women who gaped at them in awe in the 1850s and '60s. There was a refinement about their surfaces, equal to the refinement in their poses and their sentiments, which spoke in sympathetic syllables to genteel ladies whose houses were decorated with needlepoint mottoes and whose evenings were spent with sentimental novels. It was an art whose values were by intention superficial, if superficial means what goes on on the outside with little regard to what is beneath. It was the skin that mattered and the sentiment, and not only artists but also what can be called men of informed taste will put up with such nonsense just so long before they revolt.

It was not the sculptors who settled in Rome and Florence and kept aloof in their several versions of Paradise, a comfortable ocean away from the war that rent the nation, who brought sculpture down from the slopes of

Mount Parnassus and the company of ancient Muses; it was a more earth-bound lot of art-makers. It is not easy to say if they were a more talented lot essentially, but it was their good fortune to arrive on the scene at a moment when the stars of Canova and Thorvaldsen were fading and the neo-classical began to seem old-hat and remote and, from their point of view, debilitating.

John Quincy Adams Ward was born in 1830, five years after Frazee is said to have carved the first piece of marble ever made into a statue by an American. He lived into this century, but he had already become the dean of American sculptors by the 1870s. Ward was deeply suspicious of the influence of Rome on American artists. "There is a cursed atmosphere about that place," he told an interviewer from *Harper's Monthly,* "which somehow kills every artist who goes there. The magnetism of the antique statues is so strong that it draws a sculptor's manhood out of him. From the days of Thorvaldsen the works produced there are weak and namby-pamby when compared with those glorious models." Ward had watched the demands on sculpture change from his boyhood, through the rising temperature of the decades preceding the War Between the States and through its agonies and the postwar attempts to celebrate its heroes. The eyes of the art-makers were turned inward on their own soil (this was also true of the landscape painters) and their own subject matter (as was true of the genre painters like Mount and Bingham). "A modern man has modern themes to deal with," Ward said, "and if art is a living thing, a serious, earnest thing fresh from a man's soul, he must live in that which he treats. Besides, we shall never have good art at home until our best artists reside here."

Not that "here" offered a great deal of encouragement to artists, or so Ward thought. There was not what he called an "art atmosphere"—too few other sculptors to talk with, too little public interest in the arts, too little "proper assistance," as he put it, and patronage. That is not to say that Ward and some other stay-at-home sculptors were without commissions; far from it. But commissions for a few prominent monument-makers did not, he felt, make "an atmosphere" conducive to great things.

The atmosphere, however, had been gradually changing and the climate of the arts had warmed up considerably since the days when Greenough and Powers and Story and the other stonecutters had headed for Europe. There had been the flurry of excitement created by the Art Union and the subsequent letdown when it was discovered that it was the gambling spirit rather than heightened aesthetic sensibilities which had caused such an upturn in the art-makers' fortunes. On the other hand, there had been some agreeable signs of interest, signs that lifted the heart, for example, of

Tuckerman. Perhaps his dream of the time when "the superstructure of the beautiful could be reared" had arrived, for he was constrained to write in 1867, "Within the last few years the advance in public taste and the increasing recognition of art in this country, have been among the most interesting phenomena of the time."

For evidence he could have cited the remarkable fact that William W. Corcoran, a financier, had given $300,000 to build a museum in Washington "to be devoted to Art-purposes, and particularly to the encouragement of American Genius." (Its opening as an art gallery was delayed until 1870 by the Civil War; the building was completed just before war broke out and was taken over by the government to house the headquarters of the Ordnance Department.) There were also rumblings and stirrings to create a truly national museum of the arts. Critics and artists had been crying out for the establishment of such a place for years; it was needed, they said, as a touchstone for the taste of Americans, as an inspiration to American artists, as an evidence that America had come of age. At a celebration of the nation's ninetieth birthday in Paris at the Pré-Catelan in the Bois, the Honorable John Jay, at that time Minister to Austria, said that "it was time for the American people to lay the foundation for a National Institute and Gallery of Art and that the American Gentlemen then in Europe were the men to inaugurate the plan." The idea that had long been smoldering caught fire, and with the poet and editor William Cullen Bryant to fan the flames the Metropolitan Museum came into being in New York in 1870.

If the external evidence of a warmer climate for the arts seemed convincing, Ward's estimate that there was no true "art atmosphere" was closer to the truth than Tuckerman's optimism. James Jackson Jarves viewed the scene with much the same skepticism as did Ward, and he spoke even more pointedly about what he saw. He found the public smug and the journalists who wrote "criticism" the cause of their smugness. They praised where no praise was justified. "Feeding artists on this diet is like cramming children with colored candies," he wrote, but what worried him more than this was how little art essentially had to do with American life, discouraged by its bustle and hurry:

> We think we have not the leisure to allow the feeling for art its legitimate rights, and so crowd it aside, or talk business to it. It is an affair of idle moments, a phase of fashion, or the curiosity of a traveller, who brings the trick of bargaining into his new-born love of beauty, and fails to appreciate an object of art except as it is cheap or dear . . . an article to be ashamed of for its cost, yet

to be proud of, in being able to own,—a necessity of gentility,—a presumptive evidence of cultivation or refinement. . . .

But whether their tastes were as yet, or were ever likely to be, dictated by aesthetic considerations, they were most certainly subject to patriotic sentiment, the belief that American heroes were as noble as any country's heroes. Though tastes were almost as subject to rapid change then as they are now, the public could be satisfied to honor the great only in the most permanent materials. Bronze was far less subject to the ravages of the weather than marble, and bronze for heroes became the fashion. Bronze, indeed, has a way, because of its patina, of looking more heroic, more timeless, every year.

Bronze casting, a complex technique of turning statues from plaster to wax to metal, though ancient was new to America in the 1840s. A few sculptors experimented with what is known as the "lost-wax" process in their own studios, but the first prominent piece of any size to be cast in America was the rather ridiculous statue of Andrew Jackson clad in his general's uniform on a rearing horse. It stands today, precariously perched on its hind legs, as it has since 1853, in Lafayette Park across from the White House in Washington. It was the work of Clark Mills, who spent about five years on it, and whatever it lacks in sculptural quality it made up for in the eyes of his contemporaries by the ingenuity with which it balances on its pedestal. It was no mean trick to find the precise center of the horse's and Old Hickory's gravity and keep them from falling forward. But Mills, who learned to model by working as a pargeter, or ornamental plasterer, had managed to fashion not only the first equestrian statue made by an American but performed the apparent miracle of making one that would stand unsupported on its hind legs, a feat which Leonardo da Vinci had tried to accomplish and failed. Part of Mills's success came from a very heavy tail that he put on the horse as a counterweight. When his friend Henry Kirke Brown, also a sculptor, visited Mills's studio while the model for the horse was still in plaster, he was astonished to see "this immense horse standing on its hind legs balancing himself with an enormous tail which could not contain less than a barrel of plaster. . . ."

The realism that Mills achieved and the ingenuity of his device were very much to the taste of his contemporaries, who, by and large, were more impressed by mechanical inventiveness and the details of buttons and epaulettes and harness than by what gave a piece of sculpture its monumental quality. On January 13, 1853, *The New York Times* in reporting the unveiling of Mills's achievement said, "The Washington people are in

Before CLARK MILLS modeled his "Andrew Jackson" for Lafayette Park in Washington, no sculptor had made the horse of an equestrian statue balance on its hind legs without other support. It was unveiled in January 1853 to great popular and critical acclaim. (*Library of Congress, Washington, D.C.*)

ecstasies with the Equestrian statue. . . . The first appearance of this piece of art calls forth unbounded enthusiasm." It noted, however, that "Criticism has not yet put on his spectacles. He has not yet brought its minute defects under the microscope. . . ." But nonetheless it concluded, "It was certainly a great day for Mr. Mills, and if his work encourages in our countrymen a taste for sculptural adornments to our public gardens and squares, it will prove to have been a good day for us."

The *Times* reporter spoke more prophetically than he knew. Within a few decades city parks and village squares were to blossom with bronze monuments to the great and to the fallen heroes of the Civil War. There was scarcely a hamlet that did not honor its dead with a statue held aloft on a granite base, and hardly a city park that was not adorned with a memorial or with images of illustrious Americans or noble savages. The men who made these were prominent in their day and they commanded high prices for their work—men like Leonard Wells Volk and Launt Thompson and Franklin Simmons and George Edwin Bissell, whose creations are still visible not only in public places but in museums (when they are not gathering dust in the

basements) but whose names are all but forgotten.

Not all the bronze artists who were their contemporaries have fallen into obscurity, and, for one reason or another, some are not likely to. One of these, Thomas Ball, claims a certain place in the history of the American arts less because of the art he made, though he was an unusually competent performer and famous in his day, than because he sat down in his old age and wrote his reminiscences. He called them *My Three Score Years and Ten* (he actually lived to be fourscore years and twelve), and as an account of an artist's life which spans a very large segment of the nineteenth century his book is not only illuminating about the profession of art-making but entertaining as well. Ball must have been a man of considerable charm.

Three others whose reputations remain somewhat lustrous (or, in any case, are being refurbished after a period of strong reaction against them in the general wave of discrediting what the Victorians and the Edwardians admired) have better claims to artistic eminence: John Quincy Adams Ward; Augustus Saint-Gaudens, a flamboyant character who came as close as any nineteenth-century American sculptor to the genius of Dr. Rimmer; and his friend and pupil Daniel Chester French, a somewhat lesser but nonetheless highly touted talent, much of whose work is still too recent to have been revived, as it will unquestionably soon be, by fashionable art circles. (Rimmer and Saint-Gaudens are already enjoying, if that is the word, critical revivals.) In any event, Ball, Ward, Saint-Gaudens, and French all command our attention, and it is chronologically reasonable to consider them in this order.

AN ART-MAKERS' ART-MAKER

Thomas Ball stood astride the older generation of smooth-skin stonecutters and the postwar dispensers of bronze monuments. He was born in 1819 in Charlestown, Massachusetts, not far from where Washington Allston had just begun to struggle with his unfinishable masterpiece and was bemoaning the philistinism of Bostonians. Ball's father was a "house, sign, and fancy painter," a kindly man with quickly changing moods and the eye of an artist. "Do you think," he asked his six-year-old son one day as they were crossing Cambridge Bridge, "you could ever learn to paint those waves?" Neither waves nor any other aspect of land- or seascape was ever to become

part of Ball's artistic repertory, though he was a painter of fairly expert if modest accomplishments before he became a sculptor. His father died at about the age of thirty, leaving a widow and six children, and young Thomas' first job to help support his family was in a grocery store that, as respectable emporia did in those days, also harbored a bar; there, he noted, "I received one dollar a week for my valuable services." He was a rather dreamy employee, with his enthusiasm divided between music and mechanics, and he changed jobs frequently, until he saw a "Boy Wanted" sign in the New England Museum in Boston and got a job sweeping floors, dusting the pictures, polishing the glass on the exhibition cases, and showing visitors around. The glass went mostly unpolished, but he made up for it in other ways. Museums in those days were collections of the odd, the mechanical, the artistic, and the historical—any sort of curiosity of nature or man-made gadget from two-headed calves, dwarfs, and "mermaids" to mechanical displays—the progeny of old Charles Willson Peale's museum in Philadelphia and the forerunners of the great P. T. Barnum's collection of marvels and monstrosities in New York. It was the same sort of place of innocent entertainment and natural and unnatural science that Mrs. Trollope and Hiram Powers had brought to life with their screeching and moaning and firelit version of hell in the Western Museum in Cincinnati.

This was young Ball's delight. Like Powers, he was as much mechanic as artist, and he had spent a good deal of his boyhood making toys and scrupulously accurate ship models. His first accomplishment at the museum was, as he said, "in making things 'go' that had been resting in idleness for a long time." Among the things he made go were life-size dolls of "little girls" representing the original thirteen states, each one holding a hammer and a bell. "These bells," he wrote, "were graduated to form a musical scale of an octave and a half. At the end of the row was attached a good sized hand-organ, which played all the patriotic airs, accompanied by the little girls on their bells." It had been one of the most popular exhibits, especially with country people, but it had collapsed. In a few days Ball had it ringing out again, and in a few months he had restored a "Hall of Industry" in which dozens of little figures worked away furiously at their trades, impelled by an invisible crank on the back of the display, and several other marvels of mechanical ingenuity. But his skills were not limited to mechanics. "As nature, absent minded," he wrote, "split my talent into kindling-wood, if I ever expect to set the river on fire it behooves me to make the most of every stick." He made flutes and fiddles and invented an instrument (or thought he had), a kind of harp which he discovered already existed and was called a zither. He found he had a talent for cutting silhouettes, which were popular

especially with country visitors, and he did a brisk business at twelve and a half cents for a head (a half-shilling piece was current then) and fifty cents for a full figure. To speed up the work, he bought a pantograph for $10 and soon had it paid for. It was his first excursion into the graphic arts, and he turned his hand to drawings and watercolor and decided he wanted to be an artist.

It was music, his "best and most constant friend since childhood," that provided the money for him to study drawing as a wood engraver's apprentice. He played a fiddle at the museum in the evening and worked at becoming an art-maker during the day. Engraving bored him, and he took to miniatures, for which there was a good market at $10 apiece. As a boy he had, evidently, a spectacular soprano voice, and as he grew up, already a skillful singer, he became one of Boston's most accomplished vocal musicians. During the early days of his career as a painter he helped to support himself with singing in church choirs, and he had the distinction of being chosen to perform the title role in the first American performance of Mendelssohn's oratorio *Elijah*. By the time he was twenty-one his paintings were exhibited at the Athenaeum in Boston and by the Apollo Association in New York, and in 1848 the powerful Art Union had smiled upon the efforts of the young man from Boston. By then he was trying his hand at history painting with such works as "Christ in the Temple" and "A Scene from *King Lear*." For the latter he got the splendid sum of $250 and considered himself launched on a career.

It was a disappointment in love that turned him from painter to sculptor. A friend, the painter George Fuller, introduced him to a young lady of "glorious color in hair and flesh," a blonde with regular features and of a stature that he found perfect as a model for the "ideal" figures in his history pictures. She kindly deigned to pose for him whenever he asked her, and the more he gazed on her and the more responsive she was to his requests to pose, the more he found himself stricken with what he thought an undying love. He finally declared himself and was brushed aside. "I woke the next morning," he wrote, "amazed that I felt so calm, but weak as if just recovering from a fever." For therapy he took turpentine to the picture he had painted of her and put it on the floor and with a piece of pumice turned her into a "muddy veil." "So much," he said, "for my last two months' work." A week later, unable to paint but restless to get to work, he went to see a friend named King, a sculptor, who furnished him with a piece of clay as big as his two fists. With sticks that he had whittled into sculptor's tools he fashioned a little head and the beginning of an illustrious career. All that remained of his love was a "not unpleasant melancholy in heart."

When P. T. Barnum brought Jenny Lind, the "Swedish Nightingale," to Boston, it was inevitable that Ball, the singer, should be there and perhaps more than most of "the multitude" which came to hear her he was engulfed in admiration of her charm and skill. The next day he gathered all the photographs of her he could lay his hands on and modeled a small bust that, he said, was his first piece of sculpture to "go out into the world." It was an immediate success, and he could not make plaster copies of it fast enough to meet the demand for them. In spite of his having spent $30 to patent the bust, an "Italian pirate in New York" flooded the market with copies "at starvation prices." This was not his only experience with plagiarists. He made two small busts of friends of his in Providence, Rhode Island, one of the ex-mayor and one of the mayor's brother-in-law. One was tall and slim, the other robust and heavily bearded, and they were so pleased with what Ball contrived that they each wanted a dozen copies to give to friends and relatives, a not uncommon practice in those days before the cabinet portrait photograph was commonplace. Ball ordered the busts to be made by an Italian in New York who specialized in such work, and not long after this the bearded gentleman encountered on a Providence street an "image vender" carrying on his head a board covered with little statues. Among them he spotted his own image and that of his brother-in-law. "Who is that?" he demanded, pointing to the bust of himself. "That," the vender said, "is the man that was hung the other day in Boston; and that thin one is the man he killed." Ball admitted that there was an undoubted resemblance between the brothers-in-law and the murderer and his victim. "Imagine," he said, "one's surprise and indignation at meeting one's own portrait peddled about as that of a murderer, and only a few rods from one's own house."

Ball made a good thing for a while of the smaller-than-life-size-portrait business, but he was moved by the features of Daniel Webster, a personal hero of his, to make a somewhat larger-than-life portrait of him, his shoulders draped in a crisp bit of cloth. By luck (Ball's, not Webster's) the bust was completed just a day or two before Webster died at Marshfield, a town on the coast south of Boston. "It was pronounced a wonderful success," Ball wrote, "and numerous demands were made for casts of it. I put up a subscription paper in front of it, and in a very few days had nearly a hundred names upon it." Chester Harding, the portrait painter, was among the subscribers. This was in 1853, when Ball was thirty-four.

Ball fell in love again, this time requited, and he prospered sufficiently to marry. He made a full-length figure of Webster about thirty inches tall, which he sold to a dealer for $500 with the rights to its reproduction. (It

was, Wayne Craven says in his excellent *Sculpture in America,* one of the earliest sculptures to be mass-produced and patented; it preceded by seven years the first of the greatly popular Rogers Groups.) The dealer, Ball recorded wryly, "must have made five thousand dollars out of it, at the very least." In any event, Ball was prospering and had managed to set aside $2,000 to go to Italy, a sum which sufficiently impressed the father of his intended bride so that he permitted her to marry the promising young sculptor and locally famous singer.

Florence rather than Rome attracted Ball. Hiram Powers was there, basking in the fame of his "Greek Slave"; his studio was already a tourist attraction, and his wife's weekly evening receptions were crowded with English and American visitors who listened to literary conversation and music and feasted decorously on tea and cakes. Joel Hart, another sculptor to whom Ball had a letter of introduction, helped Ball find a studio with a room next to it for a stonecutter. He had brought several plaster busts with him from Boston with commissions to have them rendered in marble. As one would expect, he set out to make "ideal" sculptures in the current mode, first a "Pandora," for which "six or eight" models posed at various stages. ("I must say," he wrote, "I was disappointed at first at not finding the models all Venus de Medicis.") He also tried his hand at a "Shipwrecked Boy," but neither of these statues ever satisfied him, and in any case he could not afford to have them cut in marble; by temperament he was not a neo-classicist but a naturalist. He had little sympathy, however, for the realists, who, he thought, were seeing too much of the "most hideous phases of Nature . . . gloating over them as something new and interesting. . . ." "Purity has had her day," he wrote; "it's time she retired and made room for nightmares and nastiness." Noble reality was one thing to him, and searching realism quite another, though there was little enough of it to bother him in the art of America of his time.

Ball's first stay in Florence lasted about four years. He came home to Boston in 1858 and worked there until 1866, busy and increasingly successful. The years in Florence had been a time of just scraping along, but once home he turned out a series of successful portrait busts of illustrious citizens, and he was commissioned to make relief panels for the pedestal of a statue of Benjamin Franklin by Richard Greenough to stand in front of Boston's City Hall. Another commission, a bust of the famous preacher Henry Ward Beecher, took him to New York, where Beecher insisted that Ball get to Brooklyn each morning to have breakfast with him, and then, while posing, the preacher dictated his sermons to a shorthand reporter. The pieces which pleased Ball most from this period and which spread his

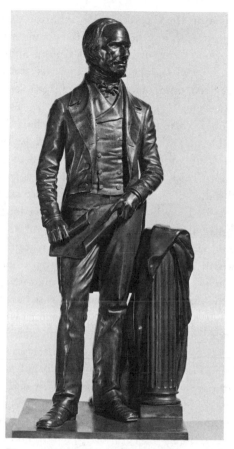

Henry Clay's friend, the statesman and orator Edward Everett, gave THOMAS BALL an enthusiastic testimonial for his statuette of "The Great Pacificator" when he visited Ball's studio in Boston in the summer of 1858. (*North Carolina Museum of Art, Raleigh*)

fame widest were a small, full-length figure of Henry Clay (he thought it inferior to his Webster) and the equestrian statue of George Washington in Boston's Public Garden, a commission for which he had yearned but never expected would be awarded to him.

Ball was still in Florence when he read in an American paper that a group of Bostonians were planning to finance an equestrian Washington, and he started at once "to study the anatomy of the horse." News soon followed that Thomas Crawford, who had made the figure of "Armed

Victory" that stands atop the Capitol in Washington, had been selected to do the job, and Ball gave up any hope that the commission might come his way. But the unfortunate Crawford died of a brain tumor in Paris, and the project was momentarily abandoned. Ball, however, was sure in his heart that it would be revived, and, as he said, "I resolved that I would be prepared for such an event."

His preparation involved making a model half life-size, which he showed to a committee of artists when he got back to Boston. They were enthusiastic and in turn got together a committee of locally prominent citizens who set out to raise the money for the full-scale sculpture. The "colossal," as Ball called it, required a tremendous studio, and since he could not find one, he had one built. It was sixty feet long, forty feet wide, and thirty feet high, with a large door at one end so that as the work progressed Ball could view it from a considerable distance. First he made a plaster cylinder, which was the barrel of the horse's body. This was constructed on a horizontal timber fastened to the top of an iron post about ten feet high. Then on the platform from which this rose he marked the position where the horse's hoofs would stand and bent irons which reached from the platform to the body; around these he roughed out the legs in plaster. "After this," he wrote, "the building up of the neck and head of the horse was a simple matter." The modeling, however, was not a simple matter. He mixed his plaster in very small quantities at the far end of the studio from the statue, so that he could see it whole and decide precisely where he needed to apply the plaster and model it. Plaster dries quickly, which explains why he mixed only a bit at a time. "You can imagine how many miles I must have walked backward and forward the length of my studio," he wrote.

He completed the horse, except for final finishing, before he began the figure of the rider, which initially he made as a straw man and then covered with plaster. He oiled the plaster saddle on the horse so that the figure of the rider could be hoisted off to be worked on more conveniently. The work, complicated as it would have been under the very best conditions, was made still more difficult by keeping the temperature of the studio above freezing in the cold Boston winter and by the odd fact that there was a firearms factory near the studio where three hundred rifles at a time were tested for the Union Army. The concussion shook the studio, and the first time it happened the shock broke the plaster on all four of the horse's legs. Fortunately, the proprietors of the factory were sympathetic with Ball's plight and built a new platform for the statue, so constructed that it did not transmit the shock from the ground to the horse; even if the noise of the blasts did not abate, the work could still proceed. When the sculpture was

completed it was sixteen feet long and sixteen feet high. Ball did not work on it alone. A young sculptor named Martin Milmore, who had arrived one morning at the vast studio and asked if Ball would take him as a pupil, helped with the work. He was a gifted young man who, as we shall see, left a deep impression on the members of the sculpture fraternity. When the plaster was completed a Mr. Mossman came from the Ames foundry in Chicopee, "cut the model in pieces, fitting them with the greatest precision as he proceeded, ready to be moulded without loss of time." But the war demanded bronze for cannon, and the casting of the colossal Washington had to wait until 1869. It cost the citizens of Boston $42,400, a quarter of which was put up by the city; another quarter was raised by giving a fair, and $12,000 came from "donations from friends." The remainder was accrued interest and a flat donation of $5,000 from "the Everett Statue Committee," a group who had raised funds for a quite other statue. The Washington was unveiled with considerable pomp in the Public Garden in the late afternoon of July 3, 1869.

Between the time Ball completed his work on the Washington and its public appearance he and his wife and small daughter went back to Florence, taking with them several portrait busts to be cut into marble. While he was there he made one of his best-known pieces, an "Emancipation Group" of a standing figure of Lincoln and a kneeling freed slave, an idea that had been "impatiently bubbling" in his brain since the news reached Europe of Lincoln's assassination. It is a dramatic and vigorous piece and in a revised bronze version stands larger than life in Washington. Ball, unable in Florence to find a model that suited him, posed for the slave himself. "I did not require an Apollo," he said, and "by lowering the clay so that I could work upon it while in a kneeling position, and placing a looking glass on each side of me, I brought everything quite conveniently before me." He thought the nude figure one of the very best he ever made. The original head on the statue was an "ideal" one, but in the final version he used the head of Archer Alexander, famous as the last slave to be recaptured under the Fugitive Slave Law.

Ball's reputation by the time he returned to live more or less permanently in Florence assured him of all the commissions he could manage. At the suggestion of Hiram Powers, he bought a vineyard near where Powers was building a villa and built one for himself; he settled down to become one of the prominent Americans in that tea-drinking colony of expatriates who were visited by the Trollopes and the Brownings and William Dean Howells. Ball kept two Italian stonecutters busy turning his clay and plaster busts into immortal marble. He did large pieces and small, monuments to

THOMAS BALL was an ardent and active abolitionist who sculpted his "Emancipation Group" (also called "Freedman's Memorial") in the 1870s. Casts of it are in Washington and in Boston. (*National Park Service, U.S. Department of the Interior*)

distinguished patriots and professionals and ideal statues of "Eve Stepping into Life" and "Love's Memories" and other such sops to Victorian sensibilities. He had become, by the time he returned to America, a grand old man of sculpture, not as famous perhaps as William Wetmore Story and certainly not as well known as Hiram Powers, who died while Ball was still living in Florence and to whom he wrote an epitaph in verse (or doggerel) which started with the lines, "Found rest within this hallowed retreat/One of the noblest hearts that ever beat." As a sculptor he was not a match for John Q. A. Ward, a fellow naturalist, and to the younger generation dominated first by Saint-Gaudens and then by French (who was his pupil),

he was passé. It would be unjust to this exceedingly pleasant and modest man, however, to underestimate either his very considerable prowess or his popularity with the public and with his peers.

DEAN OF THE BRONZE AGE

As Ball stood astride the neo-classicists of the Greenough-Powers persuasion and the naturalists like Henry Kirke Brown and John Quincy Adams Ward, so Ward started with both feet in naturalism and ended with at least a finger in the kind of romanticized realism purveyed by Saint-Gaudens and Daniel Chester French. Ward was happiest when his feet were most firmly planted in observable truth. As the interviewer from *Harper's* said, "Mr. Ward goes direct and often to nature; he forgets himself in his studies of the external world." When he decided to make a large statue of an Indian hunter from a small clay model he had shaped as a young man, he was not satisfied until he had taken a trip to the West and the Northwest so that he could see for himself precisely how the Indians of those regions lived, how they hunted, how they moved. The results of this kind of conscientious research into verifiable facts were certainly a far cry from what had been passed off as an Indian by Greenough in his group for the Capitol called "The Rescue." Ward had some of the anthropological intensity that caused the painter George Catlin to spend so much time among the "savages" and to record their lives with such relish and precision.

It was Ward's consummate ability to make the real look real and at the same time noble that made him the most revered sculptor of his day. Everybody understood him, as everybody understood the anecdotal little groups by John Rogers; everybody admired his skill, the amount of money he made, his friendships with the rich and famous, and his lack of "side." He was made in America for Americans, and he democratically believed that art belonged and spoke to everyone. "The masses of the people," he said,

> if they don't get the whole of what an artist has expressed, certainly get a part of it. I have never yet seen a really good art work go a-begging in New York. We artists sometimes whine about the lack of appreciation, but in nine cases out of ten the cause of our sorrow lies in ourselves. A true work of art will meet

A crowd of "three or four thousand" gathered in Union Square in New York in 1856 to watch workmen hoist Washington into the saddle of this equestrian bronze by HENRY KIRKE BROWN. (*Photo Art Commission of the City of New York*)

the wants and therefore stir the feelings of the ordinary human heart. It is sure to win recognition.

This is not a sentiment one hears in the twentieth century from American artists.

Ward came from the heartland, and his father was a farmer. He was

born in Urbana, Ohio, in 1830 and his father hoped he would one day take over the farm or, failing that, become a physician. But young Quincy, as he was called, liked to make things, and as a boy he amused himself modeling little figures of men and animals in clay he got from a potter's shop near his home. He escaped to the art world earlier and under better auspices than most young men ambitious to be artists. An older sister who had come home from New York for a visit took his side and said she would arrange to have him meet Henry Kirke Brown, whose studio in Brooklyn was in her neighborhood. Quincy, then nineteen, showed the distinguished sculptor some of his models; Brown was impressed and agreed to take him on as a paying pupil. Within a short time Ward was working as Brown's paid assistant, and before long they were no longer master and pupil but fast friends, accomplices, fishing companions, and, finally, friendly rivals for commissions.

When he was twenty-six Ward left Brown's studio to set up on his own, and, since Washington was where the great debate of the day was going on, he headed for the capital and for some success in getting commissions to make portrait heads of politicians. These were forthright men, and Ward sculpted them in a forthright way—true, unidealized portraits of Hannibal Hamlin, who became Vice-President to Lincoln; Senator John Parker Hale of New Hampshire, the man who became Jefferson Davis' Vice-President of the Confederacy; Alexander H. Stephens; and others equally prominent in the uneasy capital city. But Ward had, as happens to artists still, an urge to get back to New York, where the arts were lively and where there was a community of Upper Bohemians of common cultural interests. New York was more than that. It was a teeming metropolis bursting with energy and hope-filled immigrants, with vitality and ambition, already on its way to becoming one of the great cities of the world. Its harbor was filled with clipper ships and steamers and its waterfront with bars and brothels. Toughs swaggered on the Bowery and toffs in tall hats and ladies in enormous crinolines and bonnets rode in their elegant carriages drawn by fine horses on Broadway. It was one of the busiest and most hazardous boulevards in the world, so busy and crammed with drays and omnibuses and carts that it took a body half an hour with his life in his hands to get across it on foot, and it frightened visitors from the country half out of their wits. The face of the city seemed to change every day. "There is scarcely a block in the whole of this fine street," the aging Philip Hone said of Broadway in 1850, "of which some part is not in a state of transmutation." It was the beginning of the dreary seepage of brownstone over the city, but brown was considered elegant and genteel then.

But not all was genteel by any means. To the countryman New York

was the great wicked city where all the stolid virtues were abandoned in the search for sensation, where millionaires wasted their money on lavish parties in their ostentatious houses, and where visitors were parted from their fortunes in emporia like a new palace hotel, the St. Nicholas, which opened on Broadway in 1853. A newspaper reporter called it "a display of barbaric splendor" and was not wide of the mark.

If New York was barbaric in its rampant prosperity, it was also on its way to becoming the intellectual center of the nation, Boston to the contrary notwithstanding its early eminence, its Edward Everett and Emerson and Longfellow, its Athenaeum and Harvard College. New York was the center of book publishing and the home of *Harper's New Monthly Magazine,* which first appeared in 1850 and not long after boasted the largest circulation of any magazine in the world. But from Ward's point of view New York was also the center of the art world, the home of the Art Union and the National Academy of Design, of innumerable painters and architects who were changing the American vision, of Cole and Morse and Kensett and Church, of Upjohn and Renwick and A. J. Davis and Richard Morris Hunt, and of patrons like Luman Reed and John Taylor Johnston, who opened his private gallery to the public and later became the first president of the Metropolitan Museum. There were poets as unalike as the unfamous Walt Whitman in Brooklyn and Bryant, perhaps the most publicly visible poet America has ever produced, with his hand on the cultural tiller of New York.

More than any other city in America it had what most attracted art-makers—it had the cosmopolitanism of a great seaport, a strong sense of civic pride, and the desire to ornament the city; it had, moreover, wealth enough to pay for the adornments that are thought to be a part of culture. By the 1850s artists were welcome as guests in many of the most socially respectable and wealthiest houses; social status meant something to an artist in those days that it does not today. Artists, indeed, had authenticated their respectability by forming, together with other professional men, the Century Association, a club in which lawyers and physicians were invited to join with artists and authors and architects in the exchange of high thoughts, conviviality, and the consumption of large quantities of oysters and cheese. Ward's mentor, Henry Kirke Brown, was among the founders of the club, as were Asher B. Durand, Bryant (of course), Daniel Huntington, Henry Tuckerman the critic, Gulian C. Verplanck the patron, and a couple of dozen other movers and shakers in the arts. Ward became a member of the Century in 1864 and in due course its vice-president.

But before he did he had made a considerable name for himself. His

Two versions of "The Indian Hunter" were made by JOHN Q. A. WARD—this small one, sixteen inches high, and a life-size one in New York's Central Park. It launched Ward's considerable reputation. (*The New-York Historical Society, New York City*)

"Indian Hunter" first called general as well as critical attention to his work, and it deserved the enthusiasm it commanded. The half-crouching figure, restraining a dog with its right hand, is filled with real vigor, a sense of alert power in a body tense with anticipation. Though it is a formal triangular composition, it is anything but static; it has a sort of restless reality with enough detail of costume and fur and weapons to satisfy the most ardent anecdotalists but at the same time simplified so that the detail in no way detracts from the monumental character of the piece or dimin-

ishes the tension which Ward built into the figure. Before he went to the West to refine his knowledge of the Indians, the statue in its small version had already caused some stir, and a writer in *The New York Times* in 1863 said that it was "a great refreshment after our plumed, bald-headed, Roman-nosed and immemorial acquaintance, the Indian of English poetry, of bank notes, school orations and the stage." It was also rather a relief after Longfellow's highly romanticized *Hiawatha*, published eight years earlier —or so a few people thought. The final plaster version of "The Indian Hunter" was so greatly admired that a fund of $10,000 was raised to pay the sculptor and to have it cast in bronze. It is now in Central Park in New York, and another casting ornaments Delaware Park in Buffalo, New York. Many years later Lorado Taft, a sculptor of the next generation, recorded Ward's delight in his first "ideal" piece. "How much this initial piece meant to the young sculptor," he wrote, "is evident when Mr. Ward talks of it today. His eyes gleam; he illustrates the expression—the gliding agile step. He is as convincing as his statue."

Between the time Ward first modeled the Indian and the time it was cast in bronze, he fashioned another piece that attracted considerable attention and was greatly praised by his contemporaries, though when it was first shown at the National Academy of Design it was tucked away in an alcove, "dimly lighted, crowded into a corner." The piece was called "African Freedman," and a critic for *The New York Times* found it a blessed relief from those "emasculations . . . called, incessantly, 'Hope,' 'Faith,' or 'Innocence' to suit the pleasure of the purchaser, and may be changed at his sweet will, so that one statue can be made to do service for a whole gallery of sentiments." The piece depicted a slave, a nude seated on a stump holding in one hand the chain he had broken to escape. "It symbolizes the African race of America—the birthday of a new people into the ranks of Christian civilization," Jarves wrote, and in one of his infrequent bursts of enthusiasm about any art that was American he said, "We have seen nothing in our sculpture more soul-lifting, or more comprehensively eloquent." Ward was deeply involved in the abolitionist movement, as Thomas Ball was also, and his "Freedman" caused much the same kind of sensation that Rogers' first successful group, "The Slave Auction," did when he had a Negro boy sell copies on the streets of New York in 1860.

After the Civil War, Ward encountered the full delights of success. It was partly the demand for monuments to the war's heroes and partly a national desire to ornament public places with bronze that made him not only famous but as prosperous as any sculptor in the world in the 1870s and '80s. The list of his commissions is long, but the quality of the statues is

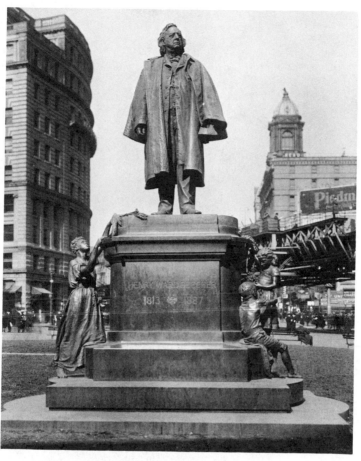

Henry Ward Beecher, of whom JOHN Q. A. WARD made this
memorial in 1891 for Brooklyn, weathered a fierce marital scan-
dal to retain his position as the greatest preacher of his day.
(*Photo Art Commission of the City of New York*)

uneven. He was obviously most in command of his talent and his medium
when faced with the actual rather than the ideal and with a living model
rather than the problem of re-creating a past hero from secondhand
sources. He performed less well, for example, when he modeled a "Union
Soldier" as a monument for New York's Seventh Regiment (a generalized
hero now in Central Park and the prototype for war monuments almost
everywhere) than when he confronted a vigorous figure like Henry Ward
Beecher, one of his greatest triumphs both sculpturally and personally.
(Fifteen thousand people turned up and sang "Love Divine, All Love
Excelling" and cheered lustily when the piece was unveiled in front of

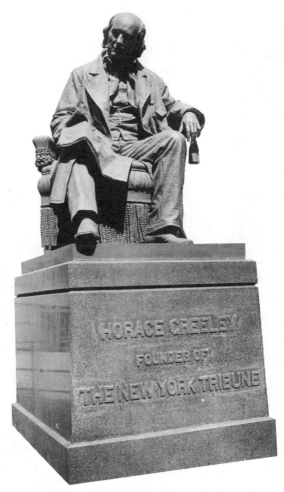

JOHN Q. A. WARD, the dean of monument-makers of the second half of the century, modeled this portrait of the famous editor Horace Greeley for the Tribune Building. It is now in City Hall Park in New York. (*Photo Art Commission of the City of New York*)

Borough Hall in Brooklyn in 1891; the piece was worth cheering for.) The pedestal on which Beecher stood in his Inverness cape with his chin thrust out was adorned with delightful figures, a woman on one side looking up and a pair of children on the other engrossed in each other, genre figures with much the same kind of charm with which Rogers endowed his groups but modeled with an even surer touch. The monument that Ward made for

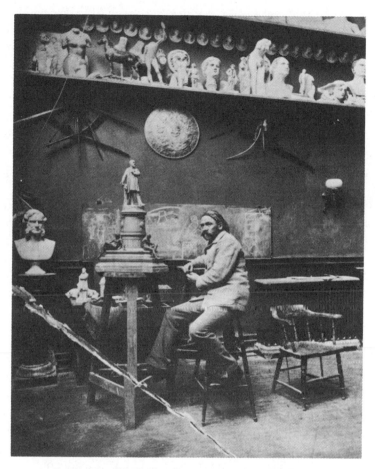

JOHN Q. A. WARD prospered as few American sculptors ever have, and few art-makers were as popular with their colleagues as he. This is the studio he occupied in the 1880s in New York. (*Photo Archives of American Art*)

Washington of President Garfield was less successful; the figures at the base of the truncated column on which Garfield stands are rather mannered; Ward had some trouble with Garfield's face, one biographer noted, because his "good looks made him a difficult subject for modern portraiture"—a nice comment on the aesthetic problems of naturalism!

One can walk in many parts of New York and encounter the pleasant products of Ward's hands. In City Hall Park sits "Horace Greeley" taking his ease in an upholstered and befringed chair; he was moved there from the old *Tribune* building, the offices of the newspaper of which he was the

founder and editor, just before America got involved in World War I. In front of the Sub-Treasury Building on Wall Street stands Ward's "George Washington," there by special permission of Congress. Just down the block is the sculpture he designed for the pediment of the Stock Exchange Building in his last years; executed by his assistant Paul Wayland Bartlett, it enjoys the title, "Integrity Protecting the Works of Man." There are four of his pieces in Central Park—a "Shakespeare," a "Pilgrim," and the two already mentioned, "The Indian Hunter" and the Seventh Regiment memorial. Still other pieces are secluded in the basements of museums in the city, perhaps soon to be dusted off and exposed again to public gaze. Ward must be ripe for revival.

Prosperity brought with it a new style of life for the sculptor. He engaged his friend Richard Morris Hunt, a fellow member of the Century, to design a house for him in 1882. It had a very large studio and a frescoed reception room in the Pompeiian style. It was on West 52nd Street in New York and became a celebrated gathering place for artists and writers, editors and architects. Scarcely an honor that an American artist could achieve did not befall this adroit, charming, and friendly man. He was elected a member of the American Academy of Arts and Letters and of the American Institute of Architects, an uncommon recognition for a sculptor. When he died at the age of eighty he was still a commanding figure among the art-makers of America. "He was a fine figure of an American," one of his Century Club friends wrote of him, "supple in his frame, in his later years a trifle bowed, but still erect in spirit, and self-reliant in bearing. His brow was massive, his eyes keen and observant, his nostrils full and broad, and there was a play about his mouth and chin which argued the nervous readiness of a man able to uphold the beliefs which he held." This, of course, sounds like the epitaph it was, but a comment by Lorado Taft, who conversed with Ward when he was seventy-three, has the ring of delight. "One feels after a talk with him," he wrote, "that the average human being is half asleep."

THE LION OF THE BRONZE AGE

Henry Kirke Brown, whose beneficence and friendship launched Ward on his career, was no match for his pupil, and Ward, who was responsible for

Augustus Saint-Gaudens' first important commission, was in turn a less talented art-maker than the beneficiary of his kindness and interest. In 1876, the centennial year when the nation was filled with pride for the enormous accomplishments of its industry, its westward expansion, its railroads, and its prowess on the high seas, a committee of New Yorkers decided that the moment had come to erect a memorial to Admiral Farragut, the hero of New Orleans and Mobile Bay. The fact that at that same moment a frightful financial depression had sent a number of banks to the wall and caused the failure of some 50,000 businesses did not deter the Farragut Monument Association from its determined course. As one would expect, the commission was offered to Ward; a monument of such eminence demanded a sculptor of equal eminence, and Ward was the obvious first choice. Saint-Gaudens, however, was also on the committee's list of possibilities, and as Ward was extremely busy with commissions, he urged the committee to give the job to the young sculptor. Saint-Gaudens was twenty-eight at the time.

Saint-Gaudens was not only an extremely gifted art-maker (some critics believe that he was the most gifted artist America produced in the nineteenth century) but also a flamboyant character of great personal charm and good looks, filled with enthusiasm, conviviality, and a sense of his own powers. His father was a Frenchman and his mother an Irishwoman, and they came to New York when Augustus was an infant. When he was about thirteen his father, a shoemaker with a shop right next door to the Venetian palace that was the National Academy of Design, asked his son what he wanted to work at, and the boy said, according to his *Reminiscences,** "I don't care, but I should like it if I could do something which would help me to be an artist." Children, of course, do not talk quite like that except in retrospect, but young Saint-Gaudens had displayed enough skill with a pencil to make his father, of whom he wrote with great affection, believe that his son's ambition should be taken seriously. He got him an apprenticeship with a cameo-maker, a man named Avet, whom Saint-Gaudens intensely disliked but who taught him a skill that served him in many ways until he was finally established as a sculptor of the first order. He worked for three years cutting stone cameos before Avet fired him one day in a pet over crumbs from lunch left on the floor. Avet, realizing he had lost a good thing, came to the Saint-Gaudens shoe shop to try to hire the boy back at an increase in wages of $5 a week. It was a lordly raise for a boy in

* *The Reminiscences of August Saint-Gaudens* in two volumes was edited by the sculptor's son, Homer Saint-Gaudens, with a good deal of supplementary comment on his life and the art of his times. It is a very revealing and readable book but, unfortunately, out of print. It was published in 1913.

those days, but the young man would have none of it, and his father, delighted with his son's courage and independence, found him another job with another cameo-cutter who was kindness itself.

His new employer was interested in the boy's ambitions and let him spend an hour a day working with clay. In the evenings Augustus went to drawing classes at the Cooper Union (his father was the Cooper family's shoemaker) and he worked there often until eleven at night, full of energy and a sense of his powers. "I can remember thinking in public conveyances," he wrote of his youthful conceit, "that if the men standing on the platform around me could realize how great a genius was rubbing elbows with them in the quiet-looking boy by their side, they would be profoundly impressed." When he was nineteen, his father gave him the money to ship by steerage to France to further his studies in art.

His account of his days as a student in Paris fairly bounces with good spirits and amusements, with outings and practical jokes. He was the happy possessor of a highly marketable skill; cameos were greatly in demand, and he was apparently as accomplished as anyone at cutting them. He had little trouble supporting himself at just the level necessary to allow him the time he needed for his drawing classes and his modeling. Nine months passed before he was admitted to the Ecole des Beaux-Arts, but during the interval he studied in one of the many small ateliers. When it was announced in an official document from the American minister to Paris that he had been accepted by the Beaux-Arts, he joined the classes of Jouffroy, which had a reputation for producing prize-winning students in quick succession. He drew and modeled from the nude until late in the evening, and then went to a gymnasium and exercised violently. "At this time I was active beyond measure," he wrote. He swam and hiked as far from Paris as the seaport of Dieppe. He went to Switzerland with a knapsack and 150 francs, as far as Strasbourg by train and then to Basle on foot, hungry for sights and excitement. When the Franco-Prussian War broke out, he decided to join either the ambulance corps or the army, but was dissuaded by a letter from his mother "so pathetic that my courage failed."

His career as a sculptor began to take on aspects of reality when he arrived in Rome in 1870. He was twenty-two, filled with excitement by the visual seductions of the Eternal City, but Rome was never the trap for him that Ward so strongly warned against. The "cursed atmosphere" that Ward said "kills every artist who goes there" caught Saint-Gaudens briefly but by no means fatally in its miasma of neo-classicism. He was soaked in the French style by his three years of study in Paris, and smooth-surfaced goddesses were not to his taste. He felt called upon, however, to create an

ideal piece; he had greatly admired Ward's "Indian Hunter" and decided on Hiawatha as a suitable subject to establish a reputation for himself. The result, which is in marble in Saratoga, New York, is a pensive Roman-Indian seated on a stump and carrying on his smooth shoulders the burdens of his race. It is expert, but a far cry from Ward's vigorous "Indian Hunter" and just as far from what Saint-Gaudens achieved when he escaped from the "cursed atmosphere" and became his own master. Saint-Gaudens supported himself by cutting cameos in Rome, where jewelers paid him better than they had in Paris, where food and rents were cheaper, and where, like the rest of the American artists in Rome, he drank coffee late at night at the Caffè Greco. He seems not to have had much to do with the Storys or Miss Hosmer or the others of that (to him) old-fashioned group. He got a few portrait commissions from Americans while he was in Rome and orders to make copies of Roman busts. He was nearly always broke, occasionally the victim of the Roman fever, but on the whole he enjoyed himself with his usual exuberance. After two years he went back to New York.

He walked into his father's shop unannounced and to great rejoicing. For the next two years he kept himself busy with portrait busts, busts of ancient philosophers, and odd jobs of design. It was a struggle; money was scarce and patrons were hard to come by. He headed back to Rome with a commission to make a sculpture called "Silence" for the Masonic Building at 23rd Street and Sixth Avenue in New York. "The less said about that sculpture the better," he wrote to a friend. The man who had commissioned it had suggested that the figure be done in the Egyptian manner, but Saint-Gaudens had written him, "I have . . . got all the necessary information for the Egyptian figure in case you wish it. But I very strongly prefer what I have done. . . . Beside, the subject being abstract, I think it better after all not to follow any exact style, for the reason that Silence is no more Egyptian than it is Greek or Roman or anything else. I think in that case 'Le Style Libre' is the best." Here, with a vengeance, was revolt against costumed anecdote. This was illustration of abstract ideas, not of sentiments adorned with fussy buttons and bows and little marble chains in the manner of Rogers or of Powers. Something new in subject matter was brewing which eventually turned into symbolic figures of "Justice" and "Victory" and "Peace," and, as Craven says, "Silence" was "the prototype for the many allegorical and personifying maidens that were to follow in the next decades."

While he was in Rome, Saint-Gaudens had a hopeful eye on the opportunity of exhibiting at the Centennial in Philadelphia. He modeled "Mozart, nude, playing the violin" evidently for the fun of it. "Why under

heaven I made him nude," he wrote a friend, "is a mystery." Another piece
was a "Roman slave holding young Augustus on the top of a Pompeian
column and crowning him with laurel." He recalled that a Swiss architect
friend said that it "looked like a locomotive." But his ambition to exhibit at
the Centennial was realized; his "Hiawatha" and a bust of Senator William
M. Evarts were there along with pieces by Story and Randolph Rogers and
others, but they caused no such sensation as, for example, did the "Death of
Cleopatra" by Edmonia Lewis, the Negro sculptor, or even Daniel Chester
French's "The Minute Man of 1776." Saint-Gaudens' reputation, even if it
had not yet caused any public stir, was growing with his professional
colleagues.

With his contemporary colleagues, that is. He was not so highly
regarded by the members of the National Academy of Design, and when a
piece of his was rejected for exhibition in the annual show in 1877, he was
infuriated. There had been a movement headed by Richard Watson Gilder,
who became famous as the editor of *The Century Magazine,* to start a new
artists' organization because, as Gilder said, "the old academicians were
carrying things with a pretty high hand." Gilder's wife, the painter Helena
DeKay, together with John La Farge, Abbott Thayer, William Morris
Hunt, Albert Ryder, and several others whose paintings had been rejected
by the Academy in 1875, had organized an exhibition at the Fifth Avenue
showrooms of Cottier and Company, and it had received some favorable
notice in the press. Saint-Gaudens, however, was not interested in joining
this group until he, too, met with a snub from the Academy. When they
turned down a piece he had modeled in Rome (he some years later admitted
that it was not much good), he went in fury to Gilder. Gilder summoned
several other artists to meet at his wife's studio, and then and there they
organized The Society of American Artists. In a few months it had ex-
panded and became the American Art Association, with Walter Shirlaw as
its president, Saint-Gaudens as vice-president, and Louis C. Tiffany as
treasurer. This defiance was nothing compared with the artistic revolutions
of the twentieth century, but it was a healthy flexing of young muscles when
it happened.

There is little to be gained from following Saint-Gaudens back and
forth across the Atlantic, a trip he frequently made. He married in 1877
and took his bride to Paris, where he set to work on a relief of the "Adora-
tion of the Cross by Angels" for St. Thomas's Church in New York. His
friend John La Farge was in charge of the interior decorations of the
church, and the piece that Saint-Gaudens produced (a writer in *Harper's
Magazine* described it as "one of the most important and beautiful works in

John La Farge, painter and maker of stained glass, persuaded SAINT-
GAUDENS to undertake ''The Adoration of the Cross'' for St. Thomas's
Church in New York City. It was destroyed when the church burned
in 1905. The only records of it are engravings, such as this one from
Harper's Magazine. (*Collection of the author*)

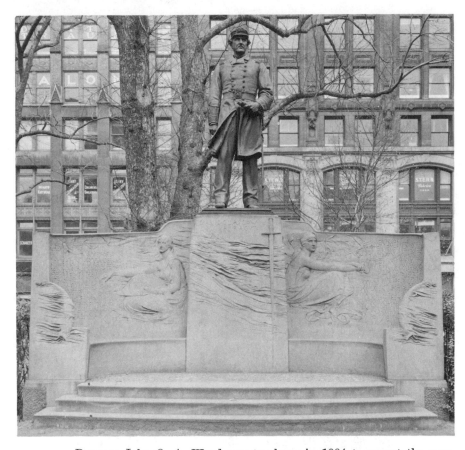

Because John Q. A. Ward was too busy in 1884 to accept the commission for the Admiral Farragut Memorial, he recommended the promising young AUGUSTUS SAINT-GAUDENS for the job. Saint-Gaudens' friend STANFORD WHITE, the architect, designed the base. (*Photo Art Commission of the City of New York*)

the country") marked him as the most promising young sculptor of his day, "superior in technical skill" and "moved by a genius thoroughly trained in the best modern school of plastic art, that of Paris. . . ." Unfortunately, the piece is known today only from engravings; St. Thomas's burned in 1905. From Saint-Gaudens' point of view, however, the relief changed his fortunes. From the time it was unveiled, he was never without commissions.

The Farragut monument, the commission that Ward had turned his way, was his consuming project once the St. Thomas's relief was done. He worked on it with his friend, the architect Stanford White, who designed the base for it as he did for a number of other monuments that Saint-Gaudens

sculpted. He was troubled by the problem of how to cope with "our infernal modern dress" with its fussy details and clumsy shapes. It was not easy to make a hero look heroic in what were then known as "tubular clothes," especially if he were not on a horse, and admirals were rarely equestrian except in victory parades. Farragut stands on his pedestal as though on the bridge of his ship, his coat blowing in the wind, his binoculars in his hand, and he gazes at some point in the far distance. The base of the statue was not at all the standard granite pedestal. White designed a wide base on which Saint-Gaudens made two ideal female figures in relief, tying them together, so to speak, with flowing abstract drapery. The effect has some of the character of the Pre-Raphaelite painting of Rossetti and Burne-Jones and a hint of Art Nouveau, which came into being just a few years later in the 1880s. Here was something Quincy Ward would not have conceived of as a realist nor Story and his ilk as neo-classicists: this was naturalism and the ideal combined, the pragmatic and the visionary, and perhaps the more American for combining hard fact with a frosting of idealism. In any event, with this work Saint-Gaudens opened a new field of exploration for sculpture in America which was to be more or less supreme until well into the twentieth century.

Saint-Gaudens carried the concept of naturalism combined with the ideal still further with the Shaw Memorial in Boston, in which the figure of the colonel who led his Negro troops in the Civil War rides his horse not ahead of but accompanied by his infantry, and above them floats in relief a figure of a woman with palms and laurel. His son wrote that "the flying figure drove my father nearly frantic in his efforts to combine the ideal with the real," and evidently he never was entirely satisfied with her. Years later he complained that "the flying figure was not mysterious enough." When a friend took exception to the figure ("Your priestess merely bores me" he said), Saint-Gaudens was convinced that the photograph of the monument which he had seen was misleading. The idea, he was sure, was sound. "After all," he said, "it's the way the thing's done that makes it right or wrong, that's about the only creed I have in art."

If that was his creed, which on the face of it seems to be concerned only with technique and not with concept, he underestimated his own powers of originality and the intellectual basis of his work, and there is no better example of his ability to cope with abstractions than the remarkable Adams Memorial in Rock Creek Park in Washington.

Henry Adams, a restless historian who made a career of writing about America and a lasting literary reputation with his book *Mont St. Michel and Chartres* and his third-person autobiography, *The Education of Henry*

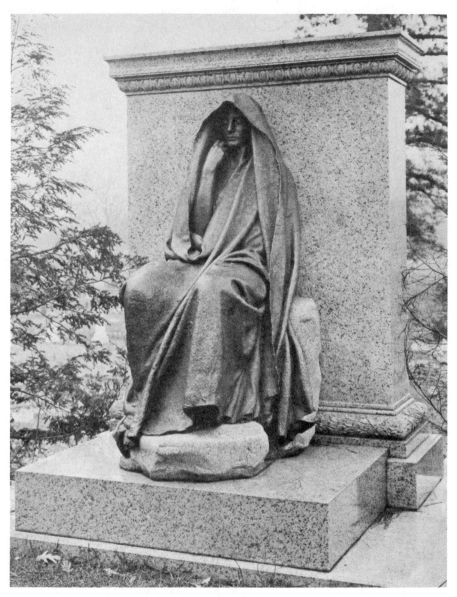

Henry Adams commissioned SAINT-GAUDENS to make a memorial to his wife in Rock Creek Cemetery in Washington. When it was completed in 1891, a constant stream of visitors came to puzzle over it. Nothing of its kind had ever been made in America. (*Photo Archives of American Art*)

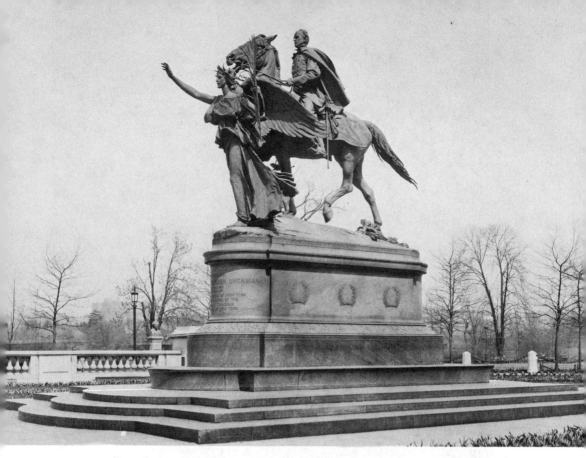

Commissioned in 1892, AUGUSTUS SAINT-GAUDENS' "General Sherman
Monument" at 59th Street and Fifth Avenue in New York was com-
pleted in 1903. Originally the sculptor covered it with a double layer
of gold leaf. (*Photo Art Commission of the City of New York*)

Adams, commissioned Saint-Gaudens to make a memorial to his wife, Mar-
ian, who had died by her own hand in 1885. It was probably John La Farge,
a close friend of Adams, who suggested Saint-Gaudens to the historian, who
did not want any sort of banal presiding angels, any Christian symbols.
Adams had immersed himself in philosophies of the Orient; he wanted no
hell or heaven, but Nirvana and a figure "to symbolize 'the acceptance,
intellectually, of the inevitable.'" Saint-Gaudens tried many sketches,
and in one of his notebooks he jotted: "Adams / Buddah / Mental
repose / Calm reflection in contrast with the violence or force in nature."
The seated figure, shrouded in heavy drapery modeled in broad, simplified
folds, is totally unlike anything America had produced before. It lingers on
the edge of sentiment, but does not step over. It is very nearly melodra-
matic, but it is too restrained for that. It is almost "ideal," but it is not
trumped-up classicism. The very fact that it comes so close to the precipice

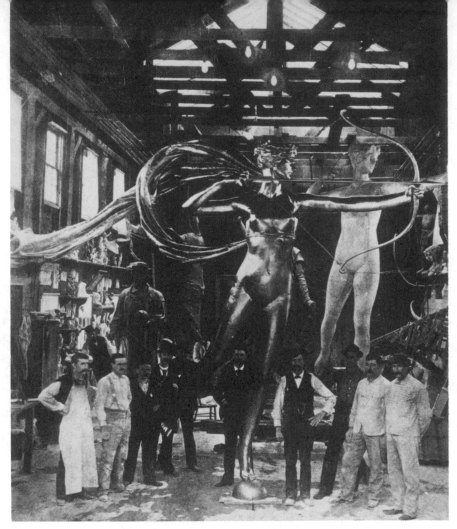

To top the Madison Square Garden, which was built by his friend Stanford White, AUGUSTUS SAINT-GAUDENS modeled a colossal Diana, here seen in the sculptor's studio in plaster and in bronze. She is now in the Philadelphia Museum of Art. (*Photo Courtesy of the Board of Trustees of Dartmouth College*)

of being terrible is what makes it remarkable. Adams, who was traveling in the Orient when it was erected, was deeply impressed and visited the sculpture frequently when he came home. He sat and watched the sightseers who flocked to it. Any Oriental child would understand the meaning of the figure, he said, just as no child brought up a Christian could. "None felt what would have been a nursery-instinct to a Hindu baby or a Japanese jinricksha-runner." He was especially interested in the reaction of the clergy who came. "One after another brought companions there," he wrote in his *Education*, "and, apparently fascinated by their own reflection, broke

out passionately against the expression they felt in the figure of despair, of atheism, of denial. Like the others, the priests saw only what they brought. Like all great artists, St. Gaudens held up the mirror and no more. The American layman had lost sight of ideals; the American priest had lost sight of faith."

Saint-Gaudens, according to his son, was especially fond of the Adams Memorial, as it "was one of the few opportunities offered him to break from the limitations of portraiture, limitations from which all his life he longed to be free, in order to create imaginative compositions." John Hay wrote to his friend Adams, "The work is indescribably noble and imposing. It is to my mind St. Gaudens' masterpiece." But Saint-Gaudens was continually commissioned to make portraits, some of them monumental, some on a small scale. Some he did for pleasure, such as the relief of Robert Louis Stevenson, whom he greatly admired and who posed for him seated on a chaise-longue with a fringed blanket over his knees. When Stevenson wrote to Saint-Gaudens from Samoa to order several copies of a smaller medallion that he had made, he addressed his letter, "My dear God-like Sculptor." But in addition to the portraits there were monuments like "The Pilgrim," a massive, dour figure in a cloak and a flat-brimmed hat, the personification of unrelenting puritanism and virile godliness. Also there was the "Diana" for the tower of Stanford White's Madison Square Garden. It was the only female nude he ever made, and it was of hammered copper sheeting. There was a standing Lincoln for Chicago. Saint-Gaudens had watched Lincoln's funeral procession from the top of a building in New York as a boy; the day before, he had seen Lincoln lying in state in the City Hall and had twice joined the "interminable line" to see the corpse of the great man.

The climax of Saint-Gaudens' career was the great equestrian statue of General Sherman led by a "Victory" at the southeast corner of Central Park in New York. It was commissioned in 1892, but Saint-Gaudens let several years go by before he got to work on it, and not until 1903 was the piece cast and unveiled in New York. It was a great personal triumph for the sculptor, who was then within four years of his death. It is surely the piece of his work which is more familiar to multitudes of people than any other. Thousands pass it each day; a few look at it, but it is doubtful if one in a hundred thousand knows the name of its creator.

William Dean Howells, the novelist who was the editor of the *Atlantic Monthly*, sat for Saint-Gaudens with his daughter for a dual portrait, and after Saint-Gaudens' death he wrote to Homer, the sculptor's son, reminiscing about his friend. "His face was to me full of a most pathetic charm," Howells said, "like that of a weary lion, and, after seeing him so constantly,

my daughter and I were finding sculptured lions all over Europe that looked like St. Gaudens."

A LOCAL BOY WHO MADE GOOD

Compared with the vigorous, gutsy, tough-minded Saint-Gaudens, the man who succeeded him in reputation as "dean of American sculptors" seems merely facile, flamboyant, and somehow soft at the core. Daniel Chester French was an exceedingly gifted art-maker with, for a man of so slight a frame, an astonishing energy, and he produced a vast amount of sculpture, some of it of truly vast scale. Scarcely any American artist was the recipient of such lavish public, official, and, indeed, critical praise as he or left more conspicuous monuments in the American landscape. He is best known now for his seated Lincoln in the Lincoln Memorial in Washington, the building of which was designed by the architect Henry Bacon, French's close friend and frequent collaborator. Every day of every week the solemn figure seated in the Doric temple, his head slightly bowed with the tragedies of the world, is gazed upon with awe by hundreds of men and women and, perhaps more awe-struck than any, of children. French was a talented storyteller with some of Hiram Powers' gift for anecdote, a somewhat sentimental moralist, and, viewed from the perspective of about forty years since he died in 1931, more period piece than artist—a judgment not easily explained.

Less than half of French's active life as a sculptor can be called truly nineteenth-century, though the nineteenth century pervaded his work until the end. He was briefly a student of Dr. Rimmer when that extraordinary man was giving his anatomy lectures in Boston, and he was inspired with a respect for the eccentric doctor and his sculpture which caused him (as we have noted) to be the first, many years after Rimmer's death, to have the "Dying Centaur" cast in bronze. He was also for the short space of a month a paying student in John Q. A. Ward's studio in Brooklyn, and in his early twenties he worked in Thomas Ball's studio in Florence for a couple of years. In other words, the roots of his knowledge and of his style were in the naturalist rather than the neo-classic traditions of the nineteenth century, and there is something of the attitude of John Rogers' little anecdotal groups in even French's most lordly attempts to overlay anecdote with "high art."

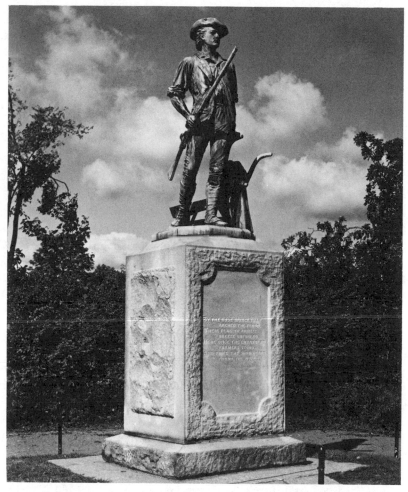

DANIEL CHESTER FRENCH had made only little comic sculptures when he was commissioned by his home town, Concord, Mass., to make ''The Minute Man.'' He was only twenty-four in 1874 when the statue brought him instant fame. (*Photo Keith Martin, Concord*)

From its very beginning French's career was an almost uninterrupted series of successes, and none was greater than his very first, the statue of "The Minute Man" he made when he was in his early twenties. He was living in Concord, Massachusetts, with his father, a judge who later became Assistant Secretary of the Treasury, his stepmother (his own mother had died when he was six), and his sister and older brother. There was rivalry between Concord and Lexington as to which town could claim to have first battled the British; Concord insisted that whereas at Lexington the pa-

triots had merely let themselves be killed, the farmers (or Minute Men) of Concord had made the first resistance and had demonstrated the superior marksmanship of the natives over the trained English militia. In any event, the families of Concord felt called upon to celebrate the centennial of the event with a suitable monument, and who better to make the statue than the local young man who had made a few dollars out of selling models in Parian of some owls making love and a few little groups illustrating the stories of Charles Dickens? There was nothing ordinary about Concord in those days. Quite the contrary; it was regarded as a modern if minute Athens, a cultural center of no mean pretensions. What other town could boast the residence of old Ralph Waldo Emerson, whose essays were already considered masterpieces, as well as Bronson Alcott, the transcendentalist philosopher and educator whose head burst with new theories, and whose daughter Louisa May had become a household word with the publication of *Little Women* in 1868? Thoreau had lived there, and so had Hawthorne for a while (he never lived in any place for long), and James Russell Lowell and the astonishing feminist, Margaret Fuller, who matched wits with the intellectuals of her day on whatever continent she encountered them. Concord was most certainly not unaware of its abiding importance a century after the "shot heard round the world" had been fired there.

French submitted a small model of his "Minute Man" to the local committee (Mr. Emerson was a member of it), and they approved it enthusiastically and told him to go ahead. They agreed to cover his expenses, but they did not offer to compensate him for his work. The project became one that involved and excited the community. Neighbors dug out of their attics ancient clothes until a proper farmer's costume of 1775 was assembled. Authentic old rifles were lent to French, as well as a powder horn, a cocked hat, and, perhaps most important of all, an old plow of the period, for French's model called for both firearms and farm implements to tell its story. The model was finally finished in a rented studio in Boston. French used a plaster cast of the "Apollo Belvedere" which he borrowed from the Athenaeum as the model for the figure except for the forearms; he wanted them to be the tough ones of a man of the soil, and for those a Concord farmer posed. When the clay was completed, French and his father made the plaster cast in the family's barn in Concord with a gathering of neighbors looking on. The bronze for the final monument was acquired by a local judge, who persuaded the federal government to provide nine old brass cannon. It was the Ames Foundry at Chicopee, the same firm that cast Ball's equestrian Washington, that poured the "Minute Man."

French was not on hand for the unveiling of his statue, but President

"That is the face I shave," said Ralph Waldo
Emerson to the sculptor DANIEL CHESTER
FRENCH, who made this portrait of the essayist
in 1879. (*The Metropolitan Museum of Art, Gift
of the Sculptor, 1907*)

Grant was and Speaker Blaine, several members of the Cabinet, and the
Marine Band. So were Longfellow and Lowell and, of course, Emerson and
about five thousand citizens, including Louisa May Alcott. The day was
bitter cold and the crowd shivered through a two-hour oration by George
William Curtis, who should have known better. French was in Florence
working in a corner of Ball's studio, learning his craft.

It was Hiram Powers' son, Preston, who persuaded French to go to
Florence rather than to Paris to study sculpture, though in the long run he
was far more a Beaux-Arts sculptor than a worker in the Powers tradition
of secondhand Canova. He spent two years in Florence and then came back
to America to set himself up as a professional art-maker. After a triumphal

visit to Concord he joined his family in Washington and busied himself with portrait busts and standing figures, and when his father's term as Assistant Secretary of the Treasury was up, he returned with his family to Concord. Portraits were the mainstay of French's business between the time he came back from Europe and when he returned there in 1886, and the two most celebrated were his seated figure of John Harvard with an open Bible in his lap at Harvard University and a bust of Emerson. According to French's daughter and biographer, the aging philosopher said to French as he posed, "You know, Dan, the more it resembles me, the worse it looks," and when it was completed he is said to have commented on the likeness, "That is the face I shave." It is a vigorous portrait of a vigorous face.

Portraits, however, were not French's only concern. He was involved in more high-flown matters suitable perhaps to an age of ebullience, of an expanding economy, and of giving lordly attributes to not entirely un-worldly pursuits. It was a time of translating, or trying to, general concepts into idealized stone maidens accompanied by props straight out of some imaginary property closet and, where necessary, a few attendant figures. Such a group, for example, was "Law, Power, and Prosperity," which French made in 1879 for the United States Court House in Philadelphia, and two groups for the Boston Post Office in about 1882 called "Science Controlling the Forces of Steam and Electricity" and "Labor, Art, and the Family." He also managed to portray "Brooklyn" and "Manhattan" as two seated females, the former rather pretty and the latter haughty, for the entrance to the Manhattan Bridge, and he made colossal statues of Asia, Africa, Europe, and America for the United States Customs House in New York which have to be seen to be believed, so rich and so trumped-up and pompous is their iconography. To many of his contemporaries they were works of the highest art—moral and uplifting.

One of his first groups, however, preceded most of these moral abstractions, and it is worth mentioning on two counts: first, it is a far more characteristically nineteenth-century piece of naturalism than the later iconographic gymnastics, and, second, it says something about French's character. The piece was a statue of "Gallaudet and His First Deaf-Mute Pupil," and it depicts the experimenter seated with a young girl leaning against his knee, looking up at him as they make similar signs with their right hands. It is a conversation piece of considerable charm and directness with a somewhat sentimental overlay. When French had nearly finished it, Saint-Gaudens visited him in his studio, and as he was leaving, French asked what he thought of the piece. "Oh," said Saint-Gaudens, "it's a good statue, but the doctor's legs are too short. I thought you knew that." This

"The Angel of Death and the Sculptor" was a memorial to Martin Milmore, a pupil of Thomas Ball and close friend of DANIEL CHESTER FRENCH. French sculpted it in 1891–92, a decade after Milmore died at the age of thirty-seven. (*The Metropolitan Museum of Art, Gift of a Group of Trustees, 1926*)

criticism was made at a moment when French was about to marry his cousin, Mary French, but he thought that the piece had to be set right (it meant lengthening not only the doctor's legs but the child's and the legs of the chair as well, a major bit of surgery). He wrote his fiancée that their wedding would have to be postponed a month. Daniel Chester French was an earnest young man with a kindly nature and, one cannot help but feel from his work, not a grain of humor.

Except for two years when he studied in Paris in the 1880s perfecting his modeling technique in the studio of Mercié, he worked in his Greenwich Village studio in New York or, later, at his studio in Stockbridge, Massachusetts, called "Chesterwood." The studio is now a sort of museum and

The original, impermanent version of "The Republic" by
DANIEL CHESTER FRENCH stood sixty-five feet high and dom-
inated the Chicago World's Fair (The Columbian Expo-
sition) of 1893. This bronze cast, thirteen feet smaller, now
stands in Jackson Park in Chicago. (*Photo Russell Lynes*)

shrine with a splendid view of Monument Mountain, a favorite subject of the Hudson River School landscapists. Compared with Saint-Gaudens' rather slender output and the care with which every piece was conceived, worked over, and never released until he was sure it was just as he wanted it, French turned out statues in a torrent—enough angels, one might say, to people the head of a pin. None of his angels was more popular than the "Angel of Death" under a billow of marble (it also existed in bronze) staying the hand of the young sculptor Martin Milmore. Milmore was the young man who had appeared some years before at Thomas Ball's studio and been invited to work with him on the equestrian Washington. It happened, also, that when French rented a studio in Boston to model his "Minute Man," Milmore had a studio in the same building and they became friends. Milmore was a successful statue-maker and modeler of busts and Civil War monuments and was liked by his colleagues. He was, according to French, "a picturesque figure, somewhat the Edwin Booth type, with long dark hair and large dark eyes. He affected the artistic (as all of us used to, more or less), wearing a broad-brimmed soft black hat, and a cloak. His appearance was striking, and he knew it." Milmore died at the age of thirty-seven, and in his memory French made a large relief entitled "The Angel of Death and the Young Sculptor," which depicts a rather Renaissance-looking young man caught in the act of carving the head of a sphinx (Milmore did one for the Boston Public Garden) by a draped female clutching poppies in her right hand and weighed down with wings that from top to tip are about a foot taller than she is. It was considered a work of art of great solemnity and power by French's contemporaries, an attitude difficult to recapture today.

The culmination of French's nineteenth-century career was at the Columbian Exposition in Chicago in 1893, for which he devised a figure called "The Republic," sixty-five feet tall and referred to in a picture book of the fair as "doubtless the best colossal effigy ever moulded into human form" and as the "chief marvel of Western sculpture." She was made of an impermanent material called "staff" for the lagoon of the White City (as the fair was called), but she exists today in Chicago in gilded bronze, somewhat smaller in size though still towering enough to be imposing.

The White City, however, was far broader in its implications than the sculpture that adorned it. It was in many respects the bow on the top of the package in which the arts of the nineteenth century were put away, and will in due course be looked at with closer attention in these pages.

By the time of the Columbian Exposition, the White Marmorean Flock were long forgotten, their reputations as dead as the marble out of

which they had carved them was cold. Greenough's attempts at classicism were looked on with contempt, even if his ideas about architecture were still smoldering and about to be fanned into life again by a young man named Louis H. Sullivan. The shock value of the nude that made Powers famous had been vitiated by hundreds of nudes, or near-nudes, on public buildings dressed in the decency of "Justice" or "Death" or "Memory," though the nude in painting was, except for symbolic purposes in official murals, very rare indeed. Naturalism, the familiar, and the anecdotal dominated painting, which remained to all intents and purposes untouched by the industrialization of the country or the growing conflicts between the managers and the managed, the financiers and the fleeced.

But painting had witnessed the rise of several giants at the same time that Ball and Ward and Saint-Gaudens and French were making their reputations among the hundreds of sculptors who were doing journeyman work in the creation of monuments and memorials and figures to ornament the gravestones and the tombs of the rich. Among the sculptors were men of genuine talent, but few of them were innovators. Painting in the second half of the nineteenth century in America was a richer and more varied menu than sculpture, and by and large it turned its eyes on America and ignored the upheavals that were so radically changing painting in Europe. Not that the art-makers were being chauvinist; they were merely surer in their own convictions and of their place in the American scheme of things.

11

THE EYE ON THE OBJECT

"He paints what he has seen; he tells what he has felt; he records what he knows."

GEORGE W. SHELDON in
The Art Journal, 1880

That inveterate and imaginative tinkerer Samuel F. B. Morse helped to tinker portraiture, as the one reliable staple of the journeyman art-maker, almost out of existence. When he was in Paris in 1838 wrestling with the problems of getting a French patent for his telegraph, he visited Daguerre, who with Nicéphore Niepce had performed a feat which had Paris agog and which Morse described as "wonderful results in fixing permanently the image of the camera obscura." Morse was fascinated by what he saw. Here by the science of optics and with a chemical process the minutest details of nature could be delineated as no artist had ever been able to draw or engrave them. Here on paper was the image of a pile of objects in Daguerre's studio which the inventor of the daguerreotype had put together to make a still-life—a wicker flask, casts of two putto heads, a plaque, a cast of a ram's head. Morse wrote to the *New York Observer* that what Daguerre had achieved was "Rembrandt perfected." When he got back to New York he immediately put his head together with that of a colleague at New York University (Morse was basking in the unprofitable title of Professor of Fine Arts there), the chemist John William Draper, and together they experimented with the new "sun pictures." Morse says that perhaps the first portrait made with a camera was by Draper or, on the other hand, perhaps

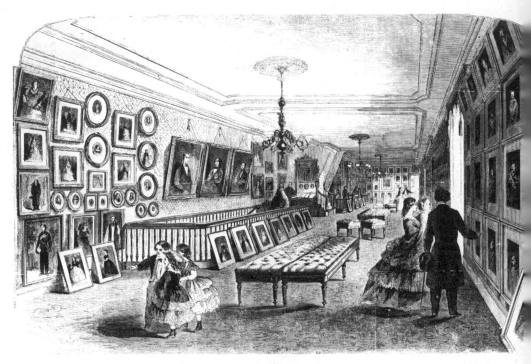

By the time MATHEW BRADY opened his photographic gallery in New York in 1853, photography had made deep inroads into the main source of livelihood of painters—the portrait business. (*Photo New York Public Library from* Frank Leslie's Illustrated Newspaper, *January 5, 1861*)

the first was one Morse himself took of his daughter Susan and a friend of hers who posed in the bright sun with their eyes closed for between ten and twenty minutes. Because of the slowness of the process, Daguerre hadn't thought it would become useful for portraits, but within a few years daguerreotypes had put miniaturists out of business. In fact, Morse and Draper set themselves up in a glass studio on the roof of New York University and made portraits and taught the process to anyone willing to pay to be instructed. One of those who was willing was a young man who clerked at Stewart's Dry Goods Store, named Mathew B. Brady.*

In some respects Brady the photographer was one of the most distinguished artists to grace the nineteenth century in America, but the high quality of his portrait photographs (and there seems to have been scarcely

* Brady's middle initial, like Harry S Truman's, was purely ornamental. It stood for nothing.

a distinguished statesman, general, author, jurist, or performer who did not pose before his great box of a camera) did contemporary painters no good. The public was fascinated by the absolute veracity of what the camera saw. (Nobody could quibble about there being "something not quite right about the mouth," as people always felt impelled to say when looking at a painted portrait.) From the sitter's point of view, the process was rapid (even if it was so slow by modern standards that the head had to be held steady with a clamp), and compared with the painted portrait it was extremely inexpensive. Anybody could afford a portrait of some sort. The upshot, as E. P. Richardson has pointed out, was a social calamity for artists, who for 250 years had depended on portraiture for their basic livelihood. "As the portrait painter vanished," he wrote in *Painting in America,* "there appeared the impoverished bohemian artist, insecure, embittered, earning his living by teaching instead of practicing his art, and dependent for the sale of his work upon the whims of fashion." The painted portrait, of course, did not vanish, any more than vanity vanished. There continued to be the rich, the official, the dominant in society or industry for whom anything less than immortality in paint was considered unsuitable.

But Brady did more than interfere, as many of his less distinguished contemporary picture-takers also did, with the portrait-painting business. He became the American father of documentary photography and removed the recording of an event or a scene from the subjective observation of the artist and gave it to the uncompromising (or so it was thought) lens of the camera. He persuaded President Lincoln to let him accompany the army of the Potomac in a buggy that was a mobile darkroom, and in the course of the conflict he and several assistants made 7,000 negatives of every aspect of war except action. It was impossible to record movement with the slow wet plates Brady had to use. But if there was no action, there were the horrifying results of action—blasted villages and burned towns and bridges, corpses strewn in trenches, a solitary boy dead with his rifle lying across his body, the wounded in field hospitals. And there were pictures of Lincoln in the field with his generals, of bivouacs, of peaceful landscapes, of men in formation and men relaxing. When processes for the successful reproduction of photographs in magazines were achieved toward the end of the century, the camera was to put another crimp in the art-makers' livelihood.

Morse greatly underestimated the effect of the daguerreotype (and its survivor, the photograph) on both the practice and the profession of painting. At the annual dinner of the National Academy of Design in 1840 he acclaimed the new gadget with which an artist could "furnish his studio with facsimile sketches of nature, landscapes, buildings, groups of figures,

MATHEW BRADY photographed Union soldiers wounded at the Battle of Fredericksburg (May 3, 1863) as part of his remarkable record of the Civil War, one of the great feats of a very considerable art-maker. (*Library of Congress, Washington, D.C.*)

etc., scenes selected in accordance with his own peculiarities of taste; but not, as heretofore, subjected to his imperfect, sketchy translations . . . but painted by Nature's self with a minuteness of detail which the pencil of light in her hands alone can trace." The effect of the camera on painting was not what Morse expected it to be. It turned painters away from the delineation of accurately represented minutiae of the sort the Hudson River painters had so delighted in; it was not the painter's function to rival a mechanical instrument. The camera urged breadth on the artist and encouraged him to eliminate detail in favor of form and mood and what light fell upon, not as a "pencil of light" but as a broad brush.

A DOWN-EAST GENIUS

While Brady in his flat hat and long linen duster was following the troops to whom his pince-nez and pointed beard and his buggy known as the "what-is-it" were a familiar sight (they called him "the grand picture-maker"), a gifted young man from Boston named Winslow Homer was also reporting the war. *Harper's Weekly*, a magazine which called itself "A Journal of Civilization" (and to which today's *Life* and *Look*, which combine the treatment of serious subjects with lively pictures, can trace their journalistic ancestry), had asked Homer to go to the front as its correspondent. He had been sending the magazine drawings from Boston, where he had learned the techniques of drawing for such publications; he had been a regular contributor to *Ballou's Pictorial*, a magazine of high standards and unbending propriety. He knew how to draw on a prepared block of boxwood in such a manner that an engraver could cut his picture and endow it with a vitality and sparkle unmatched by any of his contemporaries.

The first drawings he had sent to *Harper's Weekly* were, like those he did for *Ballou's*, scenes of Boston life of the more elegant sort—fashionable ladies in great crinolines and bonnets arm in arm with gentlemen in the tallest and most dashing hats. Even in a drawing of a "foot-ball" match at Harvard several of the players wore their toppers. Homer had also sent scenes of rural gaiety, of Thanksgiving Day, and corn-huskings and dances and harvesting—a representation of New England life, which one would think was forever without anything but the pleasantest toil and the gayest intercourse. Homer had a flair for a kind of joyous and stylish informality, a delight in the capers of the young, an eye of unending pleasure in pretty young women of unswerving wholesomeness. It was shortly after Homer moved from Boston to New York in 1859 that *Harper's Weekly* offered him a salaried job as a staff artist. He refused it. He had put in several miserable years as apprentice to a lithographer named Bufford in Boston, and he turned down the *Harper's* job because, as he told a friend, "I had had a taste of freedom. The slavery at Bufford's was too fresh in my recollection to let me care to bind myself again. From the time I took my nose off that lithographic stone, I have had no master; and never shall have any." When *Harper's* asked him to join the Union troops at the front, he agreed to go in the same capacity in which he had been working for the magazine—as a free-lance.

When the Great Russian Ball was held in New York on November 5, 1863, WINSLOW HOMER did a drawing from which this engraving on wood was made. It was published in *Harper's Weekly*. (*Collection of the author*)

If Homer and Brady met when they were both with the Army of the Potomac, the biographers of neither have recorded it, though it seems most unlikely that their paths did not cross. A. R. Waud, an English artist who was also sending drawings from the front to *Harper's*, traveled with Brady and they were friends. But the truth of the matter was that Homer did not spend a great deal of time with the army and most of his Civil War drawings were made in New York from sketches he had jotted down on a few relatively brief trips to where the action was taking place. There is no question that he saw action, for his sketchbooks were filled with fast, intense impressions of cavalry officers in combat and infantrymen at the moment of being struck down by bullets, but most of his pictures are of army life, of men in encampments pitching horseshoes, opening Christmas packages, drinking away their environment, homesick soldiers and bored ones.

Homer was twenty-five when General Beauregard ordered his men to fire on Fort Sumter and the hostilities began; he had been in New York for about two years, busy, surrounded by friends and relatively prosperous for a young man. *Harper's* was paying him $60 apiece for full-page drawings on wood, and he was determined that one day he would be a

painter and not just an illustrator. How he learned to paint with as much fluency and authority as he did can be explained only by an uncommon talent, for he had almost no instruction. The only man he is known to have studied with was a painter named Frédéric Rondel, who had a studio in the Dodsworth Building (where the Metropolitan Museum was later established), and from him he had only four or five lessons on Saturdays in 1861, just enough to find out how to handle a brush and set a palette. The following year he bought a tin box of paints and brushes and tried his hand at painting directly from nature. The first two paintings in oil from his easel were one of a sharpshooter and one called "Punishment for Intoxication," a picture of a soldier made to stand on a box with a log on one shoulder. (Some years later Homer said of this painting, "It is about as beautiful and interesting as a button on a barn door.") Homer told his brother Charles that if he did not sell these two pictures he would take a steady job with *Harper's*. Not until several years later did he discover that Charles had bought the pictures himself, and he was furious at him.

Out of Homer's Civil War experience came a painting, "Prisoners from the Front," which more than any other established his reputation as an artist to be reckoned with. It was not a large picture, about three feet wide and two high, but it made a large impression at a time when big pictures were extremely popular. A young Union officer, his hands behind his back, faces three somewhat bedraggled but nonetheless dignified prisoners, one an old man, one a defiant young trooper, and one a young officer as jaunty as his captor. The confrontation, entirely without sentimental overtones, is a meeting of men, not of conqueror and vanquished, and its drama is intensified by its matter-of-factness. Tuckerman, who makes no other mention of Homer in his *Book of the Artists*, describes it as "an actual scene in the War for the Union," and says that it "has attracted more attention and with the exception of some inadequacy in color, won more praise than any *genre* picture by a native hand that has appeared of late years." When it was shown at the National Academy of Design in the spring of 1866, Homer's reputation was made overnight. "No picture has been painted in America in our day that made so deep an appeal to the feelings of the people," a critic, Clarence Cook, wrote some years later. "Though painted in the heat of the war, and when bitterest feelings were aroused on both sides, the influence of this picture was strong on the side of brotherly feeling." Homer was thirty when he caused this sensation; he had already exhibited at the Academy for four years, and when he was twenty-nine he had been elected to full membership in that august company of art-makers, one of the youngest painters ever to be so honored.

WINSLOW HOMER was an artist-correspondent for *Harper's Weekly*, and out of his war reporting came "Prisoners from the Front." Painted in 1866, it was the picture that established Homer's reputation as a painter. His reputation as an illustrator was already secure. (*The Metropolitan Museum of Art, Gift of Mrs. Frank B. Porter, 1922*)

Homer was a private young man and to the end of his life kept his own counsel. Not long before he died a critic who had long been enthusiastic about his work asked for some details to be used in a biography of the artist, and Homer wrote: "It may seem ungrateful to you that after twenty-five years of booming my pictures I should not agree with you in regard to the proposed sketch of my life. But I think it would probably kill me to have such a thing appear, and, as the most interesting part of my life is of no concern to the public, I must decline to give you any particulars in regard to it."

This is, obviously, the kind of statement that leads to speculation, but the speculation leads to nothing. Scholars have puzzled over the statement that "the most interesting part" of Homer's life was not his work at his easel. Such of his correspondence as survives consists of affectionate but

uninformative letters to his family, and some letters to clients and dealers which are concerned primarily with money matters. He did not take part in the life of the art world in New York, and he did not personally help to promote the sale of his works as many artists have always done. Though he does not seem to have been uneasy in the company of his contemporaries or unamused or unenthusiastic about social gatherings either rural or citified —certainly not from the evidence of his drawings and paintings as a young man—he lived most of the last thirty years of his life as more or less a recluse on the coast of Maine at Prouts Neck. He spent his leisure exploring the forest and streams where he delighted to hunt and fish and paint, or the beaches of islands in the Caribbean.

There is, indeed, little about his career that was characteristic of those who followed the profession of artist in his day. Not only did he achieve a certain financial independence with his pencil at a very early stage in his career and earn a solid reputation while most of his friends were struggling to be noticed, but his way of looking at the world about him and the art of his time was quite different from that which sent so many of his contemporaries to pursue the hard academic training of the Beaux-Arts and Düsseldorf and Munich. Homer was his own man and he did things in his own way, independent but not eccentric, private but not perverse.

Like other artists of his day, however, he went to Paris, but more to observe than to study. He left in 1867 and he had the pleasure of seeing two of his paintings (one of them was "Prisoners at the Front") exhibited at the Great Universal Exposition in Paris and praised by the press both French and English. "Certainly most capital for touch, character and vigour, are a couple of little pictures taken from the recent war, by Mr. Winslow Homer of New York," the *London Art Journal* said. "These works are real: the artist paints what he has seen and known." The little pictures must have been a relief among the vast salon paintings of literary and classical subjects, as pompous as they were ponderous, and as slick as they were mindless. Homer never painted anything that he had not "seen and known," and his approach to what he saw in Paris was not that of a student seeking to learn his way but that of a man sure of his commitment and eager to extend his experience. Paris was not only the center of the art world, a far ebullient cry from provincial New York, but it was the center of luxuriousness, of gaiety and glamour, and the young man with his splendid red hair and mustache and the air of a gentleman (he was by temperament not a bohemian and had no need to adopt the airs of an artist as his contemporary Whistler did) took it in stride.

It was apparent that something revolutionary was stirring in the art

world of Paris. There was evidence of it at the Exposition, where the
painters from Barbizon offered a contrast to the inevitably popular story
pictures of Gérôme and Meissonier and Cabanel with their infinitely refined
detail and studio lighting. The poetry of Millet's peasants in their fields,
the misty, feathery landscapes of the aging Corot, and the open glades of
Daubigny and somber woods of Rousseau were unfamiliar departures from
the tight-lipped "high art" of the Academy and the Beaux-Arts. Not only
that, there was an exhibition—quite separate from the Exposition—of two
artists unacceptable to the established *maîtres:* Gustave Courbet, a realist
continually at loggerheads with the Academy and politically suspect for his
socialist views as well, and young Edouard Manet, only four years older
than Homer, who had shocked Paris with his "Déjeuner sur l'Herbe" (the
very idea of nude women picnicking in the Bois with men in business suits!)
and his forthright picture of a courtesan which he called "Olympe," even if
the pictures did echo Giorgione and Titian. There is no record that Homer
saw either of these exhibitions, but it would be strange indeed if he had not.
His American friends in Paris would have taken it for granted that any
young artist would look at what was being talked about by everyone and not
have bothered to record the obvious in their letters, and Homer was as
uncommunicative about his stay in Paris as about everything else. He must
also have seen and been impressed by the extensive display of Japanese art
and manufactures at the Exposition, an exposure that vastly changed the
course of French art and, to a lesser degree, American painting. It affected
Whistler and Mary Cassatt most obviously, but it changed Homer's vision
as well, less in his design than in his dashingly free handling of the water-
color brush.

Homer was not without companions of his own calling and from his
own country in Paris. The days were past when art students had gone to
London as the faithful went to Mecca; as Albert Gardner says in his inter-
esting study of Homer, young American artists went to Paris to learn their
craft because prominent English painters were being so successful finan-
cially that they did not want to be bothered with students unless they were
willing to pay very high prices for instruction. French artists, on the other
hand, however distinguished and successful, by tradition felt it incumbent
upon them to visit the studios of the young and aspiring and to give them
advice and criticism. Homer, however, was not inclined to take advantage of
this generosity, or at least there is no record that he was. He worked while
he was there and, in addition to sixteen paintings, produced two illustra-
tions for *Harper's Weekly* which its editors published with what was tanta-
mount to an apology for stepping so close to the precipice of indelicacy.

One of them was of the shocking can-can as high-kicked at the Mabille; the other was a couple waltzing violently (her feet were swept off the floor) at the Casino as a crowd watched their indecorous display. His scenes of the French landscape and of figures were as purely his own as his work at home had been. Not surprisingly, his peasants look like Millet's peasants—they were, after all, French peasants—but Homer painted them with a clarity and sharpness quite different from the moody overtones of Millet. Like Mount before him, Homer painted toilers as men and women, not as romantic symbols.

Homer was thoroughly broke when he left Paris and had to borrow money from a friend for his passage, offering him in exchange any painting of his that he might want. Back in New York, he healed his sickly coffers by illustrating for *Harper's* and several other magazines and by illustrating books. Seven years later in 1875 he gave up illustration entirely and never returned to it again. He grew more and more jealous of his privacy, and it was a time when very few painters had dealers and most sales of pictures were made either from the Academy shows, from auctions, or from the painter's studio. Homer had no trouble finding room in the exhibitions (though his paintings were hung not in the best-lighted rooms but in corridors), and as his reputation increased, more and more people tried to see him in his studio. They often found him inaccessible. A journalist who tried to interview him said: "He is pose in the extreme, and affects eccentricities of manner that border on gross rudeness. To visit him in his studio, is literally bearding the lion in his den." On another occasion, a friend of his recorded, he put a sign on the door of his studio that said "Coal Bin," and when asked why, he said, "Oh, my father sent word that he was coming down yesterday, and I put up that sign so that he wouldn't find me."

If his fame spread, it was not because of the praise of the critics, who, by and large, seemed to disapprove of his disregard of the pretty virtues they associated with art, the prettiest and most acceptable of which was a story with a proper sentiment. They questioned his lack of technique; they blamed him for the want of "finish" on his paintings; they quarreled with his not carrying what they considered sketches through to completion; they did not like the fact that he could not be fitted neatly into some school of painting. Such criticisms seemed to have little effect on him, but he did say to his friend Arthur Stonehouse, "for fifteen years the press has called me 'a promising young artist,' and I am tired of it." It had been "Prisoners at the Front" which made him "promising," and he said, "I'm sick of hearing about that picture."

One would not suspect from the paintings that came from Homer's

brush as a young man that there was a trace of the recluse in their maker.
Once he was through painting scenes of the war, he chose subjects that
exhibited a delight in the way the sun fell on bonnets and hoopskirts, the
way it could turn a stretch of sand and bathers into a golden harmony
accented with the bright colors of parasols and summer dresses. He painted
"scenes," not anecdotes, unless three women in billowing skirts and a gentle-
man in a bowler playing croquet can be called an anecdote. The subject of
the picture is light on flesh and material and grass. He delighted in paint-
ing pretty young women, sometimes at fashionable resorts, sometimes on
their way to work in mills, sometimes sidesaddle on a horse in the mountains,
and almost always in the bright sun. Unlike his friend and contemporary
Eastman Johnson, he very rarely painted an indoor scene, though one of his
best-known early pictures is "The Country School," in which a young
woman stands behind a desk surrounded by inattentive children sitting on
benches. But this is no dark interior; sun floods through the windows and
everyone, including the teacher, seems to want to be out of doors, playing
snap-the-whip, the subject of one of Homer's most ebullient early pictures.
(It reminds one of Eastman Johnson's pictures of children playing.)

Even before he went to Paris Homer had started to experiment with
watercolors and was one of the founders in 1866 of the American Society of
Painters in Water Colors. It had been a medium associated with the pas-
times of proper young ladies who were expected "to draw a little" as they
were also supposed to sing a little for company. In 1873 Homer took
seriously to watercolor and found it greatly to his taste. As Lloyd Goodrich
says in his indispensable biography of Homer, "The medium suited him
perfectly from the first. In it he could work directly from nature, recording
his impressions swiftly, securing an instantaneous grasp of mass and ac-
tion." Compared with the watercolors he did when he hit his stride, his early
ones are more like colored drawings than like paintings, but when he
mastered the technique he gave it a vitality and breadth and sparkle that no
one else, I venture to assert, has matched. It is surely true that many
thousands of people who never heard of Homer know his watercolors,
especially those of Bermuda and Nassau which have been so widely and so
accurately reproduced. It was a medium suited to his excursions into the
forests on fishing and hunting trips, to his vacations in the tropical islands,
and he used it with brilliance as long as he lived.

There is a legend in the Homer family which is recounted to explain
why Homer withdrew from the world and lived quite alone. In his painting
called "High Tide," one of the three young women on the beach is said to
have been the girl with whom Homer had fallen in love but whom he could

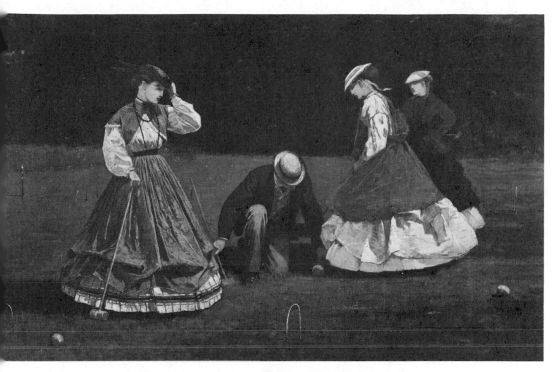

"Young ladies are proverbially fond of cheating at this game," an 1865 manual on croquet said, "but they do it only because . . . they think that men like it." WINSLOW HOMER painted "Croquet Scene" in 1866. (*The Art Institute of Chicago*)

A gentle humor and warm sunlight pervaded many of WINSLOW HOMER's early paintings. "The Country School" was painted in 1871, when Homer's livelihood came mostly from magazine illustration. (*City Art Museum of Saint Louis*)

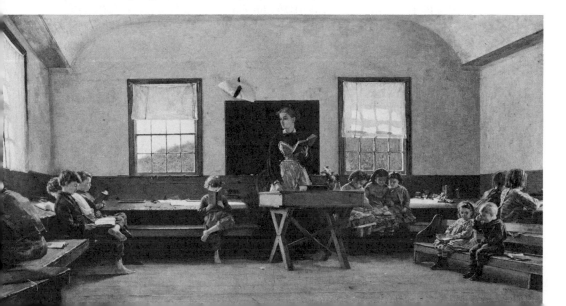

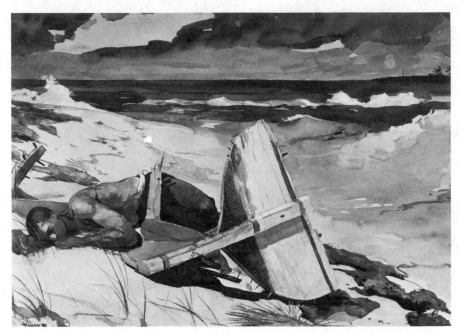

No other American watercolorist could match the vitality and vibrancy of Winslow Homer. He painted "After the Hurricane" in the Bahamas in 1899. (*The Art Institute of Chicago*)

not marry because he did not have the money. Many years later when he was living alone at Prouts Neck on the coast of Maine he kept on an easel in his studio a picture of a brown-haired young woman, her face filled with vitality, seated on the grass and holding a few cards. The picture was called "Shall I Tell Your Fortune?" It is true that for a time things went badly financially for Homer. In the 1870s he asked prices as high as $1,500 for his pictures exhibited at the National Academy, but he had no takers, and even when he cut his prices the following year to $300 and $800, he did little better. One of his paintings, "Uncle Ned at Home," he asked $600 for, but it went at auction for $215. J. Alden Weir, a painter and a friend of Homer, found him one day sorting through a pile of drawings and watercolors on the floor. Weir asked him what he was up to, and he said, "I've been offered $500 for a hundred drawings and paintings and these are the ones I've picked out. When I get the money for them I'm going to leave New York for good."

A sharp change took place in Homer's life in 1881. He went to England and settled in a small village on the coast near Tynemouth on the North Sea. He took a cottage with a high fence around it and a gate that he

could lock, and he did his own cooking. What else he did can only be surmised from his paintings, for he gives no account of his life. From the bright light that fell on fashionable women and the flashing colors of his paintings of Negro life, his view, if not always his palette, had turned somber. The coast where he had settled was known for the fierceness of its storms, for the dangers to which the fishing folk were subjected and the hardiness of their breed. It was their life and especially that of the sturdy women who supported their men with work and patience, with mending nets and carrying great baskets, with watching for the sails of the fishing fleet, that occupied his pencil. They were the antithesis of the graceful femininity that Homer had so delighted in painting; these were hardy, stolid, heroic, and stoical young women, and he drew them, as Gardner has pointed out, like the Pre-Raphaelite women of Burne-Jones and Dante Gabriel Rossetti —"country cousins perhaps," he says, but the similarity is striking. More important, it was at Tynemouth that Homer discovered the sea as a power, as a place where men worked and which shaped their daily lives and their character, sometimes because of its menace, sometimes its docility. The sea in relation to man, as a place for him to earn his bread, for him to struggle with or against, or merely to look out upon with respect, became to Homer a subject to be explored again and again as it had to no painter before. He reported it dramatically and sometimes romantically, always with an eye on its subtleties and its character. To Homer the sea was a living thing without a conscience. It was nothing to be sentimental about.

He was two years in England, and when he came back he sought the seclusion of Prouts Neck, now a resort, but then a rather bleak fishing village on a rocky peninsula about ten miles south of Portland on the Maine coast. There are grander coasts in America than Maine's but none more rugged or defiant, none where the sea dashes with greater fierceness in a Nor'easter. Homer's family had gone there in summers, and they were for many years the only "summer people." Just before Homer's mother died in 1884 Homer's brother had bought a partially built house and had it completed as a place for his parents. Homer tried for a brief while to live in the new house with his father and to work there, but he soon found a refuge in making over the stable into a house with a studio in it and a porch facing out to sea.

The last twenty-six years of Homer's life were spent almost entirely at Prouts Neck, with occasional hunting and fishing trips in the Adirondacks or to the beaches of the West Indies, and his subject matter turned away completely from fashionable scenes. Women disappeared almost entirely from his pictures, even the stalwart sort he had drawn in Tynemouth and

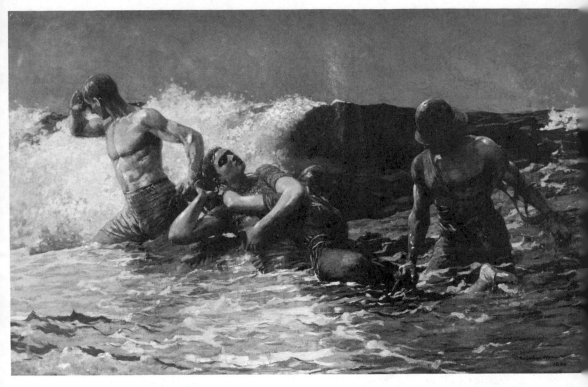

When WINSLOW HOMER painted "Undertow" in 1886, he posed two young models in bathing suits locked in each other's arms on the roof of his studio building in New York and doused them with a bucket of water. (*Sterling and Francine Clark Art Institute, Williamstown, Mass.*)

used soon after he got back in paintings like "Undertow," which was inspired by a near-drowning at Atlantic City. Just before he settled in Prouts Neck and for several years thereafter he got caught up in the etching craze that so many artists were finding profitable in the 1880s and '90s, but the subjects of his prints were merely the subjects of his paintings done over in another medium—such favorites as "Eight Bells," "The Life Line," and "Undertow," as well as a few hunting and fishing scenes of which he had made watercolors. He did not stick with the process for long because he never got much money from it. His watercolors, on the other hand, sold very well, though he priced them modestly at about $125 apiece in 1890. By then his oils had attracted the attention of Thomas B. Clarke of New York. Clarke collected American paintings avidly and with discretion as no other man of his time did, an amateur who went far beyond merely satisfying his

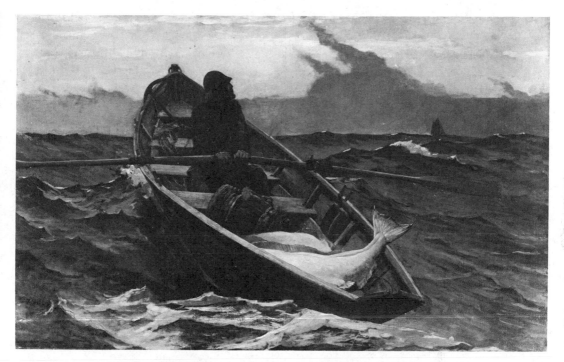

Like no other marine artist of his time, WINSLOW HOMER painted men
pitted against the power of the sea from which they wrenched their
living. "The Fog Warning" was painted in 1885 after Homer had
sequestered himself in Maine. (*Museum of Fine Arts, Boston, Otis
Norcross Fund*)

urge to own works of art. He helped artists sell their pictures, arranged
exhibitions for them, and encouraged his rich friends to collect. At one time
he wanted to establish a "Homer Gallery" in his house and told Homer that
John Singer Sargent had recently visited his collection especially to see the
Homers. According to Goodrich, "Next to Charles Homer [the artist's
brother], Clarke was the strongest outside influence on the artist's career."

By all odds the largest number of the paintings for which Homer is
famous today (and probably no one of our nineteenth-century art-makers
with the possible exception of Whistler is more famous) were painted after
he had settled in Prouts Neck, and very nearly all of them have to do with
the sea (with men working it, defeated by it, defying it, or with its portrait
in varying moods—pictures such as "Eight Bells" and "The Gulf Stream,"
"Northeaster" and "Kissing the Moon") or with the streams and forests
where he hunted, the fish and beasts that lived in them, and the guides who
walked their trails and shot their rapids.

To say that Homer was a recluse is to imply that he disliked his fellow man. On the contrary, he greatly enjoyed his friends (and they him), delighted in the company of children, admired women and painted them as a young man with a sympathy and pleasure not matched in America by any of his contemporaries. He was not a recluse, but he needed seclusion in order to work, and being an artist was more important to him than anything else. Possibly he was driven to a life apart by the fact that he enjoyed too much being with others and knew that only by going away could he serve his gifts. He knew he was good; he did not need the flattery of art-lovers and dealers to keep him at his easel any more than he needed to adopt the poses of the eccentric to show his individuality and independence. He worked on at Prouts Neck until he died on September 19, 1910, at the age of seventy-four. The postmaster at Scarboro, the nearest town, wrote an obituary for him: "He was a good man and a good citizen. If any man had a setback he was the first to help him. He was good to the poor. We shall miss him for a long time to come."

AN INDEPENDENT PHILADELPHIAN

When Thomas Eakins was asked by an interviewer in his old age whom he considered the greatest American artist, he replied, "Winslow Homer." When John Singer Sargent, the most fashionable painter America can claim (on somewhat doubtful grounds) as her own, visited Philadelphia about 1900, his hostess asked him if there were any Philadelphia artists he would like her to invite for dinner. "There's Eakins, for instance," Sargent suggested, and his hostess replied, "And who is Eakins?"

Eakins was eight years younger than Homer and twelve years older than Sargent, and though in many respects he was the match for both of them, in others he was their superior. He was never well known, never sought a popular or fashionable audience, and caused so little stir in the art world (except for minor scandals in easily scandalized Philadelphia) that during his lifetime not a single full-length article appeared about him in any magazine . . . not even in any art journal. On the other hand, he does not fit into the ignored-genius class of art-makers. He was elected to the National Academy of Design (though late in his career); six of his paintings were exhibited at the Centennial Exhibition (though only five in

Memorial Hall) ; he won a bronze medal at the Chicago Columbian Exposition in 1893; and after the year 1900 honors of a particularly notable (but financially insignificant) sort were showered on him, too late either to give him much satisfaction or to help him make a living. When Isham wrote *The History of American Painting* (1905), he lavished praise on many of Eakins' (and his own) contemporaries, but complained of Eakins' "neglect of the beauties and graces of painting." Eakins, who very probably saw this comment (though he read little art criticism, preferring books on mathematics), unquestionably thought Isham was right but for the wrong reasons. Eakins did not give a tinker's dam about the "beauties and graces of painting," at least as Isham interpreted them.

It was the character of the object on which he fixed his steady and questioning gaze which mattered to Eakins—the truth of the matter, whether it was a face or a fan, a river or a pair of shoes, a hand or a horse—and character to Eakins could be revealed only by what seemed to many of his contemporaries a merciless delineation of the precise truth, unenhanced by the "beauties and graces of painting." Character, however, was to Eakins not something to discover flaws in, as this might suggest, but something to reveal the beauties of, the beauties of truth as opposed to the beauties of the studio, of the object rather than of the imagination, the perceived fact rather than the fancy. But the truth, even when lovingly expressed, puts many people off (as it did many of Eakins' sitters) if it is the truth about themselves or their own times rather than about the past. Eakins, the friendliest of men, generous, gregarious, with a fine Rabelaisian humor, and a sportsman, was not in any sense a misanthrope, though he was a man of unbending principles—sometimes, it seems, beyond the call not only of conscience but of reason. Every trace of tact in dealing with those who did not see things precisely as he did was missing from his nature, where his art was concerned, and it did not occur to him to be politic to get his own way. He was called stubborn, not without reason. As he believed in the exactitude of mathematical perspective as a means to visual truth (he made elaborate perspective studies for his interiors and landscapes with figures), so he believed in exactitude in his relations with other people when his artistic principles were in question. Eakins had no "give," and this, as much as any aspect of his character, explains his relative obscurity while he was alive and the incandescence of his reputation today as one of America's three or four greatest painters.

Philadelphia was always Eakins' home, and, except for a very few years, from the time he was two years old in 1846 he lived in the same house at 1729 Mount Vernon Street. It was a red brick house in a street of red

brick houses with white stone doorsteps, high ceilings, filled with dark furniture and flowered carpets and the clutter on tables and in curio cabinets so treasured by the age; light filtered only sparsely through its shuttered windows. Eakins' father was a writing master of very considerable skill and an engrosser of documents with a steadiness of hand which his son inherited. He was a man who liked the outdoors, made a good living, and was canny enough to invest in Philadelphia real estate, a stroke that made it possible for his painter son to live and work without ever making enough from selling his pictures to support himself and his wife. When young Tom was in school he drew so well (surely far better than his teachers) that his grade for four years in that class was invariably 100. He was uncommonly good at mathematics and languages, loved to skate, to hunt railbirds with his father, to swim with his friends, to sail and to row single sculls on the Schuylkill River. He was casual in his dress, which he liked to discard completely whenever he could; he liked to swim in the nude and to lie in the sun, and he had little concern for what others may have thought proper. Appearance in the social sense never meant anything to him; the appearance of what was around him meant a great deal, and what lay beneath the appearance was essential.

Even before he went to Europe to study when he was twenty-two, he had got permission while a student in the particularly "fusty, fudgy" art school of the Pennsylvania Academy to attend courses in anatomy at Jefferson Medical College and to dissect human and animal corpses. He felt impelled to know not just what things looked like but why, and though he painted the nude rarely during his long career, he wrote to his family from Paris:

> The French court has become very decent since Eugenie had fig leaves put on all the statues in the Garden of the Tuileries. When a man paints a naked woman he gives her less than poor Nature did. I can conceive of few circumstances wherein I would have to paint a woman naked, but if I did I would not mutilate her for double the money. She is the most beautiful thing there is—except a naked man, but I never yet saw a study of one exhibited.

Paris to Eakins was a continuation of school, and, unlike most painters today and many of his contemporaries, he did not think he should attempt to paint a "picture" (as opposed to "studies") until he was the master of the basic techniques of his craft. He managed to get into the classes of Gérôme, the most sought-after and the most demanding of the instructors in the Ecole des Beaux-Arts, a perfectionist in his demands on his students,

but, as Eakins said, "He treats all alike, good and bad. What he wants to see is progress. Nothing escapes his attention. . . . The oftener I see him the better I like him." Eakins stuck to his studies in Paris. The Bohemian life so attractive to most young American artists was not for him, though there was nothing prissy in his attitude. He made friends easily among his contemporaries at the Beaux-Arts (though they hazed him elaborately when he first turned up), and he quickly learned to speak French with fluency. He was extremely conscious of the fact that he was dependent on funds sent him by his father, to whom he was devoted, and time was something that this casual-looking young man in his big gray hat, sack coat, greasy trousers, and colored shirt could not in all conscience, or by temperament, waste.

It was in Spain that he discovered what he only vaguely knew he had been looking for but recognized the moment he saw it. He arrived in Madrid in December 1869 and headed straight for the Prado. "I've seen big painting here," he wrote home, ". . . I have seen what I always thought ought to have been done and what did not seem to me impossible. O, what a satisfaction it gave me to see the good Spanish work, so good, so strong, so reasonable, so free from affectation." It was Velásquez of whom he wrote primarily and of Ribera, the baroque master who had learned his craft in Rome and Naples. Velásquez was a naturalists' naturalist, completely sure in vision and in hand, a master of his medium to whom no visual subtlety seemed impossible, who combined veracity with elegance—not just in the fashionable but in the mathematical sense—but who was not put off (or put on) by pomp and circumstance. His painting was as different from Gérôme's precise craftsmanship and slavery to detail as it could conceivably be. It was rich in texture, in color, in *matière*, and it bespoke a vision that penetrated, as Eakins dreamed of doing, to the heart of the matter. Ribera presented another dimension—figures emerging from deep shadows, their flesh firmly painted, muscles that worked, wrinkles unspared, dark figures with bones in their bodies and hair on their arms, dramatic but poised, heroes and martyrs made of the man on the street in the manner of Caravaggio and the painters of Naples. His was a way of seeing and of using chiaroscuro which stuck by Eakins and served him well.

He also saw Rubens plain at the Prado, and his dislike of what he saw explains as much about his temperament and his aesthetics as what he liked about Velásquez and Ribera. He wrote to his family:

Rubens is the nastiest most vulgar noisy painter that ever lived. His men are twisted to pieces. His modelling is always crooked and dropsical and no marking is ever in its right place or

anything like what he sees in nature, his people never have bones,
his color is dashing and flashy, his people must all be in the most
violent action, must use the strength of Hercules if a little watch
is to be wound up, the wind must be blowing great guns even in a
chamber or dining room, everything must be making a noise and
tumbling about there must be monsters too for his men were not
monstrous enough for him. His pictures always put me in mind of
chamber pots and I would not be sorry if they were all burnt.

Eakins painted his first "picture" in Seville. "The trouble with mak-
ing a picture for the first time is something frightful," he said in a letter to
his parents. To paint out of doors was a very different matter from making
studies in a studio. "Picture making is new to me; there is the sun and gay
colors and a hundred things you never see in studio light, and ever so many
botherations that no one out of the trade could ever guess at." The picture,
called "A Street Scene in Seville," was of a child in costume dancing against
a wall on a city street, her father and mother providing music on a flute and
a drum. A mother and child watch them through a window, and the shadows
of spectators are cast on the pavement from figures outside the picture. For
so sprightly a theme, it makes a rather solemn comment; there is no
pleasure in the little group waiting to be thrown coins for their perform-
ance, but Eakins could not have pictured gaiety where there was none, and
if the picture lacks spontaneity, so does its subject. Indeed, spontaneity is
never characteristic of Eakins' paintings. Even his pictures of sports have a
static quality of motion permanently arrested rather than caught in a
moment of continuity.

When he felt he was ready to set himself up as an artist and able to
make his living by his craft, Eakins came home to Philadelphia, and a room
on the top of the family house was made over into a studio. His was a
pleasant and devoted family, and Eakins painted his parents and his sisters
one after another in his straightforward, unflattering, but invariably
searching manner. These were people, not "portraits"—more nearly genre
than sitters posed to be painted. His first large portrait was of Katherine
Crowell, the sister of a boy who had been a close friend of his in high school.
She and Eakins had fallen in love and were engaged. He painted her seated
in a large Victorian armchair, a white fan in her right hand and a cat in her
lap. Light from a single source falls on her white dress, on the fan, and on
portions of her young but not pretty face, most of which is in shadow. It is
one of Eakins' most appealing pictures of a person, though there is not a
trace of sentimentality in it. Uncompromising in its veracity, it is tender

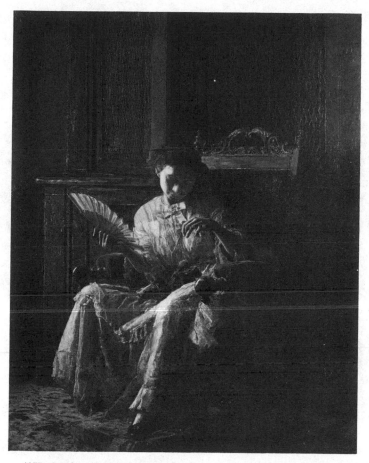

"Katherine," whom THOMAS EAKINS painted in 1872, was his fiancée for seven years. She died at the age of twenty-seven in 1877. (*Yale University Art Gallery, Bequest of Stephen Carlton Clark*)

withal and a lesson in the ways in which the stuffiness of the 1870s weighed on young, lithe shoulders.

The year after Eakins got home from Europe he painted one of his most successful pictures, perhaps his masterpiece, certainly his best-known painting, "Max Schmitt in a Single Scull," now in the Metropolitan Museum. It is essentially an autumn landscape, the water of the Schuylkill flattened to an almost metallic sheen and smoothness with a reflecting surface like silver. Schmitt, his oars at rest, looks out of the picture, just as the fur trapper and boy look out of Bingham's misty river scene, gazing at the spectator full in the eye, with the result that one is drawn into the placid

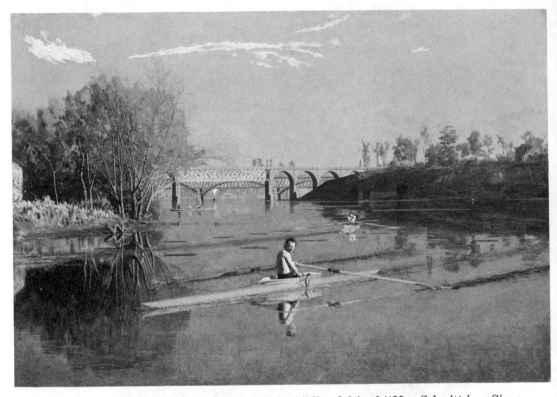

THOMAS EAKINS painted his childhood friend "Max Schmitt in a Single Scull" on the Schuylkill River in 1871. Eakins himself is in the scull in the middle distance. (*The Metropolitan Museum of Art, Alfred N. Punnett Fund and Gift of George D. Pratt, 1934*)

picture, into its very center, and feels the stillness of the autumn afternoon not just in front of but around one. The picture is intricately composed, mathematically precise in its perspective, sharp but suggestive in its detail, in its reflections, in the bridges in the distance, in the small figure rowing a single scull in the far-middle ground: Eakins himself—his first self-portrait. It is one of a number of paintings of men rowing in shells on the Schuylkill, a sport and a place that had delighted Eakins from childhood and in those days of dark interiors a bright, exciting, and gaily colored contrast to life indoors. Water, indeed, preoccupied Eakins as a young man, the smooth, sporting water of rivers and bays, playing fields for sailing and rowing and swimming, never ominous and never the open water of the ocean that preoccupied Homer. He painted regattas and men shooting in marshes and sailing before sometimes generous but never dangerous winds.

In spite of the number of boating and hunting scenes Eakins painted

as a young man, he is more an indoor than an outdoor artist. He liked the mathematically precise light of a controlled environment better than the constantly changing light of day; indeed, even his outdoor scenes have a static indoor quality, as though his trees and rocks were furniture and his water mirrors or rumpled pieces of goods. By all odds the largest portion of his work was portraits of men and women (he painted children very rarely), and his nudes, other than those done as studies, are small in number, though impressive in quality.

It was a portrait that first brought him notoriety, a picture that was later to contribute greatly to his fame. While a student at Jefferson Medical College he had frequently watched Dr. Samuel D. Gross, one of the most famous surgeons of his day, operate in the surgical amphitheater, surrounded by medical students and assisted by other surgeons. He persuaded Dr. Gross and a number of other doctors as well to pose for him, and he produced his most ambitious and powerful composition, a group portrait dominated by the massive head of Dr. Gross, who has paused, scalpel in hand and blood on his fingers, to explain a procedure to the students, a curtain of dim figures looking down on him. In the back of Eakins' mind was obviously Rembrandt's "The Anatomy Lesson," but this was no fashionable group portrait; it was genre at its most intense and descriptive.* A woman seated in the well of the amphitheater, her hands clutched into talons before her face to hide the scene to which she must be a witness, contrasts anguish with the coolness of the work at hand. (There was a requirement in those days that a relative of the patient be present as a witness to a charity operation.)

"The Gross Clinic," as the picture is called, was first exhibited in Philadelphia at the Haseltine Galleries, and the public and critical reaction was immediate, astonished, and largely hostile. One critic hailed the work of "an artist who in many particulars is far in advance of any of his American rivals. . . . we know of nothing in the line of portraiture that has ever been attempted in this city, or indeed in this country, that in any way approaches it." On the contrary, most observers were profoundly shocked. It was the blood on Dr. Gross's fingers which they found most repugnant, though the notion that a scene of such "brutality" should ever have been painted, much less exhibited, was hard for them to conceive. "No purpose is gained by this morbid exhibition, no lesson taught," one critic wrote, and another, S. G. W. Benjamin, who was respected as one of the leading art critics of his day (he was a frequent contributor to such family magazines as *Harper's*), said more about his own time than about Eakins when he wrote:

* It is closer to another group portrait by Rembrandt, "The Night Watch," in dramatic lighting and baroque composition, than to "The Anatomy Lesson."

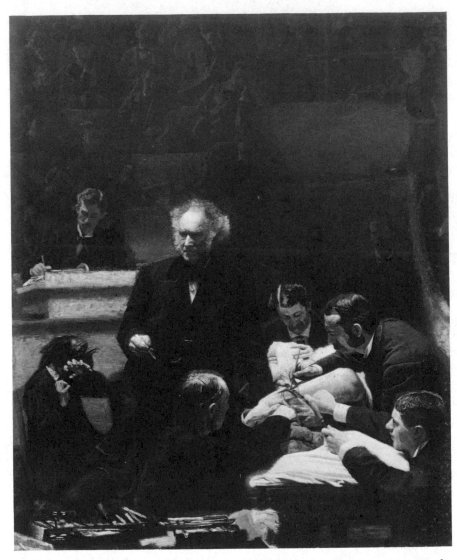

THOMAS EAKINS' ''The Gross Clinic'' was considered too brutal to be included in the art exhibition of the Centennial World's Fair of 1876 in Philadelphia. It was shown there with the medical exhibits. (*Jefferson Medical College of Philadelphia. Photo Philadelphia Museum of Art*)

As to the propriety of introducing into our art a class of subjects hitherto confined to a few of the more brutal artists and races of the old world, the question may well be left to the decision of the public. If they demand such pictures, they will be painted, but if the innate delicacy of our people continues to assert itself there is no fear that it can be injured by an occasional display of the horrible in art, or that our painters will create many such works.

The stir caused by the painting did Eakins' public reputation more harm than good. He submitted it along with other paintings to the Centennial Exhibition, whose buildings were rising above the Schuylkill while he was at work on "The Gross Clinic," but it was considered too brutally realistic for the polite company of pictures that would hang on the walls of Memorial Hall, and it was relegated to the medical exhibition. As it had not been commissioned, he even had trouble disposing of it; after three years it was finally bought by the Jefferson Medical College (which still owns it) for $200. Eakins was only thirty-one when "The Gross Clinic" was finished in 1875, and no work of the rest of his career equaled, much less surpassed, it, though there are those who would attribute superior virtues to another portrait of a surgeon working before his students and with his colleagues, "The Agnew Clinic," painted fourteen years later.

Such butter as painting put on Eakins' bread was put there by portraits, and there was not much of it. He could not bring himself to flatter his sitters, and he said of painters who depended on their social graces to sell their pictures, "Pickpockets are better principled than such artists." A great many of his paintings he gave as presents to those who sat for them, since many of the sitters were friends, and even his sales were at low prices —a few hundred dollars as opposed to the few thousand that fashionable portraitists got as a matter of course. He did not even permit his friends to put on their best clothes to be painted in; when he painted his friend James W. Holland, the dean of the Jefferson Medical College, in his academic robes reading the roll call at commencement, he got him to put on his old shoes because they were more interesting to paint than new ones. Some of his sitters who were paying clients turned down his pictures or paid for them and offered to return them. When Lloyd Goodrich was doing his catalogue of Eakins' work some years ago, the daughter of one of Eakins' subjects, a "member of a prominent Philadelphia family," wrote of her father's portrait, "It was so unsatisfactory that we destroyed it, not wishing his descendants to think of their grandfather as resembling such a portrait." Walt Whitman, who was living in Camden, New Jersey, just across the

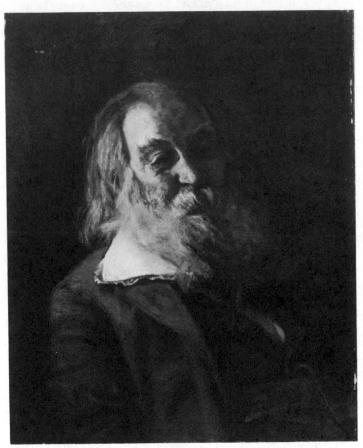

"Walt Whitman," of whom THOMAS EAKINS painted this portrait in 1877–78, said of him, "Eakins is not a painter; he is a force." (*The Pennsylvania Academy of the Fine Arts, Philadelphia*)

Delaware from Philadelphia, also sat for Eakins and greatly admired him. "I never knew but one artist, and that's Tom Eakins," he said, "who could resist the temptation to see what they think ought to be rather than what is." Whitman liked Eakins' portrait of himself better than any others, and, comparing it with one by John W. Alexander, he said, "Tom Eakins could give Alexander a lot of extra room and yet beat him at the game. Eakins is not a painter, he is a force. Alexander is a painter." And he also said, "Tom's portraits, which the formalists, the academic people won't have at any price . . . are not a remaking of life but life, its manifests, just as it is, as they are." But people did not want force, they wanted flattery, and two of Eakins' good friends, William Merritt Chase and John Singer Sar-

gent, were past masters at the fashionable portrait and at the same time men whose talent he regarded with respect, if not always with approval.

Eakins painted a very few nudes (except as studies) in spite of his fascination with the structure and beauty of the human body. Nudes were not popular except over bars in saloons; indeed, except for the white marble maidens made acceptable by Powers' "The Greek Slave," they were not morally (which essentially meant socially) acceptable. "Such subjects," an artist and writer who was a contemporary of Eakins wrote,

> were not in accord with the national habit. . . . We are a north-
> ern nation and a decorous nation, unlearned in artistic traditions
> and unacquainted with the artistic view-point. Interest in a pic-
> ture is apt to depend on the object represented, and before a
> painting of the nude the average beholder experiences something
> of the same embarrassment that he would feel before the reality.

When there was an occasion that justified painting the nude, Eakins enjoyed it; in a few instances he made such occasions—never ones, however, that could offend the proprieties of his contemporaries. A salacious or a suggestive stroke never escaped from Eakins' brush. His first nude appears in a delightful picture of William Rush, whom we met many pages back as the first Philadelphia sculptor of note, carving his allegorical figure of the Schuylkill River. A young woman holding a book on her shoulder (the book is a bittern in the sculpture Rush is carving) stands with her back to the spectator; seated by her is a chaperon knitting, and on a chair her clothes are casually strewn. The sculptor in the shadow works with his mallet and chisel. It is a gentle, poetical, albeit literal painting, of which Eakins late in life did a tougher and less successful version. Several years after the first "Rush" picture he painted a group of young men swimming in a river, a carefully composed triangular design of unidealized bodies—"naked" as Eakins would have put it, not "nude." He never used the genteel word for the direct one. (To him an "artist" was a "painter" and a "studio" a "workshop.") He painted a Crucifixion to demonstrate that no other artists had ever really shown the weight of a body hanging by the nails in its hands, and toward the end of the century he was introduced to boxing matches by one of his pupils and became an enthusiast. There are, as a result, a number of ring pictures (both boxing and wrestling), strong factual statements filled with the cigar smoke and sweat of the arena, but without violent action of any sort—exercises in mood and anatomy, not exercises in exercise.

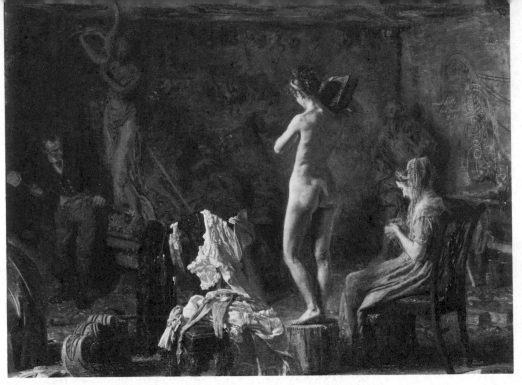

Though he was a thorough anatomist and a teacher from the nude, THOMAS EAKINS rarely painted the nude himself as he did in "William Rush Carving His Allegorical Figure of the Schuylkill River" in 1877. Rush's carving is reproduced on page 113. (*Philadelphia Museum of Art*) THOMAS EAKINS painted "The Swimming Hole" in 1873 after having prepared wax models of each of the figures. Eakins himself is the figure swimming at the right. (*Fort Worth Art Center Museum*)

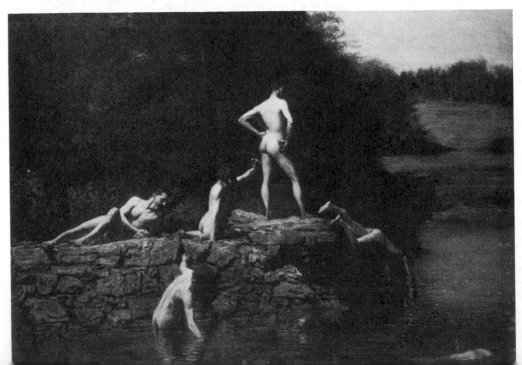

The range of Eakins' subject matter was narrow, but so was the range of what was considered suitable subject matter for paintings in the years following the Civil War. The public liked what was picturesque, and though there was something picturesque about farmers in fields or maidens with spaniels or sleigh rides, the labors of men in the new age of mechanization were merely a fact of life. What was romantically appealing about a McCormick reaper or a steelmill or a sweaty factory worker? The man with a scythe, the cowboy on the range, even the Negro in his dooryard were suitably picturesque to those who saw no artistic merit in the no more grubby but somehow less romantic circumstances of industrialization. There are, indeed, only a very few paintings of consequence which used industrial America as their subject after the Civil War and before the turn of the century, and none of them is by Eakins, whose naturalism and interest in mechanical things one would have thought might have led him to such subjects. In the same year that Eastman Johnson painted his "Old Kentucky Home" (1867), John F. Weir,* who became the first director of the Yale School of Fine Arts, painted the interior of a gun foundry and in the following year a picture called "Forging the Shaft" which used the drama of factories as subjects. Thomas Anshutz, one of Eakins' most accomplished pupils (and, like Eakins, a great teacher), painted laborers relaxing outside a mill in "Steel Workers' Noontime," the first "labor" painting in America.

Eakins' reputation as a teacher was both sound and shocking; his serious students regarded him with justification as one of the greatest teachers of painting ever to guide the young in America; proper Philadelphia was outraged by what they considered his improprieties. His method of instruction was his own, and it was revolutionary in the days when drawing from antique casts was the discipline to which every beginning artist was subjected for months on end. He taught his students to draw with paint in large masses of color and to build their figures from the inside out rather than by making meticulous outlines and then filling them in with anatomical details. "The outline is not the man," he said. "The grand construction is." He insisted that his students understand the precise function of the muscles and tendons and the skeleton, and they studied not only dissection but the naked model—and by naked Eakins meant just that.

For a few years after the Pennsylvania Academy moved into a brand-

* Weir was the son of Robert W. Weir, Greenough's friend who brought him home from Rome when he had a breakdown. The elder Weir was later drawing master at West Point and a history painter who did one of the murals for the Rotunda of the Capitol in Washington, "Embarkation of the Pilgrims."

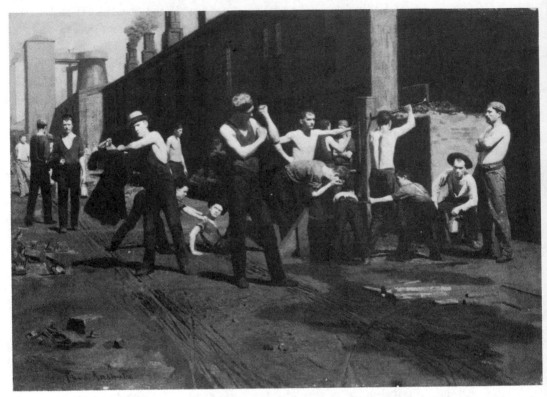

"Steel Workers—Noontime" by THOMAS ANSCHUTZ (about 1790) is to
industrial workers what Mount's "Farmers Nooning" (page 243) is
to agricultural workers. Farmers, however, were frequently painted;
this is one of the rare nineteenth-century American labor pictures.
(*Collection of Dr. and Mrs. Irving Burton, Detroit*)

new building in the centennial year, Eakins acted as the instructor of life
classes without pay; by 1882 he was the Academy's paid director. Not all of
the proper gentlemen who constituted the Academy's board approved of the
young radical who was so boldly supported by one of their number, Eakins'
friend and patron, Fairman Rogers, the chairman of the School Commit-
tee.* Eakins ran a tough and demanding curriculum, excellent for serious
students, some of whom came from great distances to study there, but
hardly suited to the desires of eligible young ladies who wanted to acquire
polite accomplishments. Eakins was outspoken, and some of the young
ladies took umbrage at his frank attitude toward the nude and the ways in

* In 1879 Eakins painted a delightful coaching picture, "The Fairman Rogers
Four-in-hand," now in the Pennsylvania Museum of Art, Philadelphia.

which he used the model for instruction. On one occasion, when a professional model failed to turn up, he asked a young woman in the class to take off her clothes so that he could demonstrate a point he was making about the structure of the female back. She burst into tears, fled, and went home to tell her father, who was outraged and complained to the directors of the school. On another occasion, in order to demonstrate the action of the male pelvis, he had his model remove his loincloth, an instance that so shocked a few of the students and caused such a scandal that Eakins was given the choice of changing his teaching methods or resigning. He resigned, of course. This was in 1886. The Academy lost its most distinguished teacher, and some of its students organized an Art Students League with Eakins as its head, though he was reluctant to press for any such attempt on the part of his pupils to shore up his reputation.

The break with the Academy was a sorry blow to Eakins, and the Art Students League was not long-lived. Eakins continued to lecture on anatomy at the National Academy of Design, at Cooper Union in New York, and at Drexel Institute in Philadelphia, where another scandal, concocted out of whole cloth by a journalist, made trouble for him. Even so, he seemed impelled to make trouble for himself over the issue of nudity (he frequently asked ladies who sat to him for their portraits to pose in the nude for him). Other considerations aside, one should remember that this was a time when decency required almost complete obscuration of the female figure, including the ankles; a woman had to discard a great deal of wool and flannel and silk to become nude. Even Eakins' tactlessness was stubborn, as though he felt it his moral and aesthetic duty to stand firm on a matter that went beyond principle to a kind of obsession.

Eakins' concern with anatomical functions led him not only to trouble, of course, but to investigations that were of scientific importance and, indirectly, to public entertainment and mass communication. In 1894 he produced a paper on the functioning of the muscles which contradicted a long-held theory of flexors and tensors, and it was published in the *Proceedings* of the Academy of Natural Sciences of Philadelphia. He was also responsible for pushing forward the use of the camera in the direction of motion pictures. He was an expert photographer in the days when photography was not for amateurs, and he became fascinated by the work of a photographer named Eadweard Muybridge, whom Governor Leland Stanford of California had employed to help settle a $25,000 bet about the nature of a horse's gait. Muybridge had set up twenty-four cameras in a line beside a track, and on his glass plates he had recorded the movements of a horse as it sped by the lenses. Eakins, not surprisingly, was attracted by

One of the earliest experimenters with multiple exposures of figures in motion, THOMAS EAKINS made this photograph of George Reynolds pole-vaulting in the 1890s. (*The Metropolitan Museum of Art, Gift of Charles Bregler, 1941*)

this method of recording anatomy in motion, and he invited Muybridge to lecture at the Pennsylvania Academy School when he was its director. In 1884 Muybridge continued his work with several cameras at the University of Pennsylvania under a supervising committee of which Eakins was a member. Not satisfied with the multiple-camera technique, Eakins devised a method of his own which employed two disks revolving in front of a single lens so that the movements of the image were recorded on a single plate. For a couple of years Eakins was engrossed in experimenting with his photographic device and made pictures of athletes and horses in motion. He displayed his results with a projector called a zoëtrope, an ancestor of the moving-picture projector. Muybridge eventually shifted from his own method to one closely resembling Eakins', and though Muybridge is celebrated as a precursor of the motion picture, Eakins is not and should be.

There was no serious aspect of visual representation which did not interest Eakins and few he did not practice. He was a skillful watercolorist (though no match for Homer), and he was a sculptor of modest pretensions and production—about fifteen pieces in all, including his sketches. One cannot escape a comparison between Eakins and his Philadelphia forerunner, the scientist-painter Charles Willson Peale. Both of them ran head on into local prudery, as both of them firmly believed that it was essential for

the artist to learn to draw and paint from the living figure in the nude; but both of them enjoyed and took a lively part in the scientific excitement that pervaded the intellectual atmosphere of the city. Both were mechanics, both were concerned with the moving picture (as opposed to the later motion picture), Peale in the moving dioramas he made for his museum and Eakins as a means of discovering the exact nature of animal movement. They were both art-makers with firm aesthetic convictions who discovered their subject matter in the American environment. They were both friendly and gregarious men without airs or graces, dogged, concentrated, and endowed with an unremitting curiosity.

When Peale was a young man there was no place for an aspiring artist to learn his craft except Europe; indeed, the same was largely true when Eakins set out for Paris at the age of twenty-two in 1866. By the end of his career (he died in 1916 in the Mount Vernon Street house) Eakins was able to say: "In the days when I studied abroad . . . the facilities for study in this country were meagre. There were even no life classes in our art schools and schools of painting. Naturally one had to seek instruction elsewhere, abroad. Today we do not need that." He had been as responsible as anyone for this transformation. He was called a radical and a "young firebrand" when he came back to Philadelphia from Europe. To tell the unvarnished visual truth then was to be a radical, and when Whitman said that Eakins was "not an artist," he was digging at the pretensions of the aesthetic craze of which Whistler was an exemplar. Like Whitman, he had an abiding belief in democracy and in America as a source of inspiration and subjects for its artists. In an interview in his late years Eakins said:

If America is to produce great painters and if young art students wish to assume a place in the history of art of their country, their first desire should be to remain in America, to peer deeper into the heart of American life, rather than to spend their time abroad obtaining a superficial view of the art of the Old World.

THE EYE-FOOLERS

Neither Brady with his vast slow camera, nor Homer with his eye that stopped movement like a focal-plane shutter, nor Eakins with his eye that pierced the surface to the structure beneath could see an object with the

The most accomplished and most popular of the American eye-foolers at the end of the century was WILLIAM HARNETT of Philadelphia. He painted "Old Models" in 1892. (*Museum of Fine Arts, Boston, Charles Henry Hayden Collection*)

same kind of clarity as a man named William M. Harnett. He had a passion, it appears, for surfaces—the texture of wood, the hardness of steel, the pliability of paper, the softness of rabbit fur. He also had a passion for combining all of these in formal designs of the most elegant and subtle relationships in the very ancient tradition of fooling the eye. He made the man who stood before his painting want to reach out his hand to see if, indeed, the ivory-handled revolver hung by a nail on a painted door could be taken down and examined, and if the scrap of newspaper stuck to the door could be pulled off by its dog-eared corner.

Harnett was almost exactly Eakins' contemporary, and they were both residents of Philadelphia. Like Eakins, Harnett studied at the Academy School, but, unlike him, he took as a matter of course the "fusty" academic training of interminable drawing from casts. Eakins and Harnett had little in common socially, economically, or artistically. Harnett's parents migrated from Ireland when Harnett was an infant, and his father died soon after the family had settled in Philadelphia. When he was seventeen he went to work learning to engrave on wood and steel and copper and finally on silver, and it was as a silver engraver that he principally earned his living as a young man. When he was nineteen he started taking night classes at the Academy, and two years later, in 1869, he moved to New York, where he worked for several large jewelry firms and studied at the National Academy of Design school and in the free courses in the great red building of Cooper Union. He took a few lessons from a portrait painter who, he said, "didn't exactly say I would never learn to paint, but he didn't offer me any encouragement." There was a slump in the silver business (as in all business) in 1875, and Harnett turned to painting as a profession. He couldn't afford to hire models, he recalled in an interview some years later, so he used what was at hand—a pipe and a German beer mug. "After the picture was finished," he said, "I sent it to the Academy and to my intense delight it was accepted. What was more it was sold. I think it brought $50. That was the first money I ever earned with my brush and it seemed a small fortune to me." A year later he went back to Philadelphia, set up a studio, and, in effect, hung out his shingle as a bona-fide art-maker.

Unlike Eakins, he made a living at his profession; he had a very marked gift for a certain kind of picture for which there was a market, and he stuck to it, with only rare essays into any other kind of painting. That is not to say that his work is monotonous or without very considerable variety within the range of still-life. The depth of a Harnett is never more than a few feet, and usually it is only a few inches. The deep pictures are objects arranged on a table—a jar, a candlestick, books, a pipe, sometimes a vase of

flowers and a piece of Oriental rug, all very much in the manner of many Dutch still-life painters of the seventeenth century. The pictures that are a few inches deep show objects hung on a door or wooden panel—a violin and its bow, a sheet of music, a horseshoe with sometimes a few books, a nautilus shell, a candlestick on a narrow shelf at the bottom of the picture.

If Eakins was in the scientific art-maker tradition of Charles Willson Peale, Harnett was in the still-life tradition of a number of other members of the Peale family. Peale's brother Francis, by profession mainly a miniature painter, also painted meticulous still-life and, more important, so did Peale's son Raphaelle, who is an ornament of American art. Painters who considered history paintings as the highest art in the early part of the century looked upon still-life as the lowest, though Washington Allston said, "I cannot honestly turn up my nose even at a piece of still life." There was, however, some market for such pictures, and Raphaelle, who suffered from ill health and intemperance, achieved great subtlety in the handling of textures in his collections of fruit and fish and vegetables and jars, which very strongly influenced Harnett's early attempts. Raphaelle, moreover, delighted in fooling the eye and never more successfully than in his painting "After the Bath," in which the canvas is largely occupied by a beautifully painted white sheet above which emerges the arm of a young woman—a picture that not only fooled the Philadelphia eye but scoffed at its prudery. Still-life was never a dead art in the nineteenth century even if it was a minor one. Its subject matter was nothing to put off the unadventurous, and it commanded good prices; indeed, Harnett is said to have got $10,000 for his "Emblems of Peace," which he painted in 1890.

Even before this windfall, Harnett had prospered sufficiently to travel to Europe, and he spent six years there, chiefly in Munich, which had replaced Düsseldorf as a magnet for American painters. When he returned to America in 1886, he set up his studio in New York. Six years later he died, leaving a legacy of imitators and a field day for forgers.

Alfred Frankenstein in *After the Hunt* has written a fascinating account of his adventures in sorting out the Harnetts from the forgeries and in establishing the reputations of two other still-life painters (and eye-foolers), John Frederick Peto and John Haberle. Both were contemporaries of Harnett and, though lacking Harnett's extraordinary ability to depict not only the texture of a surface but the density and character of the material behind it, both were men of like vision and like interests in *trompe l'œil* and the pleasure of a static object for its own sake, and, in many cases, for its anecdotal suggestiveness. As Frankenstein says, these painters of the ordinary junk of life cast their shadow far forward to the Pop artists

RAPHAELLE PEALE painted "After the Bath" in 1832 as a sort of leg-pull—a *trompe l'œil* of a woman hiding behind a bath towel with only her arm and her foot in evidence. (*Nelson Gallery—Atkins Museum, Nelson Fund, Kansas City, Mo.*)

of the 1960s, and their delight in the ordinary gurry of everyday living, its cast-offs, its sentimental memorabilia. It also suggests an affinity of the mid-twentieth century for the clutter, the bibelots, the fancy-work and fringe of the last quarter of the nineteenth century, of the twentieth-century "family room" for the nineteenth-century parlor, of the "den" of today for the "smoking room" of yesterday, and the pub of today for the saloon of our great-grandfathers. I commend Frankenstein's extremely

The still-lifes of JOHN F. PETO, who painted "Market Basket, Hat and Umbrella" about 1890, are frequently confused with those of Harnett. Indeed, Harnett's signature was forged on many of them by unscrupulous dealers. (*Milwaukee Art Center*)

readable book to anyone who likes an art-historical detective story and the methods of art detection, and I do so rather than recount in brief his delightful adventure with the late-nineteenth-century eye-foolers and their parasites.

A room occupied by Brady, Homer, Eakins, and Harnett would obviously have been far more interesting than a chapter occupied by them, four men with eyes on the object, seeing it in four different ways for four different purposes and with four quite different temperaments. But they were all of an era, all of a persuasion that art had to start from the object, from the visual fact, and be revealed in a visual truth. And they were all Americans, looking out of their own surroundings at their own surroundings. None of them filtered his vision, except tangentially, through the vision of art-makers anywhere else.

12

A QUARTET OF ROMANTICS

"I have a strong tendency to see in things more than meets the eye."

ELIHU VEDDER in
Digressions of V, 1910

Happily there are always art-makers who decline to be classified except in the most general ways because they quite simply follow their own unpopular lines of inquiry. By unpopular I do not mean that the work they produce is not in most cases readily acceptable to at least a portion of the public once it is produced, but it does not set out to catch the popular fancy or to follow any prescribed rules for doing so. Furthermore, it is not likely, since it is of such a personal nature, to invite followers or start schools of art or attract imitators. The fact that an art-maker is off the beaten track does not make him any greater than one who is a monument or a signpost on the main highway, but it adds to his attraction an appealing kind of oddity which most people enjoy in artists and which they forgive (or praise) as eccentricity.

Four painters whose lives among them span more than a full century and whose work declines to be pigeonholed are William Page, who knew Trumbull and Morse; Elihu Vedder, who was in Rome in the days of the White Marmorean Flock; George Inness, who started out as a disciple of the Hudson River School and drifted into mistier matters; and Albert Pinkham Ryder, a genuine recluse, whose intensely romantic vision sequestered him from the aesthetic fads of his day. The first of these men was born

in 1811; the last and youngest was born in 1847 and lived until 1923. Very
nearly the only things they had in common were that they were all painters,
that they all occupied a large piece of the same century, and that they were
all Americans. One could add to this that they were all romanticists rather
than classicists, though this distinction is not much of a clue to their work or
to their personalities.

William Page came from a rather footloose family and was a restless
spirit with a facile and eloquent tongue and pencil and a philosophical and
inventive turn of mind. He was born in Albany, New York, where his father
was a plane-maker (he had tried a bit of many things from shopkeeper to
mail-carrier to navigator on the Hudson), but the family picked up once
more in 1820 when William was nine and moved to New York City. When
he was eleven he won a prize from the American Academy for a pen-and-ink
drawing and at about the same time a lecture from Colonel Trumbull about
the nonsense of trying to make a living out of being an artist, advice that
seems to have deterred the boy not in the least. At sixteen he joined the
drawing classes that Samuel F. B. Morse had initiated with the new Acad-
emy of Design and at the end of his first year won a silver medal. He was
not, however, convinced that he wanted to be an artist, and for two years he
studied theology, first at Andover and then at Amherst. Presbyterianism,
he discovered, was not for him; indeed, as a young man he found no aspect
of Christianity that satisfied his bent, and he went back to Albany, where he
set himself up as a very successful portrait painter with the customary urge
to paint history pictures and to escape to Europe and the study of the Old
Masters. He was deterred by falling in love with a pretty young Irish-
woman, the daughter of an actor, married her, and painted a picture of her
with their baby. On account of the popularity of this painting he was
elected an associate of the National Academy of Design. This was in 1835,
when he was twenty-four and bursting with theories about art to which, he
discovered, his fellow members of the Academy paid no heed. They were, it
seems, quite satisfied with their own theories and not interested in his
philosophical speculations.

Boston, to which he moved in 1843, and the transcendentalists made
him feel at home. Here were men of an intellectual seriousness and scope
against whose responsive minds he could beat his theories of art. Here were
men who believed that the highest intellectual achievements were to be found
in writing and who regarded painting as an art only to be tolerated. Here
was Emerson, who thought that sculpture was nonsense and that only the
image made by God himself in the shape of man mattered; here was the
novelist Hawthorne, who was glad to discover that some paintings exhibited

at the Athenaeum in Boston were somewhat less offensive than some others. They enjoyed Page's discourses on the scientific principles that underlay the visual expression of painting, his belief in immutable laws of art, and his eloquence. His young wife, however, did not, and, as Flexner neatly put it: "As he talked with his new friends, his wife became so bored that she found herself with child by a taciturn stranger."

Page divorced her and married again twice, first a young woman whom a correspondent in the *Boston Daily Advertiser* said was "certainly the handsomest woman I have ever seen" and who not many years later deserted him in Italy for a count (and finally became the wife of Boss Tweed's lawyer, Peter B. Sweeney) and then a woman who took him and his disregard of practical matters in hand and ran his life for him.

In some respects Page's paintings pleased his contemporaries for their directness, for their charm as portraiture, sometimes dramatic but always honest, and in some respects he shocked them by painting subjects that were not considered decent. He was a sensualist as well as an intellectual with mystical leanings. He painted four versions of a "Venus," standing, full-length, and life size, two of which were rejected by the Royal Academy in London and the Salon in Paris, one of which found its way to the cellar of the Boston Athenaeum, and the last of which went on a scandalous tour in America and was scrupulously avoided by most self-respecting citizens. His "Cupid and Psyche" is a mysterious small painting of naked lovers embracing in a passionate kiss. Page insisted in defense of its propriety that it was painted from sculpture; it was permitted to be shown at the Athenaeum in 1843, but was rejected as scandalous by the Academy of Design in New York. One of Page's most delightful pictures is of two newsboys ("The Young Merchants"), a very carefully composed genre painting that includes solid and crisp still-life with solid and convincing figures overlaid with a minimum of anecdote and an obvious delight in the sensual pleasure of putting paint on canvas. His best-known portrait is of Mrs. Page (the third Mrs. Page) standing in front of the Colosseum in Rome, a strong figure simplified into large masses completely free of fussiness and just as completely free of the clichés of nineteenth-century American portraiture.

There is in Page's work a conscientious simplification of forms which gives it a sculptural quality. He believed, indeed, that history pictures should be based on sculpture in order to achieve a monumental poise, and he cited the precedents of Tintoretto and Poussin to support his contention. To him the Venetian painters stood above all others, and above all other Venetians stood Titian. Page was an inveterate experimenter with methods of how paint should be applied, how flesh should be built up, how glazes

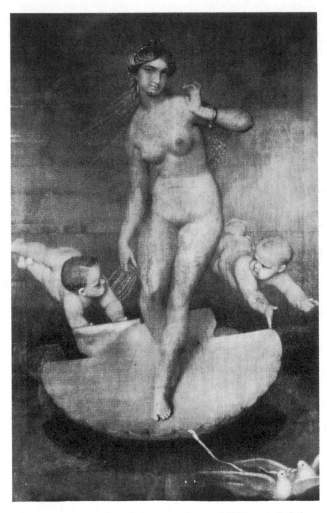

WILLIAM PAGE painted four versions of "Venus Guiding Aeneas and the Trojans to the Latin Shore," and this is thought to be the 1862 version. He was shocked when the Paris Salon turned down the first version on grounds of indecency. (*Photo Archives of American Art, Collection Mrs. Leslie Stockton Howell, West Palm Beach, Florida*)

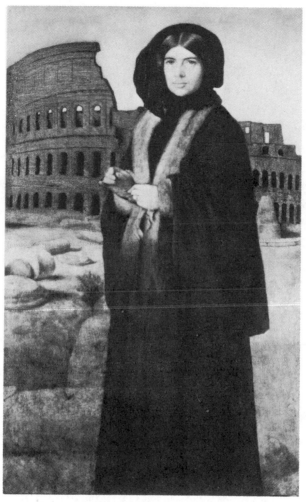

WILLIAM PAGE's portrait of his third wife, painted in Rome in 1860–61, has a sculptural quality and a poetical stature rare in American portraits. (*The Detroit Institute of Arts*)

should be put on, but his experiments and pigments often played him false, with the unhappy result that many of his canvases have quite simply fallen apart—their surfaces cracked and sometimes flaked off. Like so many of the art-makers of his time, he was a tinkerer and inventor, and he held patents on devices for improving guns and boats. But it was as an expounder of art philosophy and as an eloquent conversationalist rather more than as a painter that he mesmerized his contemporaries and caused no less

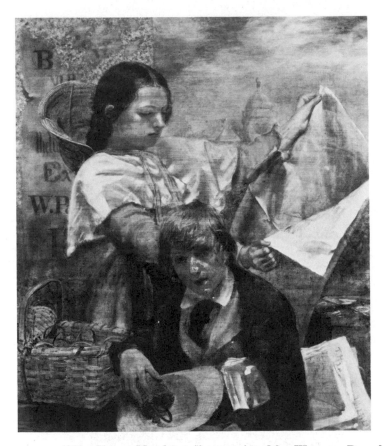

"The Young Merchants" was painted by WILLIAM PAGE before
his first trip to Europe in 1844. It is a genre picture of a kind
not regarded as "high art" by Page's contemporaries, who cared
more about sentiment than solidity of painting. (*The Pennsyl-
vania Academy of the Fine Arts, Philadelphia*)

august (if not always perceptive) a figure than the sculptor Story to call
him "truly" a man of genius.

Page was in Italy for eleven years (1849–1860), and during that time
he lived and worked in Florence as well as in Rome. In Florence he met and
evidently fell somewhat under the spell of Hiram Powers, then at the zenith
of his fame. They must have enjoyed each other's conversational gifts and
had a mutual admiration for each other's mechanical inventiveness, if not
necessarily each other's aesthetic achievements. Page was certainly a more
passionate and subtle artist than Powers, but it was Powers who opened to
Page the doctrines of Swedenborgianism. Here at last was a religious

philosophy he could reconcile with his theories about art, as he had been unable to do with Christianity as propounded by the Presbyterians. A mysticism based on the visions of a scientist suited this maker of forms.

When Page came back to America he settled in the vicinity of New York. He was neither a representative of the old school of Allston and Morse, both of whom he knew and who had helped to form his ideas about art, nor was he part of the new movement with which the younger painters who had gone to Düsseldorf or to Paris identified themselves. Neither his contemporaries nor his juniors were interested in his pronouncements or in the restlessness of his experimentation, which led him from style to style and method to method. He was briefly in 1871 the president of the National Academy of Design, but as a seer, as a master, as a prominent figure of the art world he was all but forgotten when he died in 1885 at the age of seventy-four.

THE UNNATURALIST

Elihu Vedder, who was twenty-five years younger than Page but, like him, spent a good many years in Italy, is considered something of an enigma in the annals of American art, a reputation he most assuredly would enjoy. He was a jolly, outgoing, gregarious soul with the demeanor of a sportsman and the air of a *bon vivant*, humorous, relaxed, and affable. His paintings, on the other hand, seem to have the attributes of a dark mind concerned with mysterious matters, brooding, mystical, and enveloped in the shrouds of the occult. One is tempted to conclude that the mysterious pictures were a pose, a substitute for conviction, indeed, a gadgety alternate for thought —a means for attracting attention rather than an attempt to discover truth or even genuine fantasy. His contemporaries were impressed by his strange pictures of serpents and sphinxes and most especially by his illustrations for the Rubáiyát of Omar Khayyám, which he did in the 1880s and which made him famous. He was, in fact, an illustrator at heart, and one senses in his paintings the process by which he arrived at a subject worth illustrating rather than at a concept worth painting—the very opposite of Page with his abstract aesthetic theories to be practiced on whatever place, person, or concept was at hand.

Odilon Redon, a romantic precursor of Surrealism, once said to the

So when the Angel of the darker Drink
At last shall find you by the river-brink,
And, offering his Cup, invite your Soul
Forth to your Lips to quaff — you shall not shrink.

ELIHU VEDDER made the fifty-odd drawings for Edward Fitzgerald's translation of the Rubáiyát of Omar Khayyám between May 1883 and March 1884 while living in Rome. No other work of his did so much to spread his reputation. (*The New York Society Library*)

American painter and writer Walter Pach, "I have tried to put the real at the service of the unreal," and this applies almost exactly to Vedder, a careful draftsman (almost, indeed, a pedestrianly careful draftsman) who by juxtaposing one reality against another reality in an unusual relationship concocted something that had an air of unnaturalism. His most famous picture, "The Lair of the Sea-Serpent," an enormous, slithering denizen of the deep curled around sand dunes, is precisely such a trick. The serpent is an eel Vedder saw on a beach (or so it was believed); he made a careful pencil drawing, and it becomes a monster by being set on sand dunes scaled down to the size of anthills. The effect is ominous even if the means of achieving it were not. It is a child's nightmare, nothing more.

It was said by ELIHU VEDDER's contemporaries (and he denied it) that a pencil drawing he made of a dead eel was the basis for "The Lair of the Sea Serpent" (1864), probably his most famous painting. (*Museum of Fine Arts, Boston*)

To dismiss Vedder, however, is to miss an opportunity to look not only at an entertaining figure in the art world during and after the Civil War but also at the kinds of subject matter which made his contemporaries shudder with delight, a dose far less lethal than the daily diet of children today. Vedder, like the makers of monster movies and comics, was cheerfully macabre and mysterious and seemed to take delight in making the spines of ladies tingle within their tightly laced corsets or to yearn for an unrestricted Nirvana in which robes flowed like blowing silk over bodies as fluid as water.

Vedder had scarcely any training as an artist, and all his life he wished that he had. "My pictures always have to me a homemade air which I don't like," he wrote in his memoirs.* "I mean, they lack the air of a period or a school, and this—I say it seriously—seems to me a great defect." When he

* *The Digressions of V*, published in 1910, is a lively, somewhat corny, but good-hearted recital of Vedder's life and opinions.

was a boy in his teens his parents let him leave New York City, where they were living, to study in upstate Shelburne with a painter named Tompkins H. Matteson, who did a good business in genre pictures with the Art Union. Matteson specialized in pictures of Pilgrims "either departing or arriving," and he sported a "steeple-crowned hat and a short mantle" like the subjects of his paintings. Vedder was one of six in a class conducted by Matteson, and he stayed only briefly, though he had great respect for his teacher and thought that if Matteson had ever been able to afford to study in Europe he would have made quite a name for himself. Unfortunately, Matteson's wife produced a baby a year and his family responsibilities kept him struggling on the verge of poverty.

In 1856, when he was twenty, Vedder "with a new gold watch, a new trunk, and a pocket well-supplied [by his father] with money" set out for Paris, a voyage in a ship "with a screw propeller" which took eighteen days. Once in Paris he sought admission to the Atelier Picot because he had been told that it had a reputation for producing more winners of the Grand Prix de Rome than any other. For eight months he made careful drawings from plaster casts and then abandoned the atelier to go with a friend to see Italy. Later he wished that instead of Picot's atelier he had chosen to work with Couture, as William Morris Hunt, who later helped to launch his career, had done. "I might have gone there," he wrote, "and gotten over a faithful but fiddling little way of drawing which hangs around me yet."

Italy was satisfactorily overwhelming, precisely as all young artists in the 1850s expected it to be. "At that time so much Art burst into my unprepared mind," he wrote, "that the resulting confusion has lasted me for the rest of my life." He was at one moment determined to be a landscape painter, the next a painter of figures; in Venice he "absorbed color like a sponge" and set out to be a colorist; he sketched incessantly, but when he tried to turn his sketches into finished pictures he "killed the feeling." In Florence he viewed from the outside the literary and fashionable circles where Powers and the Brownings and Hawthorne reigned and "immensely enjoyed" the "rich romantic sadness of youth" which impelled him to conceive of paintings of alchemists and hermits dying, of an old man at the gate of a graveyard, pictures "with few exceptions, never executed."

After four years in Europe Vedder went back to New York, stopping in Spain, where he was stuck for lack of funds in Cadiz and did not get to see the pictures in the Prado which had such an effect on a number of his contemporaries, most especially Eakins and Sargent. (One wonders what would have been the effect of the grim fantasist Hieronymus Bosch on the jolly Mr. Vedder.) New York, when he arrived, was consumed with the war.

He tried to enlist, but because as a child he had been accidentally shot in the left arm by another boy and the arm was not of much use, he was turned down. It was not a time when there was a good market for paintings, and he supported himself by drawing comic valentines, for which he was also expected to write the verses. ("You artists can make anything but money," his employer said.) He supplemented this small income with illustrations for a book on calisthenics (it was the era of wooden dumbbells) and for *Enoch Arden*. Book illustration was just beginning to be an acceptable occupation for artists who were regarded as serious painters. So was it the beginning of the kind of reportorial drawings which Winslow Homer and A. R. Waud made at the battlefront for such magazines as *Harper's Weekly* and *Leslie's*. "Those were the times," Vedder said, "when we made drawings of battles before they had taken place."

In the years just following the War, Vedder was elected an associate of the National Academy and his paintings—"The Lair of the Sea-Serpent" (called by his cronies "The Big Eel" and for which he was paid the lordly sum of $300), "The Lost Mind" (called "The Idiot with the Bath-Towel"), "The Questioner and the Sphinx"—began to attract serious attention and some purchasers. His cronies were, among others, George Inness, the sculptor J. Q. A. Ward, and the landscapists James Hart and Homer Martin. Martin did not achieve popular success until he painted a landscape called "Harp of the Winds" in the 1890s (now in the Metropolitan Museum), but he had a reputation for wit among his friends. Vedder recalls: "Late one day he was found very busy painting some plants in the foreground of a picture: on being asked what the plant was, he said, 'Why, don't you know that plant?—that's the foreground plant; I use lots of it.' "

Before Vedder went back to Europe in 1866 he spent some time in Boston, where William Morris Hunt (whose word on art was law) took him under his wing. "Hunt was . . . a most generous man," he wrote. "On seeing my pictures for the first time he wrote me a most appreciative and encouraging letter, doing me no end of good, and when I went on to Boston he proved in deed as well as word a sincere friend." John La Farge, a pupil of Hunt, was also there and "If Hunt was comforting, La Farge was inspiring." Vedder was especially comforted by the imagination and dexterity with which Hunt used profanity, and especially inspired by the dexterity with which La Farge painted flowers. But Boston could not hold him, and Vedder went back to Europe and settled in Rome, which he made his home for the rest of his long life. He lived to be eighty-seven.

From the tone of his memoirs Vedder seems to have been a man with a somewhat surprised delight in his accomplishments but with no great illu-

sions about his talents. On one occasion he painted a "dear little girl,
barefooted, wearing a quaint cap and feeding some motherless chickens,"
and he called it "The Motherless." It was a great success and, he said, "Had
I been wise I could have gone on painting Motherlesses, until every refined
home had one of my little pictures, and I should have had a villa on the
Hudson." But he was a more conscientious artist than that, or a more

restless one, and he went on thinking up subjects that were out of the ordinary and trying his hand at a variety of ways of treating them and of painting the Italian landscape. He also turned his skills to jewelry and to sculpture of no special distinction.

"I am not a mystic, or very learned in occult matters," he wrote. "I have read much in a desultory manner and have thought much, and so it comes that I take short flights or wade out into the sea of mystery which surrounds us, but soon getting beyond my depth, return, I must confess with a sense of relief, to the solid ground of common sense." And he added, "I have a strong tendency to see in things more than meets the eye."

Actually he saw very little more than the surface of things, and even that he saw with little subtlety, compared with Page or with his friends Hunt and La Farge and Homer Martin. What he saw was improbabilities. "Vedder alarms the reason," Jarves said, "lest these things be so." But, unlike Goya or Bosch, whose alarms still have the quality of fire sirens, Vedder's are whispers that one detects only by cupping one's hand to one's ear.

"THE BYRON OF OUR LANDSCAPISTS"

There have not been many American art-makers who were regarded by their contemporaries as bonded geniuses. Allston was one, as were Thomas Cole and Kensett and Frederic Church; another, George Inness, had the temperament, the talent, and the gift for attracting attention (which he professed to despise, and possibly did) that caused critics to trip over their tongues in their searches for superlatives. Even the tough-minded Jarves was smitten with Inness' gifts when the painter was still in his forties and far from the height of his career, but Jarves was aware of what he called "the startling inequalities" that marked Inness' work; if he reached heights, he also sank to depths, and he seems not to have had much sense of which were which, for whatever came furiously from his brush was what he passionately believed to be sublime. When he died a torrent of encomiums gushed forth. "George Inness's landscapes are the best painted in our time and country," a critic wrote in the Boston *Transcript*, "in many instances the best painted in any time or country." Little memorial volumes printed in limited editions appeared to commemorate and bemoan the passing of America's aristic

giant. Alfred Trumbull, the author of one such slim volume (I consulted copy number 32 of an edition of 150), explaining the reason for his monograph, said of Inness' death: "It means not only the disappearance from active existence of a great and original man, but of a man so great, so original, so progressive and powerful in expressiveness, that he leaves a significant void in our art; one which certainly cannot be repaired at the present time, and probably not for a long time to come."

Inness was a talker, more brilliant, it was said, than Page, a theorist of painting whose speculations took him off into pastures (quite literally) that were far afield from Page's tighter, more scientific ideas about paint and structure. If Page was a romanticist with a theological turn of mind and a scientist's delight in experimentation, Inness was an out-and-out romantic (Jarves called him "the Byron of our landscapists") with an entirely personal bravado, when faced with a canvas, and a spirit eager to discover a religion that satisfied his inquiring intellect and his restless beliefs. It is not surprising that Page and Inness became furiously argumentative friends. It was Page who introduced Inness to Swedenborgianism, which he embraced but with which he wrestled. (When Inness interested himself in a subject, he pursued it through volume after volume with intense doggedness, often for years. He believed in the Single Tax with all the same intensity with which he embraced a religious philosophy, and would propound its virtues with detailed economic arguments to anyone who would listen and, evidently, to many who did not wish to.) Page, who devised a theory of the "middle tone" which posited the idea that the horizon should be a tone "half-way between the lightest light and the darkest dark" in a picture, tried to demonstrate this to Inness by painting on a strip of tin a series of stripes ranging from white at one end to black at the other and saying that the gray in the center was "the true middle tone." Inness turned up at Page's studio the next day with his own strip, which arrived at a totally different middle tone. "Then the fight was on," Inness' son and biographer, who was also a painter, recalled, "and those two gentlemen, after yelling themselves hoarse and saying some very uncomplimentary things to each other, would break away, and not speak to each other for days." The row went on for several years until Page moved away (not because of this quarrel, which unquestionably delighted both men) and built himself a house on Staten Island, which he painted white and then glazed down to a "middle tone." The sun, however, faded out the tone, to Inness' evident delight. It proved, he said, that there was no such thing as a middle tone, and, anyway, Page was a fool.

Nothing except painting pleased Inness as much as theorizing about it and expounding on it with or without an audience. Anyone who happened

into his studio was likely to find himself bombarded with a running sound-track on the creation of the picture on which he was working away at the moment; indeed, if no one was there to listen, the lecture went on all the same, his beard waggling, his sharp eyes peering through his little spectacles, as he darted at his canvas. His son recorded many of Inness' running comments. "Confound it, George! It's got too much tone. We don't know just what it's going to be, but it's coming," he would say as he painted out what he had just put in. "We don't care what it is so it expresses beauty." Or, "Tickle the eye, George, tickle the ear. Art is like music. Music sounds good to the ear, makes your feet go—want to dance. Art is art; paint, mud, music, words, anything. Art takes hold of you—sentiment, life, expression. . . ." On some occasions he would make a minor addition to a picture to please a customer; on other occasions he would throw a customer out who made a suggestion or pressed him too far. To a woman who had bought several of his paintings and who suggested it would be nice to put a little dog following the figure of the man in one of his landscapes, he bawled, "Madam, you are a fool!" She never showed her face again and sold the Innesses she had previously bought. It was probably this incident that prompted him to say to his son: "Never paint with the idea of selling. Lose everything first, George. You can put in a little dog, maybe, and it will buy you an overcoat. Lose everything first. Be honest; somebody's going to find out. . . . Gad! the struggles I've had in my life to be true! Dealers come in and offer me money to put in this or that, and I have to do it, because I have to live."

By the time he was in his fifties he was living very well indeed. His pictures were bringing handsome prices, and he was established in an ample house and studio in Montclair, New Jersey, and was regarded as a philosopher, patriarch, and something of a national ornament. His path to this eminence, while it was strewn with compliments, had not been strewn with money. He was born near Newburgh, New York, where his father, who had prospered in the grocery business in New York, had bought a farm, but when he was still an infant the family moved back to New York and after a few years to the village of Newark, New Jersey, and into a house on a hill that looked out over farm land. Inness' father hoped he would become a grocer and set him up in a small store of his own when he was only fourteen. Inness couldn't be bothered with his customers; he kept an easel behind the counter, and those who wanted to buy could not get his attention. The store was soon closed, and though his father had no sympathy whatsoever for his son's becoming an artist, he let him take drawing lessons with a man named Baker, who, after a few months, said the boy had learned all he could teach

him. Inness worked briefly in an engraver's office and studied briefly with a French artist who had settled in New York, Régis Gignoux, but it was, he insisted, some prints of Old Masters that he saw in a shop which opened his mind to "nature represented grand instead of being belittled by trifling detail and puny execution." He found he was impressed by "a lofty striving in Cole," and a "more intimate feeling of nature" in Asher Durand, and he determined to put them together. The results were in the manner of the Hudson River School, as one would expect, and as he wrote in a letter many years later, "At twenty-two, I was looked upon as a promising youth and was able to sell to the Art Union as high as $250.00 and I believe in one instance $350.00. Some of my studies were very elaborate."

Europe, of course, was his ambition, as it was of every other young art-maker, and he achieved it first in 1847 after a brief but tragic marriage. (His bride, according to Inness' son, caught cold on their wedding day and died six months later of "consumption." Inness, Jr., dismissed it: "This marriage seems to have been of little importance; it was apparently only an episode in his early life.") He headed for England, following the tradition so firmly set by his elders, and was, he said, greatly impressed by Constable's landscapes and somewhat less by those of Turner who, he thought, spoiled his pictures with "claptrap" that was untrue to nature. England was no longer the painter's Eden it had once seemed when Benjamin West held sway, and Inness took himself off to Rome, where he first encountered his future friend and sparring partner Page. He stayed there for more than a year, and his ideas of what was true and what false in the painting of nature began to take shape. "They told me I would never succeed," he said, "that I was a fool to try to set myself against the rules laid down by my betters, and if I did not paint my trees brown in the foreground, I was sure to fail." He was impelled, he said, to paint things as he saw them and not according to any formula set by tradition or by any new aesthetic fashion.

Paris, however, had a greater effect than Italy on his painting and on forming his personal style. His second trip to Europe in 1850 took him there with his second wife (aged seventeen), and it was financed by his first real patron, Ogden Haggerty, a dry-goods auctioneer. According to a pleasant anecdote that Inness liked to relate, he was sketching in a square in New York one day and a small crowd gathered to watch him. When the crowd melted away, one man remained and said to him, "If you will bring the picture to my house when you finish it, I will give you a hundred dollars for it." The man was Haggerty, and he became "one of the main factors" in Inness' "development as a painter." Though he was enough of a customer to be called by the more elegant name of patron, it is unlikely that he did

"June," painted by GEORGE INNESS in 1882 when he was fifty-seven, is a far cry from the detailed style of the Hudson River School to which he was devoted as a young man. (*The Brooklyn Museum*)

GEORGE INNESS was living in Montclair, N.J., when this photograph of him was taken in his studio about 1885, by which time he was one of America's most sought-after art-makers. (*Photo Archives of American Art*)

anything for Inness more important than to give him the opportunity to arrive in Paris at the moment when the new school of landscape painters from Barbizon was beginning to find acceptance. Their approach to the outdoors was a far cry from the detailed grandeur of Thomas Cole and his followers; this was an outdoors filled with air, an intimate outdoors of short vistas, not grand views. This was the landscape of a tamed countryside painted by Jean François Millet, by Corot and Daubigny, by Rousseau and Diaz. "He lived, as he said, in a sort of stupor of intellectual amazement," Trumbull wrote, "working almost mechanically, but instinctively in the direction which he felt to be the true one." But he went on from Paris to Italy again and stayed for nearly two years in Florence, where his first child was born (he named her Rosa Bonheur after the painter of the enormous "The Horse Fair," considered one of the wonders of the age, and long in the Metropolitan Museum), and then returned to New York, where he was elected an Associate of the Academy at the age of twenty-eight. New York did not hold him for long. He was soon back in Italy and soon after that back in America, where he settled in Medfield, Massachusetts, and produced a somewhat contradictory body of work—some of it finicky in the Hudson River School manner, some of it broad and simplified in the manner he ultimately came to adopt as his own.

He stayed in no place for long. From Medfield he moved to Eagleswood, New Jersey, and from there to Brooklyn; then he was off to Europe again, his trip financed this time by his dealers, who thought that he needed the refreshment of new sights and that they needed pictures with European subject matter to sell. Finally he settled in Montclair, and except for occasional forays to Europe he stayed there until 1894. In that year, being in poor health (he was an epileptic and never robust), he was advised by his doctor to take a trip abroad for rest and a restorative change of scene. He died in Bridge-of-Allan in Scotland, collapsing, it is recorded, as he watched the sunset and exclaiming, "My God! Oh, how beautiful!"

Inness had no followers. He was not a "school" painter, and he did not attract (or want) pupils. He was not merely critical but scornful of the Pre-Raphaelites on the one hand and the Impressionists on the other. "While Pre-Raphaelitism is like a measure worm trying to compass the infinite circumference," he wrote in 1884, "Impressionism is the sloth enrapt in its own eternal dullness." On another occasion he said: "Now there has sprung up a new school, a mere passing fad, called impressionism, the followers of which pretend to study from nature and paint it as it is. All these sorts of things I am down on. I will have nothing to do with them. They are shams." Inness sketched from nature and developed a vast vocabu-

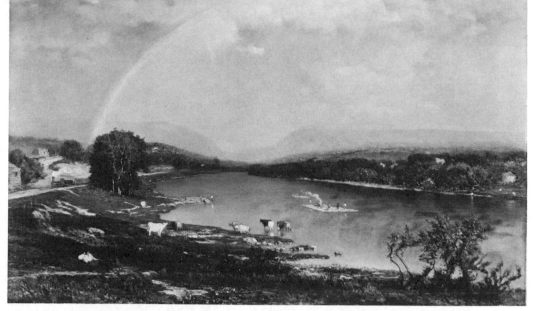

GEORGE INNESS painted this version of "The Delaware Water Gap" in 1861, when he was thirty-six and still somewhat constrained by his delight in the detailed manner of the Hudson River School. (*The Metropolitan Museum of Art, Morris K. Jesup Fund, 1932*)

GEORGE INNESS was at the height of his powers when he painted "The Coming Storm" in 1880. Nothing pleased him more than to take a completed picture and repaint it with gusto into something quite different. (*Addison Gallery of American Art, Phillips Academy, Andover, Mass., Photo John D. Murray*)

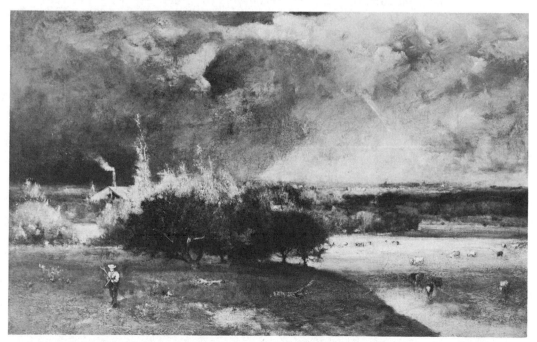

lary of images on which he could draw, but he painted in his studio, sometimes with fifteen canvases in progress at the same time, darting from one to another as the mood took him. He was as likely as not to take what he had started as a seascape and change it to a pastoral scene. Rocks turned into apple trees, the "raging sea" into "a rich grass meadow." Indeed, he did precisely this to a painting which a man had bought from him and which Inness asked to have back to touch up. Happily, the purchaser liked the new picture better than the one he thought he had bought.

After his death Inness' reputation increased rather than diminished . . . at least for a time. The auction of the paintings in his estate, which was held in New York in 1894, though it fell far short of what Kensett's pictures brought, did well. $108,000 was paid for 240-odd pictures, ranging from $100 for a little sketch to $2,100 for a very large landscape called "Sundown" painted the year before Inness died. In the record of that sale, as in the record of the sale of Richard H. Halsted's collection of twenty large canvases by Inness (they brought a total of $31,350), no museum was among the purchasers, though the Century Club and the Union League Club, both of New York, each bought one. Today, of course, his pictures are owned by museums almost everywhere in America. The Art Institute of Chicago has, for example, one of his early, tight, detailed landscapes strongly influenced by Cole. It is called "The Old Mill." The Albright Gallery in Buffalo, New York, has one at the other extreme of his brush, a loosely painted "The Coming Storm" of 1878, and the Metropolitan Museum has, among others, his "Delaware Water Gap," painted in 1861 when he was first breaking loose into a style of his own, and the best known of all his landscapes, the enormous "Peace and Plenty," painted in 1865. They look less like miracles today than they did to the romantic eyes of a century ago.

A SPIRIT OUT OF CONTEXT

The darkest, most sonorous, and deepest notes sounded by any of this quartet of romantics came from the member of it who was by all odds the least in evidence in his time. Albert Pinkham Ryder had a problem he wanted to solve with his brushes and pigments, and he devoted his life to it, without animosity to his fellow man but without concern for impressing him, seeking his approval, or asking his favors. That is not to say Ryder was not

pleased and gratified when his pictures found favor, but it seems not to have occurred to him that he had any choice but to pursue his own search for solutions to the aesthetic problems he set for himself. In a sense he painted variations on a single theme (though by no means a single subject), and for that reason a Ryder is easy to recognize, though it is frequently difficult to distinguish one from a "Ryder." Ryder has been the forgers' delight for half a century, and there are, according to Lloyd Goodrich, five times as many fake "Ryders" changing hands as there are genuine ones from Ryder's own fiercely struggling brush.* Load on the paint, abstract the clouds into geometric shapes against a sky almost black, use a dark boat and a heavy sail, some yellowed moonlight, maybe a ghostly figure, small in scale and fuzzy in outline, and bake until the paint cracks quite badly—something of the sort was the formula for the forgeries. It was not Ryder's formula, for the very good reason that, search as he would for the way to paint a picture, he never found an answer that fully satisfied him. He was not seeking, as Inness was, a way to paint nature; he was seeking a way to breathe the life of nature into paint, to use nature as an element in a poetical vision that was plastic in the strictest sense of tangibility. He abstracted nature, but only after the most careful observation of its movement as well as its static forms, of its moods as well as its components. The result of half a century of such searching was a relatively few paintings, and many of those were ruined by his methods of overpainting, his carelessness about the chemistry of paint, and his financial incapacity to buy the best pigments.

Ryder is a singularly attractive figure in the history of American art-making. He was other-worldly without a hint of affectation. As he grew old he was in essence a recluse, but he never turned away from his door anyone who wanted to see him, though he asked his old friends not to bring new friends because he found them too exciting and distracting. "It breaks me up for days when I meet new people," he said. He cared not a whit for the creature comforts that most of his contemporary art-makers labored to achieve; there was not a drop of social ambition in his veins, and in a society that was frantically concerned with building, amassing power, and showing its muscle he was oblivious of the simplest facts of what impelled the people around him to hustle. There is a story that in his advanced years, when he was living on what seemed to be nothing at all, a painter friend, Horatio Walker, asked if he had any funds, and Ryder said that there were "some on paper in the cupboard." Walker found a number of uncashed checks, one for more than $1,000, and he told Ryder that he should open an account

* E. P. Richardson in *Painting in America* says "ten times as many forgeries as originals." No one, of course, knows for sure.

at a bank. This seemed to Ryder an admirable suggestion, and he went along with Walker to a bank to do as he proposed. He later told one of his friends that Walker was not only a splendid painter but a remarkable financier.

New Bedford, Massachusetts, when Ryder was born there in 1847, was a whaling port at the height of its vitality, and the life of the city was elegant and prosperous on the one hand, tough on the other, and threatened always by the anxiety of the unforeseeable violence of the sea. When he was a small boy, Ryder's eyes were damaged by an ill-administered vaccination, and he never could read for long or paint for many hours without his eyes becoming inflamed. He got no further than grammar school in his formal education, and his sister-in-law (the wife of his older brother, who supported him for most of his life) recalled that as a child "he did not care so much about drawing so long as he had his colors." Because of his health his family indulged him in his bent to make pictures. It can be argued, without stretching the point, that his style was to some extent determined by his faulty eyes. He explained it somewhat differently. He found that his attempts to "serve nature as faithfully as I serve art" led him to get "lost in a maze of detail" and that, compared with what he saw, his "finest strokes were coarse and rude." "The old scene presented itself one day before my eyes framed in an opening between two trees," he wrote.

> It stood out like a painted canvas—the deep blue of a midday sky —a solitary tree, brilliant with the green of early summer, a foundation of brown earth and gnarled roots. There was no detail to vex the eye. Three solid masses of form and color—sky, foliage, and earth—the whole buried in an atmosphere of golden luminosity. I threw my brushes aside; they were too small for the work at hand. I squeezed out big chunks of pure, moist color and taking my palette knife, I laid on blue, green, white and brown in great sweeping strokes. As I worked I saw that it was good and clean and strong. I saw nature springing into life on my dead canvas. It was better than nature, for it was vibrating with the thrill of a new creation. Exultantly I painted until the sun sank below the horizon, then I raced around the fields like a colt let loose, and literally bellowed for joy.

When he was twenty-three, in 1870, Ryder moved to New York, where his older brother had opened a successful restaurant, and he set about getting some training as an artist. The National Academy of Design school turned him down the first time he applied, but he became friends with a portraitist and engraver who also painted religious subjects and romantic

pieces, William E. Marshall; he had studied in France with Couture. He urged Ryder to come to him for criticism and advice. On his second try Ryder was admitted to the Academy school, but, like so many adventurous young art-makers of his day, he found the drudgery of drawing from casts more than he could abide, and he quit after a few months. He made several trips to Europe, more, it appears, for the opportunity to watch the effect of moonlight on water than for what he hoped to learn from museums about painting, and he made no effort to study in the ateliers of Europe. He was considered sufficiently accomplished by the jury of the Academy exhibition of 1873 to have a picture accepted for show, though in the next seven years his work appeared there only once.

Scholars have considerable difficulty in putting Ryder's work in chronological order because he never dated his pictures—indeed, he rarely signed them. But his early paintings are dominated by pastoral scenes of barnyards and grazing cattle, vistas with static figures, and occasional mythological constructions that show the distant influence of the metaphysical William Blake. None of this is remotely in the manner or mood of his contemporaries, and if one did not know Ryder's origins and dates, one would be hard put to assign him to either a place or a time. Salvator Rosa and the Italian romantic landscapists seem to hover in the background, and so does the jewel-like brushwork of Delacroix and his precipitous draftsmanship, and somewhere in the future, too, one can anticipate the mystical quality coupled with rich surfaces of Rouault in the early years of this century and the hazy figures of Odilon Redon. But the comparisons are misleading, perhaps, and if the origins of Ryder's style are obscure, the influence of his pictures is equally obscure. He does in many respects, however, seem to belong more reasonably to the spirit of exploration and explosion of the early twentieth century than to the dying days of the nineteenth.

At the time when Ryder first appeared in the Academy show the painters of vast canvases, the pictures of little people in big places, dominated the American art world and at the same time led and reflected its taste. As Lloyd Goodrich says, the old-line academicians had not yet brought themselves to accept the work of Delacroix, much less Corot, who by then were considered entirely acceptable in France. Ryder, as a painter in revolt, became identified with the "New Movement" of young artists who had studied in Paris and Munich and he was one of those with La Farge and William Morris Hunt and Saint-Gaudens who founded the Society of American Artists as a challenge and response to the stuffiness of the Academy. He exhibited with them throughout the 1880s, and, as one critic of the time who admired him said, "If it had not been for the Society of American

Artists it is doubtful whether such an unmistakably genuine painter as Mr. A. P. Ryder would ever have had his pictures hung where they could be seen."

His work was more generally ignored than either attacked or praised, though there were some perceptive critics who said good things of him and a few collectors—most notable among them, Thomas B. Clarke of New York, Homer's patron and a man with an eye for quality among his contemporaries—who bought his pictures. Some measure of the popularity of Ryder in comparison with his contemporaries emerges tidily from the prices brought at the sale of Clarke's collection in 1899. Inness' "Gray Lowering Day" fetched $10,150, while two others from his hand brought $8,100 and $6,100. Winslow Homer's "Eight Bells" went for $4,700, and Homer Martin's "Adirondack Scenery" got $5,500. By contrast, Ryder's "The Temple of the Mind" was knocked down for $2,250 and his "Christ Appearing to Mary" for $1,000.* Obviously Ryder was not unnoticed, but just as obviously he was not among the mighty. It would have surprised him greatly if he had been.

Like Inness, Ryder had trouble finishing his pictures because he thought they always could be improved upon, but, unlike Inness, he was trying to attain a surface the very richness of whose texture was an almost tactile delight. Into this surface he painted images from the Bible and from Shakespeare and Wagner—"Jonah" (of which he said, "such a lovely turmoil of boiling water and everything," and of which a critic said, "chiefly remarkable for the bad taste in the attempts to represent the Almighty"), "Macbeth and the Witches," and "Siegfried and the Rhine Maidens" among others. His most frequently forged pictures are geometrically conceived scenes of ships at sea at night, and one of his most moving paintings is of a dead bird, painted on wood and smaller than five by ten inches.

"The canvas I began ten years ago," he said to an interviewer, "I shall perhaps complete today or tomorrow. It has been ripening under the sunlight of the years that come and go." He did not like to let his paintings out of his sight until he was convinced no touch of his brush could bring them closer to his hopes for them. He told Walter Pach about one of his admirers who bought a picture. "I was worried somewhat at first," he said, "by his wanting to take his picture away before I had finished, but lately he has been very nice about it—only comes around once a year or so."

* To be sure, both of these are relatively small pictures. "The Temple of the Mind" is 17¾" x 16" and the "Christ Appearing to Mary" 14¼" x 17½". The former is now in the Albright Art Gallery, Buffalo, New York, the latter in the National Collection of Fine Arts in Washington, D.C.

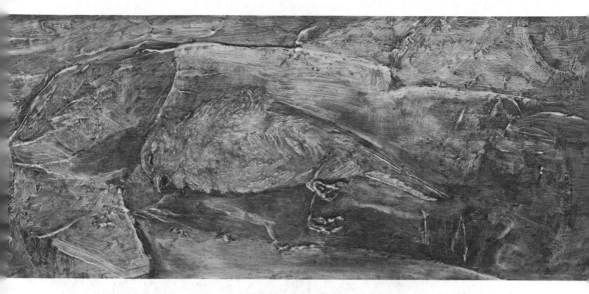

"The Dead Bird" by ALBERT PINKHAM RYDER is a tiny painting (4½ by 9⅞ inches) on wood, and yet it is a monumental description of death and decay. (*The Phillips Collection, Washington, D.C.*)

Though he is greatly admired today for the abstract vitality of his seascapes, such as "Marine Moonlight," RYDER had few followers in his day. This picture was probably painted in the 1880s, though he often worked over his canvases for years and consequently they are impossible to date. (*The Metropolitan Museum of Art, Samuel D. Lee Fund, 1934*)

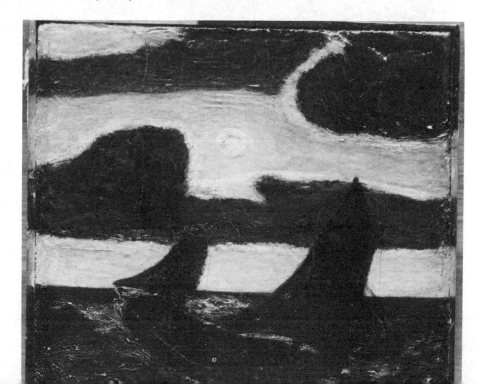

RYDER frequently drew subjects from Shakespeare and the Bible. This, however, was inspired by Wagner and is "Siegfried and the Rhine Maidens." It was first shown in 1891, and Ryder told a friend, "I worked forty-eight hours on it without sleep or food." (*National Gallery of Art, Washington, D.C.*)

When Ryder was a young man he had a red-brown beard and dressed with a New England regard for the proprieties. He enjoyed the company of his friends and met with them often, though it is said that he would rather listen than talk. He was particularly fond of Olin Warner, the sculptor, and of J. Alden Weir, a well-regarded painter,* and he was fond and respectful

* Weir was one of a group who exhibited under the name of Ten American Painters, "a kind of academy of American Impressionism," as Richardson calls them. The others were Thomas W. Dewing, Edmund C. Tarbell, Frank W. Benson, Joseph De Camp, John H. Twachtman, Willard Metcalf, E. E. Simons, Childe Hassam, and Robert Read.

of his dealer, Daniel Cottier, who showed his work along with La Farge and Hunt in the days before the Society of American Artists came into being. As he grew older he kept more and more to himself. He dressed in shabby work clothes and a torn sweater; his fine beard had become patriarchal and his long hair always looked "as if tossed by a gale." The children on his block called him "Uncle Ryder," and as he wandered the streets of what is now called the West Village, he was occasionally accosted by kindly people who tried to give him money. Now and then he would put on a frock coat and a high hat of ancient vintage and go up to Fifth Avenue "to see the pictures" in the dealers' shops.

He lived and worked in a shambles. His studio was a back room of a tenement, piled high with old clothes, with books and furniture and ashes, and he cooked on a little coal stove "an unsavory brew . . . that was food, drink, and medicine for him." Pach one day suggested that he would like to bring his wife to see Ryder and the painter said he'd like some warning so that he could "fix up the place," which he did by shoveling out a path to his easel and his stove and a place by the window. "I never see all this unless someone comes to see me," he said to Marsden Hartley, a young painter who greatly admired him (and who became a very considerable artist in his own right), and on another occasion he said, "The artist should not sacrifice his ideals to a landlord and a costly studio. A rain-tight roof, frugal living, a box of colors and God's sunlight through clear windows keep the soul attuned and the body vigorous for one's daily work."

At about the turn of the century, when Ryder was in his fifties, his inspiration seemed to run out; he lost the verve with which he once could lay in the groundwork for a new conception and a new painting. Like so many other art-makers, he also wrote poetry, but, like most of theirs, his verses were not realized with the same sureness that came from his brush or carried so far toward what he hoped to be wholly realized. But the poetic image was as naturally in his mind as the brush was in his hand. He explained himself in such an image better than anyone else has explained him. He said: "Have you ever seen an inch worm crawl up a leaf or a twig, and then clinging to the very end, revolve in the air, feeling for something to reach something? That's like me. I am trying to find something out there beyond the place on which I have a footing."

It is a romanticist's metaphor, and it applies equally, if differently, to William Page and Elihu Vedder and George Inness.

13

THE ART-MAKERS
AS TASTEMAKERS

"In another country I might have been a painter."
WILLIAM MORRIS HUNT

It was not so much that art was becoming fashionable after the Civil War as that artists were. In Boston, William Morris Hunt, the architect's brother, held ladies enthralled with his wit, his flowing beard, his eccentricity, the dark artistic look in his eyes, and his doctrine of art for art's sake. They so crowded his painting classes that he had to give over his elaborately decorated studio to them and paint in a smaller one. His words were regarded as trays of sharply cut but unset gems, sparkling, of great value, to be saved and cherished. They were, indeed, written down with the greatest loving care and published for posterity. In New York, William Merritt Chase, with pointed beard and waxed mustache, strode up Fifth Avenue with a wolfhound on a leash and a Munich student's cap on his head. Outside his studio on Tenth Street stood a black servant in a red fez, and two bright macaws and a white cockatoo looked down from the railing of his studio. Indeed, the Tenth Street Studios, as they were known, were filled with fashionable artists and visited by fashionable women who occasionally went so far as to buy a picture.

That is not to say that either New York or Boston was an artistic

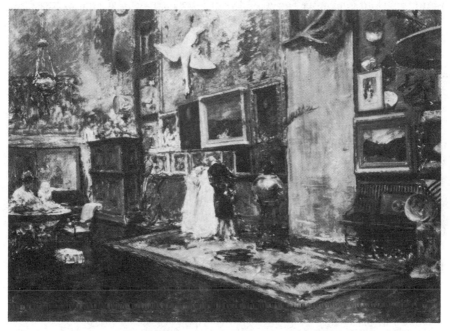

The Tenth Street Studios in New York, where WILLIAM MERRITT CHASE occupied the largest quarters of all in the 1880s (and where he painted this picture), were called "a cheerful hive." They were not only workrooms but galleries for the display and sale of artists' work. (*Carnegie Institute, Pittsburgh. Photo Archives of American Art*)

Mecca; it merely suggests that they were not quite as indifferent to the blandishments of art as they had been since the collapse of the Art Union had taken the gamble out of collecting. Neither city had an art museum; most merchants who sold art were frame-makers first and art dealers second, though a department store occasionally had a single large canvas on display and for sale, and it was still a common practice for an artist to hang a picture in his studio and charge admission to see it. Flamboyance, however, was a cultural condition of which Americans approved. They liked the arts, or anyway the artistic situation—big and exotic and gaudy in the days after the war. They liked rich materials in their parlors and exotic bibelots from far-off lands in their whatnots. They liked their furniture richly carved, their draperies to be of damask with deep fringe and their lambrequins elaborately swathed. Carpets were gardens of rich roses or the unpredictable and yet mathematical patterns of Persian rugmakers. Candelabra and chandeliers were hung with crystal dangles; it wasn't enough that they should be prismatic, they were ornamented as well. In the home the boxlike

pianoforte had long since replaced the quieter harpsichord, and bigness had become a mark of musical virtue along with showmanship. To be sure, Jenny Lind had balked at Barnum's wanting to introduce her by letting her down from the top of a vast circus tent like an angel; but that was in the early 1850s. In Boston at the Grand National Peace Jubliee in 1869 one hundred Boston firemen in their bright-red uniforms beat out the rhythm of the Anvil Chorus from *Il Trovatore* on one hundred anvils accompanied by a large chorus and a full orchestra. A few years later at the second Peace Jubilee in Boston, Johann Strauss, the "Waltz King," conducted an orchestra of two thousand musicians and a chorus of twenty thousand. It required several assistants to relay the conductor's beat to the singers in the distance. This festival was opened in 1872 when an official pressed an electric bell that exploded a powder charge in a cannon. "The spirit of flamboyance and the necessity of commercialism," Nicholas Slonimsky, historian of American music, has written, "affected the manner of presentation of musical performances all over America. Showmanship was paramount." Robert Swain Gifford, a landscape painter of the 1860s, contended that American art suffered from the concern with flamboyance, and because of it, he said, "simplicity has evaded us all."

The role of the artist as a respectable member of society had changed markedly by the middle of the century, and though he was still looked on with suspicion as a trifler by men who thought nothing so important or delightful as driving a competitor in business to bankruptcy, he was at least achieving some respect from women and from men in other professions. In New York the Century Club was the symbol, in a manner of speaking, of the fact that artists were gentlemen, for the club was an association of painters, architects, sculptors, lawyers, editors, writers, physicians, military men, and businessmen generally considered to be cultured. In other words, besides the artists, its roster, while exclusive, was illuminated with the names of many of the city's most respected citizens if not necessarily its most socially proper or financially spectacular. In Boston the Athenaeum provided exhibitions for painters in groups now and then, and there were (as there also were in New York) rumblings that presaged the founding of a museum of fine arts. In both cities the artist was assuming a new role that was evidence of his self-confidence. Instead of merely trying to sell his wares, he took to selling ideas about taste; he sold not just canvas or marble or bronze, he sold theories and he sold himself as their embodiment or as their prophet. He became a tastemaker as well as an art-maker.

Possibly it was because of their confidence in their own social position, possibly because they had been largely educated in the sophistication of

European manners and intellectual environment, possibly because of their undeniable personal charm that seemed to capture all sorts of their contemporaries, but the brothers Hunt—William Morris and Richard Morris— were the first truly influential artist-tastemakers in America. Others had, of course, proselytized for their professions and, as Latrobe had with the Greek Revival, spread with great success an aesthetic gospel, but the Hunts went further than anyone had before. Richard, the architect, made princelings out of tycoons and filled their wives with rich dreams and their houses with what he thought was suitable to such *nouveau* royalty. When he told his son that it was his first duty to please his clients, as we have seen, he really meant that it was his first duty to so educate his clients' taste that they would yearn for what he had taught them they wanted. William Morris Hunt, painter, was a man of different temperament from his younger architect brother, but he was no less a mentor. Both of these men were prophets with very considerable honor in their own country.

William Morris Hunt talked art better than he made it, a characteristic frequently found among effective tastemakers. He combined with elegant social graces a poetical tongue and the sophistication of a man who had savored the arts of Europe and had made friends with masterpieces of the past and masters of the present. He had gone to Europe in 1843 with his widowed mother and his brother, Richard, after a brief and, from Harvard's point of view, unsuccessful two years of entertaining undergraduate life. During his period of "rustication" (i.e., suspension) from Harvard he had contracted what threatened to be consumption, and his mother had decided that the climate in Europe would be better for his health than the rigors of his native New England. His mother was a vigorous, determined widow of a Congressman from Brattleboro, Vermont, and she believed in giving her children "the advantages," a program in which she most notably succeeded. William and the younger Richard were exposed to an intensive dose of European culture, and William decided that he wanted to become a sculptor. He studied briefly with Barye, then famous principally as a sculptor of animals and a teacher at the Ecole des Beaux-Arts, but William soon decided that he would follow the path of painting to Düsseldorf, which, as it came about, he could not abide. He found it a school based "upon the principle that the education of art genius, of a mechanic, and a student of science were one and the same thing—a grinding, methodical process for the accumulation of required skills." Nothing could have been further (except possibly the curriculum of Harvard) from this young man's taste, and he was soon back in Paris working again on sculpture. It was a picture by Couture, "The Falconer," that turned him to painting. Here were a style

and an atelier that suited his ideas of the artistic life, fluid and flowery and somewhat sentimental. He worked so well in the manner of his master that it was said that his painting of a rather luscious head called "The Jewess" could be mistaken for a piece from Couture's own hand. Another painting, "The Prodigal Son," which caused such a stir in Paris that he was invited to send it to the annual exhibition at the National Academy of Design in New York in 1850, was not to the precise taste of Americans. It showed, one critic said, "what could be done with a trowel." American taste and French taste were still an ocean apart in spirit as well as fact. It was Hunt, more than anyone else, who was to bring them close together.

It was the somber side of French taste, not the flamboyant, that Hunt brought home and laid at Boston's fashionable doorsteps. He was introduced to Jean François Millet, the painter of peasants, and spent two or three years in Barbizon following him, dressed like the master in smock and beret and sabots, buying his paintings, and, though Millet would not impart his techniques to anybody, studying his methods from the finished products. "You want a picture to seize you forcibly as if a man had seized you by the shoulder," Hunt said some years later to his pupils. He had himself been thus seized by Millet's "The Sower," and had bought it for $60 long before Millet's work was being bought by his compatriots. When he came back to America in 1856 Hunt brought with him a rich store of Barbizon paintings, not just by Millet but by Corot and Rousseau and Daubigny, bought for a pittance because there was no fashion for them yet in France.

After a year spent in his native town, Brattleboro, he settled in Newport and employed his brushes largely on portraits, though, having married a rich Bostonian, face painting was not forced on him by financial necessity. He also taught in his studio, and among his pupils were the James boys, William and Henry, still in their teens. (Henry was in search of cultural experience; William had notions of becoming an artist.) But he also had one pupil of very considerable gifts and consequence to the art of the century, a young New Yorker with a wealthy Southern background who was sent to him by his architect brother. This was John La Farge, an artist more talented than Hunt but, like him, a man who was to become—as well as a painter, a decorator, and a maker of stained glass—a maker of popular tastes.

When Hunt moved to Boston in 1862 he was thirty-eight, a striking figure in his "little soft felt hat, turned up all around" and flowing beard, the embodiment of the artistic albeit gentlemanly eccentric. His studio was not a workshop of the sort most art-makers took for granted as a place to labor but a gallery of Hunt's taste, with rich fabrics draped over the

"The Flight of Night," the sketch for which hangs above a portrait in WILLIAM MORRIS HUNT's studio in 1879, was his last and most exhausting commission. He painted it for the dome of the Capitol in Albany, N.Y., but it survived only briefly. (*Photo Archives of American Art*)

furniture and Japanese decorative objects and prints (just beginning their vogue in France but startling to Bostonians) on the walls. "I like joy in my studies!" he said. "I don't like *literary indigestions!*" This was his answer to the history painting that so occupied the academicians of his day. Spontaneity, the quick vision immediately recorded, was what delighted him and what he tried to make delight the young ladies who flocked to his classes. He kept 150 canvases within easy reach in his studio, it is said, so that he could "record inspiration of various kinds spontaneously."

According to one of his biographers, Hunt "threw himself heartily into the struggle" of the Civil War shortly after he had moved into the Studio Building in Boston in 1862. His contribution to the struggle was "executing works like 'The Bugle Call' and 'The Drummer Boy,' an epic poem, a work full of strength and enthusiasm, expressed in the eager, handsome figure of a boy posed high against a sky background, beating a drum, with the motto, 'To Arms! To Arms!' " Hunt's war effort was more like Eastman

Johnson's than like Winslow Homer's, which is not surprising considering the differences both in age and in temperament of the two men. Hunt was twelve years older than Homer, and there wasn't a drop of journalist blood in his veins. He was an artist in the Washington Allston tradition, his eyes filled with the works of European masters and his heart bent on the pursuit of beauty. Like Allston, he encouraged younger artists with his praise and suggestions and tried to imbue the community with his own aesthetic ideals. Unlike Allston, he was one of Boston's social ornaments, pursued for his witty conversation, his skill as a mimic, and the elegance of the parties in his studio. It takes panache to be an effective tastemaker, and Hunt was blessed with it. One result was that Bostonians were taught to know and appreciate the painters of the Barbizon School before the French became interested in them, and paintings by Millet, Corot, Courbet, Rousseau, Diaz, and others of the period hung on the walls of Boston parlors before they hung in comparable bourgeois parlors in Paris.

Essentially, every tastemaker is a teacher; to him the important thing is to spread the word, and Hunt found it easier to spread it among women than among men, the common condition of tastemakers throughout the nineteenth century and much of this one. Matters of taste were, even in literary Boston, considered women's business, and the ladies flocked to Hunt's studio as much to listen to his artistic aphorisms as to sit at their easels smudging paper with charcoal. He had as many as forty of them at a time, and he was criticized for wasting his efforts on such pupils when he should have been painting. "It is not recorded," said Isham in his history of American painting, "that any of his pupils gained great distinction in art, but one envies them their excitement, their loyalty to their master, their illusions." One of his pupils who was also his assistant in conducting the classes, Helen M. Knowlton, jotted down what the master said (as she hid behind a screen lest he catch her at it) and preserved his remarks, which were later published as *Talks on Art*. They are filled with such statements as:

> Nature is economical. She puts her lights and darks only where she needs them. Don't try to be more skilful than she is.

and

> Beauty is that little something which fills the whole world, and is neither contained in a straight nose, a long eyelash or a blue mountain. Some see it in a leg of mutton; others in a compound

fracture. And to expect others to accept one's own definition of it, is as absurd as to expect all humanity to use the same toilet brush.

and

We all want to know how things are done. Boston is a great place for receipts. There is a receipt for being scientific, one for being sentimental, another for being religious. But painting is something for which you can't get a receipt; so people say that their teachers are to blame, that they "don't impart enough. . . ." Should you grow discouraged at your slow progress, try for a year to play a violin solo!

It is not difficult to understand how easily the ladies took such remarks to their bosoms or why, indeed, they were so widely admired as artistic gospel in their day.

As a painter Hunt turned his hand to a little bit of everything—not only to portraits but to landscapes (with and without cows), to genre scenes more in the Millet manner than in that of Hunt's contemporary Eastman Johnson, and finally to murals. There is a softness and sentimental quality that oozes from his pictures of farm girls with cattle and from many of his female portraits that would have made Eakins wince. His most famous painting is of a boy standing on the shoulders of another boy in a pond or river, more a mood than a nude, more feminine than masculine, as Hunt was the first to admit. He made a copy of his original version of the picture on a larger scale, and though he was aware of errors in the original, he did not correct them. He said of the original:

I don't pretend that the anatomy of this figure is precisely correct. In fact, I know it is not. It's a little feminine but I . . . was chiefly concerned with the pose, I do think the balancing idea is well expressed, and it is the fear of disturbing that which prevents my making any changes in the figure. I know I could correct the anatomy, but if the pose were once lost I might never be able to get it again.

On another occasion he said, "A thing corrected is like a whipped dog." Ideas about correctness had gone a long way from the time when Allston struggled in vain with his "Belshazzar" in another Boston studio.

The culmination of Hunt's career was a large painting as ill-fated as

"I don't pretend that the anatomy of this figure is pre-
cisely correct . . . ," WILLIAM MORRIS HUNT said of
"The Bathers" (1887), ". . . I do think the balancing
idea is well expressed. . . ." (*Worcester Art Museum,
Worcester, Mass.*)

Allston's "Belshazzar" but for quite different reasons. He was commis-
sioned in 1878 to paint two large murals for the dome of Albany's capitol
building, then under construction, a feat that had to be accomplished in a
matter of two months. Hunt reached back into his bag of ideas conceived
when he was a pupil of Couture and pulled from it schemes for "The Flight
of Night" and "The Discoverer," which his wife later described as "allegor-
ical representations of the great opposing forces which control all nature."

The subjects were large ones, too big for his talent, and the spaces they had to fill were also large ones, too big for his technique. The results, which in reproduction look rather vacuous, were a great success with his contemporaries, who flocked to see them . . . but not for long. Hunt had had to work under great pressure on a surface that was ill-suited to receiving his labors. Either his paint soaked into the porous stone or it threatened to peel off, and when he had finished he had so exhausted himself that he fell into a state of melancholy. Several months later he was found floating in a pond in the Isles of Shoals, an evident suicide. He was fifty-five when he died, and the paintings did not long outlive him. Dampness got into them and they so decomposed that they had to be covered over.

"In another country," Hunt once said, "I might have been a painter." Like Thomas Cole, he complained of the American concern with money and things and an atmosphere unsympathetic to art. Like Cole, who, once he was launched, was very successful and financially secure, Hunt had no money worries. "Amusingly enough," James Thomas Flexner noted in *That Wilder Image*, "the artists who blamed their troubles on American materialism were usually those most shielded from its influence by independent incomes." To this observation might reasonably be added that artists with private wealth were those who felt most impelled to prove their professionalism by competing in the art marketplace. But there was no question that Hunt more than anyone else of his time in Boston reduced the New England animosity toward art and perceptibly raised the temperature in that cold aesthetic climate. Not that this was any great favor to his contemporary art-makers. He had instilled in his neighbors a taste for French painting, a taste that was to grow more fashionable as the century progressed and to become a drain of fashionable dollars that might have been spent on American paintings.

AN ECCENTRIC CONFORMIST

John La Farge was eleven years younger than Hunt, and he was just emerging into the light of prominence in the late 1870s when Hunt died. In some respects the two men had much in common: both studied in Paris with Couture, both were quite at home in foreign lands—"cosmopolitans," that is, and "internationalists"—both were verbally as well as visually adept and

had the capacity for charming audiences with their manner, appearance, and style of speech. Both were deeply concerned with spreading what they believed to be sound aesthetic gospel and with bringing converts into the fold. Furthermore, they both represented the "new movement," the break from the dour realism preached in Düsseldorf and from the meticulous detail with which the Hudson River School painters viewed the landscape. They experimented in the 1860s with atmospheric light in the landscape, and La Farge went further than his contemporaries in his attempts to capture a precise moment, "to indicate," as he said, "very exactly the time of day and the exact condition of the light in the sky," and in so doing to anticipate the *plein-airisme* of the Impressionists in France by a decade.

La Farge was a tougher-minded man than Hunt, a man with a more penetrating intellect and of wider curiosity and experience. If Hunt left his mark on the taste of collectors, La Farge left his where it showed most—in the decoration of the architecture of public buildings. He left it in paint and glass and, moreover, in half a dozen volumes of lectures and essays on art and as a member of the committee that in 1869–1870 planned the Metropolitan Museum of Art, where many of his lectures were given.

His friend, the critic Royal Cortissoz, who was also his biographer, describes him as a most fastidious man of "good height" and commanding good looks, a man who disliked personal contact to the point of avoiding shaking hands with friends if he possibly could. He wore only the finest linen and silk and drew only on the finest Japanese paper. "Never for an instant," Cortissoz wrote, "did his conformity to a severe standard of taste chill or otherwise overpower his sheer delightfulness. . . . I have heard some brilliant talkers, Whistler among them, but I have never heard one even remotely comparable to La Farge." To his close friend Henry Adams it seemed that

> La Farge alone owned a mind complex enough to contrast against the commonplaces of American uniformity. . . . His approach was quiet and indirect; he moved round an object, and never separated it from its surroundings; he prided himself on faithfulness to tradition and convention; he was never abrupt and abhorred dispute. . . . To La Farge, eccentricity meant convention; a mind really eccentric never betrayed it. True eccentricity was a tone,—a shade,—a *nuance*,—and the finer the tone, the truer the eccentricity.

This eccentric conformist had no intention of being an artist when he was a young man. His interests were wide-ranging, and his curiosity about

JOHN LA FARGE, William Morris Hunt's only important pupil, painted this self-portrait in 1859 when he was working with Hunt in Newport, R.I. (*The Metropolitan Museum of Art, Samuel D. Lee Fund, 1934*)

many things offered him a menu of delightful temptations. He had been brought up in a house (his family was of French origin) which, as he said, "did not belong to the Victorian epoch in which I was growing up" but to the Empire period. He was educated largely in Catholic schools and, as his family was prosperous, he was under no compulsion to hasten to make a living. When he went to Paris in his early twenties, it was not with the intention of becoming an artist; he took to painting partly because he thought it a graceful accomplishment and because his father thought he ought to put his mind on art "partly," he said, "as an escape from my desultory interest in too many things." He enrolled in Couture's atelier as a

student, but Couture reportedly said after a few weeks, "Your place is not among these students. They have no ideas. They imitate me. They are all trying to be little Coutures!" He spent long hours drawing in the Louvre; he traveled to Munich and Dresden and to Copenhagen, assiduously drawing from the Old Masters, and he finally arrived in London, where he was smitten with admiration for the Pre-Raphaelite painters, Rossetti and Ford Madox Brown, who were experimenting in color in ways that made sense to him. While he had been in Paris he found himself faced with the battle of styles then fashionable to argue about. Were you on the side of Ingres and classicism? Or did you side with Delacroix and the romantics? He sided with Delacroix, but he had his own ideas about style; by studying the Old Masters, he said, "I kept in touch with that greatest of all characters of art, style, not the style of the Academy or of any one man, but the style of all the schools, the manner of looking at art which is common to all important personalities, however fluctuating its form may be."

In some respects La Farge was too literate to be a painter, too cerebral, too tasteful, too catholic in his appreciations, too little impassioned, too various in his gifts. "Painting is, more than people think," he said, "a question of brains." Like Hunt, he spoke of painting better than he made it, and it was this rather than what came from his easel which influenced the taste of his contemporaries. He offered them no revolutions, no challenges to upset their tastes; he offered them only refinements and late-nineteenth-century adaptations of traditional forms and techniques—a slight readjustment of the past, not a break with it.

In this respect he was superficially like his great good friend, the architect H. H. Richardson, but where Richardson was a designer from whom energy burst in every creation of his pencil, La Farge was an artmaker to whom subtlety was paramount. It was not surprising, however, that Richardson called upon La Farge to decorate the interior of his Trinity Church in Boston, or that the decorations are an enhancement in muted tones of Richardson's intentions, for La Farge was nothing if not discreet. He understood probably better than any other American painter of his time the relationship that tradition had established between painting and architecture, a "tradition" not a little conditioned by what centuries of smoke and grease had done to dim the surfaces of walls and pictures.

By the time Richardson asked him to do the interior of Trinity Church he was engaged in a venture that was to enhance his reputation greatly. After returning to America and studying with Hunt, he had set himself up in the Tenth Street Studios, but his paintings had met with only moderate success. He painted still-life and flower pieces skillfully and subjects such as

"Idyl—Shepherd and Mermaid" and "The Muse of Painting" with Pre-Raphaelite overtones and decorative compositions and details. They were not without charm, but they must have seemed curiously uninspired even in their day—set pieces to which was applied a modern technique. He went back to Europe in 1873 and was struck by the stained-glass windows that the Pre-Raphaelites were designing. When in the following year the architect Henry Van Brunt, a friend of his (and a pupil of Richard M. Hunt), asked him to design a window for Memorial Hall at Harvard, he gladly accepted. He made a design and the glass was cut and leaded, but La Farge was deeply disappointed in the result and had it destroyed. The glass was lifeless and the color insipid, but La Farge was not easily put off. According to Cortissoz, La Farge was lying in bed one morning recovering from an illness when his eye lit on a piece of cheap colored glass with tooth-powder in it and the light from the window struck it in such a way that it became opalescent. The story does not say that he leaped from his bed, but within a few months he had found in Brooklyn a glassmaker from Luxembourg "with whom he would sit drinking beer and talking until he got him interested in his plans and committed to share in them." Together they devised a glass which La Farge called "opaline," and which was to transform his reputation as the sun had transformed the tooth-powder glass.

La Farge redid the window for Harvard with his new glass and it was regarded as a miracle. No one had seen such glorious color since the glass of the Middle Ages, and his windows became so in demand for churches and mansions that he did, it is said, about two thousand of them. He not only designed them but he was convinced that he must stay with their manufacture through every step. The failure to do so, he believed, was why glass in England had ceased to improve. "This was," he said, "mainly because the designers had become separated from the men who made the actual windows. . . . It occurred to me that . . . I should follow the entire manufacture, selecting the color myself, and watching every detail."

Today La Farge is more highly regarded as an innovator in glass than as a painter, though he painted large murals for many churches, the best known of which was for the chancel of the Church of the Ascension in New York. He also did decorative murals for the private houses of Cornelius Vanderbilt and for Whitelaw Reid in the New York mansion built for Henry Villard by McKim, Mead & White. He was, indeed, the inspirational father, if not the founder, of a school of mural painters who covered empty acres of canvas with rather empty allegorical figures at the Chicago World's Fair of 1893 and who painted decorations for libraries (including

Toward the end of the century a new element of neo-classic symbolism had invaded mural painting as it engulfed the "Athens" by JOHN LA FARGE in 1898. (*Bowdoin College Museum of Art, Brunswick, Maine*)

the Library of Congress) and hotels and courthouses and private palaces in which studio models draped in what looked like costumes hired from a theatrical costumer struck "meaningful" poses, with scrolls or torches or harps in their hands and garlands on their brows. The muralists whose reputations were at their apex at the turn of the century, men like Edwin H. Blashfield and Kenyon Cox, are now largely forgotten, and their pictures seem to have faded mercifully into the architecture they adorned. By comparison La Farge seems a minor giant among minor pygmies.

La Farge was also celebrated for his illustrations in the *Riverside Magazine* and for watercolors he made of Samoa a decade before Gauguin went to the South Sea islands. They are rather reportorial sketches, expert, pleasant, but without Homer's vitality or breadth of either vision or brushwork. La Farge's eyes seem to have been the servant of his intellect; he saw what he applied his mind to and his pictures seem to come from what excited his mind rather than what excited his eye.

"He founded no school," Cortissoz wrote accurately of La Farge. He was a tastemaker, not an aesthetic innovator; an inventor rather more than a creator. "His work exerted a spiritual force," Cortissoz said in summary. "It refined taste and fostered imagination. It made powerfully for the

establishment of a high ideal." He affected taste as much by talk as by precept, and probably more by the power of his personality than by his brush. His contemporaries regarded him as "something Leonardesque," "something of a universal genius." It is interesting that Virgil Barker in his *American Painting*, published in 1950, forty years after La Farge's death, mentions him only once—along with the James brothers—as a minor pupil of Hunt in Newport.

TWO UPPER-BOHEMIAN WIZARDS

The Tenth Street Studios, where La Farge painted for many years, became legendary as a place that exuded what was called an "art atmosphere," and nobody contributed more to the legend than the ebullient and dapper William Merritt Chase. Chase was about thirty when he moved in with his wolfhound and birds and velvet coat, fresh from six years in Europe, most of them in Munich and Venice; they had been refreshing to his ego and had given him the happy assurance of a career. He brought with him a miscellaneous lot of treasures, for he was an inveterate, albeit tasteful, magpie, and his studio was a gallery of bric-à-brac, pieces of exotic textile, and palms in large brass pots. He had the biggest studio in the building, a room originally intended as a gallery to show the works of the artists who lived there—an unsuccessful venture—and it must have had the attributes of a tidy (if there is such a thing) bazaar or thieves' market. From the wall hung a stuffed flamingo above rows of paintings in ornate gold frames. On a richly carved armoire were a model of a warship half hidden by the cast of a classic head, a small figurine, and a pot, and on the shelf below were bowls and bouquets and a collection of painters' brushes. Drums and shields and mandolins adorned the walls; throws of silk spread over the backs and seats of benches, and a brass chandelier from Turkey or North Africa hung from the tremendously high ceiling.

"Many an artist who remembers it as his first impression of an artistic studio," Chase's biographer, Katherine Metcalf Roof, wrote in 1917, "has said that in creating the Tenth Street Studio alone Chase did an immeasurable service to art." And she adds: "Overcrowded though it may appear in photographs, the painters who remember it distinctly say that its whole effect was one of great beauty and color."

"Art atmosphere" was something new to New York, something quite unlike the dignified, conservative attitude of those art-makers whose concern was to make their profession respectable. "The painter of the Victorian age was a decorous person, professional rather than artistic," Miss Roof said, though she conceded that some were eccentric enough to wear their hair a little longer than other men and some sported velvet coats. But by the 1880s the mood was changing. Young artists had been to Paris and Munich and drunk of the wine of Bohemianism, and when they came home it was not just with a slashing and brilliant new way of handling their brushes, but a somewhat slashing attitude toward social conventions and a sense of belonging to a group set apart (and above) the fusty men of merchandise and briefs and mortgages. Not, to be sure, that they had gained any financial advantage to support their social indifference. Indeed, the market for their works was in a frightful state. The bottom had dropped out of the portrait business, as we have seen; photographers had become "artistic" and their works were invested with the atmosphere of paintings by elaborate backdrops and hand-tinting. But, worse than that, the Centennial Exhibition had made every foreign artifact more attractive than anything American, and the "artistic craze" of the late seventies and eighties turned starry eyes to the exotic wares of the Orient, to teapots and *Hokusai* prints, but also to almost anything from the brush of a Frenchman. In New York and Chicago the very rich (like the department-store magnate A. T. Stewart, who made a sensation when he bought by cable, sight unseen, a picture by Meissonier for $60,000), gathered up French paintings by academicians such as Bouguereau and Rosa Bonheur, while Bostonians bought Mr. Hunt's Barbizon friends. The less rich bought less expensive French or German paintings by men whose names are now forgotten, but, with a few notable exceptions, neither rich nor merely well-to-do bought American pictures. At the end of the decade of the seventies the attitude was very different from what it had been in 1872, when the contents of Kensett's studio had brought the magnificent sum of $150,000. As Isham wrote, "When the younger men went abroad to study [in the 1870s], painting was a lucrative profession; when they returned they found it was not possible for a man to live by it, even if he were talented, well taught, and hard working." *

As artists of his day fared in the marketplace, Chase did well, though he largely supported himself as a teacher. He was born in Indiana in 1849

* Isham should know; he was just such a young man himself, and when he got back in 1878 from studying painting in Paris, he gave it up and studied and practiced law, though he subsequently returned to the profession of art and eventually became a member of the National Academy.

and learned the rudiments of painting from a local portrait painter in Indianapolis and from classes at the National Academy of Design in New York. When he was twenty-two he went to St. Louis to hang out his shingle, and most of his paintings were still-lifes; these so impressed a number of local businessmen that they offered to send him to Europe to study. "My God," he said, "I'd rather go to Europe than to heaven." He spent six years in Munich and the better part of a year in Venice with his friend and fellow practitioner Frank Duveneck, a painter from Cincinnati who made a considerable stir with his pictures when they were shown in Boston in 1875 and was greatly praised by Hunt.* While he was in Venice, Chase was offered a job as teacher of painting in the newly formed Art Students League in New York, and with considerable misgivings (he was afriad he might not be able to teach) he came back to New York and started on his new career as teacher and tastemaker.

Chase was a painter with a good deal of elegance of style in the broad manner that also characterized John Singer Sargent, a sense of the elegant and the fashionable, and a pleasing élan. He painted many still-lifes. (He especially liked to paint fish on a table with accompanying pots and vegetables, and Oliver Larkin has described him as "the John Sargent of the English cod.") His portraits—largely of friends, though he was not without commissions—could not have been painted fifteen years before he did them. They are pictures of people rather than of personages, rather casually posed or, as in the case of his splendid portrait of Whistler, posed rather dramatically. He used a fluid technique, and he believed in the virtue of speed rather than labor as a means of achieving an effect. (He used to say to his students who were learning to paint landscapes, "Take plenty of time for your picture; take two hours if you need it.") Since he had a kind of wizardry with his brush, a delight in the outdoors, and a pleasure in life which permeates his canvases, his pictures emanate an amiable charm.

But his importance as a painter, such as it was, is overshadowed by his remarkable career as a teacher, as a friend of artists, and as a maker of taste. "I believe I am the father of more art children than any other teacher," he said, and he may well have been. Hundreds of young men and women studied under him at the League in New York. Hundreds of others

* Duveneck, something of a hero in Cincinnati today, was a sensation in the seventies. As Richardson says: "The past three quarters of a century have been filled with a succession of such overnight successes. They sweep across the country, each a national sensation (we love sensations and novelties), setting up a shock wave that swings a whole school of imitators, minnow-like, into its train and it rolls across the continent; then fade, like Duveneck."

Wᴉʟʟɪᴀᴍ Mᴇʀʀɪᴛᴛ Cʜᴀsᴇ and James A. McNeill Whistler met in London in 1885 and painted each other's portraits. As a consequence of Whistler's fame, this portrait of him is Chase's best-known painting. (*The Metropolitan Museum of Art, Bequest of William H. Walker, 1918*)

worked with him in Chicago, Philadelphia, Hartford, and Brooklyn and in summer classes in California and in Europe. His friends among his profession were numerous and distinguished. At the request of his friend Sargent, he made his studio available to Mrs. Jack Gardner, the famous Boston collector, for an opportunity to see a celebrated Spanish dancer, Carmencita,* perform. If Chase would lend his studio, Mrs. Gardner "would provide the Carmencita and I," Sargent wrote, "the supper and whatever other expenses there might be." Chase and Sargent asked their friends and fashionable acquaintances, and the effect when the artists "made her rub the make-up off her face, and brushed her frizzed hair back from her forehead" was that she danced with a passion not often seen in polite circles in the 1880s. "Women tore off their jewels to throw them at the singer's [sic] feet," Miss Roof recalled, and noted that "one emotional lady returned the next day to ask the painter to recover her gems." Carmencita merely "shrugged and snapped her fingers in true Latin fashion."

The most spectacular of Chase's acquaintances was James Abbott McNeill Whistler, who is usually celebrated as an American painter but who will be given only a brief if enthusiastic mention in these pages.† Whistler was the son of an American army officer, a major who distinguished himself as an engineer, and on his account Whistler was admitted as a cadet to the Military Academy at West Point in 1851. He studied drawing there with Horatio Greenough's friend Weir, but he flunked out in his third year because he declined to learn chemistry. He worked briefly for the United States Coast Survey in Washington, but his stipend, he said, hardly paid for his gloves, and in the following year at the age of twenty-one he left for Europe and never again returned to America. Whistler was not a painter when he left America; his training, such as it was, was entirely European, and so were his home and his places of practice. To call him an American artist is like calling Benjamin West an American artist, which he was only by birth but not by training or by career. Like Hunt and La Farge, Whistler had extraordinary verbal gifts, though his were spent largely at the expense of his friends (and enemies) rather than on their behalf. His portrait of his mother (originally called "Arrangement in Black and Gray, No. 1") is unquestionably the most famous "American" nine-teenth-century painting, though Americans did not think well enough of it to buy it and it was bought by the Louvre. (It appeared on an American

* Both Chase and Sargent painted Carmencita; Chase's painting is in the Metropolitan Museum of Art, New York, and Sargent's was bought by the Luxembourg in Paris.

† Biographies of Whistler abound. He is probably the most extensively chronicled artist ever to come out of America, not on merit but on wit.

JAMES ABBOTT MCNEILL WHISTLER was in his twenties when he painted "Wapping on Thames" in 1861, two years after he settled in London. It was at this same time that he made his famous series of sixteen Thames etchings. (*Collection of Mr. and Mrs. John Hay Whitney*)

postage stamp some years ago in celebration of Mother's Day, with a little vase of flowers inserted in the composition by the Post Office Department as a sop to the florists' lobby.)

When Chase met him in London in 1885, Whistler was at the height of his fame or, one might as easily say, notoriety. He lived in London not because Londoners liked him, but because he had some market for his paintings there; he took some satisfaction in insulting his patrons after they had bought his pictures, and frequently he was not allowed in their houses. It has been suggested that he did not settle in Paris, where he had his first success as a young man with "The Woman in White" (it was something of a sensation in Paris at the Salon des Refusés in 1863, where it was in the company of Manet's shocking "Déjeuner sur l'Herbe"), because he did not want to compete in that extraordinary league of geniuses who were shaking painting loose from the talons of the Academy. The Pre-Ra-

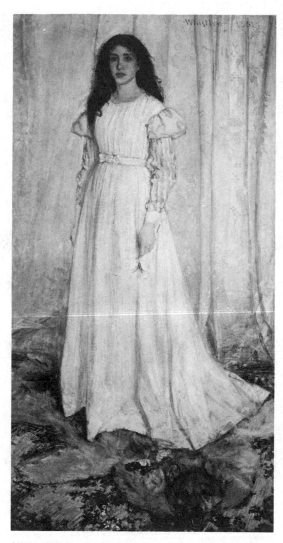

"The White Girl" by WHISTLER was refused by the Royal Academy in London in 1862 and by the Paris Salon in 1863, but it caused a sensation, along with Manet's "Déjeuner sur l'Herbe," at the Salon des Refusés. (*National Gallery of Art, Washington, D.C.*)

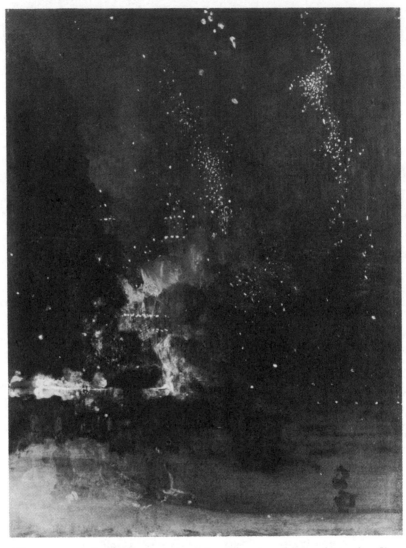

"I never expected to hear a coxcomb ask two hundred guineas for fling-
ing a pot of paint in the public's face," said John Ruskin of WHISTLER'S
"Nocturne in Black and Gold: The Falling Rocket" (painted about
1874) and precipitated a lawsuit which the artist won. (*The Detroit
Institute of Arts*)

phaelites were no more to his taste. He ran headlong into Ruskin, who described his painting "Nocturne in Black and Gold—the Falling Rocket" as the work of a "coxcomb . . . flinging a pot of paint in the public's face." Whistler brought suit for libel, won it, and was awarded a farthing and a good deal of ridicule for his pains. On the one hand he was a dandy who spent hours primping before appearing in public, his hair carefully curled and in his yellow-gloved hand his long wand of a cane, and on the other he was a worker who exhausted himself with the most painstaking struggles at his easel. He was a remarkable draftsman, as his etchings and early paintings reveal, and he was a colorist more interested in mood than, as the Impressionists were, in the exact moment. He was by no means immune to fads or influences that were popular (as in his absorption with Japanese prints), and he loved fashion, so long as it followed him and not he it. He preached a stinging gospel that all artists were superior to all non-artists, who, *per se*, were insensitive; that the "artistic" was the special province of an elevated band of aesthetes and what they (and especially he) took seriously was all that mattered. Whistler was a man who collected himself. "No more faithful Boswell of himself—ever lived," Chase wrote from London, saying that Whistler kept a notebook in which he jotted down his own witticisms. His fame, of course, spread to America, and artistic circles claimed him as American, while, on the other hand, those he regarded as philistines were delighted that he made his home an ocean away and spent his wit largely on the British. The "aesthetic movement" also spread to America as the "artistic craze," and, as Richardson so neatly put it in his *Painting in America,* "Unfortunately those whom he influenced lacked the intelligence and style that gave strength to Whistler's most fragile creations and what emerged was a weak parody—a pale estheticism combined with a pose of arrogant superiority toward all who were not artistic."

THE INEFFABLE MR. SARGENT

Like Whistler, Chase's friend Sargent was an American artist only by lineage,* but there the likeness between the two artists stops. They could not

* Henry James in an article in *Harper's Magazine,* October 1887, wrote: "Is Mr. Sargent in very fact an American painter? The proper answer to such a question is doubtless that we shall be well advised to claim him, and the reason of this is simply that we have an excellent opportunity."

SARGENT painted this watercolor of Mme. Roger-Jourdain when he was a young man (probably in the late 1870s). He dropped the medium for many years, returning to it with great gusto when portraits bored him. (*Collection of Mr. and Mrs. John Hay Whitney*)

have been more different in temperament or in training or in their aesthetic ideas other than that, since they were contemporaries, they shared a common aura and breathed the same artistic air. In some respects Sargent is less an American artist than Whistler. He was born in Florence in 1856 (his father had been a physician in Philadelphia, but his rich wife had persuaded him to give up his practice for the pleasures of travel), he studied drawing as a boy at the Academy of Fine Arts in Florence, and he got his training as a painter in the studio of Carolus-Duran in Paris, where he turned up at the age of eighteen with a portfolio of drawings, hoping to be accepted as a pupil. Carolus-Duran thought his rather meticulous drawings of nature and copies of paintings showed uncommon promise and took him on. This "very tall, rather silent . . . rather shy" young man demonstrated a facility for learning which in a very few years had turned into an extraordinary command of his brushes, a command, indeed, that was one of the wonders of his day. Henry James was moved to remark on "the slightly 'uncanny' spectacle of a talent which on the very threshold of its career has nothing more to learn." In 1878, when he was twenty-two, his painting "Oyster Gatherers at Cancale" was shown at the Salon (it is now in the Corcoran Gallery in Washington), a delightful genre scene on a beach, and it bears a pleasant affinity to the beach scenes that Homer painted a few years earlier.

Sargent's first portrait to make a public appearance was of his master,

JOHN SINGER SARGENT was twenty-two in 1878 when he painted "The Oyster Gatherers of Cancale." Henry James, the novelist, spoke of "the slightly 'uncanny' spectacle of a talent which at the very threshold of its career has nothing more to learn." (*The Corcoran Gallery of Art, Washington, D.C.*)

Carolus-Duran, in the Salon the following year, a picture that demonstrated beyond a doubt that Sargent was in entire command of his medium. It started him on a long and vastly successful career as a portraitist, though he was no face painter by temperament and, it is said, he painted as many portraits as he did over his long career because he was a friendly man who disliked to say no to those who pleaded with him. In 1880 he went to Spain and, like Eakins, saw in Velásquez the ideal painter, though the qualities that most moved him were not, in all likelihood, those that had moved Eakins. Brilliance of brushwork was Sargent's forte, not penetration of the surface, which was Eakins', and Velásquez, of course, had both.

He was busy with both genre pictures and portraits, but more especially with the latter, making his headquarters in Paris until 1885, when his portrait of Mme. Gautreau (called "Madame X") caused such an outcry that he was impelled to move to London, which from then on was his home.

He had urgently wanted to paint Mme. Gautreau, a celebrated and aristo-
cratic beauty, and made many drawings of her before committing himself to
a full-length portrait of a woman with milk-white skin, dressed in a black
velvet gown with an expanse of flesh above a deep *décolletage*, her head
turned in profile. Mme. Gautreau despised the picture, and so did her
friends (or they professed to). It was considered the scandal of the Salon,
and crowds flocked to see it, to jeer at the flesh, which was said to look
"decomposed," and to laugh at the immodesty of the sitter who had allowed
herself to be painted thus. The press, some of it, was more rational and in
some instances complimentary, and one writer noted that there was nothing
wrong with the painting which was not also wrong with Parisian high life.
Mme. Gautreau's mother pleaded with Sargent to remove the portrait from
the Salon, saying that her daughter's reputation was ruined. Sargent, who
was astounded at the furor caused by the picture, flatly refused. He was not
a man to lose his temper, but on this occasion he did, and he told Mme.
Gautreau's mother that "Nothing could be said of the portrait that had not
already been said of the sitter, and in print."

It was not the furor that drove Sargent to live in England; it was the
consequences of it. The fact was that no Parisian wanted to sit to him, to
risk the forthright definition of personality and character to which he had
subjected Mme. Gautreau. His portrait business declined to absolutely
nothing, and he was driven to London in order to make a living. Commis-
sions, however, were slow in coming, and Sargent spent a good deal of his
time at Broadway in Worcestershire with his friend Edwin Austin Abbey, a
muralist and illustrator (mostly for *Harper's Magazine*), and with Henry
James. He had his mind set on doing a large painting that he could be
proud to exhibit at the Royal Academy annual show, and he worked off and
on for two years on a picture of two little girls dressed in white, lighting
Japanese lanterns in the early evening among flowers. He called it "Carna-
tion, Lily, Lily, Rose." It was not an Impressionist picture (it was not a
moment painted all at once), but it was a moment, nonetheless, and he found
that there were just twenty minutes of the day when the light was precisely
as he wanted it; he had to wait from one summer to the next to finish the
painting. Sargent was not an Impressionist, though he had discovered
Monet for himself as a young student and professed to be "bowled over" by
the clarity and vibrancy of his work, but to the Academicians in London
Sargent was shocking. As one of his biographers said: "anything particu-
larly brilliant in the way of painting looked like something foreign, French,
and naughty. Sargent was nothing if not brilliant, ergo, Sargent must be
tainted with the well-known immorality of France." The painting, however,

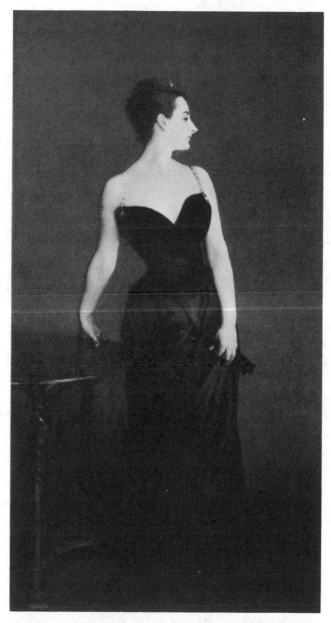

"Madame X" (as the portrait of Mme. Gautreau was called) made JOHN SINGER SARGENT notorious overnight when it was shown at the Paris Salon of 1885. It also temporarily ruined his portrait business and caused him to move to London. (*The Metropolitan Museum of Art, Arthur Hoppock Hearn Fund, 1916*)

was accepted for the exhibition, and it caused something of a stir because of its brilliance and informality among the staid paintings of the Academy. It was, furthermore, bought by the Tate Gallery, an acquisition that unquestionably put some official noses out of joint.

Obviously, Sargent's reputation was growing in England, but his bank account was not. Portrait commissions were few, but then in early 1887 came an opportunity at which he leaped; he was invited by Henry Marquand of Newport to paint Mrs. Marquand's portrait. The timing was perfection. At just about the moment of his arrival in America, *Harper's Magazine* published an article in which Henry James sang his praises. He was a success both artistically and socially, and Boston took him to its bosom. In the following year he had an exhibition of his paintings at the St. Botolph Club which a Boston paper reported "would have made a sensation in New York, or Paris, or London." He had for the first time struck gold. The fashionable women of Newport and Boston could scarcely wait to pose for him. Mrs. Jack Gardner, who plagued him with her archness, also promoted his career, and as she was the most explosive and daring collector of art in Boston, her patronage meant prestige as well as money. The exhibition was partly portraits and partly landscapes and interiors from Venice and England; most of the pictures were specifically mentioned by James in his article, and they were richly and warmly coated with his praises. If Sargent can be said to have belonged to any part of America, he must be considered a Bostonian by adoption.

The art-maker friends he made in America stood him in good stead, especially Stanford White and Charles McKim, protégés of H. H. Richardson, as we have seen, who were to become as famous as any architects of their day. It was they who were responsible for Sargent's being invited to paint murals for the Boston Public Library, which McKim, Mead & White designed (more specifically, it was McKim who was the essential artist). The murals became a project that occupied Sargent's mind for about thirty years. His conscientious researches for them took him to the Holy Land, to Egypt and Greece, and even to the Orient in search of models of gods and prophets.

After he returned to England from his first trip to America, he found himself besieged by profitable portrait customers, and it is as a portrait painter that he is best known. He set a standard that many copied and no one matched, a brilliance of brushstroke with a semblance of character, the perfectly "caught" likeness without any unpleasant overemphasis on the substance of the person behind the exterior. But portraits bored him. He was weary of "mugs." They made him famous and they made him rich, for

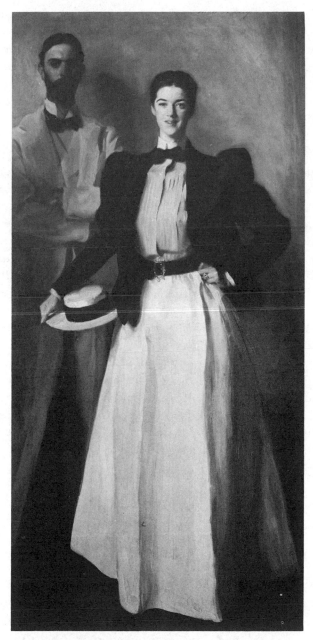

In 1887 Mrs. Isaac Newton Phelps Stokes came directly to SARGENT's studio from the tennis court, and he was so delighted that he decided to paint her in her tennis dress. He later added her husband's portrait in the background. (*The Metropolitan Museum of Art, Bequest of Edith Mintum Stokes, 1938*)

to have one's portrait painted by Sargent was a mark of wealth, social distinction, and sometimes of public importance as well. His contemporary Isham, who was aware of his shortcomings as well as his excellences, wrote: "he has talents manifest and unmistakable that give him securely his position as the first portrait painter since Reynolds and Gainsborough." The next generation of critics looked on him with reserve and the one following it in the 1920s and '30s with something close to contempt.

If Sargent has come back into fashion somewhat, it is as a painter of genre scenes, of dark Venetian interiors illuminated with brilliant streaks of light, of landscapes saturated with sunshine and with violet shadows, and of watercolors of figures drawn with a sureness that is mesmerizing for its facility. "I do not dig beneath the surface for things that do not appear before my eyes," he once said to one of his sitters, and on another occasion he said, "I do not judge, I only chronicle." He was, in other words, the antithesis of Eakins and of Homer, but it is not difficult to understand his affinity with Saint-Gaudens, a fellow worker on the Boston Library, or, most assuredly, his friendship with Chase, who was inclined to embarrass him with overenthusiasm. In Sargent's presence he once told a group of students, "I want you all to remember this moment. You are in the presence of the greatest living painter!" If Sargent belongs to any national tradition, it is to the English portrait tradition, in much the same way that Stuart and Sully did. If he belongs to a school, it is to the French of the second half of the nineteenth century, to the realists of Manet's kind and the Impressionists of Monet's. Where he came from, however, is less important than where he led to. Unfortunately, he did not seem to lead anywhere but to drawing rooms and fashionable parties.

THE LADY FROM PHILADELPHIA

There is perhaps less justification for calling Mary Cassatt an American painter than there is for us to adopt either Whistler or Sargent, but she most assuredly had an impact on American taste which still persists. Miss Cassatt was to all intents (and her own purposes) a French Impressionist, more closely identified with Degas than with any of the others, and though she is often captured by enthusiasts and claimed as an American, there are historians who decline even to mention her name in their surveys of Ameri-

can painting.* The justification for calling this talented, intelligent, and opinionated woman an American artist is much the same as for calling Whistler an American—they were both born in America and lived here until their early twenties. Mary Cassatt was born in Allegheny City, Pennsylvania, in 1844 and as a young woman studied for several years at the Pennsylvania Academy of the Fine Arts in Philadelphia. Eakins was a student there at the same time and, like him, young Miss Cassatt found the old-fashioned requirements of drawing from casts deadening, though she stuck it out for four years. Like Eakins, she left to study in Paris in 1866, though her father, a broker, looked upon painting as a scarcely decent profession for a young woman. There is no evidence that Cassatt and Eakins were friends, and surely they had little in common, as their reactions when they each visited the Prado and saw Rubens plain for the first time would indicate. Mary Cassatt was as enthusiastic as Eakins was repelled. The brilliant flesh tones which disgusted Eakins delighted her so that she pursued Rubens' work to Antwerp, and his impress on her palette stayed with her work always.

For a young woman Mary Cassatt was surprisingly successful in the rigorous competition of Paris. She had a painting accepted for exhibition in the Salon in 1872, and two years later Degas spotted a small portrait head by her there and said to a friend, *"C'est vrai. Voilà quelqu'un qui sent comme moi."* Three years later an incident occurred which soured her on the Salon. The jury declined a painting of hers (a portrait of her sister) because it was too bright; she toned it down, and the next year it was accepted. This she thought utter nonsense, and when Degas came to her studio with a mutual friend in 1877 and asked her to show with the Impressionists, she at once accepted and never showed again at the Salon. The Impressionists, who appealed to Cassatt not only because of their work but also because of their independence, had got their name, as is so often true of names of schools or periods of art that become eminently respectable, as an epithet of abuse.† A critic in *Le Charivari*, reviewing an exhibition of a group who called themselves *La Société Anonyme des Artistes, peintres, sculpteurs, graveurs, etc.*, had lit upon a painting by Monet called "Impression: Sunrise" and in ridicule attached the name Impressionist to the

* Her name does not appear in Larkin's *Art and Life in America,* in Isham's *The History of American Painting,* or in Barker's *American Painting.* Richardson grants her two brief paragraphs in *Painting in America.* He says: "Mary Cassatt is one of the few American painters known to European critics and mentioned in European histories of art."

† "Gothic," "Romanesque," and "Baroque" were all originally terms of opprobrium.

whole group, which, of course, included Degas, Renoir, Pissarro, and Sisley.

Of the group, Degas became Cassatt's closest friend. He was astonished that any woman could draw as well as she or hold such sharp opinions about painting or speak them so directly and frankly. She, on the other hand, enormously admired his work (she had urged a young friend of hers to buy a picture by him several years before they met) and she had the utmost regard for the accuracy and sharpness of his criticism, though it was sometimes so devastating that she crumbled before it. As for Monet, she thought him a dullard; Renoir's sensuality met with her disapproval. Miss Cassatt exhibited with the Impressionists for the first time in 1874, and she was one of fifteen artists. Monet sent twenty-nine paintings, Degas (who promised thirty-five) sent eight, and Pissarro contributed thirty-eight. The group tried to shake off the Impressionist name in favor of the Independents, but they had no success. The exhibition made a profit of 6,000 francs, and with her share Cassatt purchased a Monet and a Degas.

Within five years Mary Cassatt's name was well known in French art circles and her reputation was established. She was little known, however, in America, and few of her paintings had been seen in New York or Philadelphia, but in 1879, at the second annual exhibition of the Society of American Artists, "The Mandolin Player" was lent by an American collector, and, according to Frederick A. Sweet, this and other pictures she showed at the Society were "probably the first Impressionist pictures shown in America."

Chase was the earliest American artist to make a genuine attempt to get recognition for the Impressionists in America, as Hunt had done for the Barbizon School. In 1881 he had encouraged the American painter J. Alden Weir, who was studying in Paris, to buy Manet's "Boy with a Sword" and "Woman with a Parrot" for a New Yorker, Edwin Davis, who had asked Weir to get him some French pictures. And two years later Chase and his friend Carroll Beckwith, in an attempt to raise funds toward building the pedestal for the Statue of Liberty on Bedloe's Island in New York harbor, put on a show of paintings which included not only Barbizon pictures but Impressionists as well. The first Impressionist exhibition in America of real consequence was the work of the Paris dealer Durand-Ruel in the gallery of the New York Art Association in Jackson Square. It was such a success (or, in any event, caused such a furor) that it was moved to the galleries of the National Academy of Design and enlarged by twenty-one pictures. In all there were 310 paintings shown, including two by Mary Cassatt; these were lent by her brother Alexander, the president of the Pennsylvania Railroad, whom she had converted to being a collector of

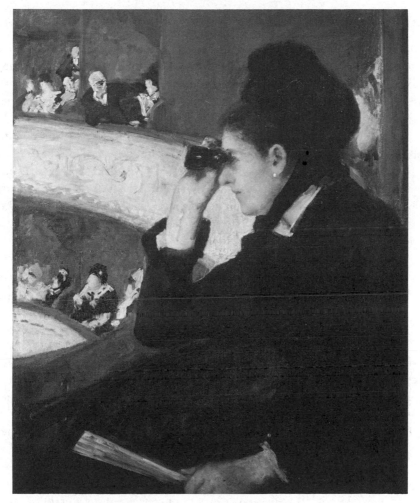

Light reflected from the stage onto the faces of women in opera boxes provided MARY CASSATT with the illumination of a number of her most successful canvases. She painted "At the Opera" in Paris about 1880. (*Museum of Fine Arts, Boston, Charles Henry Hayden Fund*)

Impressionists. Paintings worth $18,000 were sold, and the word Impressionism was on the lips of the fashionables and blue-stockings and literary coteries from then on, more often as a term of opprobrium than otherwise. Sargent was tagged an Impressionist and Henry James felt called upon to say, "It is not necessary to protest against the classification if this addition always be made to it, that Mr. Sargent's impressions happen to be interest-

ing." James regarded most "impressions" as mere oversimplifications.

Mary Cassatt thought less than nothing of Sargent; indeed, she despised him as an artist capable of serious work who gave it up to become a slick portrait painter and a toady to society. When she first saw this young painter's work (she was twelve years his senior) she was favorably impressed with his canvas of "The Boit Children," and when he had made such a stir with "Madame Gautreau" and was *persona non grata* in Paris, she invited him to join the Impressionist group. He declined. One did not snub Miss Cassatt, and many years later when Sargent called on her she refused to see him on the grounds that he had painted a "dreadful" portrait of her brother Aleck. Indeed, she had little regard for Henry James, and Edith Wharton she thought beneath contempt as a writer. Whistler, on the other hand, she considered an artist worthy of her respect, though a frightful procrastinator when it came to finishing a portrait of one of her relatives.

Whatever Mary Cassatt's contribution may have been to the history of French painting (and she was a very considerable talent), her contribution to American taste was the result not of her brush but of her extraordinary eye for quality and her ability to convince those who could afford first-quality paintings to buy them. Without taking away any credit from Mr. and Mrs. H. O. Havemeyer for their perception and for their wit in knowing good advice when they heard it, the basic responsibility for the paintings in the Havemeyer collection was Mary Cassatt's. When Mrs. Havemeyer was a proper young lady of seventeen absorbing culture in Paris (she was then Louisine Waldron Elder), she met Mary Cassatt, who was then twenty-eight, and because of Louisine's prococious interest in art and because they both came from the same Philadelphia circle, they became friends. One day, the story goes, Miss Cassatt took her young friend to look at a pastel of a ballet rehearsal by Degas which was hanging in a shopwindow and persuaded her to buy it. "I scarce knew how to appreciate it, or whether I liked it or not, for I believe it takes special brain cells to understand Degas," Mrs. Havemeyer recalled some years later. "There was nothing the matter with Miss Cassatt's brain cells, however, and she left me in no doubt as to the desirability of the purchase and I bought it on her advice." In order to do so, she had to borrow from her sister to supplement what she had already saved up to buy pictures. The pastel cost 500 francs, roughly $100, and she learned later that the money got to Degas, who was broke, just in time to save him from abandoning painting for some other way to make a living.

Miss Elder was bitten by the collecting bug; she had nerve and judgment and the sound advice of Miss Cassatt, and she married a man who also liked to collect on a large (sometimes alarmingly large) scale and who had

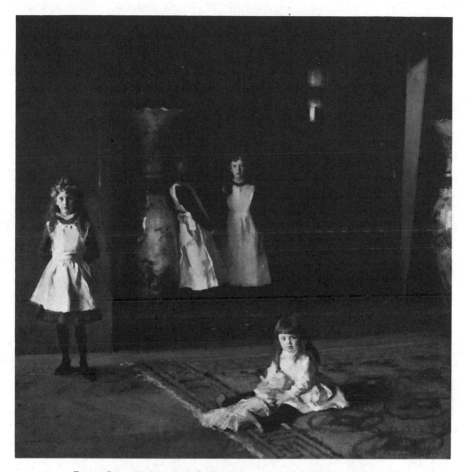

JOHN SINGER SARGENT was twenty-six when he painted the daughters of his friend Edward D. Boit in their French home in 1882. The picture was exhibited in the Paris Salon of 1883, where artists liked it but critics did not. (*Museum of Fine Arts, Boston. Gift of daughters of Edward D. Boit in memory of their father*)

the wealth to indulge himself and his wife. When they married his taste was for porcelains and other three-dimensional objects, especially from the Orient, and he bought them not by the dozens but by the hundreds. He owned, for example, 475 Japanese tea jars. Miss Cassatt and Mrs. Havemeyer together wooed him into collecting paintings, with the result that the Havemeyer Collection, the best of which was bequeathed to the Metropolitan Museum, and first shown in 1929, was a revelation to a great many

people. Unlike most other collections started by rich Americans in the
nineteenth century, it was neither expensive salon pictures nor thoroughly
acceptable and fashionably bonded Old Masters. It was extraordinarily
adventurous, and it was not by any means all "modern." In it were El
Grecos bought when El Greco was considered a painter with astigmatism
and his distorted figures were thought laughable. Greco's "View of Toledo"
and his portrait of a Cardinal left the public gaping. Here, too, were Goya's
"Women on a Balcony" and his "City on a Hill," Courbets, Manets,
Renoirs, Cézannes—a rich mixed bag that evidenced both discernment and
courage. Mary Cassatt was also responsible for the discovery and ulti-
mately the purchase of Greco's "Assumption of the Virgin" by Martin
Ryerson for the Chicago Art Institute.

Occasionally Miss Cassatt expressed bitter regret that her work was
not better known in America; however, even American painters looked upon
her not as one of them but as a French artist. Her charming paintings,
loosely brushed, often high in key and with strong color, sometimes subtly
composed of lavender and pinks and silvery blues, with the flesh tones of
Renoir and the elliptical (and, for their day, shocking) compositions of
Degas, or the flat patterns of Manet and the careful distribution of shapes
as in Japanese prints . . . there was no question where her loyalties and her
inspiration lay. There is nothing in her work which relates her to America.
Very nearly all of her paintings are of women or women with infants and
small children—ladies pouring and drinking tea, young women in opera
boxes, mothers bathing their babies. She had an entirely feminine under-
standing of the quality of young children, this tough-minded old maid, and
I can call to mind no one who painted them as convincingly, as unsentimen-
tally, or as appreciatively. Certainly no other American artist approached
her in this respect or seemed to want to.

Possibly it was because she was a woman that the American art-makers
had no special interest in claiming her; possibly she put them off by the
toughness of her intellect, her arrogance, and her lack of enthusiasm for
what American artists were doing. Possibly they misunderstood her identifi-
cation with an *avant-garde* that was more than many of her compatriots
could stomach. In any event, she became and remained "French." When in
1913 the Armory Show in New York introduced the Cubists to the Ameri-
can public and caused such a shock that the public sensibilities have never
been the same again, there were also many paintings by the Americans who
had arranged the show and subscribed to it and many by foreign artists
other than Picasso and Matisse and Duchamp, whose "Nude Descending a
Staircase" made the loudest fuss of all. *The New York Times* of February

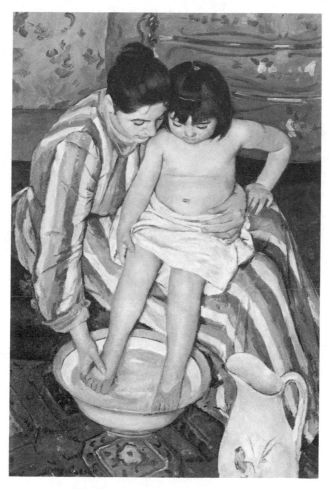

Mothers with their young children were a favorite sub-
ject of MARY CASSATT. "The Bath," painted about 1892,
shows strongly the influence of the great 1890 exhibi-
tion of Japanese prints in Paris, where she lived. (*The
Art Institute of Chicago*)

17, 1913, reported: "In gallery O we find Monet, Pissarro, Manet, Sisley,
Degas, Lautrec, Mary Cassatt, Seurat, and Renoir, a thoroughly compan-
ionable group."

It would be difficult to invent three "artistic temperaments" more
unlike than those of the three most prominent American expatriate artists
of the late nineteenth century—Whistler, Sargent, and Cassatt—and yet
they had one quality in common: a need to be where art was generally

considered worth fighting for and about. The atmosphere to which Hunt referred when he said, "In another country I might have been a painter" kept them away, but it did not keep them, any more than it kept Hunt or La Farge or Chase, from stamping their imprint on American taste.

14

PALACES, PALACES, PALACES

*"Make no little plans. They have no magic to
stir men's blood. . . . Remember that our sons
and grandsons are going to do things that would
stagger us."*

DANIEL HUDSON BURNHAM, 1912

No one could say that words failed to describe the magnificence of the
opening of the Chicago World's Fair on the first day of May 1893. Words
poured out from everyone, from politicians, from poets, from journalists;
they poured into the air, into ladies' diaries, into the wires of Mr. Morse's
gadget, the electric telegraph, and into histories to "acclaim the opening of
the grandest achievement of American pluck, enterprise, and generosity."
Three hundred thousand people in bowlers and bustles, in feathers and
blankets, in exotic costumes of the Orient, gathered in the great court
before the Administration Building, which the aging patriarch of American
architecture, Richard Morris Hunt, had designed to dominate the regal
grounds of the fair which his friend Frederick Law Olmsted had in just two
and a half years rescued from a swamp. The throng waited for President
Cleveland to press an "electric button" that would start the "miles of
shafting, the innumerable engines and machines and the labyrinth of belt-
ing and gearing" whirring in such a manner that the gorgeous "White
City" (this "Park of Palaces," as one of the orators called it) trembled with
sheer mechanical genius. At the same moment the warship *Andrew Johnson,*
just offshore in Lake Michigan, let go with a salute from all its guns, and

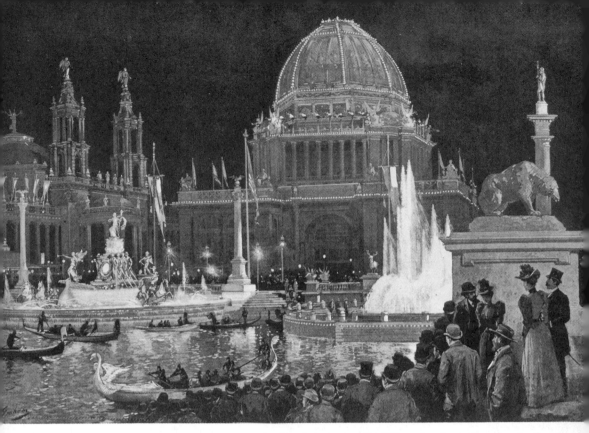

RICHARD M. HUNT's Administration Building dominated one end of
the Grand Court of the Columbian Exposition in Chicago in 1893;
D. C. French's colossal statue of "The Republic" gazed at it across
the waters of the Lagoon. (*From* Harper's Weekly, *collection of the
author*)

seven hundred pennants were let fly at the signal and "streamed out under
the sky in scarlet, yellow and blue." Within sight of the platform, flags of
all the nations of the world that were represented at the fair were let loose,
and above the President's head the largest flag of all, "Old Glory," "fell in
graceful folds."

Only a few people who pressed close to the platform on which were
deployed the President and his Vice-President, Adlai Stevenson, and his
Cabinet and a number of foreign dignitaries could have heard what the
President had to say. There were, of course, no microphones or loudspeak-
ers, and his platitudes floated out into the murmurings of the crowd and
were lost, though his text was not. "Let us hold fast to the meaning that
underlies this ceremony," he shouted, "and let us not lose the impression of
this moment. As by a touch the machinery that gives life to this vast
Exposition is now set in motion, so at the same instant let our hopes and
aspirations awaken forces which, in all time to come, shall influence the

welfare, the dignity and the freedom of mankind." With that he pushed the button—not an ordinary button but a telegrapher's key made of solid gold with an ivory finger piece, standing on a pedestal upholstered in navy blue and golden yellow plush. Not only did the multitude burst into a roar of applause but fountains shot their streams into the sky, bells rang out from the exhibition halls, and the band struck up the "Hallelujah Chorus." There were ten minutes of happy bedlam, and then the women "breathlessly fought their way through the masses to reach their own Mecca," the Women's Building. Officially "emancipated" for the first time by a World's Fair, they jammed into the symbol of their freedom, their dresses torn and their bonnets crushed. It was a glorious day for everyone.

In Chicago, that is. Other cities had lobbied earnestly but unsuccessfully to be the site of the celebration of the four hundredth anniversary of Columbus' adventure. Chicago had sent a committee to Paris in 1889 to study the Universal Exposition there and gather ammunition for its scheme. Engineering was the hero of the Paris fair with its marvelous 984-foot tower built by Alexandre Gustave Eiffel, and Chicago had already demonstrated with architectural experiments and tall buildings that it was the engineering hero of America. Furthermore, it could command more money and create more acreage than any other city was prepared to commit. In April 1890 the Congress awarded the commission for the fair to Chicago. It was obvious that not even superhuman effort could construct an exposition in two years and be ready for the four hundredth anniversary of the discovery of America, but even three years was little enough to promulgate and realize so grandiose a scheme. The greatness of a nation was no small theme, and here was a chance to glorify in magnificent surroundings, with all of the ingenuity and inventiveness on which Americans prided themselves, the emergence in a century of a nation from a recalcitrant offspring of Europe into a world power . . . not to mention the emergence of Chicago from a tiny cluster of shacks to a proud metropolis in a mere matter of sixty years.

The job of planning the fair was awarded to Daniel Hudson Burnham and his partner, John Wellborn Root. They were a formidably talented pair of architects, and together they had designed a number of tall buildings that had helped to give Chicago its reputation as the most advanced center of architecture in America if not the world. Burnham's gifts were for organization rather than design, and Root's were imaginative, original, and unhampered by the heavy hand of tradition. Harriet Monroe, who as a young woman wrote one of the commemorative odes for the dedication of the buildings at the fair (and later founded and edited *Poetry*, a distinguished

magazine of verse), called Burnham the lightning rod around which played the flashes of Root's brilliance. Burnham, the son of a wholesale druggist from western New York, had his heart set on being a millionaire and came to architecture by way of mining and selling plate glass. It was his idea, he told his contemporary, the remarkable Louis Sullivan, "to work up a big business, to handle big things, deal with big businessmen," and he had a flair for just such dealings and the abilities to organize others to do his bidding and promote his schemes. Root, on the other hand, was all architect and designer. He had worked in the office of James Renwick, Jr., the architect of Grace Church and St. Patrick's Cathedral in New York, and with Peter Bonnett Wight, had designed the Venetian palace that housed the National Academy of Design. Sullivan described the partners as "dragon fly and mastiff." Root, he said, was "a facile draftsman, quick to grasp ideas, and quicker to appropriate them; an excellent musician; well-read on almost any subject . . . and vain to the limit of the skies." It was he who designed the Monadnock Building in Chicago, sixteen stories of masonry, unrelieved by ornament, with a remarkable undulating surface of bays running almost the full height of the walls from a base that spread gracefully below the second story. As partners, Root and Burnham were also responsible for the Rookery Building, strongly influenced by H. H. Richardson.

The details of how Burnham got the job of planning the Columbian Exposition and the "autocratic powers" that were given him are not part of the record, but get them he did, and he and Root set out to design a fairyland of pavilions and pagodas and other fantasies in a medley of styles. The planning of the site was assigned to Frederick Law Olmsted, the creator of New York's Central Park, and his young partner, Henry Codman, and they decided to make water—fountains and lagoons plied by gondolas and electric boats—a dominant note of their plan. Root, however, died shortly after he had started to apply his facile pencil to the fair's fantasies, and Burnham changed his mind about how and by whom the exposition should be designed.

It is said by some historians that it was Burnham's social ambitions that caused him to call in the fashionable architects of the East to give shape to the grand scheme of the fair and design its most conspicuous structures. By his own account, he was worried about how slowly plans were taking shape, and he urged on the committee for the fair, "three of whom were in political life," a plan to engage five Chicago architects and five "outside" architects. The three politicians voted against him, but the other four members of the committee took Burnham's side, and he went off to New York to sell his scheme to Richard Morris Hunt, George Post, and McKim,

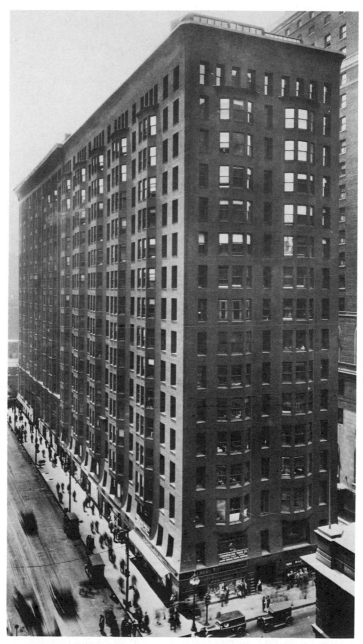

Louis Sullivan described the Monadnock Building, built in 1891–93 by the architects BURNHAM and ROOT, as "an amazing cliff of brick work, rising sheer and stark, with a subtlety of line and surface, a direct singleness of purpose, that gave me the thrill of romance." (*Photo Chicago Architectural Photographing Company*)

Mead & White, who somewhat reluctantly agreed to go along with his suggestion. He also invited the firms of Peabody & Stearns of Boston and Van Brunt & Howe of Kansas City. George Post and Henry Van Brunt were both pupils of Hunt and his ardent admirers, and it was the spirit and commanding personality of Hunt and the nimbus of the Beaux-Arts in Paris that set the tone and provided the aura for what the fair was to become. It might have been a very different sort of fantasy if Root had lived, one which would have laid a less heavy hand on American architecture for the next half-century.

When Hunt and his collegues arrived in Chicago to hear of Burnham's plans, representatives of the Chicago firms were also there, and one of them was Sullivan, who recalled in *The Autobiography of an Idea* that Hunt, as "acknowledged dean of his profession," was in the chair. When Burnham —who, he said, was "not facile on his feet"—began to apologize to the Eastern architects "for the presence of their benighted brethren of the West," Hunt would have none of it. "Uncle Dick," as Sullivan calls him, interrupted and said, "Hell, we haven't come out here on a missionary expedition. Let's get to work."

The first work was to parcel out the buildings to the architects on the basis of a ground plan provided by Olmsted and Henry Codman, whose "knowledge of formal settings," according to Burnham, "was greater than that of all the others put together." The Administration Building, which dominated the lagoon, was, of course, awarded to "Uncle Dick." McKim, Mead & White got the Agricultural Building, Van Brunt & Howe the Electricity Building, Peabody & Stearns the Machinery Hall. Sullivan and Adler, who had hung back at first, unsure that they wanted to be party to this particular architectural extravaganza, were given the Transportation Building, which, perhaps not surprisingly, did not conform to everyone else's Beaux-Arts notions. Henry Ives Cobb, the architect of Mrs. Potter Palmer's castle, got the Fisheries Building.

It seemed like an auspicious start, but this was not to be just an architects' show; it was to be a flowering of all the plastic arts, of painting and sculpture and decoration as well as architecture. Burnham invited Saint-Gaudens to come and advise the committee on what sculptors should adorn the buildings especially those of the Court of Honor, which was the heart of the fair, a lagoon surrounded by palaces of vast dimensions and blinding white façades. Decoration was to be in the hands of "a man named Prettyman," as Burnham called him. He was a friend of Root's, but he and Burnham had a falling out over the question of the "general coloring" of the fair. Prettyman was for ivory; the architects were for white, "perfectly

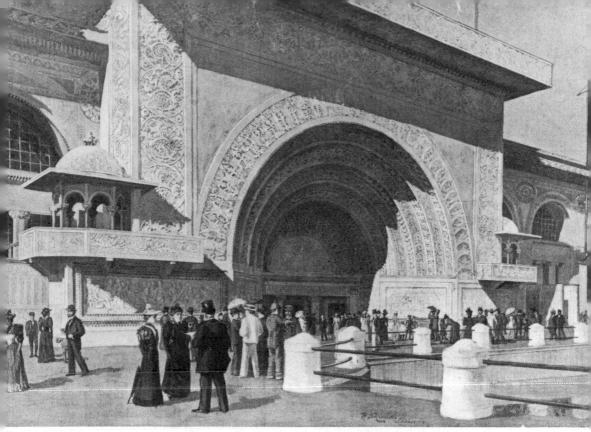

LOUIS SULLIVAN's "Golden Doorway" of the Transportation Building was one of the sensations of "The White City," as the Columbian Exposition of 1893 was called. It was not in the manner decreed by Hunt and it was not white. (*From* Harper's Weekly, *collection of the author*)

white." Prettyman, "outraged" when he came back from a trip to New York and found one of the buildings white, told Burnham that he had no business to interfere—which was not the sort of thing one said to Burnham. Prettyman quit and was replaced, at McKim's suggestion, by the painter Frank Millet, who insisted on being paid $15,000 because he said he could not afford to live for less. Millet was a man of modest talents but of wide acquaintanceship among fellow artists, and he rounded up a small horde of painters who, whatever they may have been up to that time, became muralists for the White City. Not only that, he was Burnham's kind of man. "Frank organized the whitewash gang," Burnham said in an interview. "Turner of New York got up a method of blowing paint on buildings; this Frank adopted, and it is now in common use in car shops." The long line of American artist-inventors would have nodded in approval.

Saint-Gaudens rallied the sculptors and dealt out the jobs. French got

The Columbian Fountain by FREDERICK MACMONNIES splashed at
the other end of the Lagoon from French's "The Republic." It
was surrounded by statues of prancing horses emerging from the
water and by a multitude of spouts. (*From* Harper's Weekly,
collection of the author)

one of the principal plums, the colossal figure of "The Republic" which
stood in the Lagoon at one end of the Court of Honor, and Frederick
MacMonnies got the other most conspicuous spot, in front of the Adminis-
tration Building. There he created one of the most ambitious and, in
retrospect, most ludicrous sculptural complexes ever perpetrated anywhere.
It was called the "Columbian Fountain" and it represented a fanciful sort
of boat in the prow of which stood a winged female with a trumpet. On
either side of the boat four rather decently clad maidens appeared to propel
it with oars that rested in garlanded oarlocks, and behind them Father Time
used his scythe as a tiller. In the center of the boat on a tall pedestal sat an
erect Columbia, her breasts bared, her thighs covered with drapery, and
her eyes peering straight ahead at the distant gilded "Republic." Around
her sported seahorses in the spray of water jets. Hunt himself chose Karl
Bitter, a Viennese by birth, to take charge of the twenty-two colossal
sculptures that he wanted to ornament his Administration Building, and
Bitter turned out remarkable clusters of Beaux-Arts beauties looking for

Hundreds of workers made the sculpture for the White City out of an impermanent mixture of plaster and fibers called "staff." This crowd surrounds one of the colossal groups that PHILIP MARTINEZ, a pupil of Saint-Gaudens, modeled for the Agricultural Building. (*Collection of the author*)

all the world like Berninis made of white rubber and inflated with a pump. To say that they were not in keeping with the occasion would, however, be inaccurate. The White City fairly crawled with sculpture made of staff, a blessedly impermanent material. French with his collaborator Edward C. Potter (to whom he was accustomed to assign the animals in his pieces) did a "Columbus Chariot" with four horses and two maidens to top an arch that opened from the Lagoon into Lake Michigan. Lorado Taft, a Chicagoan in his early thirties (he later became one of the great showmen of the arts and the first historian of American sculpture), managed two pieces for the Horticulture Building called "Sleep of Flowers" and "Awakening of Flowers." Everywhere one looked, the eye was arrested by blind-eyed maidens or beasts or muscular sub-heroes.

Saint-Gaudens himself was too busy with his own commissions to take on a piece for the fair, but his friend Stanford White prevailed upon him to allow the "Diana" that Saint-Gaudens had made to embellish the tower of

Madison Square Garden to be used as the crowning glory of the Agricultural Building. Saint-Gaudens, as maestro, was in his element, and at a meeting of the large Committee on Grounds and Buildings he clasped Burnham by both hands and declared, "Look here, old fellow, do you realize that this is the greatest meeting of artists since the fifteenth century?"

Modesty was not a characteristic of the architects or sculptors or painters of the Columbian Exposition; indeed, if they had been modest, they could never have undertaken such a colossal project on such short notice or, without a good deal of gall and enthusiasm for their own powers, have completed it. In retrospect, not all of them, of course, seem to justify the loftiness of their reputations at the time when they worked on the fair, but to suggest that they were not an extremely talented lot with at least one genius in their midst would be to deny them their due.

GENTLEMEN ARCHITECTS

First let us look at the architects, for it was a moment when they were riding higher than they ever had in American esteem, and architects believed then (as many do now) that architecture is the pivot around which all other arts must spin.

No other architect had more artisans and art-makers spinning around him than Hunt. He was sixty-six when he was invited to take the chairmanship of the design committee of the fair, and he suffered from severe arthritis. All of his best work was behind him—the great "cottages" at Newport, the châteaux of Fifth Avenue, and Biltmore in Asheville—and the Administration Building with its dome rising high above all other structures at the fair was, or so it seems from photographs, a sort of dunce cap on this eminent career. The Beaux-Arts was in Hunt's blood, and he transfused it into his pupils, with the result that it lingered long into the twentieth century. He has been called the great prophet of "adaptation," by which was meant that he could take any style of the past and with uncommon ingenuity adapt it to whatever function his client wished him to enclose in stone and mortar. There is no question that whatever he did he did with gusto and usually with charm. If he was not attuned to the advances being made by industrialists in technical matters, he was most assuredly attuned to the social ambitions of their wives and knew how to

give their setting an elegance in depth which may have been somewhat unfair to their personal elegance of surface. His attitude toward progress was to hide its crudities behind time-tested styles, and, as he explained to his fellow members of the American Institute of Architects while the fair was being built, he did not feel that America was up to coping with the new "Iron Architecture" that had already been used in two French expositions. "Much yet remains to be accomplished [with iron] before the artistic mind will be satisfied," he said, and his will prevailed. He died just two years after the fair had opened but his swan song echoed throughout the nation for decades.

Among the "Eastern" architects whom Burnham invited to overshadow his colleagues in Chicago and to impress the local industrialists and merchants were Messrs. Charles Follen McKim, William Rutherford Mead, and Stanford White. They constituted, now that Richardson was dead, the most distinguished architectural firm in the country. In his *Architecture, Ambition and Americans* Wayne Andrews makes the observation that while Hunt was concerned with achieving magnificence for his clients, McKim, Mead & White "reasoned that elegance was just as desirable," and if Hunt's domed building for the fair seems ponderous, those committed by McKim and White seem gracefully elegant by comparison. Both of these men were at the very peak of their careers in 1891, with the accomplishment of public and private buildings of commanding stature on which to rest their reputations.

McKim and White first met, as we have noted, in the offices of Richardson, where together they worked on the drawings for Boston's Trinity Church. The two young men could scarcely have been more different in temperament or more akin in their passion for architecture. McKim graduated from Harvard and went straight to the Beaux-Arts in 1867. He was a diligent student with a coolly analytical mind that reduced architectural problems to their essentials. "You can compromise anything but the essence," he was fond of saying, and once his mind was made up he was next to impossible to budge. "A gentle obstinate is he," Saint-Gaudens said of him, but his obstinacy was overlaid with a persuasive charm that melted his clients into submission to his will. White, on the other hand, was flashy, ebullient, with red hair and natural gifts for personal publicity, a facile designer and, like McKim, an extremely gifted one. He could (and did) turn his pencil to all manner of things from jewelry to magazine covers to pedestals for sculpture, from charming summer houses to stately public buildings, from gentlemen's clubs to palaces for magnates. He left for Europe to study after he met McKim in Richardson's offices (but not, as we

have previously seen, before he suggested the tower on Trinity Church be based on that of the old cathedral in Salamanca). Mead was the oldest of the partners by just a year. He graduated from Amherst College in 1867 and went to work for Russell Sturgis, an architect who is better known now for his architectural criticism and histories than for what he designed. He and McKim set up an office in 1872 and White joined them in 1879 after a stay in Europe. Mead was the balance wheel of the firm, the solid member and pacifier who, he claimed, spent a great deal of his time keeping his two colleagues from "making damn fools of themselves."

It is unlikely that there has ever been a firm of architects in America to whose name more magic was attached than that of McKim, Mead & White. At the height of its reputation, which was just before the turn of the century, the partners were symbols of refined design in the Renaissance manner, of taste of the most exquisite kind, the epitome of gentlemanly artistic achievement, art-makers with impeccable credentials that could equally impress the wife of William K. Vanderbilt, Jr., the directors of the Pennsylvania Railroad, and that very nearly omnipotent financier J. Pierpont Morgan. The reputation of the firm was first made by the construction of elegant dwellings (if a summer cottage at Newport can be called by such a homely word) in the shingle style. In their hands in the late 1870s and '80s the Queen Anne house was disciplined and reshaped into brand-new forms of great simplicity. The fussiness dissolved under their pencils into an informality combined with an easy but inescapable dignity, and the shingle style reached its most sophisticated treatment at their behest. The Casino at Newport was one of White's first triumphs in the shingle style, and it was built at the whim of the extravagant playboy son of the publisher of the New York *Herald*, James Gordon Bennett, who had been the first to discover that there was a national curiosity about the private antics of the rich and had vastly increased the circulation of his paper by exploiting it. Young Bennett, who succeeded his father, commissioned White to design the Casino in a pet over what he considered an affront to a friend; the gentleman's guest card was withdrawn from a Newport club because on a dare he had ridden his horse into its front hall. This fantasy of shingle with its delightful tower capped like a Georgian saltcellar, its wide latticed verandas, its once grassy and befountained courtyard * made it the fashionable center of relaxation for ladies with parasols and gentlemen in white flannels. It was, moreover, a new departure for the fashionable shingle style.

* The grass and fountain have been replaced by a tennis court with a composition surface.

CHARLES F. McKIM, of the firm of McKim, Mead & White, designed this splendid "shingle-style" house for William G. Low in Bristol, R.I., and built it in 1887. It was destroyed as inconvenient and out-of-date in the 1960s. (*Photo Wayne Andrews*)

There is some dispute about which of the partners designed which of the shingle houses, but many of the designs are identified, and it is McKim whose work seems at the same time the most daring and the most successful. The firm built many shingle houses in which the plan had an openness of room flowing into room from a central living hall that was ideally suited to the informality of expensive summer living and a generation later became the standard for inexpensive servantless living. The most successful design of all was McKim's house for W. G. Low in Bristol, Rhode Island (now unfortunately destroyed). A concept surprisingly simple, as simple as a triangle with a wide base and very gradually sloping sides, it was the prototype of much building in the 1940s in the Northwestern part of the country and the very antithesis of the A-frame with its steeply sloping sides which became a roadside cliché in the 1960s.

The work for which the firm was most famous, however, and that which surely inspired Burnham to invite McKim and White to help him design the Columbian Exposition was on a far grander and more formal scale than mere houses of wood. It was palaces that attracted Burnham, and McKim, Mead & White had made them in many sizes for many purposes. For Henry Villard, the magnate of the Northern Pacific, they built a complex of mansions on Madison Avenue just behind Renwick's St. Patrick's Cathedral, a Renaissance palace with distant but unidentifiable ancestors in Rome. For gentlemen in New York, Stanford White had designed the

The so-called "Villard Mansions" (now largely occupied by the Archdiocese of New York) were built for the railroad financier Henry Villard and four of his friends by McKim, Mead & White in 1885. (*Photo Landmarks Preservation Commission of the City of New York*)

Century Club on West 43rd Street and McKim had built the more magnificent University Club on Fifth Avenue. The firm had built a palace for the Pennsylvania Railroad, the vast station on Seventh Avenue, and a palace for culture, the Boston Public Library, ornamented with murals by Sargent and sculptures by Saint-Gaudens. They had built a library for J. Pierpont Morgan on Madison Avenue and 36th Street which Morgan complained was really more McKim's library than his. They had built a palace for sport, the Madison Square Garden, and planned the complex of intellectual palaces at Columbia University, none grander than the Low Library, with Daniel Chester French's ponderous "Alma Mater" on the steps before it, looking a little as though the giantess "Republic" from the Lagoon at Chicago has sat down to rest.

Neither McKim nor White long outlived the century. McKim's most passionate interest became the American Academy in Rome, to the founding of which he devoted his energies and to the perpetuation of which he bequeathed his fortune, which, considering the richness of his clientele and

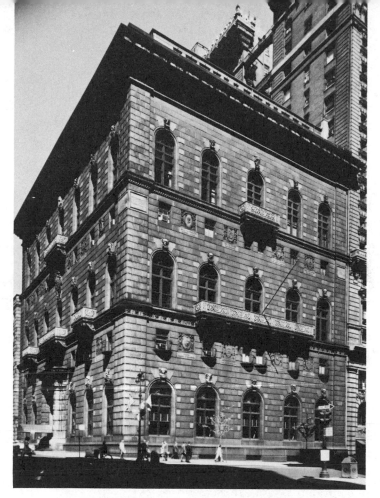

Men's social clubs were often built as Renaissance palaces in the 1890s and none was more stately than McKim, Mead & White's University Club at the corner of Fifth Avenue and 54th Street in New York. It was erected in 1899. (*Photo Wayne Andrews*)

the mountain of work produced by his firm, was not large. He left about $200,000, but he got his client Mr. Morgan interested in the affairs of the Academy, which in many respects was the embodiment of the nineteenth-century art-makers' dream, and he had come forth with the money to get it under way. McKim died in 1909, three years after White was murdered by Harry Thaw at a theatrical performance on the roof of Madison Square Garden. The work of the firm, without losing any of its extravagance or elegance, had turned from a preoccupation with the Italian Renaissance to a glorification of the American Colonial, and white columns ornamented their façades. It had become fashionable for the rich to live less like princes than like country squires in surroundings somewhat less ostentatious on the outside, however many footmen in livery there might be within. Though the

Colonial Revival started before the turn of the century, it is essentially a twentieth-century story, and its origins were scarcely visible at the Columbian Exposition.

SULLIVAN—NOBODY'S MAN BUT HIS OWN

If there was an architectural genius at work at the fair, it was a skeptical, disenchanted, and sharp-tongued member of the Chicago branch of the fraternity, and he refused to play the Renaissance Revival game to which the others, under Hunt's eye, committed themselves. Louis Henri Sullivan was nobody's man but his own. He was not sure, in fact, that he wanted any part in the nonsense in Jackson Park, for he was first of all an idealist and an artist who believed in the perfectibility of man and in the ultimate triumph of truth over trumpery. To him the fair was trumpery.

To many people who do not know what his buildings look like, Louis Sullivan is known as the author of the phrase "form follows function." This aphorism—which sounds like an echo of Greenough's "principle of unflinching adaptation of forms to function" enunciated many years before in his *Travels of a Yankee Stonecutter*—does not in context seem quite as pat as it does in isolation. In *The Autobiography of an Idea* Sullivan wrote (the autobiography is in the third person) :

> He could now, undisturbed, start on the course of practical experimentation he long had in mind, which was to make an architecture that fitted its functions—a realistic architecture based on well defined utilitarian needs—that all practical demands of utility should be paramount as basis of planning and design; that no architectural dictum, or tradition, or superstition, or habit, should stand in the way. He would brush them all aside, regardless of commentators. For his view, his conviction was this: That the architectural art to be of contemporary immediate value must be *plastic*; all senseless conventional rigidity must be taken out of it; it must intelligently serve—it must not suppress. In this wise the forms under his hand would grow naturally out of the needs and express them frankly, and freshly. This meant in his courageous mind that he would put to the test a formula he had evolved, through long contemplation of living things, namely that *form*

follows function, which would mean, in practice, that architecture might again become a living art, if this formula were but adhered to.

He evolved this philosophy of architecture, he said, when he was twenty-five, when he "felt he had arrived at a point where he had a foothold, where he could make a *beginning* in the open world." He had good reason to believe he had a foothold. Dankmar Adler, a Chicago architect with an exceptional knowledge of engineering, took him into partnership in 1880 with full knowledge of the young man's uncommon gifts for invention and his uneasy temperament. For so young a man, Sullivan had gathered to himself a varied training and experience. He had studied at M.I.T. under William R. Ware, who had been one of Hunt's pupils, but left after a year to try to find a job in Philadelphia and succeeded in getting employment with the distinguished Frank Furness, an architect of genuine originality and of a spirit much to Sullivan's taste. The panic of 1873 and the subsequent depression put a sharp crimp in architecture, always one of the first professions to feel the scissors in such circumstances. Out of a job, Sullivan went first to Chicago, where despite the depression there was work, commissioned before the panic, still to be completed, and he worked in the office of Major William Le Baron Jenney, who was responsible for the first steel-skeleton skyscraper but whom Sullivan considered "not an architect except by courtesy of terms." After an uneasy year he took off for Paris and the Beaux-Arts to refine his ideas at what he believed to be "the fountainhead of theory." One year of that was enough for him, and back he came to Chicago, where, he was convinced, lay the future of American architecture. Five years after he had left for Paris his name was painted on the door of the offices occupied by Adler on top of the Borden Block and the new and now famous firm of Adler & Sullivan came into being.

Sullivan was only thirty-three when he and Adler produced a building in Chicago which was a success so spectacular that President Benjamin Harrison, who was present at its opening, turned to his Vice-President and said, "New York surrenders, eh?" It was the Auditorium, an opera house conceived by Ferdinand W. Peck, which he believed should not just be for "grand opera" for the rich but opera for everyone. He chose the firm of Adler & Sullivan because of Adler's reputation for coping with the subtle problems of acoustics, but in Sullivan he got more than he bargained for. The exterior of the Auditorium is not a little in debt to Richardson for the arched simplicity of its walls and its dignified tower, but the auditorium itself is a triumph of pure Sullivan inspiration. Its golden arches sparkled

with Sullivan's extraordinary gift for ornamental design of a richness and invention such as no other American architect had ever produced. Ornament flowed from his pencil with the ease of water from a fountain and with as great variety of pattern where it landed. But the building, except for the luxuriousness of its ornament, was not a hint of the architecture that was to make Sullivan's lasting reputation.

While Root, who, Sullivan thought, "had it in him to be great," and Burnham, who "had it in him to be big," were working on the initial plans for the fair, Sullivan was struggling with the future, not the past. He was worrying the problem of the skyscraper, the building hung on a steel frame, the aesthetics of a new form for a new function with new materials in a new kind of society. "How shall we impart to this sterile pile," he asked himself, "this crude, harsh, brutal agglomeration, this stark, staring exclamation of eternal strife, the graciousness of those higher forms of sensibility and culture that rest on lower and fiercer passions?" Root had almost done it with the Monadnock Building, which Sullivan so admired, but he had had to rely on stone, not on steel, to support his structure. Two years before the fair Sullivan demonstrated with the Wainwright Building in St. Louis that it could be done. Here was a building nine stories high, its height emphasized by vertical brick panels running to the full height of the building with windows and terra-cotta ornamental panels between them. "Here was the 'skyscraper,'" Frank Lloyd Wright, Sullivan's pupil, wrote many years later, "a new thing beneath the sun, entity imperfect, but with virtue, individuality, beauty all its own. Until Louis Sullivan showed the way, high buildings lacked unity. They were built up in layers. All were fighting height instead of gracefully and honestly accepting it." Wright said, "This was a tall building born tall."

The Transportation Building that Sullivan designed for the fair was not one of those on the Court of Honor, though that was no reflection on its architect. It faced a lagoon that a contemporary critic said "invited a picturesque and irregular architecture." Sullivan's building was not in the eclectic throwback style prescribed by Hunt, and instead of treating staff and plaster as though they were meant to look like stone, Sullivan used the materials for what they were. Montgomery Schuyler in the *Architectural Record* the year after the fair said, "It is the most ambitious of all the great buildings, for it was nothing less than an attempt to create a plaster architecture." To give life to staff, Sullivan made a portal of semicircular arches one within another, glittering with gold leaf, and he painted the outside walls of his vast building in a variety of colors. The portal, the famous "Golden Doorway," was one of the most astonishing sights at the

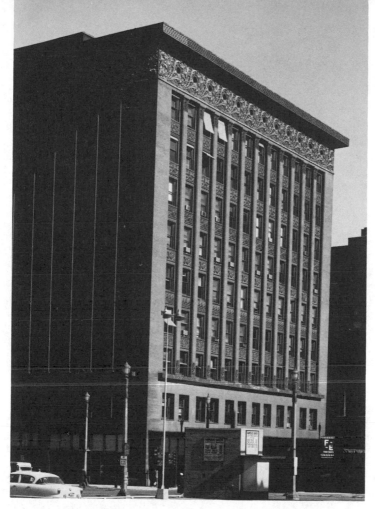

Frank Lloyd Wright called Louis SULLIVAN's very early sky-
scraper, the Wainwright Building in St. Louis, Mo. (1890–91),
"a new thing under the sun. . . . This was a building born tall."
(*Photo Richard Nickel*)

fair, and there was some resentment on the part of some of the other
architects at Sullivan's abandoning the pattern in favor of an experiment
of his own.

He never stopped experimenting, but after the fair his life became
increasingly difficult. Before the year 1893 was out, there was a new finan-
cial panic; banks failed at an appalling rate, 491 of them in a year, and it
was reported that more than 15,000 commercial institutions had gone
under. Adler & Sullivan had to let many of their draftsmen go as the work
in the office came to a near standstill. Finally Adler himself gave up and
took a job at a handsome salary with the Crane plumbing company, and
Sullivan—an artist and not, like Adler, an operator—found himself at sea,

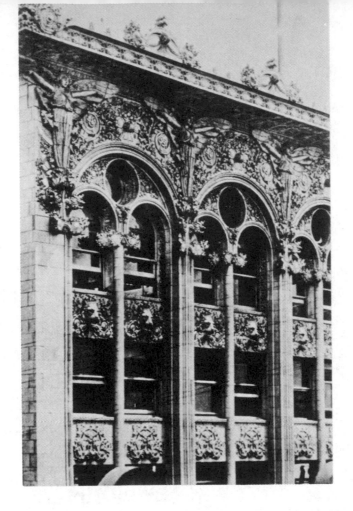

LOUIS SULLIVAN, a master of ornament as well as of structure, built only one building in New York, the Bayard Building (now the Condict Building) on Bleecker Street in 1897–99. The cornice and supporting angels are of terra cotta. (*Photo Landmarks Preservation Commission of the City of New York*)

so to speak, without a rudder. Big commissions for skyscrapers like the Prudential Building in Buffalo and the Condict Building in New York, for great stores like the gloriously ornamented Carson, Pirie, Scott & Co. in Chicago, gave way to smaller jobs after the turn of the century, but the quality of his imagination never faltered, and the banks he did in small cities of the Middle West are among the greatest of his works—in Owatonna, Minnesota, in Sidney, Ohio, in Grinnell, Iowa. But they take us beyond the end of our story. Sullivan was a twentieth-century architect even when he was at the height of his powers in the nineteenth century, a

one-man aesthetic watershed who changed once and for all the course of the art he practiced.

The change was a long time coming. If Sullivan in the end won the war of styles, Hunt and his battalions won a smashing victory at the battle of Chicago, one that held the public imagination for years, put white columns on all manner of public buildings from banks to railroad stations, and made "adaptation" the credo of nearly all successful architects.

THE STATUE BUSINESS

What the fair did for architecture it did in the same breath for sculpture. The architecture of the Beaux-Arts cried aloud for sculptural ornament, for pediments crowded with symbolic figures, for groups to stand on great pedestals to guard not just the entrances to libraries and customs houses but the approaches to bridges. Thanks to the architects, sculpture became big business, and though there seems to have been a great deal of back-slapping and mutual admiration among the practitioners, there was also a good deal of intense infighting for the big commissions. Saint-Gaudens and French had all the jobs they could manage, and in French's case many more than he could execute except hastily, which he did not hesitate to do.

Haste, indeed, was a prime asset to the sculptors of the fair and their successors in the rapid creation of sculptural ornament. The situation at the fair, where the sculpture was made of staff by large crews, was one thing; turning out similar groups in stone was a quite different matter. How could Karl Bitter have turned out his twenty-two groups to ornament the Administration Building of the fair without haste? Or, more important, without crews of workers? He had eight sculptors building statues of staff on wood-and-iron armatures in a section of the Forestry Building which was set aside for them. French had a good many more than that working on his "Republic" and the "Columbus Chariot." The colossal figure was made in layers, also in Forestry Hall, and when the layers, each about ten feet high, were finished, they were piled one on top of another on the pedestal in the Lagoon. Mrs. French in her book *Memories of a Sculptor's Wife* recalled that where French and Potter were making the chariot piece with "the attendant figures of girls and pages" they shut off a corner of the improvised studio from public view because "here the models came and posed for

them, some in Greek draperies and sometimes, I imagine, without draper-ies." Her husband discovered, she said, "that the workmen outside were making holes in the plaster walls of the studio—pinholes on the inside, but large enough on the outside to accommodate a human eye, and allow the curious to gaze upon the mysteries of studio life!" It was Burnham who, not apropos of the fair but later when he was trying to get acceptance for his plan for Chicago, said, "Make no little plans. They have no magic to stir men's blood." The sculptors were making no little sculptures and their scale did indeed have the magic to stir men's blood in the White City.

The lessons of the fair were carried by sculpture-makers into practice on all manner of other commissions, but there was one obvious difference. What they made for a library or a railroad station or a federal office or a park monument had to be in a permanent material, and the truth of the matter was that none, or almost none, of those highly paid art-makers knew the first thing about cutting stone. That, however, did not deter them; there were imported craftsmen from Italy ready to take on the jobs, most notably the New York firm of the Piccirilli Brothers, which sometimes had as many as fifty stonecutters making big marbles out of small casts with the aid of the most accurate pointing machines. Ten years after the fair about a third of the cost of a piece of sculpture was paid by its designer to the stonecut-ters. If the price of a portrait figure was $25,000 (which was about the standard), the Piccirillis got between $7,000 and $10,000, depending on how intricate a job was called for.

"A sculptor with these big jobs hasn't got time to carve," Hermon McNeil, one of the young sculptors who worked on the Electricity Building at the fair, said some years later. "I learned in Paris, years ago, and once carved a head of my wife. But that's about all. It isn't so much the model that takes the time. It's the politics."

It was inevitable, with so much demand for sculpture, that the men who made it would find themselves locked in politics, in competition and price cutting, and they resolved this difficulty by forming the National Sculpture Society. It came into being within a month after the opening of the Chicago fair; Saint-Gaudens, J. Q. A. Ward, French, Olin Warner, and several other sculptors were on its board, along with representatives of the architec-tural profession, including Hunt and Stanford White, and several laymen and amateurs and manufacturers. Its purpose, according to a report in *The New York Times* on May 31, 1893, was

> to spread knowledge of good sculpture, foster the taste for, and encourage the production of, ideal sculpture for the household, promote the decoration of public bldgs., squares, and parks with

sculpture of a high class, improve the quality of the sculptor's art as applied to industries, and provide from time to time for exhibitions of sculpture and objects of industrial art.

It was a tight little group and powerful. It was also tight-minded and sure that it had all the answers to what sculpture should and could be. It was natural that it should keep a close grasp on sculpture commissions and see that its members got the prize jobs dealt out within the society with something for everybody. It was also inevitable that it would come eventually to represent the most reactionary elements of the art-makers and cry loudest when the winds of sophisticated taste shifted in the early years of the twentieth century.

Between the Columbian Exposition, however, and the earthquake that shook the art world of America in 1913 when the Armory Show opened in New York, there was time for the Beaux-Arts sculptors to have it all their own way. Out of the fair came new reputations, and new names were prominent when the decorations of the Pan American Exposition were installed at Buffalo in 1901 and at the great fair at St. Louis ("Meet Me in St. Louis, Louis") in 1904, a glorious dream city that really put the cap on the nineteenth-century bottle of architectual and sculptural foam and fizz. Bitter, who had done the sculptures for Hunt's Administration Building at Chicago, was in charge of sculpture at both Buffalo and St. Louis. His "Standard Bearers" at Buffalo had been called "the finest pieces of exposition sculpture ever executed," and his reputation for efficiency readily equaled that of his prowess as an art-maker. To get the mass of sculpture finished for the St. Louis fair he rented an Erie Railroad roundhouse at Weehawken, New Jersey, and had the sculptors deliver their small models there. A crew of workmen made them large as life or colossal in size under Bitter's supervision, and they were loaded on flatcars and shipped to St. Louis, to the astonishment of those who saw their progress by rail across country.

One of the sculptors who had done two groups to ornament the Buffalo Fair was a young man named George Grey Barnard. He had made a sudden reputation in 1894, when he was only thirty-one, with the exhibition of a marble of two figures called "The Two Natures of Man" at the Salon in Paris. Not only were the public and the press in Paris impressed, but so was the great Auguste Rodin, and it is not difficult to understand why. The "Two Natures," the theme of which came from Victor Hugo's "*Je sens deux hommes en moi,*" is a piece of vigorous sculpture, boldly modeled, filled with arrested power, and, in spite of its title, it is a piece conceived as sculpture and not as anecdote. It is, indeed, one of the most thoroughly sculptural

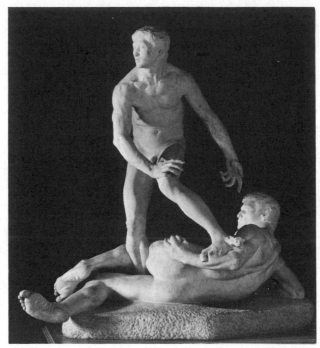

"I was only twenty-one or twenty-two when I did that,"
GEORGE GREY BARNARD said of his "Two Natures of
Man," which he modeled in clay in 1889. The marble
version was finished five years later and stands 101½
inches tall. (*The Metropolitan Museum of Art, Gift of
Alfred Corning Clark, 1896*)

pieces made by any American in the nineteenth century and ranks with, if it
does not surpass, the tortured figures of the strange Dr. Rimmer. Barnard's
story, however, belongs to this century; he was not a note in the swan song
of the nineteenth but a slightly premature trumpet at the beginning of the
twentieth.

A PALACE FOR ART

Saint-Gaudens, a man with a taste for superlatives, declared that he
thought the Art Palace at the White City "unequaled since the Parthenon."
It was the work of Charles Atwood, a man of flashing facility of pencil
whom Burnham had taken on to replace Root and who was responsible for

the design of sixty buildings at the fair. The Art Palace provided some five acres of galleries and was, as one observer called it, "a noble sermon in architecture." But what was in it stirred the observer even more—"the most important as well as the most extensive display of contemporaneous art that has yet been seen in any country," and he did not exclude the Paris Exposition of 1889. By comparison, the Centennial Exhibition's Memorial Hall was peanuts with its mere 70,000 square feet of wall space; Chicago boasted (and the word is used literally) 145,852 square feet! Indeed, the authors of *The World's Fair as Seen in One Hundred Days* so looked down on the sensibilities of the generation which preceded them that they felt impelled to say "there was scarcely any American art to speak of" at the time of the Centennial. Now the White City offered not just to Americans but to foreign visitors from all over the world a chance to measure American artists against the cream (or whatever it was that had risen to the top of official taste) of the art of all other major countries. Here were the works of the most highly respected and respectable artists of France, England, Germany, Holland, Russia, Spain, Belgium, Italy, Austria, Norway, Sweden, Japan, Denmark, and Mexico to compare with the masters of America. A few celebrated Americans were missing (including Frederic E. Church and Albert Bierstadt), but there were plenty to make up for their absence. Here was George Inness, "a thoroughly American painter" according to the guidebook if not according to fact. Here were Eastman Johnson, James A. McNeill Whistler, John Singer Sargent, and—equally "recognized the world over" and now all but forgotten—W. T. Dannat and Alexander Harrison. Abbott H. Thayer was represented by several works, but most notably by his "superb 'Virgin Enthroned,' " which had been proclaimed by Thayer's peers in New York "the best work yet produced by an American artist." There were works by George de Forest Brush, by Winslow Homer and John La Farge, by Gari Melchers and William Merritt Chase. Eakins, whose "Gross Clinic" had been relegated to the medical display at the Centennial, was recognized as an artist in Chicago by the inclusion of his "Agnew Clinic." There were also works by illustrators like Frederic Remington, A. B. Frost, and Edwin Abbey.

The art from Europe with which the visitor might compare the Americans in the Art Palace show was not the art by which we now judge the nineteenth-century accomplishments of France, most notably, and her neighbors. There were no pictures by Daumier or Degas or Courbet or even Corot in the official representation of France. Among what were billed as the "Triumphs of French Art" were works by James Tissot, Bonnat, and Jules Breton. Gérôme was there with a few old favorites and so was Duez.

From England were luminaries like Sir Frederick Leighton, the president of the Royal Academy, and Sir John Millais, whose boy with a bubble pipe was greatly admired, George Frederic Watts (most famous for his "Sir Galahad," which hung in photographic reproduction in many American parlors) and Alma-Tadema. In other words, what came from abroad came with the stamp of approval of academies, of the officialdom of the arts, which is, of course, not surprising. It was a time when the affairs of art-makers were in the grip of their own self-created bureaucracies while the rebels were either thumbing their noses at the academies or quietly pursuing their Muses into as yet unexplored aesthetic territories.

The American paintings at the fair were not, however, merely put in heavy gold frames and hung molding to molding on the walls of the Art Palace. Frank Millet's wall decorators were covering still more acres of canvas with vast if not precisely stirring murals. He was the kind of gregarious and friendly man who could get anybody to do anything he wanted done. He had been a drummer boy in the Civil War, a newspaper correspondent in London and America; "democratic to the last degree," Burnham's biographer said of him, "and with a heart that vibrated in sympathy with every person in distress. . . . There was no person however exalted and no person however humble who did not respond to his genial humor." He was just the man to get the walls covered at what must have seemed to the painters breathtaking speed. But they were a clever lot and facile even if they included no Tiepolos or even La Farges. Alden Weir and Kenyon Cox, Gari Melchers, Walter MacEwen and Walter Shirlaw, and dozens of others climbed on ladders and scaffolds to fill canvases with somewhat vacant figures in the best Beaux-Arts tradition of mural painting, a tradition that continued until nearly forty years after the White City, along with the murals that decorated it, had vanished.

A by-product of the fair (though those who made it possible thought it no by-product but a major assault on the bastion of male supremacy) was the liberation, in a manner of speaking, of women artists. Mrs. Potter Palmer, wife of the owner of the famous Palmer House hotel, was a power to be reckoned with in Chicago, a woman of commanding presence, considerable beauty, intelligence, and social ambition with the wealth to realize it. She was also a patron of the arts—indeed, the most important patron of the arts away from the Eastern Seaboard in the 1890s, or, in any event, the most highly visible one. It was she who took command of the "Lady Managers" (they didn't like the name; it smacked, they said, of "saleslady" and "forelady") who rallied the support of "women of push and energy all over the country." They made it quite clear that their pavilion was going to show

once and for all that women were quite as capable as men of dealing with large projects. They insisted on having a woman architect to design their building, and the competition for it was won by a twenty-two-year-old young lady from Boston, Miss Sophia G. Hayden, "a modest girl of such retiring appearance that architecture is the last thing one would think her guilty of." She was, however, a graduate of the Massachusetts Institute of Technology. A surprising number of women competed for the prize offered for the best design, and most of them were under twenty-five. Miss Hayden's design was suitably in the Renaissance style and hence compatible with Hunt's dictum. Her plan was rewarded with $1,000 and fleeting fame.

A collaborator on the decoration of the building, however, was Mary Cassatt, Mrs. Potter's friend and adviser on what pictures to collect. Mrs. Potter persuaded her to paint a decorated panel fourteen feet high and fifty-eight feet long. She also persuaded Mrs. MacMonnies, the wife of the sculptor who did the fountain in front of the Administration Building, to execute a similar panel. Unlike Harriet Hosmer, the sculptor who so shocked Roman society with her independence many years before, Miss Cassatt was unwilling to risk climbing on a scaffolding; instead she had a glass-roofed building constructed and a trench dug in it so that the canvas could be lowered into the ground when she wished to work on its upper portion.*

Miss Cassatt's painting in three sections, "surrounded by a border of deep blue medallions on which [were] exquisitely painted nude figures of a myriad of children," had as its subject the "state of modern woman." Allegorically speaking, that is. Some were chasing "something dim and elusive and mysterious in the shadowy distance," some were in an orchard tasting "the rosy ripened fruit of the tree of knowledge," and some were making a "half-playful declaration of independence" by pulling up their skirts. Mrs. MacMonnies, on the other hand, represented "primitive women" in what was described as an "Egyptian effect." There were also paintings by other American ladies, and Queen Victoria honored the pavilion by contributing six watercolors by her own royal hand as well as a straw hat "beaded and sewed by herself."

The decorative arts at the White City were everywhere. As they had been at the Centennial Exhibition, they were known as "art manufactures," and in the pavilions of each country were proudly displayed the works of cabinetmakers and furniture manufacturers, of silversmiths, glassblowers

* The whereabouts of these two panels and several other side panels made to ornament the Women's Building does not seem to be known.

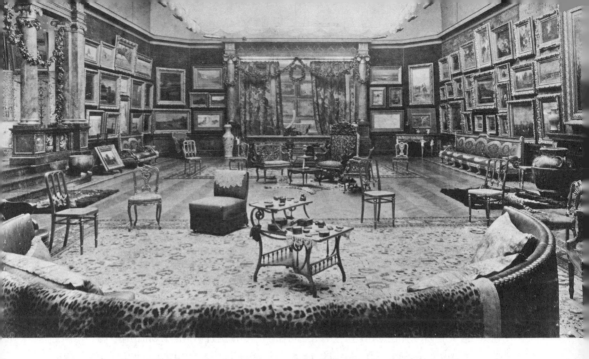

In Chicago in 1892 Mrs. Potter Palmer hung her collection, partly assembled with the help of her friend Mary Cassatt, in the picture gallery of her famous "castle." It was fashionable in the last decades of the century to hang pictures in tiers.

The rich in the 1890s liked their interiors exotic and cluttered with furniture and bibelots from far places. This "grand drawing room" was in the house of Mme. de Barrios at 855 Fifth Avenue in New York. (*Photo by Byron, the Byron Collection, Museum of the City of New York*)

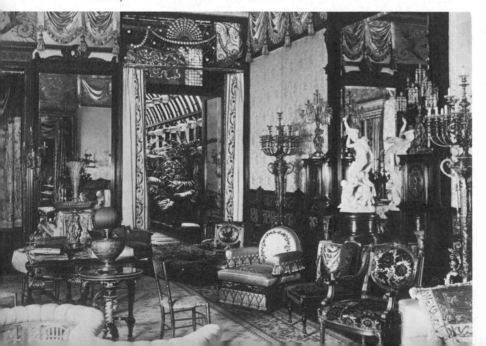

and cutters and molders, makers of lamps and of china and pottery. The skyrocket that Eastlake had sent into the firmament of taste about twenty years before had long since burst and scattered its stars across the landscape, with one little flame sputtering in almost every household. The enthusiasm for the "sincere" and the "moral" in bookcases and chairs and beds and the tiles around fireplaces had dimmed. The peacocks that once had strutted on the lawns of mansions had been stuffed and put on the newel posts of staircases ornamented with elaborate screens of wooden spindles. Stained glass let in mottled flickers of amber and mauve and emerald and ruby to play on the stair landings or the sideboards and Oriental rugs in the dining room, or to reflect upward to the high plate rail on which stood brass salvers and Oriental platters. It was a time when the very rich ordered brand-new copies of antique furniture from Europe, great Renaissance tables and benches and high-backed chairs, all carved anew possibly because they did not want things that were secondhand. The slightly less well-off had a taste for French and Italian importations of modern manufacture— lamps and candelabra, urns and clocks, and table bells, "embracing the usual goddesses, cupids, fauns, and satyrs." And there were new kinds of lamps designed specifically for electricity. The French pavilion featured a "figure of 'Spring' holding aloft a garland of flowers in the calyxes of which the bulbs are concealed." There was also an electric lighting fixture of "three cherubs racing . . . exquisite in old bronze, each figure holding in outstretched hands incandescent globes."

There was, however, one extremely distinguished maker of decorative arts to represent America at the fair, though what he exhibited there was scarcely domestic in nature. Louis Comfort Tiffany, the son of the famous jeweler, was represented in the American exhibition of paintings in the Art Palace by five canvases, but his contribution to the fair that caused the greatest comment was a "Byzantine Chapel" which he designed and had made in his glass studios and which was displayed in the Manufactures and Liberal Arts building. It attracted almost as much attention and praise, especially from foreign visitors, as Louis Sullivan's "Golden Doorway" to the Transportation Building. It was lavish and mysterious, an encrusted composition of iridescent glass mosaic, of peacocks and vine scrolls in blues and greens, lighted darkly through twelve stained-glass windows and by what Tiffany's biographer describes as "an elaborate cruciform bejeweled sanctuary lamp . . . suspended in the center of the domelike space." *

* The chapel was presented to the Cathedral of St. John the Divine in New York and was used for services for many years in the crypt until the main choir was completed in 1911. Tiffany repossessed it in 1916 and moved it to his Long Island house. It is now at Rollins College in Winter Park, Florida.

Louis Tiffany, whose name persists in the language as the maker of Tiffany Glass, was, like Louis Sullivan, a man of both the nineteenth and the twentieth centuries, a bridge between the spirit-of-crafts movement of which the English designer William Morris was the spiritual father (and of whom Eastlake was a disciple) and the mass-production spirit of the twentieth century. Unlike Sullivan, Tiffany was an astute businessman and promoter, and he was already well established by the time of the Chicago fair. He was born in 1848 and had made a reputation as a painter before he turned to the decorative arts. He had a taste for the exotic (he had spent a good deal of time painting in Morocco), a talent for the flamboyant, and a gift for extravagance, and anything he put his hand to was both a reflection of the advanced taste of his day and an exaggeration of it. As a decorator he espoused the Oriental and the North African and the Middle Eastern (so did the *Ladies' Home Journal*) and his houses were escapes into romantic retreats hung with chains and brass lamps, with Oriental rugs and spears. With the aid of a German chemist he invented a formula for an iridescent glass of remarkable subtlety which he named "Favrile" and which made him famous. With it his studio fashioned not only vases and wineglasses and bowls and a great variety of subtly designed small objects, but also leaded-glass lampshades (the elegant prototype for all sorts of currently chic bits of inelegant camp) and stained-glass windows for churches and houses.

His involvement with the Chicago fair came about through his friendship with a Paris dealer in art named S. Bing. (There is some doubt as to whether the *S.* stood for Samuel or Siegfried, and Bing carefully would not say, as he was avoiding both the anti-Semitism and the anti-German sentiments that followed the Franco-Prussian War.) The French government had sent Bing to America to survey the state of architecture and the decorative arts in this country, and Tiffany had entertained him with an open hand. Bing was the blossom about which the busy bees of the new taste for Oriental art buzzed in Paris, and his shop was a center for artists, who came and pored over his importations of artifacts and prints, especially those from Japan. Van Gogh came there, and Sarah Bernhardt, and the critic and collector Edmond de Goncourt. Bing has been called the father of Art Nouveau, and surely Tiffany became the foremost protagonist of the style in America.

It was Bing who suggested to Tiffany that being represented only by paintings in the Art Palace did not do him justice and urged on him the creation of the chapel, which was shown in New York before being installed in the area reserved by Tiffany & Company, Jewelers. The suggestion

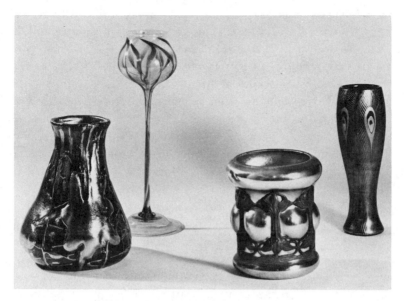

LOUIS COMFORT TIFFANY was the principal exponent of Art Nouveau in America. These four exceptionally fine pieces of "Favrile" glass are, from left to right, a Volcano, or Lava, glass vase; a Flower Form wineglass; a gold glass vase with bronze overlay; and a Peacock Feather vase. The tallest is 11½ inches high, the smallest 5⅞ inches. (*Collection of Mr. and Mrs. Samuel B. Feld, New York City*)

served Tiffany well: it especially served to publicize his stained-glass windows, which, he claimed, were the most advanced in technique of any that had ever been made. "That our knowledge of glass is greater than the past cannot be denied," he wrote without credit to La Farge. "Our range of color is far in excess of the palette of the 13th century. The mechanical contrivances that are used in the construction of windows and in preparing the leads are greater in number than those at the command of the medieval glazier." Here was a good, forthright statement of the nineteenth-century belief in the marriage of industry and art, of technical proficiency in production and the high aesthetic. It was, furthermore, the basis of Tiffany's fortune, for this eccentric and outgoing man turned the mass production of art objects from his studios (if mass production can be equated with handicrafts turned out by the thousand) into a very considerable financial success, the legacy of which still today, through the Tiffany Foundation, provides fellowships for artists to study abroad.

Tiffany lived until 1933, by which time, though his name was legendary, his glass was out of fashion. When he was eighteen he had declared to his family, who hoped he would carry on the jewelry business, that he was

going to be an artist, and he spent long hours in the studio of George Inness watching the landscapist at work. Inness took him as his only pupil, but he is said to have declared, "The more I teach him, the less he knows, and the older he grows, the farther he is from what he ought to be." His tastes were far from the poetic landscapes of his teacher; he liked things vivid and strange. When he was only nineteen he had a picture accepted for exhibition at the National Academy of Design; at twenty-one he was the youngest man ever to be elected a member of the Century Club; at twenty-three he was an associate of the Academy; and, having exhibited at the Centennial Exposition in Philadelphia when he was thirty-two, he was elected to full membership in the Academy at thirty-six. He had shocked critics with a grubby New York street scene as early as 1875, a precursor of the scenes painted by the so-called Ashcan School some thirty years later. His paintings of romantic scenes in exotic places, his snake charmers and marketplaces, look thin and only moderately talented today, but they were surprising, as were his decorative talents, in the 1870s and '80s. His lasting reputation was based on the decorative output of the Tiffany Studios. He worked with architects, perhaps most notably Stanford White, in the ornamentation of houses. He worked with Candace Wheeler, a writer on taste who was the first to encourage women to take up the profession of interior decoration. (It was she who was the "color director" for the Women's Building at the White City and who in the 1870s had organized the Society of the Decorative Arts in New York "to encourage profitable industries among women" and use what she believed to be their natural gifts for tasteful decorative schemes and objects.) Tiffany designed rooms for the Vanderbilts and the Goelets and was even called in to redecorate the White House for President Arthur, who, when elected, refused to move in until something was done to clean up and refurbish the mansion even if he had to pay for it himself. Candace Wheeler and Tiffany worked together, and they had twenty-four loads of furniture hauled away and sold at auction. Miss Wheeler was in charge of draperies and Tiffany built an opalescent glass screen. "Reaching from floor to ceiling, it was placed in the first-floor hall to provide more privacy for the President's family." It did not, however, long survive. Theodore Roosevelt, when he moved in, had his architect, McKim, get rid of it.

A good deal of what Tiffany wrought was got rid of, or at least whisked out of sight onto cupboard shelves and into attics, when the turn of the tide of taste came shortly after the beginning of this century. The Art Nouveau that made such a splash in Europe in the first decade of the 1900s caused, by comparison, only a slight ripple in America, though it is easy to judge how chic it was from the number of advertisements which used its

clichés of flowing plant forms, and iris and lilies and women with billowy tresses, in their layouts. The popular new style in America was the style set by the White City at its most neo-classical. It was the memory of columns and massive statues and pediments and volutes that the visitors took home with them as the doctrine of all that was artistic and beautiful; it was not the "Golden Doorway" of Sullivan or the "Byzantine Chapel" of Tiffany.

The Columbian Exposition closed with a hush. Two days before its gates were to shut for good on October 30, Mayor Carter Harrison of Chicago was assassinated in his own house, and what was to have been a celebration of a magnificent spectacle accomplished became something close to a wake. "On the closing day the weather-stained banners were pulled down almost in silence," wrote a historian of the fair. "At five o'clock there was a little puff of smoke from the United States steamer *Michigan,* which lay at anchor off the grounds. Twenty more peals followed. All the flags had been at half-mast; but when the twenty-first gun was fired they were pulled simultaneously to the flagstaff's peak, and, after fluttering there for a moment, as if in farewell, they went down for the last time." Only the American flag continued to fly over the almost deserted palaces of Jackson Park.

The fair left the public exhilarated, if footsore. Chicagoans were convinced that they had displayed their prowess and their promise of future greatness to the world. But by no means everyone was sanguine about what the residue of the fair might be, however much pleasure and instruction it had given to the 23,500,000 visitors who had inspected its wonders. The post-mortems—and they were many and thoughtful—ranged, so far as the arts were concerned, from self-satisfaction to gloom.

Burnham, whose reputation was on the line, was satisfied that what he had brought into being was, on the whole, good. He believed that the art of architecture had been saved from itself. "The influence of the Exposition on architecture," he said, "will be to inspire a reversion toward the pure ideal of the ancients. We have been in an inventive period, and have had rather contempt for the classics. . . . The intellectual reflex of the Exposition will be shown in a demand for better architecture, and designers will be obliged to abandon their incoherent originalities, and study the ancient masters of building." It is possible that he had Louis Sullivan in mind when he spoke of "incoherent originalities," but it is more likely that he was looking back at the fantasies of architecture, the babel of styles, which followed the Civil War. He concluded, "The people have the vision before them here, and words cannot efface it."

Words did indeed not efface it, but there were many that challenged it,

and many that merely quibbled about it. Montgomery Schuyler, an eminent critic of architecture, thought that it had for its "temporary and spectacular purposes" been a success "admired by all the world." He scolded the critics: "To quarrel with the incredibilities . . . is to show not only a hopelessly prosaic but a hopelessly pedantic spirit." The basic landscape plan of Olmsted and Codman "was the key to the pictorial success of the Fair as a whole," but it was magnitude that made its impression unique. Schuyler was not worried about whether it was "American" or not. How could it be American and create such an illusion? "It is a seaport on the coast of Bohemia," he said. "It is the capital of No Man's Land."

No Man's Land? Not to everyone. Richard Watson Gilder, the editor of *Century* magazine, found the ancient world on the shores of Lake Michigan. He wrote:

> Say not, "Greece is no more."
> Through the clear morn
> On light wings borne
> Her white-winged soul sinks on the New World's breast.
> Ah! Happy West—
> Greece flowers anew, and all her temples soar!

To Louis Sullivan this kind of sentiment was the most arrant nonsense, and in his autobiography he let fly at the way the American public had been duped. "The crowds were astonished," he wrote. "They beheld what was for them an amazing revelation of the architectural art. . . . To them it was a veritable Apocalypse, a message inspired from on high. . . . Thus they departed joyously, carriers of contagion, unaware that what they beheld and believed to be true was to prove, in historic fact, a calamity." The disease was a belief in the rightness of ancient ideas for a new kind of industrial society. "Thus architecture died in the land of the free and the home of the brave," he wrote, "in a land declaring its fervid democracy, its inventiveness, its resourcefulness, its unique daring, enterprise and progress. . . . The damage wrought by the World's Fair will last for half a century from its date, if not longer."

He was not far wrong in his estimate. Across the continent great railroad stations, libraries, state capitols, business buildings, museums, and memorials to heroes rose in the quasi-classic spirit and style of the impermanent palaces of the Court of Honor to squat as the permanent residue of the fair. Look almost anywhere; they have become a part of the landscape. . . . Burnham's railroad station in Washington, but also the National Gallery of

Art, erected almost half a century after the fair, the New York Public Library, the Boston Library, the Jefferson Memorial and that last gasp of the Greek Revival, the Lincoln Memorial, primarily impressive, like the White City, for its "magnitude."

Was this what America was about? Was this what it wanted to become? Henry Adams wondered. "The exposition itself defied philosophy," he wrote in *The Education of Henry Adams*, and he sought earnestly to find an explanation.

> Here was a breach of continuity—a rupture in historical sequence! Was it real or only apparent? One's personal universe hung on the answer, for, if the rupture was real and the new American world could take this sharp and conscious twist towards ideals, one's personal friends would come in, at last, as winners in the great American chariot-race for fame. If the people of the Northwest actually knew what was good when they saw it, they would some day talk about Hunt and Richardson, La Farge and St. Gaudens, Burnham and McKim, and Stanford White when their politicians and millionaires were otherwise forgotten. The artists and architects who had done the work offered little encouragement to hope it; they talked freely enough, but not in terms that one cared to quote; and to them the Northwest refused to look artistic. They talked as though they worked only for themselves, as though art, to the Western people, was a stage decoration, a diamond shirt-stud, a paper collar. . . .

Here was Henry Tuckerman's dream come true. Here in spades was what years before he had said the young nation was too busy with practical concerns, with commerce, with expansion, with industrial growth, with "utility," to realize. Here finally, whatever it said about America that puzzled Henry Adams and to which he could find no answers, was the art-makers' answer. Here at last in all its brilliance (and impermanence) was "the superstructure of the beautiful."

15

A POINT OF ARRIVAL

"The lights flashed, the crowds sang, the sirens of craft in the harbor screeched and roared, bells pealed, bombs thundered, rockets blazed skyward, and the new Century made its triumphant entry."

The New York Times,
January 1, 1900

The last decade of the century was less a waning of old ideas than the waxing of new ones. What had been wrought at the Columbian Exposition was, in some respects, a grand climax to a century of national struggle to become a major power in the world, and it lingered on as a symbol. The land mass of the continent had been conquered (if not entirely tamed) and tied together with thousands of miles of steel. Steam and gas and electricity had become household servants and public servants. Everything but the once untrammeled landscape had got bigger; land had shrunk as cities sprawled across farms, as forests had been laid waste to make tillable soil and lumber for balloon-frame houses, some trimmed with wooden ornament cut into frills with the scroll saw. The "business block" of brick or brownstone was being replaced by nine- and ten-story skyscrapers, palaces of commerce to match the palaces in which those who manipulated money and men and mergers dined with footmen standing behind their Renaissance chairs. State legislators, like federal legislators, conducted their deliberations beneath vast domes, some of thm gilded and topped with bronze maidens depicting

the civic virtues. Even the arts now lived in palaces (if artists did not). By 1900 there was scarcely a major city that did not boast a massive and dignified structure called a museum of art. New York and Boston had had theirs for nearly thirty years. The first city away from the Eastern Seaboard to build an art museum was Cincinnati, quickly followed by St. Louis and San Francisco and a little later by Chicago and Pittsburgh and Milwaukee. Cities that did not have museums had "Art Associations" for the promotion of cultural interests among the ladies (primarily) of the community. Nashville, Tennessee, had such an organization, as did Denver, Colorado, and Jacksonville, Illinois. There was no question that the arts had establishd a claim on the public conscience or that there was a considerable degree of smugness among those who planted the seeds and watered the garden of culture. The White City had helped. A great many people who did not pretend to know anything about art when they arrived at the fair were convinced when they left that they did.

One of the things they were convinced about was that, compared with Europe, America was something of a cultural backwater, and the rich supported this theory. Few wealthy collectors, as we have seen, thought that American paintings were good enough (or, more likely, fashionable enough, since their standards for judging art were less acute than their eye for what was modish) to hang on their damask walls. Furthermore, the very architecture of the White City was European in inspiration if not in execution. It was the Beaux-Arts that blossomed on the shores of Lake Michigan, not anything even remotely indigenous except possibly the work of the eccentric Mr. Sullivan. Even the carloads of impermanent sculpture were secondhand European. While this made little or no difference to most Americans, who were quite content to be told what was art and what was not, it was a matter of crucial importance to the art-makers and especially those who were just setting out on their careers.

Centuries do not come in tidy packages, though for storing (and restoring) the past they are nearly indispensable. Even if one lops off the extremities, Procrustes fashion, the body with its vital organs and, indeed, its personality remains intact. In my judgment, the nineteenth century ended with the Columbian Exposition, though, as Louis Sullivan said it would, the shadow of the White City lay over American architecture for the next fifty years. The art-makers who as young men were working in the dying days of the century belong more properly to the twentieth—men like the remarkable Frank Lloyd Wright, who worked as a draftsman for Adler and Sullivan and who, though he opened his own office in 1893, did not hit his stride until after 1900. There was Gustave Stickley, who fiercely pro-

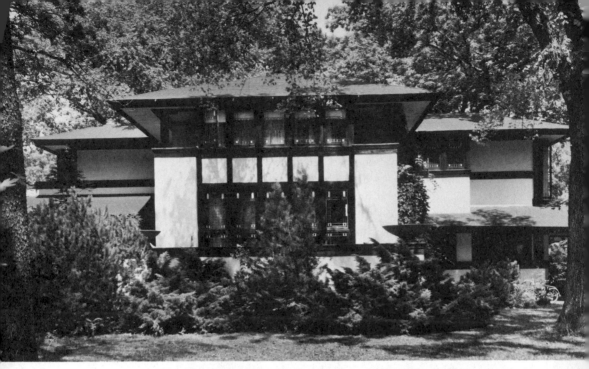

FRANK LLOYD WRIGHT, who was thirty-one when the nineteenth century ended, was just beginning to hit his stride. He designed this early, but characteristic, house in Highland Park, Ill., for Ward W. Willitts, and it was built in 1902. (*Photo Wayne Andrews*)

moted the crafts movement that sprang from the doctrines of Ruskin and William Morris (and of which Eastlake was a by-blow). He was making furniture in the most "sincere" possible way in the 1890s, but his pronounced influence on the looks of America, indoors and out, came in the first decade of the twentieth century. It was he who was responsible for the foursquare and almost indestructible furniture known as "Mission" and the proliferation of the "bungalow." It became the ranch house of its day and, in the hands of architects like Greene & Greene of California, genuine architecture.

It was also in the last years of the century that the profession of interior decorator came into its own. Until then it had been in the hands of upholsterers who also acted as advisers on how to decorate. Candace Wheeler in the *Outlook* in the 1880s had first promoted the idea in an article called "Interior Decoration as a Profession for Women," and the spectacular Elsie de Wolfe, who liked to stand on her head to impress her guests, made a fortune as "America's first woman decorator." But here, again, it was not until this century that interior decoration (now called interior design) really got professional recognition. To be sure, a few of the rich had enjoyed the talents of Stanford White and Louis Tiffany as designers

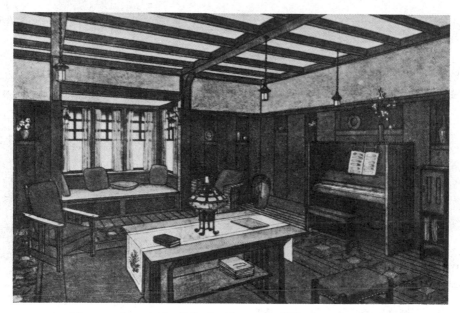

The prophet of the "Crafts Movement" in America in the 1890s and early 1900s, GUSTAVE STICKLEY, published this "Mission" interior in *Craftsman Homes* in 1909. It was his answer to Victorian clutter. (*Collection of the author*)

of their interiors, but these were few indeed.

The nineties also witnessed the burgeoning of American Impressionism. William Merritt Chase had been called an Impressionist and his work was known in New York in the 1880s, and in 1888 Theodore Robinson came back from Paris to New York and showed at the Society of American Artists a large group of paintings that were obviously influenced by the Impressionists. The American critics, who had been exposed to the French Impressionists in the exhibition that the French dealer Durand-Ruel had set up in New York several years before, nodded their heads in approval. Robinson paved the way for the acceptance of the winter scenes of John Twachtman with their soft light and poetic subtleties of pattern, and the sparkling cityscapes and interiors by Childe Hassam, which vibrated with color and a delight in the warmth of sunlight. There were others—William J. Glackens and J. Alden Weir and Maurice Prendergast, mild revolutionaries in the 1890s who became accepted masters in the early twentieth century, when they did most of their work.

Still other young men working in the 1890s who belong to our century were the painters who called themselves "The Eight" and who were nick-

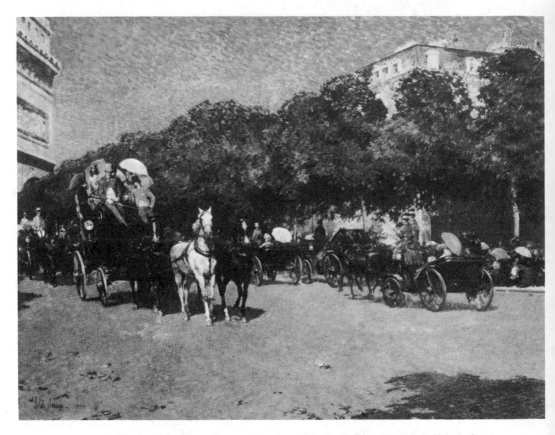

CHILDE HASSAM, the most accomplished of the self-styled "American Impressionists," went to Paris when he was twenty-seven in 1886. "Le Jour du Grand Prix" derived from his Paris sojourn. (*The New Britain Museum of American Art, New Britain, Conn.*)

named the Ashcan School because they painted scenes of urban life which were certainly not "beautiful" by the standards of their contemporaries and were considered hardly suitable for art. These were scenes of alleys, of urchins playing in dirty streets, of laundry lines and low life. This was a new kind of "realism" with social comment and satire and criticism of a sort which was a far cry from Mount and Bingham and Woodville. These men were not anecdotalists, they were reporters, often with their knives out but more often with a feeling for the vitality of a kind of urban life that art-makers of the nineteenth century had preferred to overlook. This was the generation that organized the Armory Show of 1913. Nothing could have been further from the nineteenth century in spirit than that whirlwind

which tossed accepted criteria of art in disarray about the tidy landscape of acceptable taste.

More than three-quarters of a century have gone by since the White City shut its gates, a long enough time for the pendulum of taste to have made a full swing—from revulsion through tolerance back to sensible concern. We are about to witness, I expect, a revival of the arts of nineteenth-century America very much like the Colonial Revival that started with the houses of McKim, Mead & White in the 1880s, was enormously spurred on by the opening of the American Wing of the Metropolitan Museum in 1924, and was frozen in crystal with the reconstruction of Williamsburg, which commenced in 1927. (Williamsburg is usually called a "restoration," but "reconstruction" is more accurate, as almost none of the original buildings were still standing when the work began.) In the last fifteen years or so there has been a revival of interest, especially among architectural historians and a handful of scholars of American studies and painting, in what the art-makers of nineteenth-century America were producing and what relation it bore to the society in which they had their being. There have been "Gay Nineties" revivals of various sorts, primarily in the decoration of restaurants and saloons, where the emphasis has been on the can-can, gaslight, plush, and ball fringe associated with expensive honky-tonk and with what was once known as "sin." There has been great interest in what we call Victorian interiors exhibited by a few institutions like the Brooklyn Museum, the Museum of the City of New York, and the Munson, Williams, Proctor Institute in Utica, New York. They have installed or refurbished rooms of great elegance. In the last twenty years there have been searching exhibitions of our nineteenth-century painters at museums such as the Corcoran Gallery in Washington and the Cincinnati Art Museum, and dealers are beginning to do a land-office business in painters entirely ignored a few years ago. One suspects, however, that the rush is just beginning, and that we will witness the same sort of turning out of attics and cellars that happened in the 1920s and '30s when the "Antiques Craze," as it was called, grabbed suburban ladies by the throat and turned ordinary homes into imitation saltbox houses and taverns filled with cobbler's benches and spinning wheels and pewter candlesticks.

It seems more than likely that the exhibition "19th- Century America," organized as part of the celebration of the centennial of the Metropolitan Museum of Art, will produce a response not unlike that of the opening of its American Wing. It will, that is, give official sanction to the art-makers of the nineteenth century, the painters, architects, sculptors, and designers

of furniture, silver, glass, and other decorative (and useful) objects, by sorting out of the vast mass of the century's art production (as that century called it) examples of the best that was created. It will arouse the curiosity of a great many people who consider themselves art-lovers and who had not noticed what was under their noses. It will turn pictures bequeathed by ancient aunts and hidden for years in storerooms into treasures to hang on living-room walls. It will cause furniture manufacturers to mass-produce whatnots and curio cabinets, dos-a-dos, and, perhaps, carpets adorned with cabbage roses. If we are fortunate, it will produce more than just high prices for dealers and conversation pieces for collectors; it will invoke a genuine delight in what was produced by a great many talented, serious, and imaginative men and a few women who devoted their lives to making art, and to making their contemporaries accept what they made.

Between the time when "Clio" wrote in the New York *Commercial Advertiser* in 1804 that "the arts are in their infancy among us. They have taken a goodly nap on this side [of] the water" and Saint-Gaudens' outburst at the time of the White City, "Look here, old fellow, do you realize that this is the greatest meeting of artists since the fifteenth century!" America had turned from one kind of civilization into another, from a nation of farmers and merchants and craftsmen to one of cities and magnates and organized labor. It had, in other words, experienced the Industrial Revolution much as England had, but with more elbow room to accommodate it. It had also, of course, experienced a most divisive Civil War at about the same time that it was unifying itself with railroads and canals. In the North the economic gap between the industrialist and the laborers in his mills had become comparable to the gap between the Southern landholder and his slaves, but movements were afoot to remedy these inequities of which many citizens who considered themselves pious, charitable, and concerned were oblivious. In spite of its protestations of republicanism, the nineteenth century was extremely class-conscious, and to many it mattered greatly who was born on which side of the tracks.

It would be extremely difficult—indeed, impossible—to read these changes in the pictures which came from the easels of the nineteenth-century art-makers. Portraits and genre paintings, of course, reveal changes in fashion, and changes in how people dress are a measure of how they live and look upon their roles in relation to society. The very rigidness with which sitters posed was a reflection of propriety, an attitude that became a great deal more relaxed at the end of the century, when portraits were more theatrical or more natural. But the subjects of pictures, from the time

Trumbull was painting his battle scenes to Ryder's romantic and tumul-
tuous visions of the sea, speak not at all of the material and political
changes in America, though they say a great deal about how artists thought
about their function, about where they fitted into society, about their
relations with their patrons, and about what constituted "art."

Trumbull was concerned with painting history, with glorifying the
heroes of the Revolution, with helping to establish the arts in America as an
essential ingredient of the aspirations of the new nation. Ryder was con-
cerned with painting his own inner vision, almost entirely oblivious of the
world around him except as the sun crinkled the surface of a treetrunk or
the moon carved shapes in clouds. Between these extremes painting had
followed a path from the ideal to the observable truth, from the carefully
constructed reconstructions of mythical and religious subjects of Washing-
ton Allston, through the matter-of-fact made poetical by Mount and
Bingham in one generation and Homer and Eastman Johnson in the next, to
a new kind of mythology peopled by figures of "Justice" and "Peace" and
other virtuous abstractions by the muralists of the White City. Landscape
painting had followed a parallel path from the ideal Italian landscapes of
Allston and Morse to the discovery of the details of the American landscape
and the fact that detail could be coupled with vast sweep, the vast canvases
of the Hudson River School and the discoverers of the wildernesses and
mountains of the West, to be followed by the confined and tamed landscapes
of Hunt and La Farge and Inness. Portraits had gone from rigid and flat-
tering likeness against formal backgrounds or no backgrounds at all to the
uncompromising veracity of Eakins, on the one hand, and the flashy chic of
Chase and Sargent on the other.

The voyage of sculpture from Greenough's borrowed classicism to
French's borrowed Beaux-Arts is less complicated. The kind of slick ab-
straction of which Powers was the master, with his inhuman females clothed
in their own mechanically made skin, gave way to heroes in their own
clothes, as in the strong, competent hands of John Quincy Adams Ward and
the monument-makers after the Civil War. To naturalism Saint-Gaudens
added his personal kind of abstraction—the abstraction of ideals and ideas
made plastic, as in his memorial to Mrs. Adams and in the floating figure
with which he embellished his Shaw Memorial in Boston. The century ended
with French making a kind of pretentious caricature of this.

The tortuous path of architecture from Jefferson's love affair with a
Roman temple to Sullivan's with the skyscraper is far more revealing of the
social and economic changes that had taken place in America than any of
the other arts. From the attempt to establish a new Greece in North

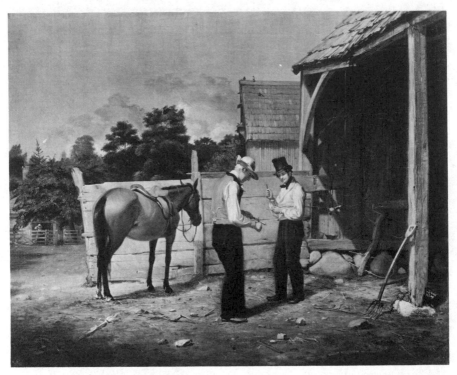

The quality of observation and skill in rendering in WILLIAM SIDNEY
MOUNT's "Bargaining for a Horse" override sentiment and nostalgia
today and we can only guess at what its initial impact must have been
on Mount's contemporaries. (*The New-York Historical Society, New
York City*)

America, to the ornate mansions of the rich industrialists (with Downing's
voice calling for restraint in the background), to the massive temples to
celebrate the railroad empires, the vast palace hotels, the department
stores, the story of material development and of social class is written in
board and brick and marble and finally in steel.

The decorative arts are a quite different matter. They met a fearful
crisis when suddenly it became possible to mass-produce the kinds of furni-
ture which had until about the 1830s been painstakingly made by crafts-
men, and when the power loom replaced the hand loom and carpets and
fabrics came not just by the yard but by the mile. Attempts like those of
Ruskin and Morris and Eastlake to return to the dignity of crafts were
ridden over rough-shod by manufacturers meeting the demands for the
latest in taste and fad and fashion. The clutter that prevailed in the parlors

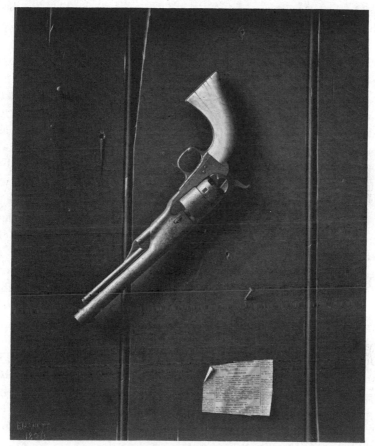

"The Faithful Colt" by WILLIAM HARNETT, once a symbol of se-
curity, has, for all its dignity, become a piece of nostalgia today.
(*The Wadsworth Atheneum, Hartford, Conn.*)

of the nineteenth century bespoke the American love of "things" which had
so bothered an artist like Cole in the 1830s and which was glorified by
Harnett in his still-lifes at the end of the century. The attempt to marry art
with industry, nobly tried by Prince Albert at the Crystal Palace exhibition
in London in 1851, was tried again at Philadelphia in 1876 with results that
seemed to reveal only that art had no more concept of what industry was
about than industry had about art. It was a long, hard road from Duncan
Phyfe and Charles Honoré Lannuier and their elegant chairs and tables to
the exotic productions of Louis Comfort Tiffany and the moralized furni-
ture of Gustave Stickley, not in the least ameliorated by the fact that those

who could best afford to support native manufacture and design bought everything they could from Europe.

It is impossible, of course, for us to see the nineteenth century as those who lived in it saw it. We can see it whole, in a sense, whereas their view was one of an unrolling screen, but we cannot feel it even in its details. The arts that we look at distantly now spoke a language of immediacy to the art-maker's contemporaries. To us they speak a language of nostalgia. We have no personal concern with the scenes he painted or the buildings through whose portals he walked. When Mount's contemporaries looked at his painting of horse traders, they said, "This is it." We can only say, "This is what it must have been like." We cannot know the people. The sounds that surrounded them we cannot hear, or know what was the smell in their nostrils. We have never seen a landscape like those that Cole or Kensett saw, and we never will, because those landscapes existed only in the nineteenth-century eye, and we have been taught by a century of painters that the landscape is made up of colors quite different from those that were on the land and water and sky a century and more ago. We can reconstruct in a limited way what a man like Harnett had thrown on the back of his worktable to make a still-life, but we cannot smile with the same pleasures of recognition as his contemporaries did at the calling cards and stamps and postcards that he pinned to a door, or know the heft and security of a Colt revolver. So much of what we have looked at in this book is completely lost to us; it disappeared when the people for whom it was made disappeared, when the nineteenth century vanished forever in the burst of fireworks that greeted the twentieth century.

SOURCES AND
ACKNOWLEDGMENTS

If Simon Michael Bessie of Atheneum Publishers and George Tresher of the
Metropolitan Museum of Art in New York had not put their heads to-
gether, I would not have undertaken to write this book. The occasion for its
publication is an exhibition called "19th-Century America," a part of
the celebration of the Metropolitan's Centennial. Its purpose is to provide
the layman (like myself) with an overview of the American arts of the
nineteenth century and the context in which they were made. It is not its
purpose to parallel the Metropolitan's exhibition except in most general
ways. It makes no attempt to be inclusive lest it read like a laundry list of
names and places and pictures, objects, and buildings. It is a once-over-
lightly by a non-art-historian who fancies himself as an amateur of the arts
or, if you prefer, a dilettante. It is my hope that this book may encourage a
few others to enjoy what I have enjoyed and to discover many delights I
have not discovered. Writing this book has not been a rehash of what I have
long known but a voyage of discovery; at the same time it has not in any
sense been a work of original research. I have relied entirely on authorities
in the fields they have diligently tilled and from whose harvests I have been
able to pilfer.

 The reader will find here no extensive bibliography, but I list a number
of sources which I have consulted (plundered would be more accurate) with
pleasure and benefit and which will be useful to anyone wishing to pursue
these matters further. These books have bibliographies, some of them very
extensive, some of them with critical comments. It appears that new volumes
are being published frequently this year which illuminate the nineteenth-
century American arts, and so my list cannot include what happens between
its compilation and its publication. I have quoted often from a number of
critics who wrote in the nineteenth century about their contemporaries,
most particularly William Dunlap (*A History of the Rise and Progress of
the Art of Design in the United States*, first published in 1832), Henry T.
Tuckerman (*Book of the Artists: American Artist Life*, 1867), and James
Jackson Jarves (*The Art-Idea*, first published in 1864 and reissued in

1960). These books still make excellent reading, and Jarves was surely one of the most perceptive critics America has produced. At the turn of the century the painter Samuel Isham wrote *The History of American Painting* in which he discusses our early painters as well as a good many men he knew and worked with, and the sculptor Lorado Taft wrote *The History of American Sculpture*, the first attempt at a discussion of its kind. Both of these books are more than merely useful; their enthusiasm is still contagious.

Though I mention some of their books below, I would like to pay tribute to a number of men who pioneered in the serious consideration of our arts long before they became a somewhat popular concern. These are Lewis Mumford, E. P. Richardson, Virgil Barker, Oliver Larkin, James Thomas Flexner, A. Hyatt Mayor, John A. Kouwenhoven, Henry-Russell Hitchcock, Wayne Andrews, Marshall B. Davidson, Lloyd Goodrich, John I. H. Baur, and Albert TenEyck Gardner.

My principal sources (not including those mentioned above and a number of excellent monographs by Lloyd Goodrich, E. P. Richardson, Oliver Larkin, David C. Huntington, and others, and many catalogues of exhibitions) have been:

ON THE ART-MAKERS AND SOCIETY

The Editors of *Art in America* and the Archives of American Art, *The Artist in America*, New York, 1967

W. G. Constable, *Art Collecting in the United States of America: An Outline for a History*, New York, 1964

Marshall B. Davidson, *Life in America* (two vols.), Boston, 1951

Harold E. Dickson, *Arts of the Young Republic: The Age of William Dunlap*, Chapel Hill, 1968

W. D. Garrett, P. F. Norton, J. T. Butler, A. Gowans, *The Arts in America: The 19th Century*, New York, 1969

Neil Harris, *The Artist in American Society: The Formative Years 1790–1860*, New York, 1966

John A. Kouwenhoven, *Made in America: The Arts in Modern Civilization*, Garden City, 1948

Oliver Larkin, *Art and Life in America*, New York, 1949

Russell Lynes, *The Tastemakers*, New York, 1954

Richard McLanathan, *The American Tradition in the Arts*, New York, 1968

Lewis Mumford, *The Brown Decades*, New York, 1931

Berry B. Tracy and William H. Gerdts, *Classical America*, Newark, 1963

ON PAINTING AND PAINTERS

Virgil Barker, *American Painting*, New York, 1950

John I. H. Baur, *American Painting in the Nineteenth Century: Main Trends and Movements*, New York, 1953

Alexander Eliot, *Three Hundred Years of American Painting*, New York, 1957

James Thomas Flexner, *America's Old Masters*, New York, 1939

——, *The Light of Distant Skies, 1760–1835*, New York, 1954

——, *That Wilder Image: The Paintings of America's Native School from Thomas Cole to Winslow Homer*, Boston, 1962

Alfred Frankenstein, *After the Hunt: William Harnett and Other American Still Life Painters 1870–1900*, revised edition, Berkeley, 1969

Albert TenEyck Gardner and Stuart P. Feld, *American Paintings: A Catalogue of the Collection of the Metropolitan Museum of Art, Volume I, Painters Born by 1815*, New York, 1965

Samuel Isham and Royal Cortissoz, *The History of American Painting*, New York, 1936

Metropolitan Museum of Art, *Life in America: A Special Loan Exhibition of Paintings*, New York, 1939

Barbara Novak, *American Painting of the Nineteenth Century*, New York, 1969

E. P. Richardson, *Painting in America from 1502 to the Present*, revised edition, New York, 1965

——, *The Way of Western Art, 1776–1914*, Cambridge, 1939

James Thrall Soby, *Romantic Painting in America*, a Museum of Modern Art catalogue, New York, 1943

John Wilmerding, *A History of American Marine Painting*, Boston, 1968

ON SCULPTURE

Wayne Craven, *Sculpture in America*, New York, 1968

Albert TenEyck Gardner: *American Sculpture: A Catalogue of the Collection of the Metropolitan Museum of Art*, New York, 1965

——, *Yankee Stonecutters: The First American School of Sculpture*, New York, 1945

Margaret Farrand Thorp, *The Literary Sculptors*, Durham, 1965

ON ARCHITECTURE AND DESIGN

Wayne Andrews, *Architecture, Ambition and Americans*, New York, 1955
——, *Architecture in America*, New York, 1960
——, *Architecture in Chicago and Mid-America*, New York, 1968
——, *Architecture in New York*, New York, 1969
Alan Burnham, *New York Landmarks*, Middletown, 1963
John Burchard and Albert Bush-Brown, *The Architecture of America: A Social and Cultural History*, Boston, 1961
Marshall B. Davidson, editor, *The American Heritage History of American Antiques from the Revolution to the Civil War*, New York, 1968
——, *The American Heritage History of American Antiques from the Civil War to World War I*, New York, 1969
James Marsden Fitch, *American Building: The Historical Forces that Shaped It*, revised edition, Boston, 1966
Alan Gowans, *Images of American Living: Four Centuries of Architecture and Furniture as Cultural Expression*, Philadelphia, 1964
Talbot Hamlin, *Benjamin Henry Latrobe*, New York, 1955
Henry-Russell Hitchcock, *The Architecture of H. H. Richardson and His Times*, revised edition, Cambridge, 1961
Frances Lichten, *Decorative Arts of Victoria's Era*, New York, 1950
John Maas, *The Gingerbread Age: A View of Victorian America*, New York, 1957
Celia Jackson Otto, *American Furniture of the Nineteenth Century*, New York, 1965
Vincent J. Scully, *The Shingle Style*, New Haven, 1955
George B. Tatum, *Penn's Great Town: 250 Years of Philadelphia Architecture*, Philadelphia, 1961
Theo B. White, editor, *Philadelphia Architecture in the Nineteenth Century*, Philadelphia, 1953

Many individuals have helped me in many ways and my indebtedness to them is great. I should like first to thank John K. Howat, Associate Curator for American Painting and Sculpture, and Berry B. Tracy, Curator in Charge of the American Wing, both of the Metropolitan Museum of Art. They have been extremely generous with their advice and guidance, but to avoid imposing on their generosity or in any way implicating them in what I have written I have not asked them to review my manuscript. There are, however, several pairs of expert eyes which have read the text with care. Katherine Gauss Jackson, to whom this book is dedicated, has watched it

with an eagle (albeit sympathetic) eye from the start. Her advice, as one of the most discerning editors I have known in my many years of experience as an editor, has been of inestimable help and reassurance. The manuscript has also been combed by William E. Woolfenden, the Director of the Archives of American Art, but I take full responsibility for any errors of fact or interpretation that may have escaped him. Simon Michael Bessie, president of Atheneum, who edited a book of mine called *The Tastemakers* fifteen years ago, has applied his sharp and always friendly criticism to this book as well, greatly to my benefit as well as my pleasure.

The illustrations presented a number of sticky problems which a number of generous persons have helped me solve. I am especially indebted to Wayne Andrews, whose photographic archives of American architecture are extraordinary in quality and scope—revelations of a very gifted photographer and an architectural historian who combines wit and grace with scholarship. The sources of all photographs used here are given in the captions, and I am grateful for the generosity and cooperation (some more generous than others) of the institutions there cited. Some institutions look upon the use of their materials in books as part of their educational commitment.

It has been my great good fortune to have been associated with the Archives of American Art for some years, and in addition to my debt to Mr. Woolfenden, its director, I have had the continually cheerful, thoughtful and generous help of its staff and particularly of Garnett McCoy, Butler Coleman, and Jemison Hammond. The Archives is a remarkable resource for anyone interested in the American arts. Started at the Detroit Institute of Art by E. P. Richardson and Lawrence A. Fleishman, it has recently become affiliated with the Smithsonian Institution in Washington, with branches in Detroit and New York. I have used its original papers and microfilms of documents and its photographic files with great benefit. I would also like to thank the library of the Metropolitan Museum, the New York Society Library, the New-York Historical Society, the Century Association (especially librarian Louis Webster and Andrew Zaremba), and the American Academy in Rome, all of whose hospitality I have enjoyed and profited from.

A number of friends have come to my aid in various generous ways—Theo B. White, John A. Kouwenhoven, Edgar Kaufmann, Jr., Alan Pryce-Jones and the late Mrs. Pryce-Jones, Lewis Iselin, James T. Flexner, E. P. Richardson, Lloyd Goodrich, Alan Burnham, James H. Ricau, Ann Hatfield Rothschild, Lillian Green, Harry Ford, Linda Hyman, Jay Cantor, Marilynn Johnson, Stuart P. Feld. I am grateful to them, as they well know.

When this project was first suggested to me, I was wary of it for a number of reasons, not the least of which was the brevity of the time in which to do the reading and contemplation it demanded, to get the words on paper and the illustrations collected. It has been possible to do these things only because my wife has been immeasurably helpful as guardian of my privacy, cheering section at moments of discouragement, discreet and sympathetic but acute critic, and in the final sprint to gather illustrations a miracle of efficiency, humor, and judgment. My debt to her is perpetual and inexpressible.

INDEX

A CATALOGUE OF
SELECTED DOVER BOOKS
IN ALL FIELDS OF INTEREST

A CATALOGUE OF SELECTED DOVER
BOOKS IN ALL FIELDS OF INTEREST

RACKHAM'S COLOR ILLUSTRATIONS FOR WAGNER'S RING. Rackham's finest mature work—all 64 full-color watercolors in a faithful and lush interpretation of the *Ring*. Full-sized plates on coated stock of the paintings used by opera companies for authentic staging of Wagner. Captions aid in following complete Ring cycle. Introduction. 64 illustrations plus vignettes. 72pp. 8⅝ x 11¼. 23779-6 Pa. $6.00

CONTEMPORARY POLISH POSTERS IN FULL COLOR, edited by Joseph Czestochowski. 46 full-color examples of brilliant school of Polish graphic design, selected from world's first museum (near Warsaw) dedicated to poster art. Posters on circuses, films, plays, concerts all show cosmopolitan influences, free imagination. Introduction. 48pp. 9⅜ x 12¼.
23780-X Pa. $6.00

GRAPHIC WORKS OF EDVARD MUNCH, Edvard Munch. 90 haunting, evocative prints by first major Expressionist artist and one of the greatest graphic artists of his time: *The Scream, Anxiety, Death Chamber, The Kiss, Madonna*, etc. Introduction by Alfred Werner. 90pp. 9 x 12.
23765-6 Pa. $5.00

THE GOLDEN AGE OF THE POSTER, Hayward and Blanche Cirker. 70 extraordinary posters in full colors, from Maitres de l'Affiche, Mucha, Lautrec, Bradley, Cheret, Beardsley, many others. Total of 78pp. 9⅜ x 12¼. 22753-7 Pa. $5.95

THE NOTEBOOKS OF LEONARDO DA VINCI, edited by J. P. Richter. Extracts from manuscripts reveal great genius; on painting, sculpture, anatomy, sciences, geography, etc. Both Italian and English. 186 ms. pages reproduced, plus 500 additional drawings, including studies for *Last Supper*, Sforza monument, etc. 860pp. 7⅞ x 10¾. (Available in U.S. only)
22572-0, 22573-9 Pa., Two-vol. set $15.90

THE CODEX NUTTALL, as first edited by Zelia Nuttall. Only inexpensive edition, in full color, of a pre-Columbian Mexican (Mixtec) book. 88 color plates show kings, gods, heroes, temples, sacrifices. New explanatory, historical introduction by Arthur G. Miller. 96pp. 11⅜ x 8½. (Available in U.S. only) 23168-2 Pa. $7.95

UNE SEMAINE DE BONTÉ, A SURREALISTIC NOVEL IN COLLAGE, Max Ernst. Masterpiece created out of 19th-century periodical illustrations, explores worlds of terror and surprise. Some consider this Ernst's greatest work. 208pp. 8⅛ x 11. 23252-2 Pa. $6.00

DRAWINGS OF WILLIAM BLAKE, William Blake. 92 plates from Book of Job, *Divine Comedy, Paradise Lost,* visionary heads, mythological figures, Laocoon, etc. Selection, introduction, commentary by Sir Geoffrey Keynes. 178pp. 8⅛ x 11. 22303-5 Pa. $4.00

ENGRAVINGS OF HOGARTH, William Hogarth. 101 of Hogarth's greatest works: *Rake's Progress, Harlot's Progress, Illustrations for Hudibras, Before and After, Beer Street and Gin Lane,* many more. Full commentary. 256pp. 11 x 13¾. 22479-1 Pa. $12.95

DAUMIER: 120 GREAT LITHOGRAPHS, Honore Daumier. Wide-ranging collection of lithographs by the greatest caricaturist of the 19th century. Concentrates on eternally popular series on lawyers, on married life, on liberated women, etc. Selection, introduction, and notes on plates by Charles F. Ramus. Total of 158pp. 9⅜ x 12¼. 23512-2 Pa. $6.00

DRAWINGS OF MUCHA, Alphonse Maria Mucha. Work reveals draftsman of highest caliber: studies for famous posters and paintings, renderings for book illustrations and ads, etc. 70 works, 9 in color; including 6 items not drawings. Introduction. List of illustrations. 72pp. 9⅜ x 12¼. (Available in U.S. only) 23672-2 Pa. $4.00

GIOVANNI BATTISTA PIRANESI· DRAWINGS IN THE PIERPONT MORGAN LIBRARY, Giovanni Battista Piranesi. For first time ever all of Morgan Library's collection, world's largest. 167 illustrations of rare Piranesi drawings—archeological, architectural, decorative and visionary. Essay, detailed list of drawings, chronology, captions. Edited by Felice Stampfle. 144pp. 9⅜ x 12¼. 23714-1 Pa. $7.50

NEW YORK ETCHINGS (1905-1949), John Sloan. All of important American artist's N.Y. life etchings. 67 works include some of his best art; also lively historical record—Greenwich Village, tenement scenes. Edited by Sloan's widow. Introduction and captions. 79pp. 8⅜ x 11¼. 23651-X Pa. $4.00

CHINESE PAINTING AND CALLIGRAPHY: A PICTORIAL SURVEY, Wan-go Weng. 69 fine examples from John M. Crawford's matchless private collection: landscapes, birds, flowers, human figures, etc., plus calligraphy. Every basic form included: hanging scrolls, handscrolls, album leaves, fans, etc. 109 illustrations. Introduction. Captions. 192pp. 8⅞ x 11¾. 23707-9 Pa. $7.95

DRAWINGS OF REMBRANDT, edited by Seymour Slive. Updated Lippmann, Hofstede de Groot edition, with definitive scholarly apparatus. All portraits, biblical sketches, landscapes, nudes, Oriental figures, classical studies, together with selection of work by followers. 550 illustrations. Total of 630pp. 9⅛ x 12¼. 21485-0, 21486-9 Pa., Two-vol. set $15.00

THE DISASTERS OF WAR, Francisco Goya. 83 etchings record horrors of Napoleonic wars in Spain and war in general. Reprint of 1st edition, plus 3 additional plates. Introduction by Philip Hofer. 97pp. 9⅜ x 8¼. 21872-4 Pa. $4.00

THE SENSE OF BEAUTY, George Santayana. Masterfully written discussion of nature of beauty, materials of beauty, form, expression; art, literature, social sciences all involved. 168pp. 5⅜ x 8½. 20238-0 Pa. $3.00

ON THE IMPROVEMENT OF THE UNDERSTANDING, Benedict Spinoza. Also contains *Ethics, Correspondence,* all in excellent R. Elwes translation. Basic works on entry to philosophy, pantheism, exchange of ideas with great contemporaries. 402pp. 5⅜ x 8½. 20250-X Pa. $4.50

THE TRAGIC SENSE OF LIFE, Miguel de Unamuno. Acknowledged masterpiece of existential literature, one of most important books of 20th century. Introduction by Madariaga. 367pp. 5⅜ x 8½.
20257-7 Pa. $4.50

THE GUIDE FOR THE PERPLEXED, Moses Maimonides. Great classic of medieval Judaism attempts to reconcile revealed religion (Pentateuch, commentaries) with Aristotelian philosophy. Important historically, still relevant in problems. Unabridged Friedlander translation. Total of 473pp. 5⅜ x 8½. 20351-4 Pa. $6.00

THE I CHING (THE BOOK OF CHANGES), translated by James Legge. Complete translation of basic text plus appendices by Confucius, and Chinese commentary of most penetrating divination manual ever prepared. Indispensable to study of early Oriental civilizations, to modern inquiring reader. 448pp. 5⅜ x 8½. 21062-6 Pa. $5.00

THE EGYPTIAN BOOK OF THE DEAD, E. A. Wallis Budge. Complete reproduction of Ani's papyrus, finest ever found. Full hieroglyphic text, interlinear transliteration, word for word translation, smooth translation. Basic work, for Egyptology, for modern study of psychic matters. Total of 533pp. 6½ x 9¼. (Available in U.S. only) 21866-X Pa. $5.95

THE GODS OF THE EGYPTIANS, E. A. Wallis Budge. Never excelled for richness, fullness: all gods, goddesses, demons, mythical figures of Ancient Egypt; their legends, rites, incarnations, variations, powers, etc. Many hieroglyphic texts cited. Over 225 illustrations, plus 6 color plates. Total of 988pp. 6⅛ x 9¼. (Available in U.S. only)
22055-9, 22056-7 Pa., Two-vol. set $16.00

THE STANDARD BOOK OF QUILT MAKING AND COLLECTING, Marguerite Ickis. Full information, full-sized patterns for making 46 traditional quilts, also 150 other patterns. Quilted cloths, lame, satin quilts, etc. 483 illustrations. 273pp. 6⅞ x 9⅝. 20582-7 Pa. $4.95

CORAL GARDENS AND THEIR MAGIC, Bronsilaw Malinowski. Classic study of the methods of tilling the soil and of agricultural rites in the Trobriand Islands of Melanesia. Author is one of the most important figures in the field of modern social anthropology. 143 illustrations. Indexes. Total of 911pp. of text. 5⅝ x 8¼. (Available in U.S. only)
23597-1 Pa. $12.95

THE COMPLETE BOOK OF DOLL MAKING AND COLLECTING, Catherine Christopher. Instructions, patterns for dozens of dolls, from rag doll on up to elaborate, historically accurate figures. Mould faces, sew clothing, make doll houses, etc. Also collecting information. Many illustrations. 288pp. 6 x 9. 22066-4 Pa. $4.50

THE DAGUERREOTYPE IN AMERICA, Beaumont Newhall. Wonderful portraits, 1850's townscapes landscapes; full text plus 104 photographs. The basic book. Enlarged 1976 edition. 272pp. 8¼ x 11¼. 23322-7 Pa. $7.95

CRAFTSMAN HOMES, Gustav Stickley. 296 architectural drawings, floor plans, and photographs illustrate 40 different kinds of "Mission-style" homes from *The Craftsman* (1901-16), voice of American style of simplicity and organic harmony. Thorough coverage of Craftsman idea in text and picture, now collector's item. 224pp. 8⅛ x 11. 23791-5 Pa. $6.00

PEWTER-WORKING: INSTRUCTIONS AND PROJECTS, Burl N. Osborn. & Gordon O. Wilber. Introduction to pewter-working for amateur craftsman. History and characteristics of pewter; tools, materials, step-by-step instructions. Photos, line drawings, diagrams. Total of 160pp. 7⅞ x 10¾. 23786-9 Pa. $3.50

THE GREAT CHICAGO FIRE, edited by David Lowe. 10 dramatic, eyewitness accounts of the 1871 disaster, including one of the aftermath and rebuilding, plus 70 contemporary photographs and illustrations of the ruins—courthouse, Palmer House, Great Central Depot, etc. Introduction by David Lowe. 87pp. 8¼ x 11. 23771-0 Pa. $4.00

SILHOUETTES: A PICTORIAL ARCHIVE OF VARIED ILLUSTRATIONS, edited by Carol Belanger Grafton. Over 600 silhouettes from the 18th to 20th centuries include profiles and full figures of men and women, children, birds and animals, groups and scenes, nature, ships, an alphabet. Dozens of uses for commercial artists and craftspeople. 144pp. 8⅜ x 11¼. 23781-8 Pa. $4.50

ANIMALS: 1,419 COPYRIGHT-FREE ILLUSTRATIONS OF MAMMALS, BIRDS, FISH, INSECTS, ETC., edited by Jim Harter. Clear wood engravings present, in extremely lifelike poses, over 1,000 species of animals. One of the most extensive copyright-free pictorial sourcebooks of its kind. Captions. Index. 284pp. 9 x 12. 23766-4 Pa. $8.95

INDIAN DESIGNS FROM ANCIENT ECUADOR, Frederick W. Shaffer. 282 original designs by pre-Columbian Indians of Ecuador (500-1500 A.D.). Designs include people, mammals, birds, reptiles, fish, plants, heads, geometric designs. Use as is or alter for advertising, textiles, leathercraft, etc. Introduction. 95pp. 8¾ x 11¼. 23764-8 Pa. $3.50

SZIGETI ON THE VIOLIN, Joseph Szigeti. Genial, loosely structured tour by premier violinist, featuring a pleasant mixture of reminiscenes, insights into great music and musicians, innumerable tips for practicing violinists. 385 musical passages. 256pp. 5⅝ x 8¼. 23763-X Pa. $4.00

TONE POEMS, SERIES II: TILL EULENSPIEGELS LUSTIGE STREICHE, ALSO SPRACH ZARATHUSTRA, AND EIN HELDEN-LEBEN, Richard Strauss. Three important orchestral works, including very popular *Till Eulenspiegel's Marry Pranks,* reproduced in full score from original editions. Study score. 315pp. 9⅜ x 12¼. (Available in U.S. only)
23755-9 Pa. $8.95

TONE POEMS, SERIES I: DON JUAN, TOD UND VERKLARUNG AND DON QUIXOTE, Richard Strauss. Three of the most often performed and recorded works in entire orchestral repertoire, reproduced in full score from original editions. Study score. 286pp. 9⅜ x 12¼. (Available in U.S. only)
23754-0 Pa. $7.50

11 LATE STRING QUARTETS, Franz Joseph Haydn. The form which Haydn defined and "brought to perfection." *(Grove's).* 11 string quartets in complete score, his last and his best. The first in a projected series of the complete Haydn string quartets. Reliable modern Eulenberg edition, otherwise difficult to obtain. 320pp. 8⅜ x 11¼. (Available in U.S. only)
23753-2 Pa. $7.50

FOURTH, FIFTH AND SIXTH SYMPHONIES IN FULL SCORE, Peter Ilyitch Tchaikovsky. Complete orchestral scores of Symphony No. 4 in F Minor, Op. 36; Symphony No. 5 in E Minor, Op. 64; Symphony No. 6 in B Minor, "Pathetique," Op. 74. Bretikopf & Hartel eds. Study score. 480pp. 9⅜ x 12¼.
23861-X Pa. $10.95

THE MARRIAGE OF FIGARO: COMPLETE SCORE, Wolfgang A. Mozart. Finest comic opera ever written. Full score, not to be confused with piano renderings. Peters edition. Study score. 448pp. 9⅜ x 12¼. (Available in U.S. only)
23751-6 Pa. $11.95

"IMAGE" ON THE ART AND EVOLUTION OF THE FILM, edited by Marshall Deutelbaum. Pioneering book brings together for first time 38 groundbreaking articles on early silent films from *Image* and 263 illustrations newly shot from rare prints in the collection of the International Museum of Photography. A landmark work. Index. 256pp. 8¼ x 11.
23777-X Pa. $8.95

AROUND-THE-WORLD COOKY BOOK, Lois Lintner Sumption and Marguerite Lintner Ashbrook. 373 cooky and frosting recipes from 28 countries (America, Austria, China, Russia, Italy, etc.) include Viennese kisses, rice wafers, London strips, lady fingers, hony, sugar spice, maple cookies, etc. Clear instructions. All tested. 38 drawings. 182pp. 5⅜ x 8.
23802-4 Pa. $2.50

THE ART NOUVEAU STYLE, edited by Roberta Waddell. 579 rare photographs, not available elsewhere, of works in jewelry, metalwork, glass, ceramics, textiles, architecture and furniture by 175 artists—Mucha, Seguy, Lalique, Tiffany, Gaudin, Hohlwein, Saarinen, and many others. 288pp. 8⅜ x 11¼.
23515-7 Pa. $6.95

THE AMERICAN SENATOR, Anthony Trollope. Little known, long un-available Trollope novel on a grand scale. Here are humorous comment on American vs. English culture, and stunning portrayal of a heroine/villainess. Superb evocation of Victorian village life. 561pp. 5⅜ x 8½.
23801-6 Pa. $6.00

WAS IT MURDER? James Hilton. The author of *Lost Horizon* and *Goodbye, Mr. Chips* wrote one detective novel (under a pen-name) which was quickly forgotten and virtually lost, even at the height of Hilton's fame. This edition brings it back—a finely crafted public school puzzle resplendent with Hilton's stylish atmosphere. A thoroughly English thriller by the creator of Shangri-la. 252pp. 5⅜ x 8. (Available in U.S. only)
23774-5 Pa. $3.00

CENTRAL PARK: A PHOTOGRAPHIC GUIDE, Victor Laredo and Henry Hope Reed. 121 superb photographs show dramatic views of Central Park: Bethesda Fountain, Cleopatra's Needle, Sheep Meadow, the Blockhouse, plus people engaged in many park activities: ice skating, bike riding, etc. Captions by former Curator of Central Park, Henry Hope Reed, provide historical view, changes, etc. Also photos of N.Y. landmarks on park's periphery. 96pp. 8½ x 11. 23750-8 Pa. $4.50

NANTUCKET IN THE NINETEENTH CENTURY, Clay Lancaster. 180 rare photographs, stereographs, maps, drawings and floor plans recreate unique American island society. Authentic scenes of shipwreck, lighthouses, streets, homes are arranged in geographic sequence to provide walking-tour guide to old Nantucket existing today. Introduction, captions. 160pp. 8⅞ x 11¾. 23747-8 Pa. $6.95

STONE AND MAN: A PHOTOGRAPHIC EXPLORATION, Andreas Feininger. 106 photographs by *Life* photographer Feininger portray man's deep passion for stone through the ages. Stonehenge-like megaliths, fortified towns, sculpted marble and crumbling tenements show textures, beauties, fascination. 128pp. 9¼ x 10¾. 23756-7 Pa. $5.95

CIRCLES, A MATHEMATICAL VIEW, D. Pedoe. Fundamental aspects of college geometry, non-Euclidean geometry, and other branches of mathematics: representing circle by point. Poincare model, isoperimetric property, etc. Stimulating recreational reading. 66 figures. 96pp. 5⅜ x 8¼.
63698-4 Pa. $2.75

THE DISCOVERY OF NEPTUNE, Morton Grosser. Dramatic scientific history of the investigations leading up to the actual discovery of the eighth planet of our solar system. Lucid, well-researched book by well-known historian of science. 172pp. 5⅜ x 8½. 23726-5 Pa. $3.50

THE DEVIL'S DICTIONARY. Ambrose Bierce. Barbed, bitter, brilliant witticisms in the form of a dictionary. Best, most ferocious satire America has produced. 145pp. 5⅜ x 8½. 20487-1 Pa. $2.25

AMERICAN BIRD ENGRAVINGS, Alexander Wilson et al. All 76 plates. from Wilson's *American Ornithology* (1808-14), most important ornithological work before Audubon, plus 27 plates from the supplement (1825-33) by Charles Bonaparte. Over 250 birds portrayed. 8 plates also reproduced in full color. 111pp. 9⅜ x 12½. 23195-X Pa. $6.00

CRUICKSHANK'S PHOTOGRAPHS OF BIRDS OF AMERICA, Allan D. Cruickshank. Great ornithologist, photographer presents 177 closeups, groupings, panoramas, flightings, etc., of about 150 different birds. Expanded *Wings in the Wilderness*. Introduction by Helen G. Cruickshank. 191pp. 8¼ x 11. 23497-5 Pa. $6.00

AMERICAN WILDLIFE AND PLANTS, A. C. Martin, et al. Describes food habits of more than 1000 species of mammals, birds, fish. Special treatment of important food plants. Over 300 illustrations. 500pp. 5⅜ x 8½.
 20793-5 Pa. $4.95

THE PEOPLE CALLED SHAKERS, Edward D. Andrews. Lifetime of research, definitive study of Shakers: origins, beliefs, practices, dances, social organization, furniture and crafts, impact on 19th-century USA, present heritage. Indispensable to student of American history, collector. 33 illustrations. 351pp. 5⅜ x 8½. 21081-2 Pa. $4.50

OLD NEW YORK IN EARLY PHOTOGRAPHS, Mary Black. New York City as it was in 1853-1901, through 196 wonderful photographs from N.-Y. Historical Society. Great Blizzard, Lincoln's funeral procession, great buildings. 228pp. 9 x 12. 22907-6 Pa. $8.95

MR. LINCOLN'S CAMERA MAN: MATHEW BRADY, Roy Meredith. Over 300 Brady photos reproduced directly from original negatives, photos. Jackson, Webster, Grant, Lee, Carnegie, Barnum; Lincoln; Battle Smoke, Death of Rebel Sniper, Atlanta Just After Capture. Lively commentary. 368pp. 8⅜ x 11¼. 23021-X Pa. $8.95

TRAVELS OF WILLIAM BARTRAM, William Bartram. From 1773-8, Bartram explored Northern Florida, Georgia, Carolinas, and reported on wild life, plants, Indians, early settlers. Basic account for period, entertaining reading. Edited by Mark Van Doren. 13 illustrations. 141pp. 5⅜ x 8½. 20013-2 Pa. $5.00

THE GENTLEMAN AND CABINET MAKER'S DIRECTOR, Thomas Chippendale. Full reprint, 1762 style book, most influential of all time; chairs, tables, sofas, mirrors, cabinets, etc. 200 plates, plus 24 photographs of surviving pieces. 249pp. 9⅞ x 12¾. 21601-2 Pa. $7.95

AMERICAN CARRIAGES, SLEIGHS, SULKIES AND CARTS, edited by Don H. Berkebile. 168 Victorian illustrations from catalogues, trade journals, fully captioned. Useful for artists. Author is Assoc. Curator, Div. of Transportation of Smithsonian Institution. 168pp. 8½ x 9½.
 23328-6 Pa. $5.00

YUCATAN BEFORE AND AFTER THE CONQUEST, Diego de Landa. First English translation of basic book in Maya studies, the only significant account of Yucatan written in the early post-Conquest era. Translated by distinguished Maya scholar William Gates. Appendices, introduction, 4 maps and over 120 illustrations added by translator. 162pp. 5⅜ x 8½.
23622-6 Pa. $3.00

THE MALAY ARCHIPELAGO, Alfred R. Wallace. Spirited travel account by one of founders of modern biology. Touches on zoology, botany, ethnography, geography, and geology. 62 illustrations, maps. 515pp. 5⅜ x 8½.
20187-2 Pa. $6.95

THE DISCOVERY OF THE TOMB OF TUTANKHAMEN, Howard Carter, A. C. Mace. Accompany Carter in the thrill of discovery, as ruined passage suddenly reveals unique, untouched, fabulously rich tomb. Fascinating account, with 106 illustrations. New introduction by J. M. White. Total of 382pp. 5⅜ x 8½. (Available in U.S. only) 23500-9 Pa. $4.00

THE WORLD'S GREATEST SPEECHES, edited by Lewis Copeland and Lawrence W. Lamm. Vast collection of 278 speeches from Greeks up to present. Powerful and effective models; unique look at history. Revised to 1970. Indices. 842pp. 5⅜ x 8½. 20468-5 Pa. $8.95

THE 100 GREATEST ADVERTISEMENTS, Julian Watkins. The priceless ingredient; His master's voice; 99 44/100% pure; over 100 others. How they were written, their impact, etc. Remarkable record. 130 illustrations. 233pp. 7⅞ x 10 3/5. 20540-1 Pa. $5.95

CRUICKSHANK PRINTS FOR HAND COLORING, George Cruickshank. 18 illustrations, one side of a page, on fine-quality paper suitable for watercolors. Caricatures of people in society (c. 1820) full of trenchant wit. Very large format. 32pp. 11 x 16. 23684-6 Pa. $5.00

THIRTY-TWO COLOR POSTCARDS OF TWENTIETH-CENTURY AMERICAN ART, Whitney Museum of American Art. Reproduced in full color in postcard form are 31 art works and one shot of the museum. Calder, Hopper, Rauschenberg, others. Detachable. 16pp. 8¼ x 11.
23629-3 Pa. $3.00

MUSIC OF THE SPHERES: THE MATERIAL UNIVERSE FROM ATOM TO QUASAR SIMPLY EXPLAINED, Guy Murchie. Planets, stars, geology, atoms, radiation, relativity, quantum theory, light, antimatter, similar topics. 319 figures. 664pp. 5⅜ x 8½.
21809-0, 21810-4 Pa., Two-vol. set $11.00

EINSTEIN'S THEORY OF RELATIVITY, Max Born. Finest semi-technical account; covers Einstein, Lorentz, Minkowski, and others, with much detail, much explanation of ideas and math not readily available elsewhere on this level. For student, non-specialist. 376pp. 5⅜ x 8½.
60769-0 Pa. $4.50

THE EARLY WORK OF AUBREY BEARDSLEY, Aubrey Beardsley. 157 plates, 2 in color: *Manon Lescaut, Madame Bovary, Morte Darthur, Salome,* other. Introduction by H. Marillier. 182pp. 8⅛ x 11. 21816-3 Pa. $4.50

THE LATER WORK OF AUBREY BEARDSLEY, Aubrey Beardsley. Exotic masterpieces of full maturity: *Venus and Tannhauser, Lysistrata, Rape of the Lock, Volpone,* Savoy material, etc. 174 plates, 2 in color. 186pp. 8⅛ x 11. 21817-1 Pa. $5.95

THOMAS NAST'S CHRISTMAS DRAWINGS, Thomas Nast. Almost all Christmas drawings by creator of image of Santa Claus as we know it, and one of America's foremost illustrators and political cartoonists. 66 illustrations. 3 illustrations in color on covers. 96pp. 8⅜ x 11¼.
23660-9 Pa. $3.50

THE DORÉ ILLUSTRATIONS FOR DANTE'S DIVINE COMEDY, Gustave Doré. All 135 plates from Inferno, Purgatory, Paradise; fantastic tortures, infernal landscapes, celestial wonders. Each plate with appropriate (translated) verses. 141pp. 9 x 12. 23231-X Pa. $4.50

DORÉ'S ILLUSTRATIONS FOR RABELAIS, Gustave Doré. 252 striking illustrations of *Gargantua and Pantagruel* books by foremost 19th-century illustrator. Including 60 plates, 192 delightful smaller illustrations. 153pp. **9 x 12.** 23656-0 Pa. $5.00

LONDON: A PILGRIMAGE, Gustave Doré, Blanchard Jerrold. Squalor, riches, misery, beauty of mid-Victorian metropolis; 55 wonderful plates, 125 other illustrations, full social, cultural text by Jerrold. 191pp. of text. 9⅜ x 12¼. 22306-X Pa. $7.00

THE RIME OF THE ANCIENT MARINER, Gustave Doré, S. T. Coleridge. Dore's finest work, 34 plates capture moods, subtleties of poem. Full text. Introduction by Millicent Rose. 77pp. 9¼ x 12. 22305-1 Pa. $3.50

THE DORE BIBLE ILLUSTRATIONS, Gustave Doré. All wonderful, detailed plates: Adam and Eve, Flood, Babylon, Life of Jesus, etc. Brief King James text with each plate. Introduction by Millicent Rose. 241 plates. 241pp. 9 x 12. 23004-X Pa. $6.00

THE COMPLETE ENGRAVINGS, ETCHINGS AND DRYPOINTS OF ALBRECHT DURER. "Knight, Death and Devil"; "Melencolia," and more—all Dürer's known works in all three media, including 6 works formerly attributed to him. 120 plates. 235pp. 8⅜ x 11¼.
22851-7 Pa. $6.50

MECHANICK EXERCISES ON THE WHOLE ART OF PRINTING, Joseph Moxon. First complete book (1683-4) ever written about typography, a compendium of everything known about printing at the latter part of 17th century. Reprint of 2nd (1962) Oxford Univ. Press edition. 74 illustrations. Total of 550pp. 6⅛ x 9¼. 23617-X Pa. $7.95

THE COMPLETE WOODCUTS OF ALBRECHT DURER, edited by Dr. W. Kurth. 346 in all: "Old Testament," "St. Jerome," "Passion," "Life of Virgin," Apocalypse," many others. Introduction by Campbell Dodgson. 285pp. 8½ x 12¼. 21097-9 Pa. $7.50

DRAWINGS OF ALBRECHT DURER, edited by Heinrich Wolfflin. 81 plates show development from youth to full style. Many favorites; many new. Introduction by Alfred Werner. 96pp. 8⅛ x 11. 22352-3 Pa. $5.00

THE HUMAN FIGURE, Albrecht Dürer. Experiments in various techniques—stereometric, progressive proportional, and others. Also life studies that rank among finest ever done. Complete reprinting of Dresden Sketchbook. 170 plates. 355pp. 8⅜ x 11¼. 21042-1 Pa. $7.95

OF THE JUST SHAPING OF LETTERS, Albrecht Dürer. Renaissance artist explains design of Roman majuscules by geometry, also Gothic lower and capitals. Grolier Club edition. 43pp. 7⅞ x 10¾ 21306-4 Pa. $3.00

TEN BOOKS ON ARCHITECTURE, Vitruvius. The most important book ever written on architecture. Early Roman aesthetics, technology, classical orders, site selection, all other aspects. Stands behind everything since. Morgan translation. 331pp. 5⅜ x 8½. 20645-9 Pa. $4.50

THE FOUR BOOKS OF ARCHITECTURE, Andrea Palladio. 16th-century classic responsible for Palladian movement and style. Covers classical architectural remains, Renaissance revivals, classical orders, etc. 1738 Ware English edition. Introduction by A. Placzek. 216 plates. 110pp. of text. 9½ x 12¾. 21308-0 Pa. $10.00

HORIZONS, Norman Bel Geddes. Great industrialist stage designer, "father of streamlining," on application of aesthetics to transportation, amusement, architecture, etc. 1932 prophetic account; function, theory, specific projects. 222 illustrations. 312pp. 7⅞ x 10¾. 23514-9 Pa. $6.95

FRANK LLOYD WRIGHT'S FALLINGWATER, Donald Hoffmann. Full, illustrated story of conception and building of Wright's masterwork at Bear Run, Pa. 100 photographs of site, construction, and details of completed structure. 112pp. 9¼ x 10. 23671-4 Pa. $5.50

THE ELEMENTS OF DRAWING, John Ruskin. Timeless classic by great Viltorian; starts with basic ideas, works through more difficult. Many practical exercises. 48 illustrations. Introduction by Lawrence Campbell. 228pp. 5⅜ x 8½. 22730-8 Pa. $3.75

GIST OF ART, John Sloan. Greatest modern American teacher, Art Students League, offers innumerable hints, instructions, guided comments to help you in painting. Not a formal course. 46 illustrations. Introduction by Helen Sloan. 200pp. 5⅜ x 8½. 23435-5 Pa. $4.00

THE ANATOMY OF THE HORSE, George Stubbs. Often considered the great masterpiece of animal anatomy. Full reproduction of 1766 edition, plus prospectus; original text and modernized text. 36 plates. Introduction by Eleanor Garvey. 121pp. 11 x 14¾. 23402-9 Pa. $6.00

BRIDGMAN'S LIFE DRAWING, George B. Bridgman. More than 500 illustrative drawings and text teach you to abstract the body into its major masses, use light and shade, proportion; as well as specific areas of anatomy, of which Bridgman is master. 192pp. 6½ x 9¼. (Available in U.S. only)
22710-3 Pa. $3.50

ART NOUVEAU DESIGNS IN COLOR, Alphonse Mucha, Maurice Verneuil, Georges Auriol. Full-color reproduction of *Combinaisons orne-mentales* (c. 1900) by Art Nouveau masters. Floral, animal, geometric, interlacings, swashes—borders, frames, spots—all incredibly beautiful. 60 plates, hundreds of designs. 9⅜ x 8-1/16. 22885-1 Pa. $4.00

FULL-COLOR FLORAL DESIGNS IN THE ART NOUVEAU STYLE, E. A. Seguy. 166 motifs, on 40 plates, from *Les fleurs et leurs applications decoratives* (1902): borders, circular designs, repeats, allovers, "spots." All in authentic Art Nouveau colors. 48pp. 9⅜ x 12¼.
23439-8 Pa. $5.00

A DIDEROT PICTORIAL ENCYCLOPEDIA OF TRADES AND IN-DUSTRY, edited by Charles C. Gillispie. 485 most interesting plates from the great French Encyclopedia of the 18th century show hundreds of working figures, artifacts, process, land and cityscapes; glassmaking, paper-making, metal extraction, construction, weaving, making furniture, clothing, wigs, dozens of other activities. Plates fully explained. 920pp. 9 x 12.
22284-5, 22285-3 Clothbd., Two-vol. set $40.00

HANDBOOK OF EARLY ADVERTISING ART, Clarence P. Hornung. Largest collection of copyright-free early and antique advertising art ever compiled. Over 6,000 illustrations, from Franklin's time to the 1890's for special effects, novelty. Valuable source, almost inexhaustible.
Pictorial Volume. Agriculture, the zodiac, animals, autos, birds, Christmas, fire engines, flowers, trees, musical instruments, ships, games and sports, much more. Arranged by subject matter and use. 237 plates. 288pp. 9 x 12.
20122-8 Clothbd. $14.50

Typographical Volume. Roman and Gothic faces ranging from 10 point to 300 point, "Barnum," German and Old English faces, script, logotypes, scrolls and flourishes, 1115 ornamental initials, 67 complete alphabets, more. 310 plates. 320pp. 9 x 12. 20123-6 Clothbd. $15.00

CALLIGRAPHY (CALLIGRAPHIA LATINA), J. G. Schwandner. High point of 18th-century ornamental calligraphy. Very ornate initials, scrolls, borders, cherubs, birds, lettered examples. 172pp. 9 x 13.
20475-8 Pa. $7.00

ART FORMS IN NATURE, Ernst Haeckel. Multitude of strangely beautiful natural forms: Radiolaria, Foraminifera, jellyfishes, fungi, turtles, bats, etc. All 100 plates of the 19th-century evolutionist's *Kunstformen der Natur* (1904). 100pp. 9⅜ x 12¼. 22987-4 Pa. $5.00

CHILDREN: A PICTORIAL ARCHIVE FROM NINETEENTH-CENTURY SOURCES, edited by Carol Belanger Grafton. 242 rare, copyright-free wood engravings for artists and designers. Widest such selection available. All illustrations in line. 119pp. 8⅜ x 11¼.
23694-3 Pa. $4.00

WOMEN: A PICTORIAL ARCHIVE FROM NINETEENTH-CENTURY SOURCES, edited by Jim Harter. 391 copyright-free wood engravings for artists and designers selected from rare periodicals. Most extensive such collection available. All illustrations in line. 128pp. 9 x 12.
23703-6 Pa. $4.50

ARABIC ART IN COLOR, Prisse d'Avennes. From the greatest ornamentalists of all time—50 plates in color, rarely seen outside the Near East, rich in suggestion and stimulus. Includes 4 plates on covers. 46pp. 9⅜ x 12¼. 23658-7 Pa. $6.00

AUTHENTIC ALGERIAN CARPET DESIGNS AND MOTIFS, edited by June Beveridge. Algerian carpets are world famous. Dozens of geometrical motifs are charted on grids, color-coded, for weavers, needleworkers, craftsmen, designers. 53 illustrations plus 4 in color. 48pp. 8¼ x 11. (Available in U.S. only) 23650-1 Pa. $1.75

DICTIONARY OF AMERICAN PORTRAITS, edited by Hayward and Blanche Cirker. 4000 important Americans, earliest times to 1905, mostly in clear line. Politicians, writers, soldiers, scientists, inventors, industrialists, Indians, Blacks, women, outlaws, etc. Identificatory information. 756pp. 9¼ x 12¾. 21823-6 Clothbd. $40.00

HOW THE OTHER HALF LIVES, Jacob A. Riis. Journalistic record of filth, degradation, upward drive in New York immigrant slums, shops, around 1900. New edition includes 100 original Riis photos, monuments of early photography. 233pp. 10 x 7⅞. 22012-5 Pa. $7.00

NEW YORK IN THE THIRTIES, Berenice Abbott. Noted photographer's fascinating study of city shows new buildings that have become famous and old sights that have disappeared forever. Insightful commentary. 97 photographs. 97pp. 11⅜ x 10. 22967-X Pa. $5.00

MEN AT WORK, Lewis W. Hine. Famous photographic studies of construction workers, railroad men, factory workers and coal miners. New supplement of 18 photos on Empire State building construction. New introduction by Jonathan L. Doherty. Total of 69 photos. 63pp. 8 x 10¾.
23475-4 Pa. $3.00

THE DEPRESSION YEARS AS PHOTOGRAPHED BY ARTHUR ROTH-STEIN, Arthur Rothstein. First collection devoted entirely to the work of outstanding 1930s photographer: famous dust storm photo, ragged children, unemployed, etc. 120 photographs. Captions. 119pp. 9¼ x 10¾.
23590-4 Pa. $5.00

CAMERA WORK: A PICTORIAL GUIDE, Alfred Stieglitz. All 559 illustrations and plates from the most important periodical in the history of art photography, Camera Work (1903-17). Presented four to a page, reduced in size but still clear, in strict chronological order, with complete captions. Three indexes. Glossary. Bibliography. 176pp. 8⅜ x 11¼.
23591-2 Pa. $6.95

ALVIN LANGDON COBURN, PHOTOGRAPHER, Alvin L. Coburn. Revealing autobiography by one of greatest photographers of 20th century gives insider's version of Photo-Secession, plus comments on his own work. 77 photographs by Coburn. Edited by Helmut and Alison Gernsheim. 160pp. 8⅛ x 11.
23685-4 Pa. $6.00

NEW YORK IN THE FORTIES, Andreas Feininger. 162 brilliant photographs by the well-known photographer, formerly with Life magazine, show commuters, shoppers, Times Square at night, Harlem nightclub, Lower East Side, etc. Introduction and full captions by John von Hartz. 181pp. 9¼ x 10¾.
23585-8 Pa. $6.95

GREAT NEWS PHOTOS AND THE STORIES BEHIND THEM, John Faber. Dramatic volume of 140 great news photos, 1855 through 1976, and revealing stories behind them, with both historical and technical information. Hindenburg disaster, shooting of Oswald, nomination of Jimmy Carter, etc. 160pp. 8¼ x 11.
23667-6 Pa. $5.00

THE ART OF THE CINEMATOGRAPHER, Leonard Maltin. Survey of American cinematography history and anecdotal interviews with 5 masters—Arthur Miller, Hal Mohr, Hal Rosson, Lucien Ballard, and Conrad Hall. Very large selection of behind-the-scenes production photos. 105 photographs. Filmographies. Index. Originally Behind the Camera. 144pp. 8¼ x 11.
23686-2 Pa. $5.00

DESIGNS FOR THE THREE-CORNERED HAT (LE TRICORNE), Pablo Picasso. 32 fabulously rare drawings—including 31 color illustrations of costumes and accessories—for 1919 production of famous ballet. Edited by Parmenia Migel, who has written new introduction. 48pp. 9⅜ x 12¼. (Available in U.S. only)
23709-5 Pa. $5.00

NOTES OF A FILM DIRECTOR, Sergei Eisenstein. Greatest Russian filmmaker explains montage, making of Alexander Nevsky, aesthetics; comments on self, associates, great rivals (Chaplin), similar material. 78 illustrations. 240pp. 5⅜ x 8½.
22392-2 Pa. $4.50

AMERICAN ANTIQUE FURNITURE, Edgar G. Miller, Jr. The basic coverage of all American furniture before 1840: chapters per item chronologically cover all types of furniture, with more than 2100 photos. Total of 1106pp. 7⅞ x 10¾. 21599-7, 21600-4 Pa., Two-vol. set $17.90

ILLUSTRATED GUIDE TO SHAKER FURNITURE, Robert Meader. Director, Shaker Museum, Old Chatham, presents up-to-date coverage of all furniture and appurtenances, with much on local styles not available elsewhere. 235 photos. 146pp. 9 x 12. 22819-3 Pa. $6.00

ORIENTAL RUGS, ANTIQUE AND MODERN, Walter A. Hawley. Persia, Turkey, Caucasus, Central Asia, China, other traditions. Best general survey of all aspects: styles and periods, manufacture, uses, symbols and their interpretation, and identification. 96 illustrations, 11 in color. 320pp. 6⅛ x 9¼. 22366-3 Pa. $6.95

CHINESE POTTERY AND PORCELAIN, R. L. Hobson. Detailed descriptions and analyses by former Keeper of the Department of Oriental Antiquities and Ethnography at the British Museum. Covers hundreds of pieces from primitive times to 1915. Still the standard text for most periods. 136 plates, 40 in full color. Total of 750pp. 5⅜ x 8½.

23253-0 Pa. $10.00

THE WARES OF THE MING DYNASTY, R. L. Hobson. Foremost scholar examines and illustrates many varieties of Ming (1368-1644). Famous blue and white, polychrome, lesser-known styles and shapes. 117 illustrations, 9 full color, of outstanding pieces. Total of 263pp. 6⅛ x 9¼. (Available in U.S. only) 23652-8 Pa. $6.00

Prices subject to change without notice.

Available at your book dealer or write for free catalogue to Dept. GI, Dover Publications, Inc., 180 Varick St., N.Y., N.Y. 10014. Dover publishes more than 175 books each year on science, elementary and advanced mathematics, biology, music, art, literary history, social sciences and other areas.